Sons of the Gods, Children of Earth

*Ideology and Literary Form
in Ancient Greece*

Peter W. Rose

Cornell University Press

Ithaca and London

First published 1992 by Cornell University Press.

International Standard Book Number 0-8014-2425-9 (cloth)
International Standard Book Number 0-8014-9695-0 (paper)
Library of Congress Catalog Card Number 91-31562
Printed in the United States of America

Librarians: Library of Congress cataloging information appears on the last page of the book.

⊗ The paper in this book meets the minimum requirements of the American National Standard for Information Sciences—Permanence of Paper for Printed Library Materials, ANSI Z39.48-1984.

For Susan, Jessica, and Daniel—
my favorite comrades

Contents

Preface ix

Introduction: Marxism and the Classics 1
 The Problem of Methodology in the Study of the
 Classics Today 3
 Orthodox Marxism 6
 After Orthodoxy: Some Unorthodox Marxists 12
 Marxizing Alternatives to Marxism 14
 Marx and Utopia: The Quest for Realizable Freedom 17
 Consciousness, Class, and Doing History 21
 Marx and Cultural Production 24
 Mediation, Hegemony, and Overdetermination 27
 Jameson: The Double Hermeneutic and the Utopian Impulse 33

1. How Conservative Is the *Iliad*? 43
 The Form: Determinism by Rhythm, by Mode of Composition,
 by Genre 43
 The Traditional Poem and a Traditional Worldview? 46
 The World in the Poems and the World of the Poems 52
 Ideology in the Poems 58
 Formulas: Birth and the Conflict of King against King 64
 Type-Scenes: Contradictions over Property and Merit 78
 Major Story Patterns 82
 The Poet and His Audience 89

2. Ambivalence and Identity in the *Odyssey* 92
 Relation to the *Iliad*, Hesiod, and History 93
 Innovations in the Narrative Structure of the *Odyssey* 98
 The Poet in the Poem 112
 Historicizing the Hero's Identity Abroad and at Home 119
 Ambiguity, History, and Utopia 139

3. Historicizing Pindar: *Pythian* 10 141
 Pindar's Place in the So-Called Lyric Age 142
 The Problem of Pindar's Politics 151
 The Epinician Form 159
 Toward a Double Hermeneutic of *Pythian* 10 165
 History and the "Inner Logic of the Poem" 182

4. Aeschylus' *Oresteia:* Dialectical Inheritance 185
 The Politics of the Tragic Form 185
 Aeschylean Dialectics 194
 Justice and Aeschylus' Presentation of Class 197
 Sexual Politics and the Aristocracy 221
 Politics in the *Libation Bearers* 232
 The Politics of Aeschylean Religion 236
 Patriarchy and Misogyny in the *Libation Bearers* 242
 Democracy in the *Eumenides* 246
 Sexual Politics: Vision and Reality 256
 Utopian Vision versus Tragic Reality 260

5. Sophokles' *Philoktetes* and the Teachings of the Sophists:
 A Counteroffensive 266
 Sophokles and Aeschylus 266
 Aristocratic Terminology and the Role of the Sophists 270
 Sophistic Anthropology: Three Stages 273
 Sophokles' Response: Transforming Anthropology into Drama 278
 The Way Out: The Supersession of the Sophists 319
 The Athens of 409 B.C. 327
 The Utopian Moment 330

6. Plato's Solution to the Ideological Crisis of
 the Greek Aristocracy 331
 Ideology and History 332
 What Crises? 335
 Plato's Response: The Form and Structure of the *Republic* 341
 General Characteristics of Plato's Solutions 348
 Plato's Discourse of *Phusis* 351
 Phusis and *Didachē:* The Collapse of an Opposition 365
 Conclusion 369

 Afterword 370

 References 375

 Index 407

Preface

I attempt in the Introduction to set forth my critical goals and presuppositions. It may be helpful, however, if I indicate briefly here some of my more mundane operating assumptions.

Although I have extensively revised the parts of the text originally presented separately, I have retained a certain amount of repetition of critical issues and even of historical data from chapter to chapter in order to make each chapter internally coherent. I have tried to limit this repetition to those critical concepts and data that seem to me essential to the argument of the individual chapters.

Except where otherwise noted, all translations of Greek cited in the text are my own, and it may help the reader if I explain my procedures. Although I have made no effort to retain the original meter or some modern approximation, in translating poetry I have been at pains to retain as much as possible of the content and emphases of the original line units, occasionally using italics to suggest the force of an emphatic particle in the Greek or an emphatic initial position in a line or colon. Nowhere am I more painfully aware of the truth of the old cliche *traduttore traditore* than in dealing with the language of Aeschylus, in which the deliberate exploitation of the inherent ambiguities of language reaches some sort of ne plus ultra. Although at times I have envied the complexity that a text like Goldhill's book-length study of the *Oresteia* can achieve by not translating—in many cases not even paraphrasing—Greek that is notoriously difficult even for a trained classicist, I feel strongly that the advantage of accessibility to the Greekless reader is well worth the risks of distortion. The field of classical liter-

ature and thought daily demonstrates its capacity to engage the lively intelligences of an extraordinary range of intellectuals who happen not to know Greek but are conscientious in their efforts to benefit from the works of those who do. I have accordingly transliterated all the Greek terms I cite, but I have not been completely consistent. In the case of proper names, I have transliterated all but those that struck me as most familiar in their Latinate form. Even with these I have usually preferred the more Greek *k* to *c* in names such as Herakles or Kimon, but here too I have not been completely consistent. On this matter we are still in a transitional phase in which what looks too Latinate or too gratuitously pedantic to one reader looks normal to another. My subjective criterion has been how I find myself pronouncing the name in my classes. Thus, though I have taught Lattimore's translation of the *Iliad* for many years, I still cannot bring myself to say "Achilleus" rather than "Achilles"—much less write "Akhilleus."

In transliterating Greek I have indicated long *e*'s and *o*'s but have ignored long *a*'s, *i*'s and *u*'s. This practice is arbitrary, but it corresponds to the Greeks' own use of different symbols only for the long *e* and long *o*. It has, moreover, the advantage of indicating to the Greekless reader that such important value terms as *timē, dikē,* and *aretē* do not end in a silent *e*.

Preliminary efforts that culminated in this text were made possible by an NEH Fellowship in 1979–80. Subsequent released time from Miami University is also gratefully acknowledged. In the course of so long a project I have incurred many debts from those who read and offered comments on various drafts of various chapters. If I omit any names here through oversight, I beg these persons not to perceive the omissions as ingratitude: Judith deLuce, Walter Donlan, Michael Gagarin, Peter Green, Mitchell Greenberg, Judith Hallett, Britton Harwood, Albert Henrichs, Susan Jarratt, Frank Knobloch, W. Thomas MacCary, Steven A. Nimis, Douglass Parker, Charles Segal, Linda Singer, Georges Van Den Abeele, Nat Wing, Betsy Wing, R. P. Winnington-Ingram, Froma Zeitlin. If at times I have too sharply differentiated my views from those of these scholars', I can only hope that this too is not perceived as ingratitude—only as proof of how far they are from any share in my own errors.

Quite apart from his kindnesses as a reader, Steven Nimis has been a guide of saintly patience through the Hell of Gutenberg into the Purgatory of Microsoft Word.

A special sense of indebtedness and sadness invades me at the thought that I shall never know the responses, some doubtlessly scathing, of three friends now dead who were in varying degrees also mentors and with whom I so enjoyed discussing and arguing over the Greek

texts that are the subject of this volume: Cedric Whitman, Eric Havelock, and Adam Parry.

My debt to Fredric Jameson is of a quite different order. Encountering his work in the mid-1970s fundamentally changed my conception of the relation between my political commitments and my pedagogical and scholarly activities. Some eight years of attending the summer Institutes on Culture and Society, of which Fred was a founder and has remained a crucial component, have confirmed and developed my sense that there is a broader audience for the issues raised here than the "community" of classical scholars who previously tended to define my horizons of the possible. I feel indebted to all the participants at these institutes but must single out, in addition to Fred Jameson, Paul Smith, whose special contributions have been instrumental in organizing some of the best institutes and whose rather different critical concerns have repeatedly challenged and informed my own. The friendship of both has been sustaining.

Though it may seem perverse, I thank all the comrades in various struggles, local, national, and international, whose exhortations and inspiration over the years have guaranteed that this book was so long in coming: from New Haven I recall especially Liz Farrell, Bob Cook, Karin Cook, Dave Dickson, George Johnson, Liz Henderson, Alice Mick, Henry Tamarin, and Rick Wolff; from Austin, Julianne Burton, Martin Wiggington, Bobby Nelson, Cam Cunningham, Chris Cunningham, Terri Allbright, and Mike Rush; from Santa Cruz, Gill Greensight, Mike Rotkin, Candace Falk, and Lowell Finley; from Oxford, Ohio, Susan Eacker, Joe Napora, Linda Kimball, and Rick Momeyer. I believe that even books such as this one ultimately derive whatever value they may have from lived experience. All these people and so many more I cannot name have immeasurably enriched mine.

I also express my deep appreciation for the sustained interest and patient cajoling of Bernhard Kendler. No small part of his help consisted in finding such perceptive, challenging, and helpful readers. Where I have not followed all their many fine suggestions, it has been with grave qualms. I am well aware how much they have improved this text. Whoever you are, many thanks! Finally, many thanks to John Thomas for intelligent and sensitive copyediting.

Some of the following chapters include material adapted from texts that have previously appeared in print: Chapter 1, "How Conservative Is the *Iliad*?" *Pacific Coast Philology* 13 (October 1978); Chapter 2, "Class Ambivalence in the *Odyssey*," *Historia* 24/2 (1975); Chapter 3, "The Myth of Pindar's First Nemean: Sportsmen, Poetry, and *Paideia*," *Harvard Studies in Classical Philology* 78 (1974), and "Towards a Dialectical Hermeneutic of Pindar's Pythian X," *Helios*, n.s. 9 (1982); Chapter 5,

"Sophocles' *Philoctetes* and the Teachings of the Sophists," *Harvard Studies in Classical Philology* 80 (1976). I gratefully acknowledge the permission to use these texts granted by the Philological Association of the Pacific Coast, *Harvard Studies in Classical Philology*, *Helios*, and *Historia*.

PETER W. ROSE

Oxford, Ohio

Sons of the Gods,
Children of Earth

The world has long dreamed of possessing something of which it has only to be conscious in order to possess it in reality.

—Karl Marx

The task to be accomplished is not the conservation of the past, but the redemption of the hopes of the past.

—Max Horkheimer and Theodor Adorno

Every image of the past that is not recognized by the present as one of its own concerns threatens to disappear irretrievably.

—Walter Benjamin

Introduction:
Marxism and the Classics

In this book I propose to apply what I characterize as a Marxist approach to several ancient Greek texts. For me, such an approach implies a simultaneous concern with the politics of artistic form and with a central ideological theme. That theme, which has largely determined my choice of texts, is *inherited excellence*—the ways in which ideas about descent from gods or heroes and about aristocratic origins play a central role and undergo significant transformations in texts that both reflect and constitute the Greek cultural heritage.

There is of course no innocence in my choice of the theme of inherited excellence. Contemporary debates over "nature versus nurture," ethnic difference, gender essentialism, sociobiology, and various other modern equivalents of social Darwinism have enormous consequences in concrete contemporary political struggles. At the same time, I am wary of suggesting a simple continuity between ancient Greek ideological struggles and contemporary issues that operate at a whole other order of complexity.[1] I offer neither a full Foucauldian archaeology of

[1] There is a world of difference between the evolutionary speculations of Xenophanes or Democritos and the revolutionary consequences of Darwin's lifework. For an exceptionably readable and intelligent account, see Clark 1984. For some of the more contemporary ideological struggles in which Darwin and ideas about inherited characteristics are a key factor, see Lewontin et al. 1984 and Gould 1981. For a specifically Marxist exploration of some of these issues, see Williams, "Ideas of Nature" and "Social Darwinism" (1980: 67–102). The debate both within feminism and against feminism centered on concepts of nature is so extensive and intense that it would perhaps be folly to signal a few representatives; but there is a useful historical perspective in Merchant 1980. See also Fuss 1989 and J. W. Scott 1988. Marable (1983: 252–53) comments

the concepts at stake nor a simple set of ancient origins, but I believe that the contemporary relevance of this theme emerges clearly.

I attempt neither complete readings of the texts nor complete coverage of all the ramifications of my theme, but I have chosen texts in which the ideas about inherited excellence attract to themselves many traditionally central issues such as the nature of the Greek hero and the relations of gods to mortals or of individuals to communities. At key points the exploration of inherited excellence in turn leads to more contemporary issues such as sexual politics or the opposition between nature and culture. On the formal level, my texts include the major genres of epic, choral lyric, tragedy, and philosophical dialogue. I attempt to integrate my reading of the historical emergence of these forms with the shifting treatments of my central theme.

Between the *Iliad* of Homer and the *Republic* of Plato there are many other texts one might examine to support, amplify, or qualify any conclusions one might draw from the texts I have chosen. I particularly regret, for example, not discussing Sophokles' *Ajax* or Euripides' *Electra* or *Herakles,* in each of which ideas about inherited excellence figure prominently. I have tried, however, to suggest an approach rather than to exhaust the topic. The major drawback of a more narrowly focused traditional philological approach—one that might be called something like "*Phusis:* its roots and branches"—is that it precludes grasping the rich relations of this central theme with the full range of other ideological themes in the works where it occurs.[2]

Though I eschew the completeness of an exhaustive philological survey, I have chosen some of the major moments in any trajectory one might draw of this theme from Homer to Plato. I offer only a severely abbreviated account of the period between the *Odyssey* and Pindar because of the paucity of complete texts germane to my theme. Nonetheless, I comment in some detail on relevant dimensions of Hesiod, whose texts, in my reading of the *Odyssey,* function almost as a running gloss. So too in my treatment of Pindar I discuss early lyric, the Presocratics, and Theognis. I touch on Hesiod and Solon in my analysis of the trilogy form apropos of the *Oresteia.* Rather extensive discussions of the Sophists are central to my chapters on Sophokles' *Philoktetes* and

on the neoracist efforts to seek a natural basis for the exploitation of one race by another in the work of Carleton Coon, William Shockley, and Arthur Jensen. Gould has ably commented on the reactionary thrust of sociobiology (in Montagu 1980: 283–90; see also Steven Rose's contribution, 158–170).

[2]This is not to suggest that I have not learned much from more traditional philological or sociological works such as Beardslee 1918, Thimme 1935, Haedicke 1936, Heinimann 1965 [1945], Lacey 1968, Donlan 1980, or even Arnheim 1977.

Plato's *Republic*. Moreover, for reasons that become clear later in this introduction, I include more detailed historical analysis than is generally fashionable today in studies of literary texts. Although variations on the theme of inherited excellence do not end with Plato, his *Republic* constitutes an appropriate terminal point for exploring a set of ideological and practical alternatives that reach a kind of crisis by the end of the fifth century—a crisis to which Plato responded with so radical a solution that subsequent debate must in some sense start with him.

The Problem of Methodology in the Study of the Classics Today

The issue of how to approach the classics is particularly vexed in public discussions and is at least potentially a troubling personal question for anyone who earns a living today by teaching the classics. The classics in the West today appear to face two obvious and not necessarily incompatible options. On the one hand, their study may be reduced to a purely antiquarian hobby, either by benign neglect or by self-conscious rejection on ideological grounds. A variety of progressive groups have rightly objected to being indoctrinated with an imposed canon of texts which, whatever their virtues, are strikingly elitist and misogynistic as well as more subtly racist. On the other hand, the classics have recently been subjected to yet another attempted appropriation by a new wave of reactionary ideologues—the so-called New Right. Though this is not the place for a full history of appropriations of the classics, in the light of this contemporary crisis it is worth recalling briefly a few historical markers in the career of classics as an ideological signifier.[3]

For a committed monarchist like Thomas Hobbes in the seventeenth century, the political influence of the classics was overwhelmingly progressive and as such utterly pernicious:

> By reading these Greek, and Latine Authors, men from their childhood have gotten a habit (under a false shew of Liberty,) of favouring tumults, and of licentiously controlling the actions of their Soveraigns; and again

[3]Jennifer Roberts's intriguing examination of English views of Athenian democracy from the 1630s to the late 1940s has appeared recently (1989). For early American appropriations, see Meyer Reinhold's "Introduction" (1975: 1–27). Turner's fine study, particularly his chapter "The Debate over the Athenian Constitution" (1981: 187–263), covers a wider range than the word "Victorian" in its title suggests. His work is put to good use in E. M. Wood's opening chapter, "The Myth of the Idle Mob" (1989: 5–41).

of controlling those controllers, with the effusion of much blood; as I think I may truly say, there was never any thing so deerly bought, as theseWestern parts have bought the learning of the Greek and Latine tongues. (1950 [1651]: pt. 2, chap. 21, 183)

Yet to a revolutionary Christian like Blake, the task of building a new Jerusalem "among these dark Satanic Mills" evokes a bitter condemnation of

the Stolen and Perverted Writings of Homer & Ovid: of Plato & Cicero which all Men ought to condemn. . . . Shakespeare & Milton were both curbed by the general malady & infection from the silly Greek & Latin slaves of the Sword. . . . We do not want either Greek or Roman Models if we are but just & true to our own Imaginations. ("Milton, a poem in 2 Books," Preface. Blake 1982 [1804]: 95)

Throughout the nineteenth century, classics played a significant role not only in training bureaucrats and imperialists but in reinforcing gender roles (Ong 1962; Fowler 1983). By the Victorian period, however, as Eagleton (1983) has reminded us, classics stood generally for a crumbling elitist cultural hegemony, one no longer adequate to the need of controlling the so-called rising classes: "The urgent social need, as Arnold recognizes, is to 'Hellenize' or cultivate the philistine middle class" (24). Eagleton also quotes from a study of English literature written in 1891: "The people . . . need political culture, instruction, that is to say, in what pertains to their relation to the State, to their duties as citizens; they also need to be impressed sentimentally. . . . All of this [Eagleton summarizes here] . . . could be achieved without the cost and labour of teaching them the Classics"(25–26). The solution, as Eagleton goes on to show, was the invention of English literature as a central component of the middle-class liberal arts curriculum, leaving classics in the original as the prerogative of the elite schools.

Today the agenda of the New Right is to use the classics of Greece and Rome along with other classics of a specifically Western tradition to rephilistinize, so to speak, progressive forces in our society. I have specifically in mind the enthusiastic support of the classics by such figures as Allan Bloom (1987), who sees in the canon of "great books" a prestigious vehicle for repudiating the demands of women, people of color, gays, and workers for an education supportive of their aspirations to full humanity.[4] Any sort of "relativism" is anathema to Bloom,

[4]For one classicist's assessment of Bloom, see Nussbaum 1987. I also wish to express my enjoyment of comments on Bloom by James Dee and Susan Ford Wiltshire at a meeting

who assures us that "the claim of 'the classic' loses all legitimacy when the classic cannot be believed to tell the truth" (374). For Bloom, it seems, there can only be one truth, which, he repeatedly claims, is founded in nature. "The women's movement," he assures us, "is not founded on nature" (100), and he invokes the most misogynistic moment in Aristophanes to support this conclusion (99). Similarly, William Bennett, while Ronald Reagan's secretary of education, tirelessly bounced around the country upholding his version of the classics to indict women's studies, black studies, film and popular culture studies, deconstruction—in short, any form of intellectual endeavor that offers a meaningful critical perspective on the hegemonic discourse (Franco 1985).

In the light of these unacceptable options, my project consists in opening to scrutiny dimensions of classical texts that have been thus eagerly appropriated for an allegedly univocal canon of Western "masterpieces"—works offered as quite transparent embodiments of eternal truths of "the human condition" or the "human essence." To suggest provisionally another perspective on the value of the classics, I quote here a few excerpts from Antonio Gramsci's analysis of the old educational system in Italy in the early part of this century. He views with a cold, ironic eye the class functioning of the access to classics and the essential arbitrariness of their constitution as the literally privileged educational vehicle:

> The fundamental division into classical and vocational (professional) schools was a rational formula: the vocational school for the instrumental classes, the classical school for the dominant classes and the intellectuals. . . . The technical school . . . placed a question mark over the very principle of a concrete programme of general culture, a humanistic programme of general culture based on the Graeco-Roman tradition. This programme, once questioned, can be said to be doomed, since its formative capacity was to a great extent based on the general and traditionally unquestioned prestige of a particular form of culture. (1971: 26–27)

At the same time, Gramsci singles out for praise in this older classical education the built-in invitation to make connections, an opportunity all too rarely realized in the teaching of classics today:

> In the old school the grammatical study of Latin and Greek, together with the study of their respective literatures and political histories, was an educational principle—for the humanistic ideal, symbolized by Athens and

of the Classical Association of the Midwest and South (April 1988) and my appreciation for an opportunity to read some unpublished remarks by Norman O. Brown.

Rome, was diffused throughout society. . . . His [the male child's] educa-
tion is determined by the whole of this organic complex, by the fact that he
has followed that itinerary . . . has passed through those various stages,
etc. He has plunged into history and acquired a historicizing understand-
ing of the world and of life, which becomes a second—nearly spontane-
ous—nature. . . . Logical, artistic, psychological experience was gained
unawares, without a continual self-consciousness. Above all a profound
"synthetic," philosophic experience was gained, of an actual historical de-
velopment. This does not mean—it would be stupid to think so—that
Latin and Greek, as such, have intrinsically thaumaturgical qualities in the
educational field. (37–39)

Classics as a field of inquiry has no unique claim as the vehicle for
teaching students how to integrate the "scattered limbs" of a culture,
but at its best it is an excellent vehicle for critical exploration of how
different aspect of a culture relate to each other. I believe that an ap-
proach, which I call Marxist, offers extraordinary advantages for such
a critical appropriation of the classics. The ambiguities, however, which
the term "Marxist" has acquired—not to mention the much heralded
death of Marxism in Eastern Europe—might understandably suggest
to some that it can be discarded as meaningless. My own perception is
that the virulence with which the term is hurled as a mark of oppro-
brium and the ferocity with which it is claimed by some and denied to
others indicate that the term itself is still very much a site of struggle.
Particularly at a moment when the declarations of the end of Marxism
are most strident, I am loathe to jump on that particular bandwagon.
As someone who grew up in the 1950s, when demonstrations of the
irrelevance of Marxism constituted a veritable branch of academic in-
dustry, I am as skeptical about claims for the irrelevance of Marxist
methodology as I am about claims for the end of history.

Orthodox Marxism

Most of us grew up with what we thought was a pretty clear idea of
what "Marxist" meant. It meant, above all, economic determinism. In
this perspective, the mode of production is all important. The mode of
production consists of two elements: first, the forces of production—
the sum of the available technological and human means for the sup-
port of human life through the exploitation of nature; and second, the
relations of production—the social relations of human beings resulting
from the organization of that production. These two elements together
constitute the determining base or infrastructure of a society. Political,

legal, religious institutions and beliefs, arts, philosophy—culture in general—all are envisioned as a superstructure, more or less passively dependent on and determined by this base.[5] Since in all known historical societies the relations of production involve profoundly unequal distribution of work, power, and privilege, social relations amount to class relations of an inevitably antagonistic character. Thus, within this superstructure, ideas—whether set forth in works of art or abstract theory or promulgated by various institutions within the society, constitute ideology, which simply reflects these base structures distortedly as in a *camera obscura*.[6] The degree of the distortion itself is a direct consequence of the class interests of the propounders of the ideas—the ideologues. These elements—mode of production, forces and relations of production, base and superstructure, class, ideology and reflection—constitute the chief thematics of orthodox Marxism.

Marxist historiography in this older sense was concerned first of all with the periodization of the past and the characterization of societies in terms of modes of production: primitive communism or tribal society, the Asiatic mode or Oriental despotism, the ancient or slaveholding mode, feudalism, capitalism, and—if the future turns out right—communism.[7] Once this periodization is granted, the content

[5]Marx's classic statement of the base/superstructure dichotomy is in the preface to *A Contribution to the Critique of Political Economy* (1859): "In the social production of their existence, men [human beings] inevitably enter into definite relations, which are independent of their will, namely relations of production appropriate to a given stage in the development of their material forces of production. The totality of these relations of production constitutes the economic structure of society, the real foundation, on which arises a legal and political superstructure and to which correspond definite forms of social consciousness." *MECW* 29:263. Note that the superstructure in this formulation has two aspects: the legal and political aspects, which Marx seems to recognize as themselves institutions and practices, and corresponding forms of consciousness, which Althusser (1971: 127–93) insists are equally embodied in material institutions and practices, that is, "ideological apparatuses of the state." [Whenever possible I cite Marx from the still-appearing *MECW*. I have found no translation that is sensitive to the sexist use in English of "men" or "man" for human beings in general. I have checked the German only of the *Economic and Philosophic Manuscripts of 1844*, the *German Ideology*, the *Eighteenth Brumaire of Louis Napoleon*, and *Capital*, vol. 1 (the most generalizing texts I cite). Marx consistently uses *Mensch* or *die Menschen* where translators use "man" or "men" in the (sexist) generic sense.]

[6]The phrase *camera obscura* was applied by Marx and Engels in the *German Ideology* (1845–46) to the distorted image of reality presented in all ideology: "If in all ideology men and their relations appear upside-down as in a *camera obscura*, this phenomenon arises just as much from the historical life-process as the inversion of objects on the retina does from their physical life process" (*MECW* 5:36).

[7]Marx and Engels first articulated the concept of a sequence of modes of production in the *German Ideology* (*MECW* 5:32–35), adding various refinements and modifications over the years. The Asiatic mode seems to have been the most tentatively proposed and most readily abandoned in subsequent theory, in part perhaps because it was understandably offensive to Stalin (Treadgold 1987: 309). For a survey of the checkered history of the concept and an attempt to revive it on a new basis, see Godelier 1965: 2002–27

of history consists, in the one hand, of detailed analyses of the level of technology (i.e., the most emphasized aspect of the forces of production) and, on the other, to cite the *Communist Manifesto* (1848), "the history of class struggles" (i.e., the relations of production): "Freeman and slave, patrician and plebeian, lord and serf, guild-master and journeyman, in a word, oppressor and oppressed, stood in constant opposition to one another, carried on an uninterrupted, now hidden, now open fight, a fight that each time ended, either in a revolutionary reconstitution of society at large or in the common ruin of the contending classes" (*MECW* 6:482).[8]

The predictability of this sort of Marxism for classical studies is neatly illustrated by Chester Natunewicz's bibliographic survey of Eastern European classical scholarship (1975: 171–97; cf. 1971: 146–50).[9] First, there have been elaborate studies of the slave mode of production. Discussions of slavery—with particular emphasis on rebellions or stirrings of discontent—have taken into account not only slaves but also gladiators, soldiers, provincials, the Romans' so-called allies, peasants, and urban masses. Literary studies have focused on the class role of authors and reflections of class struggle in their work, enlisting this or that poet, historian, or philosopher on the side of reaction or progress: Homer and Vergil, Plato and Thucydides are clearly "bad guys," whereas Epicurus and Lucretius—the chief representatives of ancient materialism—have been singled out for virtual canonization among socialist saints (Natunewicz 1975:174–75).

In English and American classical studies, this orthodox Marxism has been essentially all we have known until quite recently (Padgug 1975; Arthur and Konstan 1984). The work of Gordon Childe, Benjamin Farrington, Alban Winspear, George Thomson, and the Woods comes immediately to mind. I am concerned neither to correct it nor to defend it as such. The value of the questions such work poses in the scrutiny of Greek and Roman societies is in any case separable from the

and 1977: 99–124. For the role of the Asiatic mode in the debate over Marx's alleged europocentrism and unilinear developmental model, see Lekas 1988: 59–71. In his "Critique of the Gotha Program" (in Tucker 1978: 525–41), Marx breaks down the future communist society into two phases (531), and this distinction is usually read as a distinction between a socialist phase and a true communist phase.

[8]It is worth underlining Marx's final phrase here as a corrective to those more exhortatory passages that suggest Marx's naive belief in the inevitability of progress. He knew too much history not to be aware of the real possibility that full-scale conflict could indeed lead to the common ruin of the contending classes.

[9]I should add that my sense of the predictability of this work, which I do not know firsthand, may derive in no small measure from Natunewicz's manner of presenting it. But we are much in his debt for his extensive labors in this apparently barren vineyard. The work of Andreev, some of which has been translated into German, suggests the sophistication possible within this framework.

value of any specific answers these scholars may have offered. Indeed, no set of presuppositions can guarantee insightful or sophisticated results, but they can either open or bracket indefinitely whole sets of questions. The errors of George Thomson, for example, have been best pointed out by scholars essentially within that tradition, most recently G. E. M. de Ste. Croix (1981: 41), who has brought his massive learning and considerable sophistication to bear in the finest demonstration to date of what this orthodox Marxism has to offer the study of ancient history.[10] The most interesting qualifications in turn of some of Ste. Croix's conclusions have come from the equally orthodox Ellen Meiksins Wood (1989: 39–40, 121).[11]

Orthodox Marxism at its most mechanical, though committed to frequent citations from the authority of Marx himself where possible, owes far more to Engels's efforts to promote Marxism as a comprehensive, totalizing science equally relevant to the analysis of natural phenomena and of human social formations.[12] To invoke nature as the

[10]A sampling of the reviews of Ste. Croix suggests just how vulnerable his will to orthodoxy has made his work to the heavy ironies of those classicists who are, we must assume, themselves quite free of any taint of ideology. Sealey (1982: 319–35) and Green (1983: 125–26) are not surprisingly the most savage and patronizing, saddling Ste. Croix with the horrors of Stalin and even Cambodia (a little historical background of this particular nightmare might at least spread the blame around a little more accurately; see Kiernan 1985). Badian (1982: 37–51), arguably the most prestigious of the lot, is also the most generous. While he too is full of heavy ironies at the expense of Ste. Croix's self-presentation as "properly" Marxist, he is also able to acknowledge that "no other living scholar would be able to produce a book equal to its sweep" (47); "This is an impressive work, and not only in its vast sweep and in the numerous points of detail where Ste. Croix has seen more clearly than others" (50); "Like every major work of history, certainly of ancient history (one thinks of Grote and Mommsen) . . . it is a work of passion" (51). But having put him in the class with giants, Badian is typical in insisting that whatever is valuable in the book is somehow in spite of its Marxism. Apropos of St. Croix's study of the decline of the Roman Empire, Badian declares, "This is the more persuasive the less we hear of strictly Marxist class analysis and the more we mix it with the simpler Aristotelian categories of the rich and the poor and with the status analysis of Finley" (50). In fact, one of the more telling theoretical arguments in Ste. Croix's book is his critique of Finley's preference for the Weberian concept of social status (58, 85–96).

[11]Some might object that E. M. Wood cannot be called an orthodox Marxist because she attempts to attack the orthodox Marxist idea that the slave mode of production offers the best explanation of the historical phenomena of democratic Athens (1989: esp. 36–41). What strikes me as more profoundly orthodox in her most recent book on Athens is her will to explain all political and cultural phenomena as determined quite directly by the class struggle at the level of production. For her more overtly polemical orthodoxy, see her attack on Poulantzas, Laclau, and Mouffe et al. in *The Retreat from Class* (1986).

[12]McLellan (1977: 102–4) notes a general split between, on the one hand, Marx's roots in Hegel and French socialism with a corresponding emphasis on politics, consciousness, and class struggle, and, on the other hand, Engels's concept of development based on technology more clearly inspired by Enlightenment thought and the direct experience of the Industrial Revolution in England. On the reasons for being wary of Engels, see also Lukács 1971, discussed in the text.

foundation for one's views has constituted (for quite a long time, as the ensuing chapters show) perhaps *the* most fundamental ideological gesture.[13] The tendency, observable in Lenin, emerges in its most blatant and disastrous form in Stalin's pamphlet, a work alas long canonical among the Stalinist faithful, "Dialectical and Historical Materialism." This text begins with the declaration:

> Dialectical materialism is the world outlook of the Marxist-Leninist party.
> It is called dialectical materialism because its approach to the phenomena
> of nature is *dialectical*, while its interpretation of the phenomena of na-
> ture, its conception of these phenomena, its theory, is *materialistic*.
> Historical materialism is the extension of the principle of dialectical ma-
> terialism to the study of social life . . . to the study of society and its history.
> (1940: 1)[14]

Marx here is turned on his head: an analytic method focused entirely on the phenomena of social life in history with passing metaphorical invocations of the laws of natural science is here presented as primarily an approach to nature and a study of society and history only by extension. The direct consequences of this perspective in the brutal quest for a purely technological solution to Russia's chronic underdevelopment and a savage enforcement of what soon became not just the party's but one man's version of scientific truth are essential components in the catechism of contemporary anti-Marxism.

In Marx's own historical context it is perhaps no exaggeration to say that no one could offer an analysis of any significant phenomena claiming serious attention without as well claiming for it the prestige of science. The Hegelian dream of subsuming empirical sciences under "absolute science" was swept away by the overwhelming triumphs of

[13]It would not be an overstatement to say that a principal goal of *Capital*, subtitled *A Critique of Political Economy*, is to refute the claims of classical economics that capitalism is natural by historicizing both capitalism itself and earlier accounts of its workings. One example must suffice: "One thing, however, is clear—Nature does not produce on the one side owners of money or commodities [*Geld-oder Warenbesitzer*], and on the other men [those sc. *Besitzer*] who possess nothing but their own labour-power. This relation has no natural basis, neither is its social basis one that is common to all historical periods" (1967 1:169). An excellent, more contemporary statement of the role of nature in mystifying ideology may be found in Barthes' concluding essay of *Mythologies* (1972: 109–59).

[14]This work was published in 1938 as chap. 4 of Stalin's *A History of the Communist Party of the Soviet Union (Bolsheviks): Short Course;* see Davies sub nomine in Bottomore et al. 1983: 460. See also McLellan, who rightly comments, "It would be putting it mildly to say that Stalin was no very subtle mind when it came to Marxist theory" (1979: 134). For a not very subtle defense of Stalin's theoretical contributions to Marxism, see Cameron 1987: 82–87.

natural science.[15] It is accordingly true that Marx was fond of invoking the notion of laws of economic change applying analogies from the physical and biological sciences.[16] Marx was, however, quite clear that the sort of laws he envisioned are specific to each mode of production and therefore subject to historical modification. They are thus of an entirely different order from the laws posited about natural phenomena.[17] Moreover, as Lukács rightly emphasized as early as 1923, the Hegelian core of Marx's political philosophy was the *"dialectical relation between subject and object in the historical process"* (1971: 3; his emphasis).[18]

Thus even within what could be called orthodox Marxism there existed a marked polarity between, on the one hand, a rigid scientism

[15]Cf. Taylor 1979: 136–37 and Hegel's contrast between knowledge in anatomy ("a collection of items of knowledge, which has no real right to the name of science") and (true) philosophy (1967 [1807]: 67). Hegel subsequently argues that "true thoughts and scientific insight can only be won by the labour of the notion [*Begriff*]. Conceptions alone can produce universality in the knowing process. This universality is critically developed and completely finished knowledge" (128).

[16]In the first preface to *Capital*, vol. 1, for example, Marx speaks of the economic cell-form, compares his work to that of a physicist, and alludes to the natural laws of capitalist production defined as "tendencies working with iron necessity toward inevitable results" (8). His "ultimate aim" is "to lay bare the economic law of motion of modern society" (10)—a clear allusion to Kepler, one of his favorite heroes (cf. McLellan 1973: 457). But even in this first preface it is clear that Marx found the scientific models of life sciences and Darwinian evolution far more congenial to his own Hegelian organicism than were the physical sciences. He defines his standpoint as one "from which the evolution of the economic formation of society is viewed as a process of natural history" and notes as a climactic point, "within the ruling class themselves, a foreboding is dawning, that the present society is no solid crystal, but an organism capable of change, and is constantly changing" (10). For Marx's interest in Darwin, see Letter to Engels, December 19, 1860 (*MECW* 41:232), and Letter to LaSalle, January 16, 1861 (*MECW* 41:246–47), where he declares, "Darwin's work . . . provides a basis in natural science for the historical class struggle. One does, of course, have to put up with the clumsy English style of the argument. Despite all its shortcomings, it is here that, for the first time, 'teleology' in natural science is not only dealt a mortal blow but its rational meaning is empirically explained." See also Krader in Hobsbawm 1982 (192–226).

[17]Marx is more precise in his use of "laws" in his afterword to the second German edition (1873), in which he opposes through quotations from a Russian reviewer the rather platonic assumptions of classical economic theory that "the general laws of economic life are one and the same, no matter whether they are applied to the present or the past" (18–19).

[18]Failure to grasp this fundamentally dialectical character of Marx's thought leads Lekas (1988) to posit the most mechanically deterministic version of the base/superstructure dichotomy as the only truly Marxist view. Every departure from this mechanistic view in Marx's analysis is then seen as an exceptional insight, contradicting and transcending Marx's own orthodoxy. It is striking in fact how many of the insights Lekas praises come from the *Grundrisse*, a lengthy, private, exploratory work in progress (1857–58) at the same time as the composition of the very brief attempt at a simple summary, the preface to the *Critique of Political Economy* (1859), from which the canonical version of the base/superstructure dichotomy is drawn.

obsessed with technology and claiming access to absolute truth by invoking transcendent laws, and, on the other, a more Hegelian tendency, focused on the history of human society and on the dialectic of human action and natural process, and committed to changing the rules of society's games. In this Hegelian sense, science is essentially serious, systematic knowledge worthy of being taken seriously.

After Orthodoxy: Some Unorthodox Marxists (Including Karl)

Although it would be too much to say that the burden of scientism in orthodox Marxism has been discarded, nonetheless de-Stalinization (the 1956 invasion of Hungary, the 1968 invasion of Czechoslovakia, and persecution of Soviet Jews) and the recent breakup of the whole Stalinist empire have contributed progressively during the past four decades to the fragmentation of the Soviet-oriented organized left within the capitalist orbit and fostered a corresponding new openness in Marx-inspired thought. One should add that perceptions of the work of Marx and Engels themselves have been transformed, not only by these political upheavals but also by the publication and dissemination of texts heretofore lost or ignored such as the *German Ideology,* the *Economic and Philosophic Manuscripts of 1844,* and the *Grundrisse,* a massive collection of notebooks constituting preliminary sketches for *Capital.*[19] The result has been a far more complex—more Hegelian, more humanistic—image of Marx, counterbalancing the relentless scientism usually associated with *Capital.*

In addition to Marx and Engels, major Marxist thinkers of the 1930s who were either outside the orbit of Soviet orthodoxy or engaged in a

[19]*The Economic and Philosophic Manuscripts of 1844* were first published in an incomplete form in Russian translation in Moscow in 1927. The first full edition of the German text appeared in 1932. *The German Ideology,* written during 1845–46, Marx and Engels, in their own words, "abandoned to the gnawing criticism of the mice." It was first published by the Marx-Engels Institute of Moscow in 1932. The *Grundrisse,* written in 1857–58, was first published in excerpts in two volumes in 1939 and 1941. The first full German text appeared in 1953. An English translation of the section entitled "Pre-Capitalist Economic Formations" with an excellent introduction by Hobsbawn was published in 1964. For an intelligent appreciation of the *Grundrisse,* see Nicolaus, "The Unknown Marx" in Oglesby 1969 (84–110), largely incorporated in Nicolaus's foreword to his Penguin translation (1973). *MECW* vol. 28 (1986) contains roughly the first half of the *Grundrisse;* vol. 29 (1988), the balance. It is no accident that, as noted above, most of the brilliant insights of Marx in which Lekas finds Marx contradicting Marxist orthodoxy come from the *Grundrisse* (1988, chap. 4). But a significant number also come from the posthumous vol. 3 of *Capital,* which hardly suggests that the *Grundrisse* represents a temporary aberration. For a brilliant and valuable attack—still haunted by the dream of Marxist "science"—on some consequences of the recent attention focused on the early works of Marx, see Althusser, "On the Young Marx" (1969: 49–86).

virtual underground struggle within it have at last received a serious hearing in the wake of de-Stalinization. Antonio Gramsci meditated in a fascist prison on the experience of the Italian left in terms that have seemed far more relevant to many European and American leftists than inferences drawn from the Soviet and Chinese experiences.[20] The Frankfurt School of Marxists, uprooted exiles from Nazi Germany, combined a profound interest in Freud and bourgeois sociology with a specifically Marxist sociology.[21] Georg Lukács, alternately an apologist for and crypto-critic of the Soviet orthodoxy of "realism" in art, has received a more sympathetic reassessment in the post-Stalin era, and his early work has been recognized as itself one of the inspirations for the Frankfurt School.[22] Ernst Bloch, a lifelong friend of Lukács, spiritually a member of the Frankfurt School but scorned for his Stalinism in the 1930s, became a significant inspiration for independent Marxists only in the 1960s, after his conflicts with the East German government led him to ask for asylum from the West German government, which in turn found him a hard pill to swallow.[23] Mikhail Bakhtin, whose book on Dostoevsky appeared in 1929 only after he had been arrested in a purge, was virtually unknown in both the East and the West until an edition of the Dostoevsky study was permitted to appear in the Soviet Union in 1963. After this point his works began to resurface amid a

[20]For an appreciation of Gramsci's contributions to Marxism, see especially Mouffe 1979, Sassoon 1982 and 1987, Femia 1987 and Buttigieg 1986. In addition to the *Selections from the Prison Notebooks* (1971), two collections of Gramsci's political writings have also appeared (1977 and 1978) as well as a collection of his writings on cultural issues (1985). See also the useful *Reader* by Forgacs (1988).

[21]For a useful collection of some basic texts, see Arato and Gebhardt 1978. For attempts at historical and critical assessments, see Jay 1973 and Held 1980. Jameson 1971 is primarily devoted to the work of the Frankfurt School but also includes discussions of Lukács, Bloch, and Sartre. Buck-Morss 1977 concentrates on Adorno's intellectual interactions with Benjamin but is full of insights on the whole experience and intellectual trajectory of the Institute for Social Research.

[22]For a sympathetic assessment that situates Lukács rightly within the general critical framework of the Frankfurt School, see Jameson 1971: 160–205. I also find Sontag's brief essay (1966: 83–92) on Lukács extraordinary for its time (first published in 1964). She rightly, in my view, celebrates the political philosopher of *History and Class Consciousness* over all the simplistic literary criticism that magisterially designates "good guys" and "bad guys" while virtually dismissing a serious encounter with most of the artistic production of the twentieth century. At the same time, her 1965 postscript, while rightly critiquing the inadequate theorization of form and content in Hegel-inspired, "historicizing" critics, seems to endorse a notion of the total autonomy of art from history and society that solves a problem by merely refusing it. For the specifics of Lukács's influence on the Frankfurt School, see Buck-Morss 1977: 25–28. Jameson in *The Political Unconscious* (1981: 13) alludes to "the flawed yet monumental achievements . . . of the greatest Marxist philosopher of modern times, Georg Lukács." More recently, (1988b), he has again taken on the task of defending Lukács's contemporary relevance. See also G. Steiner 1970: 305–47 and Feenberg 1986.

[23]For a suggestive overview of Bloch's life and work, see Zipes's "Introduction" in Bloch 1988 (xi–xliii). See also Hudson 1982 and Jameson 1971: 116–59.

seemingly undiminished crescendo of enthusiasm in the West for his achievements.[24] All these figures have in varying degrees contributed to and enriched the meaning of a Marxist approach to cultural analysis.

Marxizing Alternatives to Marxism

Several highly influential European intellectual developments, most notably structuralism, have clearly acknowledged their profound indebtedness to the writings of Marx (e.g., Lévi-Strauss 1974: 57–58; 1967: 340–41). Some have labeled themselves post-Marxists to indicate how much they owe to Marx's critical method but also to distance themselves from adherence to the alleged eternal verities and essentialism of orthodox Marxism.[25] A similar ambivalence characterizes much political and cultural theory produced by feminists and those who define their positions primarily in terms of struggles against racism or for the environment: key aspects of Marx's analysis are seen as indispensable while others are rejected as untenable or potentially counterproductive.[26] Ironically, then, the prestige of Marxism has risen dramatically from its nadir in the 1950s, but a new array of philo-

[24]For an account of the fortunes of Bakhtin's reputation, see Clark and Holquist 1984: vii–x.

[25]I refer especially to the paired work of Hindess and Hirst (1975 and 1977) and to Laclau and Mouffe 1985. On the relation of Laclau and Mouffe to Marxism, see the lively exchange between them (1987) and Geras (1987 and 1988) as well as the far more sympathetic critique by Mouzelis (1988). The embarrassingly savage polemics of Geras and E. M. Wood (1986), though they occasionally score some points with which I would agree, seem so innocent of the Saussurean revolution that one often feels they are unaware of the very crisis to which post-Marxism, whatever *its* lacunae, seeks to respond. See also the work of French post-Marxists, whose titles are often indicative of their post-Marxist posture; e.g., Baudrillard's *The Mirror of Production* (1975), Lyotard's *The Postmodern Condition* (1984), Nancy's *La communauté désoeuvrée* (1986) [= "Community at Loose Ends"(?)—*désoeuvrée* is an untranslatable pun that also suggests the irrelevance of the category of work (*oeuvre*) and perhaps workers to any notion of community, which in any case is itself presented as a dangerous illusion], or Gorz's *Farewell to the Working Class* (1982).

[26]On feminism, see Firestone 1970: chap. 1; Hartmann in Sargent 1981 (1–42), as well as the extensive responses in the rest of that volume; Vogel 1983; Delphy 1984; Donovan 1985: 65–90; MacKinnon 1982: 515–44; Hartsock 1983; Barrett (1988); and Nicholson in Benhabib and Cornell 1987. Barrett, once the most persuasive of "Marxist-feminists," has more recently espoused a position very sympathetic to Laclau and Mouffe (presentation at the annual meeting of the Modern Language Association, Washington, D.C., 1989). On Marx and issues of race, see Marable 1983. Hooks spans both feminism, and the black movement (1981 and 1984). On Marx and the environment, see Merchant 1980, Gorz 1980, and Weston 1990, which surveys recent leftist pronouncements on ecology and calls attention to the appearance of an impressive new journal edited by Marxist economist James O'Connor, *Capitalism, Nature, Socialism*. See O'Connor's theoretical introduction (1988).

sophically and politically compelling objections have increased the intellectual stakes in any explicitly Marxist critical endeavor.

Another consequence of these complex developments is that the term "Marxist," as a characterization of an approach to history, culture, and society, is by no means clear. In classics, the relatively orthodox work of Ste. Croix, while inspiring in some quarters the expected ire provoked by anything called Marxist, has been respectfully received by at least a few highly reputable non-Marxist scholars. Far more acceptable, however, to a broad range of American and English classicists is the rich output of post-Marxist Jean-Pierre Vernant and his associates, who in general have eschewed all labels.[27] More relevant is the fact that the richness and sweep of the approaches they combine in their analyses presuppose a serious encounter with the work of Marx. But whatever their relationship to the Marxist label, it is no accident that such perceptive readers display such varying reactions and frequently deep ambivalence toward Marx. This is perhaps an inevitable function of deep tensions within Marx's own work—tensions concisely summed up by Maynard Solomon:

> Marx's work arose in part as a reaction against the grandiose attempts at the systematization of knowledge by his metaphysical predecessors. His intellectual labors can be regarded as a perpetual tension between the desire to enclose knowledge in form and the equally powerful desire to reveal the explosive, form-destroying power of knowledge. Cohesion and fragmentation warred within him. It cannot be accidental that he brought none of his major system-building works to completion. (1979: 8)

Clearly, some of Marx's epigones threw themselves into what they perceived as the unfinished business of system building, while others responded primarily to the critical edge, from which Marxism itself is not immune. It is thus no surprise that Marx himself declared, "I am not a Marxist" (McLellan 1975: 78).

[27]For relevant bibliography, a fuller assessment, and warm appreciation of Vernant's work and its origins, see Segal 1982: 221–34). There is, however, no reference to the role of Marxism in Segal's essay. See also Arthur and Konstan's assessment of Vernant's influence on whatever there is of a left in American classical studies (1984: 59, 63, 65). Though Vernant himself might bristle at the label "post-Marxist," I intend it respectfully and think there are real affinities between his critical position and theirs. In his essay "The Tragic Subject: Historicity and Transhistoricity" (Vernant and Vidal-Naquet 1988: 237–47) he is at pains to defend himself against the charge of non-Marxist ahistoricism; the doctrinaire source of the charge was specified in an oral version of this essay some years ago at Berkeley. On the other hand, it is not entirely surprising that a militant post-Marxist such as Baudrillard repeatedly enlists the authority of Vernant's work in his own assault on Marx (1975: 82, 100, 101–102).

Although I am wary of the aberrations of some twentieth-century Marxist system builders, nonetheless one of the deepest attractions of Marxism parallels Gramsci's grounds for admiring the old classical education—namely, its invitation to make connections, to bring some coherence to the understanding of phenomena that bourgeois analysis seems bent on keeping separate in ever more refined and narrow categories (academic departmental turfs and specializations are the most obvious instances). Lukács's defense of the methodological centrality of seeking to understand the social totality, "the total historical process" (1971: 9–10), still strikes me as a worthy aspiration, even if its full realization is impossible. Against the post-Marxists' ever more frantically expressed fears of totalization as automatically equivalent to totalitarian thought must be set the sheer hollowness and political impotence offered by a world of subtly differentiated fragments and deconstructed subjects.[28] I believe that Marx himself offered the best critique of pure "critical criticism" (the battle cry of the Young Hegelians) by his own shift in emphasis toward praxis, actions that change the rules of the game. There can be no activist politics without a ground[29]— even if one's ground turns out to be, as a black Christian Marxist has described Christianity itself, an "enabling metaphor."[30] The provisional character of the Marxist explanatory model—its openness to and need for constant revision—must replace the old assertions of privileged access to a single, unmediated truth. The provisional character of one's efforts to approach the real must, however, be sharply distinguished

[28]Cf. Lyotard in *The Postmodern Condition:* "In communist countries, the totalizing model and its totalitarian effect have made a comeback in the name of Marxism itself" (1984: 13). Derrida describes as his principle motivation in deconstruction "the analysis of the conditions of totalitarianism in all its forms, which cannot always be reduced to names of regimes" (1988: 648). This equation of totalizing with totalitarian, though not without historical grounds, is especially characteristic of the French post-Marxists and intimately connected, I believe, with the character of the Stalinist French Communist party. As Foucault remarked in a *Telos* interview, "since 1945, for a whole range of political and cultural reasons, Marxism in France was a kind of horizon which Sartre thought for a time was impossible to surpass. At that time, it was definitely a very closed horizon" (Raulet 1983: 197). Cornel West rightly sees the effort to deal with this problem as perhaps the central feature of Jameson's critical project (West 1982b: 179). This position is explicitly confirmed in one of Jameson's most recent publications, in which, commenting on the "demarxification of France" he gives voice to "the suspicion that at least a few of the most strident of the anti-totality positions are based on that silliest of all puns, the confusion of 'totality' with 'totalitarianism.' I am tempted to conclude that what is here staged as a principled fear of Stalinism is probably often little more than a fear of socialism itself" (1988b: 60). This article offers a particularly compelling defense of taking seriously Lukács's articulation of the quest for the social totality from a contemporary, specifically feminist, standpoint.

[29]I owe this particular way of making the point to the late Linda Singer. But cf. Spivak apropos of Marx: "A purely philosophical justification for revolutionary practice cannot be found" (1984: 238).

[30]Cornel West, in conversation. But see West 1982a: esp. "Introduction."

from a simple epistemological relativism; some models of knowledge have distinctly superior explanatory power. All models of knowledge have consequences for how one lives and acts.

Marx and Utopia: The Quest for Realizable Freedom

Because the critical model I apply involves—in its emphasis on the utopian dimension of Greek literature—a minority position even within Marxism, it may be helpful to indicate briefly how this emphasis relates to the work of Marx himself. The whole trajectory of Marx's work from his moving essay as a teenager on the choice of a profession (1835) through his doctoral dissertation on Democritus and Epicurus (1841) right up to his "Critique of the Gotha Program" (1875) is a discourse on the dialectic of necessity and human freedom. In this discourse the central struggle is simultaneously to grasp in all their complexity the barriers to freedom and to forge the means of smashing them. The content, so to speak, of human freedom in his vision owes a great deal to his direct knowledge of classical celebrations of the autonomy and space for full mental and physical development of the Greek free adult male citizen, a human being whose full individual development was clearly linked with his deep integration in a political community—especially in Classical Athens. To cite just one example from Marx's pervasive allusions to and echoes of classical texts (cf. Prawer 1978: esp. chaps. 1 and 2), here is a comment from a letter to Arnold Ruge written when Marx was twenty-five years old:

> The self-confidence of the human being, freedom, has first of all to be aroused again in the hearts of these people [the Germans]. Only this feeling, which vanished from the world with the Greeks, and under Christianity disappeared into the blue mist of the heavens, can again transform society into a community of human beings united for their highest aims, into a democratic state. (*MECW* 3:137)

To be sure, Marx's vision was further enriched through his immersion in the Renaissance neoclassical ideal of the fully realized, fully developed courtier/prince/artist—*l'uomo universale* (Burckhardt 1958: 1:147–50). Thus for Marx, unlike William Blake, there was no contradiction between an almost obsessive love of Shakespeare—family readings of whom formed a major source of entertainment in the Marx household (Prawer 1978: chap. 3)—and love of the "silly Greek & Latin slaves of the Sword." Finally, both these related ideals were distilled, elaborated, and updated for Marx in Hegel's vision of the fully

conscious philosopher who is truly heir to the whole history of the human species.[31]

To present the whole goal of Marx's project as "work" or "labor" without explaining what these terms imply to Marx is to cut him off from both his classical and his Hegelian roots.[32] Labor for Marx is emblematic of all expenditures of human energy, but the highest vision of that activity is the autonomous realization (i.e., making real in the material world) of specifically human desires and pleasures—discovered and affirmed in an open-ended, historical process of sensuous enrichment:

> Only through the objectively unfolded richness of man's essential being is the richness of subjective *human* sensibility (a musical ear, an eye for beauty of form—in short, *senses* capable of human gratification, senses affirming themselves as essential powers of *man*) either cultivated or brought into being. For not only the five senses but also the so-called mental senses, the practical senses (will, love, etc.) in a word *human* sense, the human nature of the senses, comes to be by virtue of its object, by virtue of *humanized* nature. The *forming* of the five senses is a labour of the entire history of the world down to the present. (*Economic and Philosophic Manuscripts of 1844*, *MECW* 3:301–302)

Elsewhere in the same text Marx makes even clearer the open-ended, distinctly sensuous character of his vision of liberation: "The abolition of private property [i.e., capitalist property relations] is therefore the complete *emancipation* of all human senses and qualities, but it is this emancipation precisely because these senses and attributes have become, subjectively and objectively *human*" (*MECW* 3:300).

It is not uncommon to dismiss the utopian side of Marx as an early aberration corrected by the discovery of Marxist "science." On the contrary, the presupposition of the entire critique of capital is an ever-

[31]Cf. Lichtheim's attempt to sum up the originality of Hegel: "He remains the first thinker to have set forth the aim of representing in logical form the rise of consciousness as it gradually unfolds from bare sense-perception to Reason as absolute knowledge of the world and all there is in it. This unfolding is not simply that of the individual's self-education into philosophy. It is at the same time the record of Mind's long travail, for Man's self-education reflects and recapitulates the story of Mind's manifestation in nature and history" (Hegel 1967: xxxi–xxxii).

[32]The cliched versions of this critique rely on a literal interpretation of the phrase in the "Critique of the Gotha Program" (quoted in context subsequently in my text) "after labour has become not only a means of life but life's prime want." Baudrillard is only slightly subtler in always stressing the word "productive" or "production" in connection with Marx's concept of labor (1975: chap. 1). He acknowledges the element of the "esthetic of non-work or play" (38–41) only to denounce it as a "bourgeois" holdover—as if he himself had some post-bourgeois alternative!

deepening commitment to a largely implicit vision of an alternative so-
cial, economic, and political structure. The unpolished, unfinished
capstone of his analysis, vol. 3 of *Capital,* contains a passage that clearly
shows both the persistence of the quest for realistic liberation, for a *eu-
topia* that is some place, and the depth of its grounding in an economic
analysis.[33] In this sense it forms the climax of the whole massive analytic
effort. That climax is a tenaciously realistic opening of a vision of hu-
man freedom:

> The actual wealth of society, and the possibility of constantly expanding its
> reproduction process, therefore, do not depend upon the duration of
> surplus-labour, but upon its productivity and the more or less copious con-
> ditions of production under which it is performed. In fact, the realm of
> freedom begins only where labour which is determined by necessity and
> mundane considerations ceases; thus in the very nature of things it lies
> beyond the sphere of actual material production. . . . Freedom in this field
> can only consist in socialised man, the associated producers, rationally reg-
> ulating their interchange with Nature, bringing it under their common
> control, instead of being ruled by it as by the blind forces of Nature; and
> achieving this with the least expenditure of energy and under conditions
> most favourable to, and worthy of, their human nature. But it nonetheless
> remains a realm of necessity. Beyond it begins that development of human
> energy which is an end in itself, the true realm of freedom, which, how-
> ever, can blossom forth only with this realm of necessity as its basis. The
> shortening of the working-day is its basic prerequisite. (1967: 3:819–20)

A classicist might easily recognize the roots of this utopian vision in the
visions first articulated in ancient Greece for adult male slaveowners.
In particular, the anthropological speculations of the Presocratics and
Sophists in which Nature cast as Necessity plays so decisive a role echo
through the centuries in Marx's vision of necessity's persistence even in
a regulated "interchange with Nature." There is, I believe, a further
more general affinity between the relentless insistence in Marx on the
material prerequisites to real freedom and the pervasive tragic realism
of Greek reflections on human freedom from Homer to Aristotle.[34]

[33]Sir Thomas More called his imaginary island "Utopia" as a transliteration of a
Greek-based neologism: *ou* = "no," and *topia* from Greek *topos* = "place." But, as Manuel
and Manuel note, "in the playful printed matter prefixed to the body of the book the
poet laureate of the island . . . claimed that his country deserved to be called 'Eutopia'
with an *eu,* which in Greek connoted a broad spectrum of positive attributes from good
through ideal, prosperous, perfect" (1979: 1).

[34]Marxist sociologist Alvin Gouldner has appreciated this tragic realism in his focus on
the "contest system" (1969). For his critical Marxism, see the eloquent obituary notice by
J. Alt (1981: 198–203) and Gouldner 1980.

Finally, in virtually the last serious political text Marx composed, his scathing *Critique of the Gotha Program* (1875), the dialectic between material prerequisites and a deeply classical utopian vision of full, free human development shines through:[35]

> In a higher phase of communist society, after the enslaving subordination of the individual to the division of labour, and therewith the antithesis between mental and physical labour, has vanished; after labour has become not only a means of life but life's prime want; after the productive forces have also increased with the all-around development of the individual, and all the springs of co-operative wealth flow more abundantly—only then can the narrow horizon of bourgeois right be crossed in its entirety and society inscribe on its banner: From each according to his ability, to each according to his needs! (Tucker 1978: 531)

Any vision of human freedom must be measured against the historically determined actual material constraints of freedom within which choices are made—choices that either limit or expand possible freedom. I would add that the qualitative possibilities of freedom under changed material conditions are a direct consequence of the quality of the whole preceding tradition of more limited *visions*. If it is true that "the tradition of all the dead generations weighs like a nightmare on the brain of the living" (*Eighteenth Brumaire, MECW* 11:103), it is also true that a better future requires achieving what "the world has long dreamed of possessing" (Letter to Ruge, *MECW* 3:144). Moreover, I take as literally true Marx's judgment that "the forming of the five senses is a labour of the entire history of the world down to the present" (*Economic and Philosophic Manuscripts of 1844, MECW* 3:302; cf. Vernant and Vidal-Naquet 1988: 239–42); a truly historical perspective on the cultural production of ancient Greece does not measure it in a simple scale against the visions of freedom realizable in our own time but analyzes its decisive pedagogical contribution to those very visions. Only a critical continuity with the rest of history offers the richest transcendence of what was possible in the past.

[35]It is often assumed that Marx's emphasis on human labor is entirely incompatible with the perspective of ancient Greece, where, we are repeatedly told, labor was disparaged. What was disparaged was in fact unfree labor—as in Marx. For an ancient Greek, as for Marx, unfree labor included both slavery and paid labor under the command of another. Without denying significant shifts in conceptualization, I would argue that the point of continuity between Marx's vision of free human labor and Greek ideals is the pervasive emphasis in the latter on autonomous, self-chosen action—the very core of Homeric and Sophoklean heroism. Moreover, the specifically fifth-century perception of the link between political freedom and the unleashing of human energies and capacities is a central component of Marx's vision. For elaboration of this latter point, see Chapter 6. For a recent orthodox Marxist attack on the "myth of the idle mob" in ancient Athens, see E. M. Wood 1989: chaps. 1 and 2.

Consciousness, Class, and Doing History

Since a primary interest of my chosen texts is the way they both re-
flect and constitute consciousness, the issue of consciousness and ideo-
logical struggle centrally affects the senses in which I most often invoke
the concept of class. Thus, although I do not dispute Ste. Croix's dem-
onstration of the centrality of slavery in generating the surplus that
made possible a highly self-conscious, leisured, ruling class,[36] nonethe-
less the institution of slavery and the consciousness of slaves remains at
best a "structured silence" (Macherey) or, as Fredric Jameson might
say, the political *unconscious* in these texts.[37] I have more to say later
about structured silences; but, for the most part, rather than focus my
analysis primarily on filling in these lacunae in the texts, I focus on the
aspects of class conflict that seem to me leave more readily perceptible
symptoms in them. Most often these take the form of ideological strug-
gle over the bases for justifying or questioning the existing social, eco-
nomic, political, and sexual hierarchy.[38] Moreover, however rooted the

[36]E. M. Wood (1989: 64–80) does launch a full-scale attack on what she sees as Ste.
Croix's erroneous assumption that slavery was the only alternative to hired labor for ex-
torting a surplus. She stresses among other factors the traditional role of rent in the pan-
oply of means available to landed aristocrats for exploiting peasants. But see Ste. Croix,
"Forms of Exploitation in the Ancient Greek World, and the Small Independent Pro-
ducer" (1981: 205–75).

[37]Ste. Croix argues: "Actual slavery ('chattel slavery') . . . was the main way in which
the dominant propertied classes of the ancient world derived their surplus. . . . The
small free, independent producers (mainly peasants, with artisans and traders) who
worked at or near subsistence level and were neither slaves nor serfs . . . must have
formed an actual majority of the population in most parts of Greece" (1981: 52). Lekas,
citing Vernant, finds again in Marx's discussion of the ancient mode an insightful viola-
tion of Marxist orthodoxy; but though he rightly focuses on Marx's *political* analysis of
class warfare in the polis, he goes too far in saying that rich and poor have no qualitative
difference in relation to means of production (1988: 90–91). As Ste. Croix has demon-
strated, it is precisely slavery that provides a qualitative as well as quantitative difference
between rich and poor citizens. It is perhaps a vestige of M. I. Finley's own early expo-
sure to a certain Marxism that the topic of slavery stands out as his most abiding con-
cern—a point stressed by the anonymous author of his *London Times* obituary (June 26,
1986).

[38]For the political aspect of class warfare in ancient Greece, see Ste. Croix's summary
of enthusiastic endorsement of Aristotle's analysis of political activity in the Greek polis
(1981: 71–80) and his "The Class Struggle in Greek History on the Political Plane"
(1981: 278–326). Badian, in his review, accuses Ste. Croix of making Aristotle into a
"proto-Marxist" (1982: 47) and himself seems to prefer the "simpler Aristotelian cate-
gories of the rich and the poor" (50). The "advantage" of such categories is that they are
often tacitly presumed to be constituted in isolation. The unpleasant notion that there
are poor because there are rich and vice versa is absent from such categories—as it is
from the minds of most contemporary ancient historians. At the same time, Aristotle's
assumption that the motive force of so much of ancient Greek politics resides in the con-
flict of rich and poor is something of a sticking point, one would imagine, for those who
want to banish any version of economy-related class conflict from their account of an-
cient Greece.

conflicts between peasants and the ruling class may be in struggles over control of the economic surplus, the form in which those conflicts become conscious and are struggled over is more often linked to issues of social status, political power, gender roles, and ultimately epistemology. Accordingly, my analysis attempts to make connections among various sorts of struggles without being confined to a narrowly economic definition of conflicting groups.

The consequences of Marx's analysis of consciousness and class for the writing of history are substantially at odds with the ideal pursued by most practicing classicists.[39] First of all, Marx's analysis of the fundamental link of ideas to the whole complex of realities subsumed under the concept of mode of production precludes the sort of fragmentation and specialization that for many are the marks of serious scholarship:

> Morality, religion, metaphysics, and all the rest of ideology as well as the forms of consciousness corresponding to these . . . no longer retain the semblance of independence. They have no history, no development; but men, developing their material production and their material intercourse, alter, along with their actual world, also their thinking and the products of

[39]Cf. Ste. Croix's citation from the preface of a recent book on Roman history of the usual cliches of alleged objectivity and freedom from irrelevant modern theories (1981: 81–85; cf. 33–35). See also Fredric Jameson's meditation on a certain "antiquarian" practice in some approaches to classical antiquity: "Simple antiquarianism, for which the past does not have to justify its claim of interest on us, nor do its monuments have to present their credentials as proper 'research subjects' . . . [but are] validated as sheer historical facts with the irrevocable claim on us of all historical fact—lead a ghostly second existence as mere private hobbies. One is tempted to say that this position 'solves' the problem of the relationship between present and past by the simple gesture of abolishing the present as such" (1979b: 45). Badian, in his review of Ste. Croix, shows his annoyance at the term "antiquarian," which he quite unfairly calls "his [Ste. Croix's] term for a specialist scholar" (47). The point of both Fredric Jameson and Ste. Croix (quite independently, I am sure) is not to disparage the intelligence or even the potential usefulness of the type of work they so designate but rather to call attention to its relative naivete or disingenuousness about its own presuppositions. Every text has its unconscious, but the sort of scholarship they have in mind is self-congratulatory precisely about its own unconsciousness. Or, as Sullivan puts it, "there can be no un-ideological writing of history. The question is whether the historian is consciously aware of his approach and perspective" (1975: 6). The charge, central to Lekas's indictment (1988) of Marx, of imposing contemporary intellectual models on the past needs to be examined in light of the accusers' own accounts (usually missing) of the basis for *any* contemporary relevance available in the study of the past. There is a difference between asking questions of an ancient society that it would never ask itself and asking truly pointless questions. Moreover, for any answers about a different society to be intelligible to us, they must at least be cast in terms that are analytically productive for us. This is by no means to efface the difference between past and present; on the contrary, it theorizes difference as the most relevant object of inquiry.

their thinking. It is not consciousness that determines life, but life that determines consciousness. (*German Ideology, MECW* 5:36–37)[40]

The goal toward which many of us classicists were trained to strive is to re-present as accurately as possible what the ancient peoples themselves actually thought and believed. This is precisely what Marx attacks:

> The exponents of this conception of history have consequently only been able to see in history the spectacular political events and religious and other theoretical struggles, and in particular with regard to each historical epoch they were compelled to *share the illusion of that epoch*. . . . The "fancy," the "conception" of the people in question about their real practice is transformed into the sole determining and effective force, which dominates and determines their practice. (*German Ideology, MECW* 5:55)

Marx also posits an easy slippage from this kind of willing subordination to the self-conceptions of past eras into pure Hegelianism:[41]

> The Hegelian philosophy of history is the last consequence . . . of all this German historiography for which it is not a question of real, not even of political, interests, but of pure thoughts, which must therefore appear to Saint Bruno [Bruno Bauer, a leader of the Young Hegelians] as a series of "thoughts" that devour one another and are finally swallowed up in "self-consciousness." (*German Ideology, MECW* 5:55)[42]

Marx's scorn of this approach is summed up in a climactic antithesis:

[40]The preface of a recent study of the Presocratics states with particular blatancy the author's (Hegelian?) faith in just the sort of total independence of philosophy's history to which Marx's alludes: "I do not believe that a detailed knowledge of Greek history greatly enhances our comprehension of Greek philosophy. Philosophy lives a supracelestial life, beyond the confines of space and time; and if philosophers are, perforce, small spatio-temporal creatures, a minute attention to their small spatio-temporal concerns will more often obfuscate than illumine their philosophies" (Barnes 1982: xii).

[41]Fowler, for example, points out (1987: 4) the dependence of the whole Fränkel-Snell school on what is clearly a Hegelian notion of the *Geist* of an era. Cf. the Hegelianism—articulated with rare and praiseworthy explicitness—of MacCary (1982: esp. 16–25), whose whole project is tied to Snell and Fränkel (3). Jaeger's canonical *Paideia* (1945) is Hegelian in its whole conceptualization. This is by no means to suggest that these approaches are devoid of value—far from it—but to underline the extent to which so much work in classics still operates on Hegelian idealist assumptions challenged by Marx.

[42]At this point in the manuscript there is a marginal note by Marx demonstrating his sense of the close link between the two historiographical types: "So-called *objective* historiography consisted precisely in treating the historical relations separately from activity. Reactionary character" (*German Ideology, MECW* 5:55).

Whilst in ordinary life every shopkeeper is very well able to distinguish be-
tween what somebody professes to be and what he really is, our historiog-
raphy has not yet won this trivial insight. It takes every epoch at its word
and believes that everything it says and imagines about itself is true. (*Ger-
man Ideology, MECW* 5:62)

The alternative is sketched in terms which, for all the rhetorical em-
phasis on the primacy of production, insist on a dialectical reciprocity
of the economic sphere with forms of consciousness and on the decisive
role of revolutionary action in effecting structural change:

This conception of history thus relies on expounding the real process of
production—starting from the material production of life itself—and
comprehending the form of intercourse connected with and created by
this mode of production . . . and also explaining how all the different the-
oretical products and forms of consciousness, religion, philosophy, moral-
ity, etc., etc., arise from it, and tracing the process of their formation from
that basis; thus the whole thing can, of course, be depicted in its totality
(and therefore, too, the *reciprocal* action of these various sides on one an-
other) . . . it . . . explains the formation of ideas from material *practice*, and
accordingly it comes to the conclusion that all forms and products of con-
sciousness cannot be dissolved by mental criticism . . . that not criticism
but revolution is the driving force of history. . . . It shows that circum-
stances make men just as much as men make circumstances. (*German Ide-
ology, MECW* 5:53–54, emphasis added)

Marx and Cultural Production

Marx himself did not produce a full-fledged theory of cultural pro-
duction dealing with the whole range of complexities arising from art
and literature. In this sense, "Marxist" approaches to these topics are
only more or less credible extrapolations from the texts we have al-
ready considered together with a rich array of brief comments scat-
tered throughout the corpus of Marx's surviving texts.[43] Cutting short
a potentially very long detour, I excerpt several issues arising from
Marx's own wide-ranging analyses and explore a few twentieth-century
elaborations more relevant to my own project. Most of the key issues in

[43]Solomon, who has an excellent brief selection from Marx and Engels at the outset of
his own sweeping overview, notes that the collection begun in the 1930s by Lifschitz and
Schiller of all the relevant material comes in the German edition (Kliem 1967) to over
1,500 pages (1979: 5). In English, see Baxandall and Morawski 1973. Prawer 1978 offers
an excellent overview of Marx's knowledge of and thoughts about literature. Demetz
1967 has useful material; its lacunae and distortions are ably criticized by Solomon (7–8).

this area fall into significant, often overlapping polarities. On the one hand, art, insofar as it is a mere vehicle for class ideology, may transmit a class-bound, self-serving distortion of real conditions. On the other, as the "dream" which "the world has long been dreaming" and which only the future can bring to realization, as a decisive component in that "formation of the five senses" which is the "work of all history," art corresponds to the creative, mental activity that precedes all truly human accomplishments. As Marx put it:

> a spider conducts operations that resemble those of a weaver, and a bee puts to shame many an architect in the construction of her cells. But what distinguishes the worst architect from the best of bees is this, that the architect *raises his structure in imagination* before he erects it in reality. At the end of every labour-process, we get a result that already existed in the imagination of the labourer at its commencement. (*Capital*, 1967: 1:178, emphasis added)

A classicist may recognize here an echo of Aristotle's use of the house builder in his discussion of the four causes (*Physics* 195b5–6), but the implications of the architectural metaphor are rather different in the context of Marx's preoccupations and ours. What is true of the labor process in general links the artist with all those who engage in any sort of productive labor. As Gramsci rightly insisted, there is no purely physical labor without some intellectual component (1971: 8–9). Artists, however, are among the generally privileged category of workers specifically charged with the task of reflecting on past human action and imaginatively projecting new structures of human thought, perception, and action. To be sure, the fact of their relatively privileged status suggests the likelihood of this process leading to self-serving consequences. But, to the extent that it posits a future different from the status quo, it contains a potentially liberating dimension by virtue of its implicit negation of that status quo.

Marx's own appropriation of the undoubtedly self-serving utopian visions of Greek male citizen slaveowners suggests that he was well aware that the same artist could perform both roles simultaneously— that in the act of projecting a flattering and distorted image of the good life of the ruling class the artist makes available a discourse of freedom that can guide those excluded from freedom on a path toward actualization of a more gratifying future. The utopian visions of a narrow elite furnish guideposts for a struggle to extend that freedom to groups rigorously excluded from the initial vision.

I offer an example from postclassical history recently elaborated by post-Marxist thinkers: Laclau and Mouffe argue that the emergence in

eighteenth-century bourgeois male ideologues of a doctrine of the "rights of man" (specifically, of white male property owners) made available a discourse susceptible of being fought over and for by women and people of color and in general by all those excluded from full rights (1985: 154–56).[44] It follows from this line of argument that there is no necessary correlation between the artist's explicit or even implicit intentions and the full consequences of the work created either in its own moment or for posterity.

Moreover, in addition to this projective, utopian function of art, the artist quaideologue may serve a cognitive function. Like those ideologues of a dying class who perceive the real movement of history and align themselves with the rising class, the artist may serve a progressive educational function by presenting a truer image of the real conditions of society than is available from other sources. This artistic, critical negation of the status quo may occur independently of the artist's own personal political allegiances. Thus, for example, Marx was a great admirer of Balzac, whom he called "generally remarkable for his profound grasp of reality" (*Capital*, 1967: 3:39). According to Marx's son-in-law, Paul Lafargue, Marx considered that Balzac united both the cognitive and projective functions of the artist: "He considered Balzac not only as the historian of his time, but also as the prophetic creator of characters which were still in embryo in the days of Louis-Philippe and did not fully develop until after his death, under Napoleon III" (Prawer 1978:181).[45]

The noncongruity, then, of the author's class allegiance and his insights and the nonsynchrony of those insights and real conditions militate against the assumption of any simple equation of class position and artistic production or of art as nothing more than a reflection of the present circumstances. A Marxist historical focus on forms of consciousness thus implies neither complete immersion in the "illusion of the epoch" nor a mechanical extrapolation from the "material conditions."

[44]Laclau and Mouffe focus primarily on the origin of feminism, but they also note "the profound subversive power of the democratic discourse, which would allow the spread of equality and liberty into increasingly wider domains and therefore act as a fermenting agent upon the different forms of struggle against subordination" (1985: 155). They call the emergence of a new vision of the human a "different discursive formation" (154) and are not specifically concerned with art. But their analysis is in this area quite consonant with the Frankfurt School Marxists' analysis of utopian thought.

[45]Prawer notes in this context that Marx used Balzac's Crevel from *La cousine Bette* in an ironic compound, "Véron-Crevel," at the end of *Eighteenth Brumaire* (*MECW* 11:196) to suggest precisely that Louis Véron, the editor and owner of *Le Constitutionel*, was the real-life embodiment of Balzac's projective creation. It is amusing that the apparently still Stalinist editors of *MECW* assure us in a note that Crevel was "a character based on Dr. Véron." For them, life must precede art.

Mediation, Hegemony, and Overdetermination

How then is one to "historicize" properly classical antiquity? I have already suggested the inadequacy for my purposes of Ste. Croix's impressive but quite orthodox Marxist version of the nature of class struggle. Admirable and subtle as are his discussions of most sorts of historical data, precisely when he touches on literary evidence he falls back on a simple reflectionism that characterizes not only most older Marxist but most historical approaches to literary texts (Rose 1988: 6–11). In attempting to move toward what I consider a more properly dialectical conception of the relation of the literary text to the economic, social, and political structures of ancient Greece, I have found among twentieth-century Marxists Bakhtin, Gramsci, Althusser, and Fredric Jameson to be most helpful. Because for my purposes his work incorporates and carries forward that of his predecessors in crucial new directions, I discuss Jameson in a separate section.

Bakhtin, assuming for the sake of argument—or for his own survival—the party's one-way reading of the determination of superstructure by the economic base, goes a long way toward subverting the model by suggesting some of the inevitable mediations in that process. Taking the example of an alleged connection of the image in a novel ("Rudin as superfluous man") with the degeneration of the gentry class, he notes,

> even if the correspondence established is correct . . . it does not at all follow that related economic upsets mechanically cause "superfluous men" to be produced on the pages of a novel. . . . The correspondence established itself remains without any cognitive value until both the specific role of the "superfluous man" in the artistic structure of the novel and the specific role of the novel in social life as a whole are elucidated. (Voloshinov [Bakhtin] 1973: 18)[46]

Thus there is a logic internal to the specific work of art, and any interpretive enterprise must first give an account of how any particular element relates to that logic before exploring its social, political, or economic resonances. Second, Bakhtin indicates that we need to try at least to specify the politics of the particular form or genre in which such an element occurs—that is, what sorts of functions it performs in relation to what sorts of audiences.

[46]On the grounds for considering the work published under the name of Voloshinov to be in fact the work of Bakhtin, see Clark and Holquist 1984: 146–51. For a vigorous defense of Voloshinov's authorship which gives me some pause, see Titunik's introduction in Voloshinov 1987 (xv–xxv).

Bakhtin proceeds to elaborate other significant mediations:

> Between changes in the economic state of affairs and the appearance of the "superfluous man" in the novel stretches a long, long road that crosses a number of qualitatively different domains, each with its own specific set of laws and its own characteristics. . . . the "superfluous man" did not appear in the novel in any way independent of and unconnected with other elements of the novel, but . . . on the contrary, the whole novel, as a single organic unity subject to its own specific laws, underwent restructuring, and . . . consequently, all its other elements—its composition, style, etc.— also underwent restructuring. And what is more, this organic restructuring of the novel came about in close connection with changes in the whole field of literature, as well. (18)

I would wish to distance myself somewhat from the apparent formalist assumption here of an inherent unity in the literary text, but Bakhtin rightly argues that any alleged element in the work under discussion must be examined in terms not only of the way it is affected by the specifically literary character of its context but also of how it correspondingly affects the whole of that extraliterary context. In turn, he enjoins us to keep in mind how the specific literary text is affected by its whole set of relations with other literature in its tradition and in its own moment.

Bakhtin, in a specifically twentieth-century extension of Marx that responds to Saussure, argues:

> The problem of the interrelationship of the basis and superstructures . . . can be elucidated to a significant degree through the material of the word. . . . The essence of this problem comes down to how actual existence (the basis) determines sign and how sign reflects and refracts existence in its process of generation. . . . The word is the medium in which occur the slow quantitative accretions of those changes which have not yet achieved the status of a new ideological quality, not yet produced a new and fully-fledged ideological form. The word has the capacity to register all the transitory, delicate, momentous phases of social change. (19)

What Bakhtin prescribes here is a kind of Marxist philology—a relentless attention to historical shifts in the meanings of words which is sensitive to the ideological, political, and social dimensions—aspects that in fact the best classical philologists, for all their Hegelian idealism, have explored richly.

The Soviet official theorists against whom Bakhtin was reacting subsumed this whole area under the rubric "social psychology." Accordingly, Bakhtin attempted a strategic redefinition:

It follows that social psychology must be studied from two different viewpoints: first from the viewpoint of content, i.e., the themes pertinent to it at this or that moment in time; and second, from the viewpoint of the forms and types of verbal communication in which the themes in question are implemented. . . . This issue of concrete forms has significance of the highest order. . . . Each period and each social group has had its own repertoire of speech forms for ideological communication in human behavior. Each set of cognate forms, i.e., each behavioral speech genre, has its own corresponding set of themes. An interlocking organic unity joins the form of communication . . . the form of the utterance . . . and its theme. (20–21)

Bakhtin's intense focus here on the tight linkage between the ideological content and the specific form of communication implies a serious politics of forms, of genres, which it is a central goal of the following chapters to elaborate. Here I underline the decisive shift in emphasis this linkage implies from simple determination by the base toward explorations of the mediations intrinsic to the process of ideological communication.

In exploring how the texts under consideration actually function within Greek society and the ways that process is potentially meaningful for us, Gramsci offers the most broadly useful conceptual framework. Fundamental to Gramsci's thought is the distinction between *dominance* and *hegemony*.[47] A dominant class is able to impose by force its will on the dominated classes. But, in fact, Gramsci argues, no regime remains in power exclusively by brute repression except in periods of revolution.

Every dominant class seeks to become hegemonic; that is, it seeks to achieve supreme moral and intellectual authority in the minds of all classes or, in Lyndon Johnson's notorious phrase, to "win the hearts and minds of the people." Gramsci thus focuses central attention on the role of intellectuals and cultural production in class struggle. A

[47]Gramsci argues, "We can . . . fix two major superstructural 'levels': the one that can be called 'civil society' (that is, the ensemble of organisms commonly called 'private'), and that of 'political society' or 'the State'. These two levels correspond on the one hand to the function of 'hegemony' which the dominant group exercises throughout society and on the other hand to that of 'direct domination' or command exercised through the State and 'juridical' government. . . . The intellectuals are the dominant group's 'deputies' exercising the subaltern function of social hegemony and political government. These comprise: 1. The 'spontaneous' consent given by the great masses of the population to the general direction imposed on social life by the dominant fundamental group; this consent is 'historically' caused by the prestige (and consequent confidence) which the dominant group enjoys because of its position and function in the world of production. 2. The apparatus of state coercive power which 'legally' enforces discipline on those groups who do not 'consent' either actively or passively. This apparatus is, however, constituted for the whole of society in anticipation of moments of crisis of command and direction when spontaneous consent has failed" (1971: 12).

dominant class needs effective intellectuals to stay in power. A challenging class that has succeeded on the level of moral and intellectual authority is in the best position to displace a dominant class. This is not to reinstate the illusions of the young Hegelians that "reforming consciousness" will alone and of itself transform society. Gramsci, like Marx, recognizes that there are situations in which the metaphorical weapon of criticism must be supplemented by the metaphorical criticism that consists in weapons. But, as Marx puts it, "material force must be overthrown by material force; but theory also becomes a material force as soon as it has gripped the masses" ("Contribution to the Critique of Hegel's Philosophy of Law: Introduction," *MECW* 3:182). What Gramsci adds is a richer elaboration of the subtle and complex range of social mechanisms by which contending forces in society struggle to seize the minds and hearts of the masses. Gramsci's analytical framework insists on the centrality of all intellectual production to class struggle, whether (to echo the *Communist Manifesto*) "open or hidden." Moreover, as Fredric Jameson has pointed out (1981: 287; Said 1983: 171), a genuine appreciation of the concept of hegemony implies severe limitations on a simple coercive, manipulative, or functionalist conception of culture. Culture for Gramsci is by its very nature an attempt at persuasion, a form of rhetoric. As Said puts it, "well before Foucault, Gramsci had grasped the idea that culture serves authority, and ultimately the national State, not because it represses and coerces but because it is affirmative, positive, and persuasive" (1983: 171).

Althusser's major contributions in this area are, for my purposes, four. First, he has elaborated Gramsci's focus on struggle in the ideological sphere by examining the specific material social institutions—what he dubs the "ideological state apparatuses" (1971: 127–86)—which, as opposed to the more familiar "repressive state apparatuses" (police, courts, army), systematically attempt to reproduce in the consciousness of each individual spontaneous consent to those relationships of dominance and subordination that perpetuate the status quo. He cites, for example, such institutions as the church, the educational system, the mass media, cultural entities, and political parties.

Second, Althusser's notion of "interpellation"—from the Latin *interpellare*, "to accost," "to hail" someone (1971: 170–83)[48]—has given far greater precision to the mechanisms by which ideological practice so-

[48]As it happens, this is the least common sense of the Latin verb, which most often has the sense of "interrupt" or "obstruct"—connotations quite alien to the largely unconscious process envisioned by Althusser.

cially constructs individual identity. By summoning individuals to spontaneous assent and concrete forms of behavior (e.g., saluting the flag, genuflecting before the altar, deferring to or abusing women) or to a proffered identity ("we French," "we Catholics," "we men"), ideological apparatuses attempt to instill a totally unconscious acceptance and practice of the social relations of the status quo as entirely natural.

A third contribution of Althusser to contemporary Marxist analytic discourse is his polemical defense of a Marxist appropriation of Freud (1971: 189–219). To be sure, he was not the first, and we look subsequently at the very different articulation between Freud and Marx effected by the Frankfurt School. Althusser lays primary stress on "the unconscious and its 'laws'" (204), on "'mechanisms' and 'laws' of dreams" (207). Following Lacan's appropriation of Jakobson's enormously influential elaboration of metonymy and metaphor, Althusser endorsed the reduction of Freud's analysis of these mechanisms to two: displacement and condensation (207).[49] He argues, perhaps too forcefully, for the independence of psychoanalysis in terms that in fact have a broadly anthropological thrust: "History, 'sociology,' or anthropology have no business here, and this is no surprise for they deal with society and therefore with culture, i.e. with what is no longer this small animal—which only becomes human-sexual by crossing the infinite divide that separates life from humanity, the biological from the historical,

[49]I find this move unfortunate. The sixth chapter of *Interpretation of Dreams* (Freud 1958–74: 5:277–338, 6:339–508), on the dreamwork, is widely recognized as Freud's most brilliant. In particular, his analysis of the grammar of dreams, the problems of representability and symbolism, should not be subsumed under the first two mechanisms he discusses (i.e., condensation and displacement). The point is of concern to me because one of the most progressive attacks on Freud in the field of classics (duBois 1988) focuses exclusively on the ancient symbolization of women in the light of Freud's account of women as symbolically castrated males. Although duBois offers a trenchant critique of Freud's appropriations of ancient Greek myth and elaborates a compelling case for an alternative symbolization of women in ancient Greece, she does not address the issue of the unconscious and its mechanisms as such. It is one thing to historicize Freud by demonstrating that different cultures symbolize sexual difference in significantly different ways—ways that in part reflect their economic structure. It is quite another to contend, as duBois does, that "the weight of Freud's insight is lost if we abandon the theory of castration, which is indissolubly linked to the description of sexual difference. Little boys would not fear castration, would not resolve their Oedipus complex, if they did not know of the existence of 'the other,' the castrated sex" (1988: 12). Such an analysis, if I read it rightly, seems to preclude the symbolic representation in ancient Greek texts of male fears of castration—not to mention the representation of Oedipal conflict. Since I find both quite prevalent, I can only conclude that we need a better account of what is involved in historicizing the products of the unconscious. I have long been struck by the anthropological plausibility of Crews's distillation of Freud's view of a human being as "the animal destined to be overimpressed by his parents" (Crews 1970: 12). This seems to me to be valid regardless of how that overestimation manifests itself symbolically.

'nature' from 'culture" (206). Whereas he only glances defensively at the substantial problems implicit in historicizing Freud (211 n. 4 and 217), Althusser insists rightly on the central relevance of Freud to "all investigations into ideology" (219).[50]

Finally, Althusser's concept of "structural determination" or, borrowing from Freud, "overdetermination" goes a long way toward liberating Marxist discussions of base and superstructure from both the procrustean bed of Stalinism (or, to use Althusser's term, "arthritis") and the circularity of a purely Hegelian version of dialectic.[51] Mechanistic causality of the Stalinist variety has too often presented the superstructure as a sort of baseball impelled by the bat of technology and other purely mechanical economic factors.[52] Hegel, to whom anti-Stalinists such as Lukács and the Frankfurt School were inevitably drawn, "solves" the relation of the part to the whole by positing the same substance, Geist (soul/mind), undergoing the same immanent developments at all levels. In effect, the whole of reality is conceived in ways that bear a distinct similarity to what Foucault (1970: 17–25) has analyzed as the Renaissance/medieval *epistēmē*—as a series of correspondences, though to be sure the Hegelian ones are all, so to speak, Geist. For Hegel the passage of the world spirit from natural consciousness to alienation to full self-consciousness corresponds to the development of each individual and in turn to the movement of all history. Althusser's model, like Bakhtin's, stresses the relative autonomy of various spheres—economic, political, cultural—which operate in accordance with their own specific laws but at the same time are incessantly and deeply interactive. Thus the serious exploration of the causes of any significant phenomenon (he uses as his example the Russian Revolution) reveals that each component is determined by and itself determines a multiplicity of other phenomena—much as an element in a dream turns out, on analysis, to have a multiplicity of determinants while its presence in the dream itself affects all the other elements.[53]

Despite the subtlety and usefulness of Althusser's analyses, despite his own recognition of the cultural sphere as "the site of class struggle"

[50]For a more detailed and nuanced discussion of Althusser's use of Freud and Lacan in the analysis of ideology, see Paul Smith 1988: 18–23 and Barrett's second thoughts in her new introduction to *Women's Oppression Today* (1988: xv).

[51]The best statement is in "Contradiction and Overdetermination" (Althusser 1969: 87–128). See also "Marx's Immense Theoretical Revolution" (Althusser and Balibar 1970: 182–93).

[52]Here I disagree with Fredric Jameson (1981: 37 and n. 19) in seeing "Hegel" as the codeword for Stalin, since the model of changes in production driving the whole process of change is, to my mind, a perfect example of bat-strikes-ball mechanical causality.

[53]For the link between Althusser's and Freud's uses of overdetermination, see Althusser's appendix "Freud and Lacan" (1971: 189–219) as well as the translator's useful glossary in Althusser 1969 (s.v., 252–53).

(1971: 147), Althusser has been rightly criticized for offering too pessimistic a picture of the process of ideological reproduction (Giroux 1983: 263–64; Paul Smith 1988: 18). The status quo seems to have all the advantages in its ceaseless and relentless brainwashing of passive subjects, whom Althusser presents precisely as "subjected" to reigning hegemonic ideas.

Jameson: The Double Hermeneutic and the Utopian Impulse

Fredric Jameson, whose name I invoke partly as a shorthand for all the insights of the Frankfurt School he has done so much to bring to English-speaking readers (esp. 1971), offers, in my view, the single most relevant critical model for a Marxist reading of the classics. Not only are his central concepts more deeply in tune with the liberatory thrust of Marx's own work; Jameson's more openly dialectical conception of the process of ideological struggle offers the most meaningful way out of the depressing either/or designation of particular classical authors as "good guys" or "bad guys" which has, as noted earlier, characterized much of previous Marxist or even loosely political readings of the classics. Moreover, though his own work has largely ignored issues raised by feminists, his critical model has been fruitfully appropriated for a feminist analysis of contemporary cultural production.[54]

The critical concept in Jameson which seems to me most decisive in opening classical texts to the fullest Marxist reading is his notion of a double hermeneutic. The idea of a hermeneutic in general has nothing uniquely Marxist about it. Leaving aside its Aristotelian sense and its role in biblical exegesis, Jameson focuses on the medieval Christian interpretive enterprise: the Christian hermeneutic incorporates alien cultures and philosophies by demonstrating through a kind of translation their underlying (unconscious) anticipations of Christianity (1971: 84).[55] Vergil (that *anima naturaliter Christiana*) has perhaps been

[54]The finest example I am aware of is Modleski's brilliant application (1982) of an explicitly Jamesonian double hermeneutic to Harlequin romances, Gothic novels, and television soap operas.

[55]The argument on hermeneutics is far more tortuous in chap. 1 of *Political Unconscious* because, as Jameson notes, "it is . . . increasingly clear that hermeneutic or interpretive activity has become one of the basic polemic targets of contemporary poststructuralism in France" (1981: 21). The hermeneutic model elaborated there returns to the notion of allegory on four levels (cf. 29–33) which he first explored apropos of Walter Benjamin (Jameson 1971: 60–61). See also his fuller elaboration of the relation of Marxism to Christianity (1971: 117–18). For my purposes, the older "double" model is

the most frequent subject of this approach.[56] A classicist may say cynically, "better to Christianize Vergil than to burn his poems," but object that any such interpretive enterprise is a hopeless distortion. But the Vergil of modern classical literary scholarship is fully and necessarily as remote from the Vergil appropriated by the original audience as is the Christianized Vergil. The most professedly antiquarian Vergil scholar (in the sense described earlier) is not really content to refuse all claims of relevance for this text. Yet relevance implies some hermeneutic operation, some interpretive recasting or translation of the apparently alien elements into an accessible form. The hermeneutic enterprise has long been, to this extent, the humanistic alternative to iconoclasm in its most brutal and irreversible forms. Totalizing systems that lack this hermeneutic impulse are capable—alas, whether they are leftist or rightist—of burning books.[57] As Adorno said in denouncing the Stalinist approach to cultural criticism, "they lack the experience of that with which they deal. In wishing to wipe away the whole as with a sponge, they develop an affinity to barbarism" (1981: 32).

Whereas Jameson is entitled to invoke older sorts of hermeneutic appropriation as a warrant for his own enterprise, I stress the fact that the peculiarly dialectical form of his hermeneutic—what makes it "double"—is the distinctive feature of Marx's own general approach to social and historical phenomena. Here it is worth recalling Marx's claim that with Hegel the dialectic "is standing on its head. It must be turned right side up again, if you would discover the rational kernel within the mystical shell" (*Capital*, 1967:1:20). The same hermeneutic characterizes Marx's interpretation of capitalism itself. Edmund Wilson long ago (1940) gave a wonderfully readable account of the many other socialist critics of capitalism in the nineteenth century, both prior to and contemporaneous with Marx. A distinguishing feature of Marx, often offensive to some of his allies, was his repeated emphasis on the progressive features of capitalism as an integral part of his indictment of its regressive aspects. There is, for example, a kind of preamble to the utopian vision of the "realm of freedom" in the passage we quoted earlier from the unfinished third volume of *Capital*. Marx there de-

more serviceable; and, I would say, the best readings of *Political Unconscious* still adhere to it.

[56]See Comparetti (1908: esp. chaps. 5, 7, and 8) and Knight, who notes—with what we can today recognize as undue optimism—apropos of Servius that he is "already inclined to the allegorical kind of interpretation which was later to reach almost the greatest depths of absurdity that the human mind has attained" (1954: 308).

[57]Lest this comment be taken too readily as the self-congratulation of a traditional liberal, I remind the reader of America's own pernicious capacity for book burning and more recently phonograph-record-burning. For an historical meditation on book-burning, see Lowenthal 1987–88.

clares: "It is one of the civilizing aspects of capital that it enforces this surplus labour in a manner and under conditions which are more advantageous to the development of the productive forces, social relations, and the creation of the elements for a new and higher form than under the preceding forms of slavery, serfdom, etc." (1967:3:819). Capitalism, in which exploitation, human alienation, and greed are structural components, is also by its very nature the most social form of production; and its very logic of accumulation prepares the way for a more civilized mode of production and social relations. This hermeneutic operation avoids both nostalgia and despair by a utopian extrapolation from the dynamic potentialities of the brutal present in its full complexity.

Jameson introduces a more rigorous conception of the dual aspect of hermeneutics by reference, not to Marx, but to a modern theologian, Paul Ricoeur. Ricoeur uses the terms "negative and positive hermeneutics" to designate a hermeneutic directed at demystification, at the destruction of illusions, and a hermeneutic that "restores to access some essential source of life" (Ricoeur 1970: 27–36; cf. Jameson 1971:119). Ricoeur himself refers to an implicit double hermeneutic in the thought of Marx, Nietzsche, and Freud. Though each was a master of the negative "hermeneutics of suspicion," their commitment to the demolition of false consciousness involved the aim of extending and liberating consciousness.

Jameson explores (1971: 120–59) a more explicitly Marxist sense of the double hermeneutic in the work of Ernst Bloch;[58] but in varying degrees this hermeneutic enterprise characterizes all the so-called Frankfurt School of Marxists: Adorno, Horkheimer, Benjamin, and (most familiar to Americans) Herbert Marcuse. My description of this Marxist hermeneutic is thus necessarily a somewhat eclectic fusion of these figures' views and Jameson's own impressive contribution.

For the Marxist, the task of the negative hermeneutic requires a rigorous, even ruthless elucidation of all the aspects of the work of art which reveal its active ideological support for the status quo—regardless of the artist's conscious intentions. The fundamental Marxist assumption (here, as in the positive hermeneutic) is that Western society has always been characterized by class struggle, "sometimes open, sometimes hidden." A second assumption for the negative hermeneutic is, as we recall from the *German Ideology*, that "the ideas of the

[58]At the time Jameson wrote *Marxism and Form*, virtually none of Bloch's work was available in English apart from occasional excerpts or essays in *New German Critique* and *Telos*. But now, in addition to Zipes's collection of Bloch's essays (1988), Bloch's massive chef d'oeuvre, *Principle of Hope*, as well as his *Natural Law and Human Dignity* have appeared in English (1986a; 1986b).

ruling class are in every epoch the ruling ideas; . . . the ideas of those who lack the means of mental production are on the whole subject to it" (*MECW* 5:59). Most Western art proclaims in various ways its allegiance to the ruling classes that by and large have sponsored it. It does not, however, simply reflect passively a static image of human existence, of social, psychological, political, and economic structures perpetrated by those ruling classes. Insofar as it is ideologically partisan, it seeks actively to contain and mystify the sources of discontent that are directed against the status quo. The oppositional voices that are responded to without an open opportunity to state their own case in their own terms constitute a "structured silence" (Macherey 1978) in the text and leave only traces or symptoms. Art, insofar as it functions as ideology, implies the impossibility or undesirability of alternatives to the status quo and thus defends the ruling-class version of reality as the only reality conceivable. Jameson adopts from Freudian Norman Holland (1968) the term "manage" to describe the functioning of ideology in the unconscious:

> This concept allows us to think repression and wish-fulfillment together within the unity of a single mechanism, which gives and takes alike in a kind of psychic compromise or horse-trading, which strategically arouses fantasy content within carefully symbolical containment structures which defuse it, gratifying intolerable, unrealizable, properly imperishable desires only to the degree to which they can again be laid to rest. (1979c: 141)

He sees this form of managing as especially appropriate to art under commodity capitalism. Yet Lévi-Strauss's analysis of preliterate myth as a mechanism for managing insoluble contradictions suggests that this process may be a general feature of all ideology: "The purpose of myth is to provide a logical model capable of overcoming a contradiction (an impossible achievement if, as it happens, the contradiction is real)" (1967: 226). This sort of management of real contradictions by supplying imaginary resolutions serves the status quo.

The specifically Marxist positive hermeneutic aims at restoring to consciousness those dimensions of the artwork which call into question or negate the ruling-class version of reality. Here one might object that there is no inherent necessity of a double hermeneutic for every work of art, because some art (Pindar, for example, seems an obvious instance) is all on one side of the struggle. Yet, even if one concedes that the ideological function of art is in some sense to manage potentially disruptive discontents within society, then by definition art cannot manage what it does not in some way reveal and evoke. The very aim

of management or containment implies the acknowledgment that what is "passed over in silence" (Pindar *Ol.* 9.103) must in some sense be present as the political unconscious of the text. Moreover, as noted above, the Gramscian conception of ideological warfare presupposes a process more of persuasion than of simple, mechanistic manipulation. To put it another way, the audience may refuse the intended solution and respond rather to the unavoidable reminder of its sources of discontent.

As Paul Smith has recently argued, even ideological interpellation, outlined by Althusser as a rather mechanistic process of constructing an obedient "subjected subject" of ideology, lends itself to a process somewhat akin to Jameson's psychic horsetrading. The multiplicity of interpellations, particularly in a period of radical change in the basic structures of society, opens a space of resistance to some interpellations and a corresponding choice of alternative roles for the subject, precisely because the subject positions offered by ideology are contradictory (Paul Smith 1988: 25).

Moreover, argued those of the Frankfurt School, art cannot be reduced solely to ideology—however crucial it is to analyze its ideological roles. Authentic art by its nature involves a re-creation of and distancing from the ordinary reality of experience: "With its built-in '*Verfremdungs-Effekt*', its intrinsic estrangement from reality, art will always preserve in sensuous representation the suprahistorical themes of life, the image of unactualized potentialities" (Katz 1982: 201–202). Insofar as artistic form subjects the reigning version of reality to art's own laws of coherence and beauty, it constitutes a critique, a negation and a utopian transcendence of that reality. These laws are, to be sure, like Marx's economic laws, historically determined and specific to particular social formations. But, as Marx also recognized, they are not in any simple lockstep with the laws of the economic base (Solomon 1979: 61–64).

Jameson, following Marcuse, brings out nicely the apparent harmony of this concept with more traditional idealist aesthetics by citing Schiller, who in the heat of the French Revolution turned to the study of aesthetics. "I hope to convince you," Schiller wrote, "that it is precisely the path through the aesthetic question that we are obliged to take in any ultimate solution of the political question, for it is through beauty that we arrive at freedom" (Jameson 1971: 86). Marcuse, whose work represents the most comprehensive Marxist appropriation of Freud, explicates Schiller as follows:

> The play impulse is the vehicle of this liberation. . . . It is the play of life itself, beyond want and external compulsion—the manifestation of an

existence without fear and anxiety, and thus the manifestation of freedom itself. Man is free only when he is free from constraint, external and internal, physical and moral—when he is constrained neither by law nor by need. But such constraint *is* the reality. Freedom is thus, in a strict sense, freedom from the established reality. (1974: 187)

Marx's own lifelong quest for human freedom as full autonomy and historically constructed sensuous gratification here meets with a politicized and historicized Freud. Marcuse sees in Schiller's play impulse the psychic drive toward total gratification which is constantly repressed by the mechanisms of society. Freud tended to view the drives of the pleasure principle as literally childish and social repression as the inevitable price of maturity. But Marcuse and the Frankfurt School generally tend to view positively the restless discontent inspired by the thwarted pleasure principle; it is a source of revolutionary energy constantly threatening the constraints of the status quo—the very principle of hope, driving humanity forward toward the realm of freedom and negating all form of unfreedom, whatever political label unfreedom may claim.

In his historicization of Freud, Marcuse further argues that Western societies have always been characterized by what he calls "surplus repression"—repression beyond that necessary to carry out the work of social survival. Further, the necessary repression has not been shared equitably in class societies; a small elite has always enjoyed a disproportionate access to gratification (1974: 37–46). The positive hermeneutic reveals the liberating potential of this imbedded vision of gratification as a potential source for "educating the five senses"— available now to a wider audience.

Marcuse's own early analysis of "affirmative culture" (1969; the essay first appeared in Germany in 1937) is not only a useful example of the double hermeneutic in action but also a salutary caution that, when a Marxist speaks in praise of art, something very different is at work from the kind of praise lavished on the classics by an Allan Bloom or a William Bennett. Indeed, Marcuse's analysis of the ambiguity of art and culture in Nazi Germany has some distressing affinities with the crisis of the classics alluded to earlier. Starting with Aristotle's division of life into business and leisure, parallel with a division between what is useful and what is beautiful (*ta kala*), Marcuse argues that "the ancient theory of the higher value of truths above the realm of necessity includes as well the 'higher' level of society. For these truths are supposed to have their abode in the ruling social strata" (91). Bourgeois society instead offers a theory in which there is no acknowledged higher stra-

tum of society: instead we get "the thesis of the universality and universal validity of 'culture'" (93). The decisive characteristic of this specifically bourgeois affirmative culture is "the assertion of a universally obligatory, eternally better and more valuable world that must be unconditionally affirmed: a world essentially different from the factual world of the daily struggle for existence, yet realizable by every individual for himself 'from within,' *without any transformation of the state of fact*" (95, emphasis added).

Marcuse argues that a peculiar development of the notion of "soul" is essential to affirmative culture, a view of soul which "means precisely what is not mind" (107): "an essential difference between the soul and the mind is that the former is not oriented toward critical knowledge of truth" (112). It is tempting here to recall Allan Bloom, who on the one hand informs us categorically that "there is no real teacher who in practice does not believe in the existence of the soul" (1987: 20) but on the other has little room in his own educational vision for genuinely critical thinking.

The darkest indictment Marcuse levels at this affirmative culture of the soul is its complicity in the success of Nazism: "High above factual antithesis lay the realm of cultural solidarity. . . . The individual is inserted into a false collectivity (race, folk, blood, soil). . . . That individuals freed for over four hundred years march with so little trouble in the communal columns of the authoritarian state is due in no small measure to affirmative culture" (125). In terms particularly relevant to the contemporary appropriation of the classics, Marcuse continues: "The new methods of discipline would not be possible without casting off the progressive elements contained in the earlier stages of culture" (125–26); that is, unless the classics are divested of their liberatory moments, they cannot serve the purposes Bloom and Bennett have in mind for them.

But even bourgeois affirmative culture, this seemingly irredeemable evil of capitalist society, is in fact also subjected to a positive hermeneutic by Marcuse:

> There is a kernel of truth in the proposition that what happens to the body cannot affect the soul. But in the established order this truth has taken on a terrible form. The freedom of the soul was used to excuse the poverty, martyrdom, and bondage of the body. . . . Correctly understood, however, spiritual freedom does not mean the participation of man in an eternal beyond where everything is righted when the individual can no longer benefit from it. Rather, it anticipates the higher truth that in this world a form of social existence is possible in which the economy does not preempt the entire life of individuals. (109)

In a hidden and distorted form, affirmative culture, for all its coop-
tive intentions, cannot fail to open a realm in which the status quo is
negated:

> The soul really is essential—as the unexpressed, unfulfilled life of the in-
> dividual. . . . There is a good reason for the exemplification of the cultural
> ideal in art, for only in art has bourgeois society tolerated its own ideals
> and taken them seriously as a general demand. What counts as utopia,
> phantasy, and rebellion in the world of fact is allowed in art. There affir-
> mative culture has displayed the forgotten truths over which "realism" tri-
> umphs in daily life. (114)

The beauty associated with art and the apparent vehicle by which it
lulls and seduces contains a deeply subversive aspect:

> Even beauty has been affirmed with good conscience only in the ideal of
> art, for it contains a dangerous violence that threatens the given form of
> existence. . . . The immediate sensuousness of beauty immediately sug-
> gests sensual happiness. . . . Beauty is fundamentally shameless. . . . It
> displays what may not be promised openly and what is denied the majority.
> (115)

It is clear from Marcuse's analysis that essential to the double herme-
neutic—what makes it work and carries us past the momentarily con-
fusing shifts of "negative," "positive," and "affirmative"—is its
dialectical character in which the notion of internal contradiction is
central. Affirmative culture can turn into its own negation because it is
founded on a contradictory impulse inherent to capitalism, namely, the
desire to win adherence by claiming for the whole of society an access
to gratification which it can structurally grant only in a distorted form
to a few. For this reason, the double hermeneutic in its strongest sense
is available as an analytic tool only to those who take a stand against
that injustice, who find positive whatever negates the injustice of the
status quo.

Jameson's version of this duality is equally founded in a notion of the
inherent contradictions of class society. All class ideology, he argues, is
simultaneously self-serving ideology and the projection of a utopian
image precisely because it projects a vision of the ruling class as an
ideal community (1981: 290–91).[59] Only someone who has become

[59]Cornel West is harsh in his denunciation of this statement: "This exorbitant claim
not only illustrates a utopianism gone mad, but also a Marxism in deep desperation, as
if any display of class solidarity keeps alive a discredited class analysis" (1982b: 195). He
goes on to characterize it as "Marxist flights of optimism . . . an American faith in the

aware of the contradictions of the society as a whole can both demystify the ideology and appropriate the vision as a prefiguration of that real community only truly possible in a society free of the exploitation of one class by another. On the other hand, the specific means by which a particular literary work may both manifest its historical moment and open a utopian dimension are not susceptible to a priori techniques of interpretation. As Jameson rightly argues, "there can be no preestablished categories of analysis: to the degree that each work is the end result of a kind of inner logic or development of its own content, it evolves its own categories and dictates the specific terms of its own interpretation" (1971: 333). So too against the simple socialist judgmental "barbarism" Adorno invokes

> immanent criticism as the more essentially dialectical. . . . It takes seriously the principle that it is not ideology in itself which is untrue but rather its pretension to correspond to reality. Immanent criticism of intellectual and artistic phenomena seeks to grasp, through the analysis of their form and meaning, the contradiction between their objective idea and that pretension. (Adorno 1981: 32)

The approach of the Frankfurt School thus precludes a simple value judgment based exclusively on explicit political content. Rather, it compels us to deal fully with the epistemology of artistic form, to see the particular genre—the epic, the ode, the tragedy—not as a simple reflection of the reality defined by the Greek aristocracy but as a largely autonomous transformation of and response to aesthetic as well as political realities, that is, the specific available literary tradition, circumstances of dissemination, and reception. Its relative autonomy is an inevitable consequence of its formal, sensuous aspects—the fact that it is enmeshed in a whole range of signifying systems such as meter, music, all the conventions of the specific genre as well as the entire Greek poetic and ritual tradition, all of which constitute in various ways intractable interference to unmediated reflection.

A related topic is the relative weight in any particular work of art of these two voices elicited by the double hermeneutic. Is there a

future" (196). This indictment misses the point of a *double* hermeneutic and precludes any serious, much less sympathetic, exploration of the deeper roots of the mass appeal of ideologies that are repellent in their practical consequences. Yet the whole project of the Frankfurt School is to understand the success of the Nazis in winning such widespread adherence to beliefs and policies which a less dialectical Marxism saw simply as contrary to the objective interests of the German working class. In this connection, it is worth remembering that—whatever the importance of Lukács for Jameson (West 1982b: 178)—Marcuse, whose scathing analysis of affirmative culture I have quoted at length for just this reason, was for some ten years Jameson's colleague and close friend.

specifically aesthetic value judgment based on this sort of analysis? Is a work of art better, because its formal aspects more intensively call into question the status quo, than a work that tends both in form and content to reinforce the status quo? The answer of the Frankfurt School Marxists seems to be a somewhat equivocal yes. As Adorno puts it, "a successful work . . . is not one which resolves objective contradictions in a spurious harmony, but one which expresses the idea of harmony negatively by embodying the contradictions, pure and uncompromised, in its innermost structure" (1981: 32). Whereas Marx himself, Engels, and in this century Lukács tend rather to invoke the highly problematic criterion of a work's truth to reality, this immanent critique values a certain lack of closure in a work, the chinks that allow us a glimpse of its political unconscious, the contradiction between its ideology and its traces of the real. But is this not, after all, what Marx and Engels so admired in Balzac?

In any case, the richness of a work of art seems a direct function of the tension between its commitment to a class-bound version of reality and its aesthetic capacity to open wider horizons, to set its own ideology in an inherently richer and freer aesthetic and cognitive context. Jameson succeeds in fusing the divergence between the Frankfurt School and the more traditional Marxist valorization of realism in the following methodological proposition:

> Great art distances ideology by the way in which, endowing the latter with figuration and with narrative articulation, the text frees its ideological content to demonstrate its own contradictions; by the sheer formal immanence with which an ideological system exhausts its permutations and ends up projecting its own ultimate structural closure. (1979a: 22–23)

This dense formulation does not posit a simple opposition between an essentialist aesthetic effect and a negatively conceived ideological effect (Lewis 1983; Paul Smith 1988: 27–29). Rather, it posits in the gap between the working out of an artistic form's own potentialities and the working out of an ideology's various strategies of containment and closure the cognitive possibility of exposing the limits of ideology.

In turning now to selected classical texts, I attempt to open these allegedly univocal repositories of elitist, misogynist, and racist ideology and permit other voices to speak. In historicizing their self-serving utopian visions, I hope also to suggest how the historically transformed ear of the modern audience may appropriate the cry of freedom, the invitation to a just community, and the *promesse de bonheur*.

1

How Conservative
Is the *Iliad*?

A major work will either establish the genre or abolish it; and the
perfect work will do both.
— Walter Benjamin
The Origin of German Tragic Drama

In approaching a text as vast and complex as the *Iliad*, we
cannot hope to deal with all the potentially relevant dimensions. Even
in attempting to keep a relatively narrow focus on the theme of inher-
ited excellence and the politics of artistic form, we find that an extraor-
dinary range of issues are relevant. Of the two major conflicts in the
narrative—one between Achilles and Agamemnon, another between
the Greeks and the Trojans—the first is centrally imbued with the
ideological ramifications of inherited excellence and the second, which
entails the broader issues of the role of the gods and the status of
women, is significantly if indirectly linked with it. The *form* of the *Iliad*
in turn raises in a particularly striking way the general issues of deter-
mination and historical reflectionism with which we are concerned
centrally in the preceding chapter. Finally, any assessment of the rela-
tion between the ideology of the poem and its form raises the issue of
its utopian dimension.

The Form: Determinism by Rhythm, by Mode of Composition, by Genre

To speak of the form of the *Iliad* is to pose immediately the question,
at what level or levels does one conceive of the form of a text? An ex-
cellent case, for example, has recently been made for viewing all early
hexameter poetry as essentially of the same form (Thalmann 1984: xi–
xiv). This approach appears to take the rhythmic structure—or lack
thereof—as the decisive criterion. But this particular rhythm in the

specific historic and cultural context of Archaic Greece (800–480 B.C.) implies more decisively the public character of the poetry, its oral reception by some sort of assembled community in a limited if not completely recoverable set of circumstances (Thalmann 1984: xiv). Research during the past sixty years has also established that this particular form of poetry is orally composed or based on a specifically oral mode of composition.[1] The essential building blocks of this mode are the repeated phrase (formula), the repeated scene or motif (type-scene or theme), and the repeated story pattern.[2]

Although these three components will constitute the decisive point of departure of my exploration of inherited excellence in the *Iliad*, they do not exhaust the question of the criteria by which we might specify the form of the *Iliad*. Since we have argued that form most profoundly mediates any relation between those ideas and any recoverable reality giving rise to those ideas, the issue must be explored somewhat further.

The broad category of rhythmic arrangement entails a whole chain of constraints and conditions of possibility for communication: the possibility or impossibility of word shapes to fit in that tight pattern, the

[1]See M. Parry 1971, Packard and Meyers 1974, Holoka 1979, and J. Foley 1985. See also Davison's survey of the Homeric Question in Wace and Stubbings 1962: 234–266, and Adam Parry's excellent introduction to his father's papers (M. Parry 1971: ix–lxii). For a broader framework of oral poetry throughout the world, see Finnegan 1977 and Zumthor 1990.

[2]In treating the formula, M. Parry's work (1971) and the subsequent formulations of his pupil A. Lord (1965, 1967, 1974, 1991) insisted on the centrality of exact repetition of phrases to any definition of orality. This view has been variously modified by demonstrations of flexibility (Hainsworth 1968), modification (Hoekstra 1964), formulary or formula-like adaptation (Russo 1963 and 1966) and extended by the attempt to demonstrate a preformulaic mental template, or *sphota* (Nagler 1974). Finnegan (1977), to be sure, has along with Douglas Young (1967) precluded a simple equation of "oral" and "formulaic," but the category of formulaic, pace Griffin (1980: xiii; and N. Austin 1975) is not therefore rendered irrelevant. Lord's quest for a statistical proportion of repeated phrases as a test of orality, though not infallible in the light of Finnegan's richer model (1977), still seems to me the most serviceable indicator of the line between oral and literate.

The first major study of the type-scene was Arend 1933, reviewed and integrated with his own formulaic focus by M. Parry (1971: 404–407), examined as "theme" by Lord (1965: 68–98) and under differing terms by Armstrong (1958), Fenik (1968, 1974, 1978), Gunn (1971), and most recently M. Edwards (1987, with references to his more detailed earlier work).

In addition to Lord's ground-breaking analysis (1965) of the major story patterns, virtually every serious study of the poem in the wake of Parry and Lord has offered some version of the role of larger narrative structures—though inevitably at different levels of abstraction. Nagler (1974) and M. Edwards (1987: 62–63) basically follow Lord's exploration of the "withdrawal, devastation, return" pattern. Thalmann, though endorsing in a general way this broad pattern (1984: 37), focuses his detailed discussion on a "rhythm of significant deaths" (45–51). Thornton (1984) examines both a more concrete "path" (*oimē*) of the whole narrative and a more abstracted pattern of repeated supplications. This list might be extended indefinitely. See my subsequent discussion in the text for other sorts of patterns.

resulting pressure to preserve the widest variety of dialect variants and historically anachronistic forms, the consequent panhellenism and emotionally evocative archaism of the diction, the patterns of word order and emphasis conducive to this meter, the mode of discourse and organizational syntactic structures conducive to oral composition and oral reception (M. Edwards 1987: 42–60; Thalmann 1984: 4–32). All these elements and others radically condition the message of the resulting text. Indeed, there is a distinct sense of inevitability in those scholars who trace this series of determinisms from a fixed metrical pattern through formulaic language, recurrent patterns of narrative and of discourse to a fixed mode of thought and to a fundamentally homogeneous, static conception of the world. Here is just one example:

> My interest, then, is in the more overt kinds of conventions—that is, in the characteristics, ideas, attitudes, and concerns that all the poems share. What seems to be most important about this poetry is that it was a means of coming to know and explaining the world and man's place in it: the history and arrangement of the physical world; the course of divine and human history; the conditions that govern men's relations with the gods and with each other; and the significance and value of human civilization and social institutions. Poetic conventions, as vehicles of meaning, furthered this aim in crucial ways and thus enabled the poetry to present a coherent worldview. (Thalmann 1984: xiv)[3]

Before considering the assumptions of this eminently plausible strategic series of moves, we need to consider the relation of these dimensions of the text of the *Iliad* to more familiar categories of literary history associated with the notion of genre as a designation of form. Here, in addition to conventions of rhythm, conditions of performance and reception, mode of composition, and characteristic patterns of organization, affect, and thought, one must consider issues of length and

[3]See also Russo 1976; Ong 1982: 41–42. I note in passing that influential discussions of Homeric epic considered within the Marxist tradition (Lukács 1971; Bakhtin 1981), although per force innocent of Parry's theory of oral poetry, are just as insistent as are those of contemporary classicists on the closed, homogenized character of the Homeric worldview. I should note, however, that Lukács in his preface of 1962 is at pains to stress that his work on the epic—dating from 1914–15—reflects his "turning from Kant to Hegel" and his "youthful enthusiasm for the work of Dilthey, Simmel and Max Weber" (1962:12). It predates his serious immersion in Marxist thought (Löwy 1979: 109–44). There emerge from its murky Hegelian meanderings sharply arresting, even haunting, claims that are virtually never supported by concrete reference to any text beyond "Homer" or "Dante." In any case, the conception of Homer and the relation of the text to its society is purely and simply Hegelian organicism. The word "homogeneous" in fact is a sort of leitmotif running through the scattered allusions to Homer (e.g., 1971: 32, 34, 66). *The Theory of the Novel* is nonetheless frequently cited as the view of the "Marxist Lukács."

subject matter. If the phrases "epic" or "heroic" poetry have any use today, the most concise definitions focus on a distinctive scope and a clearly delineated subject matter. Thus we not only break apart the broad category of early Greek hexameter poetry but must also recognize that the form of the *Iliad* owes much of its range and richness to its incorporation of a vast array of other forms or genres that demonstrably or presumably had an independent existence in the Archaic period—prayers, hymns, short narratives about the gods, and brief, paradigmatic accounts of "the glorious deeds of heroes" (*klea andrōn*), military exhortations (*parainesis*, M. Edwards 1987: 3), boast-and-insult contests (Martin 1989: 47), love poems, catalogues, genealogies, work songs, and laments for the dead (Bowra 1961: 4–6). Bakhtin contrasts the "closed and deaf monoglossia" of epic with the "polyglossia" of the novel—an openness to the clash and dialogue of a wide range of different languages from different social strata, different territories, and different literary genres (1981: 12). Yet, if the epic language appears to us to have completely integrated and homogenized these constituent voices, we must nonetheless recall that the sweep and comprehensiveness of the anomalously long *Iliad* and *Odyssey* owe much to this incorporation of all the voices of so many preexisting smaller genres.[4]

If for later generations only these two poems are the Greek representatives of the epic genres, their sharply differentiated subject matters, taken most broadly as war and homecoming, respectively, have operated as grounds for two separate subgenres, only rarely, as in the *Aeneid*, consciously combined. Thus it is worth emphasizing that the form of the *Iliad*, if we consider all elements apart from its subject matter, is paralleled only in the *Odyssey;* but if we consider as well its subject matter, it is unique, sui generis. Its store of specifically martial type-scenes and formulas, painstakingly analyzed by Fenik (1968), imply a long and subtle development of a tradition of specifically battle-oriented narratives.

The Traditional Poem and a Traditional Worldview?

In view of the enormous interest generated in all aspects of the Homeric poems, what is really extraordinary is the extent of the consensus among those working primarily at the formal level and those who

[4]Martin (1989) makes a particularly powerful case for the differentiation of voices as different speech performances by characters in the poem. His analysis of the poet's own performance in a presumed contest with all preceding epic (especially the putative epic of Herakles) also implies an almost Hegelian incorporation/annihilation/supersession of all contenders.

have focused on questions of belief systems, social function, and more traditional thematic criticism. There is widespread agreement in emphasizing the fundamentally conservative character of the poems, "conservative " in virtually every sense of the term. In the case of Homer, formal analysis has appeared to give an almost self-evident validity to pronouncements about the political and social character of the poems.

Milman Parry's ground-breaking initial study was significantly entitled "The Traditional Epithet in Homer" (1971 [1928]: 1–190). Parry begins that work with a quote from Renan urging the necessity of entering "into the personal and moral life of the people" who have made "primitive literature." Parry declares that this concept is "the central idea of [his] study" (2). Thus, at the very outset, his vision is fixed on a fundamental integration of the style of Homeric poetry with its vision of the world. At the same time, in words that echo the assumptions of those German historians so taken to task by Marx and Engels in the *German Ideology*, Parry declares, "The literature of every country and of every time is understood as it ought to be only by the author and his contemporaries" (1971: 2).

It is important to appreciate the radical integrity with which Parry attempted to adhere to that principle and at the same time to recognize its essential inadequacy. No student of Homer has surpassed him in the rigor with which he sought to grasp the world of the poems with as few preconceptions as possible, to think himself into both the minutiae of the process of composition and the vision of reality he conceived of as an inevitable consequence of that process.[5] Yet the assumption of the perfect integration of mode of expression with mode of perception is itself ideological and was most radically challenged by Parry's son, Adam Parry (1956). In a tantalizingly brief article, Adam Parry raised the possibility that Achilles' great refusal speech in Bk. 9 might best be understood as an effort to confront the inadequacy of the traditional language to express a radical perception of fundamental contradictions within the values expressed in the "normal," less self-reflexive use of that traditional language. We consider later the issue of the validity of Adam Parry's analysis; but for all the praise lavished on the son's insight, the father's perspective—backed as it is by such a wealth of argument—has remained overwhelmingly dominant.

Challenges to M. Parry, recently dubbed reactionary criticism (Martin 1989: 2; so too Lynn-George 1982), have characteristically taken

[5]M. Parry, in his Harvard address (1971 [1934]: 408–13), in which he is clearly haunted by the rise of fascism, attempts to deal more profoundly with the inevitable ideological differences in readings of texts removed from their original social context, but his tragic death the following year at the age of 33 cut off any fuller exploration of these tentative probings.

the form of fundamentally aesthetic defenses of the great poet's orig-
inality and creativity (e.g., N. Austin 1975; Griffin 1980; Mueller
1984). In my view, at least, these challenges have not in any way sup-
planted M. Parry's analysis of the mode of composition.[6]

Proceeding from the widespread recognition that the epithets were
traditional, that is, that the vast majority of them are unlikely to be the
invention of a single creative poet, Milman Parry carried Homeric
studies into a detailed demonstration of their systematicity, their essen-
tial functional role in building dactylic hexameter lines (1971: esp.
270–79). The next step was "to show that the *Iliad* and *Odyssey* are com-
posed [not only] in a traditional style [but also] are composed orally,
then to see just how such poetry differs from our own in style and
form" (269). One crucial aspect in which Parry argued that oral/tradi-
tional poetry differs from literate poetry is in the traditional poet's rel-
ative lack of freedom to express either a traditional idea in an
untraditional form or an untraditional idea in any form. In Parry's
work itself and in that of his followers, one feature after another has
been demonstrated to be traditional and, so the assumption goes,
therefore determined by the rules of oral composition. It is no accident
that Albert Lord (1965: 280), Parry's co-worker and disciple, is prob-
ably the first English-speaking classicist to cite Lévi-Strauss—no acci-
dent that recent work on both the smaller and larger components of
Homeric poetry have made dramatic use of the structuralist linguistic
analogy and techniques of narrative analysis. Both stress the automatic
character of language rules and thought processes independent of in-
dividual consciousness and with little or no focus on historically gen-
erated social conflict.

At the level of the individual phrase—whether one looks to the
"hard" Parryists gathering statistics of exact repetitions or to those in
quest of structural formulas, modifications of formulas, or the flexi-
bility of formulas, or even those who, applying a Chomskian linguistic
analogy, would abandon formulas in favor of mental templates, fami-
lies, or *sphota*—there is basic agreement that the language of Homer is
deeply traditional.[7] M. Parry himself demonstrated the traditional
character of Homeric metaphor (365–75), and subsequent work on

[6]My comment is in no way intended to dismiss the many insights in this work nor to
imply that I consider efforts to specify the differentiating features of the Homeric poems
a waste of time. Martin, who denounces these criticisms as reactionary and calls for a
"sociocultural reading" (1989: 1–2), turns out to offer us a compelling demonstration of
precisely artistic originality in a "society" of competing poets. For him, social and polit-
ical values—my primary focus—are of interest only as weapons in a rhetorical battle.

[7]For the distinction between "hard" and "soft" Parryists, see Rosenmeyer 1965; for the
other positions alluded to, see above, note 2.

the similes, whose language has been demonstrated to be generally very late (Shipp 1972), stresses that the vast majority of similes follow predictable, traditionally fixed patterns of association (W. C. Scott 1974).

At the level of motifs, themes, and so-called type-scenes—arrival, sacrifice, eating, journeys, arming, dueling, dressing, decision making—the emphasis may have moved away from the notion of mechanical repetitions toward the elucidation of fixed assumptions shared by poet and audience about a fixed number of meaningful activities carried on in a fixed way. Variations and omissions do not reveal "Homer against his tradition" (Russo 1968, modified 1976) so much as Homer exercising the peculiar spontaneity made possible only within those fixities (Nagler 1974: chap. 3). Thus scholars treating these motifs tend, pretty consistently, to perceive an implied conservative moral in the rare departures from the typical. Patroklos, in assuming the armor of Achilles, cannot take up the great Pelian ashen spear because he is not strong enough to wield it. The violation of the typical arming pattern thus implies a condemnation of his attempt to assume an identity greater than his own in the fixed hierarchy of heroic powers (Armstrong 1958; M. Edwards 1987: 73). The fact that Odysseus' starving companions cannot adhere to the full ritual proprieties in sacrificing the cattle of the sun—they cannot sprinkle grain between their horns because they have no grain—suggests the dimensions of their criminality in sacrificing them at all (Nagler 1974: 205–7). Achilles' sending the Myrmidons into battle in Bk. 16 without the traditional meal affirming social cohesion provokes an implicit condemnation in the simile of the wolves savage antimeal (Nimis 1987: 23–42).

Most clearly at the level of the larger narrative patterns that constitute the most encompassing features of the form of Homeric poetry, recent analysis leans heavily toward emphasis on the conservative thrust of both poems, but particularly the *Iliad*. Redfield's influential study of the *Iliad* (1975) combines insights gleaned from Lévi-Strauss's analysis of myth with the reactionary Aristotelianism long fostered at the University of Chicago. Both trends converge in several strictly conservative moral patterns. A good tragedy, we are told, must not present us with a view of culture as dysfunctional; we might feel "confused and disaffected" (90). Therefore good tragic heroes have to commit errors (91), which are duly punished according to the plan of Zeus (148). Achilles, we learn, despite the fact that he is guilty of several errors, is unfortunately not guilty in the narrow Aristotelian sense (106), whereas Hektor's loss of heroic balance (128) suits the bill and gives us the appropriate tragic pattern. Achilles is treated by Redfield more

anthropologically—in terms of the motifs of suppressed cannibalism and overt caninism apropos of his dog-like denial of burial to Hektor's corpse. Achilles' mistreatment of this corpse sets him outside civilization, which he can only regain in the artistically imposed, purely personal reconciliation with Priam (218). But Redfield seems to find the deepest meaning of the poem embedded in the structural opposition of Hektor and Achilles as two symmetrically opposite contradictions within heroic society: Hektor destroys himself and his society by adhering to the code of self-sacrifice demanded by that society; Achilles does likewise by adhering to the code of self-assertion that is just as much an imposition of his society. Rather than exploring the possibility that these "contradictions" imply any sort of critical distance or serious ambivalence on the part of the poet, Redfield sees a de facto homology between Aristotle and Lévi-Strauss: tragic art edifies the "bonbourgeois," Redfield's own term for Aristotle's intended audience (87), by revealing a morally coherent universe; myth mediates the contradictions that threaten the status quo by revealing that the only possible alternative to accepting them is isolation and death.

Thornton, focusing on the traditional institution of supplication (J. Gould 1973), also concludes with an explicitly Aristotelian moral: "The poem's fundamental injunction is the same as the famous proverb μηδειἄγαν 'nothing to excess,' which towards the end of the classical period of Greece is crystallized in the ethics of Aristotle" (1984: 142). Her emphasis on the homogeneity and continuity of the traditional values she finds in the *Iliad* implies a dominant, pervasive Greek conservatism in terms that substantially undercut her brief but suggestive attempt to historicize the relevance of the meaning she finds in the poem (144–47).

Nagler's analysis of the *Iliad* in terms of Eliade's "Myth of the Eternal Return" (1974: chap. 5; Eliade 1954) presents us with, if anything, a more rigorously conservative *Iliad*. Whereas Redfield at least sees in the poem some confrontation with meaninglessness (1975: 223), which is transcended and transformed in a fusion of art and myth, Nagler perceives in the amplified repetitions of withdrawal, devastation, and return an unequivocal indictment of Achilles, whose rejection of the embassy is dubbed "apparently groundless" (133), whose words to the embassy in Bk. 9 "need not be taken too seriously" since the tradition requires that they be "noble and brave, but not necessarily relevant" (133). In Bk. 9, according to Nagler, Achilles loses touch with the plan of Zeus and is "carried away by his own personal desires in the face of the overriding, living force of destiny" (155). The plan of Zeus is equated by Nagler with "just and rational ordination" (151). Achilles' final reconciliation with Priam returns him to a "state of harmony with

the divine will" (195).[8] Without at this point examining the grounds in the text for such a reading, I wish merely to stress the fact that such an interpretation on what we might call the macro level is presented as the natural consequence of Nagler's often brilliant analysis of the traditional character of the smaller linguistic constituents of the poem's final form. But at the same time it is not hard to envision the pedagogical suitability of a work so conceived for canonical endorsement of any status quo and for integration in what Marcuse called "affirmative culture."

Nagy's fascinating exploration of the *Iliad* represents perhaps the most extreme and compelling insistence on the traditional character of the composition: "the genius behind our *Iliad*'s artistic unity is in large part the Greek epic tradition itself" (1979: 79). Despite Nagy's title, one cannot really say he is interested in the major story pattern of the *Iliad*, the working out of the demonstration that Achilles is indeed the best of the Achaeans. For Nagy the wrath is not conceivable as a fundamental confrontation with the contradictions in the heroic ideology, because Nagy can offer us a brilliant demonstration of its linkage with traditional squabbles over slices of meat (1979: chap. 11). Achilles' imminent death, his sure knowledge of that death as a negation of an easy confidence in the hegemonic ideology, emerges as somehow peculiarly irrelevant to the story pattern because Nagy can demonstrate by a plethora of parallels that "as a generic warrior, the hero of epic is a *therapōn* of Ares precisely because he must experience death. The requirements of the hero's death, however, is dictated not so much by the narrative traditions of epic but by the ritual traditions of cult. Death is fundamental to the essence of the hero in cult" (295). A ritual explanation of a phenomenon is offered as if the social, political, and psychological needs met by ritual or by the narrative pattern require no explanation.

In many discussions of the poem, a distinction between analysis of the narrative structure and of the social, ethical, and political values in the poem seems almost gratuitous—one thinks especially of some of the more impressive sections of Redfield's book. But here it is worth registering the fact that to an increasing degree the discussions primarily focused on values in the poem takes some pains to stress the traditional character of the language and form in general.[9] The most

[8]Achity's analysis of Achilles in terms of the establishment of order by Zeus (1978: esp. xiii) is so much in the same vein that detailed separate discussion of his work—far less concerned with narrative patterns than Redfield's or Nagler's—seems superfluous.

[9]Adkins's initial discussion in *Merit and Responsibility* (1960) makes no use of oral theory. His *From the Many to the One* (1970) does allude to a long oral tradition (13) and assumes that the views in the poems are accordingly traditional (49). In alluding to an

intelligent and thorough of recent discussions of values are profoundly functionalist in their approach; that is, they stress the ways all the values exhibited in the poems serve to maintain the various essential structures and institutions of the society envisioned in the poems.[10]

In relation to the old analyst schools that combed the texts in search of contradictions as a basis for proving different historical layers in the process of composition, a functionalist analysis that demonstrates how apparently contradictory elements—for example, dowry and marriage gifts (M. I. Finley 1955: 167–94; cf. Snodgrass 1974: 115–25)—in fact make sense within a single social context is a distinct improvement. Positing *any* coherence is arguably more likely to lead to productive inquiry than are niggling quests for every sort of incoherence. The essential inadequacy of functionalism is, however, its hypostasization of a purely static vision of society. Here there is an interesting fusion of the influence of French, British, and American sociology and anthropology, with their implicit apologetics for the status quo, and the peculiar adaptation of Marxism in the work of Lévi-Strauss. Although Lévi-Strauss cites Marx along with Freud and geology as one of the three decisive sources of his conception of reality (1974: 57), he nonetheless has chosen to focus his life's work on those societies in which there is minimal change, in which the economy is based on a combination of nomadic hunting and gathering with relatively simple agriculture. In the work of Lévi-Strauss on myth there is indeed a strong emphasis on the notion of contradiction, which he clearly owes to Marx. But his choice of societies and his notion of a purely intellectual impulse to the exploration of contradictions in myth combine to render contradiction quite manageable; the myths either successfully mediate the contradictions or the intellectual impulse exhausts itself (1967: 226). We must therefore ask whether the society envisioned in the Homeric poems is the real society of Homer and his contemporaries—insofar as we can grasp its character—and whether the sorts of contradictions with which the poem is concerned fit the static model of the functionalists and structuralists.

The World in the Poems and the World of the Poems

Those scholars, cited earlier, who have stressed the more or less perfect fit between the traditional oral medium and the traditional con-

overly hasty collapse between a traditional language and traditional values, I am thinking especially of the revised edition of M. I. Finley's *World of Odysseus* (1978), Russo 1976, and Havelock 1963 and 1978.

[10]For an overview and critique of functionalism, see Harris's "British Social Anthropology" (1968: 514–67), which, despite its title, begins with Durkheim.

servative message of the poems largely take for granted, without extended discussion, that the actual social formations variously reflected in these poems are of essentially the same, profoundly stable type primarily studied by Lévi-Strauss.[11] I believe that this assumption is fundamentally inadequate. No society is so inherently stable that it does not need to expend considerable effort just to sustain and reproduce itself. At the same time, I think that Marx, in his admittedly sketchy speculations on precapitalistic economic formations (*Grundrisse, MECW* 28: 399–439; Lekas 1988: esp. chap. 4), rightly attempts to distinguish between those forms that are structurally most tenaciously stable and those that exhibit a built-in dynamic of instability. Chief among the destabilizing factors Marx cites are the emergence of individualism vis-à-vis the commune, and warfare and conquest as basic elements in the economy and social organization (*Grundrisse, MECW* 28: 410–11). I argue that in every alleged referent for the society represented in the poem there is just such a dynamic of radical change at work. This dynamic of change in turn opens a gap between medium and message and fosters a new level of consciousness in the most perceptive of those figures designated as the chief ideologues of their society, the bards.

Recent discussion of the relation of the society envisioned within the poems to the poet's own circumstances has tended to limit itself to a debate between the contending claims of the Mycenaean period, the so-called Dark Age (the tenth and ninth centuries), and Homer's own eighth century.[12] The terms of debate then hinge on counting various survivals, explaining away various supposed anachronisms, or stressing the distinction between physical objects—the memory of which can be preserved intact in the formula—and social institutions, which tend, it is argued, to be more reflective of the poet's own times. If, however, we look briefly at the scanty historical evidence for each of these three periods, the striking fact most relevant to our inquiry into the allegedly

[11]Lévi-Strauss does have a provocative essay titled "How Myths Die" (1976: 256–68), but he characteristically begins by declaring, "We will be concerned here with the death of myths, not in time, but in space." In fact, the essay ends with a poignant instance of a failed attempt of North American Indian myths to adapt to the crushing historical impact of European intervention and aggression.

[12]For Mycenae, see Webster 1964 and Arnheim 1977: 35; for the tenth and ninth centuries see M. I. Finley 1978: 153, Thomas 1978, and (hesitantly and equivocally) Kirk 1962: chaps. 5–7; cf. 1975: 820–50; for the eighth century, see Thomas 1966 and Murray 1980: 38–56. Snodgrass (1971: 389–94) argues that there are "only two positively and widely identifiable historical 'strata' in the world described in the Homeric poems: that of the full Mycenaean era . . . and that of the poet's own day." He concludes here as in his 1974 essay that "the Homeric political system, like other Homeric pictures, is an artificial amalgam of widely separated historical stages." This claim seems eminently sensible as far as it goes, but to leave it at that is to abandon the question of what kinds of relevance such an amalgam might have for the poet's audience.

unmediated traditionalism of the poems is that none of them qualifies as a really stable society.

The world revealed by the Mycenaean tablets, with their elaborate hierarchies and compulsive bookkeeping, seems in one sense at least the best candidate for being dubbed stable; its very complexity implies a long period of development. On the other hand, the period immediately preceding the Trojan War together with the period alleged for that war constitute an era with significant evidence of instability quite directly related to the militarization of life that so sharply differentiates Mycenaean from Cretan cultural remains.[13] The archaeological record for this period shows elaborate new fortifications and some destruction, followed not long after by widespread destruction. Vermeule, for example, describes the thirteenth century as "an age of constant aggression and civil dynastic war" (1972: 269). Then, as she notes, "in one or two generations comes the big time of trouble." In summary, "the kings of the empire age then lived through a period marked by constant aggression against one another, by involvement in the larger disasters of the Levant, by strong commercial trade and the deployment of well-trained fighting men" (270–71).

The tenth and ninth centuries, insofar as we can even lift the veil of darkness, reveal very slow recovery from the mysterious devastation and depopulation of the preceding centuries, significant if small-scale migrations, and perhaps something almost amounting to a trade and cultural hegemony exercised by Athens.[14] The mixture of peoples, the slow struggle to reestablish Mediterranean trade connections, and continued small-scale wars again scarcely suggest the image of static societies evoked by recent students of the Homeric poems. Desborough, for example, begins his account of life in the Dark Age with the terrible insecurity evoked by the very mountains that under more stable conditions might have offered grounds for comfort: "Once one could no longer be sure whether those across the mountains were friends or foes, the sense of insecurity would only be increased by a barrier that was no real protection, that could conceal an invader until the last possible moment (1972: 329–30). He notes that it is not even possible to date with any precision such major disasters in this period as the destruction of Miletos and of Emborio on Chios (333). "The tenth century produces evidence of considerable advance," but there is the

[13]See M. I. Finley's well-justified irony on the presentation of dates and evidence for this war in "Schliemann's Troy—One Hundred Years After" (1978: 158–77).

[14]Desborough (1972: 344–47) lays rather tentative stress on the central role of Athens. At p. 224 he raises the problem of whether pottery alone was the essence of Athens' claim to be "the main commercial power in the Aegean during much of the tenth century." Snodgrass (1971: 328) stresses Athens' isolation in the period from 1025 to 950.

mystery of the considerable, drawn-out movements toward the East, initiating, apparently from Athens and not due to overpopulation (343–45). Increased contacts with the eastern Mediterranean, even marked by the finding of gold objects at Lefkandi dated just before 900 B.C., suggest increased material wealth, to be sure, but not simple stability (348). On the contrary, in the ninth century and some of the eighth we see indications of a pattern of imperial expansion that led to two competing spheres of influence and culminated in a major war, the so-called Lelantine War, which seems to have more or less permanently destroyed both sides (Murray 1980: 76–79).

The eighth century, the third contender for the world in the poems, particularly the middle and later parts in which presumably "Homer" flourished, has been called by Snodgrass "an epoch of transformation rather than mere progress, the first and most mysterious of a long, but widely spaced series of such outbursts in the recorded history of Europe" (1982: 679). This period was characterized by the rise of the polis, widespread colonization, the acceleration of the replacement of kings by oligarchs, and rising economic and social conflict—if we may extrapolate from both Hesiod and later Athenian evidence.[15] The non-Homeric evidence, apart from Hesiod at the near end and the Linear B tablets at the other, is unfortunately nothing but bits of stone, bone, metal, and clay. But, to the extent that we can get some sense of these periods apart from the Homeric poems themselves, there is little basis for extrapolating a vision of simple stability. To be sure, Braudel has rightly stressed the extraordinary durability of many social patterns in the Mediterranean (1972: 19–20). Thus one could simply say that it is only a matter of nuance whether one focuses on the continuities or the threats to continuities. But here one encounters the inadequacy of a purely reflectionist view of art. Even on the assumption of unmediated reflection in the poems of one of these periods, as soon as one raises the question of choices or emphases in which aspects of that complex reality are reflected, the factor of ideology enters. In relation to the issue of stability, it is worth recalling Althusser's emphasis on the role of ideology in reproducing the status quo along with Jameson's subtler stress on the role of ideology in managing discontents and potential threats to the status quo. The Homeric poems, whatever else they may be, are ideological constructs. Thus an ideological function of maintaining the illusion of continuity, of managing whatever threatens continuity, may have more to do with elements in the poem conveying an image of stability than the specific reality of the world it reflects.

[15]See Murray 1980, Snodgrass 1980, Starr 1961 and 1977, and Huxley 1966.

The ideological use of the past, particularly under circumstances in which the mode of ideological production is especially sensitive to audience control, is quite complex.[16] Here, for all the differences, the analogy between Homeric poems and films of the wild West genre is instructive. The vast financial risk involved in film production intensifies the pressure on producers, writers, and directors to offer an image of society that is psychologically, politically, and socially gratifying. As Lévi-Strauss suggested for myth and Modleski for soap operas and Harlequin novels, the gratification of traditional types of narrative is in part a consequence of its offering imaginary solutions to real contradictions. In wild West films, an essential ingredient in that gratification derives from the illusion that the subject of the film is a different society from that of the audience—thus the vast expenditures in the interest of verisimilitude. Verisimilitude offers the distancing effect that mediates and renders gratifying the films' exploration of contemporary needs, frustrations, and tensions (Place 1974). At the same time, the ideological function of these films requires that the difference of the society they portray not be absolute: the viewing audience must also find in them an image of its own past—a warrant and a "charter" (Malinowski 1971 [1926]) for contemporary institutions, values, and patterns of behavior. One thinks, for example, of the comfortable fit between institutionalized racism against the indigenous peoples of America so blatant in the older films and institutionalized racism against black people in contemporary society, or between the behavior pattern of the gunslinger in the films and the foreign policy of the United States.

Bakhtin has gone further in analyzing the "absolute time" of the epic world—"a world of 'beginnings' and 'peak times in the national history, a world of fathers and founders of families, a world of 'firsts' and 'bests'" (1981: 13). He goes on to argue that "the absolute past is a specifically evaluating (hierarchical) category. . . . all the really good things (i.e., the 'first' things) occur only in this past" (15). Thus there is a potential tension between this powerfully valorizing image of the heroic past and the role of projection into the past as a sort of safety device for playing out the intense ideological struggles of the present. The past may be a utopian version and warrant for the contemporary

[16]There is a great difference, for example, between an imposed annual recitation of the Enuma Elish by an ancient Near Eastern priest caste tightly integrated with a powerful monarchy on a passive population (Roux 1980: 365–69) and the sort of audience control envisioned in the Homeric poems, where "People applaud by preference (*mallon*) that song, / That sounds freshest of all round the hearers' ears" (*Od.* 1.351–52). Martin (1989) is particularly compelling in emphasizing the interaction of the performing poet with the audience, though he ignores the whole issue of class and class ideology.

ruling class (Bakhtin 1981: 15), but its claims to perfection render it a potential vehicle for highlighting the inadequacy of the present generation of rulers.

Students of ancient Mediterranean cultures have long been struck by the lack in ancient Greece of a powerful, tightly organized priest caste capable of imposing ideological orthodoxy on a subjected populace.[17] The oral/traditional bard, whose conditions of performance we consider more closely in discussing the *Odyssey,* has, I argue, a fundamentally different relation to his audience from that of a Babylonian or ancient Egyptian priest. The oral bard is in a competitive situation. He must quite literally be sensitive to his audience's unconscious needs if he is to eat (*Od.* 1.351–52). A successful bard's most basic social function is to entertain—a term the implications of which, as my references to Lévi-Strauss and Modleski are intended to suggest, are by no means self-evident. Nothing is more misleading than an antithesis between mere entertainment and real art if the latter alone is presumed to have a message. On the contrary, the most successful vehicle of ideology is the most disarmingly entertaining. We can legitimately assume, I think, that like the audience for wild West films, the oral bard's audience has a need for the mediating distance of a past in which society and life have a clarity and purity of focus inherently different from any lived experience. But that gratification involves at least some indirect acknowledgment of their deeper dissatisfactions with the present.

Moses Finley some years ago made devastatingly effective use of the analogy of the *Song of Roland,* for which we do have contemporary documentary controls on the alleged events of the poem, to question naive claims of Mycenaean historicity for the *Iliad* (M. I. Finley et al. 1964: 2–4; echoed in M. I. Finley 1978: 45 and 145). The analogy might have been taken further. One would like to know what needs the *Song of Roland*'s distortions and fantasy met in the society for which it was composed; how does its image of society and human identity mediate or seek to mediate tensions felt in the world of the intended audience? It is similarly inadequate to stress the rough, very rough, approximation of some aspects of life either in Mycenae or in the tenth and ninth centuries in the Homeric poems without exploring the ways Homer's image of the past was relevant to his own society. Accordingly, as we examine the world in the poems, we are not primarily concerned to

[17]My own first encounter with this point was in a curious book by the great nineteenth-century French historian Michelet. In a memorable, if too simple formulation, he declared, "Greece, 'mother of myths,' as people so delight in saying, had two gifts at the same time—to make them, and to give them little credence" (1864: 160). The paradox is explored more deeply and provocatively by Paul Veyne (1988).

match it with an alleged referent. We can only consider what needs it may meet or what contradictions it seeks to mediate or mask by first grasping how society as a phenomenon is presented in the poem.

Here we must ask whether or to what extent the traditional formulas present us with a normative social vision and whether the development of type-scenes and the unfolding of the major narrative patterns reinforce or call into question normative features of the traditional poem. By way of anticipation, I argue that the uniqueness of the *Iliad*—its anomalous size and its status as the only surviving ancient Greek war epic—suggests that it deserves to be viewed not as a mere exemplar of a vast lost tradition—a fragment more or less accidentally preserved—but as an illustration of Walter Benjamin's insight: "A major work will either establish the genre or abolish it; and the perfect work will do both" (1977: 44). The *Iliad* does not simply pass on and preserve the traditional formulas, motifs, and narrative patterns to sustain a given status quo. It consciously confronts the ambiguities and contradictions of the tradition with a degree of negation that precludes a simple endorsement of the status quo. By the end of the *Iliad* there is, in a sense, no status quo left to endorse.

A tension between traditionalism and radical negation is manifested at every level of the poem—in individual formulas, repeated themes, and the larger narrative patterns. We may even say that this tension generates the poem. At the same time, what is exalted in the process of negation stands out with particular clarity as a utopian core in the traditional ideology: a vision of community and the "proper" hierarchy of power and rewards irretrievably betrayed by the actual functioning of society.

In trying to understand this imaginary society, we begin by looking for a general norm in its broader structures before looking more closely at how the traditional formal elements operate in the representation of the dominant "wrath of Achilles" narrative. In looking for these broader structures of the world in the poem, we follow a loosely Marxist model of base and superstructure; that is, we first consider how the poem's terminology, formulas, and type-scenes present an image of the economic sphere, then proceed to examine how this image sustains and is reciprocally affected by images of a political and social hierarchy.

Ideology in the Poems

Property and War: The Economics of Heroism

Looking at the poem's image of the world, one might still expect to find a projection of stability as the fulfillment of a deeply felt need in

a period conspicuously lacking it. In fact, however, a brief look at some crucial elements in the economic ideology of the poem demonstrates that this is not the case. The most obvious need the poem seems to meet is manifested in the gratifying vision of splendid wealth in an age of general material poverty.[18] The greater aesthetic brilliance of bronze weaponry over iron may have played far more of a role in the formulas of Homeric warfare than did concern for historical accuracy. Palaces of bronze and silver, such as never existed in Greece, serve the same need as gold cups that can more or less be matched with Mycenaean archaeological remains.

Where, according to the poem, does this dazzling wealth come from? How is it acquired or transmitted from generation to generation? An eminent historian described the Homeric poems as illustrating a "regime . . . of private ownership" where "the transmission of a man's estate by inheritance, the movable and immovable together, was taken for granted as the normal procedure upon his death" (M. I. Finley 1957: 138). Unquestionably, the world of the poems presupposes both the institutions of private ownership and inheritance of property. Control of wealth, however, like all other social relations, is presented in the poems as entirely a function of success on the battlefield. War in this sense emerges as the fundamental social and economic institution from which all others flow. Because war constantly overturns the expectation of orderly tenure or transmission of property, it emerges as a profound contradiction of those expectations. The result of the recurrent focus on this contradiction in the poem is a tone which, for want of a better term, I can only call irony.

Actual production—agriculture, animal husbandry, craftwork—is a sort of structured silence (Macherey 1978), an ideologically suppressed element in the poem traces of which appear only in the world of the similes and on the shield of Achilles. Fundamentally, the narrative of the poem shows an interest only in the property of heroes, the male warrior elite who dominate the world in the poem. The property of a hero in the *Iliad* consists of his herds, his land, his house, his store of movable goods, and his slaves. What is the hero's ideological posture toward his own property? How do his views about the acquisition of property fit into his conception of the world?

The terminology offers a hint: *khrēmata*, a noun from a verb meaning to "use," is the regular word for property in the *Odyssey*. But the *Iliad* speaks only of *ktēmata*—"things acquired," from the verb *ktaomai*, to "get, gain, win." There is, to be sure, evidence for the institution of

[18]Hopper refers to eighth-century Old Smyrna, a popular candidate for the hometown of the poet of the *Iliad*, as a slum town (1976: 81). Kirk makes some attempt to contradict the generally grim picture of life in Dark Age Greece (1962: 44–48, 126–33).

inheritance. When he contemplates abandoning the heroic life, Achilles considers living off his father's possessions (*ktēmasi*), that is, "what old Peleus *won*" (*ta gerōn ektēsato Pēleus, Il.* 9.400). Later, lamenting the death of Patroklos, he recalls how he had once hoped Patroklos would survive his own fated death and, bringing Achilles' son Neoptolemos from Skyros, show him "my possessions, my slaves, my great high-roofed home" (19.333). But this passage is characteristic of references to inheritance in the *Iliad*; rather than "an institution . . . taken for granted as the normal procedure," it emerges from the narrative as only a futile hope juxtaposed to the harsh reality of death in battle. Thus, for example, six of the fourteen instances of the adjective meaning wealthy (*aphneios*) are applied to the fathers of battle victims or victims themselves in such a way as to emphasize the futility of accumulated wealth without success on the battlefield.[19] So too Hektor urges on the Trojans with the thought that, even if they die in battle, their lot of land (*klēros*) will remain intact—presumably for their heirs (15.494–99). But in fact the Achaeans will destroy both the warriors and their heirs as well (see also 4.164–68, 6.57–60, 24.726–38).

The land of a hero, inasmuch as most heroes are also kings (*basilēes*) in their homeland, is not a *klēros* but a *temenos*, the same word used for the sacred territory reserved for a god (2.696, 8.48, 23.148).[20] A hero's *temenos* is not presented in the poem as inherited private property. The most famous reference in the *Iliad* explains the land element in the hero's economic base as conferred by the community in return for demonstrated superiority in battle, and the tone implies that the *dēmos* kept a jealous eye out for evidence of unworthiness:

> Glaukos, why is it we two are honored beyond all others
> With the chief place at table, with meats, with fuller cups
> In Lykia, and everyone looks on us as gods,
> And we have as our portion a vast *temenos* by the banks of Zanthos,
> Lovely land—an orchard and grain-bearing plowland?
> Therefore now among the front ranks of the Lykians must we
> Take our stand and confront the raging battle,
> So that some one of the tough-armored Lykians may say,

[19]*Aphneios* is used five times of a father whose son or sons are about to be slain (5.9, 544; 6.14, 47; 13.664); once of the man himself about to be slain (17.576); and once of those Trojans led by Pandaros in the catalogue (2.825), where I also believe it is legitimate to see an ironic contrast between a present condition of prosperity and imminent destruction.

[20]It is perhaps significant that, despite Finley's strenuous effort in his *Historia* article (1957: 148–56) to counter the view of the *temenos* offered here, in his revision of *World* (1978: 95, 97) he let stand his essentially correct earlier version. Webster (1964: 105–10) discusses the parallel to divinity as a Mycenaean holdover but also notes the passages in which a *temenos* is not hereditary.

"By no means do men devoid of glory rule over Lykia
As our kings, and devour the fat sheep
And the choice honey-sweet wine. But I see now their strength is
Excellent, since they fight among the front ranks of the Lykians."
(12.310–21)

Similarly, in the cases of Bellerophon (6.194–95), Meleager (9.578),
and Aeneas (20.184–86), heroes' acquisition of a *temenos* is presented as
a gift of the people in return for demonstrated prowess in battle.

The case of movable goods is similar. One finds allusions to inherited
goods, but it is not the primary focus of references to heroic property.
Thus, when Diomedes slays two brothers,

He left lamentation and cruel pangs for their father.
For he would not welcome them returning alive from battle;
But relatives would divide his goods.
(5.157–59)

Again, inheritance is assumed as in some sense the norm, but a norm
constantly subject to the grim interruption of war. In any case, the pos-
sessions with which a hero is most concerned—those most intimately
associated with his sense of identity as a hero—are the bloody spoils
(*enara brotoenta*) he strips from enemies he has personally slain, the
share he wins by lot from the division (*dasmos*) of the general spoils of
an action he has personally participated in, the special award (*geras*) his
comrades give him in recognition of superior achievement, or the shin-
ing prize (*agla' aethla*) he wins in heroic games.[21] Together these pos-
sessions embody the respect/price (*timē*) that actual achievement has
won for the hero from his fellow men. Hektor's fondest hope for his
son is, not that he will grow up to reap the benefits of his father's hard-
earned wealth, but that

Someone may say of him "This man is surely much better than his father"
As he comes back from war. May he bring back the bloody spoils
After killing his enemy, and his mother's heart feel the joy of it.
(6.479–81)

Inherited Excellence and Political Power

When amplified by the speech of Sarpedon quoted above (12.310–
21), Hektor's hope for his son (6.479–81) illustrates well the way the

[21]Actually the phrase "shining prizes" occurs only once in the *Iliad*, at 23.263. Most
often the noun appears in the singular or plural without an epithet. "Shining prizes"
seems to be what Russo once called a structural formula (1966); it occupies the same
metrical position as the common noun-epithet combination "shining gifts" (*aglaa dōra*).

language of heroic ideology presents the reality of war as the ultimate determinant of not only the economic but also the social and political hierarchy of its imaginary society. Specifically, it clarifies the relationship assumed between the inheritance of human excellence and the acquisition of political power. It is a cliche in Homeric studies to describe the society presented in the poems as aristocratic, implying a ruling class whose position and ideological self-definition depend on inherited wealth, inherited political power, and inherited excellence. To be sure, every ruling class claims that it is worthy on various grounds of its privileges. What is striking in the Homeric poems is the absence—long ago demonstrated by Calhoun (1934a)—of a terminology of *inherited* excellence and, on the contrary, the explicit insistence that success on the battlefield is the only ultimate criterion for holding political power or validating one's ancestry (Haedicke 1936: 22; Nilsson 1968 [1933]: 226).[22] This insistence is combined with a haunting sense of the ultimate arbitrariness of that success. Hektor prays that his son may be like him, "outstanding among the Trojans, in the same way successful in strength and rule over Ilion by might" (6.477–78). These lines imply superior might as a necessary prerequisite to rule, and this requirement is seen not as an automatic fact of heredity but as a prayed-for gift of Zeus. Likewise dependent on Zeus, and the unstated burden of the prayer, is the chance to grow to manhood with adequate protection from the existing powers. Hektor and Homer's audience know that this security is not forthcoming.

The necessity of actual merit in the son in order to retain the powers of the father is perhaps best illustrated by the long narrative of youthful triumph (11.688–760) to which Nestor subjects Patroklos. Neleus had had twelve sons, certainly a good augury for a secure future. But his territory had been attacked by a mightier chief, Herakles, who had killed the best fighters, including the eleven mature sons. Neleus himself, old, with a single son as yet too young for war, is then victimized by neighboring tribes, who steal his horses and drive off his herds and those of his people, now few in number as a result of their misfortunes. In the normal course of things, Neleus could anticipate a fate like Priam's or the one Achilles fears for Peleus; but his sole surviving son Nestor performs prodigious feats of war and rescues a hopeless situation, restoring the wealth of all his people, and reestablishing the power of the king. Balancing the exultation of personal triumph is the picture of the inherent insecurity and instability of political power in such a world.

[22]M. I. Finley (1978: 85) recognizes the significance of the adverb *iphi* ("by might"), which five times in the text of Homer qualifies the verb *anassein* ("to rule").

The effective prowess of young Nestor is not explicitly attributed to the force of his father's blood in him—improbable in any case, given the failure of the first eleven progeny. Rather, the goddess Athene informs the Pylians of the enemy's approach and "conducts the fight in such a way that Nestor is preeminent" (11.720–21) despite his father's attempt to prevent him from fighting. In considering generally the extent to which heroic ideology in the *Iliad* associates actual prowess with birth, we may well keep this example in mind. Divine favor here does not seem to be a direct consequence of Nestor's kinship with divinity, never specified in the *Iliad*, but essentially something that is both coextensive with his actual merit and ultimately arbitrary, a representation of factors beyond human control or prediction.

The Homeric poems lack the elaborate vocabulary of a self-conscious aristocracy that relentlessly associates all human excellence with birth.[23] A consideration of Renaissance English usage of such terms as "noble," "generous," "well-born," or a later expression like "good family" gives some clue to what in Pindar, Sophokles, and Plato amounts to a constant linguistic barrage in behalf of inherited excellence. The *Iliad*, however, in its nearly 16,000 lines contains but one instance of *gennaion* in the sense "worthy of one's birth" (of Diomedes) and one of *eupatereia*, of "excellent paternity" (Helen). Heroes on occasion boast of their ancestry (see below); but the chief emphasis falls, not on the automatic, "natural" transmission of wealth, power, and excellence through birth, but rather on the constant necessity to prove oneself before competing peers and jealous inferiors and, secondarily, on the constant threat of arbitrary loss of divine favor, the inherent insecurity of any future for one's offspring.

This necessarily brief look at some of the more explicitly economic and political elements of the ideology embedded in the presumably traditional language of the poem stresses the radical individualism inherent in its vision of war as the ultimate arbiter. Thornton, among others, has attempted to support the moralizing message she finds in the poem by suggesting a more or less direct reflection of the rise of the polis. The polis is a "common enterprise." The Trojan War is a "common enterprise." Achilles' commitment to his individual honor threatens this common enterprise. Achilles suffers as a consequence of this commitment. Thus, the poem reflects the moral values of the polis (1984: 144–47). Without entering here into the complex issues of when a polis is a polis, it seems to me clear that the Homeric poems do demonstrate a form of social organization that concentrates political,

[23]Webster's attempt (Wace and Stubbings 1962: 452–62) to historicize Calhoun's insights by pushing his own Mycenaean thesis is not an entirely happy strategy.

religious, and economic institutions within a "city" that in turn domi-
nates the surrounding agricultural and grazing territory.[24] What most
differentiates the ideology of the polis in Homer from that in Tyrtaios,
the Archaic polis-poet par excellence, is precisely the emphasis in
Homer on the decisive role of superior individuals for the survival of
the community. What and how this "reflects" in relation to eighth-
century realities is an issue to which we must return after a more de-
tailed analysis of the workings of the traditional building blocks of the
poem.

Formulas: Birth and the Conflict of King against King

If we turn now from indications of a general structure of heroic so-
ciety embedded in the formulas to a closer consideration of how the tra-
ditional elements function in relation to the narrative of Achilles'
wrath, we must begin by reopening the question of the relation of for-
mulas to the meanings of the poem as a whole. As suggested earlier,
Adam Parry's brief article on the language of Achilles (1956) first ar-
ticulated the possibility of a gap between the implications of the tradi-
tional formulas and the meaning of the poem as distilled in the
experience of Achilles:

> Achilles is . . . the one Homeric hero who does not accept the common
> language, and feels that it does not correspond to reality . . . Homer in
> fact, has no language, no terms, in which to express this kind of basic dis-
> illusionment with society and the external world. The reason lies in the
> nature of epic verse. The poet does not make a language of his own; he
> draws from a common store of poetic diction. This store is the product of
> bards and a reflection of society: for epic song had a clear social func-
> tion. . . . Achilles has no language with which to express his disillusion-
> ment. Yet he expresses it, and in a remarkable way. He does it by misusing
> the language he disposes of. (1956: 6)

Whitman, who had worked closely with Adam Parry, offered shortly
later (1958) one of the few serious readings of the *Iliad* to carry for-
ward this approach.[25]

[24]On the polis in Homer, see Gschnitzer's *Wege der Forschung* collection (1969) and
1971: 1–17. See also Hammond 1982: 738–44.
[25]Schein (1984) follows broadly in this vein. His chief emphasis, like Whitman's, is on
demonstrating the *aesthetic* richness achieved within a traditional style; as his title (*The
Mortal Hero*) suggests, the major contradictions are seen in terms of an abstracted and
implicitly essentialist notion of the human condition.

A fairly elaborate scholarly literature has sought to refute or substantially qualify Adam Parry's analysis.[26] Without attempting to address all the subtleties real and alleged of this material, I think it is fair to say, in general, that the overwhelming impulse of most of it is to save the traditional character of all Homeric speech by stressing the flexibility of formulaic language and the artist's creativity in individuating different speakers within the traditional confines. This concern at the aesthetic and linguistic level has generally downplayed or effaced Parry's challenge at the level of values.

An important article that does tackle some of Parry's major assumptions at the level of values focuses most pertinently on the inherent ambiguity of the formulas:

> The formulae do not describe a perfect and inflexible world of thought patterns that can be regarded as reality—as a system one need merely memorize and subscribe to—but are instead . . . partial and perhaps contradictory truths that must be used and manipulated by the mind to confront adequately the hard facts and contradictory demands of the world of experience. (Claus 1975: 16)

Claus's analysis suggests not just something anomalous in the representation of Achilles but a general characteristic of the formulaic system along lines which, for instance, could equally be applied to Odysseus in the *Iliad* (Fenik 1978: 71–77). Although the point about ambiguity is well taken, the net effect of leaving the issue there is still to undermine the normative force of the values embedded in the formulas; if all is really ambiguity and flexibility, there is nothing to negate. Conversely, Friedrich and Redfield, who substitute "repertoire" for "ambiguity," stress the normative force of formulaic values but reassuringly find Achilles well within the flexible boundaries:

> We do not find Achilles to be culturally deviant; his actions and responses are conditioned by pervasive cultural norms—particularly those of honor, loyalty, and the ready use of violence in defense of both. But it is also true that Achilles is unlike anyone else. Just as we think of the Homeric language as a repertoire, rather than a rigid system, so we think of the Homeric culture as a repertoire, in which different possibilities are open to different individuals. (1978: 284–85)

On the other hand, Nimis argues that, even if the formulas, like all conventional language, are shot through with ambiguities and

[26]E.g., Sale 1963, Reeve 1973, Claus 1975, Friedrich and Redfield 1978, Schein 1980, Messing 1981 (followed by a reply from Friedrich and Redfield), Nimis 1986, and Martin 1989.

contradictions, there still is something specific in the language of Achilles that differentiates his usage from others and needs to be historicized (1986: 218–25). Nimis suggests that Achilles' speeches and actions be seen as "attempts to *construct* a version of the heroic code rather than as a series of unsuccessful attempts to *represent* an idealized version he knows all along" (219).

Finally, Martin points to the ambiguity of Parry's term "language": "he used 'language' to mean two very different things: as a shorthand for 'cultural code' or 'value system,' but also in the sense of 'diction'" (1989: 152). Arguing that "formulaic 'thrift' is an illusion," Martin proceeds to analyze Achilles' persuasive strategies in such a way as to leave behind the issue of values except as elements of rhetorical differentiation.[27] I argue that, it we situate Achilles in the network of decisive formulas, type-scenes, and narrative patterns in which his wrath is embedded, the most productive concepts for understanding him and the *Iliad* are the Hegelian-Marxist concepts of contradiction and negation—a negation that implies a new and superior version of the code. The major means by which the poem generates meaning is through the cumulative impact of phrases, scenes, and stories that echo each other while establishing a system of differences. The sharpest differences converge in the representation of Achilles, where their full contradictory potential is explicitly realized.

To return to the constitutive formal elements, let us take, for example, the formula *diotrepheēs basileus*, which is applied to Agamemnon, Priam, the obscure Peteos, father of the almost equally obscure Mnestheus, and in the plural to the chiefs of the Achaeans viewed collectively. What does it mean? It is usually translated "Zeus-nurtured king" or less literally "cherished by Zeus." What does it imply? Is it a metrically different equivalent of *diogenēs* ("born of Zeus"), indicating that all kings are bloodline descendants of the most powerful divinity? Or does that divinity simply "favor" or "look after" all kings? One can easily perceive the politically conservative thrust of such notions, but the formula masks the reality that the major conflicts explored by the poet are precisely those that pit Zeus-nurtured king against Zeus-nurtured king. Many interpreters of the *Iliad* like to cite Nestor's intervention in the quarrel between Agamemnon and Achilles as a model of good sense and clear thinking:

[27]I do not mean to deny that Martin's detailed analysis offers many useful hints about the values and psychology of the persona created by this rhetorical performance. It is simply that he appears to be interested in these elements only as data for the character of that performance.

Do not [Agamemnon]—*agathos* though you are—take away the girl,
But let her be, even as the sons of the Achaeans first gave her to him as a
 prize.
Nor you, son of Peleus—do not hope to contend against
A king, since never does he have the same portion of honor,
A scepter-bearing king, to whom Zeus has given greatness.
If you are mighty and a goddess mother gave you birth,
Yet he is greater because he rules over more men.

 (1.275–81)

The superior status of Agamemnon is attributed to four elements: his
role as *basileus,* possession of the scepter, special favor from Zeus—
which seems to spell out one implication of the formula *diotrepheēs
basileus*—and more numerous followers. Yet Agamemnon, a few mo-
ments before, after haughtily dismissing Achilles with the claim that he
had others to do him honor and "most of all counseling Zeus," had de-
clared: "You are the most hateful to me of Zeus-nurtured kings!"
(1.176). Achilles, who as a Zeus-nurtured king has just acted in the role
of "primary convener" (Nagler 1974: 119–30), presumably wielded his
own scepter. Certainly the plural formula *skēptouchoi basilēes* ("scepter-
bearing kings") is applied to all the Achaean chiefs (2.86) exactly as is
diotrepheēs basileus. Are we then to assume that the essence of Nestor's
clarification lies in the implication that Zeus is on the side of big con-
tingents?

Yet Nestor's allusion to Achilles' divine parentage touches on an-
other generative contradiction, one already suggested by the ambiguity
of *diotrepheēs.* If all kings are descendants of Zeus and many are off-
spring of other divinities, how relevant is their glorious ancestry to
their actual success in conflict? The role of kinship with divinity—no
less than the role of convener/king, favor from Zeus, or the implica-
tions of the scepter—emerges as a decisive contradiction worked out
both in the major narrative pattern of the wrath and in numerous mi-
nor narratives, some of which we now consider briefly.

Tlēptolemos, a grandson of Zeus, encounters Sarpedon, a son of
Zeus, and taunts him with cowardice that belies his origin. The poet
not only calls attention to the implicit test of the efficacy of divine par-
entage by alluding to their relationship to Zeus in the same line (5.631),
he makes it the whole issue of their encounter. The son of Zeus slays
Zeus's more distant offspring, thus apparently validating a mechanical
application of degrees of proximity to divinity. But before Tlēptolemos
dies, he wounds Sarpedon. The spearpoint scrapes the bone, but, com-
ments the poet, "his father still protected him from destruction"

(5.662). Why "still"? The poet calls attention to the irony that, for all Sarpedon's proximity to Zeus, despite the "tears of blood" Zeus will shed in grief at his death, Zeus will not be able to protect him from the onslaught of Patroklos, whose lineage is relatively obscure. Glaukon, Sarpedon's companion, bitterly comments in words that expose the de facto irrelevance of divine descent: "The best of men has perished, Sarpedon, son of Zeus. But he [Zeus] did not even protect his son" (16: 522).

Askalaphos, true son of Ares, not only is a nonentity himself but is slain by a nonentity.[28] The poet shows the irrelevance of his divine ancestry by pointing out that his father is not even aware that he has fallen (13.521–25). Later, when Hera goadingly informs Ares, his pointless rage is checked by Athena, who offers this grim consolation:

> By now someone better then *he* in strength and mighty hands
> Either has perished or soon will perish. It is a hard thing
> To protect the race and offspring of all humans!
>
> (15.139–41)

In the case of Aeneas, the pervasive sense of the contradiction between the implications of divine birth and the realities of the battlefield produce a kind of irony that comes close to farce. Apollo, posing as a mortal, urges Aeneas to stand up to Achilles by arguing a very mechanical view of the efficacy of divine parentage:

> And too they say from Zeus's daughter Aphrodite
> You were born, but that man [Achilles] is from a lesser divinity.
> For Aphrodite is from Zeus, but Thetis from the old man of the sea.
>
> (20.105–7)

Aeneas seems so convinced by this argument, despite his own past direct experience of Achilles, that he devotes thirty-nine lines to informing Achilles of his genealogy—even though, as he points out, both heroes already know each other's origins. In any case, Aeneas' silly speech does not scare Achilles, from whom Aeneas has to be rescued by Poseidon.[29] Poseidon exposes the foolishness of the whole genealogical business by sarcastically asking,

[28]Thalmann (1984: 45–56) has an excellent analysis of a series of deaths, beginning with this one, which culminate in Hektor's death. He stresses solely the motif of divine impotence with little focus on the implications of kinship with divinity.

[29]Fenik (1974: 19) argues for the traditional role of citing one's ancestry as a claim to "legitimacy as a warrior on the field"; but Poseidon's comment links this passage with the others I have cited which suggest an ironic distance from just such traditional claims.

Aeneas, who of the gods is bidding you in your mad blindness
To fight this way against the great-hearted son of Peleus,
Who is both stronger than you and more dear to the gods?

(20.332–34)

Demonstrated superiority is the real sign of divine favor, and in the face of such power nice distinctions of pedigree are a dangerous absurdity.[30]

Contradictions inherent in the formulas that celebrate kinship with divinity and in the typical scenes that evoke the normal heroic assumptions about the acquisition of property and power dominate the major narrative pattern of the wrath of Achilles. As the story of Meleager's (*Il.* 9.529–99; Kakrides 1949: 11–42) devastating withdrawal and several other parallels suggest, the theme of a wrath is probably traditional; but the simpleminded moral Phoinix draws from the Meleager story also suggests the unlikelihood that any traditional treatments involved the fundamental scrutiny of heroic ideology that emerges from Achilles' wrath.[31]

Achilles' divine birth is first only indirectly alluded to by Agamemnon, who, in his blustering rage at Achilles' challenge to his authority, attempts a fumbling explanation of the difference between them: "If you are very mighty, a god I suppose gave you that" (1.178). Since it is quite normal for Homeric characters to view any extraordinary event or talent as the gift of divinity without reference to ancestry, there is no necessary reference here to Achilles' divine parentage. On the other hand, in the light of the audience's prior knowledge and Nestor's explicit reference in a line so close to Agamemnon's ("If you are mighty, and a goddess mother bore you," 1.280), it is perhaps legitimate to see here an embarrassed indirection in Agamemnon's acknowledgment of Achilles' innate superiority as a warrior.

For centuries during which the ideology of political power was less intimately linked to personal military prowess than, as we have already seen, it is in the *Iliad,* readers of the *Iliad* have been comfortable with the attempt of Agamemnon and Nestor to suggest that it is perfectly normal for a distinctly superior warrior to be subordinated to his inferior in prowess. Yet the "shocking" words Thucydides attributes to

[30]Paris's famous remarks to Hektor on the gifts of the gods which can neither be rejected nor obtained by one's own efforts (3.65–66) are a variant on the theme of where excellences come from—in that case, between brother and brother, without any reference to birth.

[31]Despite his own earlier arguments about Meleager, Kakrides in a later work declares his belief that the poet of the *Iliad* "invented an episode that tells of a great defeat of the Achaeans. He therefore devised the motif of the wrath. . . . Achilles getting angry and Achilles calming down are Homer's inventions" (1971: 23).

the Athenian envoys at the Lacedaemonian conference are only a blunt abstraction of a principle implicit in Sarpedon's speech or the very formula "to rule by might" (*iphi anassein*): "It has always been the law that the weaker should be subject to the stronger" (1.76.2, trans. Crawley). Or, as the Athenians tell the Melians, "the strong do what they can and the weak suffer what they must" (5.89). The contradictions we noted earlier in the attempt to explain Agamemnon's anomalous status by reference to kingship, scepters, and the favor of Zeus are heightened to the point of insolubility in the allusions to Achilles' innate superiority as a warrior. Moreover, although the heroic ideology is sufficiently flexible to recognize legitimate differences in the more mental aspects of political leadership—that is, planning and articulating policy (Nestor, Odysseus), settling disputes, winning and retaining the loyalty and affection of subordinates—the normal assumption is that these qualities are a concomitant of superior prowess. The narrative exploration of the differences between Agamemnon and Achilles bears out the conclusion that, whatever Achilles' absolute inferiority in "wisdom" to Nestor or Odysseus, compared to Agamemnon he has immeasurably more tact, intelligence, and charisma in dealing with his subordinates and colleagues. Indeed, thousands of freshmen essays comparing the *Iliad* and the *Aeneid* to the contrary, one may legitimately speak of Achilles before his wrath as a paradigm of a Greek *pietas*.[32]

The difference between Achilles and Agamemnon is highlighted in Bk. 1. On the one hand, the audience is exposed to Agamemnon's gratuitous brutality in rejecting the appeal of the helpless old priest Khryses for the return of his daughter and his vicious bad temper in response to the priest Kalkhas—whose analysis of the origin of the plague Agamemnon nonetheless grudgingly accepts. On the other, they can observe Achilles' pious concern for the well-being of the army in summoning the assembly, in consulting Kalkhas, and most touching in his courteous and sympathetic welcome to the terrified heralds whom Agamemnon has ordered to take away Achilles' spear-won bedmate, Bryseis. Agamemnon's capacity for self-deception is dramatically illustrated both in the dream Zeus sends him in Bk. 2. (Homer, it seems, knew something about wish fulfillment) and in the peculiarly disastrous method Agamemnon chooses for testing the dream. It is only Odysseus and Nestor who succeed in saving the day for him, a pattern repeated throughout the poem.

The anomalous quality of Agamemnon's status is perhaps best summed up in Diomedes' rebuke when Agamemnon, "weeping like a

[32]Here I qualify Gagarin's excellent discussion of morality in Homer (1987) by stressing the poem's emphasis on Achilles' moral superiority before his wrath and after it has, in some sense, been appeased in Bk. 24.

dark-watered stream," repeats in earnest his earlier "testing" advice that the Greeks return home. Diomedes comments caustically:

> To you the crooked-counseling son of Kronos gave a gift cut in two:
> With the scepter he gave you honor supreme over all,
> But he did not give you courage to fight (*alkē*), and that is the greatest
> power.
>
> (9.37–39)

The word I translate "power" here, *kratos*, contains the same root as the adjective earlier applied by Agamemnon and Nestor to Achilles to distinguish his innate prowess, *karteros* (1.178, 280). The simple reason heroic ideology normally assumes a harmony of fighting prowess and military strategic sense is also made clear in Diomedes' speech and Nestor's enthusiastic response to it: normally the best heroic strategy is simply to stick to the fight until you win or die. To be sure, Hektor is later destroyed by the inadequacy of this prescription, but its validity in the conflict between Achilles and Agamemnon finds further confirmation in the subsequent denunciation of Agamemnon by his ever-loyal supporter Odysseus. When Agamemnon later again suggests withdrawal, Odysseus' response is a scathing indictment of Agamemnon's strategic incompetence:

> Son of Atreus, what sort of speech has escaped the barrier of your teeth?
> A disastrous one! Would that you were commanding some other army,
> A shabby one, and did not rule over us, to whom Zeus
> Has allotted from our youth until old age to weave the woof
> Of grim wars until each of us shall perish.
> Are you really eager then to leave behind the wide-wayed city
> Of the Trojans, for which we have suffered many miseries?
> Be quiet! Nor let any other Achaean hear this
> Speech, which a *man* would never even bring out of his mouth,
> One who knew in his mind how to speak good sense,
> One who was a scepter-bearer, one whom armies obeyed—
> Huge armies such as you rule over among the Argives.
>
> (14.83–94)

The attitude of the Achaean troops toward Agamemnon's leadership is, apart from the questionable intervention of Thersites (Rose 1988), not directly represented. Poseidon, however, a divinity devoted to the Achaean cause, characterizes it thus as he urges on the Greek heroes in the guise of Kalkhas:

> In the *past* the Trojans were not willing to await this way in opposition
> The mighty hands of the Achaeans—not even a little bit!

But now, far from the city they fight beside the hollow ships,
As a result of the baseness (*kakotēti*) of their leader and the indifference
 (*methēmosunēisi*) of the hosts,
Who, since they've quarreled with that man, are unwilling to thrust the
 enemy away
From the swift-traversing ships—rather they let themselves be killed amid
 them.
But even if it is totally true that he is to blame—
The hero son of Atreus, wide-ruling Agamemnon—
Because he wrested away the honor from the swift-footed son of Peleus,
Still it is not possible for *you* to hang back from the war.

 (13.105–14)

I stress the indictments of Agamemnon's incompetence and coward-
ice in his specific exercise of kingly authority by others beside Achilles
because some scholars (e.g., Lloyd-Jones 1971: 12) have been quick to
rush to Agamemnon's defense against Achilles' accusations of coward-
ice in Bk. 1 (1.225–28). To be sure, Agamemnon is a formidable figure
on the battlefield; he is ready to volunteer for the single conflict with
Hektor in Bk. 7 (162), and the army seems to have confidence that he
could do well against Hektor (7.180). But when the crushing pressures
of a major war mount up, he is found distinctly wanting in the strategic
courage that is the automatic response of the best warriors.
 At the same time, the picture we glean of Achilles' kingly virtues
apart from the radical crisis of the wrath, to which we must return,
suggests that he embodies the highest level of heroic ideals to be ex-
pected from a king of his age. His courtesy, tact, and generosity are
demonstrated on a grand scale in the funeral games he offers for Pa-
troklos. He smooths chaffed egos, supplies extra prizes to ease conflict,
rewards kind words, and in perhaps the most touching moment in the
games displays extraordinary sympathy for old Nestor, whose age pre-
vents him from competing. Ajax, in the embassy scene, notes that be-
fore the wrath Achilles was honored beyond all others for his affection
toward his comrades (9.630). Not only the absoluteness of Achilles'
commitment to Patroklos but his warmth toward the ambassadors
themselves, his affectionate treatment of Antilochos, and his general
demeanor during the games suggest his preeminence in that affection-
ate charisma essential to successful male bonding on the battlefield.
 A generation of readers has been convinced of the relative insig-
nificance in the hierarchy of Homeric values of what have been dubbed
the "co-operative or quiet" values (Adkins 1960: 7, 37–40; Gagarin
1987: 300–303). And, although our analysis of the supremacy of mar-
tial prowess in that hierarchy may seem to confirm this judgment, an
examination of the other virtues attributed to Achilles suggest just how

fully the heroic ideology celebrated the assumed natural integration of the highest prowess with the highest level of humanity—as conceived at that time. "Humanity," to be sure, is a vague and historically relative term, but our contemporary usage of the word is surprisingly appropriate to Achilles' pre-wrath delicacy in respecting his victims— eloquently attested to by Andromache's recollection of his generous burial of her father and ransom of her mother (6.414–27).[33] A readiness to ransom captives emerges not as a mark of greed but of decency. Achilles, before his wrath, ransomed many (21.100–102); Agamemnon is singled out for his ferocious chiding of Menelaos (6.55–60;cf. Whitman 1958: 160)—a figure associated with kindly, "maternal" (A. Parry 1972:17) imagery—for his readiness to ransom a son of Priam. It is perhaps a moot point whether this implicit celebration of humanity is a component of the heroic ideology or an aspect of the poet's critical distance from that ideology (Griffin 1980: chap. 4). I believe the latter to be true and indicated in the poet's rare explicit and, in my view, heavily ironic judgment offered after Agamemnon declares that even the unborn male child in his mother's belly must not escape their total vengeance: "So speaking the hero turned his brother's mind/ Since what he'd argued was just" (*aisima pareipōn*, 6.61–62). We later consider the whole issue of the justice of the Trojan War in the *Iliad,* but the pervasive sympathy for wives and innocent babies built into the formulas suggests the validity of seeing irony in the poet's intervention here. In any case, the contrast to Achilles is indisputable.

If the explicit statement of Nestor and the repeated scenes between Achilles and his divine mother Thetis reinforce the view that Achilles' supreme prowess and the constellation of kingly virtues associated with that prowess are a consequence of his divine birth, what explanation emerges from the poem for the extraordinary status of Agamemnon? To be sure, his brother Menelaos is the aggrieved party in the alleged cause of the war, but the traditional mythic background offers no reason why Agamemnon rather than Menelaos should exercise supreme command. We have looked briefly at the inadequacy of Nestor's proffered explanations in his intervention in Bk. 1. The favor of Zeus—as the plan of Zeus, his deception of Agamemnon, and the disastrous consequences of Achilles' withdrawal abundantly illustrate—is not a reliable basis.

The title of "king," as we have seen, is normally assumed to carry with it the prowess and talents to rule by might. Nestor, in trying to

[33]Gagarin's discussions of pity (1987: 300–302) and the feeling for unprotected persons (290–92) are valuable. But since his topic is "morality," rather narrowly defined, it does not include such matters as tact and respect for the dignity of those who are relatively less powerful.

save the political structure headed by Agamemnon while arrogating to himself the initiative in policy, has recourse to the notion of degrees of kingliness. In the very process of leading the chastened Agamemnon by the nose, he tactfully flatters him by declaring, "You lead the way. For you are the kingliest" (*basileutatos*, 9.69). Agamemnon seems pleased with the concept, since he ends his long catalogue of gifts for Achilles with the injunction, "Let him stand below me, inasmuch as I am kinglier" (*basileuteros*, 9.160). Despite Odysseus' tactful suppression of these scarcely "honied" final words (cf. 9.113), Achilles—like the poet's audience—has heard and bitterly rejects Agamemnon's offer to be his son-in-law with the taunt, "Let him pick some other of the Achaeans, one who suits him and is kinglier" (*basileuteros*, 9.391–92).

The concept of degree is again useful to Agamemnon in Bk. 10, when his fears for Menelaos' safety in the dangerous night raid lead him to tell Diomedes,

> Choose whomever you wish as your companion,
> The best of those who have stood forth, for many are eager.
> Do not, out of respect in your heart leave the better man
> Behind, while you make the lesser man your companion, yielding to respect,
> Looking to his lineage, not even if he is kinglier [*basileuteros*].
>
> (10.235–39)

The redundancy of this speech, unusual even for Homer, not only captures the tone of thinly masked anxiety but clarifies for the audience a distinction between status and excellence quite anomalous in the *Iliad*.[34]

The greater number of Agamemnon's followers, the point on which Nestor laid climactic emphasis in attempting to distinguish the status of Agamemnon from that of Achilles, is perhaps most frequently cited by those scholars who have dealt with the problem. The term designating this sort of superiority, *pherteros* (here translated as "greater"), has been related etymologically to *pherō* ("I carry, bear"), suggesting a

[34]The comparative degree of *basileus* occurs once in the *Odyssey* (15.533) when the seer Theoclymenos reassures Telemachos that there is no line more kingly than his in Ithaka. It occurs once in Tyrtaios as an ironic hyperbole: "nor even if he is more kingly than Pelops" (12.7 West). It then disappears from Greek usage. There is no clear evidence that the Greek aristocracy, even in the heyday of its celebration of birth, developed a sharp set of criteria for degrees of nobility. Arnheim (1977: 21) cites the usage in the *Iliad* in support of his Mycenaean thesis about the specialness of Agamemnon's power, but he makes no use of the notion of degree in the rest of his study of the Greek aristocracy—where indeed it would be quite irrelevant.

dal system "in which rank was assessed according to the 'burden' assumed or imposed" (Palmer 1955: 11–12, cited by Whitman 1958: 340). But the burden of the narrative treatment of the motif of numbers is precisely their irrelevance when measured against the supreme prowess of the truly great hero-king. Bk. 2 is shot through with the irony of Agamemnon's vast numbers and, as he himself comes to state it, the course of the battle has shown that "worth many / Armies is that man whom Zeus loves in his heart, / As now he has honored this man [Achilles] and beaten the army of the Achaeans" (9.116–18).

We saw earlier that Nestor's allusion to the scepter as a decisive factor in Agamemnon's status is an ironic contradiction of the status of all the heroes as scepter-bearing kings. Yet the motif of the scepter as it is amplified in Bk. 2 is the best clue the poem gives us of the poet's conception of the source of Agamemnon's power. It is surely no accident that Agamemnon's fullest association with a particular, concrete scepter, as opposed to the more general equivalence between possession of the scepter and kingly status, occurs in the context of his most explicit immersion in delusion: "He grasped the scepter, a thing inherited from his father [*patrōion*], imperishable forever, / With this he went beside the ships of the bronze-armored Achaeans" (2.46–47). Despite the tactfully expressed skepticism voiced by Nestor (2.80–83) about Agamemnon's dream from Zeus, Agamemnon proceeds with his plan to test the dream by lying to his army. He stands up before them,

> Holding the scepter that Hephaistos wrought with effort.
> Hephaistos for his part gave it to Zeus the Kronion lord,
> But Zeus surely gave it to the running guide Argos-slayer.
> And lord Hermes gave it to Pelops, striker of horses.
> But Pelops in turn gave it to Atreus, shepherd of hosts.
> Atreus on his death left it to Thyestes rich in sheep.
> But Thyestes left it for Agamemnon to carry,
> To be lord over many islands and all Argos.
> Leaning on this, he addressed his words to the Argives.
>
> (2.101–9)

The fullness of this focus compels the audience to view the scepter as a significant component of Agamemnon's identity, specifically as the supreme scepter-bearing king (Whitman 1958: 161; Griffin 1980: 9–12).[35] Achilles' supremacy is attributed to one kind of inheritance—inheritance of supreme prowess from his divine mother. On his father's

[35] I cite here only the two modern discussions that strike me as best. Recognition of the scepter as a symbolic reflection of the central conflict between Achilles and Agamemnon goes back at least as far as Lessing's brilliant comments in *Laocoon* (1962 [1766]: 78–83).

side, acquisition of a spear only he can wield (16.140–44) marks the same conception. Agamemnon's supremacy derives from another sort of inheritance—the accumulation of wealth and political power from generation to generation. The ideological world of Homeric language presents both these sorts of supremacy as fully sanctioned by divinity.

The narrative of the conflict between Achilles and Agamemnon thus emerges as an exploration of two potential contradictions in the ideology of inheritance that is the most fundamental tenet of later aristocracies. On the one hand, valorization of the principle of inherited excellence readily leads to the consolidation of power and wealth which is sufficiently self-sustaining that ability is no longer a necessary prerequisite to the exercise of authority. As Lucretius noted later, once wealth as such enters the picture, those who have it can buy the talents of superior warriors (cf. 5.1113–16). Agamemnon's relation to property seems to dramatize the transition from the purely symbolic role of possessions as concrete manifestations of actual achievements on the battlefield to fetishized objects that seem to have an inherent power to give control over one's fellow human beings—in short, toward a money economy.[36] Thus Agamemnon both receives material objects in lieu of risk taking on the field (9.331–33) and is in a position through gift giving to buy the risk-taking services of others (9.121–61). It can therefore be argued that the narrative explores the drastic consequences for his people of the illusions fostered by Agamemnon's relation to wealth and power—his relative divorce of status from merit. This would then be a kind of defensive didactic gesture in the ideology of the poem: even if one must acknowledge potential drawbacks in the dominant institutions, the fate of Agamemnon would show that any problems can be contained and the worst damage repaired. One would then see the

[36]Cf. M. I. Finley: "Behind the market [in Adam Smith's world] lies the profit motive, and if there was one thing that was taboo in Homeric exchanges it was gain in the exchange. Whether in trade or in any other mutual relationship, the abiding principle was equality and mutual benefit. Gain at the expense of another belonged to a different realm, to warfare and raiding" (1978: 67). See also Donlan 1982, which nicely lays out the centrality of generosity in effective Homeric kingship. Donlan 1989 deals with the special case of submissive giving between *xenoi* of unequal status. He there notes in passing the impropriety of Agamemnon's offer (5–6) in view of the rules of gift giving within the same demos. Lévi-Strauss's meditation on kingship among the Amazonian Nambikwara offers a striking parallel. First he notes the consistency between Montaigne's informant c. 1560 and his own in the late 1930s in response to a question about the "privileges the chief (he used the term 'king') enjoyed in his country; the native, who was himself a chief, replied that 'it was to march foremost in any charge of warre'" (1974: 309). Lévi-Strauss goes on to stress the second major function summed up in the chief's title—"he who joins together": "In fulfilling these obligations, his primary and principal instrument of power lies in his generosity. Generosity is an essential attribute of power among most primitive peoples" (310).

other dimension of the contradiction as simply a parallel warning tale: the excessive valorization of inherited excellence must inevitably lead to social conflict if superior ability is manifested in someone of relatively lower status. On this view, Achilles must learn the moral of not pressing absolutely the claims to status implicit in his actual superiority. This line of interpretation would constitute a neat homology of corresponding patterns: one, superior wealth and status divorced from superior merit lead to destructive illusions and potentially disastrous consequences; two, actual superiority confronting the reality of unjust distribution of social rewards brings illusions of omnipotence which, instead of destroying injustice, lead to the self-destruction of the innately superior person.

I believe that some such traditional, conservative patterns lie in the background of the traditional stories used by the poet of the *Iliad;* and, as we see subsequently, later Greek poets were quick to make these "tragic" patterns explicit in a new genre. At the same time, the poet of the *Iliad* has so weighted the emotional and moral impact of those two patterns as to undercut the comfortable, reassuring vision of social reintegration so frequently imposed on the poem. The heavy emphasis we have already noted on the validity and necessity of combining actual martial prowess with exercise of leadership renders Agamemnon's continued and unshakable authority the glaring anomaly of the political world of the poem. The intense bitterness of Achilles' disillusionment suggests rather the narrative exploration of an irreversible and lamentable historical transition from one set of organizational principles to another. On this reading, Achilles represents a last and inevitably unsuccessful effort to defend a vision of society in which the principle of inherited excellence is compatible with a social hierarchy directly based on actual performance, the utopian vision of a perfect meritocracy so basic to most ruling-class ideologies. Agamemnon represents the movement away from so challenging, so inherently unstable, and so destructive a social ideology (Weil 1956 [1940]; Sagan 1979: 9–23) toward the more automatic consolidation of inherited power and wealth. The utopian vision associated with Achilles presupposes war as the dominant economic institution. Whereas Achilles' doom is imminent at the end of the poem, Agamemnon's downfall is not complete. His status is preserved and he is simply compelled by the consequences of his own folly to surrender policy decisions to his more able subordinates Nestor and Odysseus. Achilles, however, finds his only real community not with the purged Achaean host but with Priam, the only other person with a commensurate sense of the destruction of all that he values most.

Type-Scenes: Contradictions over Property and Merit

The most revealing terms of the *Iliad*'s historical confrontation with fundamental social change are, as has already been suggested, the property relations of the respective protagonists. The most significant institution in these relations is the division of spoils, the *dasmos*, pragmatically prior to and far more central to the structure of heroic society than the gift giving that has received so much attention.[37] Here, as in some of the key formulas we have already examined, the inherent ambiguities of a motif or type-scene are explored in such a way as to confront a fundamental, non-negotiable contradiction.

There are seven situations (more or less) in which the language of a *dasmos* occurs in the Homeric poems; depending on their degree of specificity, one might refer to them as motif, theme, or type-scene. The major ambiguities of the formulas associated with the *dasmos* revolve about issues of who conducts the division and who awards the special prizes. Most commonly the division appears to be carried out by the participants in the raid acting in concert. Thus we find plurals of the verb "to divide" (*dateomai*) and such plural subjects as "the sons of the Achaeans." The frequent use of the verb *lankhanō* suggests that the lot was used to ensure that "no one should depart deprived of his equal (*isēs*) share" (*Od.* 9.549; *Il.* 11.705). Yet even in a passage containing this formula, a king who stayed behind, Nestor's father Neleus, "chose out" (*ek . . . heileto*, 11.696–97; *ekselet'*, 11.704) a huge amount for himself before turning the rest over to the demos to divide. Similarly, although special prizes are often presented as the gift (*dosan*) or choice (*ekselon*) made by the group for honored members, it is also clear that the traditional language allows for leaders "choosing out" their special portions for themselves or their friends. Thus Achilles furnished a girl for Patroklos from one of his raids (9.667–68); and Odysseus, who is given a special prize after his escape from the Cyclops (*Od.* 9.551–52), speaks in his Cretan disguise of raids he led "from which [he] chose out abundant treasures and obtained a great deal later by lot" (*Od.* 14.232–33).

The conflict between Achilles and Agamemnon begins with Achilles' defense of control of the division process by the military community as

[37]See M. I. Finley's claim (1978: 65): "No single detail in the life of the heroes receives so much attention in the *Iliad* and the *Odyssey* as gift-giving." Donlan 1982 and 1989 recognize the priority of raiding, but focus on gift giving. I believe that this is another area in which a clear distinction emerges between the world of the *Iliad* and that of the *Odyssey*. This is not to suggest that gift giving is not part of the society envisioned in the *Iliad*, but that that society is conceived as so much less stable than the "world of Odysseus" that the role of gift giving is sharply subordinated to and fundamentally dependent on the institutions more directly associated with the field of battle; normally a chief acquires the means of giving gifts by his superior performance in fighting.

a whole. Agamemnon's request for a second *geras* strikes Achilles as an almost inconceivable violation of normal procedures:

> Son of Atreus, most distinguished, most enamored of possessions,
> How will the great-hearted *Achaeans* give you a prize?
> We don't even see anywhere any great *common* store;
> But whatever *we* took as booty from the cities has been divided;
> It is improper for the hosts to gather those things back together again.
>
> <div align="right">(1.122–26, emphasis added)</div>

The only way Achilles can imagine the army's meeting Agamemnon's demand is a complete redivision by the whole army of the whole store of booty. It is the obvious inappropriateness of this procedure which seems in the first instance to provoke Achilles' accusation of greed. In a society where every self-respecting male in the ruling class devotes so much energy to acquiring the enemy's bloody armor, stealing cattle, capturing women, and winning prizes in games, this may seem a disingenuous charge. Yet Agamemnon has, so to speak, invented greed by divesting these objects of their normal social symbolism. Insofar as he demands a *geras* purely on the basis of his social status, he has severed the link between privilege and risk taking.[38] A rent appears here in the whole ideology of economic heroism—a rent through which we can glimpse the naked reality of ruling-class rapine and extortion; the "illusions of the epoch about itself" no longer cover its actual relation to "production."[39]

Achilles is, to be sure, willing at this point to recognize some social service in Agamemnon's surrender of Khryseis. This, he declares, the community (*Akhaioi*) will "triply and quadruply" compensate after the destruction of Troy (1.127–29). Agamemnon's scornful rejection of this option and his escalation of his demand to include the claim that he can take away the *geras* of another *basileus* amounts to a complete negation of the community's role in determining the social hierarchy. If an individual *basileus* can invalidate and reverse the community's awards of merit and arrogate to himself the socially generated surplus wealth, then he in effect controls the basis for establishing *any* hierarchy.

[38]Benveniste sees *geras* as quintessentially the prerogative of a king. The emphasis on performance in most contexts in the *Iliad* is situated by Benveniste as, in effect, a way of conferring effective kingship (1969: 45–46). As often with arguments from linguistics, I find that the implications of etymology or comparative studies with other cultures lead to a de facto reversal of the data of the Greek text in its own specific historical context.

[39]Suzuki (1989: 30–34) has a fine discussion of the ways the wrath leads Achilles to raise uncomfortable questions about the alleged heroic motives for the war (Menelaos' honor, Helen)—questions that are in effect answered by the crudely acquisitive focus of Agamemnon, Odysseus, and Thersites.

From Achilles' perspective, this claim by Agamemnon destroys the social foundation of cooperation in warfare and transforms the ambiguity of the *dasmos* at Troy—one that up to a point parallels the situation of young Nestor and old Neleus—into an intolerable contradiction:

> Never do I get a prize equal to yours, whenever the Achaeans
> Sack a well-inhabited city of the Trojans.
> But the greater portion of grim-darting war
> My hands handle. But whenever a *dasmos* comes,
> Yours in the far greater prize, while I, with one small and dear,
> Go off to my ships whenever I'm worn out with warring.
>
> (1.163–68)

Achilles' denunciation of Agamemnon's cowardice, however unjust in absolute terms, is here specifically linked with Agamemnon's relative inactivity vis-à-vis the raids that are the prerequisite of the *dasmos:*

> As for going on an ambush with the best of the Achaeans,
> You never dare it in your heart. To you that looks like death.
> Yes, it's much better through the wide camp of the Achaeans
> To snatch back gifts from whoever speaks against you—
> King who devours his people, since you rule nonentities:
> Otherwise, son of Atreus, this would have been your last outrage.
>
> (1.227–32)

Anger at Agamemnon becomes fused with Achilles' growing disgust at the complicity of the Achaean army as a whole. It is *their* control over the social hierarchy, assumed in the traditional formulas, which Achilles has risen to defend. Instead of finding his intervention welcomed with an outpouring of rage at their obviously criminal commander-in-chief, Achilles, apart from the equivocations of Nestor, finds himself completely isolated. Achilles' clearer perception of that complicity, rather than the intervention of Athena, is the chief explanation he offers for not killing Agamemnon:[40] I will not fight you [sing.] over the girl / Not you nor any other, since you [pl.] who gave her have taken her back (1.298–99; Whitman 1958: 186).

Achilles' language in Bk. 9 reflects the final logical step in his confrontation with the ambiguities of the formulas. If the army accepts

[40]My only point here is that not only does Achilles' decision to withdraw rather than kill Agamemnon make psychological and dramatic sense apart from this divine intervention, it also makes political and economic sense in the terms of Achilles' own reasoning at 1.298.

Agamemnon's systematic acquisition of a disproportionate share of the spoils, then that division—regardless of the actual mechanics—is functionally in the hands of Agamemnon. Thus Achilles now completely abandons the formulas implying communal control:

> Twelve cities of men I sacked with my ships,
> On land I count eleven through the fertile Troad.
> From all these I chose out possessions abundant and
> Excellent, and taking them away I gave them all to Agamemnon,
> Son of Atreus. He, waiting behind beside the swift ships,
> Received them, would divide up [*dasasketo*] a little and keep a lot.
>
> $(9.327-33)$[41]

This arbitrary control of the division by a single man who did not even participate in the raid by which the wealth was acquired and who is by no means the best of Achaean *warriors* completely undermines the assumptions of the heroic meritocracy:

> Equal the portion for him who hangs back and if one wars fully.
> In the same honor we are held, both the coward and the valuable man.
> They die the same, both the man without deeds and the one with many.
>
> $(9.318-20)$

If possessions are truly stripped of their symbolic function, then they no longer measure up against heroic risk taking:

> For not worth my life is even as much as they say
> Ilion possessed, a well-inhabited city,
> In the past, in peacetime, before the coming of the sons of the Achaeans
> Nor as much as the Archer's stone threshold holds within,
> Phoibos Apollo's, in rocky Pytho.
> For cattle and strong sheep can be stolen,
> And tripods and the tawny heads of horses can be seized;
> But the life of a man cannot be stolen back again
> Nor seized, when once it has passed through the rampart of teeth.
>
> $(9.401-409)$

The whole system of the political economy of heroism—the circulation of goods by duels, raids, wars, and contests and the establishment of a social and political hierarchy according to the consequences of such systematic risk-taking and rapine—is definitively swept away in

[41]This passage was long ago seized on by analyst scholars as anomalous; see, e.g., Leaf and Bayfield 1965, ad loc.

the language of Achilles. It is the absoluteness of this negation in Bk. 9 which precludes any simple reintegration of Achilles into the society whose ideological integument he has seen through and torn apart.

It is easy to cite evidence to the contrary. Achilles does speak of gifts as if they were desirable when he warns Patroklos in Bk. 16; even his reference at 11.609 to the likelihood of the Achaeans beseeching him could be understood to imply a continuing interest in gifts (A. Parry 1956: 7). If so, it is odd that so crafty a manipulator as Nestor makes no reference to gifts in his long harangue of Patroklos but stresses rather the semidivine glory that accrues to a young man who restores the security and prosperity of his community. The situation in Bk. 16 is more complex. The appeals based on bonds of affection by Phoinix and Ajax in the embassy scene succeed in dissuading Achilles from leaving Troy (Whitman 1958: 190–93). Yet the traditional patterns of behavior offer no viable way of bringing relief to his beleaguered colleagues without at the same time subordinating himself to the repudiated leadership of Agamemnon. The initial and quite impractical expedient he adopts is to wait until the fire of the burning Greek fleet reaches his own ships. His allusion to gifts in Bk. 16 is in part a desperate retreat to an already exhausted alternative and in part a tactful suppression of his fears for Patroklos' safety (see also 18.8–14). His deeper indifference to the material perquisites of the heroic system are patently clear in his passionate debate with Odysseus in Bk. 19.

Major Story Patterns

The Herakles Paradigm

Counterbalancing and ultimately undercutting the formal gestures of reintegration into Achaean society—the unsaying of the wrath, the acceptance, however indifferently, of the gifts of Agamemnon—is the relentless focus on the certainty of Achilles' imminent death. There is a curious element of ideological blindness in some of the recent attempts to draw an inspirational picture of the harmonious social order rejoined by Achilles when the essential prerequisite of his return is his own death. His divine mother spells out the consequences of his decision to seek revenge for Patroklos by killing Hektor: "Short-lived then, will you be for me, child, from what you say. / For immediately after Hektor your destiny is ready at hand" (18.95–96). Her earlier lament to her sister sea nymphs had evoked not only his early death but the irony of his inherited excellence by a unique coinage: "ah me, cursed-

in-giving-birth-to-the best" (*dysaristotokeia*). Her divinity has only been tainted by her forced contact with mortality, and the superiority thus engendered only intensifies the sense of its futility. In a similar vein, Achilles now perceives the divine blessings associated with his begetting as a curse, symbolized in the armor of Peleus:

> huge, a marvel to look on,
> Lovely: these the gods gave as glorious gifts to Peleus
> On that day when they cast you into the bed of a mortal man.
> Would that you had stayed where you were, to dwell
> With the immortal sea nymphs, and Peleus had wed a mortal bride.
>
> (18.83–87)

The armor that had symbolized his unique superiority and the fatal inadequacy of Patroklos thus comes to stand for the deceptiveness of divine favor in the union that produced Achilles. The new armor from Hephaistos does not simply repeat the notion of the special favoring relationship between the forces that run the cosmos and those that run the social and political world. This armor is divested of any illusion of ultimate protection; rather, it functions as compensation pure and simple for the inevitability of Achilles' imminent death. As Hephaistos says: "Would that I might be equally able to hide him away / From grim-echoing Death, when his dread destiny comes upon him, / As [see to it] that he have very lovely armor" (18.464–66). The image of the world on the great shield Achilles carries back into battle, like the world of the similes (Bowra 1950: 121), is a more contemporary world in which ideological mystification is at a minimum—in which the everyday life of peasant producers is set beside war not for honor but simply for property, and the only king is seen smiling at the sight of productive work from which he will reap the chief benefits. The new shield thus figures the hero's stage of consciousness beyond the illusions of superiority inherited from the gods. Few commentators have resisted the temptation to translate this meditation on the irony of heroic mortality into transhistorical broodings about the human condition as such, that is, apart from any particular set of social relations in which it alone manifests itself. What is lost is precisely the class-bound intensity of the *Iliad*'s tragic vision here: not all human mortality, but the specific deception sensed in the mortality of the divinely endowed "best of the Achaeans," is the decisive focus.

In addition to the symbolism of armor, a new heroic paradigm signals this shift in Achilles' perception to an ironic distance from key

elements in the heroic ideology of birth. In accepting the inevitability of his imminent death as foretold by his divine mother (18.95–96), Achilles adopts the paradigm of Herakles as the embodiment of the irrelevance of divinely given innate superiority:

> My death I will accept at whatever time
> Zeus wishes to accomplish it, he and the other immortal gods.
> For not even the might of Herakles escaped death,
> Though he was dearest to Zeus, the Kronion lord.
> But his destiny beat him down, and the hard hatred of Hera.
> (18.115–19)[42]

This most radical negation in the poem, by which the hero who in Bks. 1 and 9 refused participation in a corrupted social order now refuses participation in life itself, became a powerful paradigm in its own right. Readers of Plato's *Apology* (28c-d) may readily assess how fundamentally different a meaning it took on in changed social and political circumstances.

In Bk. 19, in the apology of Agamemnon, the paradigm of Herakles is developed further. More than a symbol of the death that alienates Achilles from hierarchies both human and divine, Herakles' birth, which defrauds him of his rightful place as king and condemns him to a life of servitude to his inferior, emerges as a mythic explanation of the irrationality of Achilles' subordination to Agamemnon and, more broadly, of the final irrelevance of innate excellence to the realities of political power. In a cosmos in which the patriarchal order of Zeus is so easily thrown into confusion by the ferocious jealousy of Hera, there is no ground for confidence that those who actually hold power are truly the best. That this paradigm is offered by a king who is himself the best example of the structural inequity of the Greek political order is a mark of the poet's consummate sense of irony.[43]

[42]Martin (1989: 228–30) offers a quite exciting argument for seeing the motive of the whole *Iliad* as the effort to defeat an earlier epic on Herakles (see also Burkert 1972 and Davidson 1980). As suggested earlier, however, focusing on the putative intentions of the poet at such a level without even considering what values are at stake in supplanting one heroic paradigm by another misses key challenges in Adam Parry's analysis. What strikes me in the allusion to Herakles here and in Bk. 19 is the implicit deference to Herakles as the greatest imaginable hero of the earlier generation and the attempt to collapse any distinctions between Herakles and Achilles as heroes: both are best by birth but doomed to death by the unreason of the world.

[43]The audience of Homer may well have been aware that, not only is Eurystheus parallel—by virtue of his relation to Herakles—to Agamemnon, but also—by virtue of his father's invitation to Atreus and Thyestes and his own death—he is the actual origin of the political power of Agamemnon's family (Apollodorus 2.4.5–12).

Troy and the Oedipal Narrative Pattern: The
Irrelevance of Kinship with Patriarchal Gods

We have discussed earlier various major narrative patterns posited
by Redfield, Thornton, and others for eliciting the "moral " to be de-
rived from the *Iliad*. The most obvious traditional pattern in the *Iliad*
is the one least named as such by classicists, bluntly invoked by a soci-
ologist as "Oedipal Aggression Brings Disaster" (Sagan 1979: 24). Un-
der the safer form of "wife stealing," however, the fundamental
importance of this pattern has long been recognized (Lord 1965: 186).
In the broad form of a female object of desire fought over by two males
marked as older and younger it is strikingly central: Agamemnon
(younger) takes Khryseis from Khryses (older); Agamemnon (older)
takes Bryseis from Achilles (younger); Paris (younger) takes Helen
from Menelaos (older; cf. A. Parry 1972: 18); Phoinix (younger) at his
mother's instigation steals his father's mistress.[44] In each case the seem-
ingly clear patriarchal moral is driven home by the disastrous conse-
quences, but, as Sagan has rightly perceived, the specifically political
cast given the conflict of Achilles and Agamemnon expresses the poet's
ambivalence about legitimate authority: "The social consequences of
the world-view that certifies all authority as good are the preservation
of aristocracy and kingship—the inhibition of democracy" (1979: 39).
What I want to add is that, if the centrality of these patterns is further
historicized to include the disastrous family dynamics of ancient Greek
patriarchy, then we can perceive the profound link between Achilles'
adoption of the Herakles paradigm to express his bitterness at the use-
lessness of his inherited excellence and the broader issue of the justice
of the Trojan War, the context against which the inherited excellence
of Achilles is measured by the narrative of the wrath.

Inherited excellence is, apart from the ambiguous implications of
Helen's epithet *eupatereia* ("she of the goodly father"), exclusively a
male ideology. As such it is vulnerable to all the anxieties about legit-
imacy that characterize the transmission of private property from fa-
thers to sons. As the Romans put it, *mater certa, pater incertus*. The
sexual and social repression of women, whatever its other causes, is
thus profoundly linked with both the ideology of inherited excellence
and the institution of private property inherited through the male

[44]We might add that Meleager comes into conflict with his mother because he has
killed his uncle, though Phoinix's persuasive version of the story suppresses the element
that would explain Meleager's all too parallel indifference to the proffered gifts and the
deeper basis for Achilles' adoption of the paradigm in a sense quite contrary to Phoinix's
intentions. Because of his mother's curse, arising from her deeper attachment to the
older male uncle, Meleager, like Achilles, knows that his own death is imminent and in-
evitable. See Kakrides 1949: 11–42.

line. It is often noted that ruling-class women in Homer seem to be rel-
atively less repressed socially than their counterparts in fifth- and
fourth-century Athens (Arthur 1973; Pomeroy 1975: 25–31). Yet the
anxiety over legitimacy and the readiness to defend it with massive vi-
olence are part of the very texture of the *Iliad:* "Let me no longer be
called the father of Telemachos / If I don't . . . " (2.260), boasts Odys-
seus as he threatens the helpless Thersites.

In spite of this normative patriarchal ideology, the *Iliad*'s ironic per-
spective on kinship together with its representation of the ambiguous
status of females under patriarchy—officially powerless yet constantly
breaking apart the illusion of seamless male dominance—emerges as
emblematic of the negation of the whole social order. The goddess
Thetis, whose status as both goddess and reproductive female is re-
peatedly represented as the source of Achilles' supreme excellence, is
also, by virtue of her powerlessness to reject a literally degrading mar-
riage to the mortal Peleus, perceived by Achilles himself as the ulti-
mate source of his wretchedness. The hero still identifies with his
human father in repudiating his father's marriage. So too the symbol-
ism of Hera's ferocious, irrational hatred, a function of her ultimate
powerlessness in the face of her husband's sexual freedom, takes moral
precedence over the official evidence of a just war; and again, as in the
case of the birth of Herakles, the implication of Zeus's weakness and
stupidity (P. E. Slater 1968) hardly jibes with a celebration of his justice
(pace Lloyd-Jones 1971). In the case of both Thetis and Hera the im-
plicit misogyny of blaming them for the suffering of the respective he-
roes is inseparable from an implicit indictment of the patriarchal male
order and its ideology of inherited excellence.

The traditional justification for the destruction of Troy is the con-
flict between Paris and Menelaos over Helen, a female who is again
presented as the source of all the suffering by virtue of her powerless-
ness in the face of male sexual aggression and possessiveness. Homer
tremendously complicates the relatively simple tale of wife stealing and
revenge by his shift of emphasis from Paris to Hektor and from
Menelaos to Agamemnon. One cannot say that Homer shifts focus
away from Helen; rather, the extraordinary richness of his portrayal of
her tragic predicament undercuts any sense of her as a simple villain
(Kakrides 1971: 25–67; Suzuki 1989: 29–43). Nonetheless, the full de-
velopment of the unambiguously innocent Andromache, who is indel-
ibly linked with her infant, Astyanax, gives a terrible immediacy to
formulaic references to the wives and innocent children of the Trojans.

At the same time, an emphasis on female irrationality is sustained in
the major narrative explanations of the failure of justice in the Trojan
War and contributes substantially to the broadly pessimistic tone of the

final situation. The possibility of a simple, just settlement of the major
conflict by a duel between Paris and Menelaos in Bk. 3 is subverted by
one of the rare instances of a truly supernatural divine intervention. It
has been frequently pointed out that normally in Homer what happens
on the divine plane does not violate natural and human probabilities
but gives them a transcendent importance (Willcock 1970; see also
Snell 1960: 29–30). But in the case of Paris's rescue by Aphrodite—the
very embodiment of sexuality as irrationality—the poet goes out of his
way to display its supernatural quality:

> The son of Atreus moved back and forth through the throng like a wild
> animal,
> If somewhere he might catch sight of godlike Alexander.
> But none of the Trojans or glorious allies was able
> To point out Alexander then to Menelaos dear to Ares.
> For not out of love would they have hidden him, if any had seen him.
> For he was hateful to them all as black death.
>
> <div align="right">(3.449–54)</div>

The failure of the truce at this point is attributed to the savage anger
of Hera, whose implacable commitment to Troy's destruction inspires
Zeus to exclaim:

> Strange creature! What crimes so enormous have they committed against
> you,
> Priam and the sons of Priam, that you are so relentlessly eager
> To obliterate utterly the well-founded city of Ilion?
> If you were to go to the gates and long walls and
> Eat raw Priam and the sons of Priam
> And the rest of the Trojans, then you might slake your anger.
>
> <div align="right">(4.31–36)</div>

This nightmare vision of the utter ferocity of the all-devouring mother
figure inspires not the righteous rebuke of a just Zeus but a blandly
uxorious "Do as you like" (4.37). Indeed, Zeus and Hera strike a grim
bargain that makes a pathetic mockery of human pieties: Hera can de-
stroy Troy, Zeus's dearest city, and in return Zeus can destroy three of
Hera's favorite cities whenever he chooses (4.48–54). This haunting
image of divine malice and arbitrariness in the relations between cities
is consistent with the image of human destiny in general that Achilles
offers as a dour consolation to Priam:

> For this is the way the gods have spun destiny for pitiful mortals,
> To live in suffering, but they themselves are free of cares.

> For there are two jars that lie on the threshold of Zeus,
> One of the evils he gives, the other of blessings.
> The man to whom Zeus the thunder-lover gives a mixture of gifts
> Sometimes meets with evil, at other times with good.
> But the man he gives pure ills he renders a thing of disgust,
> And base, ox-huge hunger drives him over the shining earth,
> He wanders about honored neither of men nor of gods.
>
> (24.525–34)

Neither Hera nor Aphrodite figures in this most sweeping meditation on the human condition, but there is here a revealing blur of the social hierarchy. The speech makes an initial sharp distinction between the utterly miserable and those who receive mixed blessings. The explicit focus of Achilles' interest is Peleus as a parallel to Priam; that is, only the ruling-class figures are the direct concern of his rhetorical consolation. Yet his earlier metaphoric evocations of the "dishonored vagabond" (9.644; 16.59) suggest his deeper personal affinity with the utterly wretched or with fallen heroes who, like Bellerophon, wander, devour their own hearts, and avoid the paths of men (cf. 6.202).[45]

This generalizing pessimism that blurs the established social hierarchy is of a piece with the ambivalent perspective in the poem toward the more cosmic hierarchy of divine and human. It is a cliche of Homeric scholarship to point to the numerous references to kinship between gods and mortals, to the extreme courtesy of some of the exchanges between them and the great solicitude shown by some gods for some mortals, then to conclude that the poem envisions the heroic class as lesser nobility in an aristocracy of birth in which the gods are only the upper crust.[46] There is unquestionable evidence in the poem for such an ideology, but the bitterness of so many scenes in which the gods figure and the sweeping absoluteness of the gulf between gods and mortals in Achilles' climactic pronouncement suggest that the social relationship mirrored in them is rather that of slaves to masters than of slightly less privileged nobility to their more richly endowed cousins.[47] It is possible, of course, and usual to perceive only optimistic and pessimistic sides of the same coin, that is, a single aristocratic ide-

[45]Adam Parry long ago pointed out to me the pattern of Achilles' deep association with wanderers. Beyond his choice of the *atimētos metanastēs* as an image of his own alienation, his closest comrades, Phoinix (cf. 9.447–80) and Patroklos (cf. 23.85–88), are both wanderers. Would that I could cite a published text containing the full wealth of this most promising of Homeric scholars' insights.

[46]On kinship with divinity, see Nilsson 1964: 146–79, esp. 158–59, and Guthrie 1954: 119. On the courtesy of the gods, see Snell 1960: 32.

[47]In Near Eastern traditions the slave status of mortals vis-à-vis gods is taken for granted, and comparatists have noted the greater confidence and self-respect reflected in the Greek image of kinship with divinity. At the same time, recent studies have rightly emphasized the extensive impact of the ancient Near Eastern cultures on the Greeks;

ology that both takes great pride in the points of similarity between themselves and the gods and feels great bitterness at the points of difference, chief of which is mortality itself. Yet there is something more suggestive of the bitterness of contemporary ethnic humor toward their haughty oppressors in, for example, Hephaistos' exclamation as he tries to calm the squabble between Zeus and Hera in Bk. 1:

> Ah, surely these shall prove ruinous actions, quite intolerable,
> If indeed you two, for the sake of mortals, fight this way
> And drive wrangling among the gods. Nor shall there be any joy
> Of the goodly feast, since the inferior cause is triumphant.
>
> (1.573–76)

The agonies of the mere mortals, with whom presumably the audience has good reason to associate itself, are here dismissed as a mere nuisance at the dining table, like dogs fighting too noisily over scraps nonchalantly tossed them by their masters.

This bitter undermining of the kinship linkage with divinity combined with the representation of women as both victims and the emblem of all that is unjust in the cosmos gives voice to a protest, a negation of both the ideology of inherited excellence and the institutions of patriarchal property that sustain it. To be sure, it is only one voice among several in the poem; but it did not go unheard in the course of Greek history.

The Poet and His Audience

The tone of Hephaistos in the passage just discussed is remarkably close to that of the arrogant suitors in the *Odyssey* who complain about the beggar Odysseus; and it is hard to explain in terms of the assumption of a univocal aristocratic bias on the part of the poet or, for that matter, his audience. The class status, class loyalty, and audience of the poet of the *Iliad* are matters on which the text of the poem gives us no clear evidence. The fact that Achilles alone of the heroes is seen singing the "glorious deeds of men" (9.189) may be taken as a mark of the poet's deep sense of association with his hero,[48] but there is no basis for assuming either from what we can deduce from the *Odyssey*, from the

e.g., Walcot 1966, M. L. West 1971b, and Murray 1980: 80–99. On the general relations of gods to mortals, Lloyd-Jones perceptively comments (though not without an amusing bracketing of temporally nearer realities), "they treat men as the nobles of an *early* stage of a rural society treat the peasants" (1971: 3–4, emphasis added).

[48]E.g., Whitman 1958: 193; contra see M. Edwards 1987: 220. As noted earlier, this association is the central thesis of Martin's excellent book (1989).

scant evidence of the material culture of eighth-century Greece, or even from the questionable parallels of other societies in which heroic poetry has flourished that the poet was himself an aristocrat or that his audience was exclusively or even predominantly aristocratic.[49] It is a legitimate assumption that the ruling ideas were predominantly the ideas of the ruling class but I suggest here what can more clearly be demonstrated in the *Odyssey*—that the position of the poet toward that hegemonic ideology is ambivalent at best.[50] Both the tradition in which he works and presumably those able to pay him best bask in that ideology, but his own social status and very probably that of the majority of his audience in a period marked by severe changes incline him to profound skepticism if not open hostility toward it.

This hypothesis, and it can remain nothing more than that, offers one possible account of some of the ideological ambiguities we have already observed in the text. The poem validates the concept of kinship with divinity to the extent that the supreme hero's excellence is consistently associated with his birth from a goddess. Yet we have also seen a withering irony directed at the more mechanical implications of this tenet, a pervasive pressure to present claims of inherited excellence as valid only when demonstrated through risk taking and actual success on the field and in the trials of community deliberations. This vision of a meritocracy carries with it a bitter negation of the irreversible trend toward plutocracy represented by Agamemnon, who reflects the role of inheritance to consolidate power and wealth without any necessary supremacy in ability or moral stature. Correspondingly, we have noted an ironic distance, emerging in a grim focus on female powerlessness, bitterness, and wrath, in representing the ideological optimism that considers the patriarchal gods essentially kindred allies. This distance only reinforces the tragic vision of the gods as irresponsible overlords of their human slaves.

[49]I find odd Edwards's assumption that "a king could hardly control the techniques of oral composition" (1987: 220); cf. Bowra 1964a: 410–26, esp. 417, apropos of Achilles. The evidence of the *Odyssey* for the status and social role of poets is examined in Chapter two. For the material poverty of eighth-century Greece, see note 17 above. For other societies, see Bowra 1964a: chap. 11. Bowra assumes that close ties between bard and aristocracy were the norm in the past, but he also notes that "nowadays most bards belong to the people and practice their art among them. With such it is not always easy to distinguish between amateurs and professionals" (417). Finnegan (1977: chap. 6) begins her discussion by a general rejection of generalizations about the oral poet's relation to society, but those she discusses are all of relatively humble origins. The reader must decide whether eighth-century Greece was more like the societies described by Finnegan or the European aristocracies assumed as the natural home of oral poetry by Bowra.

[50]For a valuable qualification of the too-ready assumption that all early Greek poetry simply reflects aristocratic values, see Donlan 1973: 145–54. Donlan, however, as noted earlier, is ambivalent, not to say hostile, toward the very notion of class conflict—even in the cultural sphere (see Donlan 1980: 189 n. 7).

These ambiguities have been arrayed throughout the poem in such a way as to suggest neither separable historical layers, different poets, nor mindless equivocation in a single poet trying to please everyone; rather, the extraordinary power of the poem derives in no small measure from the poet's capacity to present the loose polarities available within a flexible tradition in such a way as to confront irreconcilable, therefore tragic, contradictions—to articulate in the language of Achilles a negation that precludes any comfortable reintegration of the status quo. Yet that very negation is the vehicle for projecting a utopian vision of a just community of truly excellent men who exercise their innate capacities, not for rewards from someone higher up, but as the affirmation of the inherent communal focus of their *aretē*. Their very dependence on communal validation makes them highly sensitive to the social identities of those less powerful. It is not a vision we can simply appropriate directly for our own time, but as a point of departure in a long historical trajectory it has its own deep power.

2

Ambivalence and Identity
in the *Odyssey*

> How does it feel
> How does it feel
> To be on your own
> With no direction home
> Like a complete unknown
> Like a rolling stone?
> —Bob Dylan

There are various levels on which one may seek to historicize a text. The most obvious is a kind of historical *con*textualization in which one attempts to situate the text in a set of plausibly reconstructed circumstances felt to belong *with* the text. But at another level one has to confront the question of how—in what sorts of ways—these circumstances might be *in* the text. Furthermore, one needs to confront the identity of the text as itself a historical fact, as an independent material existence offering its own contribution to our grasp of a historical moment. Finally, one needs to attempt at least to historicize the process by which the text can be appropriated—both in its own moment and in ours (Jameson 1981: 9–10).

In considering the *Odyssey*, a text which over the centuries has seemed one of the easiest—perhaps the easiest—text of classical antiquity to assimilate, the attempt to historicize may strike many readers as superfluous. Many of us first encountered this text in seventh or eighth grade and may well have had it assigned in two or three different college courses—so marvelously adaptable has its hero proven. The very term "hero" for the protagonist of the *Odyssey* lends itself to an easy slippage from the designation of a historically specific ruling-class figure to a generalized archetype of Everyman writ larger than life. It seems pedantic perhaps to insist on his historical specificity. But we pay a real price for the habit of appropriation that lets us forget history and the specificity of class conflict. As Fredric Jameson has said, "history is what hurts," and "we may be sure that its alienating necessities will not

forget us, however much we might prefer to ignore them" (1981: 102).

In the following pages I attempt a brief contextualization, then examine those putatively innovative elements in the structuring of the presumably traditional narrative which give us some access to the *Odyssey* poet's particular response to his own historical moment. I then proceed to a more general examination of the various components in the hero's constantly discussed identity, attempting here again to demonstrate their meaning as a historically specific set of responses to concrete situations. Although I argue that ideas about inherited excellence play an explicit and significant role in the politics of the poem, that ideological theme constitutes only one element in a configuration. Discovering the implicit content of what is inherited entails exploring Homeric notions of heroism, sexual politics, and the nature/culture dichotomy. Moreover, the politics of *how* this ideological message is conveyed leads us to the self-reflexivity of the poetic text and the epistemological revolution associated with literacy. Only on the far side of such an examination can we even begin to explore the relevance of the *Odyssey* to our own circumstances and identities.

Relation to the *Iliad,* Hesiod, and History

The grounds for dating the *Odyssey* later than the *Iliad* range from a naive feeling that a narrative that takes for granted events narrated in the *Iliad* must come after the *Iliad* to elaborate, conflict-laden linguistic, metrical, archaeological, and sociological evidence.[1] A painstaking survey of all "the pieces of evidence" by a cautious and learned Homeric scholar led him to conclude that "they are completely inadequate for any precise conclusion" (Kirk 1962: 287). Ingeniously precise arguments leading to hard dates tend to melt into sticky messes in the heat of controversy. Menelaos' reference to the island of Pharos being a day's sail from Egypt (*Od.* 4.354–57), for example, led one scholar to place the poem firmly between 650 B.C., when Herodotus said Ionians first came to Egypt, and 610 B.C., when the founding of Naucratis implied the knowledge that Pharos was only a little way offshore (Carpenter 1962: 92–100). But other scholars (J. H. Finley 1978: 62–63, with

[1]There is a subtler debate about whether the absence of incidents from the *Iliad* in the *Odyssey* proves ignorance on the part of the *Odyssey* poet or an informed, calculated response. Page (1966: 158) has argued for ignorance; Nagy, while insisting that it is an error to assume one "text" refers to another "text" (1979: 42), argues that one "tradition" may "refer to other *traditions*" of composition (1979: 43) and in fact elaborates a very subtle pattern of such references. A. T. Edwards argues that the "*Odyssey* assumes a competitive stance towards the *Iliad*" (1985: 11), and Pucci that "the *Odyssey*'s pretense of ignoring the *Iliad*—and vice versa—bespeaks a decidedly polemic, controversial relationship" (1987: 18).

his references) have pointed to the fact that the Mycenaeans had regular commerce with Egypt from the sixteenth century B.C. There is no inherently greater probability that Menelaos' words reflect the immediate confusion of late seventh-century travelers rather than a distorted traditional memory. On the contrary, the weight of admittedly inadequate probabilities puts the *Iliad, Odyssey*, and Hesiod roughly in the period between 750 B.C., the earliest likely date for the introduction of writing into Greece (Havelock 1982: 15, 34 n. 22), and 700 B.C.

A distinguished partisan of Hesiod has renewed arguments for Hesiod's priority over the Homeric poems (M. L. West 1966: 46–48). But here again apparently hard conclusions slip through one's fingers. Though I subscribe to the near consensus (e.g., Lesky 1967: 7) that the *Iliad* is at least a generation older than the *Odyssey* and that the *Odyssey* and Hesiodic poems are roughly contemporary, I am painfully aware of the tentativeness of such dating.[2] Though certainty is unachievable, the more precisely one can fix that moment and grasp its particular configuration of social, economic, and political realities, the better.

In the *Iliad* the transition from a meritocracy to a plutocracy, from inherited demonstrable excellence to inherited wealth and status, emerges as the central contradiction within ruling-class ideology. I have tentatively suggested that the ambiguous class status of the poet in a period of fundamental social transformation may have heightened his critical distance from the assumptions of the ruling element in his own time. Since on such issues the mute stones of archaeology either remain mute or speak with forked tongues, it is all but impossible to confirm this analysis outside the poem.[3] But with the voice of Hesiod and scattered later historical traditions, the relation of the world in the *Odyssey* to the world that produced and received it comes into somewhat clearer focus.

The most significant political phenomenon of the period is the displacement of the institution of monarchy by oligarchy, collectively exercised control by the heads of large estates. By monarchy, I do not mean the Mycenaean *wanax* exercising sweeping authority over an ex-

[2]On the priority of the *Iliad*, see e.g., M. I. Finley 1978: 31; see Lesky 1967: 7 for a wide range of earlier opinions. Janko argues on the basis of the notoriously slippery evidence about the Lelantine war and some parallels between Hesiod and Semonides that "Hesiod was roughly contemporary with Archilochus." He also notes that "the coincidence of his active life with the period of decisive Oriental influence on Greek vase-painting surely helps to explain the undoubted Near Eastern elements in his thought" (1982: 94–98).

[3]Cf. Vermeule: "Homer has been rejected as evidence, with a pang. He is every Mycenaean scholar's passion. . . . We are tempted to use whatever corresponds to our excavated knowledge or imagined re-creations. . . . It seems more honest, even refreshing, not to invoke Homer either as decoration or instruction" (1972: xi). But Vermeule is primarily concerned with the Bronze Age. For the eighth century, see Snodgrass 1971: 431 and Thornton's use of Snodgrass (1984: 144–47).

tensive area and administering his realm through a highly complex bu-
reaucracy (Ventris and Chadwick 1973: 120), but rather a *basileus,*
ruler of a relatively modest area including an urban aggregate who
ruled through his personal prestige, wealth, and prowess in war.[4] His
immediate circle consisted of the heads of the large estates, who acted
as advisers in peace and as officers in war. But the primary vehicle by
which he carried on public business was an open, proto-democratic as-
sembly of the adult male population. In this arena he regularly settled
private disputes as well, presumably relying in large measure on his
ability to cite apt precedents (*themistes*) (Havelock 1963: 107–111).

The later tradition preserves a few names, such as Hektor of Khios
and Agamemnon of Kyme (Wade-Gery 1952: 6–8; Thomas 1966:
404), recalls an early Ionian league (Roebuck 1955: 26–40) made up of
kings, and occasionally yields distorted but suggestive echoes of the
process by which these kings were displaced. Athenaeus, for example,
quotes an intriguing account by a local historian, Hippias of Erythrae,
of the attempt to end kingship there.[5] King Knopos is murdered at
sea by his "flatterers," who "wanted to destroy his monarchy in order
to establish an oligarchy." Aided by "tyrants" at Khios, they seize the
town and kill partisans of the king. (The plural "tyrants" is significant,
indicating another oligarchy of usurpers rather than the generally
anti-oligarchic seventh- and sixth-century individual usurpers.)[6] The
conspirators proceed to run the city's affairs and try cases entirely at
their own whim, even excluding townspeople (*dēmotai*) from the city. The
account especially stresses their elegant clothing, elaborate coiffures,
and humiliating treatment of the citizens—particularly the compelling
of daughters, wives, and sons to participate in "common gatherings,"
presumably banquets. These abuses continue until the murdered king's
brother, to whom the populace immediately rallies, defeats the tyrants
and wreaks horrible revenge—including the torture of the oligarchs'
partisans, wives, and children. A modern historian of early Ionia sug-
gests that these events should be set at about 700 B.C. (Huxley 1966:
48). Particularly noteworthy are the clear preference of the demos for
monarchy, the rhetorically embellished indictment of the oligarchs' life-
style, and the ferocity of the revenge, which, given the popular support
of the avenger, must be viewed as representing more than personal whim.

[4]See Thomas 1966: 405 and 1978: 190–94. Among the other seemingly endless dis-
cussions on Homeric kingship, see Andrëev 1979:361–84, Donlan 1979, Deger 1970,
and Starr 1986: 21–23. I consider Drews 1983 quite useless; see Donlan's review (1984:
201–2).

[5]*Deipnosophistai* 6.258–59, summarized by Huxley (1966: 48). My quotations follow the
translation by Gulick (Athenaeus 1927).

[6]The use of *turannous* at 259e10 to designate the same people earlier described as in-
tending to set up an *oligarchia* (259a5) confirms this interpretation. On the term "tyrant"
and the phenomenon, see Andrewes 1956: 20–30 and Ste. Croix 1981: 279–83.

The range of Hesiod's attitudes toward kingship and the fluctuations in his use of the term *basileus* accord well with a period of transition in which true kings are still known but wealthy landowners, perceived as a group, hold absolute power in many areas. In the *Theogony* Hesiod speaks with approval of *basilées* (80, generalizing plural) blessed at birth by the Muses who settle disputes in the assembly, and when such a man (81–87, all singular forms) goes through the assembly he is treated "as a god" (80–92, cf. also 434). A major theme of the *Theogony* is the rise of Zeus to become sole *basileus* of the gods. Though Zeus's cleverness and political skill (Brown 1953: 19–25; Detienne and Vernant 1978: chap. 3) in winning essential support is stressed in the poem (e.g., 390–403, 501–6, 624–27) and he assumes the supreme position at the urging of the other gods (833), his preeminence is clearly based on his absolute superiority in military prowess (e.g., 686–712, 838–68).

It is hard not to perceive a sharp contrast between Hesiod's idealization of monarchy in the *Theogony* and his bitter denunciation of the "gift-gobbling *basilées*" in the *Erga*. Hesiod's use of the plural to designate specifically those who yielded to the blandishments of his brother and settled the inheritance dispute in Perses' favor seems to indicate that he does not mean monarch but oligarchs, powerful landowners who control the settling of private disputes and put on airs by affecting the name *basilées* but function in concert.[7] It is in fact difficult to say positively whether the repeated plural use of *basileus* in the poet's bitter fable of the hawk and the nightingale (202–12) or in his sermon on *dikē* (248–61) represents simply generalizing plurals directed at a panhellenic audience of all figures in authority, monarchs and oligarchs, or specifically refers to the oppressors of his particular little corner of Boeotia. Certainly the differences in his use of the term cannot be explained away by purely biographical reference to his early association with the sons of King Amphidamas (*Er.* 654) and his subsequent ill treatment at the hands of Boeotian *basilées* (M. L. West 1966: 44–46). The golden age in the myth of the five ages implies both supreme kingship in heaven (*Er.* 111) and a positive, essentially idealized view (Vernant 1969: 27–29) of human kingship (*Er.* 126).

Hesiod, for all his bitterness against the local *basilées*, gives no hint of their lifestyle. But the allusion to funeral games for which there was sufficient advance notice to permit a poet from Ascra to compete in Euboea may be significant. The use of games to commemorate the

[7]West 1978 on line 38 speaks of the "noble judiciary" and cites Diodorus 4.29.4 for the information that "the rulers of Thespiae were descended from seven *dēmoukhoi* [i.e., "holders of the demos"] who were sons of Herakles and of daughters of Thespius."

dead may be very old, but the organization of regional or even pan-
hellenic competitions seems to be a new feature of eighth-century
Greece. Indeed, the first reasonably accurate date in Greek history is
the beginning of the Olympic games in 776 B.C.[8] This phenomenon
has plausibly been associated with a felt need of the aristocratic class,
newly emerging from their subordination to monarchs, for self-
advertisement (Starr 1961: 309). The less their status depended on
demonstrated prowess in battle, the greater their commitment to dis-
plays of their general physical and economic superiority as a class.[9]
To be sure, Amphidamas is said to have died fighting in the Lelantine
war (M. L. West 1966: 45), but war looms relatively small among the
calamities that haunt Hesiod's imagination. Inheritance of property is
threatened only by one's own *basilēes*, not by a raiding *basileus* from an-
other demos. Conversely, in his most idealized compliments to kings,
Hesiod never mentions a role as military protector; that role is, for
him, a mythic role associated with earlier ages (Vernant 1969: 19–47).

Hesiod's poetic achievement may be viewed in the light of another
phenomenon that reflects the self-consciousness of this emergent ar-
istocracy. The *Theogony* organizes the entire cosmos into a vast, sharply
hierarchical family dominated by Zeus and his offspring. The *Eoiai* and
Megalai Eoiai, which survive only in fragments, set forth systematically
the lines of birth connecting the rulers of the cosmos with the rulers of
Greece. Probably toward the end of the eighth century, oligarchs began
more and more self-consciously to stress birth as a decisive determi-
nant of social status.[10] Organizationally, this was reflected in the great
social pyramids called phratries—subsequently, in Athens at least,
where we have data, the primary means of fixing the individual's social
and political identity.[11] Ideologically, a new emphasis on genealogy was
combined with an ever-escalating claim that individual physical and
moral excellence was a reflection of noble birth, which is itself pre-

[8]This date has of course been challenged; see Bickerman 1968: 75 and Starr 1961: 64
n. 4.
[9]There is a striking parallel in the growth of jousting during the fourteenth century.
As Tuchman puts it, "tournaments proliferated as the noble's primary occupation [war]
dwindled" (1978: 65).
[10]See Snodgrass 1971:429–36. Again there is a striking parallel in the Christian Mid-
dle Ages; see M. Bloch 1964: esp. chap. xxiv and Duby 1982: 294–96.
[11]See Andrewes 1961:129–40, qualified significantly by Donlan (1985: 293–308). Snod-
grass (1980: 25–28) acknowledges the "thoroughness and ingenuity" of the French schol-
ars (Rousell 1976 and Bourriot 1976) on whom an approach like Donlan's depends, but
he cannot accept their conclusions. He finds it "comforting . . . that *some* form of tribal
state seems detectable in the Homeric poems" (27). To me the most plausible reconstruc-
tion involves much-decayed, old tribal structures being resuscitated and redirected in the
eighth century to the needs of a newly self-conscious ruling class. Donlan is certainly
right in stressing the functional absence of extended kinship structures in most of the
Homeric text.

sented as the natural basis of political power. Throughout Hesiod's fragments, the union of a woman who is herself *aristē* or *perikallea* with a divinity produces *basilēes* (e.g., 1.3, 129.8–10, 144, 165.8).

In the *Erga* Hesiod offers a vivid picture of the economic and social situation of those not blessed with noble birth, the peasant farmers in Boeotia, and a significant glimpse of at least one indigent Ionian, his own father, who emigrated to Ascra some fifty years earlier "fleeing wretched poverty" (633–40). What we glean from Solon (French 1964: 10–26) a century later suggests that the situation Hesiod describes was not confined to Boeotia (Will 1957: 5–50; Detienne 1963). The great driving fear is starvation.[12] The dreadful dangers of seafaring must be weighed against the constant insecurity of farming; to survive, a peasant may have to do both (618-94). One's neighbors may help the unsuccessful peasant once or twice, but the third time his begging will be in vain (394–403). Hesiod ironically lumps together the competition between beggars and that between poets (26). For him personally, the staff of the Muses may have contributed to escape from a human identity reduced to "wretched objects of shame, mere bellies" (*Th.* 26); yet for the rest of the Greek peasantry his essential solution is hard work, thrift, sexual repression, and honest dealing. His own case suggests, however, that virtue is no protection against the depredations of the gift-gobbling *basilēes*, who, as Hesiod has already indicated, have complete control of the juridical procedures and are quick to manipulate them for their own gain. The options open to those who lose their land are bleak indeed: futile begging with its concomitant burden of humiliation and verbal abuse (*Er.* 311–19, 717–18) or hard labor as a hired hand (*thēs*) for a few chunks of bread in the peak season (441–47) and the sure prospect of being turned out once the crop is safely in (602).

Innovations in the Narrative Structure of the *Odyssey*

Let us now look at the *Odyssey*. In examining the *Iliad*'s relation to traditional language, themes, and story patterns, I focused primarily on the confrontation of ambiguities as the major vehicle by which the final poet stands apart from and transcends the tradition. In the case of the *Odyssey*, the unique perspective of a specific bard in a moment of

[12]The references in the *Erga* to inadequate livelihood and starvation are sufficiently numerous to qualify the frequent assumption that Hesiod's only audience are "reasonably well-to-do freehold farmers" (Ste. Croix 1981: 278). These motifs are in fact a fundamental theme of the poem: lines 31, 230, 242–43, 298–302, 363, 404, 480–82, 496–97, 647, 686.

history is clearest in significant expansions or contractions of traditional story patterns and motifs and in the general structural weight given to various traditional elements. Most discussions of the structure of the *Odyssey* note the extraordinary narrative space devoted to Telemachos and the even longer period of narrative time expended on Odysseus' role as a beggar.[13] What appears to be the most traditional material about Odysseus, the tales of his wanderings, is given relatively short shrift. Moreover, readers have often been struck by the extent to which the poet of the *Odyssey* manages to fit poets and discussions of poets into his narrative (e.g., Redfield 1973: 146–54; Pucci 1987). I hope to demonstrate that these artistic choices reflect in a significant degree the poet's capacity to construct an artistic and ideological response to political conflicts, social upheaval, and economic distress in his own time.[14] Accordingly, I return to the wanderings only after discussing the Ithakan narrative.

The Suitors as Oligarchs

Some years ago, a scholar primarily concerned with demonstrating the artistic achievements of the final poet of the *Odyssey* argued convincingly that the poet has given the traditionally faceless suitors of the absent hero's wife far greater individuality and interest by casting them as young oligarchs, a type that would be familiar to his audience (Whitman 1958: 306–8).[15] Let me briefly review the evidence in the text. Despite the obvious preeminence of Antinoos and Eurymachos, the suitors function regularly as a group, unlike the highly individualized heroes of the *Iliad*. Indeed, the only hint of conflict among them is provoked by the "beggar"—Odysseus himself (e.g., 17.481–87, 18.399–404). When, prompted by Athena, Telemachos summons an assembly of all the people of Ithaka, old Aigyptios remarks on the total lack of assemblies during the twenty-year absence of Odysseus (2.26–27) and expresses enthusiasm for their revival (2.33-34). In the course of the

[13]See, e.g., Woodhouse 1969 (1930), J. A. Scott 1931: 97–124, Calhoun 1943b: 153–63, Page 1966 (1955): esp. 52–53, Delebecque 1958, Clarke 1967: esp. 30–45, 65–66, Thornton 1970: chap. 1, Lord 1965: chap. 8, and Heubeck et al. 1988: 13–19, with abundant references to German discussions of the structure of the narrative. It is notable that, although Heubeck offers a vigorous defense of the Telemachy and finds the adventures inherently alien to the world of epic, he is virtually silent about the whole second half of the poem, noting only the happy ending and the implicit moral affirmation.

[14]Even J. H. Finley, a militant proponent of a dehistoricized human condition as the central focus of the poem (1978: 164), notes apropos of the prominent travel motif that "the nascent age of colonization attests a poverty that soon drove Greek settlers east and west, from the Black Sea to Sicily and beyond" (212).

[15]Whitman finds the artistic gain in vividness and realism mitigated by an alleged artistic failure in the violence of the final slaughter.

assembly, when a seer speaks in favor of Telemachos, he is threatened with a stiff fine to be imposed by the suitors (2.192–93); and when Mentor berates the demos, who are "many" (*polloi*), for tolerating the suitors, who are "few" (*pauroi*, 2.240–41), he is denounced by a suitor as mad for stirring them up.

This first, tentative opposition of the many and the few in Greek literature is met by a decisive shift to the relative numerical superiority of the few to the one king: if Odysseus should return and attempt to drive the many suitors from his hearth, he would only lose his life (2.246–51). With this argument the suitor calls for the immediate dissolution of the assembly. The hostility of the suitors to assemblies, characterized in the *Iliad* as "bringing honor to men" (*kudianeira*, 1.490), is again displayed in Bk. 16.[16] After their abortive attempt on the life of the king's son, they gather in the agora but allow no one else to attend (16.361–62). Their greatest fear is that Telemachos will now stir up the people, who might drive them from their lands (16.376–82). That this is no idle fear is made clear by Penelope's later pointed reminder of a past occasion when Odysseus' intervention alone saved Antinoos' father from the people's wrath (16.424–30).

The suitors' status as *aristoi* and *basilees* in the islands (1.245, 394) seems to be due solely to the fact that they are the sons of the local *aristoi*, as Telemachos points out in the assembly (2.51). Allusions to personal achievements by any of the suitors in war or through travel are conspicuous by their absence. At the same time, the poet focuses relentlessly on their extravagant lifestyle, a daily routine consisting of a bit of sport (4.626, 17.168) and a great deal of feasting and dancing. For some at least, the day ends in sexual enjoyment of the serving women (20.7). Though there is no particular emphasis on the suitors' own clothing, there is a suggestive indication of exceptional elegance in the clothing and coiffure of their personal servants.[17] When Odysseus, disguised as a beggar, informs Eumaios of his intention to beg for a living from the suitors and do "all such work as inferiors do in the service

[16]It is difficult to find specific evidence for a distinction between the frequency of assemblies under a monarch and under oligarchs. Many historians assume with Andrewes (1967: 42) that the difference between the *Iliad* and the *Odyssey* with respect to assemblies is simply a function of the difference between peace and war. The simile at *Od.* 12.439–40 seems to assume at least some juridical activity as a normal or even daily activity in the agora. Discussions of known functioning aristocracies in the Archaic period usually stress the dominant role of the council of the heads of leading families (often a *gerousia*, a council of elders) and the extreme rarity of general assemblies; see Burn 1960: 25 and Hignett 1958: 79.

[17]One fault of Strasburger's otherwise valuable article (1953: 97–114) is his failure to consider the lifestyle of the suitors or the Phaiakians relevant to a sociological examination of the Homeric world. M. I. Finley (1978: 134) also views the lifestyle of the suitors as simply a function of the plot.

of their betters" (15.324), the kind-hearted swineherd is frightened for his guest's survival and tries to dissuade him:

> You see, not at all like you are the attendants of those men.
> On the contrary, they are young, well-dressed in cloaks and tunics;
> Their hair is always well-oiled and their faces are handsome.
>
> (15.330–32)

Parallels have been noted between these easy-living suitors and the young men of the ruling class in Phaiakia (Lang 1969: 162–68; Vidal-Naquet 1970b: 1296 and n. 2). The celebration there of a "heroic glory" (*kleos*) derived exclusively from sports (8.147–48), the self-conscious class character of their snobbery against people in trade (8.159–64), and the general emphasis on a daily routine devoted to feasting, dancing, sports, and sex (e.g., 8.244–49) all throw further light on the contemporary element in the poet's portrait of the suitors. Their lifestyle is not simply a peculiar function of their anomalous suit of Penelope; like the Phaiakians, this is really all they know how to do. I imagine that the poet's own audience knew the type all too well.

The precise goals of the suitors in relation to Penelope are curiously difficult to find. They all seem to be sincerely attracted to her sexually (e.g., 1.365–66, 18.212–13), but it is not at all clear that they perceive marriage to her as leading to the establishment of a new king with the same status as Odysseus. On two occasions, they state that they intend to divide up the royal wealth among themselves—the only "heroic" property they ever contemplate "winning"—and then turn over the rest of the household to whoever marries Penelope (2.335–36, 16.384–86). Certainly any attempt on their part to speak as the voice of the community, a community that might well have its grievances against Odysseus, is conspicuous by its absence. On the contrary, they seem distinctly afraid of a negative judgment from the community arising from their pillage of the king's property. It looks suspiciously as if they intend to break up the concentration of wealth which, as Odysseus states with almost embarrassing bluntness, is a fundamental component of successful kingship (11.356–61; cf. 14.96–108, 17.265–68). In neither their language nor his is there any hint of the property of the king as in some sense a gift of the community in return for services performed or anticipated.[18] Both they and he see his property as purely private and subject to outright theft.

[18]Alkinoos has a *temenos* (6.293), Aphrodite has one on Paphos (8.363), and the dung on which Argos dies is intended by his servant for the great *temenos* of Odysseus (17.299). These are the only references in the *Odyssey* to a *temenos;* in none of these instances is

Here again, as in so many more obviously psychoanalytic contexts, Freud's concept of overdetermination is useful. None of the evidence cited for the oligarchic character of the suitors or the Phaiakians conflicts with purely artistic goals of telling an effective tale in which fantasy plays a significant role. But precisely when the artist seeks raw material for a fantasy which is effective for his particular audience, he is most imbedded in the social, political, and economic realities of his own time. To take an example from our society, a moment's meditation on the decisive and ambiguous role of technocrats in the conflicts of advanced monopoly capitalism suggests the immediate source of so many heroes and villains in contemporary science fiction.[19] In the *Odyssey*, then, it is not a question of deciding whether the "human condition" or "social comment on the behavior of rich to poor" is the "main burden of the poem" (J. H. Finley 1978: 164). In any particular historical moment, the human condition cannot be explored apart from such mundane realities to which it is inextricably bound. Thus, although it is superfluous to debate the poet's intentions, it is, I believe, legitimate to note the wealth of detail with which this particular poet evokes the contemporary reality of oligarchy.

Inherited Monarchy under Siege and the Theme of Education

The plot of the *Odyssey* explicitly juxtaposes inherited monarchy to collective domination by the sons of the rich landowners. The terms on which kingship can be inherited constitute a major concern of the poem; and the remarkably large narrative space devoted to the education of Telemachos seems to me to be dictated by the poet's sense of the actual fragility of the institution of kingship. On the one hand, the poet is aware of the view that "few sons prove to be the equal of their fathers; most are worse, while a few are in fact better" (2.276–77). This dour and backward-looking sentiment scarcely suggests the confidence of a class whose claim to status is based first and foremost on the assumption that excellence is inherited as a matter of course. Telemachos' wish that he had been born "the son of a rich man (*makar*) whom old age had overtaken in the midst of his possessions" (1.217–18) is perfectly appropriate to the specific tragedy of not knowing his own

there a hint of the emphasis noted in the *Iliad* on the *temenos* as the gift of the community. Here Redfield's invocation (1983: 231) of such ideas in connection with the *Odyssey* seems to me off the mark.

[19]See Gorz 1968: 120–25 for the role of technocracy. On its centrality to the emergence of science fiction, see the early attempt at defining the genre by Asimov (1953: 167): "Technological advance, rapid with respect to the passing of the generations, is a new factor in human history . . . and science fiction is the literary response to that new factor." See also Amis 1960: 18.

father's fate and may be paralleled by Achilles' allusion to his own father's wealth (9.400). But that parallel—at the moment when the most heroic of Greek heroes contemplates abandoning the life of systematic risk-taking—suggests that Telemachos' wish, situated in the context of the lifestyle of the suitors and Phaiakians, may reflect the passing of a vocation for heroic kingship as such. The political vacuum in Ithaka, caused by the absence of the father, the physical infirmity of the grandfather, and the incapacitating youth of the son indicates dramatically that the king must indeed rule by might. To this extent there is a clear parallel to the consistent hostility in the *Iliad* to automatic status and a corresponding emphasis on demonstrable excellence in a context of absolute risk. On the other hand, the books devoted to Telemachos stress emphatically and repeatedly the rightness of inherited monarchy with remarkable self-consciousness.

The issue of kingship is first raised by a suitor, who grudgingly acknowledges that it is something Telemachos has derived from his father by birth (*geneēi patrōion*, 1.387). Telemachos' tactful reply that "there are many other *basilēes* of the Achaeans in sea-grit Ithaka" (1.394–95) is a fundamental gloss on the ambiguity of the term *basileus* in the world of the *Odyssey*. There is not even a clear terminology to distinguish between a true king and a rich, would-be oligarch. Inheritance alone was obviously not adequate to guarantee the distinction.

Nonetheless, the poet never misses an opportunity to stress the theme of continuity of royal status from generation to generation. When Telemachos goes to the assembly, he sits in his father's seat and even the older men yield place to him (2.14). Just so at Pylos, Nestor sits before his palace on polished white stones where his father Neleus used to sit (3.405–9). The poet even pauses a moment to remind us of the continuity of royal power:

But he [Neleus] had already been overcome by his fate and gone to Hades;
Then Nestor in turn sat there, the Gerenian, warder of the Achaeans,
Holding the scepter.

(3.410–12)

At Ithaka (1.298–300), at Pylos (3.193–200, 248–75), at Sparta (4.91–92, 517–47), and even on Olympos (1.35–47), the poet focuses relentlessly on the criminal usurpation of power by Aigisthos and his well-deserved punishment by the rightful heir to kingly status, always explicitly or implicitly paralleled to the suitors as Ithaka. Indeed, the much-discussed moral vision of the *Odyssey* is almost exclusively in the service of legitimately inherited monarchy. Telemachos' fitness to inherit his father's status is insisted on not merely by encouraging

parallels to the paradigm of Orestes (1.301–2; 3.199–200, 313–16); in addition, his physical similarity to his father is repeatedly stressed (1.208; 4.141–44, 148–50), and even the favor he is shown by Athena is attributed to inheritance (3.375–79). Subtle dramatic elements further reinforce the sense of similarity between father and son: both cover their heads to weep when they hear sad reminders in the hall of a stranger (4.114–16, 8.84–86); both are struck with wonder by a grand palace (4.43–48, 7.133–34); both affirm their identity by a proud description of their modest homeland (4.601–8, 9.21–27); both are described, twice each, in a phrase occurring nowhere else, as following in the "footsteps of the goddess" (2.406, 3.30, 5.193, 7.38).

Moreover, it is clear that this feeling for inherited excellence among the royal class is not simply a function of the plot or even confined solely to Telemachos.[20] Menelaos, as soon as he meets Telemachos and Peisistratos, without even knowing their names, declares:

> The family of your parents has not perished in you at any rate,
> But you are, with respect to family, derived from men who are kings,
> Wielders of the scepter, since base men could not beget such men as you.
>
> (4.62–64)

The *Iliad*, with its array of laudatory epithets for the size, strength, and beauty of the heroes and its detailed description of the ugliness of the unheroic Thersites (*Il.* 2.216–19), seems to take for granted the visual superiority of members of the ruling elite. But the *Odyssey* insists almost stridently on the ruling-class look (13.223, 21.334–35, 24.252–53); what is taken for granted in the *Iliad* is explicitly featured in the text of the *Odyssey*.

The inheritance of moral, intellectual, and social virtues is similarly insisted on and not confined to Telemachos. When Peisistratos later complains of the mournful tenor of the after-dinner conversation, Menelaos launches into a veritable paean to inherited excellence:

> Friend, you have spoken just what a sensible man
> Would speak and do, even a man who was older.
> For coming from such a father you too speak thus sensibly.
> Very easy to recognize is the offspring of a man for whom Zeus
> Has spun a prosperous destiny, both at his wedding and at his begetting,
> As now to Nestor he gave continuously for all his days,
> So that he himself grows old, rich and comfortable in his halls,
> While his sons in turn are both sensible and first-rank men with spears.
>
> (4.203–11)

[20]Haedicke (1936: 24–36) stresses the greater emphasis on nobles as a class in the *Odyssey*. This is an important qualification of Calhoun's otherwise crucial discussion (1934a).

Finally, the catalogue of women in Bk. 11, whatever its other functions, serves in small compass a function parallel to Hesiod's *Eoiai*, namely, to detail the origins of the ruling families in divinity.

In tandem with this heavy insistence on the continuity of excellence in the ruling families, the institution of kingship as exercised by Odysseus is praised several times in the first four books (2.46–47, 230–34; 4.689–93). In the second council of the gods, which is to set Odysseus on his path back to political power in Ithaka, Athena casts the question of Odysseus' fate virtually in terms of the effective survival of the institution of inherited monarchy by focusing on the ingratitude of those who now live under quite different circumstances:

Let no man still readily be gentle and kindly,
One who is a scepter-wielding king.
Since no one has any memory of godlike Odysseus,
No one from the hosts over whom he ruled, and he was like a gentle father.
(5.8–12)

The speech closely echoes other speeches cited earlier, but, by combining in the subsequent lines a picture both of Odysseus' predicament and the danger to Telemachos' life from the suitors, the poet focuses attention on the continuity of power from generation to generation. Finally, the constant allusions to Odysseus' heroic feats at Troy, the long narrative of his adventures after Troy, the repeated expressions of respect and affection by the "good" servants, his final self-revelation in the test of the bow and in the actual battle with the suitors—all these elements insist dramatically that Odysseus is in every relevant respect the single best man in Ithaka and therefore most fit to rule by merit as well as by birth.[21] On this theme, Bk. 24 is unquestionably a perfect capstone to the poem as a whole; the patriarch Laertes exclaims near the very end of the poem: "What a day now this one is for me, dear gods! Yes, I am very happy! / My son and my grandson are having a contest over excellence [*aretē*]!"[22]

Considered solely from this aspect—on the one hand, an insistence on the rightness of inherited monarchy, on the other, a scathing portrait of oligarchs in power—the unambiguous aristocratic bias so readily attributed to the composer or composers of both poems may be

[21]For Odysseus' feats at Troy, see, e.g., 3.126–29; 4.106–7, 241–59, 269–89, 342–44; 8.75–82, 492–520. For respect from good servants, see 14.61–67, 138–47; 19.365–68; 20.204–8; 24.397–402.

[22]On the endless arguments over the ending of the poem, see Wender 1978. I also find congenial the arguments of Vidal-Naquet (1970b: 1293 n. 1) for the structural homogeneity of a work that may in fact represent the contributions of more than one poet.

kept intact by stressing its literal emphasis on "rule by the best."[23] Indeed, the poet of the *Odyssey* emerges as a more conscious partisan of the rulers insofar as he insists to a greater degree than the poet of the *Iliad* precisely on inherited excellence. On this view, the suitors emerge simply as inadequate aristocrats, and there is no real conflict in the poet's image of society's rulers (Strasburger 1953: 113). Indeed, the orthodox Marxist view of literature as a reflection of actual historical circumstances distorted only by ruling-class bias might be reinforced by such a reading—although, to be sure, the bias toward monarchy would have to be seen as distinctly old-fashioned (M. I. Finley 1978: 48, 106).

The Beggar's-Eye View

The orthodox Marxist view of literature as politically distorted historical reflection is, I believe, inadequate. Not only is the poet's image of the world an inherently imaginary construct, the ideological posture of the text as a whole is considerably more complex. The device of the king's return disguised as a beggar significantly complicates the class perspective of the poem. If one may rely on the comparative approach in dealing with Homer, the disguise of a hero as a beggar seems to be a traditional motif.[24] If we turn to the evidence of the *Odyssey* itself, we may even surmise from Helen's story at 4.244–58 that the motif was traditionally associated with Odysseus.[25] Traditional or not, through its extraordinarily full development in the second half of the *Odyssey* the beggar motif emerges as a powerful vehicle for the poet's exploration of the social structure of his own society.[26] An eminent historian declares categorically that, "as for the main plot of the Ithakan theme, the nobility provides all the characters" (M. I. Finley 1978: 53). Yet through nearly half the poem Ithakan society and in particular these aristocrats are perceived, not in straightforward contrast to their social, economic, political superior, the king, but from the perspective of the powerless, the dispossessed, the humiliated victims of their arrogance.

[23]E.g., M. I. Finley 1978: 119 and Schadewaldt 1965: 70. Donlan 1973 rightly questions these assumptions but does not relate non-aristocratic elements to the status of the poet.

[24]Lord, in his appendix of return songs, summarizes three in which the husband returns disguised as a beggar (1965: 252–54).

[25]The text is slightly confusing as to whether he is called a beggar *(dektēi)* or a menial *(oikēi)*, but the fact that he disfigures himself and wears a poor man's garb is clear (244–45); see Stanford 1964–65, ad loc.

[26]My emphasis on the social implications of the disguise here is not intended to deny a whole array of other interesting consequences of the device (see, e.g., Murnaghan 1987a and 1987b).

One may debate whether the hired hand (*thēs*) or the hunger-driven wanderer (*metanastēs*) reduced to a beggar (*ptōchos*) is the more truly wretched bottom of the social ladder in Homer's image of society.[27] Both doubtless were extremely miserable in the real world of eighth-century Greece. There is, however, a vast difference in their relative potentialities for a narrator not naively and completely wedded to the ideology of the ruling elite. The local *thēs* is tied to the land, crushed by constant hard labor, the most limited in his knowledge of society and the world beyond the farm. The wanderer by definition brings with him knowledge of a wider world. For the audience of the *Odyssey,* the wanderer also conjures up the awesome possibility of a god in disguise (cf. 17.484–87).[28] For that audience, as well as for us, the motif of the lonesome hobo, the rolling stone, carries almost inevitably the theme of the fragility of success and the special knowledge of those who have seen through the social fabric.[29] The poet of the *Odyssey* has exploited this theme with a power and persistence that seems to spring from deep roots.

A Marxist sociologist has suggestively analyzed Greek society's peculiar obsession with this theme of a radical reversal of status. Where warfare and slavery are a way of life and male slaves are obtained primarily through warfare, a precipitous descent from the top to the bottom of the social pyramid is a haunting present danger (Gouldner 1969: esp.

[27]In the *Iliad* Achilles twice uses the image of the vagabond without status (*atimēton metanastēn,* 9.648, 16.59) to suggest how deeply humiliated he felt by Agamemnon's treatment of him. In the famous two-jars passage, the hunger-driven wanderer is presented as the worst failure he can imagine (24.531–33). On the other hand, M. I. Finley (1978: 57–58), pointing to Achilles' famous speech in the underworld about preferring to be a *thēs* for a poor farmer (*Od.* 11.489–91) and the ironic offer of employment as a *thēs* by Eurymachos (18.357–61), argues that the *thēs* represents the bottom of the social ladder in the world of Odysseus. In fact, Finley does not distinguish the *thēs,* who would also beg if circumstances demanded (see *Od.* 17.18–21), from the beggar who is clearly a foreigner (*kseinos,* see 17.382); with respect to the sense of identity and perspective, this distinction is crucial.

[28]Lord in particular seems to lay heavy stress on this motif in his interpretation of these scenes: "The return of the dying god, still in the weeds of the other world of deformity but potent with new life, is imminent" (1965: 175–77). Murnaghan (1987: 12–14) gives somewhat solider grounds for the association of the disguise motif with divinity. Her exclusive emphasis on disguise as transcendence of normal human limitations has, however, the same attraction as other utterly dehistoricized archetypal patterns. Similarly Clarke (1967: chap. 4), apparently embarrassed by the realism of Bks. 13–20, turns to mystery religions and archetypes.

[29]Fitzgerald (1963: 328) actually translates the rare Greek word *proprokulindomenos* at 17.525 by "a rolling stone washed on the gales of life"—apparently expanding on Stanford's (1964–65, ad loc.) "like a rolling stone or wave." The theme of insights specifically associated with downward social mobility is central to the Bob Dylan song, "Like a Rolling Stone," which haunted the consciousness of at least one generation. This theme occurs repeatedly in the *Odyssey;* see especially Odysseus' famous speech to Amphinomos at 18.130–42; see also 19.71–84, 363–75; 20.199–207.

25–28). It is thus possible to view this motif as the special nightmare of the most privileged. In the *Odyssey* we do in fact hear of a pampered king's child sold into slavery (15.414–72), and one of Odysseus' lies recounts his reduction from a rich man's bastard to the repeated threat of slavery (14.200–340). But, as the case of Hesiod reminds us, fear of descending into unbearable poverty was not confined to the highest stratum of society, nor was war the only motor of economic marginalization. The *Odyssey* poet's treatment of the beggar motif goes significantly beyond general meditations on human illusions in times of prosperity. So relentless, so embarrassingly specific is his focus on the compulsion of hunger and the concomitant humiliations of the hungry wanderer that the major dramatic effect of Odysseus' long trial as a beggar is a vast crescendo of barely suppressed rage against his arrogant, gluttonous, and ignorant masters. The anger of the disguised king thus comes to take on a peculiarly underclass character.

The compulsion of hunger is associated with Odysseus long before he returns to Ithaka. One might concede perhaps a touch of humor in the simile that compares his sortie among the frightened maidens of Phaiakia to the attack of a rain-soaked, wind-blown lion on cattle, sheep, or deer: "His belly orders him make a try on the sheep and even approach the sturdy dwelling" (6.133–34). At the court of Alkinoos the newly arrived wanderer discourses to his carefree hosts about the compulsion of hunger in a sustained piece of personification almost unparalleled in Homeric epic:[30]

> Let me take my supper, in deep sadness though I am,
> For there is nothing more bitch-shameless than hateful
> Belly. She orders a man to remember her under compulsion,
> Even though he is very worn out and has grief in his heart,
> Just as I have grief in my heart; but constantly, relentlessly
> She orders me to eat and to drink, and makes me forget
> All the things I have suffered, and bids me fill myself.
>
> (7.215–21)

In the steading of Eumaios, Odysseus again generalizes on the power of hunger:

[30]The personification of the Prayers (*Litai*) at *Il.* 9.502–12 is the closest parallel of which I am aware. Commentators (e.g., Leaf and Bayfield 1965 [1895] and Monro 1884) debate whether that passage constitutes allegory. Willcock declares categorically, "It is an allegory, like something from Bunyan's *Pilgrim's Progress*, and has no parallel on anything like the same scale in the *Iliad*" (1978: 280).

There is nothing else worse for mortals than wandering;
But for the sake of disastrous Belly men endure grim troubles,
Whenever wandering and suffering and woe come on a man.

(15.343–44)

The compulsion of hunger meets with sympathy and generous relief from Nausikaa, Alkinoos, and Eumaios; but when Eumaios warns Odysseus to expect far different treatment from the suitors, Odysseus once again dwells on the compulsion of the belly, which is now presented in startlingly unheroic fashion as the underlying motive of all seafaring and raiding:

There is no way to hide away Belly in her eagerness,
Disastrous, she gives many sufferings to men.
For her sake even well-benched ships are fitted out
On the barren sea, bringing suffering to men.

(17.286–89)

The structured silence in the *Iliad* about crude economic motives underlying heroic adventures is here spoken out with Hesiodic bluntness.

There is something disturbingly excessive about these passages. Some critics have been inclined to explain such excesses as consciously humorous.[31] But, whereas gluttony has consistently provided rich matter for comedy, the hunger resulting from poverty offers tasteless fare at best. I suggest that, rather than humor, it is the reality of economic distress in the consciousness of the poet and his audience that undercuts the presentation of heroic raids as the chivalric adventures of the economically secure. Certainly it is hard to find any humor in Odysseus' speech when Antinoos, after refusing him food, hurls his footstool at him:

Listen to me, suitors of a queen most renowned,
So I may tell you what the spirit in my breast bids me say.
There is no pang at all in one's mind, nor any grief,
When a man as he fights for his property
Is struck—when it is for his cattle or his shining white sheep.
But Antinoos has struck me because of dismal Belly,
Disastrous, she gives many sufferings to men.

[31] J. A. Scott 1965: 192 is typical: "Odysseus had an enormous appetite and seemed always ready to eat. The fact that he ate three times in one night has caused anguish of soul to the critics"; so too Heubeck et al. (1988, ad loc.), who speak of "this amusing passage."

But if somewhere there are gods and avenging spirits for beggars,
May death's end overtake Antinoos before his marriage.

(17.468–76)[32]

We can detect here, I believe, more than the anger of a disguised king
insulted by his inferior. We hear the pained protest of a proud peasant
farmer, who would fight bravely in defense of his flocks, but who has
been reduced by some other cause than war to humiliating poverty. So
too in the parallel reply of Odysseus to the tauntings of Eurymachos
about the beggar's insatiable belly (18.364), the defiant challenge to a
contest of harvesting or ploughing (18.366–75); this passage has often
been cited as proof that Homeric kings worked, but it is more relevant
to perceive here the angry protest of normally hard-working peasant
farmers who have lost their land through economic forces not unlike
those that a century later in Attica enslaved so many Athenian
peasants.[33] Thus reduced, they must now endure the jeering charges
of shiftlessness from the idle class that has appropriated their source of
livelihood. Certainly the dour reflection of the slave Eumaios that
"Zeus of the wide brow takes away half of a man's excellence [*aretē*]
when the day of slavery seizes him" (17.322–23) evokes more than a
simple validation of the social hierarchy based on birth and seen from
the top. It is not another servant but Penelope herself who points out
that "mortals age early in wretchedness [kakotēti]" (19.360).[34]

Because Eumaios' view of slavery is articulated by a man of demon-
strated excellence who has himself endured enslavement, it implicitly
calls that hierarchy into question from the bottom. The fact that Eu-
maios was born a king's son (15.413–14) may seem to some a valid basis
for dismissing his words as in any sense characteristic of the perspective
of a true slave. I suggest rather that Eumaios' noble birth in fact an-
ticipates a development we see more fully in the fifth century. Royal
descent, a seemingly clear sign of membership in the ruling elite, is
transformed into a metaphor for demonstrable excellence regardless

[32]The idea of avenging deities for beggars may in fact amuse some, but I believe that
the feeling in this passage is nearer to Hesiod's invocation of the justice of Zeus; see
Havelock 1978: esp. 187.

[33]Strasburger (1953: 104) and Starr (1961: 128) both see here evidence that Homeric
kings worked. M. I. Finley (1978: 70) simply dismisses the idea that Odysseus ever did
any work on his estate. Donlan (1973: 153) is nearer the truth in perceiving an anti-
aristocratic flavor. In another context, even M. I. Finley (1978: 122) observed that "the
heroes had a streak of the peasant in them." I find that Redfield's interpretation of this
passage misses the point: "Agricultural labor, like games and warfare, is a proper test of
manhood, and as such is classless" (1983: 232).

[34]Vidal-Naquet (1970b: 1279 and n. 4) notes that this line is in several manuscripts of
Hesiod's *Erga* as line 93 (expunged by M. L. West). The French translation of *kakotēti* as
misère brings out its real force as "poverty."

of the actual station of the individual. The opposition established in the *Iliad* between radiant Achilles, son of a goddess, demonstrably the best of the Achaeans, and Agamemnon, mediocre ruler over golden Mycenae and all Argos by virtue of inherited status and wealth, is not immeasurably far from the implicit opposition in the *Odyssey* between the "noble-born" and "noble-acting" slave Eumaios and the corrupt suitors, who owe all their status to birth. In this sense Eumaios looks forward to Euripides' noble (*gennaios*) farmer, chosen as Electra's husband on account of his lack of distinguished ancestry, yet whose noble-mindedness summons forth an explicit questioning of the foundations of society's hierarchies (*Electra* 367–90).[35] That there are unequivocally lowborn characters at least a match for the suitors in prowess is clear from the martial achievements of the cowherd Philoitios (e.g., 22.285–91) and the arming of Dolios and his six sons (24.496–99). Moreover, as Murnaghan (1987a: 39–41) points out, the winning alliance put together by Odysseus depends on blurring the birth-enforced hierarchy of the *oikos* by assimilating subordinates into kinship relations: Eumaios and Philoitios become "brothers" (*kasignētō*) of Telemachos (21.213–16).

The literary character is, of course, not a real person but the product of complex and potentially contradictory drives within the text and the world that generates the text. Thus the picture here is complicated by the fact that in many respects the poet is anxious that his audience remember Odysseus as a genuine, old-fashioned Trojan War hero-king. In the reply to Antinoos quoted above, he shifts brusquely from farming to warfare, and it is easy to feel that the voice of a Hesiod is supplanted by the accents of a Diomedes. Unlike the suitors and the Phaiakians, Odysseus knows warfare firsthand, not just from poetry. As a similar complication, one may cite the sharp differentiation between the beggar Iros, a relatively unsympathetic character, and the king merely disguised as a beggar. But even in the scene that pits Odysseus against Iros, the emotional force cuts two ways. On the one hand, there is the satisfaction of the worm turning, as the seemingly helpless old man roundly defeats the big, loudmouthed bully. But at the same time, the poet focuses sharply on those who organize and enjoy watching this sort of fight. We are informed about the light-hearted laughter (*hēdu ekgelasas*) of Antinoos as he exclaims, "What a rare delight the gods have brought to this house!" (18.35–37). We hear of the laughter of all the suitors as they gather about the "poorly clad beggars" (18.41), Antinoos' hideously brutal threat of disfigurement and mutilation to

[35]See Denniston's commentary (1939, ad loc.). Compare Rousseau's subversion of aristocratic terminology in the eighteenth century by the coinage "noble savage."

the already terrified Iros (18.83–88), and the poet's final ironic hyperbole as Iros collapses in the dust spitting out blood and teeth: "But the illustrious suitors / Threw up their hands and died with laughter" (*gelōi ekthanon*, 18.99–100).[36] Even allowing for the less-censored sadism of Homeric society, we can detect in this scene a bitter irony directed against the callous arrogance of the ruling oligarchs who find such hysterical sport in the sufferings of poor men compelled to fight over food.

One must add to these striking passages all the other derogatory references to the needs of the belly (17.228, 502, 559; 18.2, 53–54), all the snide comments about how hungry beggars ruin the feast (17.220–23, 376–77, 446; 18.401–4; 20.178–79) or are a "burden on the earth" (20.377–79), the humiliating advice that "shyness ill befits a beggar" (17.347, 578), and finally the arrogant remarks—characteristically heard from the economically secure in times of widespread unemployment—that the beggars are too lazy to work (17.226, 18.362–63, 20.373–74). The fact that some of these remarks come from the feigning Telemachos or from Penelope only indicates more emphatically that this is the expected response from the ruling element. Cumulatively, the strongly generalized focus on hunger, wandering, and the humiliation associated with low economic status suggests that the world of Odysseus is not after all so very far from the world of Hesiod. Nor, I believe, is the consciousness of the poet's audience far removed from that of Hesiod, who, as we have seen, on the one hand looks back to an idealized image of a golden age of just kings and celebrates the triumph of Zeus as monarch while on the other rails against the gift-gobbling *basilēes* of his own day.[37] The poet of the *Odyssey*, who compels us to hear all this from the perspective of the hero qua beggar, is, like Hesiod, haunted by the constant specter of starvation, the loss of one's land, and the necessity of having to beg from unsympathetic neighbors while enduring humiliating insults.

The Poet in the Poem

If the audience of the *Odyssey* is essentially the same as that of Hesiod, we must acknowledge that the narrative mode of the *Odyssey*

[36]Stanford (1964–65, ad loc.) comments on the boldness of the phrase, which led earlier commentators to suggest emendations.

[37]We may detect further parallels between the *Odyssey* and Hesiod's ambivalence toward *basilēes*. Beside the frequent praise of kingship as exercised by Odysseus and the famous praise of a "faultless king" (19.109–14) which so closely parallels Hesiod (*Er.* 225–37) must be set Penelope's unflattering assumptions about the usual arbitrary and excessive behavior of a *basileus* (4.690–95)—a passage nearer in spirit to Hesiod's hawk and nightingale fable (*Er.* 202–12).

makes the question of the poet's relation to his audience and his material far more complex by virtue of its greater indirection. Nevertheless, in his own way the poet of the *Odyssey* reveals a degree of consciousness about his own activity and the status of poets (Todorov 1977: chap. 4) in heroic society which corresponds quite closely to the more obvious self-consciousness of Hesiod about poetry (Pucci 1977 and 1987). In the first place, there is both emphatic praise of song as the crowning grace of the feast (e.g., 9.5–11) and repeated focus on the conditions of performance, subject matter, talent, and social status of particular poets in the fictional world of the poem. The last factor, social status, is most relevant to my analysis.

How much can we deduce about the *Odyssey* poet's own status and audience by looking at his idealized images of a world allegedly long past? It is often stated that Homer portrays court poets in the *Odyssey* (e.g., Page 1966: 146). Phemios, ever present at the endless feasts of the suitors, and the unnamed bard whom Agamemnon left behind to keep an eye on his wife (3.267–68) do seem to fit this description. Yet the treatment accorded both these poets—one compelled to sing against his will (1.154) and very nearly to share the death of his criminal masters (22.330–36), the other casually marooned as food for the birds on a desert island (3.369–71)—suggests that the poet of the *Odyssey* could not imagine his fellow poets even of the glorious past as anything but dependents of the rulers, treated with great respect if the rulers were good, but subject to humiliation and physical abuse if the rulers were bad (M. I. Finley 1978: 55). Certainly there is no hint that these bards were themselves members of the ruling class.[38] The name and status of Demodokos, the bard of the Phaiakians, who has to be summoned (8.43) presumably from the town, suggests a hired worker among the demos who plays for (i.e., is "received by"—*dokos*) the demos as well as the *basilées*. Eumaios' inclusion of poets among the *demioergoi* ("craftsmen," lit. "workers among the people") who are summoned as stranger-guests all over the boundless earth (17.382–86) confirms that normally the poet was a wanderer whose primary audience was the demos.[39] Such status seems nearer the reality of the eighth century B.C. Given the great disparity in general economic level between the poet's own time, barely emerging from the Dark Age, and the golden past he

[38]Schadewaldt (1965: 54–70) offers an excellent analysis of the evidence in the poems about the status of bards and is particularly good on Demodokos. Yet he ignores his own analysis to argue on the flimsy grounds of a legend that Homer's real name was Melesigenes that his poet was himself an aristocrat (69–70). See also Lesky 1967: 4–7. As Kirk comments about the alleged biographical material in the tradition, "much of this information is recognizably fantastic and nearly all of it is probably worthless" (1985: 2).

[39]M. I. Finley remarks that the bards were "among the first to break the primeval rule that a man lives, works and dies within his tribe or community" (1978: 36–37).

imagines, it is extremely unlikely that even the richest members of the economic elite of his day could support a full-time poet. Local oligarchs may be his most generous patrons, and we may well see in his emphasis on inherited excellence a reflection of the pretensions of the emerging aristocracy. But we have seen that not even this motif is free of ambiguity in its verging toward metaphor; and it seems likely, if unprovable, that the poet's most reliable and most frequent audience would consist of peasants—peasants who, like Hesiod, must have felt keenly the economic pressure of the relatively easy-living oligarchs.[40] If a further speculation is correct that the creation of monumental poems on the scale of the *Iliad* and *Odyssey* resulted from the special conditions of performance at panhellenic three-day festivals (Wade-Gery 1952: 6–8), the probability of a predominantly peasant audience is increased.

If we turn from the evidence in the text about particular performing poets such as Demodokos and Phemios, there remains the more difficult evidence of the striking self-identification of the poet with his wandering hero.[41] Three times Odysseus is explicitly compared to a bard and once sharply distinguished from one. The first passage is perhaps the most suggestive. After Odysseus offers to stay a year among the Phaiakians if Alkinoos will keep gathering gifts, the king—perhaps mildly alarmed but ever tactful—replies:

> Odysseus, now we do not at all liken you, as we look at you,
> To a hustler, some thievish fellow [*epiklopos*], the sort the black earth
> Spawns in great numbers, scattered far and wide,
> Fashioning lies from sources a man could not even see;
> On *your* words there sits loveliness, and good sense is in them,
> And your story, like a bard full of skill, you recited.
>
> (11.363–68)

The poet seems here, as later when Eumaios alludes to bringing in useful outsiders like poets (17.382–87), terribly anxious to insist on the absoluteness of a distinction that might not always have been clear to his contemporaries. Alkinoos protests too much, and the redundant emphasis in his speech on the number (*pollous* . . . *polusperea*) of such hustlers is itself further evidence of widespread economic distress in the

[40]I use the term "peasant" throughout in the sense defined by Ste. Croix (1981: esp. 9–19).

[41]Of the many who have commented on this identification, I mention only J. H. Finley (1966: 12; 1978: 50), who first compelled me to think about it, and recently Suzuki (1989: 70–72) and Martin (1989: 233–34), who cites interesting parallels from other epic traditions for the bard's association with the protagonist of the tale.

world of Odysseus. More obvious, the poet's simile emphasizes the fact
that the hero's greatest asset in his battle to survive is not martial prow-
ess but poetic prowess, his mastery of speech.[42]

The distinction between Odysseus, the poetlike teller of a "true" tale
in Phaiakia, and the hungry hustler with a bag of plausible-sounding
lies breaks down even before Odysseus assumes his disguise as a beggar.
On the beach of Ithaka, Athena defines her favorite approvingly by the
same term (*epiklopos*, 13.291) that Alkinoos so emphatically demurred
from applying to his articulate and acquisitive guest. She proceeds fur-
ther to praise his deceptions and deceitful stories, suggesting that these
are her own specialty as well in divine society. But the positive valuation
placed on lying and cheating—so remote from the aristocratic frank-
ness proclaimed by Achilles (*Il.* 9.312–13) in response to none other
than Odysseus—suggests the mythic attributes not of Athena so much
as of Hermes the thief, a god whose associations with non-aristocratic
classes and values have been well established (even if the clearest evi-
dence is inevitably post-Homeric; Brown 1969: esp. 76–105). That
these values are viewed as part of Odysseus' inherited character is sug-
gested by the references in the poem to his grandfather Autolykos,
who, thanks to Hermes, "outstripped all men in thievery and [false]
oaths" (19.396–98, cf. Stanford 1963: chaps. 2, 5).

When Odysseus embarks on his career of lying and begging at the
steading of Eumaios, the first response of the kindly but highly skep-
tical swineherd is to include him in a general and clearly familiar type:

> But still wandering men in need of a livelihood
> Tell lies, nor have they any will to tell the truth. . . .
> And quickly you too, old man, might fashion together a tale
> If someone were to give you a cloak, a shirt, or clothes.
>
> (14.124–32)

Both explicitly and through a highly self-conscious pun playing on the
incompatibility of wandering (*alētai*) and telling the truth (*alēthea*), the
passage suggests how easily a wandering poet might be confused with
a ready-tongued wanderer in need.[43] Certainly after listening for three

[42]The comment of Stanford, "He may have meant a touch of sly humor in 368 since it
is really he, an *aoidos*, who is telling O.'s story" (1964–65, ad loc.), though fair enough,
trivializes the association between bard and hero which in fact goes far beyond self-
praise. But see Pucci's characteristically Derridean meditation on Phemios (1987:
chap. 21).

[43]Actually, the bard seems to be playing with these sounds and ideas for several lines:
alēthēn ("truth," 120), *alētai/pseudont'* ("wanders/lying," 124–25), *alēthea* ("truth," 125),
alēteuōn ("wandering," 126). Note that what is transliterated *th* in English is nearer the
sound of simple *t* in Greek than in English. It is not implausible that in Homer's world,

nights to this particular wandering liar, Eumaios is ready to recommend him to his queen with what appears to be the highest of compliments:

> Such stories he tells! He would put a spell on your heart. . . .
> As when a man fixes his eyes on a bard, one who knows
> From the gods and sings thrilling stories to people,
> And they are eager to hear him, without moving when he sings;
> Just that way he put a spell on me, as he sat by me in my home.
>
> (17.514–21)

The notion of enchantment (*thelgoito . . . ethelge*) emphasized in this passage puts Odysseus and perhaps even the bard in rather questionable company (Walsh 1984: 14–21) with Kalypso (1.57), Aigisthos (3.264), the Sirens (12.40, 44), Hermes wielding his magic wand (5.47, 24.3), and even Penelope casting a deceptive spell over the suitors (18.282). It is as if the poet, in the process of glorying in his own powers, were also expressing a new awareness that the mastery of formulas carries more than an accurate memory of the past (*Il.* 2.484–86; *Od.* 8.491); it includes the power to deceive by manipulating the very process of cognition (Pucci 1987: esp. 193–94; Suzuki 1989: 72–73).

It is entirely legitimate, I believe, to associate this new awareness with the dramatic technological innovation of literacy, which opened new possibilities for distancing oneself from the hypnotic spell of oral performance.[44] But literacy alone does not necessarily engender a radical reassessment of the social hierarchy and traditionally dominant values (Finnegan 1977). The confluence, however, of profound social, political, and economic upheaval with so potentially disorienting a

as in the Yugoslavia of the 1930s, there were fairly subtle gradations in the degree of mastery of formulaic speech (pace M. Edwards); many men might have had some degree of skill. A. Lord offers a suggestive comment after quoting a long series of statements by singers on their backgrounds: "We can thus see that no particular occupation contributed more singers than any other, and professionalism was limited to beggars" (1965: 18). The only nonprofessional singer we know in Homer is Achilles (9.186–87)—grounds, as argued in the preceding chapter, for seeing there too some association between the poet and his protagonist.

[44]Thus far I would follow Havelock's (1963, 1978, 1982) general emphasis on the impact of literacy. But his analysis, for all its importance, runs the risk of a certain undialectical technologism in attributing such sweeping consequences solely to a development that is itself as much a symptom of change as a cause. Moreover, the changed technology had, if the general dating is at all accurate, been around some fifty years. Its impact on Hesiod is widely recognized, whereas the poet of the *Iliad*, who may well have *written* his poem (Goold 1977), seems to reflect little internalization of the presumably brand new technique beyond perhaps (if Goold is right) the fact of composing so long a work. Thus both a time lag and, I would argue, an increase in the tempo of social change seem more relevant to the changed consciousness I am positing here than the simple fact of literacy.

technological breakthrough could in large measure account for the multiple levels of ambiguity so characteristic of this poet's vision. Just as he suggests a radical gap between appearance and reality in the social, political, and economic spheres by his handling of the beggar motif, so on the more narrowly verbal level his many puns, allegorical names, pervasive fascination with dramatic irony, lying and hypocrisy, together with the constant examination of his own craft all evoke a new sense of the potentially equivocal nature of all perception and linguistic signification.[45] That this is not simply a creation of individual genius is confirmed by the similar phenomena in his contemporary Hesiod, a poet in other respects of so different a stripe.

Certainly one cannot read the *Odyssey* poet's description of his hero's supreme achievement in fiction, his long speech to Penelope in Bk. 19, without being reminded of Hesiod's self-conscious Muses. The Muses appeared to Hesiod when he was a shepherd and proclaimed, "We know many lies to speak that are like real things; / We know too, when we want, to give voice to true things" (*Th.* 27–28). The *Odyssey* poet comments after the beggar's long, detail-laden account, "He made many lies as he spoke seem just like things true" (19.203). A clinching element in this lying tale, the detailed description of Odysseus' herald, reveals how the sense of verbal deceptiveness is completely fused with a more social and intellectual vision of ambiguity:

> And assuredly a herald a little older than he
> Followed him. And I can recount just what he was like:
> Round-shouldered, dark-skinned, and wooly haired.
> Eurybates was his name. And Odysseus honored him beyond
> All his other comrades because he had the same sort of mind as he did.
> (19.244–48)

The passage has plausibly been cited as the first description of a black in Western literature.[46] More striking are the parallel and contrast to Thersites in the *Iliad*. Both are described with realistic detail implying divergence from the heroic, ruling-class type evoked by the honorific formulas. But Thersites is said to inspire deep hatred from both Odysseus and Achilles (*Il.* 2.220), whereas the poet of the *Odyssey* implicitly

[45]Stanford (1964–65) notes some instances under "Paronomasia" and "Significant Names." Dimock (1956) makes particularly good use of them. Stanford (1963: 20–24, 35–48) discusses Odysseus' lies at length. But beyond Odysseus' own frequently noted lies, one needs to consider those of Telemachos, Penelope, and the suitors—particularly Eurymachos—as elements in this new perception of the deceptiveness of speech.

[46]Snowden 1970: 102, cf. 19. In view of the prevalence of wooly hair and dark complexions among Mediterranean peoples, this interpretation is not inevitable.

contrasts the deceptiveness of Eurybates' unprepossessing appearance
with the reality of his superior intelligence. He insists on the bond of
esteem and similarity between this servant and his master.[47] Moreover,
for all the emphasis on ruling-class looks in the Telemachy, Odysseus
himself seems also to deviate in his appearance from ruling-class type
(Stanford 1963:66–67). Although it may strike some as preposterous
to suggest that intelligence itself is perceived as characteristic of those
excluded from ruling-class status, it is noteworthy that, apart from Od-
ysseus and such aged figures as Nestor and Phoinix, Homeric heroes
are praised almost exclusively for their military prowess. In the *Odyssey*,
it is the disadvantaged hero and his oppressed wife who consistently
display the highest levels of calculation in the face of superior force and
to this extent reinforce the split between appearance and reality (cf.
Detienne and Vernant 1978: 12–13 and passim).

Hesiod effects a significant shift away from reliance on exclusively
narrative modes to more abstract principles of organization.[48] Despite
his insight into the potential duplicity of the Muses and "turning aside"
implicit in winning others over to the "straight *logos*," he composes as if
he had unmediated access to the truth (Pucci 1977: 16–21). The dra-
matic climax of the *Odyssey* reveals a similar confidence. When at last
the long, humiliating disguise of the ragged beggar is set aside in the
unequivocal demonstration of superiority, the poet once again, for the
third and last time, fuses with his hero:

> But Odysseus, full of cunning,
> Just as he had the feel of the great bow and had looked it all over,
> As when a man skilled with the lyre and in singing,
> Easily stretches a string over a new peg,
> Fastening at both ends the carefully twisted sheep gut,
> Just that way, without any effort, Odysseus strung the great bow.
>
> (21.404–9)

This deep association of the poet with his hero goes beyond his role as
storyteller. Like the disguised old king wandering from place to place,
meeting now with royal treatment but often with the arrogance of
haughty and (from his special perspective) ignorant, degenerate, and
corrupt oligarchs, the bard carries within him the vision of an immea-

[47]Following *LSJ* on *artios* contra Cunliffe 1963 (1924) and Authenrieth 1958 (1876).
LSJ gives better sense to the *hoi* as well. The parallel and contrast between Eurybates and
Thersites appears in Russo (1974: 149–52).

[48]See Havelock 1966: 59–72 and M. L. West 1966. West notes Hesiod's violation of
Zielinski's law at line 617 and again at 711–12. Delebecque's entire study (1958) shows the
extraordinary strains placed on the *Odyssey* poet by this narrative convention.

surably finer world. The poet and his hero look back to the world of the Trojan War preserved in the epic formulas of the *Iliad,* a world where, not only is life more intense and brilliant, but political power and status truly correspond to demonstrable excellence. He may reflect some of the newly self-conscious concern of these oligarchs to celebrate inherited excellence. He may appear far more conservative than they in looking back to an idealized, paternalistic monarchy. Yet his seeming nostalgia may function equally as a utopian projection for the future, a standard in terms of which he offers an openly hostile critique of the oligarchs' naive and arrogant disregard for the self-respect of less fortunate men.[49] As he dramatically involves his listeners in the grim satisfaction of bloody revenge, he expresses the emerging fierce independence of the hunger-haunted peasants, who were soon to turn again to the rule of one man, the tyrant, as the only means of checking the arrogance of the self-styled best men.

Historicizing the Hero's Identity Abroad and at Home

Thus far I have discussed the more obviously ideological, political, and social aspects of the *Odyssey,* manifested most clearly in the poet's significant structural emphasis on Telemachos as the focus of the poem's celebration of inherited excellence and on the role of the beggar in Ithaka as the negation of that emphasis. Inherited monarchy is seen in all its fragility. We cannot yet speak of a full-fledged ideological commitment as in Plato to fusing nature and nurture—that is, combining presumed inherited excellence with control of the socialization process. Yet the *Odyssey* poet does seem to imply by his remarkably full development of Telemachos' education the necessity of supplementing inherited attributes with the right sort of ruling-class role models and social relationships. At the same time, in drawing out the beggar's testing of the social strata of Ithaka and repeatedly dramatizing the beggar's conflict with the oligarchic suitors in terms that explicitly pit poor against rich, the poet calls into question the full range of assumptions underlying the social hierarchy of his own time.

If we turn now to a brief consideration of the themes and portions of the poem that have traditionally received more attention, we can see that the poet's vision is of a piece; we do not have a few echoes of contemporary social concerns obtrusively thrust onto an otherwise

[49]Here again I echo a definition of *hubris* offered by Wade-Gery in lectures on the Archaic period at Harvard in the late 1950s or early 1960s: "the arrogant disregard of another man's self-respect."

permanently valid exploration of immutable essences of human identity, the human condition, the transcendent hero, or nature and culture. The poet's handling of the beggar-wanderer motif suggests his ambiguous self-distancing from the values of the ruling elite, his sympathy with peasants and those on the margins of society. The identity of Odysseus—the content, so to speak, of what is to be inherited in the aristocratic reading of the poem—is constructed, explored, and celebrated on a variety of levels that make the poet's class sympathies still more specific and explicit. Odysseus' heroic characteristics, his psychological profile, and his cultural role evoke the energetic and aggressive elements in late eighth-century Greek society—the elements that were the real force behind the extraordinary burst of colonization into the western Mediterranean, northern Aegaean, and Black seas. Although the matter is disputed, it is probable that the overwhelming majority of colonists were not the landed aristocracy who controlled most of the wealth and enjoyed "the good things in Hellas," as Pindar was to put it, but rather all those—including poor relations of the ruling elite, peasants, and traders—who were hungry for the land and opportunity not available in a Greek world run by oligarchs.[50]

Some readers of the *Odyssey* have dubbed the identity valorized in the figure of Odysseus "bourgeois."[51] But that term, to the extent that it evokes specifically modern economic formations, is quite misleading. Greece at about 700 B.C. did not have a large, self-conscious class of wealthy, non-aristocratic city dwellers living off a surplus created by the labor of wage-earning production workers. What I call the colonizing element was made up of three components: discontented peasants, who either had inadequate land or had lost their land altogether; enterprising soldiers of fortune, who may have been déclassé aristocrats—poorer relations or bastard sons of the ruling elite, as Archilochos in the next century was alleged to be; and peasants who had given

[50]E.g., Starr (1961: 372; 1977: 46–51) assigns primary leadership to the aristocracy. But see Hopper 1976: 83–86 and Murray 1980: 107–11 for the constitutive components of what I am calling the colonizing element. Redfield (1983) also associates Odysseus with "the first great age of Greek entrepreneurial expansion" (222) and the "ethical basis of Greek colonization" (232). I do not, however, find his reflections on labor, society, and the "economic ethic" very enlightening for the *Odyssey*.

[51]E.g., Jacoby 1933: 159–94; *contra* see Strasburger 1953: 109–110. Horkheimer and Adorno too speak of the *Odyssey* "as one of the earliest representative testimonies of Western bourgeois civilization" (1972: xvi), and "the hero of the adventures shows himself the prototype of the bourgeois individual" (43). In the broad sense in which they are using this terminology they are unquestionably right that "the lines from reason, liberalism, and the bourgeois spirit go incomparably farther back than historians who date the notion of the burgher only from the end of medieval feudalism would allow" (45). Though their analysis is rich in insights, its focus precludes any sustained consideration of what the figure of Odysseus represented in the historical moment of its articulation. Redfield as well uses the term "bourgeois" to characterize Odysseus (1983: 233).

up farming for full-time trading.[52] These types are discernible in the composite character of Odysseus, who both selectively appropriates and challenges the values of the ruling elite. In attempting to historicize the exploration of the identity of Odysseus in the poem, I distinguish different levels on which it is constructed. The drive of the artist surely is to represent a coherent, autonomous subject, yet the fascination and apparent easy accessibility of this literary construct derives in no small measure from the presence of these various levels.[53]

Odysseus and the War Epic Stereotype

Nearest to the social and political levels we have already considered is Odysseus' relation to the heroic stereotypes of the epic tradition. The suitors, by their insistence on hearing the songs of Phemios, may be presumed to consider themselves worthy contemporary analogues of the heroes of the epics. As we have noted, however, the poet of the *Odyssey* underlines ironically their ignorant pretensions by the sustained contrast between the suitors and Odysseus qua legitimate Trojan War hero. A standard trope in the discussions of the hero's identity consists in emphasizing the perfect harmony between the war hero and the peacetime king, master, father, husband, and legitimate heir to the land whose reacquisition of these roles is marked in a neat series of recognitions in the Ithakan portion of the poem.[54]

At the same time, Odysseus is consistently differentiated from that stereotype by a rich variety of concrete actions, expressed sentiments, and dramatized postures toward reality (Stanford 1963: esp. chap. 5). His atypicality has many dimensions but is best summed up in his practical intelligence (his *mētis*, Detienne and Vernant 1978: 22), which does not balk at poisoned arrows, lies, or disguises, which repeatedly perceives the future in terms of nearly equally dangerous alternatives, and which consistently distrusts the appearance of success. The poet thus seems to undermine certain aspects of the hegemonic ideology, such as the military elite's naive valorization of openness, direct

[52]For part-time traders among farmers, see Hesiod *Er.* 641–49. Redfield's comment thus seems to me off the mark in terms all too well explained by Bernal (1987) when he writes, "Odysseus bristles to be called a master of *prēktēres*, traders (8.162). Only the Phoenicians trade; they are like gypsies, selling gee-gaws and stealing babies" (1983: 233). He immediately qualifies this *bon mot* by acknowledging "however it is also true that Odysseus has a trader's mind" (233, cf. 234–35).

[53]Dimock's essay (1956) is richly suggestive. Stanford 1963: chaps. 2–5 is useful; J. H. Finley has an especially nice version of the meditation on Odysseus' epithets (1978: 34–40).

[54]E.g., Whitman 1958: 301–5 and J. H. Finley 1978: 165–84, 198–200, 204–7, 224–33. Murnaghan (1987a) in a sense devotes her whole text to this framework.

confrontation, and gleeful exultation in success. At the same time, he seeks to retain the prestige of the stereotype while grafting newer values onto it. Thus Odysseus' status is upgraded by more closely linking him with Achilles as the "best of the Achaeans" (8.78); yet the pointed contrasts to Achilles, Ajax, and Agamemnon—particularly in Bk. 11— imply a critique of the inflexibility and relative naivete of these older stereotypes.[55]

Odysseus as the Threatened Male

If on the level of traditional saga stereotypes Odysseus is perceptibly differentiated from the hegemonic ideals of the landed aristocracy, the identity represented in the more obviously mythic and folkloric aspects of the poem also merits an ideological analysis. In examining the narrative structure of the *Odyssey*, we noted the general agreement that the focus on Telemachos and the lengthy focus on the real world of Ithaka are significant clues to the vision of this particular bard in relation to presumably traditional story material. At the same time, it is also widely recognized that there is a sharp disjunction between the quasi-historical saga material of the Trojan War cycle and the kind of narrative material predominant in the inserted account Odysseus gives of this own adventures (Bks. 9–12). Some would further distinguish this more magical myth proper from the more folkloric material in the central story of the long-absent husband's return.[56] If there is a political unconscious characteristic of all ideological production, this more clearly mythic and folkloric material has traditionally called forth more explicitly allegorical and symbolic interpretations—at least as far back as the ancient scholia (Segal 1962: 17)—but, to the best of my knowledge, never a *political* interpretation of its psychological implications. We look subsequently at the interpretations, derived ultimately from the structuralism of Lévi-Strauss, which focus on an opposition of nature and culture. Others have seen allegories of a journey from death to life (e.g., Clarke 1967: chap. 4; Frame 1978) and a rich array of religious and ritual symbolisms (e.g., Segal 1962; Vidal-Naquet 1970b). Part of the appeal of these most blatantly fictional narratives—that is, narratives whose raw material seems to come most di-

[55]To be sure, Nagy (1979) sees this contrast as purely within a tradition that he seems to view ahisotrically. See also A. T. Edwards's summary of his case (1985: 91–93). Pucci's evocation of Odysseus as a reader of the *Iliad* (1987: 214–27) in a sense presupposes but also brackets a historical approach.

[56]See, e.g., Carpenter 1962 and Heubeck et al. 1988: 1:15–16. Whitman (1958: 306 and n. 44) cites "The King of the Golden Mountain" from *Grimm's Fairy Tales*. See also J. H. Finley 1978: 64–65.

rectly from the unconscious—seems to lie in the invitation to fill them with whatever religious, ethical, or psychological meaning strikes the audience. Moreover, this portion of the poem, to a far greater extent than the rest of this most canonical of texts, has invited the most sweeping universalizing claims about eternal truths of an utterly dehistoricized human nature (e.g., Segal 1962). An analysis that simply brackets the whole realm of the unconscious manifestations of ideology leaves aside some of the most revealing and relevant data. I noted in my introduction the importance Althusser attached to Freud's analysis of the mechanisms of the unconscious for all serious study of ideology and also the difficulty of historicizing Freud. My own view is that the mechanisms of the unconscious (condensation, displacement, symbolization) are functions of the psychic unity of the human species (Geertz 1973: 62), but the specific raw material of the unconscious on which these mechanisms operate varies historically. What Freud calls the Oedipus complex falls in my view somewhat between a transhistorical structural mechanism of the psyche and a variable raw material: if one sees it at its most neutrally anthropological level—the psychic consequences of the extremely long period of dependence on adults to which human beings, like elephants and other large mammals, are destined—then the specific consequences are going to depend on the number, gender, and character of the primary caretakers in any particular society or any individual life. Moreover, within a specific social formation different classes and genders display characteristic postures toward the world around them—a configuration of fears, desires, and fantasies that have an ideological import. Our contemporary terms of psychological validation such as "normal," "healthy," "mature," or "successful" are not only the products of a complex historical development but also reflections of the ideological effort to impose modes of behavior conducive to the interests of the hegemonic element in our society. This is most obvious in the application of the corresponding terms of invalidation: "perverse," "sick," "childish," "dysfunctional."[57] An artist who is in touch with the deepest psychological needs of his or her audience does not simply represent their fears and desires in the most satisfying way but engages in the sort of psychic "horse-trading" that Jameson sees as central to all ideology (1979c: 141). The *Odyssey*, to the extent that it explores the identity of Odysseus on a psychological, mythic level, invokes those desires, fears, and anxieties that are perceived by males with some access to political, social, and economic

[57]See, e.g., Foucault 1973 and 1978 and Chesler 1973. On the general problem of cross-cultural definitions of psychic phenomena and the specificities of ancient Greek society, see Simon 1978: esp. 31–42.

power as the chief dangers to practical survival and success in late eighth-century Greece. Once again parallels in Hesiod suggest that, however recurrent some of these patterns may be, they are first and foremost rooted in the realities of a historically specific moment and the consciousness of a specific group.[58]

Unlike the typical war heroes of the *Iliad*, Odysseus does not seem to identify or bond primarily with other males. He has no special comrade among his followers in the adventures he narrates, only an occasional challenger in Eurylochos, whom he nearly decapitates (e.g., 10.266–69, 429–445).[59] A loner among males, his identity is primarily explored in relation to women. The central narrative movement of the *Odyssey* is the hero's movement home to his wife Penelope, his son, his palace, and its associated wealth. The indirection by which he reacquires his wife—and the property connotations of the verb accurately reflect the dynamics of much in the poem's text—once he has returned to Ithaka is held up by critics repeatedly as the mark of his special form of practical intelligence, his more mental heroism (e.g., J. H. Finley 1978: esp. 37). But some critics have been puzzled by Odysseus' clearly implied distrust of Penelope, that paragon of female faithfulness, which is suggested especially by the devoted husband's failure to inform his wife of his return until after he has slain the suitors. Indeed, a debate has arisen between those who defend this distrust and those who are so shocked by it that they have become convinced that, after all, both husband and wife were fully trusting and aware of each other's plans all along.[60] What is relevant on the psychoanalytic level is that this intense ambivalence toward the female is evoked and valorized with almost compulsive frequency throughout the poem; women are characteristically represented as either desirable but dangerous or simply dangerous.

[58]Though it will undoubtedly strike some readers as inherently unsound to generalize the psychology of a whole class fraction in a remote historical period, many Americans familiar with the history of the past forty to fifty years in their own country would agree that both the discourse and behavior of the U.S. ruling class toward what it defined as communism exhibited clear symptoms of paranoia. In the case of such prominent ideologues as Joseph McCarthy or Ronald Reagan one might even speak of a pathology. Not that there was no method in their madness: purging the labor unions of a class conscious and committed leadership, purging the school system of independent, critical thinkers, purging the entertainment industry of provocative oppositional discourse—all contributed to the consensus that made possible U.S. intervention in Korea and Vietnam, just to mention a couple of major successes. Against the danger of facile generalizations one has to weigh the danger of censoring psychoanalysis from all political discourse.

[59]For his friendship with the herald Eurybates before the war, see 19.244–48.

[60]E.g., Thornton 1970: 96–114, J. H. Finley 1978: 193–94, Amory 1963 and 1966, Stewart 1976: 101–40, and Suzuki 1989: 76–87. I find Murnaghan's discussion (1987b) most convincing in its insistence on the structurally untenable position in which heroic society placed all wives, regardless of their intelligence or moral makeup.

Our first direct glimpse of the hero introduces us to the tension be-
tween his strongly marked, passionate longing to leave Kalypso and the
implications of his seven years of lethargy. The intervention of the
gods in this case, as in the visit of Athena to Telemachos, makes ex-
plicit, external, and momentous an internal decision: the magic mo-
ment when an individual subject finally decides to confront a situation
that previously seemed quite hopeless (Segal 1962: 21). Apart from the
indirect suggestion that Odysseus had once found Kalypso pleasing,
implied by the statement that he no longer did so (5.153), symbolic at-
tributes are the primary means by which the poet indicates Kalypso's
attractions: her cave with its sweet aroma and warm fire, the lush
growth and flowing moisture about its entrance (5.57–74). Odysseus'
escape from this cozy womblike security involves a perilous sea journey,
a wrenching of his whole body—suggestively compared to the wrench-
ing of an octopus from its lair (5.432–35)—and his emergence on a
threatening shore where a second womblike enclosure preserves the
seed *(sperma)* of his life.[61] Kalypso thus evokes the female as the locus
of a security that is at once potentially gratifying and a form of non-
being, suggested by the goddess's name ("I shall hide or cover over").
Abandoning this realm is perceived as the hero's only route to sur-
vival—to having an identity as a dominant, independent male.

The next female Odysseus encounters, Nausikaa, similarly offers
him nourishment, physical comfort, and the promise of marriage and
enduring security, which he must similarly abandon if he is to survive
and return to the real world of Ithaka. There is a characteristic tran-
sition by a surface antithesis between the sexually mature goddess and
the nubile virgin mortal, but the deeper structure is the same. Indeed
the mother role of this adolescent female is adumbrated in her last
words to Odysseus: "Remember me, since you owe me first of all the
price of your life [*zōagri'*]" (8.462). To this he responds that he will pray
to her as to a divinity all his days: "For you gave me life [*m' ebiōsao*],
maiden" (8.468). Both Greek terms can be seen quite literally as re-
ferring simply to the food she gave him on his emergence from the
sea, but the psychological condensation of the nubile maiden with the
all-powerful mother figure is certainly not without parallel in early

[61]For the symbolic association of the octopus with the *mētis* of *polymētis* Odysseus, see
Detienne and Vernant 1978: 32. Joseph Russo, as far as I know, first suggested the par-
allel to birth trauma (in a public lecture at Yale; but see the essay of his teacher Howard
Porter 1962). The simile at the end of Bk. 5 (487–91) more precisely compares his life to
a "seed" of fire preserved under a pile of ashes. Though I admire many fine insights in
Segal's long article (1962), the vagueness of his characterization of the symbolism of Ka-
lypso is typical of what drives me to Freud: "Odysseus' place of 'concealment,' then, is
itself of the primal essence of the sea; he is held by the goddess in whom are reflected the
crossing and binding together of the cosmic substances, earth, sky, and sea" (1962: 20).

Greek poetry. Hesiod too fondly evokes the virgin's charms (cf. *Er.* 519–25.; *Th.* 194–206, 572–84) and waxes almost sentimental over a desexualized mother figure (Hekate, *Th.* 411–52; esp. *kourotrophos, Th.* 452). But generally Hesiod's virgins as well as mothers turn out to be very scary: all his female figures, precisely to the extent that they are capable of sexual reproduction, require suppression and containment (Arthur 1982).

The repertory of threats and temptations in the adventures is certainly wider than on Ithaka, but the moral—the psychological posture implicitly validated—is again essentially the same: in true mythic fashion, the message becomes clearer through repetition (Lévi-Strauss 1967: 226). The adventures begin on the realistic plane with a typical pirate raid against the Kikonians. There is no critique explicit or implied (pace G. Lord 1954) of attacking innocent people, killing the men, raping the women, and stealing all the movable property. Problems arise only when Odysseus' men are unwilling to delay their gratification and insist on an immediate party on the beach. Their indulgence allows time for violent retaliation by the Kikonians' neighbors. Purely oral gratification in the land of the Lotus eaters threatens the same result—loss of home, that is, loss of functional participation in the social and political hierarchies of Ithaka, perhaps not surprisingly less appealing to Odysseus' men than to the king. Here too there is a dramatic antithesis between the violent threat of the Kikonians' neighbors and the easygoing, nonaggressive Lotus eaters; but the contrast only highlights the homology in the consequences.

The psychological shift from fear of annihilation by eating to fear of annihilation by being eaten is an easy one; the infant projects a desire to devour the nurturing parent onto the parent and consequently fears engulfment. Hostility from parents is thus most readily translated by the child into anxieties about being eaten by monsters. Universal as the symbolism seems, there are significant historical differences in the relative emotional weight given to male and female devouring threats (P. Slater 1968: esp. 410–14) which suggest changed social weights in the role of primary caregivers. Male threats are more noticeable in the worlds of Odysseus and Hesiod than they are in the repertory of monsters in fifth-century Athens, where males seem to have played a small role in the rearing of young children (Lacey 1968: 168–69). Phoinix's role in the *Iliad* as the nurse of the infant Achilles (9.438–41, 486–92), though without parallel, suggests at least that male primary caretakers were not unthinkable in the Homeric world. Entrapment in the cave of Polyphemos duplicates the terror of being incorporated in the monster's male womb. Thus the parallel between Kalypso's cave and Polyphemos' echoes the movement in Hesiod's *Theogony* from being

confined inside Gaia to being devoured by Kronos (cf. Kirk 1970: 215–20). Odysseus' escape requires repression of immediate aggressive retaliation, that is, killing the threatening father figure (9.298–302), which would leave Odysseus and his men still trapped inside the cave. More censored than Kronos's treatment of Ouranos, Odysseus' aggression takes the form of a carefully calculated symbolic castration—rendering the monster nonfunctional. By another reversal on an unconscious level repellent to the logic of fully conscious thought, the symbolic castration takes the form of a symbolic group rape: Odysseus heats a long pole and with his comrades' help thrusts and twirls it in the hairy eye socket of Polyphemos (9.375–90).

The chief moral of Odysseus' encounter with Aiolos is usually perceived solely in the hero's indulgence in the gratification of sleep—relaxing at the very moment when his goal is within sight. The danger envisioned here is perhaps less psychological than political: the leader's relaxation triggers the followers' long pent-up resentment at the vast disparity between his share of the rewards and theirs (10.28–47). A temptation functioning at a psychoanalytically deeper level is the pattern of Aiolos's family: in utter security, brothers are happily married to sisters, dividing their lives between the joys of the feast and those of the bedstead (10.1–12). The escape from the incest taboo, a major source in patriarchal society of the child's profound ambivalence toward both mother and father, is a utopian image reserved for the gods. As we see in the conflict over the bow, the motif of mother-son incest recurs as more immediately relevant to the threats facing Odysseus.

The mother "as big as a mountain's crest" (10.113) and the giant, devouring fathers of the Laistragonians evoke primarily the negative pole of that ambivalence.[62] But it is suggestive that, in defiance of ordinary seafaring practice, Odysseus escapes through an apparent failure to guide his ship inside the "hollow" (*koiloio*, 10.92) harbor where promontories protrude in the harbor's "mouth" (*stomati*, 10.90) and there is a narrow entrance.[63] Once again the attraction of a secure enclosure masks the reality of fatal incorporation, and the survivor is the male most wary of the appealing channel, the one who has opted for the risks of the open sea.

[62]Vidal-Naquet (1970b: 1294) notes an interesting parallel between Odysseus' encounter here with an apparently harmless young girl who leads him to a very powerful mother and the role of Nausikaa in leading him to Arētē on Phaiakia. His focus is nature versus culture (under the forms of agriculture and sacrifice); yet from a Freudian perspective we may see again the mechanism of condensation—the innocent, appealing virgin fused with the frightening adult mother figure.

[63]The noun *koilia* does not occur in Homer but is regularly used later for all sorts of bodily cavities.

The Kirkē episode (10.234–474) has perhaps too readily been interpreted in terms of a purely genital sexual threat. The primary focus of the sexual threat is psychoanalytically more archaic, that is, oral. Kirkē transforms men into fawning animals by giving them liquid nourishment.[64] To be sure, the weapons by which Odysseus overcomes this threat are more or less suggestively genital: Hermes' gift of a magic plant "black at the root, with a flower like milk" and his sharp sword. In the short run, this phallic assertiveness of the hero seems to reverse the previous pattern. Kirkē is transformed by it from a wicked witch into a nurturing mother figure, and the hero is given divine sanction to enjoy her sexually without fear of castration (10.296–301, esp. *anēnora*, "unmanned," 301). But the consequences of this temporary yielding to a seemingly allowed pleasure are all the more devastating than his previous encounters. Odysseus himself now loses the thought of home and must now undergo "death" in order to be restored to his original goal.

In psychoanalytic terms, the meaning of Odysseus' journey to the underworld seems focused in his learning of his mother's death. Knowledge of her death formally encloses (11.84–87, 141–44) Odysseus' learning the nature of his own death from Teiresiēs (11.134–37; cf. Segal 1962: 21). The ritual purification enjoined by Teiresiēs, whatever its other symbolic associations, involves appeasing the hostile sea father who is also "Husband-of-Earth-Mother" (etymology of *Poseidaōn)* and "Earth-Shaker" *(Enosigaios)* by transforming an object usually associated with the barren sea—an oar—into an object associated with the fertility of the earth—a winnowing fan (11.121–28). Once this transformation is achieved, Odysseus must fix the oar in the earth *(gaiēi pēksas,* 11.129) and perform rituals honoring Poseidon. Thus symbolic possession of the mother is won at the cost of an elaborated show of subordination to the father, whose gift is death—at best long delayed (11.134). The culmination of Odysseus' interview with his mother is his futile attempt to embrace her, which becomes the vehicle for his learning the reality of death as destruction of the body (11.218–22). The frustrated embrace of the mother then provokes the injunction: "Struggle back to the light as quickly as possible" (11.223), which Antikleia equates with return to his wife. To seek to remain with the security of the mother is thus now literally designated death, and the wife is installed as the safe alternative.

On the other hand, the catalogue of women (11.225–329), including such dangerous wives as Epikastē, wife of Oedipus, Phaidra, Prokris,

[64]Freud (1958–74: 5:357) notes that small animals in dreams can represent children. There is nothing necessary about such symbolism here, but at least Knox's analysis (1952) of the lion in the house parable in the *Agamemnon* suggests that such associations are not alien to Greek feeling.

and Eriphylē, together with the frightening and fully developed and generalized paradigm of Klytemnestra (11.410–34), reinforces the image of all women as potentially deadly. Indeed, Odysseus specifically cites the case of Agamemnon as the grounds for his adopting the indirect strategy of disguise on returning to Ithaka (13.383–85).

The remaining adventures focus briefly on three female threats and concentrate fully on the ultimate oral testing, the cattle of Helios. The Sirens repeat the pattern of female attractiveness masking the reality of destruction (12.39–46), but the inducement here is not so obviously the traditional female attributes of nourishment, security, and sensual gratification in general. The promise of knowledge with which they seek to seduce their victims evokes especially the male world of the epic saga (12.189–90). In the context of Odysseus' emergence from the underworld, the prospect of "knowing everything that happens" suggests a repetition of the same symbolic quest in a different key: the child's insatiable curiosity about the sexuality of his parents is a concomitant of the desire to possess the mother and triggers the same fear. As anti-Muses, the Sirens' knowledge carries the same price as Antikleia's— whose name ("Against *kleos*," sc. the glory particularly associated with epic) suggests the negation of what the Sirens offer.[65]

The Skylla, whose lower half is coextensive with her hideous cavern and whose upper half is a compulsive profusion of devouring mouths with three rows of teeth (12.89–94), seems to constitute some ultimate triumph of the conjuring power of male fears of devouring, castrating female monsters. Still, Kharybdis is her alter ego and swallows Odysseus' mast, thus reducing him to the image of a pathetic, clinging bat, elsewhere the poet's image of the "strengthless" souls of the dead (24.6–10). If there is a suggestion of confidence in the hero's success in hearing at least some of the Sirens' song, Skylla and Kharybdis cut him down to size. In the case of Skylla, the utter futility of the phallic weaponry that had seemed so potent with Kirkē is dramatized both by Kirkē's chiding and Odysseus' stubborn neglect of her warning, as he puts on his armor and brandishes two spears (12.228–30).[66] In the case of Kharybdis, there is no longer even the illusion of choice or contest;

[65]Dimock (1956: 58) suggests that Antiphates means "Against-renown" and Antikleia, "Opposed-to-fame" (67). One might add Antinoos (Against the mind or purpose, sc. of Odysseus). To be sure, in the formation *antitheos* the *anti*-element seems to mean "like," or better, "a match for," as in *antianeiroi*. But in the context of so many punning names in the *Odyssey*— so nicely exploited by Dimock—and the formations *antibios, antiboleō, antithuron, antios*, it does not seem to me gratuitous to see this sense here.

[66]Those who see the futility of Odysseus' martial posture here solely as a critique of warrior values per se (e.g., Redfield 1983: 236) ignore the effectiveness of his sword with Kirkē—or for that matter, of his spear with the stag.

the hero is simply swept inexorably back to and into her, saved from total obliteration only by an equally inexorable tenacity (12.426–37).

Structurally, the encounter with the cattle of Helios is by its position and the announced program of the prologue (1.7–9) the culminating and decisive test of the hero. This fact has bothered many critics because, for a modern audience, this trial is not as dramatically engaging as many others. The reasons may have less to do with eternal laws of pure art than with differences in specific economic and social realities for the respective audiences of the poem. The peasants in Homer's audience, all those affected by the "poverty that soon drove Greek settlers east and west, from the Black Sea to Sicily and beyond" (J. H. Finley 1978: 212), may be presumed to share something of Hesiod's obsessive fear of starvation. Throughout Odysseus' adventures the balance has been decidedly on the side of oral temptations and threats compared with the more genital aspects of desire. To this extent there is a psychoanalytic logic to the prominence given to the horrors of oral deprivation on Thrinakia. It constitutes a necessary polar opposition to the relentless celebration of feasting in the transitional world of Phaiakia and the more realistic Ithakan portions of the poem.[67] Indeed, the repeated (Calhoun 1933) and lovingly described banquets of the *Odyssey* are for the vast majority of the poet's audience a perfect example of what Jameson alludes to as "gratifying intolerable, unrealizable, properly imperishable desires only to the degree which they can again be laid to rest" (1979c: 141). The oral longing is gratified in fantasy only to be recontained within the relentless moral of repression, the running critique of what Redfield has dubbed "hyperculture" (1983). Here too a parallel in Hesiod suggests that we are dealing with a temporally specific phenomenon. The least inhibited sensuous evocation of bliss in the almost completely repressive Hesiod is his description of a meal. At that time of the year when "women are most lecherous and men most withered," Hesiod proffers the consolation of shade, wine, cake, milk, veal, and the flesh of young goats (*Er.* 585–96). Human companionship is conspicuous by its absence. However deep and pervasive the sexual ambivalence toward women in the late eighth century, so frequently characterized as simply misogyny (e.g., Cantarella 1987: 26–37), in both the *Odyssey* and Hesiod it was subordinated to or combined with an overriding oral anxiety. For Hesiod the chief threat of

[67]The prominence of this critique of excessive or improper feasting leads Redfield to the conclusion, "The *Odyssey* is mostly about hyper-culture [his term for excessive luxury] because prosperity, not want, sets the most difficult ethical problems" (1983: 244). This may seem the antithesis of my emphasis on fear of starvation, which Redfield does not see at all. I have suggested that they are two sides of the same dialectic, but our differing standpoints doubtless influence what we see.

the woman who "wiggles her behind at you" is that she is "after your barn"—your food supply (*Er.* 373–74).[68]

If there is a temporally specific, realistic dimension to the most mythic portions of the poem, there is a continuing mythic element in the more realistic Ithakan section. This aspect, which we have already associated with the hero's ambivalence toward Penelope, the stated goal of all his trials, is most obviously centered on the hero's bow. Like the magic sword of Siegfried or the sword in Grimm's tale of the king of the golden mountain, it is the decisive symbol and practical means of the hero's triumph over his enemies (Segal 1962: 50–52). Most broadly it symbolizes Odysseus' absolute superiority over all the younger men, including Telemachos, who seek to replace him in his former role with Penelope. The associations it acquires through cumulative allusions to it in the poem reinforce its more specifically sexual symbolic function as the vehicle of the hero's triumphant phallic assertiveness, which both subdues male rivals and, when supplemented by the symbol of the olive tree, divests Penelope of her threatening aspect.

The terms in which the bow is first introduced and the description of the contest imply an equation between, on the one hand, stringing the bow and sending a shaft through holes of the axes and, on the other, winning Penelope as a sexual partner (19.571–81).[69] The digression on the origin of the bow (21.12–41) implicitly contrasts the justice of Odysseus, who will use it to kill the thieving non-guests in his palace, to the injustice of Herakles, who killed and robbed his true guest, Iphitos, the former owner of the bow. There is nothing particularly sexual about this, but it is noteworthy that the poet here grafts onto the bow the association of kingly, patriarchal justice normally symbolized by the royal scepter.

The subsequent, detailed description of Penelope's fetching the bow from the storeroom is more suggestive. She inserts a key, knocks the bolt up, drives the key in farther; the doors roar like a bull, then spread open; she lays the bow on her knees as she slips off its case and weeps at the sight of it (21.47–56). The response of the chief suitor, Antinoos, at the sight of the bow is an expression of religious awe *(aaatos)* and an immediate sense of the inferiority of all the suitors. The sight of the

[68]Suzuki suggests a more explicitly material, political basis for fear of women in the *Odyssey:* "Eumaios' maid, who kidnapped him and stole gold from his father after being seduced by a Phoenician trader, exemplifies the threat to property and genealogy that women's unregulated sexuality brings" (1989: 90). I discuss the threat to genealogy, to inheritance of property through the male line, in Chapter 1.

[69]There is some debate whether the text designates the holes into which an ax handle would fit or a holelike space formed by the curves of Minoan double axheads (J. H. Finley 1978: 191–92).

bow triggers first a memory of an infantile *(nēpios)* vision of the patriarchal hero (21.85–95), then rising secret hopes (21.96–97).[70]

Telemachos, after expressing his apparently illogical, giddy glee, launches into extravagant praise of his mother, which he himself describes as somehow inappropriate from his lips. He then announces that he himself will try the bow:

> If I should string it and shoot through the iron,
> My respected mother would not leave me grieving, leaving
> This house to go with someone else, since I would be left behind
> Already able to lift up my father's beautiful prizes.
>
> (21.114–17)

There is a fascinating ambiguity in these lines. The most obvious meaning is that, since she is to marry someone else anyway, he would like to demonstrate the martial prowess signifying his competence to inherit his father's economic and perhaps political status. But the syntax and particularly the word order leave open the implication that, if he can string the bow, his mother will not marry someone else, that she is herself the "lovely prize" of his father. Embarrassed commentators (e.g., Stanford 1964–65, ad loc.) feel compelled to declare themselves for the one true meaning, but perhaps it is nearer the truth to speak of a conscious intent and an unconscious wish peeking through. Certainly more than inherited excellence seems at work in Telemachos' "amazing" capacity to dig the trench and set up the axes, since on the psychoanalytic level he has indeed seen them before (21.120–23). Only the silent intervention of his father forestalls his hopes to "string the bow and send the shaft through the iron" (21:128–30). He is checked, "despite his desire" *(hiemenon per)*.

The broad comedy of the suitors' impotent efforts to heat and grease the bow (21.178–85) is only enhanced by the strong sexual associations it has acquired. Yet one could argue that Eurymachos' lament after his failure specifically downgrades the sexual function of the bow: grieved as he is over the loss of Penelope, he sees the worst aspect of his failure in the shame vis-à-vis other males at not being the equal in strength of Odysseus (21.249–55). But to speak here exclusively in terms of the vague anthropological categories of shame culture and guilt culture is to divest the notions of shame and guilt of their emotional source in censored sexual desires.[71]

[70]*Aaatos* (20.91) is a doubtful word that may be associated with *atē;* see Stanford 1964–65, ad loc.

[71]It is interesting that Dodds, who first imported these terms into classics, does offer—however timidly—a psychoanalytic hypothesis for the guilt in guilt culture (1951: 44–49) but leaves the aetiology of shame unexamined.

It is hard to miss the comic ambiguity in Penelope's decisive intervention, which enables Odysseus to try the bow:

> Do you think that if this stranger strings Odysseus'
> Great bow, relying on the force and might of his hands
> He will lead me home and make me his wife?
> I can't imagine he himself expects this in his heart.
>
> (21.314–17)

The surface expresses the unbridgeable gap in social class which makes marriage between a beggar, whatever his origins, and a queen unthinkable. But the audience recognizes that Odysseus' stringing of the bow would only regain him sexual access to a woman he had already "led home." The test for Odysseus, as he himself makes clear after his success, is whether the "vital essence [*menos*] is still securely mine" (21.426).[72] As he begins the slaughter of the suitors, he lays particular stress on their sexual crimes against him, not only in pursuing his wife but in "sleeping beside my serving women by use of force" (22.37).

Although I do believe that exploration of unconscious narrative patterns and symbols can open significant sources of emotional appeal in a literary work, my chief goal in the foregoing section is to argue that, even where traditional critics have found allegories and symbols of the most permanently human nature, there are important temporally and culturally specific ideological dimensions. Freud can and should be historicized. The sense of the immutability of psychic phenomena to orthodox Freudians derives largely from the cultural continuity, not least in sexual ideology, between ancient Greece and our own time. The negative stereotypes of women in the *Odyssey* as potentially deceitful, engulfing, castrating monsters who can be transformed into more or less trustworthy helpmates only by massive, redundant displays of phallic violence have analogues throughout Western literature and are all too easy to find in contemporary popular culture and advertising. Until very recently there has been little organized challenge to this distorted vision of alleged human nature. Only an organized women's movement and a concomitant expansion and reinterpretation of our anthropological knowledge have introduced the notion that alternatives exist and can be consciously created. In the *Odyssey*, despite Samuel Butler's famous argument (1967 [1897]) that the author of the poem was female and various more recent attempts to find a more progressive view of women in the *Odyssey* than in the *Iliad*, I see rather an intensification of

[72]On the implications of *menos*, see Onians 1988 (1951): 194. *Menos* in the final line of the Cologne papyrus of Archilochos is generally understood to designate sperm (e.g., Van Sickle 1975: esp. 5). The suggested supplement *leukon* (Degani and Merkelbach in Van Sickle 1975: 4) makes the reference more explicit still.

the traditional ambivalence toward women.[73] Where so little data is available, it is perhaps pointless to explore possible causes; but the correlation in Hesiod between an intensified sense of economic pressure and a compulsive indulgence in hostility toward women suggests a pattern not unfamiliar in other political contexts: the hostility of the upwardly mobile against those with real power is redirected against those below with even less power.

Perhaps the element that makes the sexual politics of the *Odyssey* more progressive than those in the texts of Hesiod is the recurrent presence of women, the pervasive narrative interest in them. They at least get to speak, exercise some power (cf. Arētē, 6.310–15, 7.67–77), and even, on occasion, win. Unlike women in the *Iliad*, they are not sympathetic primarily as victims but as complex and varied components of human (and divine) society. If they are all in some sense potentially threatening, they are almost all intensely interesting as well. As duBois puts it, "if women inspire fear, it is not because they are wounded, but because they have the power to wound" (1988: xii). This shift may suggest one positive consequence of the less war-dominated, less heroic character of the world of the *Odyssey.*

Nature and Culture for the Colonizer

Although Odysseus' bow proved fully adequate to awe and subdue all male rivals, the hero's success in the contest and the brutal revenge exacted with this weapon are after all not adequate for the mythic resolution of the hero's ambivalence toward his wife. The final resolution is won not by the bow, symbol of male phallic aggressivity, but by the olive, a symbol with a richer range of associations. To be sure, the inadequacy of the bow is attributed to Penelope's reluctance, not to any apparent failure on the part of Odysseus; and there is a nice dramatic reversal of roles in her testing him. Her stubborn reluctance is in fact the decisive proof of her fidelity; thus her anxieties function chiefly to reduce his. The olive of their bedpost, to be sure, retains strong sexual associations, but it also recalls the hero as carpenter, as home builder, as a figure whose identity has been seen primarily in terms of the

[73]Beye 1975 and H. Foley 1978, for example, tend to stress what they see as more positive treatments of women in the *Odyssey.* Suzuki (1989: 67) notes rightly, I think, the diminished portrait of Helen in the later poem. Redfield is one whose association of the *Odyssey* with women could never be called progressive: "The *Odyssey*, long before Samuel Butler, had the name of a woman's poem, and there is something feminine about it; it can charm us to any degree, it can, now and then, stir us to the depths, but it has not those endless sources of power, half used and half concealed, which animate the *Iliad*" (1973: 145).

structuralist opposition of nature and culture (e.g., Vidal-Naquet 1970b; Redfield 1983).

The olive, so purely phallic and aggressive in the blinding of Polyphemos, is first introduced in terms that symbolize the hero's ambivalent posture toward nature and culture. These abstractions invite the same ahistoricism as psychoanalytic approaches, but they are critically relevant to the poem's representation of the hero's identity precisely to the extent that they are given specific historical content.

Odysseus, on the shore of Skeriē, stripped of all external aspects of a specifically human cultural identity, seeks shelter in the woods:

> He went under a double thicket,
> Both growing from the same place—the one wild olive,
> the other cultivated.
> Neither the chill strength of winds traversed them,
> Nor did the blazing sun ever strike them with his rays;
> Nor did rain penetrate through—so thickly did they
> Grow intertwined with each other.
>
> (5.476–81)

Here the two forms of olive seem to reflect the poet's sense of the ambiguity of his warrior-hero's relation to culture, at once both its highest representative and its destroyer. The wild boar whose wound gives Odysseus his name emerges from a similar lair (19.439–43), but his lair is purely wild. The boar, though slain by the youthful human, nonetheless by the wound he inflicts leaves a symbolic mark of his wildness that fits the dual character of the fully formed hero: he who both inflicts and suffers pain (Dimock 1956). At the same time, the poetic amplification on the impenetrable security of these thickets links them with the haven to which Athena returns after visiting Nausikaa in a dream. The "eternally secure seat of the gods" is similarly "not shaken by the winds nor even wet with rain nor does frost ever approach it" (6.42–44). There is in fact a homology between the state of nature (the boar), the status of the gods, and the womblike enclosures that alternately preserve and threaten to hide the identity of Odysseus. He is godlike but refuses Kalypso's offer of immortality (5.208–24); he is like a lion (6.130) but achieves the name and scar that define his specifically human identity by killing the wild boar. Throughout his adventures, Odysseus is consistently defined as the mediating term in a series of oppositions. The specific characteristics by which he is differentiated constitute a partisan reflection of what I have called the colonizing element's attempt to impose their definition of culture and true manhood on Greek society.

Odysseus leaves Kalypso by exercising the technical skills of a ship-builder (5.249–51) and navigator (5.270–80). His exercise of verbal skills, psychological manipulation, and sexual restraint win him food and clothing from Nausikaa. His tact (esp. 7.303–7) and athletic prow-ess (8.186–93) win him prestige and the essential attribute of an inde-pendent eighth-century male, a sword (8.403–5). The combination of his skills wins him the gifts that constitute the economic base essential to kingly power (see esp. 11.358–61). In short, he moves on Phaiakia from the barely human, noncultural stranger to a figure who seems fully capable of permanent integration within this ne plus ultra of Greek human culture.

Still, a wide range of factors sharply differentiate Odysseus from the world of the Phaiakians (Segal 1962: 27). Though Odysseus is expert in athletics, for him they scarcely constitute the greatest source of renown (8.147); rather, they are part of a continuum leading directly into the deadly confrontations of war (8.215–29). The poet insists on Odysseus' pleasure in Demodokos' tale of divine adultery (8.367–68), but the Phaiakians' light entertainment echoes a situation that will be deadly serious for Odysseus. As the time-worn husband who will employ a stratagem to outwit his handsome young rivals, Odysseus parallels the chief butt of their laughter, the déclassé divinity Hephaistos, black-smith and master craftsman of the gods. Odysseus praises the Phaiaki-ans' elaborate dancing (8.383–84), but his praise distances himself from such frivolities. The artistic performance he personally stage manages (8.474–98) is a tale of his own role as destroyer of culture, the pain of which establishes a haunting equivalence between the city sacker and his victim:

> But Odysseus
> Melted, and tears from under his lids wet his cheeks,
> As a woman weeps, throwing herself about her husband,
> Who has fallen before his homeland and hosts,
> Trying to drive from his city and children the pitiless day.
> She, seeing that he is dying and gasping out his last,
> Pours herself about him, cries a piercing cry. But they, behind,
> Beating her back and shoulders with their spears,
> Lead her away into slavery, to endure both toil and suffering.
> Her cheeks waste away in grief most pitiful.
>
> (8.520–30)

So too with seafaring. Odysseus may be impressed with their toil-and-danger-free ships, but the navigation he knows and tells of at such length is utterly different: deadly winds, thunder and lightening, crushing waves that bring loss of ships, comrades, and all sense of di-

rection. The Phaiakians, whose lifestyle is so suggestive of the most privileged aristocracy of eighth-century Greece, are "near to the gods" (5.35)—even as the Cyclopes, who offer an image of the pastoral, non-Greek peoples of the Mediterranean, are "better than the gods" (9.275–76; Kirk 1970: 162–71). Both poles inhabit naively secure worlds far removed from the risk, work, and destructiveness that for Odysseus represent the cost of culture. Odysseus and his poet seem to know and acknowledge that every gain of this civilization is achieved at the price of truly barbarous heroism.[74]

That there is a class basis to the differentiation of Odysseus from the Phaiakians has already been suggested earlier in the broad parallel between them and the suitors on Ithaka. The accusation that Odysseus is a "leader of seamen who are men of affairs,/ A man with cargo on his mind and a sharp eye for profits/ Eagerly seized in travel" (8.162–64) demonstrates the class antagonism of the whole encounter. It simultaneously denies and reveals the class allegiance of the poet. He aspires to the full prestige of saga kingship for his hero, but the line between heroic pirate-warrior and leader of seamen hungry for profits is no more solid than that between poet and articulate beggar.

In the other adventures, we have noted already the general differentiation of Odysseus from others by virtue of his capacity to repress desire, to delay gratification. In the adventure that most obviously pits nature against culture, the encounter with the Cyclopes, Odysseus emerges most concretely as the aggressive colonist. Twenty-six lines are devoted to a detailed description of the resources in game, potential farmland, vineland, harbor, and fresh water available on an island opposite the mainland where the Cyclopes dwell: "They could have worked this island into a fine settlement for themselves," Odysseus comments (9.130), but they have no ships. At least one historian, focusing especially on the reference to wild goats, has invoked the island of Capri ("Goats") opposite the first known eight-century Greek colony at Kumē, near modern Naples.[75] From the perspective of the

[74]Consider the insight of Walter Benjamin: "There is no document of civilization which is not at the same time a document of barbarism" (1969: 256). Had Jameson not already used this as an epigraph, I would have.

[75]Wade-Gery, in his Harvard lectures. Redfield (1983: 233) suggests Pitheccousa (Ischia). There have been many popular attempts to match Homeric geography with the Mediterranean area. Bérard (1931: 121–22) was sure that the Cyclopes inhabited ancient Oinotria on the north side of the Bay of Naples. Bradford (1963) notes the frequent association of Capri with the Sirens (120), he opts for the Galli Islands) but follows Butler (1967 [1897]: 147) in associating the Cyclops's cave with Trapani on the west coast of Sicily, where the island of Favignana is in sight (47–54). Stanford and Luce (1974: 123–24) associate the Cyclopes with "the picture of the 'Apennine culture' drawn by David Trump" but ignore the issue of the island opposite. The point, of course, is not to pin

noncolonizing Cyclopes, Odysseus is simply "one who wanders randomly like a pirate over the sea, staking his life, bringing disaster to strangers" (9.253–55). As Odysseus blinds his victim, he merges, through a simile, once again with the skilled shipbuilder (9.384–86, compare 5.234–261) and—more temporally specific still (Stanford 1964–65, ad loc.)—with a smith tempering iron (9.391–93).

It is thus not accidental that Odysseus' crime against Polyphemos is repeatedly cited (e.g., 1.68–75, 13.341–43) as the reason for Odysseus' sufferings. As with the descendants of Cain, a gain in technology bears the stain of a crime against the hierarchies of the status quo. It is as if the poet has internalized the opprobrium associated with colonizers, who, like Hesiod's father, "fleeing bitter poverty," imposed their mastery on the sea and the simpler cultures living on its periphery, by either butchering them or driving them inland. Though individual aristocratic leaders of colonies are likely enough (Murray 1980: 109) and it is plausible that the ruling landed aristocracies supported the colonization movement to drain off troublesome population from the communities they dominated (Murray 1980: 108), the resulting expansion of trade must have introduced new disruptive forces in the mother cities—forces that contributed in the next century to the rise of hoplite warfare, tyranny, and a money economy. This change in turn injected a new and, from the perspective of the aristocracies, frightening fluidity into the social structure.

But if the nature/culture antithesis in the poem carries some of this burden of class guilt, the dominant note is a triumphant ethnocentric celebration not only of the superior technology and character type but also of the cultural institutions that enabled the dramatic expansion of Greek horizons and influence in the eight century. Thus, in the case of the Cyclopes, Odysseus comments scornfully on their lack of ships, agriculture, viniculture, and architecture, but also on their lack of a specifically Greek social organization: "They have no counsel-bearing public meetings [*agorai boulēphoroi*] nor legal precedents [*themistes*]" (9.112). We noted earlier that the oligarchic suitors hold an anomalous agora from which all the people are excluded (16.361–62). Usually a meeting of just the ruling figures is called a *boulē* (council) or refers to the "old men" (*gerontōn*)—even though in such Homeric gatherings Nestor is the only figure who literally fits that term (cf. *Il.* 2.53, 9.70). An agora is inherently more democratic than the closed council of chiefs, as is clearly illustrated by the political dynamics of the assembly scenes in the second books of both *Iliad* and *Odyssey*.

down a real place but to suggest some plausible concreteness to the description of an ideal colony.

So too the emphasis on established precedents *(themistes)* as an essential component of advanced culture is not politically neutral. Just as Hesiod's sermons on "justice" *(dikē)* implicitly indict the arbitrariness of the ruling element, the stress on assemblies and laws not only reflects the colonists' new self-consciousness about traditional institutions in altered circumstances but anticipates the demand for written codes of law.[76] Thus it is not gratuitous or devoid of political interest that the last simile in the adventures juxtaposes the hero as male culture figure to the forces of obliterating female nature in terms of open legal procedures:

> At the time when a man rises up from the assembly for supper,
> After judging many disputes of young men seeking a decision,
> Then indeed did my timbers appear out of Kharybdis.
>
> (12.439–41)

Ambiguity, History, and Utopia

In the foregoing discussion of the *Odyssey* I have repeatedly focused on various sorts of ambiguity and ambivalence. In doing so, I do not wish to hypostasize these attributes, in the manner of both Anglo-American and French New Critics, as the inherent ambiguity of all literature or the polysemous character of all discourse and sign systems. The specific self-consciousness of this text about the potential duplicity of poetry, its fascination with puns and names, I am inclined to relate primarily to a concrete crisis in text production itself associated with the transition from an oral to a literate culture. But even these ambiguities and certainly other ambiguities in the text must also be seen as creative responses to the political, social, economic, and psychological ambivalences of specific historical actors at a specific historical juncture.

The poet's ambiguous allegiance results, on the one hand, from his role as the bearer of the elite culture and partial dependent of the aristocratic ruling element, and on the other, from his status as a wandering craftsman and his proximity to the discontented peasants and marginal elements in society. Thus, in relation to the stereotypical

[76]See Gagarin 1986: 46–50 and Havelock 1978: 206–10 on the difficulty of translating the term. Gagarin (129–30) argues effectively against the thesis of Bonner and Smith (1930) that the colonization movement was itself the cause of written law codes. What I think is true is that the phenomenon of uprooting implicit in colonization contributed to a new consciousness about the capacity of human beings to make and unmake laws that an older period had accepted as the impositions of Zeus.

characters and values of the epic tradition, the poet oscillates between assimilation and critique. The psychological profile he imparts to his hero reflects, in terms of a fearful ambivalence toward females and pervasive oral anxieties, the emotional preoccupations of a class under severe economic pressure but aggressively on the move, ready to internalize a high level of repression in return for success in a world perceived as full of delicious opportunities and catastrophic threats. The projection of these ambivalences in the broader arena of the opposition between nature and culture reveals the tensions in the self-image of the colonizing elements in eighth-century Greece: aware of the opprobrium attached by the aristocracy to their aggressive acquisitiveness and threatening technological advances, they are at the same time defiantly proud of their achievements and determined to validate the political institutions that promise fair treatment and at least token public participation in decision making.

The role of ideas about inherited excellence is central only in the explicitly political arena of struggle over who shall rule—the one king or the few "best" people. This is obviously only one among a wide variety of factors in this broad panorama of class struggle at the cultural ideological level. But in the ensuing centuries there is a broadening and deepening of the divergent trends visible in the *Odyssey* between, on the one hand, a hardening of the aristocratic aspiration to automatic recognition of inherited superiority and, on the other, a challenge to the claims of the ruling elite with a focus on their crimes. In the fifth century, these tendencies culminate in the opposition between Pindar and Aeschylus.

There remains to consider, after this long effort at historicization, the crude question, what is in it for us? What pedagogical or political gain is there in such an exercise? As I tried to suggest in my introduction, the first task of a double hermeneutic is critique, an assessment of the complicity of the text in maintaining an order of unfreedom, of injustice. On this negative side, a clearer appreciation of the aggressivity, male chauvinism, and ruthless instrumentalism of an alleged Everyman might give us some pause about an uncritical valorization of this most canonical of texts. Even its most obvious utopian projection, the dream of a single strong man to set all our troubles straight by a bloodbath, is profoundly dangerous. At the same time, the text's own evocation of the dangerous illusions of the powerful, its profound sympathy for the pain of those cut off from human society or confined to its margins, its valorization of the long painful quest for a just and affectively bound community that prominently includes women and where kin are allies and allies are as kin—all these elements open a more worthy utopian space that makes its own contribution to the long quest of our species.

3

Historicizing Pindar:

Pythian 10

> I hope to convince you that it is precisely the path through the aes-
> thetic question that we are obliged to take in any ultimate solution
> of the political question, for it is through beauty that we arrive at
> freedom.
>
> —Friedrich Schiller
> *Letters on the Aesthetic Education of Man*

If the task of any Marxist criticism worthy of the name is
to historicize the text, the challenge is peculiarly acute in the case of
Pindar—the first major author after Hesiod to survive in sufficiently
complete texts to permit a serious encounter with a politics of form.
The problem has several dimensions, which I separate for purposes of
analysis. First is the traditional perception of Pindar's place in the un-
folding of any putative historical continuum between Homer and the
fifth century. One needs both to assess the political and social devel-
opments of this period and reassess the characteristic ways Pindar is
situated in relation to them. Second, we need to evaluate the ways Pin-
dar has until quite recently been historicized within the fifth-century
context. Here the apparent explicitness of Pindar's political allegiances,
at least in the eyes of those who acknowledge the presence of a signif-
icant political dimension in the text of his surviving odes, has con-
fronted many readers with a sense that they must take a stand against
Pindar or find a way indirectly to endorse his vision. In this connection,
the very perception of Pindar's immersion in the politics of his time has
often led to a peculiarly troubled treatment of the chronology of the
poems. Third, there is the powerful attempt characteristic of most re-
cent Pindaric scholarship to save Pindar's reputation as a poet by de-
fining his poetic activity and production in radically apolitical terms.
As indicated, I attempt to explore and respond to these aspects of what
might be called "the Pindaric problem" separately, but it is essential to
keep in mind that they arise as problems because of the ambiguity of
the notion of historicization. Finally, in the course of historicizing the

new formalism in contemporary Pindaric criticism, I offer a general as-
sessment of the relation of his deployment of the epinician form before
venturing a reading of what is generally accepted as Pindar's first dat-
able epinician, *Pythian* 10.

Pindar's Place in the So-Called Lyric Age

Pindar is almost invariably treated as the tail-end figure—sometimes
in conjunction with Bacchylides—of a temporal span beginning with
Archilochos, the first known literary figure after Hesiod and Homer.[1]
Pindar thus emerges as unambiguously backward-looking and irre-
trievably archaic in several senses of the word rather than as a figure
fully enmeshed in the intellectual, social, artistic, and political devel-
opments of the first half of the fifth century. This approach follows
from legitimate grounds; but, as I try to show, it involves some distinct
distortions.

Since one of our chief interests in this study is the politics of form, it
is worth noting that Pindar emerges as virtually the first literary figure
after Homer whose artistic output comes to us in a group of poems
primarily confined to a recognizable genre—poems that in most cases
are formally indisputably complete.[2] This is not to deny that there may
well be complete poems among the fragments of earlier lyric and elegy,
but not only does the haphazard transmission of those texts make one
wary, the very forms of the remains between Archilochos and Pindar
seem in varying degrees indifferent to considerations of completeness.
Elegy is the most obvious example.[3] One often feels a sense of the com-

[1]Murray's condensed overview is quite typical of more elaborate discussions: "The ear-
liest, . . . Archilochos. . . . Finally, the greatest of the choral lyric poets, Pindar" (1980:
24–25). It is striking that Murray's actual citations of Pindar (195–208) almost all fall af-
ter his own chosen terminus, the Persian wars. Among older treatments, Fränkel 1973 is
perhaps canonical; its final chapter, "The Last of Archaic Lyric," begins its discussion of
Pindar with the following sentiment: "As the most characteristic and *highly-bred* product
of the epoch it [choral lyric] did not attain its finest development until the epoch itself
was near its climax and decline. Thus the archaic age of Greek literature found its *ulti-
mate* crown of poetry in the choral odes of Pindar. . . . Pindar remained *untouched* by the
revolution in ideas that was going on around him" (425–2–6, emphasis added). Note also
the title of Davison's collected papers, *From Archilochus to Pindar* (1968). So too Podlecki,
despite the "early" in his title, concludes with a chapter on Pindar and Bacchylides (1984:
203–50). Fowler, who also has an "early" prominent in his title, ends his discussion of
genres with the epinician (1987: 100–101) where we might have expected a discussion of
the alleged origins in Simonides. But, in fact, his brief discussion centers entirely on is-
sues raised by Bundy about *Pindar's* handling of the genre.

[2]This comment implies no conclusions about the largely lost corpus of Pindar's work
and the forms in which these were gathered, on which see Race 1987.

[3]See Fowler's conclusion: "We are forced to conclude that elegy was not an archaic
genre, in any identifiable sense of the word. Is it then a group of genres? It might be
possible to divide the corpus according to the various occasions" (1987: 102). Although

pleteness of a particular combination of lines in Solon or Theognis, but the possibility of this sense being purely subjective is quite great. The situation is more precarious and inherently speculative in the case of the fragments of monody and choral lyric. Thus, whereas we can reasonably trace all sorts of significant developments and trends in the remains of the so-called lyric age, we would be at a loss to go very far in exploring any particular configuration of lines as the realization of a specific politics of form.

We must return to the issue of the origins and nature of the epinician form in its historical context, but first it is essential to offer a necessarily somewhat schematic overview of the most important historical developments to which historicizing reading must present Pindar's poetry as *in some sense* a response. The equivocation is essential because of the task we have set ourselves of avoiding a simple reflectionism: fused with the "reflection" of developments is a creative, constructive response to a perceived set of problems, of threats, and of limited options.

Historical analysis of a period of complex change obviously does not yield unambiguous results, and the distinction between what might be called a crisis and simply a successful adaptation of a social system to significant changes is by no means always clear (Habermas 1975: 3–8). My own tentative assessment is that the whole Archaic period should be seen as an era of ever-deepening crisis which culminates in the full crisis, or crisis proper, with the emergence of a successful democratic Athens and the concomitant elaboration of sophistic discourse. But here I only glance at some of the successive phases. By their nature, these are simultaneously at the level of both institutional and discursive shifts.

In the *Iliad* we traced the opposition within the ruling elite between a view of birth as a metaphoric image of absolute superiority and as a mechanism for transmitting wealth and power not necessarily linked with excellence. The issue is fought out within the ruling elite on the terrain of who shall be king. In the *Odyssey* this split takes on a more concrete character of interclass conflict to the extent that, behind the facade of atemporal heroics, the suitors reflect the aspirations of eighth-century oligarchy, and Odysseus evokes indirectly both the suppressed resentments of the peasants and the aspirations of the colonizing element. Within the corpus of works attributed to Hesiod we saw a parallel ambiguity between explicit peasant-class resentment directed

Fowler in fact regularly operates on the assumption that there *are* complete poems in the corpus, criteria of completeness is not an issue he deals with. Figueira (1985: 135, 139) argues that elegy in Megara was de facto an aristocratic genre to indoctrinate the young, but his formulation is too narrow to generalize about all Archaic elegy, and it comes perilously close to a tautology based on the content of Theognis.

at the oligarchs (most notably in the *Erga*) and a major contribution to the ideology of the elite in the elaborations of heroic genealogy in the *Eoiai*.

Between Hesiod and Pindar we must look at least summarily at those developments that most decisively affected the terms in which the foundational ideological construct of the Greek aristocracy—the belief that excellence of every meaningful sort is transmitted by birth—are fought over. The conditions of possibility for sustaining such a belief are constituted by the new alternatives that emerged in this period and the threats these alternatives posed. Thus, if in the *Iliad* many readers have been able to perceive *only* a univocal aristocratic message (for a contrary view see Rose 1988), with Hesiod and those who follow him the apparent aristocratic monopoly of discourse is unequivocally shattered. Peasants, colonists, men of mixed lineage on the margins of the aristocratic charmed circle, hoplites, traders, tyrants, women, dissenting and often uprooted intellectuals—"philosophers"—all in varying degrees enter the discursive arena. All constituted in varying degrees a potential threat to the aristocratic vision of reality.[4] If Pindar often gives modern readers the impression that he speaks from and to a homogeneous and untroubled aristocratic world, that is in part at least the mark of his triumph as a professional ideologue.

At the same time, it is one of the chief paradoxes one senses in reading over various histories of this period that, although the major space is understandably devoted to spelling out the emergence of all the new forces challenging the aristocracy, it is usually acknowledged that by and large "throughout the period, despite the existence of a self-conscious hoplite class, political leadership (as distinct from political power) was still in the hands of the aristocracy" (Murray 1980: 193). The aristocracy's success is due in no small measure to its capacity to engage effectively in ideological warfare on a whole spectrum of cultural fronts.

In discussing the colonizing and trading element in the *Odyssey*, we noted in passing the ambiguous posture of the aristocracy. On the one hand, we noted a self-conscious, class-based scorn of traders suggestively grounded in purely athletic prowess (see *Od*. 8.159–64).[5] On the other, we saw in the stridency with which the poem insists on the protagonist's legitimate claims to full aristocratic status a reflection of the

[4]A good recent overview of these developments is Murray 1980; Murray has a keen appreciation of the potential for overlaps between these categories.

[5]D. C. Young's failure to discuss this passage (1985) attests to his curious indifference to issues of ideology. But someone who describes the modern Olympic movement as "potentially, perhaps, [the world's] greatest hope" (ix) is—whatever his other accomplishments—not a serious political thinker.

fact that, for the colonizing element in Greek society, the attraction of colonization was to acquire the economic land base essential for realizing their own aspirations to an aristocratic lifestyle. This duality seems symptomatic of later developments. Trade and colonization constituted threats to the aristocracy to the extent that they created new wealth for non-aristocrats and exposed Greek society as a whole to a range of social and political alternatives that threatened to undermine the sense of the naturalness of the status quo that was its best defense. Thus, for example, Aristotle cites the poet Simonides' declaration that the "well-born" are simply "those whose family has long been rich" (Barnes 1984: 2422 = F92 R). The reforms of Solon in Athens constitutionally confirmed the supplanting of birth by wealth (Murray 1980: 185–87) in the designation of class, which seems to be characteristic of this period in Greece as a whole.

The aristocracy maintained down to Plato and Aristotle an official, so to speak, scorn of traders and all other nations or "races." Wealth as a criterion of worth was often bitterly denounced. The aristocrat Alkaios expresses the resentment of his class by citing a Spartan sage:

> For indeed once upon a time they say
> Aristodamos spoke in Sparta a speech
> Not devoid of value: "Wealth *is* the man,
> But the poor man's neither noble nor honored."[6]

Theognis is more explicit in denouncing the disruptive potential of wealth:

> Kyrnos, when it comes to goats, asses and horses, we seek
> Well-born ones [*eugeneas*], and one wants them to come from
> Good ones [*agathōn*]; but in marriage a noble man [*esthlos*] doesn't grieve
> at
> Marrying a base daughter [*kakēn*] of a base father [*kakou*], if she gives
> him lots of wealth,
> Nor does a woman refuse to be the bed-partner of a base [*kakou*] husband,
> If he's rich; but she prefers wealth to a noble [*agathou*].
> They honor wealth: the noble [*esthlos*] marries a base man's [*kakou*]
> daughter
> And a base man [*kakos*] marries a noble's [*agathou*]: wealth has mixed
> up lineage [*genos*].

[6]*Poetaram Lesbiorum Fragmenta* Z 37. Page cites this fragment among "The Non-Political Poems" and is at pains in his notes to deny that it is relevant evidence "for the 'struggle between a class of impoverished aristocrats and *parvenu* merchant-princes' of which we hear so much in modern accounts of Lesbos at that era" (1959: 315–16).

So don't marvel, son of Polypais, that the lineage [*genos*] of the citizens
Is being weakened: for what's noble [*esthla*] is mixed with what's base
[*kakois*].

(M. L. West 183–92)

In reality, the mixing and social confusion Theognis laments appears
to have worked both ways. As Hesiod, Solon, and others abundantly at-
test, the aristocrats were in fact second to none in their devotion to gain
of all kinds. The aristocracy usually supplied leadership to new colo-
nies, where the newly landed peasants aspired to become and not in-
frequently did become a new aristocracy, sharply distinguished in class
from later arrivals who had not benefited from the initial distribution
of land (Murray 1980: 111). Moreover, the aristocracy was sufficiently
flexible to graft the most successful of the merchant class onto its own
ideological family tree. Thus, for example, the ruling elite of the little
rocky island of Aegina could not possibly owe its great wealth to agri-
cultural land. On the contrary, there is considerable evidence for view-
ing commerce as the chief economic activity of Aegina (Murray 1980:
211–13).[7] Yet Pindar is at pains to represent Aegina's ruling families as
the supreme embodiment of the principle of inherited excellence.

We saw in the *Odyssey's* celebration of the monarchic principle not
just a nostalgic backward look at the long lost world of the Mycen-
aean *wanax* but a utopian anticipation of the return of one-man rule in
the wave of tyrants that swept over Greece in the period from the
mid-seventh century down to the period of the Persian wars. Charac-
teristically, this new political form arose in violent opposition to en-
trenched, narrow aristocracies and with the military support of
independent peasants wealthy enough to buy a set of armor (*ta hopla*)
and fight in the new, more cooperative phalanx as hoplites.[8] Whether

[7]Ste. Croix (1972; 1981: 41) is quite emphatic in his denial of this point apropos of
Aegina. But pending the appearance of his promised detailed discussion, I am inclined
by my own recollection of the rocky harshness of the terrain to be highly skeptical that
it could support even a "small, rich, landowning class of archaic type" (1972: 267 n. 61).
I also find persuasive Murray's allusion to the frequency of shipping imagery in Pindar's
Aeginetan odes—especially in the light of Aegina's clearly extensive trade (Herodotus
2.178.3, 4.152.3, 7.147.2), exceptional wealth (Herodotus 5.81.2, 9.80.3), and extraordi-
nary naval power (Herodotus 3.59.3, 5.83–89, 8.46.1, 8.93.1), with How and Wells's com-
mentary 1961 [1912], ad loc.). Ste. Croix seems to me here to be going too far in
exorcising the much ridiculed older Marxist explanation of all changes in terms of an
alleged "rising middle-class of merchants"—a theory much in evidence, for example, in
Cornford's *Thucydides Mythistoricus* (1965 [1907]).

[8]On tyrants and hoplites, see, in addition to Murray 1980: chaps. 8–10, the suggestive
juxtaposition of Cartledge 1977 and Salmon 1977. In the course of denying "political
hoplites," Salmon concedes so many grounds for anti-aristocratic sentiment among those
who became hoplites that his argument boils down to a denial of a pure technologism
(i.e., that the military innovation per se created revolutions) and a quite unobjectionable

these wealthier peasants expressed only their personal aspirations for power or acted in solidarity with the most oppressed peasants is perhaps impossible to say for the entire range of revolutions in the Archaic period. We can infer, I believe, from the Athenian evidence in the period of Solon, that his "middle" course reflected the ambivalence of the hoplite element: they opposed debt-slavery and bitterly denounced the greed of the so-called Eupatrids, but they drew the line at a redistribution of the land—their own basis for power.

In any case, the new cooperative style of warfare confirmed the military irrelevance of the old individualist style celebrated in Homer and on which the aristocratic claim of an equation between merit and birth depended. The old military aristocracy became an aristocracy of leisure. Yet the institutionalization of their chief leisure activities—games and drinking parties *(symposia)*—dominated the cultural imagination of both the tyrants, who in any case usually came from and shared the values of the aristocracy, and the new hoplite class. Though alternatives were occasionally articulated, the aristocracy generally succeeded in sustaining its cultural hegemony. But here again it is always important to stress that their hegemony is a consequence of a struggle in arenas that were significantly open to challenge from lower orders.

A vaguely populist case has recently been made with great vigor against the widespread and unfounded notion that only aristocrats participated in the games during the Archaic and Classical periods (D. C. Young 1985). What needs to be historicized, however, are the circumstances and the politics implicit in the institutionalization of, in the commitment of substantial public funds to, athletic contests during the period when the aristocracy had political dominance but was subject to the array of challenges we have described.[9] To invoke simply the

defense of the operation of multiple causes. I find Cartledge's more explicitly political analysis quite eloquent and compelling (his documentation is particularly rich). The attack on the "hoplite theory" mounted by Sealey (1976: 39–59) is by contrast aimed only at the crudest version of a technologist account and offers nothing but *disiecta data* and arbitrary speculation about peasant emotional needs in place of a coherent construction of complex phenomena.

[9]The circumstances under which the Olympic games were formally organized are completely shrouded in myth, though Strabo's view that the newly arrived Dorians (the "Herakleidai") organized them and the tradition that the Spartan king Lykourgos was somehow involved are suggestive (Yalouris 1979: 82). We know that the Pythian contest was organized by a Thessalian commander, Eurylochos, sufficiently rich himself to win a prize in the new chariot races at Olympia (Jeffery 1976: 74). As for the Isthmian games, Jeffery suggests, "possibly these were established by the oligarchic families to celebrate the return of constitutional government" (i.e., after the tyrant Psammetichos, son of Kypselos, had been deposed) (1976: 152). She has a more complex suggestion for the sixth-century organization of the Nemean games (137) but again sees them arising in opposition to a tyrant in a period when the only practical alternative to tyranny was oligarchy.

Greek's nature (D. C. Young 1985: 175) finesses the historical and political issue. To be sure, there were bound to be members of a middle class (D. C. Young 1985: 158) who has sufficient talent to achieve not only athletic success but the political stature that so often accompanied it. Young also most appropriately stresses the material rewards (115–27) that made a career in sports extremely attractive to *all* Greek males. But because it was a "symbolic test of the individual man" where "there were no trappings of birth or rank" and "on the track, noble and nonnoble necessarily looked alike" (175–76), the structural advantages of the aristocracy—leisure, wealth, family traditions—weighted this site of struggle more clearly to their advantage than the battlefield of hoplites in lockstep.[10]

But if for the sake of analysis we separate purely linguistic practice from all the social, economic, and political institutions in which it is imbedded, the clearest and deepest threats to aristocratic ideological hegemony would seem to us to come from the heterogeneous group of intellectuals usually lumped together under the title of "Presocratic philosophers"—two terms that peculiarly represent the triumph of a current of thought largely hostile to much of these thinkers' intellectual output. Plato, who, as we shall see, had a deeply partisan attachment to traditional aristocratic culture, succeeded in imposing both his master Sokrates as the watershed figure of Greek thought and his preferred term *philosophos* (lover of wisdom) over the earlier and once non-prejorative designation *sophistēs* (wiseman). Xenophanes, one of these wisemen, directly challenges one of the two major institutional foundations of aristocratic class consciousness, the great games. In one poem he declares boldly, categorically, that "better than the strength of men or of horses is our *sophia*" (*D-K* B 2.11–12). The term *sophia* here has moved from its Homeric sense of the skill of any craftsman to evoke the fruits of the intellectual's skills, which Xenophanes goes on to specify as primarily relevant to the goal of bringing the city into *eunomia* (*D-K* B 2.19), a term that during this period had come to designate whatever sort of good order proved necessary to end the threat of open class warfare.[11]

The second major ideological institution of the aristocracy in the Archaic period, the symposium, is not attacked directly by Xenophanes; rather, in another poem he seeks to purge both its form and its con-

[10] The fact that Tyrtaios, the ultimate "hoplite poet," begins his sustained priamel in praise of hoplite prowess with a dismissal of that "*aretē* of feet or wrestling" (12.1–2 West) suggests how early this agonistic individualism entered the discursive ranks against a specifically "communal good" (*ksunon esthlon*, 12.15 West).

[11] For the essential continuity between Xenophanes' *eunomiē* and Solon's, see Ostwald 1969: 69–70.

tent. He wants no outrageous violence (*hubris*, D-K B 1.17) and no drinking to excess. Poetry, which constituted the most ideologically self-conscious dimension of the symposium, should—according to Xenophanes—consist of praise of god (*theon*, sing., D-K B 1.13), prayer for the ability to act justly (*ta dikaia dynasthai prēssein*, D-K B 1.15–16), and accounts (narratives?) in which concern for excellence (*aretē*, D-K B 1.20) is uppermost.[12] But the battles of titans, giants, or centaurs are strictly forbidden subject matter. This last injunction, combined with the singular *theon*, points toward the categorical repudiation of anthropomorphic religion which Xenophanes spells out in other poems. This attack seems to be inseparable from Xenophanes' rejection of Homer and Hesiod as bad teachers who have offered scandalously immoral accounts of divine behavior (D-K B 10, 11, 12). It is a moot point perhaps how far traditional Archaic aristocrats were committed to a literal belief in the religion implicit in the texts of Homer and Hesiod. But some political consequences of undermining this religion are clear: if one were to reject completely the anthropomorphic narratives of the gods' sexual encounters with mortals, it would knock out a major metaphysical prop of the aristocrats' claims to be a race apart from mere mortals. In Xenophanes' terms, they would be no different from all other creatures that are born and grow; for "all are earth and water" (D-K B 29).

Xenophanes, to be sure, had his own particular configurations of ideas, but the thrust of all the speculations of the so-called *physikoi* together with Pythagoreans, Eleatics, atomists, or any other school of serious thinkers during this period was radically at odds with the old mythology and all the glorious, divine origins imbedded in its genealogies. In particular, whether the *physikoi* actually used such terms as *Peri Phuseos* ("About Nature") to describe their speculations, (*HGP* 1:73), the whole direction of their analyses of natural phenomena was to reduce severely the spheres and scope of unexpected and at least in appearance arbitrary divine intervention.[13] The very word *phusis* and its variant form *phuē* (Doric *phua*) mark in their development during this period the trajectory from a severely circumscribed realm of the natural to the dominant force of Nature. In Homer, where *phusis* occurs but once and *phuē* is used nine times in a corpus of 27,000 lines, the noun seems closely linked with the verb *phuō*, "to grow or grow into

[12]Gerber 1970 and Campbell 1967 both express hesitation over the text of line 20 and in particular the meaning of *tonos*, an emendation based on the analogy to Pindar *Py.* 11.54.

[13]In discussing the history of *phusis* and associated words, I am indebted, in addition to Guthrie's scattered comments, to Heinimann 1965 (1945), Haedicke 1936, Pohlenz 1953, Beardslee 1918, and Thimme 1935. The fascination of this topic to Germans during the Nazi period is striking, and it would be quite easy to expand considerably this list with German names.

something." Thus both forms seem to designate the physical, visible consequence of the growth process: *phusis* designates the appearance, the visible form of the plant that Hermes gives Odysseus to protect him from the magic of Kirkē (*Od.* 10.303), while *phuē*, almost always in the form of the accusative of respect and frequently combined with *eidos* (the "form," or simply "looks" in the modern colloquial sense) and *demas* ("living body" or "stature"), indicates the specifically human form or appearance—"build" or physical "presence" in the sense of impressive appearance.

However much the details are obscured by the fragmentary character of the direct archaic evidence, it does seem legitimate to deduce from the apparent continuities of this evidence with abundant fifth-century data that the Presocratics dramatically extended the spheres of the *regularity* associated with the consequences of the growth process. It may seem a short step from Homeric *phusis* as the actual consequences of the growth process to the sense we first have attested in Herakleitos but presumably characteristic of all the Milesians, namely, the true being or essence of a thing—its nature (*D-K* B 1, 123). But in this sense it is opposed to mere appearances and takes on the connotation of genuineness, of authenticity. What is radical in this shift and in the new prominence given to the word is the "substitution of natural for mythological causes, that is, of internal development for external compulsion" (Guthrie, *HGP* 1:83, echoing Pohlenz 1953). In Herodotus and in the medical writers of the fifth century *phusis* comes then to mean the normal condition as opposed to a sick or fortuitous state of people or things. Specifically applied to individual human beings or to the generality of human individuals, the term came to designate the particular, essential character of individuals, or human nature in general (*HGP* 2:351–53).

Can we trace a specifically aristocratic response to these developments in the conception of the specifically human? We noted that the *Iliad* was, in comparison with later developments, relatively indifferent to lineage and in fact distinctly ironic in its handling of the motif of descent from divinity. Homer has little or no vocabulary celebrating a specifically inherited excellence. The *Odyssey* shows a significantly greater self-consciousness about both the ruling-class look and the origin of human dynasties in divine rapes. But it is during the Archaic period proper that the discursive counterattack of the aristocracy emerges. On the one hand, heroic myth is relentlessly reinforced in major public festivals and vase painting.[14] On the other, a whole vo-

[14]On the cultural policies of Solon and Peisistratos, see in particular Else (1965: 46–50), who notes in passing the relative absence of heroic themes on vases before c. 580 B.C.

cabulary equating human excellence with aristocratic birth is valorized and elaborated. Homer has but one instance of *gennaios,* probably meaning something like "appropriate or worthy of one's family" *(genos)*; and Helen, daughter of Zeus, is once referred to as *eupatereia,* "child of a good father." But in the Archaic period the whole Athenian aristocracy described itself as the *Eupatridai,* literally, "sons of good fathers" (Calhoun 1934a: 197). One of the subtler forms of this linguistic strategy, clear in the passage from Theognis quoted above, is to transform the strongest terms of approbation precisely into terms implying specifically aristocratic birth. Thus the adjectives (and their prefix forms) *kalos* ("fine looking") or *eüs* ("good") or *agathos* (also "good") and *kakos* ("bad") come inevitably to mean respectively "nobly born" and "base-born."

The Problem of Pindar's Politics

We treat in more detail Pindar's relation to the discursive counterassault by the aristocracy in connection with his use of the epinician form later in this chapter. But for those aware of this development throughout the Archaic age, Pindar's special contribution—his valorization of inherited excellence under the banner of *phua*—has been a decisive factor in the widespread apprehension that Pindar is among the most blatantly political Greek poets in a tradition in which politics in most senses of the word had rarely been absent.[15] On this level, Pindar's poetry has confronted many modern readers with the fascinating problem of an art they find deeply engaging but which is, to all appearances, clearly committed to a strikingly reactionary political perspective—even in the context of its own era. A look at Pindaric scholarship suggests a more general problem, one relevant in varying degrees to the study of virtually all classical authors.

As Moses Finley asks in his review of Bowra's *Pindar,* "can one divorce a great poet from his deeply felt but odious beliefs?" (1968: 41). To Finley the answer seems clear. After literally pro forma praise for "structures . . . carefully worked" and "technical skill of the highest order" (39), Finley observes: "It is hard on occasion to resist the word 'toady', but Sir Maurice, too kind and excusing, manages to do so" (40). He concludes: "From Pindar we get neither understanding nor even

Although the precise dating of the Homeric hymns remains problematic, most are generally assumed to be from the Archaic period and associated with the various festivals inaugurated during that period.

[15]E.g., Heinimann 1965: 99–101, Thimme 1935: 18–24, Haedicke 1936: 50–56, and Beardslee 1918: 6–7.

clear awareness that new impulses are in the air for him to resist" (43). Finley's position with respect to Pindar's politics is not so far from that of Norwood, who devoted a witty chapter to demonstrating that Pindar's views on religion, ethics, sociology, and politics are "a tangle of contradictions and prejudices" (1956: 44). He exclaims in final exasperation: "Who shall discern limits to the lethal stupidity of a long-dormant class whose education has been moulded to suit, not to correct their prejudices?" (67). Unlike Finley, Norwood took formal structures and technical skill seriously. He concentrated on stylistic aspects as inherently so admirable and exciting that one could ultimately ignore the content of the poems. In this respect at least—even if his peculiar conception of symbolism has not found favor—he anticipated the dominant thrust of Bundy's (1962) and post-Bundian Pindaric scholarship, which we must consider in due course.

Pindaric Chronology

The conviction of most pre-Bundian Pindaric scholarship that Pindar is so clearly a political poet profoundly affected their relation to the always sensitive problem of the chronology of the poet's works. It is essential, I think, to stress that these scholars' assumptions about Pindar's form—the epinician genre—dictated the stance they took toward issues of chronology. This assumption was stated as well by Croiset as by anyone: "An ode of Pindar's is not a work of pure imagination created arbitrarily by the enthusiasm of a dreamer; it is in direct and compelled *(forcée)* relation with the circumstances in the midst of which it is produced" (1880: 305). Given this assumption, it indeed seemed to follow that the core of the interpretive enterprise depended on the most accurate chronological data. As Boeckh laments apropos of *Nemean* 8: "The fact that nothing survives in the scholia about the date when this exceptional ode was written is thoroughly irritating, since the subtler interpretation of the ode depends almost entirely upon this question" (1963 [1821]: 440). No wonder it seemed to Boeckh and his followers their "manly duty" *(pro virili,* 440) to extort by any means possible from the body of available historical data about Pindar's lifetime the most probable configuration of events in terms of which to carry out this "subtler interpretation."

Since our knowledge of the circumstances of any particular ode is indeed a function of the availability of data, in particular chronological data, and since Pindar is the first figure we are considering about whom there *is* something approaching such data, it may be useful to examine briefly the nature of the evidence and its early analysis.

Consciousness about chronology seems itself a phenomenon first emerging in the fifth century along with the Sophists and the first historical essays. Hippias published the first list of Olympic victors (Bickerman 1968: 75) during the second half of the fifth century; Aristotle compiled a list of Pythian victors c. 335–34 B.C. In the case of the Olympian and Pythian odes, the ancient scholia normally specify the Olympiad or Pythiad in which the victory celebrated in the ode was won (Gaspar 1900: 10). An Oxyrhynchus papyrus fragment listing Olympic victors happens to give corroborative information for ten of the fourteen Olympian odes, solving some dilemmas arising from corruptions in the manuscripts of the scholia (Gaspar 1900: 11). For the Pythiads, however, there is no such supportive prop but apparently also less evidence of corruption (Gaspar 1900: 10). Apart from these indications, the only bases for dating the odes are extrapolations from alleged references to events known from other sources. The indisputable allusions vary from the quite explicit reference to the battle of Salamis (*Isthmian* 5.48–50), to the metaphor of the stone of Tantalos (*Is.* 8.9–12), universally taken as a figure for the Persian menace, to the concrete but highly problematic allusions to the deaths in battle of relatives of the victor (*Is.* 4.16–18, 7.24–26).

Since there are few unequivocal allusions, the major problem arises with those scholars—from Boeckh to Bowra—who have attempted the circular operation of perceiving an echo of a political situation and then interpreting and dating the ode in the light of the alleged political context. Bowra, for example, following Wilamowitz-Moellendorff (1966 [1922]: 311), sees "hints of a disturbed situation after the death of Theron" (1964b: 410) and evidence of "the changed situation at Acragas" involving "a certain menace" in the following lines of *Isthmian* 2:

Now, because envious expectations hang about the minds of mortals,
Do not ever silence the excellence derived from/belonging to your father
 [*patrōian*],
Nor silence these songs. For not to
Rest unmoved did I work them out for you.

 (*Is.* 2.43–46)

One can produce many such speculations about "political uncertainties," "an air of apprehension," or other "echoes of politics" (e.g., Bowra 1964b: 99–158, 406–13), which are by no means necessary allusions. Moreover, in the case of odes for which there is no other obvious indication of date, the conclusions drawn about chronology are so wildly different as to invite us to abandon entirely the exploration of

Pindar's relation to his social and political context. *Nemean* 8 is a particularly striking example. Gaspar (1900: 42–45) gives a date of 491—a year earlier than *Pythian* 10, the earliest ode for which the scholiasts specify a date; he is following Mezger (1800: 325–26) in seeing clear allusions to the bitterness of Athens after the Aeginetans gave earth and water to Darius' envoys. Bowra, who puts the ode with a question mark in 459 (1964b: 412), follows Bergk in seeing evidence of old age; but unlike Boeckh (1963 [1821]: 440–51), who put it in 458 after the battle of Kekryphaleia, Bowra is not sure that war had yet broken out. Brown (1951: 13) argues for a date of 445, a year after *Pythian* 8, the last ode dated by the scholia. The questionable relevance of stylistic criteria for dating (e.g., Theiler 1970: 148-91) is suggested by Schmidt's claim (1973: 430) that *Nemean* 8 was a work of the poet's youth whereas others set it very late in Pindar's career and find the appropriate signs of his "mature" style.

Indeed the confidence of the historicizers is at times so great that they even dismiss the scholiasts' designations of specific dates. Gaspar (1900: 165 n. 3) notes for example that Otfried Muller, Thiersch, and Boeckh do not hesitate to challenge the scholiasts' dating of *Pythian* 8 on the basis of their interpretation of of the word *eleutheroi* ("free") in line 98 as incompatible with the domination exercised by Athens over Aegina in the scholiasts' date of 446. The fact that there are many clear examples of corruption in the transmission of numbers in ancient Greek manuscripts of very different sorts may encourage one to doubt *any* date that has no external corroboration, so that all the Pythian odes are in principle vulnerable to this sort of assault. But to the extent that the older historicizers' assumptions led in such a direction, the entire historicizing enterprise threatens to self-destruct.

Bundy's Way out of the Political

Although one of the more militant followers of Bundy has harshly denounced anyone who speaks of Bundy and his followers as engaging in rhetoric, not scholarship (W. Slater 1977: 193),[16] I believe it would be all but impossible to overestimate the impact of Bundy's work on the way we all read Pindar.[17] Bundy left the dichotomy between form and

[16]I console myself with the thought that W. Slater also declared that encomiastic poetry itself is "basically rhetoric" (1977: 195), a position with which I am in some sympathy if by rhetoric one means what Eagleton (1983: 205–6) seems to mean by it.

[17]Any consideration of modern Pindaric scholarship is much indebted to D. C. Young's ground-breaking "Pindaric Criticism" (1964), which, for all its apparent eclecticism, went a long way in supporting the logic of accepting Bundy's way as the foundation of any strategy for reading Pindar.

political content behind only to the extent that he succeeded in convincing readers that the specific historical, social, and political contexts of the odes are relevant only as poetic functions of the all-explaining *laudator-laudandus* relationship in each poem. Aspiring perhaps to become the Milman Parry of Pindaric studies, he attacked his own version of the "Pindaric problem," which he argued results from our forgetting

> that this is an oral, public, epideictic literature dedicated to the single purpose of eulogizing men and communities; that these eulogies are concentrated upon athletic achievement, that the environment thus created is hostile to an allusiveness that would strain the power of a listening audience, hostile to personal, religious, political, philosophical and historical reference that might interest the poet but do nothing to enhance the glory of a given patron. (1962: 35)

The root of our latent neglect of "the plain requirements of genre" is, he suggested, in "our distaste for the genre itself" (35). Bundy's solution to this problem was a brilliant elucidation of what amounted to the formulaic nature of the poetry of both extant epinician poets, Pindar and Bacchylides, focused single-mindedly on strategies of praise for the victor. Bundy's great achievement was to restore a basis for elucidating *one* formal level of unity inadequately recognized by previous scholarship. That basis was "the fulfillment of a single purpose through a complex orchestration of motives and themes that conduce to one end: the glorification, within the considerations of ethical, religious, social and literary propriety, of [the] victor" (91).

An admirer of Bundy's has stressed quite rightly that the formulations cited above do not exclude politics from the interpretation of Pindar (Lee 1978: 65-70).[18] Yet the strategy of those who are most indebted to Bundy's approach is most revealingly clear when they deal with the relatively few undeniable allusions to concrete political events. In these cases, the followers of Bundy have ably demonstrated Pindar's and Bacchylides' technique of translating specific historical and social

[18]Lee (1978: 65–70) begins by objecting to my characterization of Bundy (Rose 1974: 145–75). Yet in defending Bundy from the implication "that praise is the exclusive function of the elements in an ode," he cites this same article of mine for proof that "gnomic statements, often with mythical *exempla*, may serve a general paideutic function or a more narrow one of propounding aristocratic values" (67). This strikes me as curious in as much as my chief criticism of Bundy is that he and his followers generally ignore all but the function of "praise," conceived in narrowly athletic terms. Thanks to the kindness of William Race, I have had an opportunity to read Bundy's doctoral dissertation (1954). It is fascinating to trace the process by which he moves from acknowledging obviously political dimensions of the odes toward ever narrower focus on the purely encomiastic dimensions.

data into the realm of myth. The victor's battle-slain uncle becomes a mythic paradigm on a par with figures from Homeric saga (D. C. Young 1971: esp. 45-46) just as King Kroisos (Bacchylides 3) is transported by the gods to the Hyperborean utopia. In response to the chronologically based arguments of earlier scholars such as Bowra, they have had no trouble demonstrating that alleged evidence occurs not infrequently in entirely conventional elements of the *laudator-laudandus* relationship. Bowra's interpretation, for example, of the reference is *Isthmian* 2.43 to "envious expectations" would strike a follower of Bundy as a particularly ridiculous instance of a failure to recognize the purely traditional *phthonos* motif (Bundy 1962: 12, 15) combined with the equally predictable reminder of the poet's task.[19]

Neither Bundy himself in his regrettably exiguous published work nor those scholars who have followed him have chosen to explore the ideological content of Bundy's criterion of "ethical, religious, social and literary propriety." They have not considered the ideological function of Greek athletic activity itself nor the praise of it by epinician poets. They have rarely examined the ideological grounds on which "personal, religious, political, philosophical and historical references" might be interesting to both a patron and the poet.[20] On the contrary, the whole thrust of Bundy's discussions of Pindaric abstract vocabulary—that aspect of his poetry most clearly suggestive of values—is to demonstrate their concrete reference only to the encomiastic situation. Indeed, the whole direction of Bundy's doctoral dissertation (1954) was to demonstrate how an apparently very political term like *Hesychia* as it appears in the invocation of *Pythian* 8 should be divested of its po-

[19]Thummer (1968: 19–158) and Hamilton (1974: 14–25) offer what I consider particularly pure examples of Bundian accounts of the structure of the typical Pindaric ode. For the place in this structure of the "poet's task," see Hamilton: esp. 16–17.

[20]D. C. Young (1971) is a notable if only partial exception. More recently Hubbard, a self-proclaimed student and follower of Bundy (1985: vii, 2–3), has shown occasional interest in explicit political allusions (e.g., 86 n. 43). But the chief aim of his intelligent study of the "pindaric mind" is to elucidate the process by which Pindar makes his *paradigmatic* choices within an essentially Bundian syntagmatic axis (9–10). To echo Marx on the Young Hegelians, Hubbard has not inquired into the connection of this mode of thought or series of polarities and ancient Greek reality, the connection of Pindar's paradigmatic choices with the material circumstances of both poet and audience (*MECW* 5.30). Glenn Most has elegantly juxtaposed the historicizers of the old school and the followers of Bundy under the respective rubrics of "uniqueness" (emphasizing the unique historical event as the source of explanation) and "conventionality" (emphasizing the regularities of the genre or the corpus as the basis of interpretation). He points out that "their interpretative practice always consists of deferring to infinity the effective intervention into their discourse of that side of the opposition they reject" (Most 1985: 30). The alternative he himself describes in his methodological introduction under the rubric "immanent compositional unity" (42) appears, from his self-association with "especially Köhnken and Young" (47) and from his illustration in the analysis of *Isthmian* 1, to be essentially a sensitive and intelligent application of the old New Criticism.

litical associations and recognized rather as "agonistic, with reference to the peace which follows upon the outlay of labor and expense toward a successful conclusion" (158). In his published study, Bundy is more clearly at pains to stress the solely agonistic/celebratory reference of Pindar's abstractions: "No commentator will inform his readers that *Euphrosuna* in *Nemean* 4.1 (personified abstract for concrete) is a poetic word for a victory revel" (1962: 2). The Greek word *phua*, which had long been recognized as in some sense the distillation of Pindar's ideological commitment to inherited excellence, is glossed by Bundy as "the natural enthusiasm" of the *laudator* for his theme, the *laudandus*.

It does not in any way diminish Bundy's extraordinary contribution to underline the fact that his critical assumptions are themselves intimately related to a historical moment. His work represents in the instance of Pindar the culmination of the gradual conquest of classical philology by Anglo-American New Criticism, a school of criticism that in English literature was already beginning to self-destruct by 1957 (Lentricchia 1980: 3–26). One may say that in relation to the posture toward the reading process, its founding moment is the centrality of the opposition of what is extrinsic and what is intrinsic to the text. Wellek and Warren, for example, in their tremendously influential *Theory of Literature* (1956 [1942]), dub as extrinsic everything pertaining to biography, psychology, society, and other arts, whereas the intrinsic includes euphony, rhythm, meter, style, images, metaphors, symbols, myths, and genres. Without rushing to a premature dismissal of the potentially valid arguments underlying such a distinction, it is important in this context to notice the convenient fit between this radically antipolitical position and the entire intellectual climate of the Cold War–obsessed, McCarthyite 1950s.

If we are to restore the ideological content of the odes as a legitimate aspect of the analysis of their poetic meaning, it cannot be on the pre-Bundian level of positing scraps of political allusions divorced from poetic texture or citing scattered *sententiae* out of context, then either openly denouncing them with Norwooden irony or tacitly endorsing them in the process of explicating them (e.g., Jaeger 1945: 205; J. H. Finley 1955: esp. 155).[21] Fränkel's insistence (as early as 1930) that unity be sought on the level of values (1973: 350–69, esp. 366) is neither superseded by nor incompatible with Bundy's vague invocation of propriety; it at least implicity recognizes the deeper problem,

[21] In addition to M. I. Finley and Norwood, other notable practitioners of the denunciatory approach are Beye (1975: 126–27) and Bilinski (1959: 43–45). The latter, despite his primary interest in the ideological function of Greek athletics, devotes less than three pages to Pindar and ends his comments (as Beye begins his) by citing with approval Voltaire's scathing apostrophe to Pindar, cited as well by Norwood (1956: 240).

untouched by Bundy, of the relevance of athletics and praise of athletes to Pindar and his audience.[22]

Pindar and the Double Hermeneutic

The way out of the dilemma between a political judgment that simply either dismisses or endorses Pindar and an aestheticism that simply brackets the political dimension lies, it seems to me, along the lines of the double hermeneutic discussed in the introduction—an exploration of all the ways the text participates in partisan ideological struggle on behalf of the class position of the Greek aristocracy and at the same time all the ways it transcends and negates that position. Pindar is in this sense only an extreme example of a problem which, I have suggested, is really characteristic of any modern appropriation of ancient texts.[23]

The first advantage of applying a double hermeneutic to Pindar is that it recognizes the validity, even the necessity, of taking Pindar's politics seriously as an integral element of his poetry. This stance in turn implies the responsibility to seek as clear an understanding as one can of the social, political, and economic forces at play when Pindar composed his poetry. It renders chronology its due, but on a rather different basis from the old historicizers. Obviously, the more precisely one can understand the immediate circumstances of an ideological response, the more resonances with those circumstances one is tempted to perceive. Yet the older historicizers were committed to a definition of politics almost exclusively tied to concrete events in an on-going struggle conceived primarily as inter-polis bids for power. Although they were aware of the pervasive conflicts at the political level of democracy and aristocracy, they had an undertheorized conception of the class character of *ideological* struggle and how such struggle is conducted. At the level of ideological struggle, the inherently more structural sources of conflict dictate a more indirect, indeed often a more

[22]D. C. Young, in his revised version of "Pindaric Criticism" (1970: 66), has added a graceful and well-deserved tribute to Fränkel's merits as a critic and explicator of Pindar's thought. Yet, in relation to the question of unity, he has merely softened his earlier judgment that Fränkel's discoveries are "pitifully insignificant" to "rather insignificant." Fränkel's view that unity cannot reside in the individual ode but rather in the system of values revealed by the corpus of odes as a whole (1973: 489–90) violates the New Critical dogma of the organic unity of each artwork. Yet the Bundian version of the unity of an individual ode is inconceivable without relentless cross-reference to the systematic procedures that become clear only within the framework of the whole corpus. Their approach is thus radically "intertextual" *malgré eux*.

[23]I take it as a sign, however, of the peculiar appropriateness of this solution to Pindar that it has found favor with so eminent and critically eclectic a Hellenist as Charles Segal (1986a: 127 n. 12), albeit with a reversed political valence: for Segal, what the Marxist negative hermeneutic unveils is positive, and vice versa.

abstract mode of discourse than that focused on the interpretation of specific political events (this more abstract discourse used to be called "Panhellenic *paideia*"). But an essential part of this indirection is at the level of form and the relation of that form to the conditions of cultural production, performance, and reception. We cannot simply spell out an explicit political content; rather, the double hermeneutic compels us to deal fully with the epistemology of artistic form, to see the ode not as mirroring the reality defined by the Greek aristocracy but as a significantly autonomous transformation and transcendence of that reality. The ode's relative autonomy is an inevitable consequence of its formal, sensuous aspects—its relations to a whole range of signifying systems such as meter, music, all the conventions of the specific genre as well as the entire Greek poetic and ritual tradition, all of which constitute in various ways intractable interference to unmediated reflection of a completely external reality.

The Epinician Form

A word first on the occasion of the genre, the games themselves. The games may well have originated in the ritual cult of the dead and been nourished by ancestor worship.[24] But, as we have already noted, their organization on a grand scale and their insertion into the whole nexus of poetic *paideia* is most plausibly understood as an ideological gesture by the aristocracy in response to their loss of a literal role as "those who protect cities" (cf. *Il.* 9.396; see also 6.403, 16.542). We cannot say with any certainty when epinicia began to be composed to guarantee that the achievements of the victors be adequately appreciated and preserved, but the first known epinician dates from 520 B.C. and was composed by Simonides. The inference that he invented the genre is only an inference, but plausible. The founding gesture of the genre is to apply to a human achievement an old art form previously devoted to the praise of gods and heroes (Fränkel 1973: 434). D. C. Young has recently argued for the non-aristocratic origin of the earliest known recipients of epinicia (1985: 142, 155, 174; Lesky 1966b: 186; *contra* Bilinski 1959; 43). Given the democratic sympathies regularly attributed to Simonides and the rather playful tone of surviving fragments (Fränkel 1973: 435–36), it may not be amiss to recognize that the genre at the earliest point we encounter it is already constituted as an arena of ideological struggle. Indeed the founding gesture alluded to above

[24]See Meuli 1941 and Yalouris 1979: 82–84. D. C. Young (1985: 12 n. 72) is extremely skeptical about a religious origin, but his invocation of a "Greek nature" (175) is not helpful and ignores the clear effort to associate the games with religious festivals.

makes sense as more than aristocratic self-advertisement; it also makes excellent sense seen in the context of the emerging humanism of the Presocratics and the growing confidence of the hoplite class. Just as arbitrary divine causality begins to recede in the *physikoi*, so the Simonidean epinician may have celebrated purely human achievement in contradistinction to the mythic claims for gods and the sons of gods. In any case, the institutionalization of the games themselves, their success in defining the values of "all the Greeks," and in particular their heavy support from public funds were clearly matters of discursive conflict, as we have already noted in the case of Xenophanes and earlier of Tyrtaios.[25]

Whatever the necessarily tentative conclusions one might draw about Simonides, in Pindar the whole elaboration of the form is directed toward affirming the strict hierarchy of "god, hero, man" (cf. *Ol.* 2.2) and presenting any celebration of the victor's community in terms that clearly subsume the distinction of the polis under the distinction of its rulers. If D. C. Young has compelled us to abandon the automatic assumption that all participants in the games were aristocrats (1985), it is worth repeating that Pindar's patrons included some of the most powerful and politically most oligarchic (cf. Andrewes 1956: 129–36) tyrants and kings (Segal 1986a: 13–14) as well as reigning oligarchs (e.g., the Aleuadai) in the Greek Mediterranean world.

More relevant is the way Pindar structures into his odes the aristocratic concept of inherited excellence. Schadewaldt long ago suggested that the basic point of departure for the development of the epinician form was the concrete historical experience of the victory, with its formal proclamation of the victor's name, father, and homeland (1966 [1928]: 3–4). Pindar chooses to integrate the achievement of the victor with his origin. I count twenty-three odes out of the surviving forty-four in which the excellence of the victor is explicitly presented as inherited from the heroes of his homeland: *Olympian* 2, 6, 7, 8, 10, 11; *Pythian* 4, 5, 9; *Nemean* 2, 3, 4, 5, 6, 7, 8, 10, 11; *Isthmian* 1, 3/4, 5, 6, 8. Of these, all but *Olympian* 9 and *Nemean* 3 also emphasize a purely literal sense of inherited excellence by associating the victor's achievement with those of his relatives or family line. In *Olympian* 9 and *Nemean* 3, where presumably the family of the victors was not sufficiently distinguished to permit praise of a specific heritage, Pindar is nonetheless strikingly emphatic in proclaiming the principle of inher-

[25]I find it suggestive of this conflict that the final event at the Olympic games was a specifically hoplite event, the race in armor (Yalouris 1979: 133). Though I have encountered no comment on the point, it seems to me plausible that this reflects an insistence—well after the order and character of the other events had been established—on the relevance of specifically hoplite *aretē* to this arena of testing.

ited excellence (*Ol.* 9.100–104; *Ne.* 3.40–42). Moreover, in such poems as *Pythian* 8 and *Nemean* 1 (Rose 1974), in which the myths are not metaphorically grafted onto the victor's family tree, they are presented as confirmations of the principle of *phua*, a term to which, as noted, Pindar made a special contribution.

We may recall here that scholars tracing the trajectory of *phusis/phuē/ phua* have regularly singled out Pindar's heavy emphasis on the term. Following these approaches, we may say here that on this linguistic level the originality of Pindar seems to have consisted in grafting onto the Presocratic notions of reliability, fixity, and normality the aristocratic pride in special birth/growth from a specific ancestry. But simply to focus on the single word is to miss the extraordinary richness and amplification that *phua* and associated notions gain in context from Pindar's entwining them in a uniquely rich network of kinship/birth/ begetting terminology and vegetative and sexual imagery with which he insists on the genealogical principle. Consideration of this vocabulary should include terms denoting "inborn" (*phua, sungenēs, sungonos, sumphutos, emphuēs, emphulios, gennaios, gnēsios*), terms denoting the victor's family members, family, clan, or tribe (*haima, genea, genna, genethlios, genos, domos, ethnos, matradelpheos, matēr, matrodokos, matrothen, matromatōr, matrōs, patēr, patradelpheos, patrios, patrōios, patropatōr, progonos, oikothen, oikos*), terms for offspring (*pais, gonos, ekgonos, aristogonos, teknon, thalos*), terms for the physical process of the transmission of excellence (*phuō, phuteuō, mignumi, ginomai, tiktō, gona, sperma, Eleithuia*). If to these were added all the proper names that associate the victor's excellence with that of his relatives, his homeland conceived of as a mother, his homeland's heroes conceived of as ancestors, and if then full consideration were given to the imagery of plants (McCracken 1934; D. Steiner 1986: 28–39) and fields fused with imagery of human reproduction (Hoey 1965), one might begin to get some sense of the unique impress of this doctrine on the fabric of Pindar's handling of the epinician.[26] Surely we are dealing with something more than the natural enthusiasm of the *laudator* for the *laudandus.*[27]

[26]It is a characteristic mark of the power of Bundy's influence that D. Steiner begins her discussion of the metaphor of plant life by assuring us that "it emerges naturally from the context of the Games, suggested by the crown of leaves which the triumphant athlete wore" (1986: 28).

[27]D. C. Young (1968: 113 n. 4) rather grudgingly acknowledges that there are grounds for attributing an aristocratic belief in "blood" to Pindar, but he suggests that the difference between him and Bacchylides is not overwhelming. He proceeds to invoke a "Greek belief in something like genes," but neither blood nor genes is adequate to the rich and heavy sort of emphasis throughout Pindar's epinicians. Such concepts also fail to account for Pindar's persistent penchant for fusing literal genealogy with metaphorical descent from the local heroes.

Bacchylides' surviving epinicians may be too few and too fragmentary for an adequate comparison on this count, but what evidence there is suggests to me an overwhelming difference (cf. D. C. Young 1968: 113 n. 4). Beside Bacchylides' apparently occasional use (1.140–51, 2.8, 9.47–52) of a probably traditional motif stands Pindar's systematic and consistent transformation of that motif into an organizing structural principle of the ode and a vision of reality. Most revealing is the contrast between Bacchylides' 13th Ode and Pindar's *Nemean* 5, both composed for the same victory. Bacchylides celebrates the heroes of the island yet never presents their excellence as explicitly the victor's by birth, nor does he refer to other victories in the specific family of the victor. In Pindar's poem, the victor "honors the Aiakids and the city of his mother" (8). The myth celebrates a marriage of an Aiakid (Peleus) won by virtue, and the victor "falls in the arms of Victory (Nikē)" (42). His uncle honors him, "a scion of the same stock as Peleus" (43, trans. Bowra). Lest anyone miss the point, the poet declares, as he moves from the myth back to the victor, the explicit moral to be drawn: "The fate that is innate proves decisive in *all* actions" (*potmos de krinei sungenēs ergōn peri/pantōn*, 40–41, where the enjambment gives weight to *pantōn*). The core of the overwhelming majority of Pindar's odes thus emerges as a meditation on the links between the specific achievement of the victor, his immediate origin in his own family, his more remote origin in the mythically evoked heroes of his homeland, and, finally, the origin of both those heroes and the present victory in divine favor.

The qualities (*aretai*), both physical and ethical, which are celebrated within this framework—strength, daring, military prowess, foresight, hospitality, justice, and generosity—are presented as characteristic of the victor. But they are neither exclusively athletic nor apolitical essences. The consistent generalizing cast of Pindar's language, which presents the games themselves in such vague terms as "toil" (*ponos*), "trouble" (*kamatos*), "expenditure" (*dapana*), "reward" (*apoina*), or "happiness/wealth" (*olbos*), invites those in the audience who have the requisite wealth for such expenditures and efforts to find a comforting reflection of themselves in the inherited excellence of the victor. So too Pindar's clear preference for myths drawn from the panhellenic epic tradition (Davison 1968: 301–2) and encompassing a range of human activity vastly broader than athletic contests, the apparent source of Simonides' epinician myths (Fränkel 1973: 435), or even warfare seen as the doublet of athletics (D. C. Young 1971: 39–42) constantly invites the audience to perceive a message that transcends the immediate contest. Moreover, Pindar does not simply repeat the old heroic myths; he both moralizes them—thus implicitly responding to such critics of myth as Xenophanes—and integrates them into his utopian projection

of an ideal aristocratic world, where birth is the determining principle of everything worth having.[28]

At the level of language and meter, Pindar represents the culmination of a specifically aristocratic appropriation of the new possibilities opened by literacy.[29] Nothing is formulaic in Pindar except the sorts of rhetorical strategies and linkages explored by Bundy and his followers. The common store of oral formulaic language is echoed only to reinforce the celebration of individual originality. Thus, for example, the familiar epic formula "winged words" (*epea pteroenta*) is never used as such by Pindar but is characteristically presupposed and played with in such locutions as his self-exhortation to let fly a metaphorical "sweet, winged [*pteroenta*] arrow" from "the far-darting Muses' bow"; he will not set his hand to "words that are groundward-falling" (*khamaipeteōn*) (*Ol.* 9.4–12).

The situation with meter is much the same. Pindar's preferred dactylo-epitrites echo the cadences of epic hexameters and in particular the hemiepes (long/short/short/long/short/short/long). This is a very common initial unit of the epic hexameter (cf. *Mēnin aeide thea*, *Il.* 1.1); doubling the hemiepes makes the second line of the elegiac couplet. The hexameter and the elegiac couplet were meters which, in principle, were available to every reasonably talented amateur. So too the Aeolic meters are built on what in all likelihood were simple folksong meters.[30] Yet each ode is the occasion for a dazzling display of unique originality: no two have exactly the same configuration.[31]

[28]See especially Pini 1967, Thummer 1957: esp. 12–20, and D. C. Young 1968: 34. Huxley puts the case baldly and perhaps backward, but as far as it goes, justly: "Because the poet's patrons had divine ancestry, they were living witnesses to the truth of the Olympian system; aristocracy had the hereditary blessing of the gods themselves, and so Pindar's religion was politically authenticated—there is analogy here with the old adage that the Church of England is the Tory Party at prayer" (Huxley 1975: 7). Huxley's chap. 2, "The Editorial Poet" (14–22), offers a usefully concise overview of Pindar's corrections and suppressions of myths that compromise moral claims for the Olympians, heroes, and, by implication, the aristocracy.

[29]Here I disagree with Havelock's (1982: 16) endorsement of Fennell's idea that "it is probable that he did not write his odes." It may be correct to suggest a connection between a "grand style" and Pindar's sense of a "burden of social responsibility" linking him with Homer (1986: 120); but, as I suggest above, the texture and complexity of Pindar's compositions—like his extreme self-reflexivity—are best understood as a consequence of new, specifically literate possibilities. Gentili's emphasis on oral *performance* (1988: esp. 4) seems to me more relevant and more productive.

[30]I am aware of the deep scorn reserved for even the most tentative efforts at historicizing Greek meter by the great empiricists who have dominated the field (e.g., Dale 1969: 52). But, as Whitman observes in his foreword to Nagy's brilliant exercise in historical metrics (Nagy 1974: xi), "no known culture evolves the long, elaborate epic before its bardic priests address hymns to the gods and mothers sing their children to sleep."

[31]The fact that *Isthmian* 3 and 4 have the same metrical structure is one of the strongest grounds for seeing them as one poem or as a specially related pair of poems. Bowra (1964b: 317) cites these two (printed by Snell as a single poem) as the apparent exception proving the rule. As Dale observes more generally, "the repeating triads . . . give a much

It is not ignorance or insensitivity that leads so many readers to confuse the individual voice of the poet with the traditional communal voice of the chorus.[32] Pindar's sustained reflexivity on his own poetic activity and his constant parallelism between himself and the victor affirms the aristocratic, heroic ideal of individualism in its most hierarchical, winner-take-all form. It is no accident that Pindar's is the first surviving text to articulate the opposition of "born" poet and the mere "learner" (*Ol.* 2.86–88; *Ol.* 9.100–104; *Ne.* 3.40–42). We noted a bare hint of self-reflexivity in the poet of the *Iliad*, a rather striking if only implicit self-reflexivity in the poet of the *Odyssey*, and finally in Hesiod the first outright, if short-circuited, confrontation of the role of the poetic text in *constituting* the very reality that it purports to represent passively as the gift of the Muses. Pindar comes after a long development of ever-increasing consciousness among poets about the social functions of their work and the role their texts play in establishing alternative versions of reality. His own exalted sense of his poetic mission (Gundert 1935), while unquestionably integrated with his function as praise-poet, has the effect of inviting his audience—perhaps especially his future audience—to an exclusive focus on the sheer dazzle of his performance as a poetic technician. Since his usual posture is as a guest-friend of the victor or the voice of the victor's whole community, his partisan ideological role is correspondingly masked in the text.

I have emphasized these aspects of the typical structure and content of Pindaric odes because, even within the dubious limitations of the New Critical idiom, I believe that they are intrinsic to Pindar's handling of the form. As a confirmed New Critic and devoted admirer of Bundy has conceded,

the achievement of Pindaric criticism in the last two decades has been to clear the odes of the extraneous historical and biographical matter that had been read into them. The danger is that critics may now be reading *out* of the odes a good deal that is really there and in the process impoverishing rather than purifying them. . . . Somewhere along the line . . . the question comes: how much has to be excluded as irrelevant to the poet's encomiastic task? . . . What about matters which, while they may be of no immediate or obvious bearing on the victory that is being celebrated, may be of active concern to the victor and his community? The victor was after

needed check for the determination of period end; no calculation, no schematic patterns, and no appeal to rhythmical sense on our part could without this check give any assurance that we had found the right shape for a single stanza of this arbitrary, deliberately unsymmetrical, constantly inventive poetic technique, which gives to each ode its unique, *neosigalon tropon* [new-shining style]" (1969: 45).

[32]On this vexed issue, see Lefkowitz 1963 and 1975b: 80–81, Fränkel 1973: 427, Bundy 1962: 69–70, esp. n. 84, W. Slater 1969: 89–91, and Hamilton 1974: 113–15.

all a citizen, bound up with the life of his city to a degree we can scarcely picture. (Carne-Ross 1985: 184–5)

To return now briefly to what is "outside" the text but brought "inside," that is, specific allusions to political events and the political or military role of individuals in them, Bundians seem to feel that if they can demonstrate how history is transformed into allegedly universal categories they have done with politics. But this transformation is itself a key strategy of ideological mystification: to the extent that a particular class succeeds in presenting its interests, its vision of reality, as *the* universal vision of the human condition, it precludes the challenge of alternative visions. On the other hand, it is worth recalling that the specific means by which a particular literary work may be immersed in its historical moment are not susceptible to a priori techniques of interpretation. As Jameson rightly argues, "there can be no preestablished categories of analysis: to the degree that each work is the end result of a kind of inner logic or development of its own content, it evolves its own categories and dictates the specific terms of its own interpretation" (1971: 333).

Toward a Double Hermeneutic of *Pythian* 10

Before applying some of the preceding generalities to the text of a specific ode, I stress again that the double hermeneutic is not neutral. The negative hermeneutic explores all aspects of the text that support and reinforce a regime that uses both the repressive apparatuses of the state (military force, etc.) and the ideological state apparatuses to retain a disproportionately large share of the socially created surplus in the hands of a small portion of the society. The positive hermeneutic seeks to uncover those aspects which, in the perspective of the long movement of history, open a realm of human freedom and are capable of contributing to a perception of the inadequacy of the status quo, thereby fostering the principle of hope.

The Negative Side

What specifically do we know of the immediate political context of the ode? *Pythian* 10, Pindar's earliest extant ode according to the indications of the scholia, is dated to the 22d Pythiad (498 B.C.).[33]

[33]Drachmann 1964 (1903): 241. Why Gildersleeve (1965 [1899]: 348) says 502 B.C. is beyond me.

Although no Pythian victory date is independently confirmed, references in Herodotus (7.6.2, 7.130.3, 7.172.1, 9.1.1, 9.58.1–2) to Thorax and the Aleuadai confirm a date well before the coming of the Persians. The victor was a Thessalian boy named Hippokleas, who had won the double footrace (approximately 400 meters) at Delphi. Although an allusion in the text (18) implies that the victor's family was impressively wealthy—an inference in any case from his horsey name (*hipp-*,"horse"), the ode was commissioned not by the boy's father but by Thorax of Larissa (5, 64–65), a member of the ruling Aleuadai clan and *tagos*, appointed "king," of Thessaly.[34] For roughly a century before the Persian wars catapulted Athens into strategic prominence, "the revival of the military powers of kingship made Thessaly the leading state north of the Isthmus" (Hammond 1959: 142).

If we now consider somewhat more closely what I have pretentiously called the epistemology of artistic form in connection with the Pindaric epinician, we find contemporary analysts debating the relative weight to be given the "linear argument" and the role of verbal echoes or patterns of imagery (e.g., W. Slater 1977: 193–95). I would say that much of the power of Pindar's handling of the form derives from the tension between the forward thrust of the praise program and the quality of a static vision effected by the extraordinarily rich tapestry of echoes, cross-references, and direct repetitions (Greengard 1980). But there is general agreement among post-Bundians that the essential technique of the epinician poem, its rhetorical structure, consists in praising the victor by establishing a series of parallels and associations between, on the one hand, the specific action of the victory, the excellence of the victor, the victor's family and homeland, and, on the other, a broad range of usually positive phenomena. Negative phenomena, it is argued, enter only as dark foils, by virtue of which the achievement of the victory only shines the brighter (Bundy 1962: 40, n. 16; Köhnken 1971: esp. 34).

A relatively fixed set of expectations and rhetorical postures on the part of the poet organizes these associations, parallels, and contrasts. Thus a recent study of Pindaric form breaks down *Pythian* 10 as follows: Homeland Praise; Poet's Task with Breakoff Formula; Poet's Task–Naming Complex–Victor Praise; Gnome (i.e., a generalizing statement); Victor Praise–Other Praise; Future Prayer; Gnome–Gnomic Cluster–Myth; Gnome; Poet's Task with Breakoff Formula; Poet's

[34]Wilamowitz-Moellendorff remarks (1966 [1922]: 123) that the term "king" is not strictly correct since the role of *tagos* was appointed. He concludes therefore that it is laudatory. This seems a reasonable inference, but we should note that Herodotus designates all the Aleuadai as *basilēes* of Thessaly (7.6.2), presumably in the loose *Odyssean* sense of "oligarchs."

Task–Victor Praise; Gnomes; Poet's Task–Other Praise; Gnome; Poet's Task–Other Praise; Gnome (Hamilton 1974: 91).[35] It is perhaps too easy to ridicule this "computer" model of Pindaric structure (Lefkowitz 1976b: 340–41). My only concern as I embark on a negative hermeneutic of the poem is to stress that I begin from a relative consensus about what is intrinsic to the ode. Though I tend to find more value in Fränkel's proposition that the coherence—I would add the excitement—of an ode derives in large measure from Pindar's concern to demonstrate "an immense number of individual connections of all kinds and directions" (1973: 496), we are well served too by the demonstration that this process takes place within the tight framework of a small number of fixed rhetorical strategies employed again and again throughout the odes and linked by the laudatory function.

The basis of my negative hermeneutic is simply to indicate some of the major, often overlapping connections established in the poem and to suggest their partisan ideological import. The first and most dramatic connection between the felicity of this teenage athlete and the world beyond the racetrack is to associate the former with the political felicity of his homeland. The blessedness of Thessaly is boldly linked with the prosperity of the supreme power in Greece, Sparta: "Prosperous is Lakedaimon, / Blessed is Thessaly" (1–2). The specific basis for this political felicity is their form of government, inherited monarchy, traced to the same Dorian ancestor, Herakles: "From one [i.e., the same] father for both [Sparta and Thessaly] a race from Herakles best-in-battle rules royally [*basileuei*]" (1–3). The epithet of the founding patriarch Herakles—"best-in-battle"—emphasizes approvingly the military dominance particularly characteristic of the Dorian aristocratic regimes in general and of Thorax in particular, whose very name, "Breastplate," suggests his family's obsession with warfare. Given that Thessaly's ruler was not exactly a monarch by inheritance but was in fact appointed as *tagos* and to some extent constitutionally controlled (Larsen 1966: 40–41), this linkage may involve some special pleading.

Pindar's next association combines the site of the victory, the site of the victor's home (presumably), and the ruling family of Thessaly as jointly imposing the task of praise on the poet:

> Why do I boast unseasonably? Because Pythō [Delphi]—
> And the Pelinaian [a city of Thessaly] as well—cries out to me,

[35]In Hamilton's schema dashes indicate "a connection between parts" (1974: 89). The nature of the connections and whether there are connections with parts not connected by dashes are more or less moot points in his study.

> And the sons of Aleuas, wishing that for Hippokleas' sake
> I escort the voice of men that brings festivity and fame.
>
> (4–7)

The personification of places dramatically insists on a harmony of wills between the forces of nature (or better perhaps, the Hellenic physical/cultural environment) and the ruling human powers. It is this conjunction the poet offers as explaining and justifying his opening focus on political felicity. The meaning of the victory is thus first and foremost its meaning for the rulers of Thessaly.

The victory's public, panhellenic character as an advertisement for Thessaly and its regime, no less than for the boy victor, is next recalled in terms that echo the martial note of Herakles' epithet. The people to whom the proclamation was made are a "host," an "army" (*stratōi*, 8). Given the sixth-century military domination exercised by Thessaly over the Delphian Amphictionic League (Jeffery 1976: 74), the term is by no means politically neutral. At the same time, the military coloring of the term nicely anticipates one of the athletic specialties of the boy's father, racing "in the war-embracing armor of Ares" (13)—a good minor example of overdetermination.

The next major linkages are, given the extraordinary density of Pindar's text, already implicit in the opening lines. *Makaira* (2) suggests specifically divine blessing; Herakles, son of Zeus, implies the principle of divinely sanctioned transmission of excellence through birth. Thus when the poet's prayer explicitly links the boy's victory with Apollo's intention (10–12) and moves on to insist syntactically (*men/de*) on the concomitant role of ancestry, the audience has already been prepared for the point:

> Apollo, sweet grows both end and beginning for humankind when a god
> urges it on:
> By your devisings, I'm sure, he achieved this
> And the Inborn Something stepped in the tracks of his father—
> Olympian victor twice in the war-embracing weapons of Ares.
>
> (10–14)

The boldly personified abstraction ("the Inborn Something stepped . . . ," 12) insists that a universal principle is at work.[36] In the context of the opening (and, as we see below, the end) we cannot confuse this declaration with modern commonsense inferences about a

[36]Gildersleeve (1965: 352) prefers to see a less daring construction, taking *to sungenes* as an accusative of respect, a *varatio* for a dative of means. Here I agree with Farnell (1965: 215).

"born" athlete. The success of the victors, father and son, is offered as validation of an entire social and political hierarchy. The continuation of the prayer firmly links this success with an economic hierarchy as well: "May Destiny continue as their companion in later days / As well, so that heroic wealth blossoms for them" (17–18).[37] The imagery of natural growth here *(anthein)* tightens the links. It looks back to the initially weak metaphor of growth *(auksetai,* 10) in the gnomic declaration of divine involvement in the pattern of success and forward to the ringing finale, which proclaims that the Aleuadai "lift on high the Thessalians' state, / And make it grow [that is, prosper *(auksontes)*]" (70–71).

The end of the prayer associates the felicity the father and son have won in the games with an extremely abstracted vision of human (Greek) felicity in general: "Of the delights in Hellas / Their allotment is no small gift" (19–20). Burton, writing in the same year and thus without knowledge of Bundy, declares that "there can be little doubt that both *ta en Helladi terpna* in v. 19 and *aglaïais* in v. 28 denote in this context athletic glory" (1962: 6). Burton here, like Bundy (1962: 2, quoted earlier), is right to point to Pindar's usage in other poems as a basis for establishing this concrete aspect of much of Pindar's abstract diction. But both are myopic to ignore the fact that it is in this generalizing language, this crucially suggestive shift from the concretely athletic to the generally human (cf. *broton ethnos,* 28), that Pindar succeeds in insisting on the broader relevance of this particular 400-meter teenage dash. To insist by this maneuver that a peculiar physical activity, which the structure of economic life in Greece of this period substantially confined to the small class of males who could afford the leisure to train and the luxury of professional trainers, represents the summit of human happiness is supremely ideological.[38] As we have already noted, there certainly were those already in the seventh and sixth centuries B.C. who strongly disagreed.

The poet's prayer for the continued felicity of the family shifts smoothly into gnomic meditations on the limitation of human felicity inherent in the distinction between mortal and divine: "may they not

[37]The *kai* ("as well") seems to preclude interpreting the prayer as a wish that a poor or moderate family *become* rich, an inference one might easily draw from most translations. On the other hand, D. C. Young's emphasis (1985: 115–27) on the size of the material benefits resulting from winning could, in the absence of other indications of the established prominence of this victor's family, be used to suggest that future victories alone are the point of the prayer.

[38]Though, as noted, D. C. Young (1985) has effectively challenged the cliche of a total aristocratic monopoly, he has not, I think, succeeded in showing that a majority of the athletes in the early fifth century were likely to come from the small middle class. On the contrary, even he acknowledges that the really poor would be quite unlikely to compete (158–59).

encounter / Envious reversals from the gods. One heart-free of pain / Would be a god" (20–22). The image of the complete freedom of divinity from suffering functions on the eulogistic level as a foil for launching into a generalized declaration that the situation of the victor's father, who has both won victories himself and lived to see his son's victory, represents the absolute limit of *human* felicity:

> but fair-fated [*eudaimōn*] and an object of
> song that man becomes through poets,
> Who, after winning victory by the excellence [*aretai*] of his hands or feet,
> Seizes the greatest of prizes through daring and strength,
> And—still alive—
> Beholds his young son duly meeting with Pythian crowns.
>
> (22–26)

The term *eudaimōn* (22) recalls *daimonos* in line 11 and indirectly *makaira* in line 2; again the victor's felicity is linked with divine favor that extends to the political status of his homeland.

Pindar recapitulates his divine foil and his assertion that Phrikias has achieved the ultimate in human happiness by two images of journeying (*ambatos*, 27, and *eschaton ploon*, 28–29) that lead directly into the myth of Perseus' visit to the Hyperboreans:

> The bronze sky is never scalable [*ambatos*] for him:
> But as for such delights as we, the mortal race,
> grasp, he completes the sea voyage to the ultimate
> Point. Neither with ships nor if you went on foot could you find
> The marvelous way to the contest of the Hyperboreans.
>
> Beside them once upon a time Perseus, leader of the host,
> Feasted, coming on his way home,
> Happening upon them as they were performing glorious hundred-strong
> sacrifices of asses
> For the god. Continually in their festivities
> And prayers Apollo takes the greatest delight
> And laughs when he sees the towering arrogance of the beasts.
>
> The Muse does not leave town
> In response to their behavior: everywhere choruses of maidens,
> The cries of lyres and the piercing ring of flutes whirl around;
> And binding their hair with golden laurel,
> they carry on their revel harmoniously.
> Neither diseases nor destructive old age is blended
> Into that holy race. Without work or warfare

They dwell, scot-free from
Super-exacting Nemesis. But once upon a time there came Danae's son
Breathing with a daring heart—and Athena lead the way—
To the throng of these blessed men. And he slew
 the Gorgon, and the variegated head
Decked with locks that were snakes he came and brought for the island-
 dwellers
As stony death.

(27–48)

At least since the time of the scholiast, who pronounced this myth a
"senseless digression" (*alogōi parekbasei,* Drachmann 1964 [1903]: 2:
245), there has been considerable debate over its relevance to the eu-
logistic situation. Does it demonstrate the limitations of human success
or suggest the possibility for the victor of at least momentarily tran-
scending those limitations as Perseus did? This is a central issue to
which we must return, but an impressive range of scholars, culminat-
ing in Köhnken, have argued, to use Gildersleeve's words, that "the
land of the Hyperboreans is a glorified Thessaly" and Perseus is an he-
roic paradigm for the achievement of the victors.[39]

A rich array of verbal echoes and images imply these parallels. The
word Pindar uses to suggest the "gathering" (*agōna,* 30) also means
"contest" and recalls the *agōn* (16) that rendered Phrikias victorious.
Perseus shares in a banquet (*edaisato,* 31) including a sacrifice (33–34).
The lifestyle of the Hyperboreans is characterized by choral poetry,
lyres, and flutes (37–39). The banqueters bind their hair with garlands
as they make merry (40). Of these details, only the choral song (6, 53,
55–57, 65) is specified in text, but it is a reasonable inference that each
has an analogue in the setting and occasion of Pindar's ode. The Hy-
perboreans are a "holy race" (42), and the occasion of the ode inspires
Pindar to pronounce Thessaly "divinely blessed" (*makaira,* 2). Perseus is
a "leader of the people (or host)" (*lagetas,* 31), despite the fact that all
salient features of his myth deal with individual actions. As a rough
equivalent of "heroic king," the term echoes the explicit political focus
of the opening and anticipates that of the ending. Apollo, the god at
whose games the victory occurred and to whom it is in part attributed
(10–11), is prominently featured in the myth as the crowning element
in Hyperborean felicity (34–36). Perseus comes "breathing with a

[39]Gildersleeve 1965: 350, J. H. Finley 1955: 28, van Groningen 1958: 350, Burton
1962: 8, D. C. Young 1971: 35, and Köhnken 1971: 158–87. Of all the authors who have
noted various parallels between the eulogistic context and the myth, Köhnken is by far
the most detailed. By comparison, I offer only a discrete little sampling of the possible
evidence without further acknowledgment.

daring heart" (44); the victor "seizes the greatest prizes through daring and strength" (24). Perseus is the son of Danae, and Athena leads him (45); the victor trod in his father's footsteps and won by Apollo's devices (11–12). Finally, lest the audience fail to get the point of their divinely endorsed privilege, Pindar sums up Perseus' visit as coming to a "throng of . . . blessed [*makarōn*] men" (46), having earlier, as we noted, declared the victor's homeland "blessed" (*makaira*, 2).

Just as the required gnomic element lifts the specific athletic victory into an abstracted, universalizing vision of general human felicity, so the anticipated myth functions on one level to exalt the victory into the category of permanent cultural exemplars.[40] The implication is thus present that today's ruling class are worthy successors to the paradigmatic figures of the past, an idea already adumbrated in the initial allusion to ancestry traced from Herakles. The past to this extent validates the status quo. The emphasis on the justice of the Hyperboreans (44) looks forward to the explicit praise of the Thessalian regime as characterized by "an upright mind" (67–68). So the presence of the Muse among the Hyperboreans facilitates the association of the ruler's solicitude for the poet (64–66) with the uprightness of the entire regime, which itself is offered gnomically in the final lines as representative of the general superiority of inherited aristocratic political regimes:

I have confidence in the kindly hospitality of Thorax, who in solicitousness
 for my favor,
Yoked this four-horse chariot of the Pierians [Muses],
Loving one who loves him, leading one who leads eagerly.

On the testing touchstone gold shines forth
And the upright mind.
And we shall praise too the noble [*eslois*] brothers, because they lift
On high the Thessalians' state [*nomon*],
And make it grow [*auksontes*]. In the hands of the good [*en agathoisi*] rests
The careful steering of cities, handed down from father to sons [*patrōiai*].
(64–72)

The preceding points in my negative hermeneutic are all elements which in principle Norwood or Moses Finley might cite in an indictment of Pindar the "toady," Pindar the "muddle-headed reactionary." The raw material, so to speak, of this demonstration is also what proponents of the purely panegyric approach might cite in defense of Pin-

[40]For omission of myth or substitution of a compensating element in the structure, see Hamilton 1974: 39 and D. C. Young 1971: 34.

dar's fundamentally coherent and artistically adroit praise of the victor—minus, of course, the irksome intrusion of such notions as politics, class, and ideology. Although my own approach eschews a precipitous rush to judgment, I do maintain that none of these elements is truly extraneous to the text of the poem, and a definition of poetry that can give no account of them is, for me at least, inadequate.

The Positive Hermeneutic

In turning to a positive hermeneutic of *Pythian* 10, I should perhaps disabuse the reader at the outset: I do not succeed by some dazzling critical or rhetorical sleight of hand in transforming Pindar into a crypto-revolutionary. What is at stake, I must repeat, is the spontaneous acceptance of the ruling-class version of reality as the only reality. The nearest thing to a subversive activity I attribute to Pindar is the self-consciousness of his affirmation that he alone as poet controls access to that realm of full gratification which might otherwise appear as the automatic consequence of inherited wealth, political power, and athletic success. Moreover, what is most shocking in Jameson's theorization of the double hermeneutic is that fundamental aspects of what is negative are simultaneously positive. Most centrally, the utopian image of the ruling elite as a perfect community—the most obviously "toadying" aspect of the poem—is, from the perspective of the long struggle for human freedom, the dimension that most distances the poem from the actual status quo and offers us a realm of freedom to appropriate and extend well beyond its putatively intended ideological function.

But before looking more closely at the obviously self-conscious aspects of Pindar's posture toward his audience or reconsidering its most clearly utopian dimensions, it is essential to consider all the less conscious elements in his epinician, which, by virtue of their formal effectiveness, distance it from that spontaneous reflection of ruling-class reality so readily attributed to it by Pindar's politically minded detractors.

Though we have no direct access to the language by which the rulers of Thessaly or the rest of Greece constituted their version of reality, we may plausibly surmise that it was not Pindar's language. Obvious and not so obvious aspects of Pindar's language dramatically distance it from any imaginable spoken language and mark it as a vehicle for the constitution of a different sort of reality. We have already noted that Pindar's formal metrical patterns represent one of the most striking factors (perhaps more significant even than the irretrievably lost music and dance patterns) differentiating his language from the everyday

language of the ruling class.[41] *Pythian* 10, like thirty-eight of his extant forty-four epinicians, is arranged in elaborate triads, with metrically matching strophe and antistrophe, answered by an epode that recalls but does not repeat their metrical form. As noted earlier, Pindar combines various traditional metrical cadences so unpredictably that no extant complete poem has precisely the same structure. Metrically, then, the poem is simultaneously both monumentally ordered and disorientingly free. In *Pythian* 10, the so-called choriambic nucleus (long/short/short/long) of traditional Aeolic meters recurs once or twice in every line of both strophe and epode, but the amplifications before and after the nucleus are different in every line in such a way that sometimes, we imagine, it may evoke traditional folksong Aeolics, and other times it may seem to shift into a dactylic cadence.

In the handling of the triadic pattern there are in this presumed earliest poem recognizable pauses in sense between triads. Yet parallel optatives *hepoito* (17) and *epikursaien* (21) imply that we are meant to understand the prayer begun at line 10 continuing into the second triad and ending at line 21. Though we do not find in *Pythian* 10 the really extraordinary enjambments that characterize some of Pindar's greatest poems (Mullen 1982: 93–98), certainly "Olympian victor" (13), "Muse" (37), "The gods bringing to fulfillment" (*theōn telesantōn*, 49), and "testing" (*peirōnti*, 67) clearly gain in emphasis from their position as the initial words of epodes, strophes, or antistrophes. The tension created and played with between the repeating triadic structure and the linear movement of laudatory argument is a further distancing factor that sets the poet in a position of control and sets the audience in a posture of tantalized dependence.

Pindar's diction, syntax, imagery, and mastery of rhetorical tropes render his language easily the most complex and demanding in Greek literature. Given the extent of our losses, we can never be sure that a word occurring for the first time or only in Pindar is a true neologism, but the list of words which seem to fit this description in so early a poem is striking. Some are new compounds built on a clear Homeric model: "best in battle" (*aristomachou*, 3), "foot-victorious" (*kratēsipoda*, 16), "host/people-leader" (*lagetas*, 31); some are poetic abstractions, pointing the path to the diction of the Sophists: "turnings-after" (sc. reversals) (*metatropiais*, 21), "fair-speakings" (*euphamias*, 35), "steerings" or "pilotage" (*kubernasies*, 72), to which should be added the poetic abstraction formed by the article with the neuter adjective, *to sungenes*

[41]This comment in no way disparages the fascinating explorations by Mullen of the dialectic of dance pattern and meaning. Mullen himself (1982: 43–45) has given the best explanation of why there is no dance notation; his most perceptive insights presuppose the dominance of the still very observable metrical pattern (see his chap. 3, "The Triad").

(12).[42] Some of these neologisms seem merely simple realizations of linguistic potentialities of ordinary Greek: "singable" or "song-worthy" (*hymnētos,* 22), "super-just" or "super-exacting" (*hyperdikon,* 44), "without offering evidence" or "obscure" (*atekmarton,* 63). But these potentialities were apparently unrealized by earlier authors. The verb "leave town" (*apodamei,* 37) appears an almost coy, playful coinage in conjunction with litotes.

Some dozen particularly Homeric words and expressions add a distinctly epic flavor to the language of *Pythian* 10, but Pindar does more than evoke a general aura of the epics.[43] A phrase such as "breathing with a daring heart" (*thraseiai pneōn kardiai,* 44) points in the direction of his characteristic allusive posture toward epic formula: it recalls the Homeric formula "breathing might" (*menea pneontes*), which always occurs in the nominative plural. The word *apēmon* in line 23 occurs only once in the nominative in Homer (in Thetis's poignantly futile wish that Achilles might "sit by the ship free of tears and free of suffering," *Il.* 1.415–16). For an audience brought up on Homer, it is not too much to suggest that the word carried connotations of the paradigmatic Greek embodiment of mortal limitation. The word *kanakhai* is used in Homer of clashing weapons, the ominous tramping of an army's feet, the gnashing of teeth. Pindar's use of it to evoke the sound of flutes in a joyful celebration transforms its menacing connotations. His use of the Homeric *agēnor* (Doric *aganor,* lit. "very manly"), usually the attribute of bold or excessively confident heroes, to describe the exceptional wealth of the victor's family lends a note of moral ambiguity that nicely anticipates the subsequent reference to envious reversals from the gods (Méautis 1962: 37).

One must resist the temptation to try to spell out all the subtleties of Pindar's language, a favorite occupation of the belles-lettrist school.[44] These few examples must suffice. The net effect of Pindar's language is surely a dazzling display of the poet's unique power over the medium

[42]See *LSJ* s.v. IIc, where *Pythian* 10 is the earliest instance of a coinage that apparently appealed to Aeschylus, Sophokles, and Thucydides. Snell (1960: 227–28) ably comments on the great convenience for the development of scientific thought of abstractions made from the article with a verb or adjective. The point was first brought vividly home to me in lectures by E. A. Havelock, but a perusal of his published corpus has not yielded precisely the point I seek.

[43]E.g., "glorious" (*klutan,* 6); "manly" (*aganora,* 18); "free from pain" (*apēmon,* 22); "brazen sky" (*khalkeos ouranos,* 27); "scalable" (*ambatos,* 27); "accomplishing glorious hecatombs" (*kleitas hekatombas . . . rhezontas,* 33); "beasts" (*knōdalōn,* 36); "clashings" (*kanakhai,* 39); "destroying" (*oulomenon,* 41); "came" (*molen,* 45); "slew" (*epephnen,* 46); "floss"/ "flower" (but see Raman 1975) (*aōtos,* 53); "eagerly grasped" (*harpaleon,* 62); "bustling about" (*poipnuōn,* 64).

[44]For a particularly fine recent demonstration of Pindar qua jeweler of language at the level of stylistic devices, see Race 1989.

that most fully constitutes human reality. He can create new colloca-
tions, evoke and transform the authoritative world of Homer, extend
the potentialities of ordinary syntax so that his language, like his meter,
tantalizes with its simultaneous display of freedom and extraordinary
control. The power of this language is the real validation of Pindar's
claim to bestow something unique on the victor and his class. The grat-
ification it offers is simultaneously an overwhelming negation of the
discourse controlled by the ordinary members of the ruling class. Pin-
dar can justifiably imply that he alone as poet lifts the victor, his home-
land, his family, and his class out of the limitations of *their* reality into
a fuller state of being: "Fortunate [*eudaimōn*] and celebrated in song
[*hymnētos*] that man becomes [*ginetai*] *sophois*" (22–23). How are we to
understand this dative *sophois*? Most translators and commentators ei-
ther separate it from *eudaimōn* and take it as dative of agent with
hymnētos (e.g., Puech, *"Heureux et digne d'être chanté par les poètes"* 1970
[1922]: 2:147) or respect the word order and take the dative as a weak
dative of interest (e.g., Gildersleeve, "is accounted in the eyes of the
wise" 1965 [1890]: 353, or Farnell, following the scholia, "becomes in
the opinion of the wise," 1965 [1932]: 217). But Burton rightly sees in
the phrase "a further hint of the necessary connection between victory
and song" (1962: 6).[45] The actual construction boldly implies that the
man's achievement of true blessedness *depends* on his being celebrated
in song by skilled poets.

Bundy and his disciples have been at pains to stress that the persona
of the poet (what Hamilton designates "the Poet's Task") in the epin-
ician is entirely subordinated to conventional strategies of praise such
as insisting on the sincerity of the *laudator,* the bond of true friendship
between the *laudator* and *laudandus,* abjuring exaggeration, offering re-
assurance about the long-term efficacy of the praise, and so forth
(Bundy 1962: esp. 3, 40). But even granting the general legitimacy of
this approach, I am still struck by the relative prominence and boldness
of Pindar's self-presentation in comparison with our only basis for
comparison, Bacchylides. To be sure, there is less of Bacchylides, and
many of the epinicia we have are fragmentary. But in none of the rea-
sonably complete poems is there anything comparable to the propor-
tionate focus on poetry and the poet even in *Pythian* 10, which is by no
means Pindar's most self-reflexive poem. In addition to four first per-
son verbs (4, 55, 64, 69[pl.]), two emphatic first-person pronouns (4,

[45]For some parallel translations, see Bowra, "that man is happy and poets sing of him"
(1969: 22); Lattimore, "blessed, worthy of the poet's song, is that man" (1947a: 87); Nis-
etich, "worthy of song" (1980: 216). Farnell adds to his preferred rendering a second
possibility, "the dative may go directly with *hymnētos,* 'besung by the craftsmen of song' "
(1965: 217). The scholia reads *para tois sophois ginetai* (Drachmann 1964: 2: 244).

48), and an emphatic first-person possessive adjective (56), we find about thirteen lines out of seventy-two with a primary focus on the poet, poetry, or music (6, 22, 37–39, 51–57, 65).[46] Although two Bacchylides fragments (14 and 26 Snell) speak of *sophia* in terms that may imply poetry, *sophos* is used in his epinicia apropos of a skilled athletic trainer (13.201), in a priamel (Bundy 1962: 4–5) describing various sorts of human *epistēmai* (10.39), and in a simile comparing himself to a skilled helmsman (12.1). In this last case most obviously, but in the other two probably, we may suspect a coy self-reference. But nowhere in Bacchylides is there the blatancy with which Pindar uses *sophoi*, just as Xenophanes uses *sophia*, here and in later poems to arrogate to poets all skill and wisdom absolutely.

This simultaneous display of and insistence on poetic power is not politically neutral. Like the poet of the *Odyssey*, Pindar consciously distances himself from his audience in proclaiming the specialness of his powers as a poet. This distancing is not so much bridged as underscored by the numerous metaphors scattered through his poems which imply a parallel between Pindar's poetic struggles and those of athletic competitors. Pindar's prowess is in the sphere where his patrons must be presumed most inferior to him. In *Pythian* 10 Pindar celebrates a relatively modest victory in a boys' footrace, but for his own poetic act he chooses as metaphor by far the most prestigious of all contests, the four-horse chariot race (65).

To be sure, Phoinix in the *Iliad* ranks speaking along with deeds of war in the making of a hero (9.443). But even the extremely articulate Odysseus resorts to brute force when meeting a verbal challenge from someone outside the ruling elite (*Il.* 2.265–66). Pindar's consciousness about the power of speech is (regardless of his class loyalties) inextricably bound up with concurrent intellectual and political developments inimical to the interests of the old aristocratic regimes. Pindar in 498 B.C. is composing some ten years after the emergence of democracy in Athens, a development sufficiently threatening to tempt the concerted oligarchic powers of Sparta, Euboea, and Boeotia (Pindar's homeland) to seek to crush it militarily (Herodotus 5.74–78). Pindar was a contemporary or near contemporary of Simonides, Herakleitos, Xenophanes, and Pythagoras—all figures who in varying ways valorized critical, articulate thought to an extent that spelled the end of any spontaneous ideological hegemony exercised directly by the old ruling class. Not only is Norwood's characterization of Pindar as

[46]*Me* in 4, though syntactically in the unemphatic second position of its own sentence, gains emphasis by answering the first-person rhetorical question preceding it. *Emoi* in 48 is emphatic both by position and form. Cf. Bacchylides 3.57 (Snell) for the same sentiment without the personal reference.

philosophically ignorant and intellectually obtuse inherently improbable, it ignores the extent to which the very function of traveling poets and intellectuals made them the cutting edge of ideological struggle. Regardless of the help they may have extended to the ruling element, the relative autonomy inherent in their superior mastery of verbal communication and their role in the growing self-consciousness—in an age of spreading literacy—about the *constitutive* role of speech in the perception and presentation of reality rendered them a progressive force.[47] That they *could* help the ruling class was the most dramatic proof that the ruling class needed help.

If then the conventional focus on the poet's task emerges in Pindar as a two-edged weapon, concomitant with the exalting and distancing function of his language and meter, so too the required gnomic element lifts the power and felicity of the ruling-class figures into a universalized context which at the same time defines their limitations. It is not accidental in *Pythian* 10 that the affirmation of the poet's power is so intimately linked with the evocation of divine arbitrariness: the ruler's / victors' felicity is a gift of the gods, but the gods may take it away (19–21). Though the explicit *phthonos* motif invoked in *Pythian* 10 is relatively rare in Pindar, the opposition between the insecurity of the future and the confident assertion of the poet's power to memorialize the present moment of felicity is a central feature of virtually all the epinicians.[48] In *Pythian* 10, the potentially ominous allusions to "Fate" (*moira*, 17), to the possibility of envious reversals from the gods, and the reminder of suffering as endemic to the human condition (17–22) constitute a distinctly threatening foil to the bold linkage of human blessedness with celebration by poets (22–26) discussed above. The subsequent gnomic statements insist in turn that this felicity, the plenitude of which is so dependent on the poet, is the ne plus ultra of pleasure accessible to the human species (*broton ethnos*, 28):

> The bronze sky is never scalable for him:
> But as for such delights as we, the mortal race,
> grasp, he completes the sea voyage to the ultimate
> Point. Neither with ships nor if you went on foot could you find
> The marvelous way to the contest of the Hyperboreans.

> (27–30)

[47]For detailed discussion of the Presocratics, see *HGP* vols. 1 and 2. See also Havelock 1982: 220–60. That Pindar must be seen as a precursor of the Sophists is rightly stressed in Lefkowitz 1976a: 172; see also Farenga 1977.

[48]Farnell (1965: 471–72) is at pains to dismiss it as a *façon de parler*, but Burton (1962: 5) rightly recognizes it here as a more blatant form of a recurrent Pindaric *topos*.

Thus the most categorical statements of the felicity of the victor and his father are sandwiched between two equally categorical generalizations that insist on human limitations. Both syntactically point to their special relevance for the addressees of the poem (*autōi*, 27; *heurois*, 29).

To return to the myth, this expected if not obligatory element in the conventional epinician involves by its very nature an ambiguous transcendence of the ruling-class vision of reality. I have suggested several ways that the myth's parallel to the circumstances of the victory and the victory celebration constitutes an intensely partisan effort to validate the social, political, and economic status of the victor, his father, and their supremely powerful friends, the Aleuadai. But the scholarly debate over whether the myth stresses the godlike felicity of the *laudandi* or constitutes a demonstration of the mortal limitations of that felicity is naive only to the extent that participants seek to impose a univocal message on the text—*either* a simple exemplar *or* a simple sermon.[49] The rich suggestiveness of analogical thought is inevitably bought at the price of a high level of inherent ambiguity (Lloyd 1987 [1966]: esp. 385–87; D. Steiner 1986:12). Here, in his earliest extant poem, Pindar is already extremely aware of the "hidden rocks" threatening too full an exploration of his mythic analogy (cf. 51–52). His metaphor of the flitting bee invokes a poetic goal of touching only the relevant details (53–54), but no speaker using an analogy can escape the fact that whatever is illuminatingly similar sheds that illumination by virtue of being significantly different. Moreover, we have already noted that the form in which Pindar chooses to introduce his mythic analogy confronts his audience first with a difference posited as both absolute and of fundamental importance. The inaccessibility of divine felicity is the point of departure for a myth containing so many hints of godlike felicity achieved by the victor and his company.

Perhaps the most fundamental noncorrespondence of the world of the Hyperboreans to Thessaly is the temporary nature of the latter. The divine participation of Apollo in the Thessalian felicity is only a supposition ("I'm sure" or "I suppose," *pou*, 11) in regard to a single achievement; but among the Hyperboreans, Apollo's pleasure is "permanent," "fixed" (*empedon*, 34). Within the myth, the temporary character of the human hero's participation is twice stressed ("once upon a· time," or simply "once," *pote*, 31, 45). In the poet's praise of the victors, the stress on the precarious, temporary nature of their felicity is, as we

[49]Among those insisting on the sermon approach (even after Köhnken's mighty assault) must be numbered Radt, who in his review of Köhnken singles out this point on which to chastise him (1974: 119).

have seen, the point of departure for the myth. It recurs emphatically in the gnomic elements following the myth:

> Of the things each man drives after,
> Let a man, if he wins it, keep it a dear thought beside his foot;
> But what will come a year from now there is no clue to foresee.
>
> (61–64)

Even the detail of the golden garland suggests not only the transcendentally superior wealth of divine felicity but immortality in contrast to the ephemeral foliage of human banquet garlands or victory wreaths (26, 58, and J. H. Finley 1955: 53–54). Similarly, the litotes of *ouk apodamei* ("does not leave town," 37) followed by *pantai* ("on every side," 38) suggests that poetry is a pervasive and permanent feature of the Hyperborean mode of life.

The explicit catalogue of human ills from which the Hyperboreans are free (disease, aging, work, warfare, and "super-exacting Nemesis," 41–44) is the chief barrier in the text for those who wish to emphasize only the parallels. In the nonmythic portion of the poem, we have noted the apparently unqualified validation of the reliance of the Thessalian regime on military domination. To present freedom from battles as characteristic of absolute happiness does constitute a qualification, a partial negation of this aspect of the political order. Human aging too is indirectly alluded to in the praise of the victor's father for living to see his young son's success: the collocation "living [subject] still young [object]" (*zōōn eti nearon*, 25) is not without a touch of pathos. The climactic placing of Nemesis, further emphasized by the apparent neologism *hyperdikon* (44), cannot be explained away as simply a periphrasis for death, in which case it emerges as only a weak gloss on the freedom from aging.[50] It is much more appropriate, I think, to see in it an echo of the "envious reversals from the gods" (22–23). The envy of the gods is directed precisely at extreme human felicity, which they tend to punish with a reversal of fortune. To offer an image of supreme felicity that specifically escapes this danger is thus a further implicit negation and transcendence of the illusory and relatively precarious status of the rulers of Thessaly. If we say that the nonmetaphysical implications of *phthonos* and *nemesis* are envy and resentment not from the gods above but from human rivals lower on the social and political hierarchy, the relevance of the motif is more ideologically pointed.

To this extent, then, the myth projects a genuinely utopian vision; it embodies that transcendent negating "promesse de bonheur," which

[50]Cf. Köhnken 1971: 163–65—another argument challenged by Radt (1974: 119). Köhnken cites, but essentially ignores, those who relate *Nemesis* to *phthonos* (163).

Stendhal, echoed by the Frankfurt School, attributed to all true art
(Jay 1973: 179). Its laudatory function by no means exhausts its mean-
ing, for it explicitly evokes a realm of freedom available neither to the
rulers of Thessaly nor to their subjects.

Two aspects of the myth have especially troubled commentators con-
cerned with exploring its relevance to Thessaly and the victors. One is
the laughter of Apollo at the donkeys about to be sacrificed and, more
specifically, the meaning of *hubrin orthian* (36). The second is the pow-
erful sketch of the kernel of the Perseus myth, the slaying of the Gor-
gon, the revenge exacted by turning Polydectes and his followers on
Seriphos to stone. Most readers have taken *hubrin orthian* to mean that
the donkey have erections. Bowra in his translation neatly combines
this sense with the more general moral connotations of *hubris:* Apollo
"laughs as he sees / Their beasts' high-cocked presumption!" (1969:
22). On this view, Apollo's amusement at their proverbial lasciviousness
reflects his capacity as god of restraint; he laughs morally because they
will soon be punished.[51] Köhnken, presumably not out of the "prudery
of schoolroom philology" mocked by Wilamowitz-Moellendorff (1966
[1922]: 127 n. 3), has recently launched a heavy barrage at the erection
construction. Reviving an argument at least as old as Mezger (1880:
258), he cites other instances of *orthios* in Pindar that refer to pitch and
cites passages in other authors complaining of the harshness of bray-
ing. He then argues that this passage in *Pythian* 10 is a pointed foil to
the following focus on poetry. Apollo, the god of harmony, laughs at
the imminent punishment of the donkeys' disharmony (Köhnken
1971: 161–62).[52] Both views attribute a somewhat sinister moral force
to Apollo's laughter: he enjoys the prospect of repressing their "evil" by
death.

The first part of the passage on Perseus is relatively easy, as we have
seen, to integrate with praise of the victor's boldness, aristocratic de-
scent, and divine favor. But is the hauntingly powerful sequel mere
background, a sort of poetic footnote to Perseus' visit to the Hyper-
boreans (cf. Burton 1962: 9; Wilamowitz-Moellendorff 1966: 126)?
Certainly the intensity of horror and the immediacy of death it evokes
mark one of the sharpest nonparallels to the competition of young
boys on the race track. It is possible to dismiss the problem by simply
stressing that mythic paradigms in Pindar are inherently partial or by
pointing to the playful hyperboles in the fragments of Simonides'

[51]Van Groningen (1958: 350 n. 3) cites and rightly rejects the view of earlier scholars
that the reference reflects the poet's light-hearted chiding of his hosts' lascivious com-
portment. He states flatly, however, his own despair of making any sense of the passage.
[52]Like Gildersleeve (1965: 354), I do not find "as he *sees*" (*horōn,* 36) as easy to dismiss
as Mezger and Köhnken seem to.

epinicia. I prefer to see the two passages as related to each other and integrated into the various dualities I have been pointing to in the poem. Just as Apollo's laughter offers an image of the simultaneous enjoyment and cheerful suppression of raw, animal sexuality to be sublimated as poetry and song, so the kernel of the Perseus myth evokes the darker joy of the hero's violent and murderous suppression of female and male sexual threats.[53] These two passages, read in conjunction, mark in Pindar's vision of an ampler realm of being the projection of intense censorship against the very erotic energy that itself engenders the utopian impulse.

But what is censored even in utopia is within the poet's power to bestow in the real world of the athletic encomium. The songs of the poet invest the victor with enhanced sexual attractiveness to both men and women:

> I hope that, as the Ephyraians
> Are pouring forth my sweet voice round about the Peneios [Thessalian
> river],
> I shall make Hippokleas even yet more admirable
> With my songs for his crowns in the eyes both of
> his age mates and too of those who are older,
> And make him a source of love-pain to maidens. For it is true
> That passions for different people chaff different minds.
>
> (55–60)

Some commentators have been troubled by the explicitness of this gnomic statement, which seems to subsume all human wishes as various forms of erotic desire.[54] But that vision, as we have seen, is already implicit in the myth. The poet, like god and hero, can repress, sublimate, or inspire and fulfill desire.

History and the "Inner Logic of the Poem"

In the preceding application of a double hermeneutic, I have tried to respect the text of the poem and its formal dimensions, to permit, in Jameson's words, its "inner logic . . . to dictate the specific terms of its own interpretation" (1971: 333). The inner logic of *Pythian* 10 leads both to the fervent realization of aristocratic ideology in image, structure, argument, and to the transcendent negation of that ideology in its

[53]Here I am indebted to Philip Slater's brilliant and much-maligned work on Greek myth (1968: esp. 308–33).

[54]E.g., Burton 1962: 11, Farnell 1965: 219–20, and van Groningen 1958: 347–48.

celebration and demonstration of the poet's mastery of access to a realm of being free of pain and guilt, full of sensuous gratification, and quite beyond the limited reality of the Greek ruling class. Indeed, it is in the end a moot point whether the net effect of the poem is more a celebration of their power or his.

Historicizing in this sense includes a full acknowledgement of the poet's ideological function without reducing his poetry simply to a partisan political message. The pleasure that Pindar's poetry offers is neither apolitical nor a sort of seductive honey smeared on the cup rim to hide the bitter wormwood within. The pleasure of form both contributes to the effectiveness of the ideology and calls attention to its limitations by evoking a realm of gratification that transcends the power of those who rule the poet's world.

It would thus be false to conclude that only the elements of the positive hermeneutic have positive aesthetic interest and value. "Negative" and "positive" are not in this sense essentialist value terms. Although they imply taking a stand historically, because history continually changes the rules of the game, they do not define or confine the meaning or value of Pindar's poetry exclusively to its role in its own historical moment. There are in fact aspects of our contemporary ideological conflicts which render Pindar's poetic triumph as pure eulogist particularly appealing to those willing to read him. Late monopoly capitalism, especially in its phases of chronic crisis, frantically seeks to prevent us from making meaningful mental connections. It barrages us ceaselessly with a relentless compartmentalization, a radical fragmentation of every dimension of our social being (Lukács 1968: esp. 27). Private life is represented as radically distinct from public life, politics from economics, consumption from production, spiritual life from material life, and so on. In academia this is reproduced in heavily ideological efforts to sharpen and maintain strict boundaries between department, disciplines, and "terrains." Something very immediate in us, then, responds to the deeply integrative imagination of Pindar, who in contrast can articulate a vision in which the macropolitics of Greece, a specific athletic victory, divine governance, the force of heredity, the mythic past, heroic exemplars, and the intimate world of a teenage boy's sexual interest can all be harmoniously integrated with the diversity of human desires, the fragility of success, the warmth of a specific host, the world implications of poetry, and the ideal form of political constitution. The "linear argument" of the eulogistic function is in fact a point (J. H. Finley 1955: 6–8) where for a beautiful moment all the potential fragments of existence coalesce and sing. We need not adopt the content of the vision to be aesthetically enriched by the demonstration that such integration is possible.

That beyond this achievement Pindar also succeeds in exhausting and transcending the ideology of his class in a utopian affirmation of a higher order of being does enhance the aesthetic richness of his art. *Pythian* 10 is not the easiest of ancient texts to which one might apply this dialectical hermeneutic. Yet few literatures are as blatantly concerned with and implicated in the class conflicts of their societies as Greek and Latin literature. At the same time, few literatures display so self-consciously a belief in the relative autonomy of the artist. There is no pretense that a Sappho, a Solon, a Xenophanes, or a Pindar is not politically engaged; yet each, as a poet, sits in judgment on his or her society and evokes through artistic means a vision of a more profoundly gratifying world.

4

Aeschylus' *Oresteia:*
Dialectical Inheritance

Thus the act, once committed, passes into the structure of the
world itself, leaves its traces . . . and returns to confront the second
and third generations as an objective situation to which they are
not free not to react.

—Fredric Jameson
Marxism and Form

The move from Pindar to Aeschylus takes us from a world of
hegemonic oligarchs and tyrants to one recast by the invention of de-
mocracy, from the celebration of inherited excellence to the dissection
of inherited evil, from the form of choral lyric to the form of tragedy
and—even more decisive—of trilogy.

The Politics of the Tragic Form

We have seen that the invention of the epinician during the sixth
century involved the transformation and adaptation of communal
prayers celebrating gods and heroes into a form memorializing aristo-
cratic athletic victors. The impulse for such a gesture was undoubtedly
complex, but, as I have attempted to show, certainly the sense that the
political and ideological hegemony of the aristocracy was in jeopardy
was significant. Yet the overwhelming impression we get from the
surviving visual and written evidence of the Archaic period (taking
the term broadly) is of the successful domination of cultural forms by
the aristocracy. Aristocratic values and lifestyle proclaim their hege-
mony in the commemorative statues of young men (*kouroi*), the vase
paintings so dominated by scenes of symposia and heroic myth, the ep-
ics and lyrics that celebrate unique heroism in the past and loves and
hates of aristocrats in the present. We have attempted to demonstrate
how the alleged univocality of this tradition needs to be reevaluated,
how the voices of potentially counterhegemonic elements—traders,

colonists, hoplites, women, and bards—emerge in some of these texts, how a growing self-consciousness about the constitutive power of text production itself opened a significant gap in the apparently seamless fabric of aristocratic hegemony. Nonetheless, it remains true that the tragedies of Aeschylus have struck many readers as the first and in some respects only surviving frontal assault on that hegemony. Without foreclosing the possibility that the impression of such readers is simply false, I wish to inquire into the conditions of possibility of the emergence of this new cultural form and explore its relation to the surviving texts of Aeschylus.

Tyranny, as I have argued in the preceding chapter, is best understood as a consequence of the hoplite revolution. Newly empowered peasants were able to assert their power only indirectly through a champion, who himself was usually of the aristocratic class, but was prepared to check the worst abuses of the aristocracy in the name of some newly broadened conception of the political community (the polis). It is no accident that we are best informed about the domestic policies of Peisistratos in Athens.[1] He may have been typical or simply exemplary of the aristocrats' worst fears. He unquestionably infringed on the juridical, economic, and political powers of the aristocracy to the advantage of peasants and the urban demos (*Ath. Pol.* 16, with Rhodes's commentary *ad loc.*). But as Murray has pointed out, "In the age of the Peisistratidai, Athens was still a strongly aristocratic state" (1980: 253).

Tragedy arose in Athens from the uniquely imaginative struggle of the Peisistratids for hegemony on the cultural level (Else 1965: 49–50, 68–69; Andrewes 1956: 107–115). Why should a modest peasant ritual, devoted to a god who was either ignored or treated with condescension in aristocratic cultural productions (Guthrie 1954: 160) except in their exclusive symposia (Murray 1980: 199–200), become the most important state festival of Athens? Why in particular should it become the major vehicle for extending the influence of heroic, substantially aristocratic, myth? Any answer is at best a tissue of relatively fragile probabilities, but the question deserves at least as much serious attention as the exploration of the possible relevance of Chukchi sacrificial rituals of skull and thighbone offerings of Siberian hunters.[2]

[1]Herodotus (see How and Wells 1961 for references), the Aristotelian *Athenaion Politeia* (*Ath. Pol.*) 16, and Plutarch's *Life of Solon* are the most important ancient sources. In addition to Andrewes 1956: 100–115, see Murray 1980: 229, 253–54, French 1964: 30–58, and Snodgrass 1980: esp. 97.

[2]This is not to dismiss much of the exciting use of anthropology in recent work on the origins of tragedy. But I note the profoundly ahistorical or antihistorical bias that informs much of this work. An example from one of the brightest of this group: "The tra-

In analyzing Peisistratid cultural policy, the contradictory character of the solution chosen suggests the specific dangers of the initial problem confronting Peisistratos. Solon's achievement in ending debt-slavery and hektemorage for Athenian peasants had serious long-term implications for relations between classes in Athens (Murray 1980: 173–91; Wood 1989: 93–101). It seems plausible that these measures, combined with political changes—especially a council (*boulē*) independent of the aristocratic Areiopagos council—gave Athenian peasants a new and possibly unique sense of participation in the Athenian state and, for those who had land, a sense of independence profoundly linked with that ownership. At the same time, in the short run, bringing back to Attica ex-slaves who had lost their land and removing debts without a radical redivision of the land may well have exacerbated the sense of the gulf between rich and poor, particularly for the perhaps already numerous landless poor.[3] The fact of Peisistratos' two failed attempts at a tyranny before his final success certainly suggests that deep discontent remained. The fact that he succeeded only after gaining

dition of goat-sacrifice deserves to be taken seriously; it leads back into the depths of prehistoric human development, as well as into the center of tragedy. . . . It may be that the sublimation and transformation performed by the Greek poets are so fundamental as to reduce to nothingness any crude 'origins.' Or do the greatest poets only provide sublime expression of what already existed at the most primitive stages of human development? Human existence face to face with death—that is the kernel of *tragoidea*" (Burkert 1966: 121). This is the *conclusion* of Burkert's article. Whatever the merits of his research—and it is impressive indeed—one consequence is to offer instant relevance at the price of a reductionism that collapses as merely adventitious the difference between primitive hunting bands, fifth-century Athens, and contemporary Western capitalist societies. I suggest that a different sort of relevance, no less important, requires a precise consideration of those differences. The use of anthropological arguments about the origin of tragedy in Girard 1977, with its crypto-religious apologetics, strikes me as far less worthy of serious consideration than Burkert's. See the excellent critique of Girard by Suzuki, who concludes: "By claiming that acts of sacrifice and scapegoating are the crucial 'things hidden since the beginning of the world' and by purporting to reveal this secret, Girard's theory implicitly allies itself with religious revelation, at the same time privileging Christianity as the one religion aware of this secret" (1989: 7).

[3] A major problem with E. M. Wood's otherwise impressive analysis of property relations in democratic Athens is her almost exclusive focus on land-owning peasants, whom she regularly refers to as "the bulk of Athenian citizenry" (e.g., 1989: 138). Yet her own note 68 (193) cites with apparent approval an estimate (from A. H. M. Jones 1957: 8–9, 76–83) that *thētes* constituted 66 percent of the citizen population in the early fifth century B.C. and about 57 percent in 322 B.C. Even granting with Jones that the 20-minae cutoff point for *thētes* implies that some owned five acres or less of land, this still constitutes a substantial proportion of land-poor citizens. Jones may be right that "the great majority, from rich landowners to peasants working a tiny allotment, derived most of their wealth from the land" (1957: 90), but both he and Wood seem in general to downplay those who rowed the ships—for the "Old Oligarch" the essence of the democracy (pseudo-Xenophon, *Ath. Pol.* 2). Most of the rowers may have owned a tiny plot; but given the extraordinary amount of campaigning at sea during most of the period from 480 to 404 B.C., one would like to know if a majority really supported themselves primarily by farming.

access to substantial new capital in Thrace (*Ath. Pol.* 15.2, with Rhodes's commentary ad loc.) suggests the extent of the residual economic distress. Solon had articulated his attempted solution in essentially negative terms, to "check" or "restrain" (Solon 4.33–39, 9.5, 36.22, 37.6 West) both the aristocracy and the demos, eschewing, at least in the surviving fragments of his own account, any positive goal of a fundamental restructuring of society in favor of the demos. The only positive goal was to create a harmonious polis in which the class divisions were maintained with the minimum of friction.[4] Thus, on the one hand, the quest for an effective counterbalance to aristocratic cultural hegemony seems to explain the elevation of a specifically peasant festival devoted to a god respected by the aristocracy only in their cups. Indeed, to the extent that Dionysos blurs all hierarchical distinctions, including those of class, he emerges as ideally suited to the goal of building a sense of communal solidarity between all classes.[5] At the same time, one needs to explain the curious violation of the light-hearted, irreverent spirit associated with Dionysiac worship. The vast learning expended on the thesis that killing a goat (*tragos*) is inherently tragic significantly glosses over this problem. The addition of the satyr play and probably of comedy as well are probably best understood as concessions to the demos' sense that the new form with all its heroic legends had nothing to do with Dionysos (Else 1965: 18, 80). To be sure, the choice and handling of those legends may, as has been argued, illustrate a concerted effort to stress sacrificial elements (Burkert 1966: 116–20). But the form and content of Greek tragedy as far as we can reconstruct it for the sixth century and know it from the fifth involve a significant departure from Dionysiac celebration.[6]

Else's effort to understand the motive for this change by attempting to envision the affective dimensions of early tragedy is for me compelling. He raises the right question: what purposes are served by an art form that surrounds a single figure at the pinnacle of the social and political hierarchy with a chorus of ordinary citizens whose chief

[4]I do not question that the measures of both Solon and Peisistratos contributed to the development of democracy, but I do think it is important to stress that there is no evidence that either had any *intention* of altering fundamental property relations. As indicated earlier, I am persuaded by Murray 1980 and Wood 1989 that Solon in particular initiated both economic and political changes with decisive, if unforeseen, consequences. As Ste. Croix (1981: 96) points out, shifts on the political level can affect the economic relations between classes; democracy did so to the extent that it offered a partial defense against exploitation and even, through liturgies, achieved some generalized redistribution.

[5]Detienne 1979 has eloquently stated the case for Dionysos as transgression and scandal, but I am arguing here that his very liminality also made him a convenient figure to employ as social cement.

[6]Picard-Cambridge 1962: 60–101, Else 1965: 51–77, and Lesky 1972: 49–64.

action is sympathizing with him at the moment of his downfall? The single power figure is presented in his most accessibly human aspects, when the vastness of his power seems least enviable. The chorus is bound to him on terms that suggest the undesirability of such power for "mere" mortals. Moreover, the dramatization of the heroic myths most cherished by the aristocracy in a form that insists on their general human relevance enhances the collapse of class frictions which emerges as the primary goal of Peisistratos' cultural politics.[7] Indeed, it is perhaps not too much to say that the will to humanize, to universalize the sufferings specific to a ruling elite is the founding ideological gesture of the new tragic form. Failure to recognize this quest for the essentially human and universal as profoundly ideological lies at the core of most discussions of the politics of Greek tragedy (e.g., Macleod 1982: 131).

The addition of the second actor is seen by Else as simply facilitating the same goal. The second actor, he argues, would most often be a messenger whose capacity to bring information from outside would enable the interaction of king and chorus to pass through more emotionally engrossing stages as the true dimensions of his pathos become only gradually clear (Else 1965: 57, 86–87). Yet, even if we grant these advantages, the addition of another voice, by breaking the seamless dominance of discourse by the king figure, opens the possibility of a more critical distance toward the perspective of the ruler. It is surely not irrelevant then that this formal innovation is attributed to Aeschylus and occurs in a period *after* the fall the Peisistratid tyranny. In the only purely two-actor tragedies we have (Aeschylus' *Persians, Suppliant Women,* and *Seven against Thebes*) the second actor does more than bring decisive information from the world outside the ken of the chorus and ruler. In the *Persians* the messenger's news constitutes the critical reality that gives the lie to the dazzling catalogue of Persian forces (16–57) and confirms the worst anxieties of chorus and queen. The ghost of Darius levels a scathing criticism of the absent ruler Xerxes. The messenger in the *Seven against Thebes* gives scope for Eteocles to demonstrate not only the general moral superiority of his cause but also the strain of madness that vitiates his leadership (Winnington-Ingram 1977: 7–13). In the *Suppliant Women* Danaos adds a male figure to support the position of the female chorus to which the king must react.

[7]There is an undeniable element of circularity in this argument. In the absence of direct sixth-century evidence of Peisistratos' intentions, we deduce them from scattered, debatable, later data; then, looking at the resulting configuration, we find a kind of confirmation of the initial speculation. Obviously one would prefer harder evidence. But I submit that there is at least as much plausibility to this thesis as to all those elaborate interpretations that ignore historical evidence in favor of anthropological parallels.

The messenger in the same play does engage in direct conflict with the king, the first *agōn* of two individuals in extant drama.

But despite attempts to view the *agōn* of two individuals' as the essence of Greek tragedy (e.g., Girard 1977: esp. 44), Aeschylus rarely uses two actors in this way in the six plays securely attributed to him.[8] More politically suggestive in the light of Else's speculations about the Peisistratid form of tragedy is the fact that the agonistic element is overwhelmingly represented by the chorus in conflict with figures of authority—Eteocles, Pelasgos, Klytemnestra, Aigisthos, Apollo, Athena. We might tentatively conclude that the invention of the second actor amounted to an indirect subversion of the authoritarian pattern of a chorus dominated by their sovereign. By bringing new perspectives to bear on the pathos of the ruler, the second actor facilitated the transformation of the chorus, normally the representative of the demos,[9] from a sympathetic appendage swept up in the suffering of the ruler to an oppositional voice, deferentially questioning or openly challenging the ruler's version of reality. Conversely, the sympathizing role of the chorus could then be freely transferred, where appropriate, from the ruler to the ruler's victims—Iphigeneia, Cassandra, Orestes, and Electra.

The third actor, Sophokles' invention according to Aristotle (*Poetics* 4.16–17), represents a shift in the conception of tragedy best examined in discussing Sophokles. In any case, as Knox (1979: 39–55) and others have pointed out, Aeschylus' rare uses of this innovation exploit its shock value rather than its potential for dynamic individual confrontation. What is worth noticing here is that Sophokles' shift in focus from the dynamic interaction of chorus (primarily as meditative singer-dancers) and powerful actors (primarily as speaker-agents in iambic trimeter) toward a dominant focus on interactions of increasingly isolated individuals represents a political shift as well as an artistic choice.

Ascribing the invention of the trilogy form to Aeschylus is a speculation of which one must say, *se non è vero, è ben trovato*. But recent scholarship seems generally less excited by the trilogy form than an earlier

[8]I am troubled by the arguments in Griffith 1977 against the authenticity of the *Prometheus Bound* but have not yet made up my mind. An impressive paper by Thomas Hubbard at the annual meeting of the American Philological Association (December 1990) seems to meet a key metrical argument of Griffith's. I do not mean in any case to deny the great power of such scenes as the confrontation of Agamemnon and Klytemnestra or Pelasgos and the messenger. I wish here only to emphasize the relative rarity of such individual *agōnes* in extant Aeschylean drama compared to the importance of confrontations between chorus and an individual. For an analysis of the theoretical role attributed to conflict in tragedy, see Gellrich 1988.

[9]Like most cliches, this one has a solid basis in experience but requires so much caution and qualification in application that nothing can be predicted about any particular play on the basis of it.

generation. The issue is ignored or encompassed in an ahistorical, idealist formula. Older, more sympathetic views of the trilogy are summarized in the most negative terms and denounced along lines that seem to leave little room for taking the trilogy form to imply anything relevant to the interpretation of the three dramas considered as a unity. One scholar suggests in passing that "the sense of balance . . . may have been a reason for Aeschylus' apparent fondness for writing connected trilogies, where the reciprocal action and reaction of the first two plays could somehow be resolved in a final equilibrium in the third play" (Gagarin 1976: 59). But more characteristic of our historical moment is the open attack on views strongly associated with a progressive conception of the trilogy form. Thus Lloyd-Jones, for example, proclaims, "the cliché we have heard repeated all our lives, that the *Eumenides* depicts the transition from the vendetta to the rule of law, is utterly misleading" (1971: 94). This view is cited enthusiastically by another scholar as "forcefully" expressing his own "impatience" with the "nebulous allegorizing" he attributes to George Thomson (Vickers 1979: 435–36). A scholar who confines his lengthy discussion to a few lines of the *Agamemnon* nonetheless begins his study by donning armor to "combat the now popular imposition on Aeschylus of particular philosophies he did not hold (Hegelian historical optimism and a quasi-Christian regard for the redemptive powers of suffering)" (Peter Smith 1980: 9–10).

Although I have no stake in defending George Thomson at his worst or in shouldering the cross for a Christian reading of the *Oresteia,* I think it is quite inadequate to imply—as several modern scholars do—that it is simply naive to see any historical optimism in Aeschylus' choice and handling of the trilogy form.[10] The trilogy form insists on meaningful movement in time. The *Septem,* the final play of a trilogy, suggests that this movement was by no means necessarily such as to

[10]As I suggested in my introduction, the work of George Thomson, especially *Aeschylus and Athens,* weighs painfully on anyone who would attempt today to convince readers of the classics that Marxism has a valuable contribution to make to the understanding of the literature of ancient Greece. His slavish adherence to the anthropology of Morgan—compelling at the time Engels embraced it, but dated and utterly misleading in the procrustean form in which Thomson attempted to impose it on recalcitrant or nonexistent data—has done much to discredit Marxism. His readiness to find totemism, Orphism, or Pythagoreanism lurking behind every line has little indeed to do with Marx but has tended in the same direction. Finally, as Ste. Croix (1981: 41) has recently pointed out, Thomson's interest in and knowledge of history were inadequate to his chosen path. Yet, when all is said and done, Thomson too deserves to be seen in his historical moment—a moment when the ferocious hostility of the Right tended to reinforce the dogmatism of the Left. His egregious errors should be weighed against his impressive learning, indefatigable humanism, and a few valuable insights not accidentally related to his study of Marx.

inspire optimism in any glib sense of the term; but it does imply a kind of historical judgment, which, as we see, is highly relevant to the more complex historical vision of the *Oresteia* (Winnington-Ingram 1977: 42–45).

The *Seven against Thebes*, when compared with the *Oresteia*, suggests that the trilogy form itself underwent an evolution. Its earlier manifestations seem to have been confined to working out a pattern of crime and punishment through three generations (cf. *Sept.* 742–44). The moral and theological interest of this theme is frequently posited as inherent and self-explanatory. Yet its political interest, especially in the light of Solon's apparent role in articulating the theme (Lattimore 1947b: 174; Solmsen 1949: 107–23), merits some attention as well. To be sure, the generalizing tone of Solon—like virtually all Archaic poetry in the gnomic vein—offers propositions about the acquisition of wealth, divine punishment, self-delusion, and disaster which are potentially applicable to all human beings regardless of class or sex. But just as women are tacitly excluded from serious consideration, so in large measure are peasants and the urban poor.[11] Solon does envision the possibility of upward mobility, but only as the correlative of the prosperous man falling "unawares into vast and grim disaster," (13.67–70 West). He also praises himself for not giving too much to the demos lest they be corrupted by the moral pattern characteristic of the aristocracy (6; cf. 5.1–2 West). But the chief targets of his warnings about *hybris*, divine *dikē* in the form of *atē*, are the scions of wealth and power. As Aristotle summed it up, "in general, he [Solon] attaches the blame for the conflict to the rich" (*Ath. Pol.* 5.3):

> Of Wealth no manifest limit is fixed among men:
> For those of us now possessed of the greatest livelihood
> Speed on with redoubled drive. Who could glut them all?
> You see, it's the immortal gods that grant profits to mortals:
> But from profits arises the disastrous madness [*Atē*], whenever Zeus
> Sends it as punishment; and now one, now another gets it.
>
> (13.71–76 West)

Thus ends (presumably) the poem that offers at its outset dire warnings of punishment striking the unjustly rich suddenly like a violent storm (17–22). The fullest poetic force is committed to evoking this sudden and unexpected reversal of fortune for the criminals themselves. The doctrine of punishment visited on "their children, their

[11]Ste. Croix (1981: 129–30) notes that Solon 1.47–8 is the only reference we have from early Attica to the merchant and agricultural laborer.

children's children or their family thereafter" (31–32) seems tacked on—almost as a desperate afterthought to cover the manifest reality of the prosperity of the wicked. This much admired poem is too rarely related to Solon's more explicitly political indictments of the rich and powerful, whose arrogance threatens the destruction of the polis (4, 9; 33.5 West is especially interesting). To find the origin of tragedy and particularly Aeschylean trilogy in a Solonian meditation on the human condition without acknowledging that for Solon the human condition is perceived in eminently political and economic terms is to indulge in a kind of censorship (Else 1965: 34–38).

Although it is reasonable to assume that all Greeks, regardless of economic status, had a strong emotional involvement in their sons' prospects in life (concern for daughters is notoriously less obvious an inference; see Ste. Croix 1981: 101–3; Pomeroy 1975: esp. 69–70), it was the scions of the great aristocratic *oikoi* ("houses") who were most deeply committed to the whole ideology of inherited excellence and immortality won through continuity in the male line. Thus a doctrine that focused on the corruption inherent in wealth, that not only threatened the initial perpetrator of crimes with divine retribution but held out the prospect of disaster for his progeny, constituted a fundamental ideological attack on the aristocracy. A dramatic form that applies that doctrine to the body of myth from which the aristocracy in general and Pindar in particular draw the chief cultural support for its exalted status contains a distinctly anti-aristocratic bias. Thus, for example, a trilogy that presents the crime of Laios as a clear-cut choice of self-indulgence over the interest of the polis (*Sept.* 746–51), presents the crime of Oedipus as a madness (*paranoia*) stirring up a sea of troubles that threatens to engulf the polis (*Sept.* 756–61), and finally suggests that the strain of inherited madness in Eteocles threatens to vitiate all his admirable patriotic efforts and inspires fear "lest the polis perish along with its princes" (*Sept.* 764–65) is eminently political—whatever its other interests. Winnington-Ingram characterizes the politics here:

> If Aeschylus dramatized the salvation of a city which had been endangered by a *genos*, he could have had in mind a political process which had been carried to completion in his own lifetime. It had been a result, if not a purpose, of the constitutional reforms of Cleisthenes to disembarrass the political life of the city-state from the dangerous influence of the *gene*, the clans, with their loyalties and rivalries and feuds. The clans were an archaic element in the body-politic, deeply rooted in an earlier world and in its standards of value, inimical to the order of the *polis* and menacing its security. The Theban legend may have offered Aeschylus the opportunity of dramatizing this process of disentaglement. . . . The *genos*, an archaic

relic—a family of dynasts preoccupied with their wealth and privileges— endanger[ed] the state. (1977: 43)

In the context of the decisive changes wrought by democracy in the relations between aristocrats and the demos, the trilogy form implies a historical judgment—that the period during which the so-called heroes dominated societies was not a golden age meriting universal veneration but a bad time for the people at large, one that cried out—even as Solon cried out—for fundamental institutional change.[12]

Aeschylean Dialectics

The *Oresteia* is our only complete trilogy, but it appears from at least some of the more plausibly linked titles of lost trilogies that it was not the only trilogy to step beyond an implicit indictment of aristocratic rule. The combination of the *Judgment of the Armor*, the *Thracian Women*, and the *Salaminian Women* (Lloyd-Jones 1963: 456; Jebb 1962: 7: 19–23) suggests that dramatization of the heroic world of Ajax moved on to envision the creation of a new society in Cyprus under the leadership of the bastard Teucer. The *Danaid* trilogy, which like the *Oresteia* seems to have entailed a tyranny in the second play (Zeitlin 1990: 106 and n. 8), culminates in a marriage symbolizing a new dynasty. Given the probable date of 463 and the often-noted strong indications of democracy in the extant first play, it seems quite probable that this new order would have had far more the aura of a new political constitution than simply a purified monarchy. I hesitate to ascribe the Prometheus trilogy to Aeschylus, but (pace Lloyd-Jones 1971: 95–103) the surviving play suggests how prevalent notions of human progress had become at a time certainly not far later than Aeschylus' death.[13] If it is in

[12]Zeitlin rightly describes both the *Seven against Thebes* and the *Suppliants* as "centering on the problematic which is fundamental to Aeschylean thought and dramaturgy: namely the interrelationships of the *genos* . . . and the *polis*" (1990: 104) but defines the *genos* in completely apolitical terms as "family of origin, family of procreation." Although I agree that in the conflict of the sexes Aeschylus' trilogies move "towards modification, moderation, and forms of compromise or alliance" (103), I think his sense of the class menace of the specifically aristocratic *genos* to the polis is more accurately described by Winnington-Ingram.

[13]Griffith (1977: 252) concludes almost grudgingly that "the balance of probabilities continues to favor the traditional theory of a Prometheus-trilogy." He seems to prefer a date vaguely in the mid-fifth century but eschews as presumptuous any attempt to be more specific in dating the play before or after 440 B.C. (253). Dodds (1973: 5) defends an Aeschylean date for this view of progress along the same lines as Reinhardt (1949: 50–53), stressing the differences from explicitly sophistic versions of evolution. Moreover, Dodds subsequently uses the *Oresteia* as a basis for defending the evolutionary thrust of the *Prometheia* (1973: 43).

fact the last extant representative of the trilogy form, it implies that the inner dynamic of that form lies in the movement from negation of the old order to celebration of the new. Yet the very darkness of the *Prometheus* should warn us to expect no naive, uncritical endorsement of any order. The form qua form seems to insist only on meaningful movement in time, a movement away from the simple violence of the past. But whether the new order can or will realize its potential "progress" may be a very open question.

Friedrich Solmsen long ago (1949: 126–31; see also Clay 1969) suggested that the peculiar dialectic of the trilogy form manifested in the *Oresteia* presupposes neither Hegel nor Marx but is available full-blown in Hesiod's *Theogony*. The forward thrust of the evolution of the cosmos from chaos to the reign of Zeus is envisioned as a dialectic of crime and punishment rooted in the familial conflict of mother and son pitted against father. The threat of a perpetual round of new crime and new punishment is insisted on in Gaia's creation of Typhoeus (*Th.* 820–22), in Mētis's projected male offspring (*Th.* 897–98), and in Hera's less than satisfactory efforts at retaliatory parthenogenesis (*Th.* 927–29).[14] The movement from chaos to the realm of Zeus is presented as comprehensive, qualitative progress from the raw brutality of castration perpetrated by a mother-dominated son to a socially and politically advanced realm symbolized primarily by the subservient daughters of the all-powerful father: Athena, Eunomiē ("Well-Ordered Community"), Dikē ("Justice"), Eirēnē ("Peace"), and the Moirai ("Fates"), "who grant to mortal men the winning of both good and ill" (*Th.* 895–906; Solmsen 1949: esp. 34). The massive progress is dialectical to the extent that it is not simply incremental; the movement from castration of the father to ingestion of the children scarcely seems promising, much less straightforward progress, yet it functions as an essential move toward the ascendency of Zeus.

The forward thrust displays an inner logic of act and counteract in which the stakes are both sexual and political. To win kingship is also to win sexual potency. The resolution of the conflict in the third phase is correspondingly both sexual and political. The female element, defined as generative and mental by the terms of the poem, is no longer simply repressed but literally incorporated into the new order by the ingestion of Mētis ("Cunning Intelligence") and the extraordinary status granted Athena. At the same time, Zeus's new sons are all firmly allies. The new politics of Zeus combines persuasion and cooptation with the old final reliance on brute force. Symbolic representations of

[14]West rejects everything after line 900 as not part of Hesiod's poem, but the mythic patterns were surely known in the fifth century and associated with the Hesiodic version of the succession story.

the hyperbolic violence of the old order, the Hundred-handers, are won over to the new regime and given a new function as prison guards, that is, as guarantors of the permanence of the victory (Brown 1953: 1–48). Moreover, the defeated figures of the old order remain part of and to some extent efficacious in the new order: Ouranos is still the sky and Typhoeus produces certain baneful winds (*Th.* 869–80).

In the *Oresteia,* Aeschylus adapts the Hesiodic structure to a complex vision of the working out of historical change on the political and sexual levels. The *Agamemnon* fuses together a vague image of Homeric kingship with a sharply focused analysis of aristocracy—dominance of political life by the great *oikoi,* who transmit their power through inheritance. This regime is characterized as a world in which male crimes against children and women provoke an attempted usurpation by a dominant female, remarkable for her cunning intelligence, allied with a subservient male of the younger generation. The *Libation Bearers* explores the grim world of tyranny, in which intimidation and repression breed a second round of intrigue and assassination. On the sexual level, Aeschylus in a sense departs from the Hesiodic pattern insofar as the son and daughter here are already allied with the father against the mother and her young consort as in the realm of Zeus. To this extent, Aeschylus anticipates a crucial feature of the new order in the second phase, having already used the Hesiodic motif of child murder and ingestion in his first movement through the allusions to Thyestes' banquet and the murder of Iphigeneia (Clay 1969: 4). But in another sense, Aeschylus has tightened the dialectical character of the movement by, in effect, offering homologous permutations of the familial triangles exhibited in the first play (cf. Caldwell 1970: 88–91).[15] In the *Agamemnon* a father treats his daughter with ultimate hostility and is the object of hostility from the mother, who proclaims herself the ally (sc. the avenger) of the daughter. The mother effects her revenge by allying herself with someone of her son's generation—someone who, like her son, has grown up in exile—against the father Agamemnon. In the *Libation Bearers* we find in effect an alliance of son and daughter with the (dead) father against the living mother. The reversals may not fit our conception of progress; they are in a sense only alternative options in a family structure still conceived as the locus of violent hostility. Yet they echo the alliances of Zeus with Athena and Apollo as guarantors of the stability of the new regime of patriarchy at the same time

[15]Zeitlin 1978 covers much of the same ground in relation to Aeschylus' sexual politics, which I treat below. Here I am concerned primarily to demonstrate that the trilogy form as the vehicle for a progressive vision of cultural history has thoroughly Greek roots in Hesiod and that Aeschylus took full cognizance of these roots in his own handling of the form in the *Oresteia.*

as they offer dramatic symmetry with the first play. In the third play, a resolution is effected by what emerges as an alliance of a son figure (Orestes) with an affect-free father figure (Apollo) and a completely desexualized mother figure (Athena) against the collective representatives of the evil aspect of the mother (the Erinyes). These in turn are transformed by democratic persuasion into representatives of the good (fertile, nurturing) aspect of the mother (the Eumenides).

The *Eumenides* invokes as the final political stage of history Athenian democracy, characterized by courts of law and secret ballots of anonymous citizens. On the sexual plane, Hesiod's own solution, to the extent that it is represented by Athena, is the central vehicle of such resolution as is achieved in the *Oresteia*. The incorporation through Athena's effective persuasion of the female and potentially threatening representatives of the old order, the Furies, parallels the cooptation in Hesiod of the Hundred-handers, whose function as guardians of the achieved victory is analogous to the role of the Eumenides ("Kindly Intentioned Ones") in preventing future *stasis* (civil discord, revolution, factionalism) in Athens and fostering the fertility of the community.

In this rapid overview of the *Oresteia*, my limited purpose has been to demonstrate that perceiving in the trilogy form a dialectical vision of comprehensive, essentially positive change is not an alien imposition on the text of Aeschylus but a plausible reading of his chosen form and his specific, creative use of the Hesiodic model. Such a demonstration does not foreclose exploration of areas of profound ambivalence in the image of Athens that emerges from the trilogy as a whole. Indeed, I believe that it opens the possibility of such an analysis on a surer basis than glib attempts to exorcise the notions of progress and dialectic from the text entirely. Whether the vision embedded in the form entails a fully utopian critique or simply endorses the status quo is another question, which I address more systematically when my analysis is complete. But this question is in some sense present at every step.

Justice and Aeschylus' Presentation of Class

In the preceding discussion I have all but ignored the central feature of most discussions of the trilogy form in the *Oresteia*, namely, justice. *Dikē* is one of the first consequences and primary attributes of Zeus's victory in the *Theogony*, but it is at best an implicit issue in the earlier phase of the three-stage movement of the kingship-in-heaven narrative. More accurately, there is an implicit movement from raw revenge (*teisaimetha lōbēn, Th.* 165; *tisin* 210) to something like due process in the

realm of Zeus.[16] In the *Oresteia* the issue of *dikē*—what it means to whom, what relation it bears if any to the structure of reality—is pressed to the forefront from virtually the first lines to the last lines of the trilogy.[17] Yet the analysis of the issue of justice must be subordinated to the analysis of the political and sexual levels precisely because Aeschylus himself presents justice as a function of the political/sexual regime. Just as the *kind* of justice illustrated in the third play is intimately linked with the presentation of a specific image of Athenian democracy, so the kind of justice explored in the first two plays emerges as the consequence of the aristocratic, monarchic, and tyrannical forms of government, which in turn are also forms of gender politics.

The relativity of justice, the idea that it differs according to the nature of the political regime, is probably first made explicit by Plato's Thrasymachos (*Rep.* 338e1-3). Yet the concept is present in germ form in Hesiod's juxtaposition of his own divine conception of *dikē* to the *dikē* of the "gift-gobbling *basilēes*" (*Works and Days*, 39) of his home town (Wood 1989: 167). The idea is more clearly implicit throughout Herodotus' wide-ranging meditation on differing *nomoi* ("customs/laws"). It has been plausibly argued that a confrontation between the notions of *dikē* imbedded in the traditions of heroic myth and the specific institutions of democratic Athens is built in to fifth-century tragedy (Vernant and Vidal-Naquet 1988: 25–28). I believe such a self-conscious confrontation is fundamental to an understanding of the *Oresteia*.

In arguing that the trilogy represents different regimes of *dikē* in terms of a consistent conception of social and political class, I am most indebted to the work of non-Marxists Bernard Knox, John Peradotto, and R. P. Winnington-Ingram. John Jones's attack many years ago (1962; cf. Rosenmeyer 1982: 211–55) on the modern tendency to project uniquely conceived, fully rounded, individual characters onto the protagonists of Aeschylus merits transcoding into the language of ideology. The major obstacle to perceiving justice in class terms in the *Oresteia* is a contemporary class ideology focused on the fantasy of the fully formed, autonomous individual as the monadic starting point of any social aggregate. Indeed, on such terms society can only be conceived literally as an aggregate or conglomerate.

Thus, in the case of the *Agamemnon* most discussions of the issue of justice amount to a debate over free will versus determinism focused

[16]Compare West's commentary at 902 apropos of *Eunomiēn:* "It implies not so much having good laws, as a condition in which the laws are observed."

[17]Here I acknowledge my admiration for the rigor and subtlety of Goldhill's demonstration (1984) of the relentless focus on the "uncontrollable polysemy" (164) not only of *dikē* but of virtually every key term in the text. What I miss in his study is any sense of the historicity of this amply dissected crisis of meaning.

solely on the individuals Agamemnon and Klytemnestra.[18] Indeed, one scholar has not implausibly suggested that one could predict most scholars' entire view of the trilogy on the basis of their interpretation of the issue of Agamemnon's guilt in the first *parodos* (Peradotto 1969: 237). Vernant has raised some compelling reservations about conceiving the issue in such terms at that particular moment in Greek history (Vernant and Vidal-Naquet 1988: 49–84), and I believe that to discuss the issue of justice exclusively in terms of individual choice is to project a purely individualist question onto a problematic that is conceived and explored far more in terms of the behavior of a class vis-à-vis the rest of the community. But beyond the problem of our own possible historical biases, the very success of Aeschylus in creating vividly differentiated, memorable characters—one thinks especially of Agamemnon and Klytemnestra—has tended to obscure the strong generalizing thrust in the poet's presentation of the drama of Argos and Troy.[19] I would argue only that, like individualization in Homer, the uniqueness of Agamemnon or Klytemnestra emerges within the clear parameters of a limited set of typical textual elements juxtaposed, varied in intensity, and ingeniously combined.

The Lion Parable

The clearest proof of the self-conscious nature of Aeschylus' generalization of aristocratic character and the best introduction to the methods by which it is achieved is the parable of the lion cub, so brilliantly analyzed by Knox (1952: 27–38).[20] As another scholar has put it, "the

[18]A full doxography here is probably both unnecessary and impossible to achieve. I list some of the discussions with which I am familiar beyond those embedded in the commentaries of Denniston and Page 1957 and Fraenkel 1950; Reeves 1960, Lloyd-Jones 1962, Hammond 1965, Lesky 1966a, Peradotto 1969, Winnington-Ingram 1974, Mark Edwards 1977, and Goldhill 1984: esp. 29–33. I hope it is superfluous to add that, despite my feeling that the issue is generally conceived too narrowly by these scholars, I am still much in their debt for exploring issues of great complexity which are absolutely central to an understanding of the trilogy as a whole.

[19]Easterling 1973, Vickers 1979, Winnington-Ingram 1948 and 1974: esp. 15 n. 15, and Goldhill 1984: esp. 69–74 in varying ways offer valuable qualifications to the rather mechanical efforts in J. Jones 1962 and Dawe 1963 to deny psychologically rich characterization in Aeschylus. Rosenmeyer, who in general seems closer to Jones, writes disarmingly, "I hasten to confess that Klytemnestra seems to me to constitute an important exception to the standard for which we have been arguing" (1982: 235). Michelini restates and argues vigorously for Jones's emphasis on the "moral and social norm" as determinant of dramatic character in the case of "some quite abnormal and even monstrous figures," that is, Klytemnestra and the Erinyes (1979: 154). Focusing exclusively on these characters' change of heart, she makes a strong case; but she says nothing of the sexual issue, where her model of gesalt psychology is less compelling.

[20]Despite the strong influence of Knox's article on my perception—long before I had made any serious study of Marx—of the *Agamemnon* as presenting a general indictment

story of the lion-cub is an exemplar for the trilogy as a whole" (Lebeck 1971: 51). Though the parable is introduced ostensibly as a metaphor for Helen, it implies a comprehensive statement about Agamemnon, Klytemnestra, Aigisthos, Menelaos, Paris, Helen, and even Orestes:[21]

> A man once raised the son [*inin*] of a lion
> in his house. It was deprived of milk
> and loved the breast.
> In life's preludes it was
> Gentle, adoring the children[22]
> And a source of delight to the older folk.
> Many times one held it in the crook of his arm
> Like a newborn child,
> Its face bright as it fawned on his hand,
> through the belly's necessities.
>
> Passing through time [*chronistheis*] he showed forth
> the character [*ēthos*] he had from his parents: For returning
> the favor to those that nurtured him,
> Unbidden, he fashioned a feast
> Amid the madness [*atais*] of sheep slaughter.
> The household [*oikos*] was defiled with blood,
> An agony for the house dwellers they could not fight,
> A great bane full of slaughter:
> From god some butcher-priest of Madness [*Atas*]
> was reared as well in the house.

<div style="text-align: right">(Ag. 717–36)</div>

The generalizing of this paradigm is achieved most obviously by the application of the lion image itself to different characters. The prophecy of Kalkhas, reported by the chorus, sees the two Atreidai, "twins in their temperament," in the omen as the "battle-prone devourers of the [pregnant] hare" (*Ag.* 123–24). The emphatic first word quoted of his prophecy, "In *Time*" (*chronōi*, 126), associates their expedition with the force that reveals the true brutality of the lion cub. The seer in turn presents the goddess Artemis as kindly disposed toward the young of "raging lions" (141) in terms that seem to refer back to the Atreidai. On

of a whole class, Knox himself stops short of using the term "class" and would, I suspect, object to it. A parallel analysis of the motif of corrupted sacrifice (Zeitlin 1965) is full of useful insights but similarly ignores their political implications.

[21] Vickers' attempt (1979: 404) to exclude Orestes from the category of "lion cubs" ignores the precision of the verbal fit between Orestes' situation and that of the other "cubs" so clearly demonstrated by Knox. That Orestes is also quite different is not at all precluded by Knox's analysis and is cogently demonstrated in Peradotto 1969: 258–61.

[22] Knox (1979: 32 and n. 18) points out that the epithet *euphilopaida* is awkward of the lion and therefore often translated as "by the children loved." But the "force of the verb in compounds of this type is generally active, and applied to Agamemnon the adjective bears its proper meaning and produces a savagely ironical effect."

his arrival, Agamemnon himself proudly describes his triumph over Troy through this metaphor: "The lion that eats raw flesh, leaping over the tower, / Lapped up his fill of tyrants' blood" (827–28). Cassandra in the throes of her prophesy ironically designates Aigisthos as the "strengthless lion" (1224). Subsequently, in lyric outburst, she expands the image to include both Klytemnestra and Agamemnon:

> She herself, the two-footed lioness that sleeps with
> A wolf in the absence of the well-born [*eugenous*] lion
> Will kill me—poor creature that I am.
>
> (1258–60)

In the *Libation Bearers* the chorus triumphantly associates the return of Orestes with Pylades to the ancestral home by linking it in strict parallel with the time-governed process that brought justice to the clan of the Primidai:

> There came Justice to the Priamidai in time [*chronōi*],
> A punishment heavy with justice.
> There came to the house of Agamemnon
> The twofold lion, the twofold Ares.
>
> (*Ch.* [*Choephorae*, i.e. *Libation Bearers*] 935–38)

Knox (1979: 30–31), following Headlam, suggests that the impetus for this particular image came from the specific heraldic emblem of the royal family of Mycenae—still so impressive on the great monolithic lintel of the lion gate. What is indisputably clear in the language of this short parable is the redundant emphasis on words that evoke the family nexus in terms of offspring (*inin, euphilopaida, teknou*), nurture (*ethrepsen, agalakton, philomaston, neotrophou, gastros anankais, tropheusin, dait', prosethrephthē,*) and parents (*leontos inin, tokeōn*). Knox (1979: 27) also argues that the word *proteleiois* ("preliminaries," or "preludes") strongly suggests "ceremonies previous to the consummation of marriage" and notes its striking metaphoric usage elsewhere in the play (*Ag.* 65–66). The central point of the parable is the inherited character (*ēthos*) of the lion manifesting its intolerable brutality despite the generous nurture it received from those who are not of the same species. A rich variety of echoed phrases link all the major characters with the language of this parable: the language of Aeschylus shares with the language of Pindar a primary reliance on clusters of repeated images and phrases to convey its most pressing meanings.[23]

[23]Vickers's (1979: 426) complaint about Lebeck's exclusive focus on language, though not without some justification if one looks to the sorts of considerations raised by Taplin (1977), takes no account of the ways language works differently in different types of poetry and in different eras (see J. H. Finley 1955: 10–11; Zeitlin 1965: 463, 488–89).

There is no need, however, to spell out what Knox has so masterfully presented. Instead, I stress an implication of the parable that clarifies another crucial aspect of Aeschylus' presentation of class: that the very notion of class is inherently relational; no class exists as such except by virtue of its antagonistic relation to another class or classes.[24] The broad implications of the lion cub parable fit the general portrayal in the plays of the relations between these aristocratic rulers and the demos of their respective communities. There is an implicit presentation of these mythic figures as representatives of a class—a class the demos supports ("nourishes"), finds initially dazzling and endearing, but in time, after suffering horrible losses at its hands, comes to recognize as unalterably savage by birth. Helen's lionlike betrayal—the explicit point of departure for the parable—imposes "many limb-wearying wrestlings . . . on Danaans and Trojans alike" (*Ag.* 62–67; cf. 737–49). Menelaos' and Agamemnon's "lionlike" triumph over Troy is most explicitly achieved at terrible cost to the demos of Argos (428–60). The vengeance exacted by the "two-footed lioness" Klytemnestra and her "strengthless lion" lover Aigisthos is purchased at the price of tyranny imposed on the demos (1354–55). Even the salvation wrought by the "twofold" lion Orestes appears to the chorus ultimately as a potential disaster: "or should I call him a Doom [*moron*]?" (*Ch.* 1074).[25]

Taplin, whose work constitutes a salutary corrective to an exclusive focus on purely verbal elements, nonetheless rightly supports the view that all significant visual action is always indicated by words in the text (29–36). One almost shudders to think what Vickers would make of Goldhill's (1984) close focus on the play of language in terms that significantly challenge the assumed clarity of the visual signs. Yet Goldhill in particular points the way toward a basis for understanding how Aeschylus' language differs from Pindar's: in Aeschylus the rich array of echoes and associations is shot through with ironies and ambiguities that seem more directed toward provoking anxiety than the delight of recognition. Though Goldhill seems to reject categorically any movement toward even relative clarity as posited by Lebeck, his approach, when combined with those that trace the characteristic movement of Aeschylean images from a maximum of ambivalence and perversity to a maximum of clarity and sweetness (e.g., Lattimore 1953: 15–25; Macleod 1982), can take us far in grasping the historical specificity of Aeschylus' trilogic poetry.

[24]The point is ably stressed by Ste. Croix (1981: esp. 43). What may strike some readers as heretical in my analysis is that I attribute some implicit recognition and use of this conception of class to Aeschylus. The major theme of Ste. Croix's massive tome is to demonstrate both the validity of class struggle as an analytic concept in the study of ancient Greek society and, concomitantly, the compatibility of such an approach with the way the Greeks tended to view their own society.

[25]The attempt to see the parable as a meditation focused exclusively on one particularly gruesome family, or more generally to see the trilogy as concerned with one "specific human case" (Vickers 1979: 425), breaks down because Aeschylus' heavy use of poetic associations pushes us toward generalizing the pattern. I find particularly misleading in this connection an Aristotelian approach to the *oikos* which argues that "the Polis is but the family writ large" (Kitto 1956: 56; followed by Gagarin 1976: 58). There is a subtler distortion involved, I believe, in generalizing Aeschylus' analysis of the dynamics of the heroic aristocratic families as typical of all Greek/Athenian families. As

The Constitutions

The fundamental shifts in forms of political organization during the Archaic period sparked an increasingly conscious interest that culminated ultimately in the fourth century B.C. in Aristotle's collections of *politeiai*, a word somewhat confusingly translated as "constitutions" but not necessarily implying anything more sharply focused than the so-called British constitution. Given the centrality to the *Oresteia* of the issue of forms of government, a brief excursus is in order on Aeschylus' and presumably much of his audience's conception of political constitutions. For a modern reader, there is a confusingly easy slippage in the text between language that evokes government by inherited monarchy (*basileu, Ag.* 783), oligarchic government by scions of the great *oikoi* (as in the plural patronymics *Atreidai,* e.g: *Ag.* 3, 124, 310, and *Priamidai, Ag.* 747 and *Ch.* 935), and government by usurpers (*tyrannidos, Ag.* 1355). At times the text sharply marks the regime of Aigisthos and Klytemnestra as a true tyranny in contradistinction to the legitimate monarchy of Agamemnon (esp. 1355, 1633–52), but the term *turannikos* is used by Agamemnon of the royal blood his lion expedition has lapped up (828). Throughout most of the *Agamemnon* the political focus is on the *oikos* itself, which is personified from virtually the opening lines and emerges as a central character (e.g., Gagarin 1976: 58). This focus tends to blur the apparently Homeric kingship of Agamemnon into the more collective oligarchy that characterized so much of the Archaic and Classical periods.

While differing dramatic and political purposes may lead Aeschylus to stress the differences between these forms from time to time, fifth-century audiences would be comfortable with the slippage I allude to above because they were so aware of the broad similarities between monarchy, tyranny, and oligarchy: all three concentrated great wealth and arbitrary power in the hands of individuals, fostered a certain mentality, and were prone to exploit and oppress the demos. Thus, in the debate on constitutions incorporated by Herodotus into his account of the rise of Darius, the attempt by one speaker to differentiate sharply between aristocracy, democracy, and monarchy is met by the argument that the endemic contentiousness and oppressiveness of oligarchs leads inevitably to the demos' choosing a protector, who then

Lacey points out, "poorer citizens would not be likely to belong to this sort [the pre-Kleisthenic, more aristocratic] of *oikos,* nor would other citizens who owned no real estate" (1968: 94). In the *Oresteia,* what is juxtaposed to the aristocratic *oikoi* is the demos. As Dodds noted with marked understatement, "references to the demos are more frequent than we expect in a Mycenaean monarchy" (1960: 20; see also Podlecki 1986: 77–78). These insistent references belie a simple fusion of the ruling *oikos* with the inhabitants of the polis at large.

becomes monarch—in this context indistinguishable from a tyrant (Herodotus 3.81–82). Given the Athenians' experience of embittering oppression by the collective rule of the sons of Peisistratos and their near extinction by the great king of Persia, all monarchs are perceived as bad—even if they arise in response to the intolerable acts of oligarchs. Moreover, the continuing power of the great aristocratic *oikoi* under Peisistratos, noted above, and under the democracy itself may have contributed to this slippage.

The *Oikos* of the Atreidai as Emblem of the Aristocracy

As noted above, an important study of the *Oresteia* has suggested that the pervasive focus on the *oikos* of the Atreidai constitutes that *oikos* as the analogue of the polis itself (Gagarin 1976: 58). Although this does seem one possible implication of the use of *oikos* in the lion parable, I have already suggested some of the ways that the text of the trilogy as a whole insists on an inherent antagonism between the behavior of the aristocratic *oikos* and the interests of the polis and demos. The watchman and chorus may express their affection for and sense of dependence on the legitimate head of the *oikos,* but the course of events reveals a basic conflict of interests. Here I am concerned to show that the same evidence that establishes the *oikos* as a character in the drama also establishes it as the emblem of aristocratic rule in general, a form of government characterized by the transmission of power and wealth through inheritance by kinship groups.

The recurrent parallels with the ruling house of Troy guarantee the broader political significance of rule by *oikoi.* We naturally hear more of the Atreidai (I count fourteen references), the Tantalidai (*Ag.* 1468), the Pleisthenidai (*Ag.* 1569, cf. 1603), and the Pelopidai (*Ag.* 1600). Indeed, there seems to be more than *variatio* at work in this broadening of focus for the ruling element in Greece. We have encountered the Aleuadai in Pindar. Aeschylus' audience was all too familiar with the Peisistratidai, knew the horror tales of the Corinthian Bakkhiadai, probably had heard something of the Penthilidai of Mitilene, and no doubt felt varying degrees of ambivalence toward their own Alkmeonidai and Philiadai (Murray 1980: 132–52; Davies 1971; xvii–xxxi and endcharts). Such an audience was certainly capable of taking in the parallel between the Atreidai and the Priamidai (*Ag.* 537, 747; *Ch.* 935). In fact, this parallel is made categorically explicit in the *Libation Bearers* by the use of *men-de:*

There came, on the one hand [*men*], Justice [*Dikē*] to the Priamidai in time,
A punishment heavy with Justice [*barudikos*].

There came, on the other hand [*de*], to the house of Agamemnon
A twofold lion, the twofold Ares [i.e., war, destruction].

(*Ch.* 935–38)

In the case of the Atreidai, a major poetic motif, noted above in passing, is the all-pervasive personification of the house itself. This repeatedly reinforces the sense of the corporate identity of the clan, regardless of the term used to designate it. The royal house, as a physical object represented in the scene before the audience, is an ever-present symbol of all the Atreidai which tends to efface individual differences between its occupants. Because *oikos* was the commonest Greek word for a dwelling and by metaphoric extention the commonest word for family, especially the aristocratic family, once the audience perceives the political unit of the Atreidai as synonymous with their dwelling this perception extends to the text's deployment of virtually every available Greek word for house (*domos, domata, edethla, melathra,* etc.). The cumulative impact of this visual and verbal assault, which begins in the watchman's speech ("the house itself, if it could find a voice," *Ag.* 37) and extends through the *Libation Bearers,* is to stress the priority and dominance of the institution of the ruling family over any particular member of the family. In the language of the first two plays, the personified house soon becomes synonymous with its "devious housekeeper, the remembering Wrath, exacting punishment for children" (*Ag.* 155). It is this Wrath that emerges as the real source of Artemis' demand for "some second lawless sacrifice not to be eaten, a builder of feuds . . . born in the house and grown one with it" (*sumphuton,* 151).[26] The Wrath is one with the "Strife mastered by strife in the house" (*Eris eridmatos,* 1460–61),[27] which in turn is described as the "*daimon* of the race" (1476–77) and indistinguishable from the chorus of Erinyes "bred in the race" (1190, with Fraenkel, ad loc.). Given the parallels cited above of other such *oikoi,* the indictment of the house of the Atreidai implies a general judgment extending to a whole class of oligarchs. The generalizing thrust of Aeschylus' portrait of aristocratic rulers is thus an integral aspect of the text, especially of the *Agamemnon.*

The Content and Ambiance of the Aristocratic *Ethos*

Implicit in the lion cub parable and embedded in the text of the first play's treatment of all scions of great houses is a generalizing nexus

[26]Here I use Fraenkel's precise rendering, ad loc. I hope it is clear that I side with those scholars who view Artemis' demand not as an external determinism but as a symbolic representation and reenactment of the criminal proclivities of the house of Atreus as a whole (Peradotto 1969: 256; Vickers 1979: 351–57).

[27]See Fraenkel, ad loc., who rightly insists on some sort of etymological play here.

of images and associated ideas that cumulatively constitute a portrait of the ruling-class character—either a *lēma* or an *ēthos* (Peradotto 1969) and the social and economic institutions that sustain it. Implicit in this portrait is an analysis and critique of the ruling class and the forms of justice associated with them. The broad outlines of this aristocratic type are familiar from Homer; there are many senses in which Aeschylus' plays may be dubbed "slices from the great banquet of Homer" (Athenaeus 8.347e). In Aeschylus, however, the elements of critique, of ambivalence toward that type found already in Homer are updated to a specifically fifth-century psychological and social analysis that amounts to radical repudiation of values imbedded in the old oral formulas.

The hallmark of Aeschylus' presentation of the aristocratic type is his relentless focus on the dialectical interaction of material circumstances, psychology, and social practice. Fifth-century medical writers are usually given credit for first exploring the interface of climatological factors and personality (e.g., "Airs, Waters, Places," *Hippocrates I*, Loeb). Herodotus readily comes to mind for extending these insights to an overarching concern with the role of relative poverty and wealth in affecting individual personality and general behavior in different societies (Immerwahr 1966: esp. 153–61). But the germ of this approach is already present in what may be conventional wisdom in Solon: "For abundance begets violence, whenever much wealth attends / Upon men whose minds are not fit" (*tiktei gar koros hubrin, hotan polus olbos hepētai / anthrōpois hoposois mē noos artios ēi*, 6.3–4 West). A formulation that seems initially to posit a straightforward causal relation between wealth and criminal behavior ("abundance begets violence") proceeds to complicate the picture considerably by invoking a prior mental configuration unsuited to handle prosperity. Violence then results from the conjunction of the inadequate mind and the excess of wealth.[28]

Allusions to wealth are so frequent in the *Agamemnon* that the poet's own text might be dubbed *chrysopasta* ("gold-bespangled"). The text insistently associates virtually all the major characters with the corruption of wealth and luxury. This imagery is reinforced by the repetition throughout the play of explicit general comments on the deleterious impact of riches. Klytemnestra first attracts the attention of the chorus by the wealth of her offerings of "kingly sacrificial oil from the royal treasury" (*Ag.* 96).[29] To Klytemnestra is given perhaps the trilogy's most arrogant expression of confidence in inexhaustible wealth:

[28]This interpretation accords nicely with Solon's expression of his personal wish for wealth without injustice (13.7–8 West).

[29]The word *basileiōi* (kingly, royal) by its position not only modifies *pelaniōi* (sacrificial mixture of honey and oil or blood to feed the recipient) but strongly colors *muchothen* (from the innermost portion of the house); see Fraenkel, ad loc.

The sea is there. Who shall drain it dry? . . .
There is, my lord, a house[30] at hand, thank god, full of these things
For us to hold. Our home knows not how to be poor.

(*Ag.* 958–62)

Later, with withering condescension she congratulates the captive
princess Kassandra on her good luck in becoming the slave of masters
with an established fortune rather than of nouveaux-riches (1042–46).
She gloats over her murdered husband that she has caught him in "an
evil wealth of cloth" (1383). The audience subsequently can only
chuckle at her resort to euphemism when she suggests that she will be
content with "a modest portion of wealth" (1574).[31]

As a character, Klytemnestra may indeed be retreating from her ear-
lier confidence, but the association of wealth with the exercise of ty-
rannical power is presumably strong in the mind of the audience (see
Herodotus 1.61.3, 64.1) and almost immediately reinforced by her
partner-in-crime, Aigisthos. It is the bluntness of his linkage of wealth
and political power, not to mention brutal intimidation, that marks
him as a tyrant in the narrower sense of the term:

Using this man's [Agamemnon's] money [*khrēmatōn*], I shall endeavor
To rule over the citizens. Whoever disobeys me,
I shall yoke with a heavy yoke, not like some trace horse
Young and barley-fed, but hateful Starvation,
A roommate for his rage, will see him softened.

(1638–42)

The chorus's penultimate taunt to this bully implies the characteristic
fusion of glut and criminal behavior: "Go on, grow fat, polluting jus-
tice, since you can" (1669).

Agamemnon is the figure one thinks of first as the exemplar of the
corruption associated with excessive prosperity in the broadest sense of
the word (the Greek word *olbos* included notions of both material
wealth and more general happiness). Before he actually appears on
stage we get only slight hints of his association with wealth. For him the
daughter he is willing to sacrifice is the "*agalma* of his house" (208), a
term used often of dedicatory statues and ornaments in general. Many
readers seem to take Agamemnon as the most immediate referent of
the chorus's general meditation on wealth at *Agamemnon* 750–81. This

[30]Retaining with Denniston and Page the *oikos* of the manuscript contra Fraenkel.
Vickers (1979: 366), following Goheen (1955), rightly insists on the symbolism of blood
in the purple of the sea but does not seem to see the implicit linkage of wealth and crime.

[31]Douglas Young (1974) takes *ekhousēi* to govern *pan*—a further bit of arrogant boast-
ing. I agree with Vickers (1979: 385) and others who argue that Klytemnestra decidedly
retreats from her earlier confidence in the final scene of the play.

passage, polyreferential like most Aeschylean general comments, follows most directly on a meditation about the wealthy city of Troy. More directly triggered by the thought of Agamemnon are the choral broodings that follow immediately on his entrance into the house. The shakiness of the text here (see Fraenkel and Page, ad loc.) is particularly frustrating. But it is clear at least that the passage focuses on excess of wealth through a metaphor of an overladen ship that strikes on an invisible reef. Utter disaster can be avoided by jettisoning the weight of possessions (1005–14). The image forms part of an elaborate three-term comparison, a sort of climactic preamble, building to the irremediability of blood guilt. As in the Solon passage quoted above, wealth first appears as the simple and sufficient cause of criminal behavior, but an implicit qualification complicates the picture without negating the central role of wealth.

In the case of Agamemnon, Aeschylus essentially concentrates the motif of wealth in the visual and verbal climax of symbolic corruption in which Agamemnon agrees to walk on what he himself describes with a telling rhetorical figure as "wealth [*plouton*] and textiles purchased with silver" (949).[32] Agamemnon's act dramatizes spectacularly an ironic implication of Klytemnestra's penultimate argument: "It is conspicuously fitting for those who are prosperous [*olbiois*] to be conquered [viz., by such temptations as these]" (941). The decision to waste wealth is presented as a natural if not inevitable function of the possession of vast wealth. Many have noted the irony of Agamemnon's pieties before he yields to this temptation. This irony is, I believe, intensified if we recall the further irony that, on his entrance, he himself suggests the appropriateness of Troy's fall as in part at least a consequence of its royal wealth: "The storm blasts of Disaster [*Atē*] are alive; and the embers, dying hard, send forth winds fat with wealth [*pionas ploutou*] (819–20). Once again the text forces on us the *general* relevance of its exploration of the relation between wealth and crime.

The wealth of Troy, as noted earlier, seems the immediate focus of the choral meditation at *Agamemnon* 750–81, which attempts to clarify the relation of wealth to crime. The most striking feature of the passage as a whole (i.e., to 783)—despite many claims to the contrary—is that it does *not* dismiss wealth as a decisive component in crime.[33]

[32]The figure, "hendiadys" ("one through two") entails keeping on a parallel syntactical level two elements that would, in normal discourse, require the syntactical subordination of one to the other either as an adjective or a dependent genitive case—here "rich textiles" or "wealth consisting of textiles." The net effect, reinforced by the redundant "with silver," is to throw the idea of wealth into prominence.

[33]I am not particularly concerned with the alleged originality or banality of the passage. Most would agree with Denniston and Page's summary of the point: "The blame

Rather, as in Solon and an earlier choral comment in the *Agamemnon* (376–84), wealth is reaffirmed as the most relevant contributory factor despite insistence that it is not a sufficient cause in itself. The passage begins with an arresting formulation of the alleged traditional wisdom linking great prosperity and disaster:

> An account, fashioned in speech long ago, has grown old
> Among mortals, that a man's great prosperity
> Once it reaches its prime
> Begets offspring and does not die childless:
> From fair fortune there blossoms
> For the family unquenchable suffering.
>
> (750–56)

The speaker then insists on his own perspective as significantly different: it is the criminal act that begets more crimes, since without crime the destiny of just families (*euthudikōn oikōn*) is fortunate in its begetting (*kallipais*) (757–62). The adjective *kallipais* continues the heavily metaphorical use of reproductive imagery. Though the text concedes the possible association of a family—and we may think especially of aristocratic families—with justice, it avoids even here an explicit association of justice with wealth: prosperity is presented in terms of lovely children, a motif relevant to the imagery of the end of the trilogy.[34]

The imagery of human reproduction is insisted on in the subsequent lines, to which we must return later, on the tendency of the criminal act to engender similar acts in subsequent generations. The final stanza unites the themes of wealth and just action in terms that reaffirm their general incompatibility:

> Justice shines in houses
> Grimy with smoke
> And honors the righteous man.
> But gold-spangled abodes
> Smirched by criminal hands
> She leaves behind with averted eyes
> And approaches what is holy and pure,
> Showing no reverence for wealth's power—

falls not on prosperity in itself, but on the sinful acts of overprosperous men" (1957: 136). The problem is that for the British empiricist the chorus's distinction implies and irrevocable choice of two mutually exclusive terms. But the Archaic Greek mind is much more comfortable than most of us with mixed causation—important contributory factors that do not exclude emphasis on a main or decisive cause.

[34]Fraenkel translates: "For the fate of the house where justice is kept straight is always a fair offspring (of its former fate)."

> A thing falsely imprinted with praise:
> She guides everything to its end.
>
> (772–81)

The linkage of wealth and criminal action is even clearer in an ear-
lier choral reflection on the guilt of Troy.[35] The destruction of Troy
is a visitation on those whose "pride exceeds what is just and whose
houses team with wealth beyond imagining, beyond what is best"
(375–78). Here a criminal mentality is linked with criminal wealth,
and the linkage is strongly marked by alliteration, assonance, and met-
rical echo:

> *pneontōn meizon ē dikaiōs,*
> *phleontōn dōmatōn huperpheu*
> *huper to beltiston.*
> ("When they breathe more mightily than justly,
> When houses are wealth-bloated beyond bounds—
> Beyond what is best.")
>
> (376–78)[36]

The indissoluble involvement of excessive wealth with criminal action
is reaffirmed at the end of this strophe: "There is no defense / For a
man who in consequence of Wealth's Glut[37] / Has kicked Justice's
great / Altar into obscurity" (381–84).

Finally, Helen, the fatal link of Greek and Trojan societies, comes
from Greek luxury (690) and in herself constitutes the "adornment"
(*agalma* again; see 208) of Trojan wealth (740). Both her own crime and
the crime she inspires emerge as inextricably bound up with and aris-
ing from an ambiance of extreme wealth. Thus the consistent gener-
alization of wealth's dominant influence in the lives of ruling-class
figures in both Greek and Trojan society constitutes a major attribute
of the class type. In both societies, this wealth-bound *ēthos* is consis-
tently associated with criminal behavior disastrous for the demos.

The criminality associated with wealth is a major aspect of the jus-
tice available under the rule of aristocrats or monarchs from great
oikoi. But the most frequent occurrences of the terminology of jus-
tice in the *Agamemnon* are with reference to retribution for someone

[35]"Clarity" seems at best a relative term in dealing with Aeschylus. Here too we find
the seemingly inevitable textual problems: I follow Fraenkel versus Denniston and Page.

[36]The word *pneontōn* ("breathing") echoes the Homeric formula *menea pneiontes* (e.g.,
Il. 3.8), which literally means something like "breathing martial might." As so often in
the *Oresteia*, evocations of traditional heroic military prowess are negative.

[37]Taking the less stylish rendering of the genitive contra Denniston and Page, with
Fraenkel.

else's crime. This "retribution justice" associated with government by kings and princes is regularly characterized by excess. It has been frequently glossed by reference to the Old Testament phrase, "an eye for an eye, a tooth for a tooth" (e.g., Lloyd-Jones 1956: 60; Macleod 1982: 136); but the point of this much maligned phrase is insistence that the punishment be perfectly adjusted to the crime. This is precisely what aristocratic justice does *not* do. "Twice over have the sons of Priam paid for their crimes" (*Ag.* 537), proclaims the herald. The omen of the "*king* of birds" devouring the pregnant hare (114–20) and the king's sacrifice of his innocent daughter Iphigeneia are best understood as symbolic doublets insisting on the inherent excessiveness of aristocratic justice, its fatal tendency to destroy the innocent along with the guilty (Peradotto 1969: 254–57; cf. J. H. Finley 1955: 252–53).

Homer repeatedly evokes the brutal amorality of heroic warfare by focusing on the "dear wives and innocent children" (e.g., *Il.* 6.95) who are the real stakes of the struggle. The text of the *Oresteia* similarly suggests the excessiveness of aristocratic justice by focusing on the innocent wives and children (*Ag.* 326–29), but it adds a specifically fifth-century, democratic emphasis on the cost of aristocratic justice to the polis and the demos. We have already noted this motif as an implication of the lion cub parable. The immediate consequences of the expedition is to impose "many limb-wearying wrestlings . . . on Danaans and Trojans alike" (63–67). Though Paris is the obvious criminal, Kalkhas prophesies "this expedition will hunt Priam's city. . . . Fate will violently drain up in plunder all the *people's* great wealth of cattle" (*dēmioplēthē*, 126–30).[38] Paris is like a child chasing a bird, who "imposes suffering on his city beyond endurance" (394–95). The herald later expresses the same idea in an ironic, daringly anachronistic phrase: "Neither Paris nor the city that shared his tax debt [*suntelēs*] can boast an achievement greater than their suffering" (532–33). Rather than implying shared guilt, the herald's subsequent words insist that the guilt belongs to Paris but the disaster befell the whole land:

> For owing the penalty [*dikēn*] of rape and theft,
> He both lost the booty and reaped as his harvest
> The total obliteration of his father's house and the land besides.
>
> (534–36)[39]

[38]Lloyd-Jones (1970: 23) has argued that the cattle of the demos in fact stand for the demos itself that will be destroyed.

[39]The unique coinage *autokhthonon* ("land-and-all") refers not simply to the father's private domain but to the whole territory of the Trojan people, who share in the punishment of the royal house (*Ag.* 537).

Helen left behind her for her own townsmen (*astoisin*) the stir and bus-
tle of preparations for war and brought a "dowry of destruction for Il-
ion" (404–6). Menelaos' erotic visions and longings for his departed
wife in a house rich with statues are sharply juxtaposed to the suffer-
ings imposed on every household in Argos (411–35) and the grim, ma-
terial reality of "Ares, who trades gold for dead bodies" (438–44).

Critics have been prone to explain away this relentless focus on the
cost to the people of the city by citations of Hesiod and generalities
about Archaic Greek beliefs in the natural involvement of communities
in the fate of their rulers (e.g., Vickers 1979: 420). But Aeschylus pre-
sents this phenomenon as an outrage, one that inspires the active resent-
ment of the people. "The townspeople's talk is heavy with resentment:
it pays the debt of a curse ratified by the people" (*dēmokrantou*, 456–
57).[40] One scholar rightly calls this curse "the first step toward revolt"
(Fraenkel, ad loc.). This rebellion is sufficiently credible for Klytem-
nestra to cite as a pretext for Orestes' absence the danger that "the peo-
ple's shouting and lawlessness might overthrow the council" (883;
Dodds 1960: 20). Hesiod's polis may silently go down to ruin with its
unjust rulers, but for Aeschylus the cost to the city entailed in aristo-
cratic justice is grounds for popular rebellion, for seeking change.

Several other traditional features of the Homeric hero are incorpo-
rated and transformed in Aeschylus' portrait of ruling-class figures. In
every case, there is an accentuation on the negative. Cumulatively, this
imagery rounds out the portrait of a type—a character formation that
the lion parable sums up in the phrase "the *ēthos* it had from its par-
ents" (*Ag.* 727–28).[41]

It is tempting to pursue in detail the pervasive imagery of light, fire,
and radiance as both an echo and a devastating repudiation of the tra-
ditional association—particularly in Homer (Whitman 1958: 128–53)
and Pindar (J. H. Finley 1955: esp. 144)—of rulers with such lan-
guage. We have already seen in passing the effective double oxymoron
of Justice shining in the grime of poor houses and turning away from
the gold-spangled mansions mired by crime (*Ag.* 772–81). So too the
gleam of gold is juxtaposed to the ashes of dead bodies and the funeral
fires at Troy (437–44, in a context that reflects bitterly on the pam-

[40]Per Fraenkel following Porson's emendation. Douglas Young adopts the reading of
two fourteenth-century manuscripts *dēmokratou*: "that the people brew." The pun (the
root of *kerannumi* means "mix," as in *kratēr*, "mixing bowl" and *kratos*, "power") of such a
neologism in vaguely appealing but probably too cute.

[41]I retain a Greek transliteration of the term *ēthos* in part because the term has devel-
oped such widely different senses in modern criticism, particularly in the field of rhet-
oric, where it means almost the opposite of an inherited essential character. See Jarratt
and Grogan (1991), whom I thank for making a prepublication version of their text avail-
able to me.

pered rulers). In general, the dazzle associated with aristocrats emerges as disastrously deceptive appearance, masking the darkness of crime and paralleling the false lights that gleam so deceptively though the first play (e.g., Vickers 1979: 348–49).

Traditional daring (*tolmē, thrasos*), the mark of the aggressive warrior in Homer, emerges here as the unrestrained forwardness in crime of ruling-class villains. Agamemnon's decision to kill his daughter veers his mind toward complete recklessness (*to pantotolmon, Ag.* 221). The term is immediately echoed in a grimly alliterative use of the verb *tlaō:* "he dared [*etla*] then to become his daughter's [*thugatros*] destroyer" (*thutēr*, lit. "sacrificer," 224–25). Helen, in going to Troy, "dared the undareable" (*atlata tlasa*, 408). The only context in the *Agamemnon* in which daring retains any positive connotation of courage is in the ironic taunt hurled by the chorus at Aigisthos, of whose *thrasos* Klytemnestra had boasted at 1437: "You lacked the daring [*ouk etlēs*] to do this deed, to kill Agamemnon yourself" (1635).

We have already seen in the parable of the lion cub that the Homeric analogies of warriors to predatory beasts have been stripped of any grandeur, leaving only raw savagery. Two related points only need be added here. Vickers's influential treatment of the *Oresteia*, entitled "Nature versus Perversion," contains much of value but gives the entirely erroneous impression that virtually all perversion of nature is summed up in Klytemnestra's challenges to traditional patriarchal male roles (Vickers 1979: 347–437).[42] In fact, structuralist studies of the *Iliad* (Redfield 1975) and Sophokles (Segal 1981) have sensitized us to the ways profound ambivalence toward heroic figures is expressed in various eras by an opposition of nature (uncivilized, raw behavior) and culture (specifically the polis and its institutions). The heroes' positive contribution is to defend specifically human polis life, to make civilization possible; but the violent behavior that seems a necessary component of their martial function fosters a subhuman ferocity that constitutes a constant threat to civilization. I merely emphasize here that, in the *Agamemnon,* beast imagery, though frequently applied to Klytemnestra (e.g., 607, 1228, 1232), is by no means confined to her. In addition to the lion images, we find the Atreidai as vultures (49; Zeitlin 1965: 481–83), Agamemnon as a dog (896), and Aigisthos as a wolf (1259).[43] The snake images of the *Libation Bearers* apply most

[42]See especially Vickers 1979: 348, 366, 378–85. In fairness, I should also call attention to p. 360 and p. 374, where Vickers notes a parallel perversion in the behavior of Agamemnon.

[43]To be sure, the image of the watchdog here and at *Ag.* 607 is ambiguous. But in view of the pervasive irony, I find it most unlikely that the more negative connotations would not occur to the audience. See Goldhill 1984: esp. 56–57.

dramatically to Orestes (*Ch.* 549) but also to Klytemnestra and Aigisthos (*Ag.* 1233; *Ch.* 248–49, 1047; Whallon 1958: 272). The cumulative impact of all these images attached to the ruling figures in conjunction with the behavior portrayed on the stage is once again to generalize the ruling-class type as a subhuman threat to the well-being of the polis and its demos.

Inherited Guilt?

Thus far in looking at Aeschylus' presentation of class I have tried to highlight a pervasive polarity between what in contemporary terms might be reduced to "nature" and "nurture." On the one hand, the burden of the lion parable and associated images falls distinctly on "the *ēthos* he had from his parents" (*Ag.* 728).[44] On the other, a constellation of images and explicit meditations point toward a set of social and political factors that construct that *ēthos*, that surround individual aristocrats with the power and the seductive inducements to indulge in self-serving, violent behavior, and that provide compelling patterns of action in the crimes committed by parents.

The question remains, then, whether we can legitimately attribute to Aeschylus a doctrine of inherited guilt. Major proponents of such a doctrine are at pains to suggest the primitive otherness of the family curse (e.g., Lloyd-Jones 1962: 187; 1971: 90), invoking a version of historicism that discourages any hermeneutic translation into terms of potential contemporary interest. A parallel emphasis on inherited excellence in Pindar is readily perceived as celebration of a class ideology; but in the case of Aeschylus, the broad ideological implications of language focusing on the inherited curse, on metaphors of birth and procreation in the aetiology of crime, are rarely acknowledged (Haedicke 1936: 56 is an exception). Any historical parallel can offer only partial illumination at best; but before we acquiesce too readily to an irrelevantly primitive Aeschylus, let us consider a contemporary interpretation of blood guilt as a class phenomenon:

> An essential part of the inheritance of the [French] middle class, from generation to generation, is the fact of their own past violence done by their fathers and grandfathers, and it is this . . . we have called blood-guilt. This is not a theological idea but a dialectical one: the generation of 1848 decimates the workers, the workers remember and pass the memory on to

[44]The less developed parallel snake imagery has been seen to reflect "the incestuous adultery and the ritual child-sacrifice passed as a legacy from one generation to the next" (Whallon 1958: 271).

their sons, the new generation of factory owners must now face a sullen, resentful, and mistrustful working class which has made up its mind about them in advance. Thus the act, once committed, passes into the structure of the world itself, leaves its traces as repressive legislation on the one had and as profound suspicion on the other, and returns to confront the second and third generations as an objective situation to which they are not free not to react. (Jameson 1971: 285)[45]

This formulation has several features that are helpful in avoiding some of the pitfalls of past discussions of the inherited curse in the *Oresteia*. It is a determinism, but only in the sense in which Marx conceived of history as determined: "Human beings make their own history, but they do not make it just as they please" (*MECW* 11.103).[46] The crime of Atreus has consequences that confront Agamemnon with "an objective situation to which he is not free not to react," but the nature of his reaction is a more open matter. His father's response to an infringement of his patriarchal power represents an inherited paradigm, a pattern of behavior too readily available as a response to an infringement of Agamemnon's own power. That response entails the murder of innocent children as an acceptable cost of achieving revenge. Agamemnon has also inherited an enemy, Aigisthos, whose own paradigmatic response is seduction of his enemy's wife. Agamemnon chooses to adopt his father's paradigm in responding to Paris and to ignore the inherited consequences of his father's crime. This choice is not a haphazard individual whim nor the consequence of independent calculation (cf. Vernant and Vidal-Naquet 1988: 71–77). The whole *ēthos* of his class—its delight in war, its valorization of glory, deeds of daring, its characteristic insouciance vis-à-vis the interests of the demos, of women, of children, in short, all the mental reflexes of those who inherit great wealth—make this choice predictable if not inevitable. For Agamemnon inherits not a genetically impaired nor primitively polluted psyche (Haedicke 1936: 58) but a socially reinforced set of characteristic responses.

It has long been assumed that Aeschylus is essentially an Archaic theologian, but it is worth recalling that fifth-century Greece (and

[45]Jameson is here summarizing an argument from Sartre's *Critique de la raison dialectique*. If, instead of the French revolution of 1848, we substituted various nineteenth- and twentieth-century massacres of workers (e.g., Pullman strike, Ludlow, Akron), the point might become clearer to an American audience.

[46]The passage continues, "they do not make it under circumstances chosen by themselves, but under circumstances directly encountered, *given and transmitted from the past*. The tradition of all the dead generations weighs like a nightmare on the brain of the living" (*MECW* 11: 103, emphasis added). In 1865, responding to a questionnaire presented to him by one of his daughters, Marx put next to "Favorite Poet" the names Shakespeare, Aeschylus, and Goethe (Prawer 1978: 390).

especially Athens) is the birthplace of the social sciences.[47] Particularly if Aeschylus did in fact write the *Prometheus Bound*, the anthropological speculations of the Presocratics clearly had a major impact on his thought. On the basis of the *Oresteia*, Aeschylus may well merit the palm as the first Greek author to insist that political and social institutions, not inherited characteristics, are the chief determinants of social practice. The germ of this notion, one might reasonably argue, is present already in Hesiod's description of Zeus's wives and children— especially Themis, Eunomiē, Dikē, and Eirēnē (*Th.* 901–2)—as symbolic representations of the institutional content of the new order (Solmsen 1949: 34–44). In any case, the decisive role of humanly mutable institutions is explicitly proclaimed in Solon's *Eunomiē:*

> Good government [*Eunomiē*] renders everything well-ordered and right,
> And often casts fetters about the unjust,
> The rough she grinds smooth, checks Glut [*koron*]; Violence [*hubrin*]
> she dims.
> She withers the flourishing flowers of Disaster [*Atēs*],
> Straightens crooked judgements; deeds of towering arrogance
> She tames: she checks the deeds of dissension [*dikhostasiēs*],
> Stops harsh Conflict's wrath, and under her sway
> All things in the human sphere are right and sensible.
>
> <div align="right">(4.32–39 West)</div>

Koros, hybris, and *atē,* the triumvirate of individual crime, the mental aberrations, specific criminal acts and their disastrous consequences in class warfare (so I take *dichostasiē*) are categorically subordinated to the power of good government. That good government is conceived of as purely human creation is clear both from the opening of the poem, which explicitly denies divine responsibility for the dangers besetting Athens, and the consistently assertive first-person pronouns and verbal forms with which Solon describes and defends his own specific measures. It would not be too much to say that Aeschylus' whole utopian vision of Athens, a vision only complete with the completion of the trilogy, is implicit in these lines of Solon (Solmsen 1949: 208).[48]

The key terms in which the text of the *Agamemnon* meditates on inherited guilt emerge gradually as the pattern of major crimes emerges.

[47]LLoyd-Jones tells us that "Aeschylus' politics are an extension of his theology" (1971: 94). I am suggesting that the reverse is the case.

[48]Solmsen (116) argues against the notion that *Eunomiē* implies laws, which were called *thesmoi* in the Solonian era. Yet he calls *Eunomiē* "the representative of a community life that is regulated by good laws and customs" (115). See also the excellent discussion by Ostwald (1969: 62–95).

These crimes are represented with widely varying degrees of explicitness in the text, which taken as a whole invites the audience to arrange them in a chronology marked by compulsive recurrence: (1) the seduction of Atreus' wife by Thyestes; (2) the murder of Thyestes' children; (3) the seduction of Helen by Paris; (4) the murder of Iphigeneia and the destruction of Troy; (5) the seduction of Klytemnestra by Aigisthos; and (6) the murder of Agamemnon and Kassandra.

As suggested in my overview of Aeschylean dialectics, the first play does not—cannot—offer a definitive answer to the moral, religious, and political issues raised by this pattern. It does, however, in a broad movement from maximum ambiguity to greater clarity point toward the resolution in the third play, where the human social and political institutions are changed and the issue of individual responsibility is subsumed in the concern for internalizing ethical behavior in the society as a whole. The most crucial passages in this movement are the chorus's narrative of Agamemnon's murder of his daughter (184–246) and the full-scale debate between Klytemnestra, the chorus, and later Aigisthos over the murder of Agamemnon and Kassandra in terms that suggest an abortive trial.

The choral narrative of the decision of Agamemnon, to which so much attention has been devoted, is hedged about with suggestive allusions to divine intervention, an inherited pattern of crime, and dynastic ambition. At line 216 there is a much debated textual crux, which, depending on the emendation one opts for, adds the factor of peer pressure (if one reads *periorgōi sph'* at 216) or stresses the individual fatal passion of Agamemnon (if one retains *periorgōs* and takes Agamemnon as the implied subject of *epithumein*).[49] In any case, the dramatic fascination of this passage is due in no small measure to this ambiguity.

The end of the play, however, opens for direct questioning the issues of causality and responsibility, not merely through the far fuller dramatic characterization of speakers who make their *own* case, but—in the most important *agōn* of the play—through the use of open debate between the perpetrators of the crime and the chorus. This debate (1372 to the end of play) by no means arrives at a simple resolution focused on a simple cause; there are in any case two more plays to come. Yet it does, I believe, explicitly cancel some of the simpler deterministic explanations left dramatically open in the earlier focus on Agamemnon's choice.

[49]But see, in addition to Fraenkel and Denniston and Page, ad loc., Winnington-Ingram 1974: 4–5 for the suggestion that Artemis is the referent of *sph'*. See also Lesky 1966a: 82.

Klytemnestra's initial speech in this episode, in which she is visually inseparable from the corpses of Agamemnon and Kassandra she has chosen to display (1379, 1404–6), confronts the audience with the decisive deed of blood which was the climax of the choral meditation on the relation of wealth to crime (1018–34). Her unalloyed delight in this deed contrasts sharply with the earlier choral portrayal of Agamemnon's agony in the face of his decision to murder his daughter (206–13).[50] Requital of "an eye for an eye" is proffered as a defense by Klytemnestra when she brings up the murder of Iphigeneia (1414–20). But the excess, the violation of the innocent, is immediately added to the picture by her gratuitously vicious reflections on Kassandra, whose corpse is, in any case, a silent sign of excessive revenge. Sexual passion, broadly implied by Klytemnestra's daring sexual metaphors (Vickers 1979: 381–82) and allusions, emerges as a more immediately determining factor with her explicit reference to Aigisthos (1435–37) followed by his appearance. These strongly personal motives tend to undercut substantially her attribution of sole responsibility to divine Justice and the Erinyes (1432–33). Retroactively, they suggest a pattern of self-serving aristocratic argument that confirms the more indirect earlier hints of self-interest in Agamemnon's decision. At the same time, the chorus is spurred by her claims of suprahuman involvement to take a longer view, to seek an additional factor in a historical chain of circumstances.

The chorus's initial citation of Helen as the first link is not as gratuitous as Klytemnestra implies, for it is inspired by the obvious role of sexual passion (*erōs*) in Klytemnestra's own crimes. Sexual passion is not abandoned as a factor; rather, it is seen as the vehicle of the disastrous *daimōn* of the race, for that *daimōn* "works from women" (1470, trans. Fraenkel).[51] Klytemnestra proceeds to take their reference to a family *daimōn* as something totally external to herself. The chorus pauses painfully over the circular argument that Zeus as ultimate cause of everything must have some role in this act too (1487–88). But when Klytemnestra attempts to clinch the issue with too self-serving a formulation of divine intervention, the chorus retorts with an alternative that insists passionately on her responsibility while at the same time acknowledging that the deed is overdetermined:

[50]Here again I think the real point is the movement from relative ambiguity to relative clarity about the aetiology of all such aristocratic crimes.

[51]Douglas Young's translation of the *ennomōs* found in a fourteenth-century manuscript at 1472 implies a more explicit rejection of her claims of justice: "She is standing / like a dread raven above his corpse and / boasts her chanting is righteous and lawful."

> That you are guiltless
> Of this murder—who is the one to testify to that?
> How? How? But from the father's side
> There might spring an avenger as accomplice.
>
> (1505–8)

This is essentially as far as the chorus pursues the philosophical issue of responsibility in this play, inasmuch as they now retreat in confusion at the spectacle of the "falling house" (1530–32). But paradoxical as it may seem, the more explicitly the factor of an inherited pattern of crime and punishment—the force of the Erinyes—is spelled out as the sole reason for a new crime, the more clearly it takes on the character of hollow pretext. Thus Aigisthos proclaims that he sees Agamemnon "lying in the robes woven by the Erinyes" (1580–81) and gives a circumstantial account of the horrible crime of Atreus against his father,[52] but the chorus do not pause a moment over these allegedly mitigating circumstances. They declare simply that he merits death at the hands of the demos (1912–16). The tyrannical character of Aigisthos—his reliance on money, bodyguards, and threats of torture—overwhelmingly discredit what ought to be the tightest case for an inherited necessity to commit crime. Everything about his dramatic character suggests a class *ēthos* and self-serving personal motives.

There is then a steady progression toward clarity in the play's exploration of crime which, since it climaxes in the male Aigisthos, cannot be wholly reduced to a matter of sexual bias that paints Klytemnestra in darker colors than Agamemnon. On the contrary, this movement invites a kind of secondary revision of the initial ambiguities of Agamemnon's situation, suggesting that he, like Klytemnestra and her lover, was equally prone to seek pretexts to mask his basely selfish motives, motives that arise far more from his ruling-class status than from a family curse. Thus in this light his final rhetorical question as he debates murdering his daughter, "How should I become the abandoner of my fleet / By losing/failing my alliance?" (212–13), places the emphasis on the sphere of his public ambitions.

One may even sum up Aeschylus' treatment of this whole issue by saying that the family curse *is* the inherited privileged status of these wealthy, powerful aristocrats. In the text of the *Oresteia*, birth and inheritance are metaphors for a more complex vision of causality. But the specific thrust of this vision is focused on social and political institutions—aristocracy, monarchy, and tyranny—which foster and

[52]Vickers 1979: 386 notes Aigisthos' suppression of Thyestes' initial crime.

transmit from generation to generation the temperament prone to crime. In this connection, we might look again at the crucial choral pronouncements at 750–56, focusing now on the implications of its heavy metaphoricity:

> An account, fashioned in speech long ago, has grown old
> Among mortals, that a man's great prosperity
> Once it reaches its prime
> *Begets* offspring and does not die *childless:*
> From fair fortune there blossoms
> For the family unquenchable suffering.

The relation of vast wealth and disaster evokes metaphorically, on the one hand, the natural process of a cycle of growth, reproduction, aging, and death, and on the other, the social institution of the aristocratic family that perverts that natural process. The chorus's qualification of this traditional view insists more relentlessly on the metaphor. The factor of excess in aristocratic vengeance is described in terms of the "children" of the criminal deed:

> Diverse from others, I have my own understanding.
> For it is the unholy *act*
> That later *engenders* offspring more numerous [than itself]
> But similar in nature to its own family.
> For the fate of strictly just
> *Oikoi* engenders fair children ever.
>
> (757–62)

This metaphoricity here and in the following lines ("Violence [*hubris*] characteristically [lit. "loves to"] beget," 763–71) is not simply a façon de parler; it subverts aristocratic ideology where it was most confident, the very source from which Pindar consistently drew his most celebratory images, that is, the natural processes of sexual reproduction, of birth and inheritance, by giving them the most sinister connotations. At the same time, the very fact of metaphoricity where ideologies demand the literal insists that the fate of houses depends neither on nature nor on other forces beyond human control. Aeschylus thus prepares the way for compromises to come.

As suggested above, the clearest refutation of a simple determinism of inherited guilt is imbedded in the trilogy structure itself. Orestes, the heir to all this crime, both validates and breaks decisively with his heritage. More profoundly, the third play, with its shift of scene to an essentially different world and its dramatization of a new human

institution for dealing with crime, removes us from the context of the aristocratic and monarchic forms of government that are the chief fosterers of the criminal *ēthos.*

Sexual Politics and the Aristocracy

Before exploring the more explicitly political and social developments in the later plays, I examine separately the sexual dimension in the *Agamemnon,* a dimension which already in the Hesiodic model is an inextricable component in the dialectic of change and which we have only touched on in a schematic overview of Aeschylus dialectics. Still, any final judgment on the sexual politics of the trilogy as a whole must await our reading of the whole. What I note at this stage is the integration of the other elements of the critique of the aristocratic *ēthos* in the *Agamemnon* with this representation of aristocratic sexual behavior.

Older attempts based on Bachofen (1973 [1861]) to present the sexual issues in the *Oresteia* in terms of an opposition of matriarchy to patriarchy have rightly been rejected (Zeitlin 1978: 150–60; cf. Pembroke 1967; Beauvoir 1989 [1953]: 79). It would be more accurate to speak of a "myth of matriarchy" in which an attempt to establish female political dominance is decisively defeated. This myth would seem to be a significant element in the consciousness of Aeschylus' audience. The extraordinary popularity of the battle between men and Amazons in the literature and iconography of fifth-century Greece, especially Athens, amply attests to the affective investment in this myth (duBois 1982). But patriarchy was not at all a myth, and the most trenchant aspects of Aeschylus' handling of the sexual dimension from the beginning to the end of the trilogy are his insights into the dynamics of aristocratic patriarchy.

The relevant components of this patriarchy are the concentration of political, economic, social, and sexual power in the male pater familias (Greek *kurios*) over all members of the aristocratic household, which included not just biological relations but the whole nexus of slaves (both war-won and home-raised), retainers, and subordinated peasants (Lacey 1968; Ste. Croix 1981: 211). Over all these the father exercised nearly unlimited power. Much of the irony of Plato's *Euthyphro* derives from the assumption that it is bizarre, though legally imaginable, for a son (or anyone?) to call the patriarch to account for the death of a slave. Certainly the widespread use of exposure of female children implies the father's power of life and death. The patriarch also substantially controlled the sex lives of those in the *oikos,* prescribing husbands for his daughters and imposing his own sexual priorities on wife and slaves

alike. In the sphere of the aristocratic *oikos,* the individual aristocratic father is analogous to the monarch or tyrant in the political sphere.

We are far less informed about the functioning of non-aristocratic families. Although it seems plausible that attitudes and behaviors associated with male dominance would be widespread through all classes, it is not clear, for example, that in poor peasant and landless families the fathers imposed marriage partners on their daughters. In general, the more property involved, the less freedom for the women.[53] Virtually the whole nonslave citizenry were, until the reforms of Solon (*Ath. Pol.* 5–12), Peisistratos (*Ath. Pol.* 16.5), and Kleisthenes (*Ath. Pol.* 21), juridically, economically, religiously, and militarily subordinated to the various aristocratic patriarchs through hereditary phratries and priesthoods (Forrest 1966; Arnheim 1977; Wood 1989). Before the abolition of hektemorage (owing a sixth of one's harvest) and debt-slavery, before the establishment of independent people's courts, councils, and assemblies, before citizenship was based on locale rather than kinship, the modern separation of the familial and political spheres—rightly questioned in our era—is particularly inappropriate to the ancient Greek context. Ste. Croix (1981: 102) and Wood (1989: 116) have recently argued that the relative liberation of the male peasant's property in Athens entailed a marked contraction of women's relation to property. The stringent laws forbidding heiresses from ownership of property, laws that even prescribed divorce for a male relative so that he could marry an heiress in his family to preserve the property, seem to date back to Solon's reforms (*Ath. Pol.* 9.2; Plutarch *Sol.* 20.ii–iv).[54]

In the *Agamemnon* the sexual patriarchal power of aristocratic males is on a par with wealth, inherited status, and a criminal heritage as a corrupting influence. For these male "heroes," women and children emerge as little more than pawns in their dynastic competitions. Thyestes seduced his brother's wife. Atreus killed his own nephews and fed them to his brother. Paris seduced his host's wife. Agamemnon killed his own daughter. Having defeated the city of his sister-in-law's seducer, he enslaved the king's daughter and brought her back home as his mistress to live under the same roof with his legal wife. Aigisthos seduced

[53]Lacey assumes quite arbitrarily that women in the highest social class "have always had markedly more independence than among the bulk of the population" and that women whose fathers could not come up with an adequate dowry simply did not marry (1968: 107–9). The orators on whom he bases this argument are by definition speaking only of those who have enough property to fight over. If, as argued earlier, as many as 60 percent of the citizens had little or no property, such sweeping conclusions seem unjustified.

[54]Arthur (1973: 27–37) offers a more nuanced account of the pluses and minuses of Solon's provisions in relation to women—even though her account is marred by an excessive adherence to the notion of "bourgeois" Athens.

his first cousin's wife. Due to the rich web of allusions throughout the play, none of these patriarchal crimes can be declared "outside the drama." On the contrary, they are vividly and relentlessly before us together with a broad array of violent war crimes presented as characteristic of the aristocratic class.

I emphasize here the extent to which Aeschylus chooses to insist on the sexual motive in a context of excessive sexual dominance, where it is males who are in the best position to act on their whims regardless of the consequences. Klytemnestra, whom we consider below, is marked immediately as an exception among women—the absence of her *kurios* has permitted her to emerge as "male-in-her-planning" (*androboulou, Ag.* 11). We have already had occasion to note the textual crux in the final lines of the choral report of Agamemnon's own explanation of his decision to sacrifice his daughter. Does he claim that it is religiously proper (*themis*) for himself to desire passionately this sacrifice, or for the army to desire it, or most neutrally that one should desire it?[55] Whatever the correct reading, it is clear that Aeschylus has chosen to present the sacrifice as the consequence of a desire that is linguistically marked as excessive: the doubling of *orgai periorgōi* or *periorgōs* as modifiers of the verb meaning to "desire" (*epithumein*, lit. "to have a passion for," 215–18) insists with characteristic Aeschylean irony on the sickness of the passion even as the speaker attempts to justify it.

The erotic motive for the war, both in the crime of Paris (385–402) and the longings of Menelaos (410–26), we have already touched on. It is striking that the first occurrence in the play of the word *erōs* is in Klytemnestra's hypocritical wish that the conquering army commit no excesses that might endanger their return: "May no passionate desire [*erōs*] first fall upon/attack the army / To sack what they ought not, conquered by profits" (341–42). The bold paradox of a victorious army attacked (*empiptei*) and conquered (*nikōmenous*) by lust and greed effectively generalizes the corrupt desires of the ruling protagonists to the whole male army.

Klytemnestra again uses erotic language to generalize the crimes of the Atreidai as a corporate group. Her words to the chorus recall Agamemnon's justification of blood lust (215–17) most unpleasantly:

> Now have you righted your tongue's judgment,
> Naming the thrice-glutted
> *Daimōn* of this family:

[55]See note 49 above. Winnington-Ingram's suggestion, if correct, would invalidate my point. Certainty is impossible, but why should the poet give such heavy stress here to divine wrath when the rest of the play is so focused on human passion?

> For from that source the blood-licking lust [*erōs*]
> Is nourished in the belly.

> (1475–79)

The fusion of oral and sexual desire, mythically embedded in the Hesiodic model in which Kronos devours his children and Zeus devours his wife Mētis, is peculiarly appropriate to the crimes of the child-devouring Atreidai. It is most significant that this desire is attributed to males; however biased the source of the attribution, the text of the play as a whole bears it out. The heavily metaphoric description ("begets," "engenders") of the aetiology of crime at lines 750–62 strongly suggests the male role in sexual reproduction.[56]

The priority of male criminal *erōs* and reproductive activity in the *Agamemnon* and their connection with other aspects of a pervasive indictment of the aristocracy is worth stressing. This priority posits a homology between the disastrous consequences of economic, political, and juridical tyranny exercised by the aristocratic class over the demos and the absolute power of patriarchs exercised over women. It is also an important corrective to analyses (e.g., Vickers) that suggest that the association of crime and sex in the *Oresteia* is confined to women. The text represents misogynistic attitudes to be sure, but the framework within which they are represented is itself marked as the criminally distorted excess of aristocratic patriarchal power.

One of the special fascinations of Aeschylus' trilogy is that the dialectical form seems here to conflict with the multiplicity of levels on which the drama operates. The historical realities and ideological conflicts to which it responds and which it seeks to mold vary strikingly in their amenability to the logic of the trilogy form. Most obvious, it is easier to dramatize dialectical change on the political and juridical levels; here the experience of the audience must compel assent at least to the fact of significant change, if not necessarily acceptance of the implicit value judgments on these changes. But on the levels of sexuality and the politics of the family there appears to have been so little movement, let alone progress, that a dialectical negation of male sexual dominance corresponding to the negation of aristocratic economic, political, and juridical dominance seems peculiarly short-circuited. Just as feminist

[56]*Teknoō* (754) is ambiguous: *LSJ* s.v. II, "in Act. commonly of the man. . . . Med. of the female." Yet *olbon* (753) is masculine and the fear of dying childless is more suggestive of males in a society where such strong legal injunctions keep property exclusively male. *Tiktō* (759, 763) is also used of either sex, but again the concern that offspring resemble the parents seems more likely to express a male fear in a society obsessed with the fact that *mater certa, pater incertus;* cf. Hesiod *Works and Days* 182. The association of maternity with the visually observable and paternity with greater abstraction plays a key role in Goldhill's interpretation of the sexual politics of the whole trilogy (e.g., 1984: 174, 194).

scholarship has challenged the view that women advanced along with men during the Renaissance and argued that, on the contrary, women experienced some distinct losses (Kelly 1984: 19–50), there are, as noted above, grounds for arguing that Athenian women suffered significant losses with the growth of democracy. In passing, we should note that even on the economic plane there is a somewhat parallel lack of resolution envisioned in the text of the *Agamemnon*. The negation of wealth is simply juxtaposed to the valorization of poverty as conducive to virtue (cf. *Ag.* 772–80). If, as we have already noted, democracy permitted the demos to protect itself better from aristocratic exploitation, the fundamental economic divisions remained intact (Ste. Croix 1981: esp. 72–73).[57]

In the sexual sphere in the *Oresteia* we find an ancient analogue of the contemporary impasse over the priority of class or gender (e.g., Saffioti 1978; Eisenstein 1979: 5–55). Aeschylus' attempt to combine a relatively straightforward class analysis of political change with a vision of social change in which sexual conflict is decisive results in a text that is provocatively ambiguous to a modern sensibility.[58] One is accordingly tempted to separate the elements too starkly—pronouncing the dialectical movement of the text politically and juridically progressive but sexually retrograde, a monument to misogyny.[59] Though the levels operate as it were at different velocities and involve different sorts of ideological investments, both the politico-juridical and the sexual levels require a double hermeneutic—a careful unraveling of the respects in which the work functions in the service of entrenched class and sexual interests and at the same time projects a utopian vision that significantly

[57]As noted earlier, Wood (1989) is in general far more sanguine than Ste. Croix in emphasizing the economic independence of the Athenian peasant after Solon, but she seems to me to neglect the implications of the apparently high proportion of citizens who had very little or no property.

[58]In this connection I cannot resist alluding to the Cuban film *Lucía*, directed by Humberto Solás (1968). There too the trilogy form seems almost dictated as the vehicle for conveying a dialectical process of change extending beyond the scope of a single lifetime. The central focus on the role of women and sexual conflict dictates too that the third section confront the gap between massive progress on the political and economic level and the profound intransigence of traditional male expectations and biases.

[59]Zeitlin (1978: 150) actually goes farther than this. She argues that the breadth of Aeschylus' creative vision in the trilogy, "by integrating the issue [misogyny] into a coherent system of new values, by formulating it in new abstract terms, and by shifting to a new mode of argumentation . . . provides the decisive model for the future of legitimation of this [misogynistic] attitude in Western thought." I happen to have read Zeitlin's article before reading Vickers's (1979 [1973]) long chapter on the *Oresteia*. I could not help but be struck by the parallels between their readings and the absolute disparity of their perspectives (Vickers regularly seems to endorse what he explicates). At the same time, I have encountered no discussion of the *Oresteia* which comes close to Zeitlin's in its appreciation of the complexity and pitfalls of attempting to treat the ideological implications of a literary masterpiece.

negates the alleged necessities of the status quo by opening a realm of relative freedom.

In focusing exclusively on misogynistic elements in the *Oresteia,* one is in danger of castigating the text for a failure to resolve adequately the largely unconscious sexual attitudes that it is this text's special distinction to have raised consciously as a problem. Hartsock, for example, summarizes Aeschylus' account of the sacrifice of Iphigeneia in these terms: "The glories to be had in combat and the willingness to pay almost any price for them is a recurring theme in both the heroic poems and the political ideals whose birth they attend" (1983: 190). This comment suggests a simple endorsement by the text of the *Oresteia* of a Homeric perspective that is in fact profoundly problematized in the trilogy. The *Oresteia,* by its deployment of the unique resources of the dramatic and trilogic form, forces on the audience with painful immediacy what are usually unquestioned presumptions of Greek patriarchal ideology. To echo Vernant's fine formulation: "although tragedy, more than any other genre of literature, thus appears rooted in social reality, that does not mean that it is a reflection of it. It does not reflect that reality, but calls it into question. By depicting it rent and divided against itself, it turns it into a problem" (Vernant and Vidal-Naquet 1988: 33). The text confronts us with such questions as these. How could a father kill his own daughter? How could male rulers resort to war and the destruction of a whole society just to punish adultery between consenting adults? What are the human consequences for the war-captive mistress and the legal wife of traditional male sexual privileges? Why should intellectually mediocre males automatically take precedence over women of great intelligence? Should a male god, one especially associated with patriarchal privilege, use his divine powers to punish and persecute a woman who failed to gratify his sexual interest in her? It seems to me that the *Agamemnon* goes even farther: it confronts as inadequate the misogynistic reflexes with which Greek males traditionally, from Homer on, seek to explain away all their troubles as the fault of women and, more specifically, as due to the destructiveness of insatiable female sexuality.[60]

We have perhaps commented enough already on Agamemnon's murder of Iphigeneia and the full horror of the deed evoked by the chorus. The harsh choral comments on Helen and Paris certainly do not condone adultery, but they do unambiguously imply her willing participation. Thus, not unlike the dour Persian authorities cited by

[60]It should be obvious to everyone familiar with Winnington-Ingram's thoughtful essay of 1948 how deeply indebted I am to his approach, even if I carry some of his arguments to unrecognizable conclusions.

Herodotus apropos of the same issue (1.4.2–3), the chorus accordingly reserves its harshest condemnation for the excessive response of the Atreidai, who impose war on their own people and destroy all of Troy all "on account of an adulterous woman" (*Ag.* 62–67; cf. 445–55, 799–804).

Despite the repeated harsh comments on the destructiveness of Helen (esp. 681–715), which clearly express and reinforce traditional fears of female sexuality, the debate between Klytemnestra and the chorus confronts us with the inadequacy of this male attempt to attribute all human suffering to the desires and desirability of women. Dramatic dialogue breaks the male monopoly of discourse. Klytemnestra's arguments force the chorus itself to shift from woman as cause (1453–61) to women as instruments of divine ferocity (1468–74) to a momentary *aporia* at the ultimate responsibility of Zeus (1485–88). Though, as we have noted earlier, it goes on to insist on Klytemnestra's personal responsibility (1505–8), insofar as the sexual politics of the first play are concerned, we should acknowledge the specifically dramatic transformation of knee-jerk misogyny into a problematic issue.

Moreover, we cannot ignore in this connection the extraordinary dramatic space devoted to Kassandra. One of Aeschylus' great silent characters (Aristophanes, *Frogs* 911–20), she is before the audience for nearly a third of the play (782–1330) and the center of dramatic interest for almost half that time (1072–1330; Taplin 1977: 318–22). Iphigeneia we see only reflected through choral narrative as the silent victim of patriarchal power. In Kassandra the victim talks back. To be sure, her loyalty to the ruler responsible for destroying her home and enslaving her person, when combined with her corresponding ferocity toward Klytemnestra, significantly enlists her on the side of patriarchy. But before she even speaks, Kassandra bears mute visual testimony to the brute obtuseness of her captor, the inherent pathos of the victim, and the signal insult to the legal wife which characterize the sexual politics of Greek warfare.

Her first words and initial dialogue call patriarchy into question at a higher level; she confronts the audience, using all the intensity of dramatic lyric verse, with the criminal sexuality of the god who is the chief dramatic representative of patriarchy in the final play of the trilogy, Apollo. Her initial blasphemy and her revelation of the god's sexual attentions and his perverse use of his divine powers to punish her failure to satisfy his lust form an indelible and highly negative impression. Those who wish to deny the relevance of this impression in the final play must explain why Aeschylus chooses to focus so insistently on it here. The cruelty of the god's punishment in denying credibility to her prophecies is not merely something narrated about her past at Troy. It

is relentlessly dramatized before our eyes in the incapacity of the chorus to grasp her most explicit attempts to predict the imminent murder of Agamemnon and herself.

A further function of that long dramatic exchange which is relevant to the sexual politics of the play is the presentation for a second time in the same play of a woman who not only has privileged access to the reality of the situation but must endure the condescending incredulity of males who are clearly her intellectual inferiors (Knox 1979: 46). Whereas Klytemnestra's obvious intelligence has been interpreted as a masculine trait (Winnington-Ingram 1948: 131), and there is much dramatically reinforced sympathy for the chorus's resistance to her, Kassandra is an unambiguously sympathetic character without a hint of masculinity. Indeed there is a haunting pathos in her recollection of the insults she endured at Troy—"as if a wandering priestess in quest of gifts—'beggar', 'pathetic creature', 'starveling' " (1272–73). The passage evokes sympathies reaching beyond the dramatic situation for women whose intelligence ill accords with their humiliating status. The trajectory of her interactions on stage seems emblematic of the struggle of the silenced intelligent women of Athens, analogous in tragedy to what is dramatized comically in the *Lysistrata* (esp. 430–529). Kassandra is first assumed to be incapable of meaningful discourse, "like some newly captured wild beast" (1063; cf. 1050–51). Her lyric lament of her personal sufferings is immediately pronounced inappropriate speech (1075, 1079). Her lyric account of past horrors is attributed to divine inspiration (1083), but her revelations of what is really happening and what is about to happen are not grasped. Abandoning lyric for the public discourse of iambics, she metaphorically comes out of the wild zone of a purely female stereotype (see Showalter 1985: 262–63):

> All right then. My prophecy shall no longer be peeping
> Out of veils like a newly wed bride,
> But radiant-bright it is fit to dart forth
> Blowing against the sun's risings, so that like a wave
> A greater agony than this one shall dash
> Against the rays of light. No longer shall I reason through riddles.
>
> (1178–83)

For all their resistance to her knowledge, the chorus is at the end compelled to pay tribute to her courage (1302).

The characterization of Klytemnestra is of course decisive to any assessment of the sexual politics of the *Agamemnon* and crucial for the trilogy as a whole, though I have tried to show that an exclusive focus on Klytemnestra involves serious distortions. The complexity of her character, unsurpassed in surviving Greek drama, should itself be

warning against simple categorizations. We have noted already that as an aristocrat she displays in uncommon measure the common features of the super-rich—arrogance, bestial ferocity, criminal daring, and a self-serving conception of justice. As a woman, her chief characteristics are intelligence and guile, maternal love, and a keen interest in sex.

I have stated these characteristics in terms that reflect the Greek male ambivalence toward females, an ambivalence one might easily illustrate from Homer, Hesiod, and other Archaic poets. Males confront contradictions that are the consequences of the terms on which their dominance is exercised. Male reliance on physical force in the subjugation of women tends to develop mental powers in women that remain merely potential in most men (bards would be an exception). The exercise of intelligence from a position of unequal power is necessarily guile from the point of view of the male—plotting and verbal deceit.[61] Male imposition on women of total responsibility for the nurture and rearing of children in general valorizes maternal affection but involves the threat of a far stronger bond between mother and child than between fathers and their children. Limitation of the female sexual role to the production of legitimate heirs renders particularly threatening the sexuality involved in procreation. The question remains whether Aeschylus, in his portrayal of Klytemnestra, passively reflects these traditional grounds of Greek misogyny or presents them as a problem.

I have already expressed my adherence to the latter alternative, but it is worth making some distinctions about the relative weight of Aeschylus' treatment of various aspects of Klytemnestra's personality. I agree, for example, with Winnington-Ingram (1948) that the full dramatization of her superior intelligence in her exchanges with the chorus, with Agamemnon, and implicitly with Aigisthos confront the audience with a problem that the Athenians themselves had not solved—the disparity between the degraded role assigned to women and their actual capacity for political power, their capacity for effective analysis, long-range planning, and persuasive discourse. No emphasis on her frightening criminality can completely efface the dramatic presentation of her real, effective superiority to the males who seek to dominate her and to whom the whole weight of aristocratic social structure assigns the dominant role.

At the same time, even on this level the Greek dramatic convention that grants the audience so much greater knowledge of the reality of the situation on stage than is possessed by the most intelligent protagonists does certainly render Klytemnestra's powers of discourse

[61]Detienne and Vernant (1978) do not give a specifically class or gender focus to their analysis of cunning intelligence, but Brown (1969), whose work they seem not to know, brings out most effectively the correlation between powerlessness and cunning.

frightening as well as impressive. We know the truth of her marital infidelity and murderous intentions. We are thus invited to feel shock and horror at the grossness of her lies and the sinister intent of her verbal manipulation of the herald.

That the audience is invited to impute to Klytemnestra's character sincere maternal love for Iphigeneia as a component in her hatred of Agamemnon is reasonably clear. But this potentially positive, sympathetic motive is all but canceled by her unnatural treatment of Orestes—already adumbrated in the *Agamemnon* (877–85)—and of Electra (Zeitlin 1978: 157–58). Moreover, this blocking of maternal feeling is presented as a direct consequence of that frightening sexuality that males must grudgingly acknowledge is a precondition of the maternal function socially assigned to women.

As suggested above, Klytemnestra's criminal sexuality should not be seen in isolation from the general association of aristocratic crime with excessive vulnerability to *erōs*. At the same time, it must be granted that in the *Agamemnon* Klytemnestra's sexuality receives such extraordinary dramatic heightening that it emerges almost sui generis—or more accurately, sui sexus. We have already glanced at one aspect of that dramatic heightening. The audience is invited by virtue of its privileged knowledge of her liaison with Aigisthos to understand her gross guile and hypocrisy toward Agamemnon and the chorus as largely inspired by her enthusiasm for adulterous sex. The other aspect involves a similar epistemological flattery of the audience—Klytemnestra's penchant for sexual metaphor, particularly metaphors that evoke perverse sexual pleasures. Describing rather gleefully her murder of her husband, she concludes:

> So he fell, gasped out his life,
> And breathing out a swift wound [stream] of blood,
> Struck me with black raindrops of gory dew.
> I felt joy at the Zeus-given liquid in the bud's birth pangs.
>
> (1388–92)

The traditional metaphors of the procreative female as a field for sowing, of male fertilization as rain from Zeus (cf. Lloyd-Jones 1963: Frag. 25; duBois 1988: esp. 39–85), are grotesquely fused with a literal sprinkling of blood, itself transformed by a daring metaphor: whatever inspires sexual desire is itself a wound.[62] In any case, her pleasure at

[62]Fraenkel finds the metaphor too bold and marks the passage corrupt. Denniston and Page defend it with a parallel from Euripides' *Rhesus*. The wounding metaphor is present in the first line of the *Danaid* fragment cited in the text *(trōsa)*. Recall the cliche

the literal wound she has inflicted suggests what a later age would call sadism. The combination of this emotion with imagery normally evocative of the Greek male's favored image of the female's sexuality, as a happily passive field for his seed, must tap deep fears indeed.

Sadism is again suggested by Klytemnestra's description of her emotional response to her murder of Kassandra: "For me she brought on / An added dessert [*paropsōnēma*] to the luxury of my bed" (1446–47). The fusion here of sadism with the enthusiastic oral metaphor for her sexual activity gives a heightened perversity to the generalized aristocratic criminality evoked by the mention of luxury (*khlidēi*, 1447).

Klytemnestra's allusion in this same speech to her sexual partner, "as long as Aigisthos kindles the fire on my hearth" (1435–36), is a less daring metaphor. It does, however, continue into the sexual sphere the reversal of traditional aristocratic associations with brilliance and fire imagery noted earlier. In this connection, it is striking that Klytemnestra's first words in the play associate this imagery not with her sexuality as an independent woman but with her productivity as mother, a role in which she is completely ill-fated: "May Dawn be a bringer of good news, following the proverb, / Since, as child of Night, she should take after her kindly mother" (264–65). The masculine-formed adjective *euangelos* ("bringer of good news") turns out to modify a feminine noun (*Eōs*, "dawn"). This facilitates a hint of both Orestes and Iphigeneia in the image of the radiance of dawn. But the epithet "kindly" for Klytemnestra as mother applies legitimately only for Iphigeneia at best. Taken ironically, it looks forward to the utter hostility of the mother-son relationship in the second play, unforgettably symbolized in Klytemnestra's dream that she has given birth to a snake. The metaphorical play with the notion of inherited moral character—taking after one's "kindly" mother—is two-edged. By insisting on the continuity between mother and son, it undercuts Apollo's later attempt to deny the bond of kinship between mother and child, yet it here suggests as proof of the bond as a negative trait; Klytemnestra's children are like her precisely to the extent that they are not kind. Even so, the reminder in this image of a mother whose daughter is murdered by her husband and who is herself murdered by her son is not without a certain ironic pathos.

The ambivalences in Klytemnestra's portrayal reflect the broader dualities of the *Agamemnon's* treatment of male-female relations. She is the prime candidate for woman as monster in both her intellectual and her sexual femininity. But even as deceiver she commands admiration,

in Latin love poetry of the *vulnus amoris;* Lucretius 4.1048–56 seems to me to owe something to this passage in the *Agamemnon.*

while as mother she elicits some sympathy. Finally, even her frighten-
ing sexuality is presented as an extreme instance of a vulnerability to
perverse passion characteristic of her class and most often illustrated
by males, whose passions destroy whole societies. Once again, where
Pindar drew his most confident images Aeschylus presents us with aris-
tocratic sexuality and reproduction as sick, monstrous, and deadly.

Politics in the *Libation Bearers*

We must of necessity be briefer in dealing with the two following
segments of the trilogy. Although neither is a simple text, the major
issues are laid out with the richest range of ambiguities in the first
play; and the movement of the trilogy as a whole is toward rela-
tive clarity.

The political regime of Klytemnestra and Aigisthos is described in
the *Agamemnon* as a tyranny. Dependent on money and the power of
hired bodyguards rather than legitimate inheritance and the military
service of the demos, tyranny survives by intimidation. The trilogy
opens with a haunting characterization of a fearful retainer forced to
resort to riddling indirection, for a "great ox has stepped on my
tongue" (*Ag.* 36–37). The second play makes the atmosphere of fear a
keynote of life under tyranny. The *Agamemnon* hinted at significant in-
stitutional differences between the old monarchy and the new tyranny.
Agamemnon, however authoritarian his rule, at least interacts with all
the people in full assembly (*Ag.* 844–46) and seems to tolerate a certain
freedom of speech in taking counsel (799–804). The second play dis-
plays what is often seen as an uncritical nostalgia for the old order of
Agamemnon. It would be more accurate to say that it reflects in the
chorus the traditional Greek disposition to see all change as bad. More
profoundly, the second play embodies the dialectical perception built
into the trilogy form that progress is not linear; insofar as tyranny is
the negation of monarchy, it is worse; but, within the schema of the
trilogy, it has made a decisive break with the past, thus transforming
the conditions of possibility for positive change.[63] Kingship is in fact
viewed with a sense of distance which implies a historical judgment on
the consciousness it fostered:

[63]Here again I cannot resist the parallel to the Cuban film trilogy *Lucía*. The second
segment, exploring life under the neocolonialist puppet Machado, reflects the blackest
despair as compared with the exultation following the defeat and punishment of Spain's
representatives. In the final scene of the second segment, the heroine heads for the river
with the clear intention of committing suicide.

The religious awe [*sebas*]—once undisputed, indomitable, invincible—
Pervading the people's [*damias*]
Talk and their minds,
Now stands aside, and one lives
In fear [*phobeitai*].

(*Ch.* 55–59)[64]

Awed subservience to inherited authority with its aura of divinely
sanctioned status (all this is suggested in the term *sebas*) may seem pref-
erable to life under a regime of terror (*phobos*), but neither—to antic-
ipate the third play—is preferable to the internalized and self-policing
fear (*deos, to deinon*) of the law-abiding citizen of a democracy (cf. *Eu.*
517, 522).

Apart from this telling, if brief focus on the consciousness of the
demos or the polis, both entities are conspicuous by their absence in
comparison with the other two plays. Aeschylus has chosen a chorus of
foreign-born slave women. They take for granted that Orestes' victory
would be a boon to the city (*Ch.* 824) and restore "rule by the law of
citizens" (864, trans. Douglas Young). They declare that by killing the
tyrants Orestes has in fact "liberated the entire community [*polin*] of
the Argives" (1046). But their status as foreigners reinforces the mood
of alienation under the tyranny. As literal slave women, they are a con-
crete correlative of the metaphorical slavery imposed by the tyrants.
Electra declares that she is "the equivalent of a slave" (135). Orestes
complains that he was "shamelessly sold, though born of a free father"
(915). In this context, an Athenian audience would hear specific con-
notations of liberation from the slavery of tyranny.

The chorus of helpless old men in the *Agamemnon* bravely threaten
the tyrants with the people's punishment, and in the final crisis they
are ready themselves to fight against the usurpers. In the *Libation Bear-
ers* the tyranny appears securely established, and the chorus accord-
ingly see themselves as a *stasis* (458), a subversive faction. For all their
savagery in urging on the protagonists, when the assassination plot
hangs on the edge they prepare themselves to play trimmers in the
event that the plot should fail (871–74). This differentiation seems far
more a comment on the changed consciousness under a tyranny than
on the often presumed relative cowardice of women.

The critique of the aristocratic *ēthos* so pervasive in the first play is
not forgotten. Yet the components of the aristocratic nexus are signif-
icantly altered. There is still the pressure of aristocratic crime and its

[64]Smyth (1926) brings out the specific political connotations of *sebas:* "the awe of maj-
esty." Douglas Young (1974) is explicit to the point of matter-of-fact banality: "Royalty
once was viewed with respect by the people, / and the majesty of rulers."

characteristic revenge/justice. In this sense the threatening Erinys continue to be synonymous with the inherited evil of the *oikos*. After the pained broodings of the *Agamemnon* chorus, this chorus seems unambiguously enthusiastic about the simple mechanism of murder breeding murder:

> But it is custom/law [*nomos*] that drops of gore
> Spilt on the ground demand other
> Blood. For death shouts aloud, summoning the Erinys,
> Who, from those slain before, brings
> Disaster following on disaster.
>
> (400–404)

Though they are full of lamentation for the "suffering bred in the family" (*engenēs*, 466), they take apparent satisfaction in the fact that the circle of blood remains institutionalized all in the family, that the only cure can come from "within the house" (471–75). For them, Justice is indistinguishable from the family's revengeful *daimōn:*

> The foundation of Justice is firm fixed.
> Fate the swordmaker forges her weapon in advance.
> The glorious Erinys that broods in secret
> Is bringing the son home [*domois*]
> To punish in time the pollution
> Of blood spilled long ago.
>
> (646–51)

The motif of the inherited *ēthos* is prominent. Though Electra prays to be more temperate than her mother (140–41), both brother and sister, as they prepare themselves for the monstrous crime they feel compelled to perpetrate, invoke the predatory beasts of the heroic tradition in terms that insist on an inherited *ēthos* from both parents. They are the "eagle's nestlings bereft of their father" (247, cf. 256, 259, 501), who has been killed by a snake (249). Orestes again calls Klytemnestra a snake (994), and the chorus asserts that both tyrants were snakes (1048). But Orestes, in the climactic recognition scene of the play, adopts for himself the snake paradigm of Klytemnestra's dream (540–50). A central irony of this hideous dream is that the human mother who gives birth to and attempts to nurse a snake is herself a metaphorical snake. Thus Orestes accepts more than a paradigm: he affirms his inherited snake nature from his mother. As in the key parable of the lion cub (*Ag.* 717–36), he "displays in time the *ēthos* he had from his parents" (*Ag.* 728) and pays back for his nurture with slaughter. So too

Electra in preparation for the confrontation insists that she (or both she and Orestes) has "a spirit from my mother like a wolf that lives on raw flesh" (*Ch.* 421–22).[65] This language seems to insist that Electra and Orestes literally inherit the violence-prone natures of both their "heroic" parents. But that Aeschylus essentially considers this beast-like ferocity the mark of a class rather than the consequence of a specific genetic inheritance is suggested by the almost casual application of the key lion metaphor to both Pylades and Orestes. Indeed, the unusual collective singular, "a twofold lion" (938), insists on the absolute similarity of their natures.

So too with the linguistic emphasis on "daring" (*tolmē, tlaō,* etc.), which is easy to take narrowly as confirming the specific genetic continuity between parents and offspring but, like the association with predatory beasts, betokens also the continuity of the aristocratic *ēthos*. Electra indicts her "all-daring mother . . . who dared [*pantolme mater . . . etlas*] exclude citizens from a king's burial resembling an enemy's" (430–33). The words recall Agamemnon's "all-daring mind," he who "dared to become his daughter's sacrificer" (*Ag.* 221–25). Yet Orestes, who in a similar tone alludes to the daring of his mother (*tolmēs, Ch.* 996), himself had to display a daring to return at all (*etolmēsen,* 179). When he confronts the full horror of his action, he attributes to Apollo the "seductive drugs" that inspired his daring (*philtra tolmēs tēsde,* 1028). But that *tolmē* is a general characteristic is implied in a passage we have occasion to examine closely below (594–601).

In any case, alongside these indications of a relatively simple determinism of aristocratic inherited criminal *ēthos*, counterforces in the *Libation Bearers* lay the foundation for a way out. The aristocratic *trophē*, the coddling nurture bestowed on the lion cub, the corrupting luxury of extreme wealth are denied these two scions of the ruling *oikos*. Electra, as noted, lives like a slave, and Orestes is exiled from his father's wealth (*Ch.* 135–36). Some of the odium of extreme privilege is thus lifted from them at the outset of the play, and the determinism of inherited evil is significantly qualified by this decisive removal from the luxurious atmosphere in which criminal tendencies are fostered. In the case of Orestes, the point is further emphasized by the insistence that the nurse Kilissa acted the role of his mother (Peradotto 1969: 260–61). Aeschylus here seems to anticipate the valorization by some of the Sophists of environment over heredity—as we later see, a crucial point of ideological struggle in the attempt to forge a democratic theory of society and human nature.

[65]Cf. The plural verbs *tukhoimen . . . pathoimen.* Lloyd-Jones (1970) unjustifiably narrows the focus exclusively to Orestes.

The Politics of Aeschylean Religion

To analyze the role of Apollo, the major counterforce in the *Libation Bearers* to the apparent reinforcement of a mechanical determinism of ineluctable and ever-escalating aristocratic vendetta, I turn to a topic I have thus far barely touched on, a topic that until fairly recently has been the central focus of most discussions of the trilogy, namely, the presentation of the gods. The sheer wealth of argumentation threatens like a lodestone to draw all other aspects of the play into the religious nexus.[66] At the risk of seeming baldly dogmatic, I argue that Aeschylus, just as he historicizes politics and sexual conflict—albeit in differing degrees—presents an essentially historicizing vision of relations between human beings and divinities (Kitto 1956: 69). Bluntly stated, he presents as characteristic of the heroic, patriarchal aristocrats in the first play a readiness to assume that the gods and most especially Zeus—the highest male god, the patriarch of the gods (cf. Calhoun 1935)—are on their side. This presentation is both a reflection of Homeric, especially Iliadic, practice and a critique of it. The readiness, most obvious in the case of Agamemnon, to project onto the city's gods his own ambitions and to claim validation from the same source (e.g., *Ag.* 811) is part of the aristocratic arrogance and self-delusion that dooms him. So too, in a less-developed form, Aigisthos and Klytemnestra claim divine support for their criminal acts (*Ag.* 973–74, 1432, 1580). The chorus, as nonactors, as mediating figures, do not simply reflect this aristocratic view so familiar in Aeschylus' contemporary Pindar; they are the chief vehicle for transforming an ideological given of the ruling class into something profoundly problematic.

We come thus to the famous "Hymn to Zeus" at *Agamemnon* 160–83. The chorus confront the horror of Agamemnon's sacrifice of his daughter as an apparent implication of Zeus's role as guarantor that such crimes as Paris's will not go unpunished. Whereas the aristocratic figures appeal confidently to such a Zeus, indeed find in him a ready patent for their own ambitions, the chorus see Zeus himself as a question, as the locus of the apparently irresolvable "contradiction of an unspeakable crime committed in a righteous cause" (Peter Smith 1980: 41). There is more than religious deference in their recourse to Zeus as

[66]Peter Smith's book, which devotes ninety-one pages to the twenty-two lines of the "Hymn to Zeus" (*Ag.* 160–83), is symptomatic. It will be clear to anyone who has read Smith's painstaking study how profoundly at odds I am with much of his argument. At the same time, I wish to record my appreciation for the rigor and precision of his discussion, which must fill with trepidation anyone who attempts to cover briefly ground he has so thoroughly tilled.

a problem:[67] "Zeus, whoever he is, if it is pleasing / To him to be called by this name, / In this way do I address him" (*Ag.* 160–62). Zeus is not a solace to which they turn in grief, but the very source of their mental anguish. There is an intellectually and morally paralyzing contradiction for them between, on the one hand, his status as patent for royal privilege, royal crime, child murder, and a hideously destructive war and, on the other, his role as the recourse of the oppressed, as their ultimate hope that the crimes of the oppressors will not go unchecked—despite the oppressors' apparent monopoly of power. It is a contradiction between the Zeus of the *Iliad* and the Zeus who figures in the prayers and hopes of the humble and oppressed of the *Odyssey* and in the poems of Hesiod. This is above all the Zeus whose victory in the *Theogony* is the only counterforce to the downward cycle of intensified injustice, the oppression of the peasants by the *basilees* (Vernant 1965: 19–47). I can only express my amazement at those scholars who ignore the force of the Hesiodic allusion in the antistrophe of this nonprayer:[68]

> He who before was great,
> Filled to bursting with daring to battle all,[69]
> He shall not even be counted, now he is a thing of the past.
> And he who was born next, met with three throws
> From his victorious adversary and is gone for good.
> But if a man eagerly cries out the victory song of Zeus,
> He will attain the whole of wisdom.
>
> (*Ag.* 167–75)

Not only is this stanza the poet's self-reflexive gesture toward the Hesiodic source of his own dialectical trilogy form; the three stanzas of the hymn are themselves dialectical. The first, as noted above, addresses Zeus as problem. It identifies him as both the source and the potential

[67]Although I do not see the same evidence of a "more sublime religious feeling" which Fraenkel (100) finds in these words, I agree with him that "for all their apparent conventionality, [they] make ready beforehand for the conclusion that crowns the whole, the idea which is central in the poet's thought." I take that "idea" to be the historical relativity of Zeus.

[68]Peter Smith (1980: 15) nicely points out that the chorus "do not succeed in addressing Zeus in the second person. The 'Hymn to Zeus' approaches the form of a hymn but never reaches it." On the other hand, I find Smith's dismissal of Clay's and other attempts to make sense of the passage (60–61, he omits any reference to Solmsen here) unsatisfactory. That we have here merely a rhetorical "process of elimination" (19) strikes me as quite inadequate.

[69]Fraenkel, ad loc., nicely defends an allusion to the pancration in the word *pammachōi*, but I think its broader connotation of pure aggressiveness is more important for my purposes.

escape from intolerable mental anguish, the god who both favors the powerful and upholds justice for the powerless. The second stanza negates this contradiction by evoking the essential optimism of the Hesiodic evolution as an unambiguous victory over the aggressive daring (*thrasus*) of the past. The third stanza aims toward, adumbrates in highly abstract and ambiguous language, a resolution that incorporates both the full agony of the process and the decisive triumph of a movement forward:

> Zeus, who fixed the path to wisdom for
> Mortals by laying down that learning through suffering
> Should hold authoritative sway.
> There drips instead of sleep, pain-remembering
> Suffering at the heart: and to those who are
> Unwilling there comes the wisdom of self-restraint.
> I imagine there is a blessing from the gods, but a violent one—[70]
> They that sit on the ship bench that commands respect.
>
> (*Ag.* 177–84)

Two features here point toward the democratic resolution of the third play. The powerful image of internalized anxiety as the source of self-restraint anticipates the emphasis in the third play on internalized fear (*to deinon, deos*) as the essential psychological correlative of an effective government of laws. Scholars have been at pains to tell us how meaningless is the famous phrase *pathei mathos*, for none of the protagonists learns much from his or her suffering.[71] What is inadequately appreciated is that the language of the passage itself establishes a homology between the authority of the principle *pathei mathos* and the attainment of self-restraint (*sōphronein*), a correlation that is by no means inherent in the traditional associations of the phrase.[72] In the context of the trilogy, I find it impossible not to hear an echo of this passage in the choral song of the *Eumenides* in which the Erinyes shift decisively toward articulation of the democratic defense of government by law:

[70]I read the nominative form *biaios* with Denniston and Page contra Fraenkel, who defends the adverbial form found in the codices.

[71]Denniston and Page 1957: 85–86, Lloyd-Jones 1956: 62, Gagarin 1976: 139–50 and n. 25, and Peter Smith 1980: 21–26.

[72]Dodds (1960: 29–31) offers a sympathetic view of the relevance of *pathei mathos* to *sōphrosunē* and of the development of the trilogy as a whole but does not relate it to democratic theory as such. See Macleod 1982: 135–136; for all his eagerness to downgrade a political focus, Macleod is perceptive about political evidence. For the range of meanings and the centrality of the concept of *sōphrosunē* in Greek ethics and politics, see North 1966.

There is a place where Fear [*to deinon*] is well
And must remain seated as watchman over the wits.
It is beneficial
To exercise self-restraint under duress [*sōphronein hupo stenei*].

(*Eu.* 517–21)

It has long been recognized that Athena's direct address to the Athenian people, urging the preservation of their form of government, closely echoes this chorus and thus prepares the way for the eventual reconciliation (cf. *Eu.* 681–706).[73] Insistence that fear of legally imposed punishment keeps citizens of a democracy reasonable, or self-restrained, seems to have been a topos of fifth-century democratic theory.[74] Thus the argument that *pathei mathos* cannot have a paradigmatic force, that it can be relevant only to the criminal who suffers (Gagarin 1976: 212 n. 24), weakens unnecessarily the force of *kuriōs ekhein* ("to hold authoritative sway"). If the point is the establishment of the principle that all criminals will learn a lesson, then it is legitimate to see adumbrated here a democratic society in which discipline and liability to punishment are equally in force for all. The outstanding characteristic of the aristocratic criminals is their blindness, in the very moment of demanding punishment for the crimes of their enemies, to their own liability. A similar, key message of the whole trilogy for the Athenian people is summed up explicitly in the farewell of the transformed Erinyes to the "Attic host . . . acquiring self-restraint in time [*sōphronountes en khronōi*]" (*Eu.* 997–1000).[75]

[73]Thus I cannot agree that Zeitlin's (1978: 67) characterization of the Erinyes ("they champion a justice which is blind, archaic, barbaric, and regressive"), though justified by the earlier part of the play, represents the whole story.

[74]Thucydides 2.37.3 (the Funeral Oration): "Though we associate in our private affairs without nastiness, we do not transgress the law [*paranomoumen*] in our public life [*ta dēmosia*] most of all because of fear [*deos*], by consistent hearkening [*akroēsei*, i.e., obedience] both to those in authority and to the laws." See references in Headlam and Thomson 1966 (1938) on *Eu.* 517. Democritos B41 goes a step farther, but clearly within the context of the same debate in political theory: "Not through fear [*phobos*], but through what is needed [*to deon*] refrain from crimes." Indeed, I suspect a pun between *to deon* and *deos*, the more commonly used term for "fear" in such debates.

[75]Although I admire the subtlety of Goldhill's demonstration of Aeschylus confronting his audience with an epistemological crisis of accepted key terms and the processes of human communication (1984), I remain unconvinced that radical skepticism is the central or even a major thrust of Aeschylus' intellectual and political enterprise. More immediately here, I would argue that the paradigmatic correlation of *pathei mathos* and *sōphrosunē* does not seem far removed from the democratic praise of forethought, of discussion and debate prior to action. I resist the temptation to cite *Prometheus Bound* and call attention instead to Democritos B66: "It is better to deliberate before action than to repent afterwards" (trans. Freeman) and Thucydides 2.40.2–3 (again the Funeral Oration): "For we do not consider the discussions [*logous*] constitute harm to accomplishments [*ergois*], but on the contrary, the real harm comes from rushing to needed action

The second feature of this final stanza of the Hymn to Zeus which suggests democratic discipline is the image in the last line of a ship bench, which, as Fraenkel has so painstakingly established, is the seat of the helmsman. What better image for bringing home to a nation of democratic sailors the idea of authority that demands absolute obedience yet, for all its severity, is a "blessing"? Both adherents and enemies of the democracy were well aware of the decisive role of its highly trained navy.[76] Thus, the chorus here, while locked into the contradictions of aristocratic justice, point in highly abstract terms toward a vision of justice which is given explicit and concrete embodiment in the Athens of the final play. That their initial despair and final hope are associated with Zeus is not a Christian imposition (Gagarin 1976: 149) but a virtually inevitable consequence of the poet's perception of the contradiction inherent in the historically differing class roles of Zeus. The Zeus near whom sit the self-restrained Attic hosts (*Eu.* 997–1000) is distinctly changed from the Zeus who validates the Atreidai's throne and scepter (*Ag.* 43) and sends them against Troy "over a polygamous woman" (*Ag.* 60–63; cf. Macleod 1982: 133–38).

In the *Libation Bearers* there is a clearly marked difference between, on the one hand, the direct orders (backed by threats for noncompliance) given Orestes by Apollo through his oracle at Delphi and, on the other, the ambiguity of bird signs, their interpretation by Kalkhas, and the readiness of ruling-class figures in the *Agamemnon* to assume that Zeus is on the side of wealth and power. If Agamemnon "finds fault with not a single seer" (*Ag.* 186), we nonetheless are invited along with the chorus to view him most unfavorably for following such signs (*Ag.* 799–804). The difficulty lies in defining with any precision the nature of the difference in the religion of the *Libation Bearers* and interpreting it in the larger context of the movement of the trilogy.

Given the frequent collapse of the distinction between monarchy, aristocracy, and tyranny noted earlier, it would be futile to look for a specifically tyrannical form of religious experience.[77] An Athenian

[*epi ha dei ergōi elthein*] without being instructed in advance by discussion [*mē prodidkthēnai mallon logōi*]."

[76]Thucydides focuses repeatedly on the decisive role of long practice and technique in naval warfare. So, for example, Perikles points out that "naval competence is a matter of *technē*," which in turn implies constant practice (1.142.10). The Spartans had no monopoly on discipline.

[77]It would be tempting to trace the role of Delphi in the history of tyranny. Gyges seems in no small measure to have owed his successful coup to effective bribing of Delphi (Herodotus 1.13–14), whereas the bribes of the Alcmaeonidai lead Delphi to acquire great credit in the liberation of Athens from her tyrants (Herodotus 5.62–63). Winnington-Ingram (1948: 142) reminds us of Delphi's siding with the Persians in the great war, something that just might lead some of the audience to question the claims of Apollo to absolute truth.

audience might well feel a special appropriateness in the involvement of Delphi in the putting down of a tyranny, but the deeper meaning of the religious language in the *Libation Bearers* must be sought in relation to the clearer polarity between the religious assumptions of the heroic rulers in the *Agamemnon* and the religious implications of Athena and the transformed "Kindly Goddesses" of the final play.

As we have seen, that polarity rests in part at least on a historical opposition already present between the *Iliad* on the one hand and the *Odyssey* and Hesiod on the other. Insofar as Electra and Orestes are reduced to slaves and exiled from the wealth and station they would normally have inherited, they approach the status of the oppressed in the *Odyssey* or Hesiod, and their relation to divinity is thereby transformed. They appeal for divine redress against criminal power that seems to have total control of the situation.

But Orestes is also heir to the throne of Agros and all its wealth. Unlike Agamemnon, Klytemnestra, and Aigisthos, however, Orestes never uses alleged divine injunctions as a pretext for relatively base personal motives. On the contrary, he is careful to distinguish his personal and political motives from the orders of the god (*Ch.* 300–304), which implies a relatively greater sophistication about motives that points toward the court's consideration of motive (e.g., *Eu.* 426–28).

Whereas the aristocratic criminals of the first play infer divine validation of their behavior either from signs or from their sense of the logic of the situation, there is no hint in the *Agamemnon* of divine punishment if they fail to carry out the alleged injunctions of the gods. Yet this element is given great emphasis and vividness in Orestes' account of Apollo's behests (*Ch.* 271–85). Moreover, the gods in the *Agamemnon* are never represented as offering to protect the agents of their justice from its consequences, most obviously because Agamemnon and Aigisthos are too obtuse to recognize that the justice they exact involves them in injustice. But even Klytemnestra, who initially attempts to deny personal complicity, is eventually forced to acknowledge the chorus's demonstration of the logic of further punishment. Her hopes of forming a pact with and perhaps bribing the *daimōn* of the house may seem pathetically naive, but she never claims that her role as agent entitles her to divine protection.[78]

Orestes, on the other hand, is given specific pledges of protection and purification by Apollo (*Ch.* 1030–32). The very offer implies a recognition that following the god's commands will involve not only physical danger but moral danger as well. This fact is explicitly

[78]The idea of bribing the *daimōn* I find only in Douglas Young's translation: "To offer the Demon a share of our wealth is little to me, who possess it all."

acknowledged by Orestes (Vickers 1979: 392–93). Before the murder, he wishes only for death should he succeed in killing his mother (437). Confronted by her self-defense, he retorts: "You did what you ought not to have done, now you will suffer what you ought not to suffer" (930), a formulation that acknowledges the criminality of exacting so horrible a vengeance (Goldhill 1984: 183). Once his mother is dead, he does not boast of his accomplishment so much as acknowledge that his "victory" entails "unenviable pollutions" (1017). In short, there is a correlation between the explicitness of the divinity and the greater honesty of the hero. I believe that this emphasis prepares the way for government by law, according to which correct behavior is seen as the consequence of specific injunctions and specific threats and individual motivation is not merely a matter of unthinking whim but something held accountable in court.

Apollo, then, to this extent represents the progressive moment in the religious experience of the *Libation Bearers* and is clearly an improvement over the vindictive, patriarchal, would-be rapist of the *Agamemnon*. But his injunctions are nonetheless in harmony with the self-consciously primitive invocations of Agamemnon's ghost which take up so much of the dramatic time of the play. This is not to deny that Aeschylus or his audience may have believed in ghosts. Various references, not least significant those in Herodotus, suggest quite the opposite. What is primitive here in relation to the framework of ideas available in the trilogy itself is the invocation of Agamemnon's aid in the perpetuation of specifically aristocratic vengeance, where laws, courts, and political institutions are irrelevant. As we see below, the text of the trilogy as a whole is far from repudiating the irrational aspects of the moral authority of ghosts; but insofar as there is forward movement at all, it is toward a vision of society in which rational institutions are in harmony with the moral stirrings provoked by angry ghosts.

Patriarchy and Misogyny in the *Libation Bearers*

The *Agamemnon* contains a significant implicit indictment of aristocratic patriarchy and, despite strongly negative elements in the portrayal of Klytemnestra, an extensive and sympathetic focus on women not only as victims of that patriarchy but also as full human beings possessed of superior intellectual qualities. The mutilated prologue of the *Libation Bearers* heavily marks a dialectical shift to valorization of paternal power which builds throughout the play to the climax in mother murder: "Hermes of the Underworld, thou who watchest over powers

inherited from fathers" (*patrōi'* . . . *kratē, Ch.* 1; cf. *patri,* 4; *pater,* 8; *patri,* 14; *patros,* 19). It would be tiresome and pointless to cite the almost obsessive emphasis on the enduring power of the dead father, the formal invocation of which takes up nearly a fifth of the play (315–509) and hovers over most of it (Goldhill 1984: 99–207). The ending of this long invocation suggests, on the principle *qui s'excuse s'accuse,* the poet's own consciousness of this extraordinary emphasis: "Surely the two of you drew out this discourse to a length none could fault" (510).[79]

One might expect that the *Libation Bearers,* with a chorus composed of women slaves and containing repeated laments by an oppressed daughter, echoes the indictment of male power in the *Agamemnon*—except for the fact that so much of the blame and hostility are directed at the queen's role in this oppression. The dramatically specific focus on the hatefulness of Klytemnestra is generalized by the chorus into a seemingly categorical indictment of the whole female gender, or at least of female sexuality:

> Many are the fearful pangs of terrors
> That the earth nourishes,
> And the embraces of the sea team with monsters
> Hostile to mortals. Harm too comes from meteors—
> Torches in mid-air.
> Both flying creatures and those that move on the ground
> Might tell the stormy rage of whirlwinds.
>
> But who could give an account
> Of the overdaring male's mind
> And bold-minded women's
> All-daring passions [*erōtas*] that
> Share pastures with disasters for mortals?
> Love passion that is not love [*aperōtos erōs*],
> Overwhelming the female, wins a perverse victory
> Over the yoked together unions
> Both of beasts and mortals.
>
> (585–601)

This sweeping rhetorical structure, a true priamel (Bundy 1962: 4–5), juxtaposes as foil the sources of danger in the physical cosmos and

[79]In the *Agamemnon* a self-reflexive comment on the length of a speech is unmistakably ironic (*Ag.* 916). I do not mean here to imply that Aeschylus disapproves of his own artistic choice in devoting so much dramatic time to this invocation, but I think it is legitimate to see the choral comment as insisting—in the face of potential criticism—on the validity of this choice. Vickers (1979: 388) suggests plausibly that the point is to stress the religious propriety of this *threnos,* which had earlier been impiously denied the murdered father.

contrasts them to those arising from human passion, climaxing in female passion. The inclusion of male passion (cf. *andros*, 594–95) is usually ignored, but it constitutes a significant reminder. Although the emphasis has decisively shifted to the female, the indictment of male passion in the first play is not negated completely. Indeed the verbal play of *aperōtos erōs* parallels the verbal play of *orgai periorgōi* (or *periorgōs*) in the earlier evocation of the hideous destructiveness of male passion (*Ag.* 214–17). There is a significant parallel too between, on the one hand, the verbal play on *erōs* that wins a perverse victory (*paranikai*) for the females it has conquered (*thēlukratēs*) and, on the other, the *erōs* Klytemnestra envisions attacking the victorious Greek army at Troy so that they are defeated (*nikōmenous*) by hope of profits (*Ag.* 341–42). The redundant emphasis on daring (*tol-*, *tlē-*, *-tol-*) likewise echoes the relentless focus on the destructive daring of both male and female criminals in the *Agamemnon*. Finally, the broadly anthropological sweep of this passage confronts the grim paradox that the greatest threats to human civilization derive not from hostile phenomena external to it but from the passions of human beings themselves. This perspective is implicit in the wide range of bestial imagery applied in the *Agamemnon* to all the representatives of aristocratic criminality.

This is by no means to deny the intense misogyny of this choral ode, but merely to situate it in the broader context of the first play with which it is in dialectical tension—to insist that the indictment of female passion is not dramatically or ideologically gratuitous or devoid of links to the more obvious class-based indictment of aristocratic male and female passion. We may also note that the only lines in this chorus which explicitly qualify a seemingly categorical attack on the whole female gender use language highly suggestive of this dialectical tension. The chorus interrupts its lurid catalogue of mythic female crimes to comment: "I honor a home's hearth devoid of passion's heat / And a woman's spearpoint [*aichma*, i.e., spirit] devoid of daring [*atolmon*]" (*Ch.* 629–30).[80] Each of these two lines contains an oxymoron (cold hearth, unadventurous fighting spirit) that defines the acceptable female as the antithesis of the fire and martial aggressiveness traditionally associated with the heroic aristocratic male and scathingly criticized in the first play. Although a contemporary feminist may view this as an oppressively limiting vision of female options, these lines do strike a distinctly different note from the ferocious misogyny of the rest of the ode. On the contrary, this note is parallel to the valorization in the *Ag-*

[80]This metaphorical extension of the word for spearpoint to mean an aggressive, martial spirit is normally applied to males. It occurs of a female elsewhere only at *Ag.* 483, where the chorus applies it sarcastically to Klytemnestra.

amemnon of the dusky dwellings of the humble in contrast with the gold-spangled mansions of the rich (*Ag.* 772–81)—a contrast which, we may note in passing, is vividly dramatized in the juxtaposition of the good mother figure, the nurturing and loving serving-woman Kilissa (*Ch.* 731–65), to the evil mother figure, Queen Klytemnestra, who abandons and rejects her children.

The climax of this choral ode, the goal toward which its misogyny aims, is the insistence—just after Orestes has accepted the paradigm of the snake child (*Ch.* 540–50) and just before he first confronts his mother face-to-face—that the anticipated murder is justice pure and simple. Self-consciously the chorus insists on the justice of their mythic *exempla*, then vividly evokes the murder thrust as itself the act of Justice:

> Which of these [myths] do I not justly [*endikōs*] rouse up?
> The sword near the breast
> Drives its sharp point right through
> At the agency of Justice [*diai Dikas*].
>
> (638–40)

As a dramatic character, this chorus is marked throughout by its own ferocity and penchant for oversimplification. To characterize women in this way entails a common negative stereotype. But the dramatic function of this tirade is to contrast the chorus's moral simplicity with the intolerable moral complexity of Orestes' murder of his mother.

One's assessment of the misogyny of the second play turns finally on whether one feels that the play as a whole, not to mention the trilogy as a whole, invites the audience to accept comfortably the killing of Klytemnestra that the virulent arguments of this choral ode seem intended to justify. Taken at face value, the misogynistic perspective ought to sweep aside any lingering qualms about mother murder. Yet here, more obviously than in the *Agamemnon,* there is a striking countermovement that insists on the problematic character of this murder. Where Homer before him simply suppresses any hint of a difficulty (*Od.* 3.309–10) and Sophokles after him arranges the plot in such a way as to minimize the murder of Klytemnestra, Aeschylus uses all the resources of his art to evoke the full horror of the confrontation and the hideous consequences of Orestes' act.

Orestes initially hopes to encounter Aigisthos seated on his father's throne (*Ch.* 571–76) but finds he has first to deceive his mother. There is no dramatic confrontation on stage with the morally uninteresting Aigisthos, who is dispatched first. But the confrontation with Klytemnestra is truly climactic. By a dazzling coup de theatre (Kitto 1956: 55;

Knox 1979: 42), the apparent nonspeaking supernumerary Pylades must emerge from silence to counter the daring and paralyzing exposure of the maternal breast (896–98).[81] Instead of triumph and jubilation after the deed, the audience is confronted by the psychological collapse of the "hero" and his self-imposed exile as he races off stage from his internal nightmare. I cite this familiar evidence specifically in relation to the sexual politics of the play. The play emerges as dialectical in presenting the contradiction between hatred of women and the disastrous consequences of the most extreme attempt to defy the female. The unique distinction of Aeschylus' treatment is that the dialectic of political change is inextricably meshed with the dialectic of sexual conflict. The possibilities of resolution on both levels are thus the most fundamental subject of the final play. But more immediately it must be acknowledged that the whole final play stands as a dramatic demonstration that the justice of mother murder was in fact neither pure nor simple.

Democracy in the *Eumenides*

We come at last to the final play. On the political level, we have already alluded to the *Eumenides* as representing Athenian democracy. But now one has to ask, democracy in what sense? What specific elements beyond the shift of scene to Athens evoke democracy in a form recognizable for a contemporary audience? Dodds (1960: 20) calls attention to the absence of King Theseus, an absence unique in surviving dramatic presentations of mythic Athens. On a more fundamental level, I argue that the Athenian audience is invited to infer their democracy from the new institution established during the play, the court of the Areiopagos.

Such an interpretation, though not new, may seem strange in view of the history of the council *(boulē)* of the Areiopagos ("Hill of Ares"), an outcropping of rock at the front of the Athenian acropolis where traditionally the council met. Rhodes suggests that "perhaps it [the council] was thought to have been founded by Theseus when he created the

[81]Vickers (1979: 403–5) is at pains to stress how the full characterization of the nurse's role as true nurturer undercuts Klytemnestra's gesture here. He has a point. Goldhill (1984: 169–70) argues more subtly that the introduction of the nurse contributes to the separation of the maternal function from the biological parent and thus prepares for Apollo's separation of the mother from generation itself. Yet the whole impact of this scene depends on the enduring power, so hideously evoked in Klytemnestra's dream of nursing a serpent, of the breast as symbol of the intimate bond between mother and child. That it echoes a famous appeal in Homer (*Il.* 22.79–83) only adds to its power.

Eupatrid order" (1985: 79), but others (Hignett 1958: 79–82) thought Solon created it. It is more likely that Solon transformed what had been a self-constituting council of the heads of the most powerful families into a council of ex-archons, thus a council at least indirectly integrated with the voting power of the demos. The archon, elected annually from the highest income class by a vote of the whole citzenry, was the chief executive of Athens until 501/500, when the board of ten annually elected generals seems to have begun to assume the executive role. Until Solon's time the council of the Areiopagos seems to have functioned as the chief vehicle of aristocratic domination. Solon's creation of a separate *boulē* of four hundred to prepare the agenda of the people's asembly presumably entailed a significant curtailment of its prior absolute authority, but *Athenaion Politeia* is quite clear in specifying that the Areiopagos "had oversight of the laws . . . kept close watch over the majority of and the most important of political matters" (8.4). Kleisthenes, in creating a new five-hundred member council for the people's assembly, created in principle a substantial counterforce to the sweeping powers of the old Areiopagos council. But it is possible, even likely, that Kleisthenes as an exarchon was himself a member of this council (Hignett 1958: 128 n. 3) and left its traditional prerogatives formally untouched. Only with the introduction in 487–86 B.C. of choosing archons by lot rather than by election was its prestige doomed and the exclusive executive role of the board of ten generals consolidated. The reforms of Ephialtes in 462 B.C., often called a revolution (Davies 1978: 63–75; Hignett 1958: 193–213), definitively swept away all the powers of the Areiopagos except jurisdiction over murder trials, the function they have in the *Eumenides*. I believe that Aeschylus, in making the Areiopagos in this role emblematic of the new democracy, is engaging in just the sort of political tact, or cooptation, that Athena engages in when she transforms the hostile Erinyes into the supportive Eumenides. Tactical ambiguity is the essential feature of this strategy.

Athena declares that she will choose members of the first court from her best citizens (*Eu.* 487). Given the elite character of the Areiopagos, especially before 487–86 B.C. (Hignett 1958: 188), it is easy to take this phrase in strictly class terms. The terminology, however, is ambiguous. She does not use a form of *aristos*, which since Homer had connoted membership in the ruling class. The abstract plural *ta beltata* with a dependent genitive leaves open whether a moral or a class sense is uppermost, though *LSJ* indicates that *beltistos* is not used to designate an aristocrat before Xenophon.[82] Perhaps the most unambiguously democratic feature of these first judges is their anonymity. It is at least

[82]See Thucydides 6.39.1 or 8.108.4.

arguable that Aeschylus could have included a dazzling catalogue of old Attic names if he had wished to insist on the heroic character of the early jury, but arguments from silence are dubious at best. What is clear from repeated addresses and references throughout the play (*Eu.* 566, 638, 681, 807, 854, 911, 927, 948, 997, 1010) is that the judges are consistently represented as the *whole people* of Athens (Taplin 1977: 390; Macleod 1982: 127). In particular, the responses of the litigants—on the one hand, gratitude and the promise of an alliance (762–77), on the other, bitter threats to pollute the land (782–87)—insist that the court stands directly for the whole Athenian people.

Athena's extensive charge to the jury (681–710) adds to the ambiguity of the court's political character. Her wording suggests to some the unique and sweeping constitutional powers of the Areiopagos before the radical reforms of 462 B.C., a position that has had its defenders, despite its awkward consequences (Dover 1957: 234; Davies 1978: 74–75). I believe on the contrary that the court of the Areiopagos is intended to stand metaphorically for the whole set of Athenian legal institutions (Macleod 1982: 127–29). The ambiguity is then deliberate, a strategy consonant with the quest for resolution of threatening political tensions in Athens. But I also believe that the primary thrust of Athena's speech is made unmistakably clear by her insistence on the absolute uniqueness of her new court: "You would have a bulwark of the land and salvation of the city / Such as no other human beings have— / Neither among the Scythians nor in Pelops's territory" (701–3). One may doubt that the average Athenian at this period knew much about the social and political institutions of the Scythians; indeed, they probably evoked the anarchy against which Athena had just warned (696). But virtually every Athenian had some notion of the tight oligarchic control exercised in Sparta by the gerousia (council of elders) and/or the ephors, who were both a court and, as their name implies, supervisors of the constitution.[83] To Athenians the reference to Sparta may well have suggested the alternative of despotism in Athena's warning (696). In any case, the claim of uniqueness would be severely

[83]A. H. M. Jones acknowledges that ancient authors like Isocrates and Demosthenes represented the *gerousia* as "virtually the governing body of Sparta" (1967: 18), but goes on to note, "in the historical record it is conspicuous by its absence" (18). Forrest concludes that for the early period at least, "it controlled virtually everything" (1968: 47). In any case, it was a pretty typical oligarchic council. The ephorate is, to be sure, more complicated. Within the tight oligarchy of true Spartans, it could be argued that it was the most democratic aspect of the Spartan constitution, since its members were elected annually from the Spartan citizenry without regard to class (Forrest 1968; 76; Andrewes 1966: 8–10). In practice, however, and presumably from the point of view of the putative average Athenian (i.e., non-aristocrats), it probably seemed the decisive Spartan institution for maintaining the dominance of the few over the many inhabitants of the "territory of Pelops."

undercut if the audience conceived of the new court as also fundamentally oligarchic. Athenian pride in the uniqueness of her democracy as a whole is well attested in later sources. In fact, the terms in which Athena in the *Eumenides* explains her decision to avoid a unilaterial decision by forming this court (470–88) closely parallel a speech from an earlier tragedy (*Suppliant Women*) long recognized as strikingly democratic. Davies cites and translates Aeschylus' words from *before* the revolution of 462 as a good instance of the projective force of art:

> The language which he gives in 464–3 to the Argive king . . . could serve as a programme for much that was done in the next ten years:

> > You are not suppliants at my own hearth;
> > If the city in common incurs pollution,
> > In common let the people work a cure.
> > But I would make no promise until
> > I share with all my citizens.

> Or again:

> > Judgement is not easy to give; choose me not as judge.
> > I said it previously too, that without the people
> > I should not take this step, even if I have the power, lest
> > The people say
> > 'You honoured strangers and destroyed the city.'
> > > (*Suppliant Women* 365–69 and 397–401)
> > > (Davies 1978: 71–72)

Apart from Aeschylus' own texts, the earliest description of Greek democracy which has come down to us, the constitutional debate in Herodotus (3.80–83), gives pride of place to legal institutions:[84] "[Whereas] the monarch/tyrant [*mounarchon . . . andra ge turannon*] disturbs the inherited laws, rapes women and puts people to death without a trial . . . the rule of the majority [*plēthos archon*] has in the first place, the loveliest of all names, *isonomiē* [equality before the law]" (3.80.5–6).[85]

To be sure, Herodotus also cites offices by lot, power subject to scrutiny (*hypeuthunos*), and public deliberation of all decisions (3.80.6). None of these is explicitly alluded to in the third play of the *Oresteia*,

[84]Podlecki (1966a: 115), assuming the Aeschylean authorship of the *Prometheus Bound*, argues that it offers the earliest formulation of "democracy's quarrel with the tyrant." In any case, his study and others make a good case for other plays of Aeschylus as early sources aiming toward a definition of Athenian democracy (see Davison 1966: 95–104, for references only; the political argument I find preposterous).

[85]On the implications of *isonomia*, see Ostwald 1969: chap. 3.

but the trilogy as a whole focuses on justice as emblematic of whole political systems, character types, and the relation of the sexes. Thus Aeschylus' view may not be so far from that of the author of the Aristotelian Constitution of Athens: "When the people have a right to vote in the courts, they become the masters of the state" (*Ath. Pol.* 9).

The reference in Herodotus to rape of women suggests that ideologically at least, whatever the reality, democratic males prided themselves on their relatively more respectful treatment of women. It is arguable that this perspective is implicit in Aeschylus' plot choice in the *Suppliant Women* according to which women's right to choose or reject their husbands is judged worth a war to defend. Moreover, the entire analysis in the *Agamemnon* of aristocratic criminality could reasonably be summed up in Herodotus' characterization of the tyrant/monarch as "not subject to scrutiny" (*aneuthunoi*, 3.80.3).[86] In the *Eumenides*, Aeschylus has chosen to stress not simply the external restraints of a government of laws but the internal, psychological inhibitions fostered by such a society. The principle of open public debate and even, as Dodds notes (1960: 20), a *boulē* (advisory council) is taken for granted as a feature of Agamemnon's inherited monarchy as differentiated from the closed tyranny of Klytemnestra and Aigisthos. Moreover, the grounds for Athena's refusal to decide the case herself (alluded to earlier) clearly imply the fundamental assumption of specifically democratic decision making: "The matter is greater than any mortal is minded / To judge it. Nor indeed is it right for me / To decide a murder case fraught with bitter wrath" (*Eu.* 470–73). The inadequacy of a single judge, human or divine, is offered as the basis for a group decision, and the chief advantage of such a decision is precisely that it diffuses the hostility provoked by unilateral decisions. Thus, despite some ambiguities surrounding the description of the court, it nonetheless emerges as the symbolic representation of Athenian democracy insofar as it implies the rule of law, the participation of anonymous citizens, and group decision making.

The specific *ēthos* of Athenian democracy emerges more clearly by contrast to the aristocratic *ēthos* delineated in the *Agamemnon* and the tyrannical atmosphere evoked especially in the *Libation Bearers*. As we have already seen, the aristocratic *ēthos* was characterized by its corrupt relation to wealth (*olbos, ploutos*, etc.), manifested in daring (*tolma*), in

[86]Podlecki (1966a: 115) objects to an association of anti-aristocratic feeling with an anti-tyrannical sentiment on the grounds that aristocrats were inevitably the tyrant's bitterest enemies. The situation was not always so clear as that; but, even granting common hostility between them, it does not follow that from the point of view of the demos both could not share similar faults of character. As noted earlier, aristocrats seem to have retained considerable power under Peisistratos.

perverted passion (*erōs*) for glory and gain achieved through destruction of innocents, and finally in its consistent underevaluation of women. Justice, which for aristocrats is always excessive revenge, is legitimated by a self-serving assumption of divine sanction. The whole nexus of mutually reinforcing factors bears the stamp of inherited evil, though its real origins in patriarchy and aristocracy are clear. The political atmosphere of tyranny—already largely assumed in the *Agamemnon*—is characterized by profound fear and anxiety, imposed silences, indirection, factions, plots, deceit. In the *Eumenides*, prosperity (*olbos*) is presented, in lines that clearly echo the meditation on excessive wealth and the inheritance principle in the *Agamemnon* (see 750–71), as the "offspring [*tekos*] of a healthy mind" (*Eu.* 534–37). The transformed Erinyes, no longer synonymous with inherited evil, promise to the Attic people wealth (*ploutos*) "bestowed by fate" and "decent" (both meanings of *aisimos*, see *Eu.* 996). This wealth is not associated with gold and luxury but with the fertility of the land; it is peasant, agricultural wealth. Even the color purple, the symbol of blood-stained aristocratic arrogance in the *Agamemnon*, and the imagery of radiant fire, earlier so heavily associated with the deceptive brilliance of heroic individualism, are in the *Eumenides* reappropriated as manifestations of specifically civic honor (*timē*) and decorum (1028–31). In Athenian society there is no place for the bad kind of daring, which is now explicitly associated with the destructiveness of internecine war and a bestial temperament (861–63). But there is still room for the metaphorical association of *erōs* and the ambitions of war. The disastrous passions of the *Agamemnon* are not simply negated and suppressed; they are incorporated in a heroism potentially available to the humblest Athenian sailor. As the price of banishing civil strike, Athena declares: "Let there be foreign war, all too ready at hand, / In which there shall be a certain terrible passion for glory [*deinos eukleias erōs*]" (864–65). Not only does the grammatical construction leave somewhat ambiguous whose *erōs* is intended (Lattimore even takes it to mean "against the man who has fallen horribly in love with high renown"); even on the assumption that it is attributed to the Athenians, it is still called *deinos*, terror-inspiring like the hostile elements in the physical cosmos (see *Ch.* 586).[87] One may be tempted to dismiss as ridiculous the notion that Aeschylus, Aristophanes' paradigm of the old martial spirit, could have expressed antiwar sentiments. These lines in the *Eumenides* might even be cited to counteract

[87]As congenial as Lattimore's version would be to my views, I do not think the dative can possibly have such a force. Douglas Young's interpretation of *en hōi* to mean *en hōi khronōi* ("while") is, however, possible Greek. This reading would leave open the suggestion that the ready availability of foreign war is due to *foreigners'* terrible passion for glory.

the impression of the passionate indictment of the Trojan War in the *Agamemnon* (see esp. 62–67, 427–51, 799–804). Yet they offer cold comfort for such a position. A realistic Athenian in the early 450s could not possibly envision a world free of war. Celebration of a specifically military alliance with Argos (*Eu.* 287–91, 762–74), the traditional rival of Sparta for hegemony of the Peloponnesos, is built into Aeschylus' plot. This alliance, part of the radical turn of 462–61, made conflict with Sparta virtually inevitable (Ste. Croix 1972: 183–85). Still, the aggressive passion for war is here presented as at best a monstrous force to be directed outside the body politic, *faute de mieux*. If this form of *erōs* is perceived as a human attribute regardless of class, Aeschylus nonetheless suggests that the social and political institutions of democracy offer greater promise of successfully rechanneling it than does the aristocracy with its inherent inducements to individual heroics.

Unsublimated sexual passion, so frightening in the adulterous Helen, Klytemnestra, and other mythic great female characters, is celebrated in the democracy only in the context of marriage and procreative fertility. Apollo denounces the Erinyes' disregard for the "sworn pledges" (*pistōmata*) of marriage and "Kypris (Aphrodite) . . . from whom mortals have what is dearest of all" (*Eu.* 213–16). Apollo's words should be viewed in the light of the subsequent emphasis in the final choral hymn on happy marriage under the tutelage of

> Goddesses [*daimones*] of upright customs/laws [*orthonomoi*]
> Who have a share in every home,
> Who press on us at every moment
> With company that makes us just.
>
> (*Eu.* 963–66)

Together these texts not only suggest a repudiation of adultery by males or females but offer Athenian marriage as a paradigm of a union freely entered and sustained by moral choices. The fact that this seems to bear little relation to the arranged marriages of the aristocracy and the well-to-do or that known instances of an Athenian woman freely choosing her husband are extremely rare (Lacey 1968: 105–8) suggests how profoundly utopian Aeschylus' sexual solution may be. As suggested earlier, however, it is just possible that the majority of the Athenian population who had little or no property to haggle over in the form of inheritances and dowries were prepared to respect the principle that women should have a say about whom they marry.

The Athenian democratic form of justice implies a radically different relation to divinity from the religious assumptions of heroic aris-

tocrats. The full association of Athena, goddess of the city, with the implementation of courtroom justice implies that redress of grievances, revenge, is no longer the province of individuals who can claim divine support. The special relation of Orestes to Apollo remains an anomaly—relevant, we have suggested, primarily insofar as it prefigures the explicitness of laws and courtroom analysis of motivation.[88] But the chief focus on the divine role of Athenian justice is in connection with the transformation of the Erinyes into the "Kindly Goddesses." Here, as we have already suggested, the oppressive anxiety and fear that beset those victimized by tyrannical power is transformed into the good fear (*to deinon, deos, phobos*) that internalizes the rule of law. Those who see the concessions Athena grants the Eumenides either as threatening to invalidate the progress implicit in the establishment of the court or as proof that no real change is intended (e.g., Lloyd-Jones 1971: 93–96) underestimate the extent to which fifth-century arguments for and against democracy were based on psychological grounds. Here again the constitutional debate in Herodotus is a key text.[89] The chief argument against monarchy/tyranny is the absence of legal restraints, the unchallenged power of the monarch which corrupts the character of even the best of men, carrying him "outside the realm of normal thoughts" (3.80.3). It engenders "insolent violence" (*hybris*) and "resentful jealousy" (*phthonos*).[90] The oligarchic argument against democracy presupposes the same negative view of human nature as inherently prone to wildly selfish and irrational behavior when free of institutional restraints: "There is nothing more devoid of understanding or more insolent [*hybristoteron*] than the worthless mob" (3.81.1). "Whatever the tyrant does, he does knowingly, but the mob is quite devoid of knowledge. For how can it know when it has neither been taught [*edidakhthē*] nor has any inherent [*oikeion*] knowledge of what is noble [*kalon*], but attacks public business mindlessly like a river in flood?" (3.81.2–3). The pro-democracy speaker emphasizes the vulnerability to corruption of even the best of men; but, as A. H. M. Jones notes, "the [anti-democratic] philosophers are strangely blind to this danger, and are content to rely on the virtue of their hereditary or cooptive oligarchies of wise men" (1964: 61). In the Herodotean

[88]Macleod (1982: 134) stressed the relatively modest "supporting and subordinate role" of Apollo in the trial and seems to imply that this is a model of democratic religious relations. I am not quite sure how this would manifest itself in a specific religious politics.

[89]Debates about discipline and the role of fear in Sophokles' *Antigone* or *Ajax* are suggestive and chronologically nearer than Herodotus, but they have the disadvantage of requiring interpretation of the politics of each play in its entirety.

[90]Here, as in earlier chapters, I have in mind the definition of *hybris* which I heard long ago in a lecture by H. T. Wade-Gery: "the violent disregard of another person's self-respect."

debate the oligarch adds the elitist epistemological argument that the majority are inherently criminal because they are inherently (*oikeios* is frequently a virtual synonym for "innate") ignorant. The implication that aristocrats, who by and large are the only people who can afford teachers, know by nature what is noble (*kalon* has class as well as moral connotations) would be congenial to Pindar. Without resorting to extensive citation of other post-Aeschylean sources (see A. H. M. Jones 1964: 41–72), I believe it is legitimate to see these arguments as typical of anti-democratic thought.

The *Oresteia*'s response is twofold. First, the text answers the charge of irrationality by placing enormous emphasis on the positive role of internalized fear of transgressing the law. Not only do the Erinyes state the case for this fear in terms closely echoed by Athena, their incorporation into the fabric of the democratic state is the symbolic emblem of the centrality of that fear in democratic theory. Indeed, the notion of internalized fear is the chief fifth-century argument in defense of any government based on law, even the relatively repressive Spartan regime. Thus, in response to Xerxes' incredulity that free Spartans, not driven by fear of a master, could possibly stand up against his vast army, the exiled kind Dēmarētus is given the following reply by Herodotus: "Though they are free, they are not wholly free; for law is master over them, under whom they cower in fear [*hupodeimainousi*] far more than your people do under you" (7.104.4). The formulation in Herodotus is nearer to a sociological doctrine, one parallel to the emphasis on the internalization of ethical values in the early Sophists.[91] As de Romilly has ably demonstrated (1958: 113–14), the special quality of Aeschylean democratic fear is that it hovers between primitive religious fear and a self-conscious form of social indoctrination.[92] It is the poet who has chosen to tap this religious sanction for the rule of law in response both to the simple critique cited earlier of the irrationality of the mob and to the subtler critique, implicit in Pindar but spelled out only in Plato's attack on the Sophists, which focuses on the mutability and therefore unreliability of what is merely "learned."

[91]The "great speech" attributed by Plato to Protagoras in the dialogue of that name offers the earliest systematic discussion of the socialization process. I discuss this text in some detail in Chapter 6. But the fragments of Democritos already cited suggest that he too was much interested in the internalization of politically essential ethical values.

[92]Though I agree on the religious cast de Romilly stresses in *sebas* (*Eu.* 690), I also believe that here too there is a political transformation of a term with earlier negative connotations. As I argued earlier, with the support of some translators, *sebas* at *Ch.* 54 connotes specifically the reverence felt toward royal authority by an oppressed demos. The ideal Athenian democrat does not lose his sense of reverence but redirects it toward a worthier object, the laws.

Aeschylus goes even farther than employing religious sanctions in support of his vision of the good fear of Athenian democrats. As we see in Chapter 6, Plato responds to the radical sophistic analysis of socially enforced values with a complex blend of controlled breeding and controlled socialization to acknowledge their critique while establishing on a new footing an old prestige of what is supposedly innate. Aeschylus, with very different sympathies, describes this democratic fear as "innate," "inherited," using the very word that for Pindar (*Py.* 10.12, *to . . . sungenes*) marked the inherited excellence of the victor: *sebas astōn phobos te sungenēs (Eu.* 690–91). As we have seen, in the first two plays, where aristocratic pride in a literally conceived inherited excellence is countered by sharp focus on a metaphorically inherited evil, there is a fundamentally negative presentation of what is inherited. Now in the *Eumenides* this key ideological element is suddenly reversed into a metaphoric heritage of a whole people. "Inborn" thus retains all its positive connotations of what is natural, normal, real, permanent, fixed (cf. Heinimann 1965: 95–98) without the aura of class pride Aeschylus implicitly repudiates. Yet we should note in passing that this metaphoric shift has been made possible in no small measure by the aristocratic strategy we noted in Pindar, who, depending on the specific family achievements of his victor and the mythic heritage of his polis, moves easily between the most literal praise of inherited excellence and a purely metaphoric sense of inheritance in which all the citizens of the *polis* are viewed as heirs to the virtues of their mythic heroes. Aeschylus thus transforms an initially elitist strategy of cooptation into a vehicle for attributing legitimacy to the innate fear of the whole people of Athens under democracy. Pindar's utopian projection of community in the service of a specifically aristocratic vision is here transformed and extended by Aeschylus into a specifically democratic utopian community.

Aeschylus' second major defense of democratic government, that against the charge of ignorance, also has an affinity with a strategy we analyze later in Plato: as if tacitly acknowledging the inadequacy (or reactionary character?) of what is innate, Aeschylus makes *learning* bear the chief role in his ideological combat in behalf of democracy. A sort of polar complement to his positive valuation of democratic irrational fear, Aeschylus' doctrine of learning through suffering is a fully historicized defense of the proposition that a whole people, specifically the Athenian people, are capable of becoming *sōphrones* [Lit. "safe-thinking," i.e., "moderate"]—of acquiring that mental posture toward the world around them to keep them safe. As noted earlier, those scholars who insist that the protagonists of the *Agamemnon* learn nothing are quite right. Aristocrats corrupted by their own wealth are truly at the Homeric stage of *pathei mathos*—"even a fool knows it once the

deed is done" (*Il.* 17.32, 20.198; cf. Lloyd-Jones 1956: 62). But Orestes, who states early in the *Libation Bearers* his wish to die after slaying his mother, seems to know in advance of his act that it must have disastrous personal consequences. Though he is no longer the center of interest in the *Eumenides*, it is surely a significant clue to the paradigmatic nature of his *pathos* that he begins his second appeal to Athena with words that emphasize his personal learning experience: "I (*egō* is emphatic), having been taught [*didakhtheis*] in sufferings, have knowledge [*epistamai*]" (*Eu.* 276). Moreover, he follows the orders of "a wise teacher" (*sophou didaskalou,* 278). The foundation of the court to resolve Orestes' case and the *agōn* over the future of Athens which results from settling that case establish that the Athenian people are the chief target of the Orestes paradigm—as manipulated by their own *sophos didaskalos,* Aeschylus himself.[93] The conventions of a public dramatic festival may seem to leave little room for the sort of poetic self-reflexivity we noted even in the *Odyssey* poet and in such abundance in Pindar, but here perhaps it is not amiss to detect a sly pun.

In any case, the longer speeches of Athena and the final choruses are addressed directly to the entire people of Athens (*astikos leōs,* 997; *pantes hoi kata ptolin,* 1015) and represent dramatically the teaching function of drama itself: "Seated near Zeus's dear virgin and dear to her, [they, the Athenian people] are becoming wise in time" (*sōphronountes en khronōi,* 998–1000). The historicizing, progressive vision implicit in the trilogy form is summed up in this phrase, where the force of the present tense to designate an on-going process is insisted on by the addition of "in time."

Sexual Politics: Vision and Reality

In passing, I have inevitably glanced at the sexual level of the democratic vision, but this topic merits separate treatment. In contrast to the adultery associated with aristocratic patriarchy we have noted the valorization of marriage as a locus of sworn faith and laws overseen by female divinities, obligations represented as applying to male and female alike. We have also noted that the *Eumenides* as a whole has been seen as fundamentally misogynistic. It has been argued that Aeschylus'

[93]In view of Pindar's regular use of *sophos* to designate the poet, and the use of *didaskalos* for the trainer of a chorus by Aeschylus' contemporary Cratinus (256 Kock; compare Simonides 147.5 Bergk), the phrase is a far more normal way to allude to a tragedian than to the god of an oracle. I must acknowledge, however, my disappointment that such an apostle of self-reflexivity as Goldhill sees here only a crypto-allusion to the Sophists (1984: 227 n. 14).

clearly original version of the myth of the origin of Apollo's role at Delphi, presented by the Delphic priestess in the prologue (2–19), establishes the model for peaceful transference of power from female to male (Zeitlin 1978: 163). On this argument, the thrust of the final play is to celebrate the decisive change from the perverted female dominance of Klytemnestra, that is, from mythic matriarchy, to the all too real patriarchy of democratic Athens, where women were excluded from participation in political and, as far as possible, social life. Similarly, the allusion to Theseus' defeat of the Amazons in the very speech in which Athena establishes the all-male court of the Areiopagos (685–90) is symbolic of the defeat of the female element in the resolution of the chief dramatic conflict.[94] From this perspective, Apollo's argument that only the male is parent whereas the mother is merely a host for the male seed is "the hub of the drama" (Zeitlin 1978: 167–72; Gagarin 1976: 101–3). Apollo uses the example of Athena's own birth from the male god Zeus as proof of his thesis (664–66); and Athena, in explaining the grounds for her tie-breaking vote (Hester 1981: 270–72; but also Goldhill 1984: 257–58) which frees the matricide, echoes this argument (736–38).

Without denying that there is much in the text that supports such a reading, I cannot escape the impression that for such readers the decisive factor in their interpretation is their knowledge of the oppressive reality of the political, social, economic, and sexual roles of Athenian women. The tacit assumption is that the artist cannot negate or transcend what is so deeply embedded in the structure of society. Here one needs to remember, but go beyond, the dictum of Vernant quoted earlier: "Tragedy does not reflect that reality, but calls it into question" (Vernant and Vidal-Naquet 1988: 25). The status quo is called into question not (pace Goldhill 1984: 283) simply as a function of the indeterminacy of all language but by a historically specific negation and a utopian projection.[95] The artist is indeed limited by his or her own society's structures, but not limited to them. The thrust of art, like myth, is to seek imaginary resolutions of real contradictions; but to the

[94]For the general symbolism of the Amazonomachy in fifth-century thought, see duBois 1982: esp. 56–71.

[95]Overall, I find Segal's generalizations about language in tragedy nearer the mark: "The tragic *situation* distorts normal speech. . . . Language itself . . . is a major concern of Greek tragedy. Its dissolution parallels the shedding of kindred blood or incest in the familial code and the perversion of the man/god communication in the ritual code. . . . The whole *Oresteia* can be read in terms of a dissolution and *gradual reconstitution* of language which runs parallel to a destruction and reconstruction of ritual forms" (1986b: 44–45, emphasis added). Although I certainly recognize the tremendous emphasis on ritual matters in the text, I suspect that I interpret it more metaphorically than Segal would.

extent that art is more self-conscious than myth, it is capable of presenting solutions that do not simply validate the status quo but negate it, transcend it by projecting a utopian vision and inviting society to embrace that vision. In miniature, we have already seen that process at work in Aeschylus' utopian representation of democratic leadership in the *Suppliant Women*. In the tragic pattern of the *Iliad* and in the tragedy of Sophokles (see Chapter 5), art may even confront society with the impossibility of resolving its contradictions (compare Segal 1981: 51, citing Barthes).

The sexual politics of the *Eumenides* do indeed seem to wrestle with insoluble contradictions, but the movement of the play as a whole is toward a triumphant, if utopian, resolution. The alleged straightforward pattern of male triumph in the prologue admits of a more complex reading. That the male god Apollo controlled the most powerful religious seat of Greece was a given. What Aeschylus' version repudiates is precisely the misogynistic tradition of violent male conquest of a vicious female monster and punishment of female deceit, a version so vividly realized in the *Homeric Hymn to Apollo* (224–384). Aeschylus' version gives pride of place to female figures evoked in positive terms: Gaia ("Earth"), rather monstrous is Hesiod, is here simply "first in prophecy" (*prōtomantin, Eu.* 2). Themis, a figure given special honor by the author of *Prometheus Bound* (she is substituted as the mother of Prometheus), is a representation of divinely sanctioned Right of Law that is by nature never superceded, only supplemented. The shadowy titaness Phoibē has no apparent inherent significance other than her role in explaining the traditional epithet of Phoibos Apollo, the emphatically *voluntary* process of her assumption of power from her mother Themis, and the benign process by which she bestows Delphi on Apollo as a birthday gift (5–8). These female figures, like the Erinyes and unlike the dragon or Telephussa of the *Hymn to Apollo*, are not obliterated but remain centrally operative in whatever is worthy of reverence in the divinity of Phoibos Apollo. It is legitimate to see in this version a model of willing acquiescence in female subordination; but the fact of subordination was not Aeschylus' doing, whereas the myth he offers to explain it maximizes the enduring positive contribution of females to the new order and specifically rejects a version that represented them as the threat to be beaten and obliterated. The Athenians, represented in their most working-class aspect as sailors associated with Athena and as "children of Hephaistos," the humble god of craftworkers, are linked with the god's journey to Delphi as escorts and road builders through the formerly wild territory that separates Athens from Delphi (10–14).

The trial, in which the acquittal of Orestes is also a given, is likewise not so simple a triumph of male domination. As noted earlier, the ar-

gument of Apollo denying the female role in parenting is the very hub of the trilogy (Zeitlin 1978: 167) for those who see the whole structure as unmitigated misogyny. Because Aristotle a century later echoes this argument, it is often assumed that it must have been obvious or compelling to the mid fifth-century audience.[96] On the contrary, in the same section in which Aristotle makes this argument he is at pains to refute what the Hippocratic corpus reveals was a common view before Aristotle, namely, that women also produced semen and that therefore their pleasure to the point of orgasm was essential to reproduction (Aristotle *De. Gen. An.* 738b–739b; Rousselle 1988: 27–30). In the famous *Danaid* fragment giving Aphrodite's speech at the trial of the only Danaid who did not murder her husband on her wedding night, we get in the metaphor of cosmic union as close to an explicit Aeschylean description of reproductively fertile sexual intercourse as I am aware of: "The holy sky desires [*erai*] to have union with[97] the earth; Desire [*erōs*] seizes hold of Gaia to meet with union [*gamou*]" (Lloyd-Jones 1963: Frag. 25, my translation). The rhetoric of the passage marks with anaphora and adnominatio (different inflections of the same word or root) precisely the mutuality of desire. Moreover, the final play cannot simply cancel the assumptions of the earlier plays of the same trilogy (Winnington-Ingram 1948: 143). We noted in the *Libation Bearers* the emphasis on the *ēthos* Electra and Orestes inherit from their mother (*Ch.* 421–22; Lebeck 1971: 122–28). After the victory of Apollo and Orestes by the narrowest of margins, in which purely personal grounds tip the scale (Hester 1981: 271), the pattern is reversed. The female goddess Athena acts as the prototype of a democratic political leader who uses persuasion (*Peithō*, cf. *Eu.* 970) in open debate to win over the potentially destructive female Erinyes and secure the best interest of the polis. The latter portion of the play celebrates the decisiveness of females (real ones, not just virgin goddesses) in the

[96]Lloyd, for example, who gives a fairly exhaustive review of theories about the relative roles of the sexes in reproduction, states without citing any evidence that "in line with assumptions concerning the superiority of the male sex in the dominant ideology it was commonly supposed that the essential or more important contribution to reproduction and to heredity was that of the male parent" (1983: 86). He cites the *Eumenides* as his first example and considers the medical and presocratic comments in this area as departures from the dominant ideology (86–94). Subsequently, while reiterating that these philosophers were dissenting, he acknowledges in a note that "if anything, the doctrine propounded by Aristotle is the *minority* view among those attributed to *named* theorists" (107 and n. 182). Although alluding briefly to a 1980 article by Rousselle, he takes no stand on the issue whether the medical writers' information came from women or represented their own observations (62). Sommerstein (1989: 206–8) has a good summary of the weaknesses in Apollo's case.

[97]The Greek verb *trōsai* normally means "to wound," reflecting no doubt the usual violence of sexual metaphors in many cultures. *LSJ*, with that maddening coyness in sexual matters that drives any student of Aristophanes to distraction, explain this passage with another Greek work, *sunousiazein*, the most general word for sexual intercourse.

prosperity of the whole polis (959). To the extent that this celebration represents a reduction of female identity to a purely biological function within the confining reality of Athenian marriage, it is scarcely progressive. Yet alongside the strategy of containment implicit on the literal level of this celebration of fertility is the richly metaphoric fusion of the sexual/procreative role with a profoundly political role. The consequences of the transformation of the Erinyes from spirits of inherited evil, thus from a specifically aristocratic revenge ethic, into democratic inherited fear that internalizes government by law are first of all the expulsion of political factionalism (*stasis,* 977) and intrigue from the Athenian body politic and concomitantly the metaphoric prosperity of the well-ordered state. That fertility was envisioned in the more narrowly patriarchal world of Homer and Hesiod as essentially a function of male kingship (cf. *Od.* 19.109–14; *Works and Days* 225–37). Solon may have eased the transition to a conception of this force as female by his rich allegorization of *Eunomiē.* But Aeschylus, by his dual celebration of both the goddess of the city and the profoundly politicized female Erinyes, succeeds in presenting the political, social, and procreative prosperity of the democracy as entirely the gift of females. This purely symbolic political role is, to be sure, a far cry from full political *isonomia* for women. Plato will indeed come very close to that step in positing female guardians and philosopher-rulers. Aeschylus, by confronting his male audience with the problems arising from their own domination and by offering such desperately mythic and symbolic resolutions, has at best only pointed the way.

Utopian Vision versus Tragic Reality

We must ask now, finally, what is the status of the utopian vision in the Aeschylean dialectics of the trilogy? The question applies no less to the explicitly political and juridical aspects of the vision than to its sexual component. For, whereas, in the case of the sexual, one is tempted by the ugly reality to undervalue the visionary element, in the case of the juridical and political one is tempted by Athens' actual achievements to miss the visionary dimension altogether—to see the third play as nothing more than an enthusiastic celebration of the Athenian present as the triumphant end of history. But what is truly dialectical in the Aeschylean form is that what is represented as past is not simply negated but remains as a structural component of the present envisioned in the third play. Indeed we noted earlier in the Hesiodic model that Ouranos, though no longer supreme, is an indelible component of the cosmos. Within the dialectics of the trilogy, many have seen the Erinyes as

a relatively straightforward allegorical representation of the enduring aristocratic element so fully associated with the revenge ethic in the first play (e.g., Livingstone 1925: 120, cited by Dover 1957: 236; Forrest 1966: 215). The potential destructiveness of this element is transformed into a creative role by the integrating exercise of democratic persuasiveness. On this level I have argued that the monarchic leadership function is represented in the new world of the democracy by the role of Athena herself, who initiates policy, makes clear her own personal grounds for taking sides, but yields ultimate institutional responsibility to the votes of the judges. But there are severe difficulties with univocal allegorical labels in analyzing an art that operates through polysemous symbols on multiple levels.[98] Moreover, although I have attempted to avoid the simple reflexive view of art that has characterized both Marxist and non-Marxist approaches to the politics of the *Oresteia*, we must now at least explore briefly the relation of the text to the retrievable realities of Athenian social and political life. Without some such confrontation, it is impossible to assess what is visionary or utopian in the solutions the text offers to the contradictions the text generates.

At the risk of oversimplifying a deeply complex and by no means easily accessible historical situation, I would argue that the most realistic political expectations for the Athens of 458 B.C. were nearer to the world of the *Agamemnon* than the gleaming prospects of the finale of the *Eumenides*. The actual political situation in Athens, far more than the *Oresteia* as a whole, might make "one afraid for one's life" (Vickers 1979: 425).[99] The reforms of Kleisthenes (508–7 B.C.; Forrest 1966: 191–203; Murray 1980: 253–59) had far-reaching consequences, first in giving the poorer classes legal and political leverage against excessive exploitation by the aristocracy (Ste. Croix 1981: 73). This relative economic liberation was associated with Kleisthenes' assault on the role of kinship in determining citizenship under the aristocratic and tyrannical forms of government. Before Kleisthenes, citizenship required

[98]Dover (1957: 237) seems to me to reject allegorical levels for exactly the wrong reason; he sees the text as so univocal, so literal, that there is no room for allegory. An audience educated by the richly polyvalent personified abstractions that people choral lyric was scarcely incapable of simultaneously perceiving multiple meanings (see J. H. Finley 1955: esp. 5).

[99]I cannot agree with Ste. Croix's casual dismissal of the reforms of Ephialtes (1981: 289) or his subsequent murder and the oligarchic conspiracy to betray Athens to Sparta in 458–57 (1981: 291). See Forrest 1966: 209–20 and Davies 1978: chap 4. Davies begins his chapter by pointing to the most tangible evidence of the radical consequences of this revolution: "From the late eighth century onwards there is a trickle of documents from Athens written on stone, bronze, or pottery, but till the 460s only about ten of them are public documents, decrees or dedications, set up by the state or its officials. From about 460 onwards there is a flood of documentation" (462).

being enrolled in one of the four Ionian tribes believed to be descended from the four sons of the hero Ion and into which the whole population was divided. Kleisthenes devised ten quite arbitrary new tribes and an intricate mechanism for insuring that these new tribes broke up the age-old regional power of aristocratic rivals (Forrest 1966: 193–200). As Rhodes sums up a complex institutional shift, "the old tribes were based on actual or supposed kinship; the new were based on locality" (1985: 251). The aristocracy thus no longer monopolized the mechanisms by which one acquired citizenship or dominated the subjective grounds of self-esteem; the ideological hold of an identity dependent on allegedly ancient blood descent was broken with one stroke. The first result of these multiple liberations was a dazzling release of human energy that transformed Athens from a mediocre military power into a unified state capable of defeating the combined assault of three hostile oligarchies (Herodotus 5.78). The decisive role of the navy, the poorest class of Athenian citizens, in the defeat of Persia and the acquisition of an empire must have given an enormous boost to the self-esteem of this segment, by far the largest, of the Athenian polity.[100]

Yet initiative in presenting policy and implementing it militarily remained entirely in the hands of a few aristocratic families. Evidence for the fifty-year period between the Persian wars and the outbreak of the Peloponnesian War is notoriously skimpy. Indeed, Aeschylus is our only native, contemporary literary source for the cultural life of Athens after the Persian wars until the *Ajax* of Sophokles, usually dated in the early 440s. We do have inscriptions, vases, and statuary, in addition to a wealth of debatable later evidence, the best of which is in Plutarch. Without giving detailed argument, I conclude on this basis that in the period immediately preceding the *Oresteia* aristocratic hegemony of cultural values was probably still intact but, judging from Aeschylus' other surviving plays, not unchallenged. Politically, the violent internal crisis of 462–58 is best understood, I would argue, not as a direct political conflict between the aristocracy and the demos but rather as an internal split within the hegemonic class over the form in which their hegemony should be exercised. With the potentially deceptive wisdom

[100]Herodotus (8.1) puts the full strength of the Athenian navy in 480 at 200 ships. Each ship took approximately 200 men, giving a total of 40,000. Herodotus also assumes that c. 499 B.C. the total male citizen population of Athens was only 30,000 (5.97). Even assuming a large number of allied sailors, the proportion of the Athenian citizens who were also sailors must be set very high. This accords well with the evidence cited earlier that those with little or no landed property, the *thētes*, constituted the majority of citizens.

of hindsight we can say that the Periklean hegemonic model won out and seems to have remained dominant until at least 430.

This model involved continuation of aristocratic initiative in articulating policy, in persuading the demos to support it, and in carrying out its military consequences. To be sure, it also extended dramatically the relative role of the demos in deliberative and judicial functions. The military side of this model included a direct challenge to Spartan preeminence in mainland Greece. It is difficult to ascertain whether the rationale for this challenge was essentially defensive, that is, to forestall the threat of Spartan intervention against the Athenian democracy (Ste. Croix 1972: esp. 290–92), or simply represented the excessive ambition of a successful young empire (Davies 1978: 76–98). The Kimonian hegemonic model had favored the "yoke-fellow" policy (Plutarch, *Cim.* 16.10–17.1), a division of Greece into sea and land spheres of influence headed by Athens and Sparta, respectively. Domestically it implied a far more paternalistic working of the Kleisthenic constitution in which the aristocratic generals and an authoritative Areiopagos (*Ath. Pol.* 25.1) cooperated in restraining the demos.

It would seem that the Spartan's rebuff of their own ally Kimon in 462 was interpreted by the more progressive wing of the aristocracy as a sign of hardening hostility to the democracy. More simply, it may have been perceived as an intolerable insult requiring retribution on a heroic scale—ostracism of Kimon, stripping the Areiopagos of all authority except over murder trials, alliance with Sparta's bitterest traditional enemy, Argos (Plutarch, *Cim.* 17.3; *Ath. Pol.* 25.2–4). Whatever the rationale, these actions triggered violent retaliation from the conservative faction. Ephialtes was assassinated in 462. Presumably members of the same group were still sufficiently disgruntled four to five years later (458 B.C. according to Merrit et al. 1950: 3.177; 457 B.C. according to Gomme et al. 1956: 1.411–12) to have attempted to betray the city to Sparta (Thucydides 1.107.4).[101] It would be nice to know the precise date of this attempted betrayal—whether before or after the *Oresteia,* whether a stimulus for the terror of *stasis* expressed in the text or an immediate subsequent confirmation of it.

But, more generally, how should we conceive of the relation of the *Oresteia* to this whole political configuration? There is a natural temptation, which few scholars have resisted, to situate Aeschylus in one or another of the contending factions.[102] More cautious scholars have

[101]Gomme, et al., ad loc., argue plausibly that Kimon himself would have no sympathy for such an attempt.

[102]E.g., Forrest 1966: 214–15, Ste. Croix 1972: 183–85, and Davison 1966: 104.

taken the potential tangle of contradictions that arise from this effort as in itself proof of the poet's intention to avoid obvious partisanship by calculated ambiguities (e.g., Dodds 1960: 21). Though I am in some sympathy with this approach, its risks underrating both the critical edge and the utopian projection of the trilogy as a whole. I have tried to demonstrate the intensity, range, and depth of the implicit critique in the *Agamemnon* of the aristocratic domination of political and social life. The self-serving and self-deluding ambitions and hatreds that threaten to tear apart the polis are not blandly conceived or equivocally presented. In 458 B.C. Aeschylus may well have perceived, in the terms of his lion cub parable, the polis in real danger of receiving a grim return for its "nourishment" (*trophē*) from the aristocratic "lion cubs" it had reared. This is not to line him up for or against Perikles, an approach with the misleading consequence of substituting an all too palatable individual allegiance or antipathy for Aeschylus' categorical indictment of a whole class.[103]

On the other hand, the critical negation of aristocratic domination of Athenian political life encounters the insurmountable reality of the absence of any viable alternative even within the institutions of Athenian democracy. The utopian leap that projects a *stasis*-free polis must acknowledge as the price of this internal peace both accommodation of the Athenian aristocracy and external war with all the potentially destructive passion that such war engenders. More concretely, it embraces the Argive alliance as the inevitable correlative of abandoning the more paternalistic and repressive of the two available forms of aristocratic hegemony. But for me at least the choice of the female divinity Athena over King Theseus as the only representative of executive authority in Athens implies a refusal to offer concrete dramatic endorsement of even the most benignly conceived purely male leadership model. To be sure, Athena is as masculine a female as the Greek male imagination could conjure up, but the aspects of Athena stressed in the resolution of the trilogy are precisely those nearest to the democratic ideal of persuasiveness growing out of a capacity to articulate the general good and sympathetically infer the deepest needs of one's enemies.

Thus on the political level the substantial historical progress achieved by Athens may sustain Aeschylus' relatively optimistic vision as at least an attainable goal within its actual institutions. On the sexual level, the optimistic vision is in more drastic tension with the ugly contradiction it seeks to overcome. The critical edge of the trilogy confronts the audience with the intolerable human cost of unmitigated

[103]E.g., Dover 1957: 236, Davison 1966: 104, Hermassi 1977: esp. 59, and Calder 1981.

patriarchal power: murdered daughters, injured wives, foreign women raped and enslaved, seething resentment and deceit at home. Particularly the emphasis on female intelligence and political competence confronts the disruptive consequences of too narrow a restriction of female roles. The utopian resolution posits marriage as the locus of trust and sexual satisfaction while pointing in the mythic virgin female divinities toward the harmony and productivity attending a society capable of acknowledging a female role in both politics and procreation. The full theoretical rationale for expanding women's roles had to await Plato. That Aeschylus' society never even approached adoption of his vision is, however, no grounds for denying its presence in the text. That the Periklean hegemony seemed for a few years to constitute a rough approximation of the political vision of the *Oresteia* is no grounds for failing to appreciate its utopian dimension.

5

Sophokles' *Philoktetes* and the Teachings
of the Sophists: A Counteroffensive

Unaccommodated man is no more but such a poor, bare, forkt an-
imal as thou art.

—William Shakespeare
The Tragedy of King Lear

The work of Aeschylus represents, in the trajectory from
Homer to Plato, the apogee of progressive ideology manifested in a
form, the tragic trilogy, which was capable of embodying at least the
utopian hope of forward movement—however painful—out of the
brutal hierarchies inherited from the past. That past and that hope
were conceived of in eminently social and political terms, terms to
which the vast and mysterious conglomeration of forces beyond hu-
man control, the gods, was seen with cautious optimism as somehow
ultimately ("in time") amenable. The old gods, whose erotic adventures
with mortals were alleged to be warrants for ruling-class privilege,
have been swept away along with a whole array of older determinisms.
Sophokles (496–406 B.C.), roughly a quarter-century younger than Ae-
schylus, presumably learned much from Aeschylus, against whom he
won his first victory as a tragedian in 468 B.C. Yet his extant plays, dat-
ing from the early 440s to the end of his life, confront the modern
reader with a fundamentally different sense of the tragic form and a
disconcertingly different vision of human society and the forces be-
yond human control.

Sophokles and Aeschylus

Sophokles' relationship to Aeschylus has been much discussed. Of
relatively recent treatments, Winnington-Ingram has made the most
compelling case for the centrality of some Aeschylean issues in Sophok-
les and in particular a significant return to Aeschylean issues at the end

of Sophokles' career (1980: 324–27).[1] At the same time, Winnington-Ingram chooses to emphasize as the final and, one may presume, somehow dominant characteristic of Sophokles his irony—a perspective to which "we find little response . . . among the adherents of any optimistic philosophy" (329). Winnington-Ingram himself has only a little before acknowledged that Aeschylus' own "solution" is "partly in terms of society, and of the evolution of society" (325; cf. 1983: 166–74). We thus find within the same eminent critic's assessment both a case for significant continuities and, at the most abstract and fundamental level of worldview, a sharp disjuncture.

Irony may seem an abstract point indeed at which to begin our consideration of Sophokles, but it has the virtue of raising some fundamental questions that any Marxist reading of Sophokles ignores at its peril. Winnington-Ingram tries to sum up, on the last page of his study of Sophokles, his own sense of Sophoklean irony by giving a few condensed instances of situational irony from the plays and repeating the phrase, "But the world is like that!" (1980: 329). Before we generalize an ahistorical world, we need to inquire what an ironic response implies about the social and political world in which Sophokles lived and acted and for which he composed some hundred and twenty tragedies during his long career. It would be wrong, I believe, to conclude from Sophokles' irony that his texts demonstrate any denial or lack of awareness of dramatic changes in the social and political arena. Few would deny the centrality of such change in the *Ajax* or *Philoktetes*. Rather, the irony seems to derive in no small measure from invoking a transcendent realm from which more permanent realities of the world emerge as inherently intractable to mere human efforts, either at comprehension or control. Inscrutable and essentially inaccessible forces beyond human control render ironic the human struggles to impose human meaning and human values on the world. This at least is what I take to be the gist of Winnington-Ingram's view of Sophokles.[2] It is this irony with which Winnington-Ingram attempts to transcend the fundamental contradiction in interpretations of Sophokles between those who

[1] I single out for extended comment the work of Winnington-Ingram because he has contributed in major ways to our understanding of both Aeschylus and Sophokles. Whatever my disagreements with him, I have always found his work not only wonderfully learned but deeply wise and honest. Though he is clearly unsympathetic to any political reading of Sophokles (cf. 1980: 308–11), he acknowledges much of the key evidence in the texts. Though he has much sympathy for what he takes to be the religious tenor of Sophokles' worldview, he is too good a philologist to ignore the specific Greek words used for various divine forces—never falling into that infallible sign of the pietists, the use of "God" with a capital *G* to translate *Zeus* or *Ho theos* or *hoi theoi* or *ho daimōn*.

[2] This seems as well to be the direction of George Steiner's contribution to the discussion of Knox's paper "Sophokles and the *Polis*" (Knox 1983: 30).

view the plays as justifications of the actions of their massive protagonists (the "hero-worshipers") and those who find a religiously inspired critique of heroism at the heart of the tragedies (the "pietists"; 1980: 9, 322–23; see Johansen 1962: 152). According to Winnington-Ingram, the heroes are critiqued from a religious perspective for their "pathology of heroism" (305), yet their intransigence in pursuit of retaliation for wrongs (the *talio*) brings them into a unique proximity to that very vindictiveness in the gods (326–27).

Sophokles' most obvious continuity with Aeschylus, one perhaps too easily seen as simply inherent in tragedy, is his focus, again most obvious in the *Ajax* and *Philoktetes,* on figures of massive importance to the societies in which they find themselves, figures whose actions have potentially disastrous consequences on their societies. The attributes I attempted to spell out in the preceding chapter as characteristic of the aristocratic, ruling-class type in the *Oresteia* have long been recognized as components of most Sophoklean heroes (Knox 1964: chaps. 1, 2; cf. Winnington-Ingram 1980: 304–6). These characteristics include pride in aristocratic birth, exceptional daring (*tolmē*), and a single-minded determination to impose their purposes and perspectives on the world without any consideration of the potentially disastrous consequences for the society which, in some sense, is radically dependent on them. Aeschylus, however, despite attempts by Aristophanes to appropriate his name for elitist politics, is scarcely in danger of being perceived as a hero worshiper. The emphasis in his texts on the pathology of heroism is profound. Many have found grounds to sympathize with and excuse Agamemnon. Others have expressed varying degrees of grudging admiration for Klytemnestra. But not even Orestes risks being perceived as a positive paradigm held up for the audience to admire and, to the best of their abilities, emulate. Yet book after book, article after article, appears committed to this alleged "*mis*reading" of Sophokles' heroes. The pietists see Sophokles doing essentially the same thing as Aeschylus—dissecting the pathology of the powerful and dangerous figures and affirming their ultimate punishment by a wise and just divine order. The ironists, like Winnington-Ingram, seem to find an Aeschylean negation of these dangerous aristocratic types but no corresponding affirmation of an imaginable alternative.

This radical break with Aeschylus manifests itself on the formal level as well. We alluded earlier to the impossibility of discovering with certainty whether Aeschylus invented or simply found congenial the form of a trilogy of plays on connected themes. What is quite clear at least from the surviving plays of Sophokles is that Sophokles did *not* choose to connect three plays. In his extant work there is no place for the audience, or characters in the drama, to take a long view extending be-

yond the lifetime of the protagonists. To put it differently, for Sophokles only the gods can afford the long view. Aeschylean protagonists confront grim choices with vast consequences, but the audience is enabled by the trilogy form to distance itself from the protagonists and focus on the long-term consequences for society as a whole. Sophoklean protagonists tend to sweep the audience into the immediate agony of their existential choices; the unknowability of the consequences is a central element in the "heroism" of the choice.

Aristotle, who tells us that Aeschylus diminished the role of the chorus in favor of more interaction between the speaking characters, also attributes to Sophokles the addition of the third actor. There is a corresponding new diminution of the role of the chorus and an escalated emphasis on the clashing interactions of the protagonists. To the extent that the chorus represents the interests and perspectives of ordinary citizens, we find it strikingly diminished in comparison to Aeschylus.

But perhaps the most remarkable difference between the Aeschylean and Sophoklean protagonists is the latters' sense of their profound isolation and alienation from the community of which they were once a part (Knox 1964: 5, 21–22; Winnington-Ingram 1980: 305–6). Even when, within the dynamics of the play, the chorus are partisans of the protagonists, as in the *Ajax* or *Trachiniae*, the dramatist is at pains to underline the incapacity of the chorus to understand what is at stake for the protagonists. Despite the fairly open hostility of the chorus of the *Agamemnon*, Klytemnestra, like Agamemnon himself, functions as if she is in control and fully capable of communicating with the chorus. Sophoklean protagonists are isolated from that automatic domination of the social and political hierarchy that is so characteristic of Aeschylean heroes.

If we see Aeschylus as engaging in a fundamental ideological assault on the claims of inherited excellence in a context that insists on a world changed decisively by democracy, Sophokles, rather than doing the same thing, seems to me to be exploring the implications of a world in which the old elite has suffered a fundamental ideological critique and an institutional displacement. Heroes who are defined and define themselves in terms of an inherited *phusis*, who are *eugenēs* and *gennaios*—the "winners" in every sense for Pindar—in Sophokles are subjected to a withering critique and stripped of all the material and social props of their identity—wealth, power, family, and friends. Most of Sophokles' protagonists begin where Aeschylus' protagonists end: defeated, socially and politically dead. It is as if Sophokles accepted the victory of democracy, granted the validity of much of the Aeschylean critique of the scions of wealth and power, yet set about laying the

grounds for an ideological counteroffensive. Rather than a simple cel-
ebration of the Pindaric type, Sophokles engages his audience in an
essentially rhetorical operation in which key points are conceded only
to prepare the ground for a new basis on which to insist on the need of
society to be dominated morally and politically by uniquely endowed
individuals whose very excellences render them impossible for demo-
cratic society.

Aristocratic Terminology and the Role of the Sophists

Part of the thematic shift from Aeschylus to Sophokles is reflected in
a radically different usage of the vocabulary of inherited excellence—
phusus, phuō, eugenēs, gennaios, and so on. As Diller long ago pointed
out (1956), there is a conscious juxtaposition in the Sophoklean texts of
different senses and implications of these terms and, more striking, a
dramatically central consciousness on the part of the protagonists
themselves about the implications of their inherited natures. In the *An-
tigone,* for example, the character Antigone perceives and affirms her
identity aristocratically in terms of her parentage but presents the va-
lidity of that identity as a challenge to her sister: "Such now is your sit-
uation, and soon you will show / Whether your innate nature is noble
[*eugenēs pephukas*] or you were bred base from noble parents" (*Ant.* 37–
38). Yet Antigone also uses the vocabulary of innate character to de-
scribe her ethical stance in terms that either are purely arbitrary or
may be understood as a consequence of her gender: "Not to join in ha-
tred, but rather in love is my innate nature" (*ephun,* 523). There is no
ambiguity about Ismene's definition of her identity in terms of gender
(*gunaikh' hoti / ephumen,* 61–62). Haimon speaks of his natural duty as a
son (638), and Kreon defines his *phusis* in terms of his age (726–27).
This variety in conceptions of what is "innate" or "natural" for the in-
dividual invites the audience to recognize that this traditional vocabu-
lary is now "up for grabs." At the same time, the development of the
dramatic action drives us toward associating whatever moral and po-
litical value we find in Antigone's position with her *aristocratic* concep-
tion of her *phusis.*

Similarly, in the *Ajax* Ajax's wife offers a strikingly unaristocratic
conception of nobility (*eugeneia, Ajax* 485–524). The audience here too
is compelled to engage in a battle over the ethical import of this key
category of social vocabulary. The whole movement of the drama like-
wise compels the audience to judge Ajax in the light of *his* radically,
self-consciously aristocratic definition of his inherited nature (*Ajax*
430–80, 545–51). I would argue, though I cannot demonstrate it here,

that the rhetorical strategies of both these early plays succeed in valo-
rizing the protagonists' seemingly literal affirmations of their inherited
natures by transforming aristocratic vocabulary into a metaphor for
some fundamental integrity—an integrity in principle worthy of em-
ulation. De Romilly has ably shown the strain of heroic absolutism in
Perikles' Thucydidean speeches (1963: 110–55). This is not to invite a
simple equivalence between Sophokles and Perikles (see Ehrenberg
1954) but rather to suggest that there is nothing inherently improbable
in such a form of aristocratic demagoguery. What does require further
investigation is whether the specific form of Sophoklean heroism
makes a statement fundamentally sympathetic or hostile to the egali-
tarian thrust of democratic ideology. My sense in general is that
Sophokles' career might be seen in its entirety as thoughtful question-
ing of democratic ideological hegemony by an informed participant
(Knox 1983: 5, 26–27), a questioning haunted by a profound nostalgia
for the lost Pindaric vision of society ruled by the innately superior sci-
ons of the old propertied families.[3] He sees the inadequacy of this
older vision but finds nothing comparably compelling in the contem-
porary options. His plays thus imply a negation of what he sees as the
status quo. At the same time, here and there we can see hints of a uto-
pian projection of a new aristocratic order, one in which the truly best
people—in terms of ethical stature—meet with the appropriate sub-
ordination from their inferiors.

In discussing Aeschylean dialectic we alluded to the heated chrono-
logical debate over possible sophistic influence. Though such an influ-
ence seems highly probable to me, it is possible that Aeschylus
independently developed a conception in harmony with key elements
of an anthropology worked out in detail somewhat later. What is es-
sential, I believe, is to recognize (along with Havelock 1957) the central
role of this anthropology in the elaboration of a specifically democratic
alternative to the aristocratic worldview, an alternative that substitutes
a common human identity of the children of earth for the hierarchy
dominated by the sons of gods.

Sophokles is chronologically the full contemporary of the Sophists
during the period of their maximum activity and influence; his re-
sponse to them has been viewed, with few noteworthy exceptions, as
fundamentally hostile.[4] Wilhelm Nestle seems to have set the pattern

[3]Knox (1983) makes a compelling case for a consistently hostile presentation of the
claims of the polis in the *Ajax, Antigone, Oedipus Tyrannus, Philoktetes,* and *Oedipus at
Colonos* but characteristically ignores the issue of class and, in my view, understates the
relevance of the specifically democratic nature of Athens.

[4]Nestle's view is echoed with slight modifications in Busse 1927, which in turn is cited
with full approval in Webster 1936: 52. Compare Weinstock 1937: 13, Bowra 1965: 272,

in this century: "He [Sophokles] can go along with it [the Sophistic] a little way, namely, when it concerns itself solely with empirical inquiry. But as soon as the Sophistic sets about drawing conclusions based on the results of its inquiry—conclusions about a worldview and about practical conduct—their paths part. The poet then sees in it the open enemy" (1910: 134; cf. 1940: 451–55). Along the same lines, Sophokles has more recently been characterized as "the last great exponent of the archaic worldview" (Dodds 1951: 49).[5] In a rather striking departure from what one might call the Nestle consensus, Cedric Whitman argued: "If the Sophistic rationalism destroyed Euripides, its effect on Sophocles was quite the reverse. . . . Sophocles stood his ground and *thought through* the implications of religion as a human invention and man as the measure of all things. The grace and power with which his intellect moved amid and transcended and rabid theorizing of the avantgarde is one of the miracles of artistic history" (1951: 228–29, emphasis added). Apart from enthusiastic praise by Friis Johansen (1962: 161), Whitman's view had apparently little impact.[6]

In the following analysis, I attempt to take account of Havelock's more political analysis of the Sophists (1957). In the light of that analysis, I examine anew the relation of sophistic thought to Sophokles' *Philoktetes*. What emerges is a view of Sophokles that implies neither a pious polemic against the Sophists nor a whole-hearted endorsement of their fundamental assumptions. Rather, to use Whitman's phrase, Sophokles "thought through" a great deal more of the sophistic than their attacks on religion or their fascination with rhetoric. In particular, I believe that he was profoundly influenced by their comprehensive materialist analysis of the origin and development of human society

Ehrenberg 1954: 64–66, Opstelten 1952: 67, Pohlenz 1954: 159–60, Lesky 1972: 272, Kitto 1958: 63, and Craik 1980.

[5]Dodds goes on to offer a significant qualification: "the true cleavage" marking the end of the Archaic age falls "with the rise of the Sophistic Movement. . . . In his thought, though not in his literary technique, Sophokles (save perhaps in his latest plays) still belongs to the older world" (1951: 50 n. 1). More recently, Dodds goes out of his way to stress his belief that "Sophokles was no humanist, and the *Antigone* is no Protagorean tract for the times" (1973: 8). Winnington-Ingram's "Tragedy and Greek Archaic Thought" (1965) is described by its author as a gloss on Dodds's view in *The Greeks and the Irrational*. Though this is far too modest a description, the emphasis is decidedly on the more archaic aspects of Sophokles' assumptions. His comment on Knox's Fondation Hardt contribution (Knox 1983: 33) suggests his continued adherence to this emphasis: "Oedipus' violent condemnation of his won *polis* is a characteristic product of the irrational workings of his *thumos*, which increases as he approaches the status of a *hērōs*."

[6]This is not to say that no one has offered significant qualifications of the traditional view. For example, Segal (1963: 38–39; 1964, 46–66, 1981: esp. 9) relates Sophokles' view to those of the Sophists along lines similar to my view of the *Philoktetes*. A. Long concludes: "The use he [Sophokles] made of Presocratic thought, the interest he shows in sophistic attitudes and arguments exemplify a mind which was completely involved in the intellectual life of fifth-century Athens" (1968: 166–67).

and behavioral patterns, an analysis that had fascinated him at least since the time he composed the *Antigone*. In his hands, however, it is scarcely grounds for democratic optimism. It becomes rather an existential ground on which he lays the foundation for a refurbished aristocratic ideology, and ideology in which "birth" is still an essential component, but one that seeks to incorporate a full awareness of all the social factors that contribute to the construction of individual character.

Sophistic Anthropology: Three Stages

It is difficult not to be deterred from even discussing the Sophists by the sheer weight of potential problems: the relative paucity and ambiguity of the sources, the often radical differences between the views of particular Sophists on particular topics, the limitations of the very term "Sophist" in dealing with some important topics that were of interest to almost all presocratic thinkers.[7] Havelock's brilliant presentation of the case for a more comprehensive and fundamentally sympathetic conception of the Sophists met with some intemperate invective (e.g., L. Strauss 1959), but generally, almost worse, with widespread disregard. Yet the broad outlines of his thesis, particularly with regard to the role of anthropological speculation in the Sophists' conception of society, have been confirmed by the punctilious scholarship of Cole and accepted, with only occasional grumblings, by Guthrie.[8] Perhaps, then, we may concentrate on the process of reevaluating the relation of the Sophists' thought to that of major fifth-century and, as I argue in the next chapter, fourth-century figures. I begin my efforts by offering a brief, necessarily schematic summary of the major

[7]Hereafter I use "Sophists" to refer to the whole group of relevant presocratic thinkers.

[8]Guthrie (*HGP* 3.10 n. 1) cites with apparent approval Leo Strauss's bizarrely ferocious attack (1959) recently embraced by Allan Bloom, who has written an enthusiastic foreword to the recent republication of Strauss's essays (1989). Strauss rejects every major thesis of Havelock's book, especially the existence of a significant body of anthropological speculation in the fifth century. But Guthrie's own treatment of the Sophists remains deeply indebted to Havelock's work and contains (*HGP* 3.79–84) a useful appendix of passages, ultimately derived from the Sophists, descriptive of human progress. As for Cole's work, while some (e.g., Furley 1970: 147; Dodds 1973: 11) have raised doubts about the centrality of Democritos to fifth-century anthropological speculation, there is no longer room for the sort of skepticism expressed by Strauss about the comprehensiveness, subtlety, and extensive influence of this body of thought in the fifth century. In my own discussion I simply cite what I believe is a reasonable sampling of the ancient evidence. For a defense of the admittedly unclear relevance of some of these sources, the reader may consult the detailed discussions of Havelock (1957: esp. 405–20), Cole (1967), and Guthrie (*HGP* vol. 3, esp. 51–54 and the bibliography at the end of the volume). For a provocative reassessment of the contemporary relevance of the Sophists see Jarratt 1991.

sophistic views of human society and values in order to set in clear relief both Sophokles' indebtedness and his specific ideological response to those views in the *Philoktetes*.

For the sake of clarity, the sophistic analysis of society may be divided into three stages: the origin of the species and the early struggle to survive in isolation or relative isolation before the invention of the polis; the establishment of a social compact that enabled the development of cities; and the functioning of contemporary—primarily Athenian—social, economic, and educational mechanisms.[9]

A central feature of the sophistic analysis of society is a materialist anthropology, a speculative account of the origin of human society based on the assumption that human beings arose from the earth and water, began as animals, and like all other animals confronted the problems of survival with no special metaphysical or supernatural resources or direction.[10] Characteristic of sophistic anthropology is a detailed and highly evocative picture of the horrors of human existence at a presocial stage of their evolution.[11] Isolated and without the natural defenses of other animals against predators and the natural elements, primitive human beings are pictured as engaged in a desperate struggle to find shelter from storms and the winter's cold as well as to contrive weapons for self-defense and for acquiring food, which their natural helplessness rendered a perpetual source of anxiety. The development of hunting, medicine, and agriculture and, above all, the discovery of fire with its associated technologies were presented as the chief means of escaping the worst horrors of the battle for survival. In the various accounts of this presocial stage, a fairly consistent termi-

[9] The so-called great speech of Protagoras in Plato's dialogue of that name, one of the most important sources for the sophistic analysis of society, does in fact divide pretty clearly into these three stages; see 320c8–322b8; 322b9–d5; and 322d6–328d2. In the case of Democritos, Cole (1967) posits that many further substages and some forms of elemental cooperation (e.g., hunting and agriculture) precede the full emergence of the social stage; but his far more detailed analysis is not incompatible with the three broad stages I describe. In the case of other fifth-century thinkers, the evidence is far more fragmentary, but such evidence as there is seems to me to fit well into this general pattern.

[10] Anaximander *D-K* A 30; Xenophanes *D-K* B 29 and 33; Anaximenes *D-K* B 3; Archelaus *D-K* A 4.5; Democritos *D-K* A 139; cf. Plato *Prot.* 321c3–4. The kinship with divinity brought in later (322a3–4) does seem extraneous, and Havelock is probably right to see platonic contamination there (1957: 91–92). The purely materialist description in Diodorus 8.4 of earth's wombs in which embryos form, a passage closely echoed in Lucretius' fifth book, suggests how rigorously even mother earth was stripped of all divinity. It is Pindar, not the Sophists, who insists on the kinship of humans and gods through mother earth (*Ne.* 6.1–2).

[11] Aeschylus *Prometheus Bound* 422–68, 476–506; Sophokles *Ant.* 332–64; Euripides *Sup.* 201–13; *On Ancient Medicine* 3.20–30; (in Loeb *Hippocrates I*); Plato *Prot.* 321c1–322b8; Diodorus 1.8; Moschion, *Tragicorum Graecorum Fragmenta*, ed. A. Nauck, rep. 1964 [1889], sup. by B. Snell. Hildesheim: Georg Olms Verlagsbuchh andlung.

nology indicates the fundamental ideas.[12] The driving force is "need" (*khreia*) or "necessity" (*anankē*); the only relevant human goal, "survival" (*sōtēria*); the sole criterion, what is "useful" (*khrēsimon*), "helpful" (*ōphelimon*), or "advantageous" (*sumpheron*) toward the end of "supplying" (*porizō*) adequate "sustenance" (*trophē*) and other fundamental needs. The decisive human contribution to survival is the "practical intelligence" (*sophia*) that enables human beings to "learn" (*manthanō, didaskomai*) from chance "discoveries" (*heuriskō*) and convert them into "contrivances" (*mēkhanē*) and "technologies" (*tekhnē*).

A second stage posited by the sophistic anthropology has frequently been described by the term "social contract" or, as Guthrie prefers, "social compact" (*HGP* 3.135 n. 1). Technology and some minimal cooperation might secure the food supply and protection from the elements and beasts, but human beings were still prey to the violence of other human beings. Accordingly, the survival of the race required the establishment of agreed on values and rules of nonaggression (to put it most negatively, see Plato *Republic* 358e1–359b5) or, as the older and generally more optimistic thinkers put it, bonds of affection (*philia*), like-mindedness (*homonoia*), pity (*to oikteirein*), the substitution of persuasion (*peithō*) for violence (*hubris, bia, kratos*), the subordination

[12]I am aware that all the words here cited are extremely common in nonanthropological contexts, and in that sense they do not constitute a special vocabulary. What is noteworthy is the consistent nexus of ideas revealed by the frequent combination of these terms in the anthropological accounts. A portion of Diodorus 1.8, listed by Diels and Kranz among the fragments of Democritos (elaborately defended in Cole 1967, but put earlier by Guthrie, *HGP* 1.69, n. 1), suggests the character of this material: "But the first men to be born, they say, led an undisciplined and bestial [*thēriōdei*] life, setting out one by one [*sporadēn*] to secure their sustenance and taking for their food both the tenderest herbs and the fruits of wild trees. Then since they were attacked by the wild beasts, they came to each other's aid, being instructed by expediency [*hupo tou sumpherontos didaskomenous*], and when gathered together in this way by reason of their fear, they gradually came to recognize their mutual characteristics. And though the sounds [*tēs phōnēs*] which they made were at first unintelligible and indistinct, yet gradually they came to give articulation to their speech, and by agreeing with each other upon the symbols for each thing which presented itself to them, made known among themselves the significance which was to be attached to each term. . . . Now the first men, since none of the things useful for life [*tōn pros bion khrēsimōn*] had yet been discovered [*heurēmenou*], led a wretched existence, having no clothing to cover them, knowing not the use of dwelling and fire, and also being totally ignorant of cultivated food. . . . Consequently large numbers of them perished in the winters because of the cold and the lack of food. Little by little, however, experience taught them [*hupo tēs peiras didaskomenous*] both to take to the caves in winter and to store such fruits as could be preserved. And when they had become acquainted with fire and other useful things [*khrēsimōn*], the arts [*tekhnas*] also and whatever else is capable of furthering man's social life [*ta dunamena ton koinon bion ōphelēsai*] were gradually discovered [*heurethēnai*]. Indeed, speaking generally, in all things it was necessity [*tēn khreian*] itself that became man's teacher [*didaskalon*], supplying in appropriate fashion instruction [*mathēsin*] in every matter to a creature which was well endowed by nature [*euphuei*] and had, as its assistants for every purpose, hands and speech [*logon*] and sagacity of mind [*psuchēs ankhinoian*]. (Loeb translation)

of narrowly conceived self-interest (*kerdos, to sumpheron*) to respect (*aidōs*) for others, right conduct (*dikē*), and a sense of the common good (*to koinon, to ksunon*).[13] The development of language itself out of inarticulate cries seems associated with this phase in some sources, and others include the development of religion.[14] Though some later fifth-century thinkers may have presented this contract stage as a conspiracy of the weak and inferior majority to protect themselves from the superior and stronger few, I believe it is legitimate to say that the dominant note in the accounts of this stage is a benign and idealistic emphasis on the natural unity of the human species, a celebration of all the ties that bind.[15]

In the most complete accounts we have of this early anthropological speculation, the lessons and terminology of the first and second stages are applied to the new realities of the contemporary Greek

[13]Affection: Aeschylus *Prometheus Bound* 11, 123; Plato *Prot.* 322c1–3; Democritos *D-K* B 186, with Cole's discussion (1967: 117); Aristotle *EN* 8.115925–116214, with Cole's discussion (1967: 134–38). Like-mindedness: Democritos *D-K* B 186, 250, 255; Gorgias *D-K* B8; Thrasymachos *D-K* B 1; Antiphon *D-K* A 2, B 44a. Pity: Aeschylus *Prometheus Bound* 239 (the hero's sole motive in helping humankind), see 68, 238, 246, 352, 435, 648 for the persistence of the motif; Democritos *D-K* B 255, see also B 107a and 293 with Havelock's discussion (1957: 144). Persuasion instead of force: Democritos *D-K* B 181; Gorgias *D-K* 11.8; see also Plato *Gorg.* 452d5–e4, *Prot.* 337a2–b2 (parody of Prodicus) and 337c7–338al (parody of Hippias); *Anon. Iamb.* 6–7 (see Cole 1960). Association of ethics with the common good: Plato *Prot.* 322c2–5, e2–323a4; Democritos *D-K* B 179, 252, 293; *Anon. Iamb.* 6–7.

[14]Language: Sophokles *Ant.* 353–56, whereas in Diodorus 1.8.3 it precedes fire. Religion: Prodicus *D-K* B 5; Kritias *D-K* 25.9–15 = *TrGF* 43 F19 (Snell). It is striking that the Democritean account preserved in Diodorus Siculus 1.7–8 does not include religion despite the author's interest in the topic once he switches to other sources. I therefore find it extremely misleading that Segal begins his lengthy account of the *Philoktetes* by an implicit indictment of the hero's lack of religion: "In creating a hero whose struggle for survival reflects early man's establishment of civilization, he [Sophokles] omits the institution of worship, a *fundamental* point in fifth-century speculation on the origin of culture. In this respect, as in others too, the hero is *agrios*" (1981: 292 emphasis added). Included in Segal's evidence is a clearly Egyptian section in Diodorus (1.16.1). I would say that the most fundamental feature of these accounts is their materialism, not their occasional rationalist account of the origin of religion. It might be more pertinent to note that the first references to religion in the play evoke the purely formal piety that is alleged in justification of the inhuman marooning of Philoktetes (*Ph.* 8–11). A similarly misleading emphasis on religion later on in Segal enlists the dubious support of Homeric Hymn 20 to give the impression that "in the anthropology of the Sophists early man 'dwelt in mountainous caves and sunless gullies' (Moschion, frag. 6.4–6, Nauck), 'like beasts' (Homeric Hymn 20) until Athena and Hephaestus taught them the 'shining works' of civilization" (1981: 298). The point of most sophistic accounts—and, I argue, of Sophokles' *Philoktetes*—is that human beings wrested life from nature *without* any "graciousness and benevolence of the gods" (cf. 1981: 295).

[15]Plato's Kallikles in the *Gorgias* (483b4–c6) describes the social contract so forcefully in negative terms that generations of classicists have been convinced that Kallikles is the most accurate articulation of the sophistic view. Indeed, Lintott sees the Sophists only in connection with the "philosophical background to the oligarchic movement" (1982: 168–73).

and specifically Athenian society. Here again, toward the later part of the fifth century, views expressing deep disillusion or extreme cynicism are associated with specific Sophists and presented as typical, yet the evidence indicates that the major proponents of anthropological theories applied them to a fundamentally optimistic, even utopian, analysis of Athenian society. Democracy, with its egalitarian thrust and structural dependence on verbal persuasion in the assembly, was felt to be in harmony with the anthropological facts of the human condition: the necessity for cooperation, mutual respect, and the substitution of persuasion for force.[16] The same general sentiments seem to underlie the call for panhellenic unity based on broadly conceived notions of kinship often associated with the Sophists.[17] The importance of persuasion and the general celebration of human intelligence in anthropology validated the primary activity of the "Sophist" in the narrowest sense of the term, teaching rhetoric and political science to those who aspired to power in the democracy.[18]

The Sophists' egalitarian perspective and pragmatic analysis of the socialization process, education in the broadest sense of the term, often led to a marked disparagement of the claims of the aristocracy to inherited excellence.[19] Moreover, the practical, utilitarian, and generally materialist assumptions underlying the anthropological analysis of human progress readily lent themselves to a relativist analysis of ethics based on enlightened self-interest or hedonistic calculus and, correspondingly, a distrust of absolutist values supported by traditional anthropomorphic religion.[20] At the same time, traditional religious views

[16]Protagoras' whole "Great Speech" is specifically called forth in defense of the democratic practice of the Athenian assembly (*Prot.* 319b5–d7). The fact that the author of the *Prometheus Bound* casts the enemy of human culture and technological advancement as a tyrant is in keeping with the general pro-democratic bias of the anthropological thinkers; cf. Democritos *D-K* B 252.

[17]Gorgias *D-K* B 8a; Plato *Prot.* 337c7–338a1.

[18]The *Protagoras* makes the clearest connection between the anthropology, in which *politikē tekhnē* is presented as essential to survival (322b6–7), and the actual content of the Sophist's teaching (318e5–319a7). Democritos' description of education as a means of building *sōtēriē* for one's possessions and life has an anthropological ring (*D-K* B 280).

[19]Democritos *D-K* B 57, 242, 33 (on this see Vlastos 1946: 55–56); Kritias *D-K* B 9; Antiphon *D-K* B 60. Protagoras *D-K* B 3 seems moderate on this issue, but in Plato's dialogue the whole thrust of the Sophist's analysis of the socialization process is to demonstrate its priority over inherited characteristics. Moreover, like Democritos *D-K* B 56, 85, 109, 183), he undercuts the special pride of aristocratic birth by using such terms as *phusis, aphuēs, and euphuēs* to designate natural endowments that are not associated with descent from a particular family line but a matter of chance (e.g., 327b4–c3); see Adkins 1970: 94.

[20]Democritos *D-K* B 71, 74, 76, 172, 173, 188, 211, 219, 235, 237; Plato *Prot.* 334a3–c6; *Dissoi Logoi*.

and traditional values seem most often to have been reinterpreted and redefined rather than openly repudiated.[21]

The late fifth-century stereotype—later elaborated by Plato—of the Sophist as a self-seeking, double-talking relativist, a dangerous atheist committed to corrupting the minds of the young for exorbitant fees, may represent a logical, but not necessarily inevitable, development from the philosophical assumptions of the anthropologically oriented older Sophists. The impact of a long war on any sort of optimism and human kindness is surely a more relevant consideration than the usual cliches about the Sophists ruining Athens (Muir 1985: 191–93). In any case, as I hope my analysis demonstrates, Sophokles was not simply affected by that later development but also clearly grasped and was deeply impressed by the entire three-stage conception of human society and human values. Indeed, as I try to demonstrate, it is tempting to read Sophokles' play as a conscious juxtaposition of the humane vision of the older Sophists with the brutal instrumentalism of their late fifth-century followers.

Sophokles' Response: Transforming Anthropology into Drama

Sophokles was a poet, a dramatist—not a philosopher, political scientist, or a pamphleteer. Insofar as sophistic thought is present in his work it is indirectly present in the form of broad homologies between philosophical arguments and dramatic representations. These are created through the fullest possible exploitation of the fundamental elements of Sophokles' chosen medium—through plot choice and construction; setting; imagery both verbal and visual; verbal sound effects; characterization through action, interaction, speech, silence, and even inarticulate sound. Too many discussions of this play seem based on the assumption that the sole intention of this poet's careful artistry was to entertain his audience with a good play, as though the meaning of "entertainment" and "good" drama for Sophokles' audience in 409 B.C. was self-explanatory and inherently nonpolitical. Thus innovations in the myth are, we are told, designed to create intrigue, heighten dramatic or ironic tensions, endow the plot with concentration, or simply

[21]On the general topic, see Guthrie *HGP* 3: chap. 9. On Democritos' use of religious language, see Vlastos 1945: 581–82. Prodicus does appear to have been a radical atheist; see Henrichs 1975: 107–15. Apropos of Protagoras' allegedly equivocal religious views, Dodds aptly quotes Diogenes of Oenoanda: "To say that you have no means of knowing whether gods exist amounts in practice to saying that you know they do not exist" (1973: 97).

"make a good scene."[22] Although I yield to no one in my admiration for Sophokles' mastery of his medium, and I concede readily that I have learned much from such discussions, intention conceived at so low a level seems to me worse than a fallacy. "Pure art" is a dubious concept at best for any period; it is a flagrant absurdity in dealing with the drama of fifth-century Athens. Ironically, it is only in the case of Sophokles that scholars have been tempted to claim that here was a poet who achieved a proper Parnassian distance from the intellectual, social, and political revolutions that absorbed his contemporaries. Indeed, it is worth asking whether the impression Sophokles gives of a Homeric remoteness from his own times is not itself one of his most successful ideological effects.

Adequate consideration of the text itself must include the poet's use of and departures from traditional material known to his audience. It must also include the connotations for a contemporary audience of the word- and image-clusters he uses. Such consideration in turn involves awareness of the social and political realities shared by the poet and his audience. Though Sophokles' relation to these realities is often far subtler than in the case of his fellow dramatists, it is no less genuine and profound.

[22]T. Wilamowitz and his spiritual descendent Waldock are often taken to task for an approach directed purely at dramatic technique (e.g., on the former, see Schmidt 1973: 51 n. 28). Yet too often their detractors really only berate them for daring to *criticize* Sophokles from that perspective. Schmidt devotes considerable space, and admittedly it is one of the more useful aspects of his dissertation, to demonstrating Sophokles' artistic mastery in the *Philoktetes* by comparative analysis of roughly paralleled or contrasted scenes in other plays by Sophokles. Schlesinger (1968), who like Shucard (1974: 133–38) is primarily concerned with "intrigue," is much indebted to Knox's 1964 analysis of the plot structure in terms of the relations among persuasion (*peithō*), force (*bia*), and deceit (*dolos*). Innovations in the plot or difficult actions are viewed as a means for the "dramatist to heighten the tension" (99) or "to bring into prominence the end of the plot focused on intrigue" (106). Gellie (1972) is perhaps most fully in the tradition of T. Wilamowitz and Waldock: "At this point the play badly needs an injection of new material for the principal characters to chew on. . . . Whatever its weaknesses, the scene plays well" (142). Spira (1960), whose point of departure (12) is a defense of Sophokles specifically against T. Wilamowitz's denunciation of the deus ex machina, speaks on one level of the necessity of bringing in "a new theme (*Motif*) once the themes set forth in the exposition are exhausted (*erschöpft*)" (29). On another equally abstract level he emphasizes the "poet's interest in character-drawing" which explain Sophokles' willingness to bring the action to an "absurdity" (30) before resorting to the deus. Character drawing, like plots and intrigue, thus emerges as a self-explanatory interest; and the implications of the particular characters drawn for the realities facing Sophokles' audience are presumably as irrelevant as the implications of an image of life dominated by intrigue. However, pace Craik (1979), a representation of life dominated by radical, unanticipated reversals of fortune and by the machinations of subhumanly vicious people may say more about the actual life experience of the audience than an ahistorical quest for novelty on the part of late fifth-century tragedians.

The broad outlines of the plot of the *Philoktetes* are clear in the brief allusion to Philoktetes in the catalogue of ships of the *Iliad:*

> Those who had as their portion Mēthōnē and Thaumakiē
> And held Meliboia and harsh Olizōn,
> Over these Philoktes ruled, knowing well the bow—
> Seven ships of them. Fifty rowers embarked in
> Each, knowing well the bow for fighting by might.
> But *he* lay on an island suffering mighty pains,
> On very holy Lemnos, where the sons of the Achaeans left him,
> Afficted with a bad wound from a destructive-minded water snake.
> There *he* lay in agony. But soon the Argives beside their ships
> Were about to remember Lord Philoktetes.
>
> (*Il.* 2.716–25)

The *Odyssey* tells us that Philoktetes was among that happy few heroes who returned safely home from Troy (3.190), and Odysseus boasts that at Troy "only Philoktetes surpassed me with the bow" (8.219–20). Proclus' summary of the *Little Iliad* fills in the tantalizing gap between the two Homeric poems, explaining how the abandoned, suffering hero became a pattern of final success: "Odysseus, after making an ambush, captures Helenos; and after the latter made a prophecy about the capture of Troy, Diomedes brings Philoktetes back from Lemnos" (*Homeri Opera* 5.106). From Diochrysostom (49 and 52) we find out about the lost tragedies of Aeschylus and Euripides on the subject. Aeschylus has Odysseus, not Diomedes, bring back Philoktetes, and Euripides, whose play is dated 431 B.C., combines the epic and Aeschylean versions by having both Odysseus and Diomedes bring him back.

To sketch broadly my argument in advance, I believe that Sophokles' two major innovations in the myth—first, the presentation of an uninhabited Lemnos, and second, the inclusion of Neoptolemos—reflect a conscious attempt to juxtapose dramatically the three stages of the sophistic analysis of society.[23] The first stage is concentrated in the full presentation of Philoktetes' battle to survive on Lemnos in total isolation with the sole aid of his bow and the knowledge of fire making.

[23]Schlesinger with some justice presents the use of the deus ex machina at the end of the play as Sophokles' third major innovation (1968: 101–2). As should emerge clearly in the following discussion, Sophokles' use of Herakles grows organically from the poet's complex examination of and response to the Sophists' view of society. This "innovation" in my view is thus a direct if not inevitable consequence of the two logically prior innovations. But however one interprets the scene, or however drastically the scene affects one's understanding of the play, it remains a dramatic surprise at the very end of the play and takes up at most one twenty-fourth of the dramatic action. The desolation of Lemnos and the addition of Neoptolemos are introduced with heavy emphasis in the opening lines of the play and are dramatically relevant virtually every minute of the play.

This stage grimly returns in the later part of the play when lyric laments evoke the imminent death of Philoktetes through starvation or from predatory beasts due to the absence of his bow. The second stage is dramatized in the bonds—both real and feigned—established between Philoktetes and, chiefly, Neoptolemos, but also, more ambivalently, the chorus. The third stage, the only one for which a relation to sophistic thought has received much critical attention, is focused in the figure of Odysseus and emerges in the educational relationship to Neoptolemos and in his role of spokesman for the state in his dealings with Philoktetes.[24]

Though the three stages of sophistic anthropology profoundly affect Sophokles' structuring and development of the traditional myth, he transforms the ideas of the Sophists in such a way as to offer his audience a passionate and highly personal affirmation of a reformed version of traditional aristocratic absolutism. Some critics who perceive at least some of the contemporary reference in this play conclude that the form itself is thereby diminished, that the *Philoktetes* is "a tragedy of less than complete seriousness" since "topicality of reference has little place in high tragedy" (Craik 1980: 247).[25] A final answer to such a charge is perhaps precluded by the inevitable circularity of genre definitions: one deduces what the genre is from a specific, limited set of examples, then excludes from the genre instances that do not fit those deductions. On this basis, the *Prometheus Bound* with its burden of anthropological (Havelock 1957: 52–65) and political theory (Podlecki 1966a: 101–22) is not a tragedy, and of course our only surviving trilogy, the *Oresteia*, ends with a play marred by a happy ending. But the issue of how much and what kind of topicality was acceptable to a fifth-century audience is a legitimate one. Phrynikhos, the tragedian who was fined

[24]Segal (1981), as noted earlier, does deal extensively with the role of the Sophists' thought in the *Philoktetes*. Though there is much I admire in his two long chapters on the play, I do find myself at odds with the general aura of depoliticized spirituality in which he casts the issues.

[25]I believe that Craik fundamentally misinterprets the issue of comic moments in the play by ignoring the complex class role of comedy in fifth-century Greece. It is inadequate, for example, to argue that, because Herakles—the most prestigious of Greek Heroes for Homer and Pindar—is regularly mocked and debased in peasant-oriented comedy, the hero has therefore been decisively stripped of all grandeur and prestige: "The very appearance of the god would tend to raise a laugh" (Craik 1979: 26). If this were the case, Alexander's efforts some seventy-five years later to cloak himself in the aura of Herakles (Pollitt 1986: 20, 26, 38, 50–51) would be unintelligible. Rather, Herakles is clearly a major site of ideological struggle sought and challenged as a paradigm by contending classes. The very convention of satyr plays burlesquing the heroes of tragedy suggests that designating a hero as exclusively or primarily comic is questionable. In the case of Philoktetes, Craik can cite only one instance of a comic representation before Sophokles' play, but this does not deter her from concluding that "neither Odysseus nor Philoktetes was a high tragic figure" (1979: 25).

for producing a play about the capture of Miletus (494 B.C.; Herodotus 6.21) soon after the event, may well have reinforced the tendency to draw plots from the politically safer body of Mycenaean myth, a tendency already clear in the titles (e.g., *Pentheus* and *Contest of Pelias*) ascribed to Thespis by Suidas. But as Knox has argued, it was Aeschylus, the so-called father of tragedy, who consistently "impose[d] on this primitive material [Greek myth] the contemporary framework of the *polis*—still ruled by kings as in the saga but reminiscent in many suggestive details of the *polis* in which the audience lived" (1983: 6; see also Taplin on Phrynikos in Knox 1983: 36). Sophokles inherited and adhered to this fusion of the mythic and the contemporary. Given both the dangers of Athenian political life (ostracism and heavy fines are only the most obvious) and the almost constant wars in which Athens was engaged, the myth of Philoktetes—the abused hero who somehow must be reintegrated into the society that has abused him—might be said to have had an inherently contemporary appeal. The tantalizing hints of Diochrysostom about the versions of Aeschylus and Euripides make clear the heavily political appeal of the myth; and the date of Euripides' version, on the eve of the outbreak of war (431 B.C.), is especially suggestive.[26] But whether Sophokles' infusion of sophistic doctrine detracts from or deepens the appeal of the myth can only be answered by a detailed reading of the play itself.

The Primitive Struggle for Survival

The absence of human inhabitants on Sophokles' Lemnos (*Ph.* 2, 221) and even of seaports (221, 302) is a drastic innovation contradicting Homer, Aeschylus and Euripides, and the common knowledge of every member of the audience.[27] The reasons usually offered seem in-

[26]Dio even refers to the political emphasis (*to politikon, Or.* 52.15, though the Loeb translator renders it as "urbanity"). In any case, his paraphrase of the prologue of Euripides' version in *Or.* 59 has Odysseus speak of "toiling on behalf of the common salvation and victory."

[27]See Jebb's commentary on verses 2 and 302 and intro xxx-xxxi. Obviously embarrassed by the innovation, he suggests, citing a scholiast, that Sophokles may have assumed that the size of the island would make it possible for Philoktetes to think it was uninhabited though in fact it was not. Nothing in the text supports this view, and the silence of both Neoptolemos and Odysseus about any other inhabitants strongly militates against it. Nonetheless Maguinness (1958) defends his proposed emendation of line 546 (reading *pedou* for *pedon*, giving the new sense "off the same part of the land") on Jebb's literal-minded assumption that Sophokles could not possibly have implied that the island was unfrequented by ships. Albert Henrichs has called my attention to ancient lexigraphical explanations of the epithet *amikhthaloeis* applied to Lemnos at *Il.* 24.753 as meaning *a-limenos*. Jebb on *Ph.* 302 comments that the epithet was probably understood in antiquity as "inhospitable." Since serious debate over the precise meanings of rare and synonymous words began in the fifth-century among the Sophists (see Plato's malicious

adequate. The isolation of the hero is seen primarily as contributing to the pathos of his situation and perhaps better justifying his extreme resentment against those who marooned him there. Others find a symbol for an alleged psychological flaw in the hero. Still others see merely an attempt by Sophokles to avoid by this daring device the infelicities in the dramatic presentations of his predecessors. The extraordinarily persistent focus on the physical setting is described as romantic coloring and perhaps even as compensation for the inadequacy of the plot.[28] To be sure, any such element is overdetermined, but I suggest that Sophokles, in presenting Philoktetes' battle for survival in utter isolation from other human beings, is primarily offering an image of the human condition that derives ultimately from the Sophists' speculations about the conditions of human life in the primitive, presocial stage. The constantly recurring references in the play to beasts, cave dwelling, rocks, weather, the difficulties of obtaining food, the absence of all but the most primitive herbal medicine, and the pathos of isolation keep relentlessly before the audience the most basic conditions of the presocial struggle to survive.

The opening lines of the play do not merely identify the setting, they underline its total lack of human inhabitants with emphatic fullness: "This is the shore of a sea-girt land, / Lemnos, untrod on, uninhabited by mortals" (*Ph.* 1–2). Odysseus describes Philoktetes' rocky cave home in terms of two basic necessities of survival: protection against the extremes of weather (*psukhei . . . therei*, 16–17) and supply of water (*poton krēnaion*, 21). Neoptolemos' examination reveals that the cave is empty, but his phrase assumes the cave's function as a human dwelling (*kenēn oikēsin anthrōpōn dikha*, 32); and Odysseus' next question focuses on the whole range of factors that would distinguish this cave as a human habitation (*oud' endon oikopoios esti tis trophē*, 32). Neoptolemos first finds evidence of the most primitive bedding, the impress on leaves, then more decisive evidence of human presence: crude technology (*phlaurourgou tinos/tekhnēmat' andros*) and materials for making fire (35–36). The only reasons Neoptolemos and Odysseus can imagine for his absence are either need for food (*phorbēs*, 43) or relief of pain, and the latter suggests the most primitive medicine achieved by mental observation,

parody of Prodicus at *Prot.* 337a1–c4), it is possible that Sophokles was aware of these views of the word in *Il.* 24.753. But this takes us no nearer explaining away *Il.* 7.467, 14.230, or 21.40, 58, 79, or for that matter the context of 24.753, which clearly involves commercial activity on Lemnos.

[28]Pathos: Pohlenz 1954: 386; Kitto 1956: 115; Opstelten 1952: 107; Segal 1963: 38–39; Mursurillo 1967: 122; Ronnet 1969: 239, 254. Psychological flaw: Feder 1963: 40–41; Biggs 1966: 234; Gellie 1972: 145; Segal 1981: esp. 292. Avoidance of predecessors' infelicities: Jebb on line 2; Opstelten 1952: 107; Letters 1953: 273; Kitto 1961: 321. Romantic coloring: Letters 1953: 273. Inadequacy of plot: Waldock 1966: 208.

namely, "some pain-killing leaf" (44). Thus the prologue introduces Philoktetes in terms of the primitiveness of the conditions in which he must struggle to survive.

Despite what seems a dramatically adequate description of his cave home in the prologue, a primary focus of the ensuing dialogue between Neoptolemos and the chorus is the nature of Philoktetes' cave and the harsh conditions of his existence. Neoptolemos invites them to examine the place (144–46); then they ask—with redundancy remarkable even for a Greek chorus—what his dwelling is like: "What sort of chamber [*aulas*] does he dwell in as a resident. . . . What's his home [*hedra*]?" (152–58). If one adds to this Neoptolemos' preceding reference to *melathrōn* (147) and his reply ("you see a home [*oikon*] that's a rocky place to sleep [*koitēs*], 159), one almost gets the bizarre idea that Sophokles was trying to offer a survey of all the possible Greek terms for dwelling! This is not, however, mere elegant variation; it functions as a means of giving the greatest possible emphasis to the harsh conditions of Philoktetes' struggle to survive—conditions explored in the lyric dialogue that follows (160–176).

Neoptolemos repeats and expands Odysseus' earlier inference that Philoktetes' absence must result from his need for food (*phorbēs khreia*). The "essential character of his life" (*biotēs . . . phusin*) consists wholly in this quest for food through hunting wild beasts (*thēroboIounta*), and his total isolation is imagistically focused in his lack of anyone to heal his ills (167–68). The chorus picks up and expands this grim evocation of Philoktetes' isolation. He is devoid of both human companionship and aid, he is "always alone" and is "at a loss in the face of each need [*khreias*] as it arises." The repetition of *khreia* so soon after *phorbēs khreias* reinforces the focus on the absolute necessities of survival. In this context the chorus asks the question that embodies a major dramatic interest in the first half of the play: "How in the world does the poor man endure?"

Most editors print *ō palamai theōn* at line 177, that is, a purely conventional exclamation at the mysterious devices of the gods. But if the manuscript reading of the next phrase (*ō palamai thnētōn*, "O the devices of mortals!") is correct, the words express the chorus's admiration for the human resourcefulness to which they attribute Philoktetes' survival.[29] The chorus's ensuing lament (180–190) focuses once more on Philoktetes as "unaccommodated man" (*pantōn ammoros en biōi*). His isolation is again stressed, but this time the idea is expanded on by the

[29]Jebb, Webster (1970), and Dawe (1985) all accept Lachmann's emendation *theōn* ("of the gods") for *thnētōn;* but Jebb at least recognizes the true force of the manuscript reading: "*O palamai thnētōn,* if sound, would mean 'the resources of men' (as shown by Philoctetes) so Theognis 630. Cp. the praise of man as *pantoporos* [all-supplying] in *Ant.* 360."

contrast to his association with "dappled or shaggy beasts" and by fur-
ther allusion to physical pain, hunger, and "incurable and uncared-for
sorrows."[30] Then, climactically, they imagine the babbling echo that is
the only answer to his bitter cries. As Philoktetes himself is heard ap-
proaching, the chorus reverts to this image of a cry in pain which no
one hears and denies specifically the pleasant pastoral associations iso-
lation might have for a contemporary audience: he comes "not with a
pipe song, like a shepherd pasturing in the fields" (213–14).[31] At a
time when Euripides, Aristophanes, and perhaps others were explor-
ing the idea of a life of peaceful isolation from other human beings in
the friendly company of beasts, Sophokles seems to have been at pains
to emphasize the horrors of real, total isolation from human society.[32]

Philoktetes' passionate greeting to Neoptolemos and the chorus sus-
tains this emphasis on the horrors of being alone, desolate, friendless,
and miserable (*monon, / erēmon hōde k'aphilon kakoumenon*, 228–29).[33]
His allusion to his wild appearance (*apēgriōmenon*, 226) recalls the cho-
rus's evocation of his life among shaggy and dappled beasts (184–85).
His long subsequent narrative of his life on Lemnos (269–99) not only
suggests the pathos of his awful isolation but also narrates in detail the
process by which he has maintained his life in these forbidding circum-
stances. It thus answers in part the chorus's earlier rhetorical question,
how could he endure?

Philoktetes focuses on the bare necessities of human survival. He was
left by the Greeks in the protection of a cave with the crudest coverings

[30]See Page 1940: 39; accepted by Webster 1970, ad loc.

[31]See the suggestion of Dover that "even long before Theocritus a shepherd's life
and music may have been proverbially idyllic and cheerful"; quoted by D. Robinson
(1969: 39).

[32]The motif of escape, usually to some isolated spot, from an intolerable human situ-
ation by means of a fantasied transformation into a bird is a commonplace of tragedy,
especially in Euripides: e.g., *Hipp.* 732–51, *An.* 861–865, *Ion* 796–99; cf. Sophokles frag.
476 (Pearson) and *O.C.* 1081–83. In the *Helen* passage, the imagery of escape as a bird is
combined with an explicitly pastoral metaphor, "obeying the shepherd's pipe" (1484–85).
Ion's long monody (*Ion* 82–183) goes farther. He evokes in sacral and distinctly asocial
terms a happy life in relation to springs, groves, and birds—though the latter are to be
sure partly viewed as a nuisance. Aristophanes' *Birds*, though it embraces far more than
a quest for pastoral bliss, does certainly contain this element (see Whitman 1964: 168).
On the other hand, such plays as Euripides' *Cyclops* and presumably Pherecrates' *Agrioi*
(alluded to in Plato *Prot.* 327d) suggest the popularity of exploring discontent with "ad-
vanced" culture by juxtaposing it to its opposite. In particular, the type of the ferociously
misanthropic recluse seems to have emerged in the last quarter of the fifth century (see
Handley 1965 on *Dyskolos* 6). Sophokles here seems to take advantage in an original way
of available contemporary responses.

[33]Schlesinger (1968: 150) points out that *monos* ("alone"), *erēmos* ("deserted"), and *aph-
ilos* ("friendless") occur in all the extant tragedies of Sophokles, but in no other do they
play as significant a role as in the *Philoktetes*. He might have added that nowhere else are
these terms given so literal a force.

and a small aid consisting of food (*boras / epōphelēma smikron*, 275).[34] His greatest horror on awakening is the lack of human aid (280–81). He ironically sums up his total helplessness in terms of his discovery (*hēuriskon*) in the course of an exhaustive search of an "abundant provision" (*pollēn eumareian*) of "suffering" (282–84). Almost immediately he recounts the literal discovery of the barest necessities of survival through the agency of his weapon, the decisive nature of which is emphasized by its personification: "What was expedient [*ta sumphora*] for the belly / This bow you see discovered [*eksēuriske*]" (287–88). After shelter and food, his next need is water and fire to protect him from the extremes of winter. Painfully he contrives (*emēkhanōmēn*, 295) to win water and wood. Finally, his laborious achievement of fire is made the climactic item in his triumph over the most elemental forces of destruction:

> Next, there would be no fire at hand.
> But by striking stone on stone at long last
> I'd make shine forth the hidden flame, which saves me always.
> Truly, a livable chamber with fire besides
> Provides me with everything—except escape from my disease.
>
> (295–99)

The emphatic, alliterative play on *ephēn' aphanton phōs* ("I brought to light the lightless light") and the suggestive inclusiveness of the phrase *ho kai me sōizei m' aei* ("which still saves me always"), the literal sense of which is explained further in *puros metal pant' ekporizei* ("with fire provides everything"), rhetorically give to fire a role in Philoktetes' survival that may appear disproportionate to its warmth-giving function or even its function in cooking, to which no direct allusion is made. But in the context of Sophokles' anthropological metaphor of the presocial struggle for survival, fire constitutes an almost inevitable climax.

The constant concentration in the opening three hundred lines of the play on the harsh absolutes of Philoktetes' mode of survival—his rocky cave, his isolation except for beasts and birds, which constitute his sole diet, his total dependence on his bow—recurs with a grimly altered emphasis in the last third of the play when he is deprived of his bow. Much of the audience's reaction to the callousness of the chorus in proposing to leave Philoktetes without his bow (833–38) and Odysseus' ironically accommodating release of him to "tread his Lemnos" (1054–

[34]The strong poetic emphasis of the unique coinage *epōphelēma*, a word type favored by the Sophists, is stressed by Long (1968: 98). He does not, however, recognize the distinctly anthropological associations of the *-ōphel-* ("help") element in the context of a struggle to survive.

60) depends on a full acceptance of the bow as his only means of survival. It is explicitly in these terms that Philoktetes first describes Neoptolemos' act: "You have deprived me of my life [*bíon*] by taking away my bow [*toksa*]. . . . Don't snatch from me my life [*bíon*]" (931, 933).[35] Twice earlier (189, 215–16) the chorus has sympathetically imagined Philoktetes' agonized cries to surroundings devoid of human life. Now when he is again denied a human response (934), we hear him directly lament to the ever-present but isolating water, the rocky harshness of the land, the impossible companionship of wild beasts— all in language that recalls the imagery of his successful struggle in the early section of the play:

> O watery havens and headlands, O companionship
> Of mountain beasts, O jagged, broken rocks,
> To you—for I know none other to address—
> To you, my usual companions, I raise my cries.
>
> (936–39)

Initially, Philoktetes' lament centers on the human outrage perpetrated against him; the harsh environment is invoked merely as a witness. But when a second appeal to Neoptolemos again meets with silence, a second apostrophe to the physical environment becomes a meditation on the active hostility it will manifest against a man who is now stripped of defense (*psilos*) and by the same token without means for acquiring sustenance (*trophēn*) (951–53). His rocky home with its two openings is now the chamber in which he must wither away from starvation, or, as he considers more closely, fall victim to his own former victims. He focuses with relentless parallelism and alliteration on the primitive law of the jungle which it will soon be his lot to illustrate:[36]

> I myself, alas,
> By my death will furnish a feast for those on whom I fed,
> And those I used to hunt will now hunt me:
> Alas! I will pay by my death the blood price of their deaths.
>
> (956–59)

[35]D. Robinson (1969: 43–44) defends the play on *bíon* ("life") and *bión* ("bow") against Jebb, who denies its presence. For me the play is decisively confirmed by Philoktetes' later bitter allusion to Odysseus "brandishing in his hand the means of my wretched sustenance" (*tan eman meleou trophēn*, 1125–26). Henry (1974: 4) adds plausibly *Ph.* 1416–17 as a further pun.

[36]*Rhusion* (959), a word that occurs in Homer (*Il.* 11.674) to designate the rough-and-ready justice of seizing cattle in reprisal for stolen cattle, seems from its use in tragedy (e.g., Aeschylus *Ag.* 535; *Supp.* 728) to have retained connotations of direct retaliation unmediated by legal institutions.

In the long formal lament (*kommos*) beginning at 1081, the transformation of the environment implicit in 951–59 is evoked again and explored more fully. The cave's changes in temperature, so appealingly described by Odysseus (16–19), now appear in a more intensified aspect ("now hot, now icy cold," 1084).[37] What was earlier a home is now a rock hollow that will witness his death. The birds and beasts, his former prey, are now free to move or rest at will (1092–94, 1146–55), while he is fixed in his cave (1149–50). The most marked contrast between the man and the beasts is with respect to food. A man without weapons has no hope of food (1090–91); nowhere can he seek sustenance (*biota*, 1158); he must feed on air (1058). The beasts, once the threat of the human weapon is removed, will take their full vengeance on his corpse (1156–57). This reversal has been alluded to earlier, but now the pathetic helplessness of a human being in isolation is further heightened by the suggestion that the land itself feeds the beasts (cf. *ouresibōtas*, 1148) while unaccommodated man cannot enjoy any of the advantages of "life-giving earth" (*biodōros aia*, 1161).[38]

This broad contrast between the conditions of a barely successful human struggle to survive in the opening portion of the play and the prospect of total obliteration of a man by environmental forces in the latter section constitutes what I consider a strongly anthropological framework within which the drama is played out. The imagistic emphasis on beasts, food, shelter, weapons, medicine, and fire; the terminological focus on need, advantage, discovery, contrivance, supply, resourcefulness; the emotional evocations of loneliness, fear, anxiety, and pain—all echo the anthropological speculations of the Presocratics and Sophists about the circumstances of presocial human life.

Arriving at the Social Compact

The relationships that develop as the play unfolds between Philoktetes and Neoptolemos and between Philoktetes and the chorus are dramatically complicated by the deception to which Neoptolemos and the chorus are committed at the outset; it renders much of what they say of questionable sincerity. This deception is not extraneous to the

[37]Webster (1970) comments on line 16: "Odysseus describes the cave like a house-agent, implying that its desirability mitigated his cruelty (68)"; *contra* see Ronnet (1969: 259), who takes Odysseus' description as proof that "toute l'humanité possible" is employed in the accomplishment of his duty.

[38]We may recall that the special point in Protagoras' myth of the puns on the names of Epimetheus (Afterthought) and Prometheus (Forethought) is the contrast between all other animals, who are perfectly equipped by Epimetheus with the physical means to survive, and man, who is "naked, barefooted, homeless (literally 'bedless'), and weaponless," 321c5–6.

sophistic matrix of the play; it is, as I illustrate later, an intrusion from the third or contemporary level of sophistic sociology into the second stage. The situation is further complicated by Sophokles' addition of clearly nonsophistic elements, which I also discuss later. Despite these complications, the major dramatic thrust and much of the emotional power of the interaction of these characters derive in no small measure from Sophokles' exploitation of the second stage of sophistic sociology. Against the background of Philoktetes' isolated struggle for minimal survival, human bonds are established on the basis of spontaneous *pity* for a suffering fellow human being, spontaneous *affection* between human beings of the same race and same language, and, at the highest level—when deception and force have been repudiated—sincere *persuasion* aimed at the best interest of one's friends. This level is achieved only by the emergence of fundamental *agreement* about ethical and religious values: what is just, what is holy, and what is pious. The ultimate goal of the compact established at this level remains the same as the goal of Philoktetes' isolated struggle: survival.[39]

We noted earlier the climactic role given Philoktetes' achievement of the "salvation-light" (*phōs*) of fire, which saves him always (297), and suggested that that emphasis reflects the anthropologists' sense of the decisive role of fire in human survival at the presocial level. But the most frequent occurrence of the verb *sōizein* is in Philoktetes' appeals and his interlocutors' promises for salvation from the horrible isolation of primitive life on Lemnos. For Philoktetes this means a return to the society and kin ties of his home and father; for Neoptolemos, through most of the play, and for the chorus throughout the play, it means a return to the society of the Greek army at Troy and full participation in their common attempt to destroy Troy. Despite these differences over the best kind of salvation, the grounds for saving Philoktetes are consistently examined in terms of a sophistic analysis of human ties.

The chorus, "strangers in a strange land" (135), anticipate with some anxiety encountering a man they have every reason to expect will be full of suspicion (136). Their leader alludes apprehensively to the coming of the "frightening traveler" (147). But as soon as they hear the account of his grim way of life, they are overcome with pity (*oiktirō*, 169); as they meditate on his mode of life (170–90), he becomes for

[39]Avery (1965: 296) includes a brief appendix demonstrating the importance of the theme of salvation but seems to have little idea what to do with his data. M. H. Jameson (1956: 224 n. 16) alludes to *sōtēria* ("safety," "salvation") as a contemporary political slogan. This is quite plausible in the context of more than twenty years of war with devastating Athenian losses. But neither Jameson nor Bieler (1951), from whom he gets the idea, notes the specifically sophistic character of the emphasis on *sōtēria* in many of the contexts cited by Bieler, particularly those from Thucydides.

them a frightening example of the fragility of the human condition (178–90) and specifically an awesome reversal of the social order (180–86). Summing up the pains and anxieties of his life, they again pronounce him "pitiful" (*oiktros*, 186).

Neoptolemos, however, seems at first to be made of sterner stuff; to the chorus's meditation on human suffering he opposes the brisk certainty of a divine plan (191–200).[40] But whether disposed to distrust, sympathy, or cold indifference, the chorus and Neoptolemos in particular must be shaken by the dramatically unexpected outpouring of affection from Philoktetes on his arrival.[41] Over and over again he expresses the affection (*philia*) inspired by all the factors that create a bond between them: their Greek dress is "most beloved" (*prosphilestatē*, 224); their Greek speech is "dearest utterance" (*philtaton phōnēma*, 234); the very wind that brought them together is "dearest" (*philtatos*, 237); Neoptolemos' father is "dearest" (*philtatos*, 242) and his homeland is "dear" (*philē*, 242). Philoktetes appeals immediately for pity on the simple grounds of his sheer misery and isolation: "Showing pity for a man wretched and alone,/ Suffering this way, isolated and friendless" (227–28). When the chorus and Neoptolemos hesitate to reply, he begs them to speak on the grounds that is not *eikos* ("probable," "reasonable") for them not to speak to each other, implying that their humanity involves the reasonable probability of communication.[42]

After his full narrative of his abandonment by the Greeks and his long struggle to survive, Philoktetes prepares indirectly for his first appeal to be saved by describing the island and the behavior of the few previous chance arrivals. The island is not a place one chooses to visit for profit (*kerdos*) or personal comfort (303). The few who have landed against their will have offered him only verbal pity (*logois/ eleousi*, 307–8) since their pity (*oiktirantes*) extended only to the point of token gifts of food or clothing; they always balked at the fundamental service, the salvation of conveyance home (*sōsai m' es oikous*, 311).

[40] Kitto (1956: 111–12) is especially good on the defensive smugness of Neoptolemos' attempt to counter the chorus's expression of pity. His argument closely parallels Linforth's (1956: 107). See also Machin for an appreciation of the adroit way Sophokles prepares here for a later level of insight on Neoptolemos' part which would otherwise appear in harsh contradiction with his apparent level of ignorance in the prologue (1981: 63–69).

[41] This point is emphasized by Avery (1965: 280). The surprise derives in part from the contrast to Euripides' more obvious assumption that Philoktetes would be misanthropic and highly suspicious and would consider Greeks his worst enemies (see Dio. Chrys. *Or.* 59.6–7). Philoktetes' capacity, nicely stressed by Biggs (1966: 231), for a warm response to fellow human beings in spite of all he has suffered is the best refutation of the common view (e.g., Gellie 1972: 153; Segal 1981: esp. 292) that Philoktetes is too psychologically warped to participate in society.

[42] See Guthrie *HGP* 3.178–80 on the Sophists' invention of and fascination with the argument from probability.

The chorus, with a naivete—or cynicism—that is dramatically ironic, declare that they pity him (*epoiktirein*, 318) in equal measure (317) with those former arrivals.[43] Neoptolemos, however, in pursuance of the deception, appears to ignore the hint and proceeds to lay the foundation for the only bond between himself and Philoktetes conceived of in the original scheme, a shared hatred of Odysseus and the Atreidai.[44] But in the course of his lie, he is again confronted by Philoktetes' spontaneous expressions of shared love and sympathy. Neoptolemos mentions in passing his father's death only to be interrupted by Philoktetes' expression of deep distress both for the father and the son (337–38). Disconcerted perhaps, Neoptolemos dourly suggests that Philoktetes has enough troubles of his own "not to grieve at the suffering of his neighbor" (340). Despite his explicit denial, the generality of his declaration in this context invites a consideration of the bases for shared feelings between human beings in proximity (cf. Democritos *D-K* B 293; Antiphon *D-K* B 59).

The sympathetic response of Philoktetes, when Neoptolemos' whole narrative (343–90) and the chorus's supportive lyric (391–402) are over, leads unexpectedly to a further revelation of shared affections. Philoktetes asks about various heroes whom he would have expected to act as Neoptolemos' allies: Neoptolemos' cousin the greater Ajax (411), Philoktetes' "noble old friend" Nestor, Achilles' beloved Patroklos (433–34). In each case, Philoktetes expresses strong sympathy for the death or misfortune of Neoptolemos' natural allies among the Greeks. The reflections of Neoptolemos about the consequences of war (435–37) may still in part represent his deceitful pose, but it is hard not to see as well a perception genuinely shared with Philoktetes about who the "good men" (*tous khrēstous*, 437) are. Neoptolemos' farewell to Philoktetes, calculatedly brusque as it is, nonetheless expresses a corresponding concern that the gods bring him relief in the way "he himself wishes" (461–63). The dramatic irony of this casually uttered

[43]Many readers (e.g., Fuqua 1964: 105; Schmidt 1973: 79) assume that here the chorus is doing their calculating best to adhere to Neoptolemos' injunction to back him up in his lies (148–49). The ambiguity of their responses, as in the case of Neoptolemos' real feelings, is a delicate interpretative problem throughout most of the play; it is perhaps pointless to offer dogmatic judgment where the poet has clearly created an atmosphere full of ambiguity. On the other hand, the poet gives us more data than is sometimes perceived. We have heard this chorus moved to a strong, extended expression of pity (169–90) by the mere sight of Philoktetes' dwelling when there can be no question of deceit. The direct exposure to Philoktetes' pathetic appearance and speech seem dramatically more than adequate to move this chorus of Papagenos to pity. But Gardiner rightly stresses the Odysseus-like cheap cynicism of much of their behavior (1987: 20–26; 22 on this scene).

[44]K. Alt (1961: 150) correctly notes the emphasis in this scene on a shared hatred but fails to distinguish between the bond of hatred prepared for by Odysseus (59–64) and the bonds of affection and pity that arise spontaneously and have consequences much contrary to Odysseus' intentions.

phrase foreshadows the only viable basis on which the bond between these two friends can become functional, a sincere respect for the real interests of one's friend.

Philoktetes now makes a direct appeal for *sōtēria;* the verb *sōizein* recurs like a leitmotif through his speech (487, 496, 501). This appeal uses the formulas of traditional supplication, but these are transformed by the untraditional circumstances from which he pleads for rescue, namely, his isolated struggle to eke out a bare existence on Lemnos. As a suppliant (*hiketēs*), he begins with the traditional appeal in the name of his addressee's parents. His rhetorical expansion of that appeal ("in the name of whatever is dear [*prosphiles*] to you at home," 469) echoes his own earlier outpouring of affection (224, 234, 237, 242) and by its generality almost invokes a principle of affection. His appeal is not the traditional one to be spared death on the battlefield, not for protection from some powerful human enemy, not even for a simple material boon; rather, he appeals first and foremost not to be left alone in the wretched conditions which he has endured: "Do not leave me alone [*monon*] like this—/ Destitute [*erēmon*], in the miserable circumstances you see here/ And those you have heard surround my daily life" (470–72).

To support his appeal, Philoktetes enlists a whole array of traditional ethical terminology that particularly evokes the world of Homeric shame culture: "For those who are true sons of their fathers [*gennaiois*]/ what is shameful [*to aiskhron*] is hateful and what is good [*to khrēston*] is glorious" (475–76). If Neoptolemos leaves him behind he will acquire "ignoble disgrace" (*oneidos ou kalon,* 477), whereas, if Neoptolemos does as he has promised, he will win "the greatest prize of glory" (*pleiston eukleias geras,* 478). He calls for the heroic virtue of *tolma* ("daring," 475, 481) and associates proper ethical behavior with the aristocratic class term *gennaios* ("noble," characteristic of a legitimate son of a noble, 475). Yet the content of the daring, the nobility, and the glory he envisions is worlds away from either traditional heroic virtues or the values of the third stage or contemporary world of the Trojan War. As is clear to the audience, who have watched the scheme against Philoktetes arranged in the prologue, in the world of contemporary self-seeking struggles there is no glory associated with the daring or nobility involved in an act of kindness to a suffering fellow human being—especially when that kindness amounts to enduring the physical disgust occasioned by a festering wound.[45] In-

[45]Note too the fine reputation Odysseus promises Neoptolemos for a day's shamelessness (83–85), discussed below. I am indebted to Winnington-Ingram for reminding me of this clearly intentional parallel phrasing.

deed, the poet seems to invite recognition of the pathetic disparity be-
tween the ethical assumptions of Philoktetes and those of the real
world by the emphasis on heroic terminology. What Philoktetes pre-
sents as meritorious behavior is in fact a more private sort of behavior
in which pity and friendship based on common humanity, rather than
the expectation of public acclaim, must play the decisive role. And it is
precisely this sophistic "calculation" of human interdependence in the
face of a hostile and dangerous world that forms the climax of Philok-
tetes' appeal:

> *You* save me! *You* pity me, seeing
> That the state of everything is fearful for mortals,
> Full of danger, that after joy must come its opposite.
> One who stand free of pain must look out for disasters,
> And while he lives, then keep guard on his life—
> In case it be totally ruined before he knows it.
>
> (501–6)

Pity is highlighted in the chorus's response (*oiktir, anax,* 507) but com-
bined with a crude, third-stage variation of the idea of calculation of
self-interest: it is profitable (*kerdos,* 511) to help Philoktetes because he
is the enemy of their alleged enemies, the Atreidai. Their expression of
pity may appear genuine in view of their previous sympathy expressed
in his absence; but in the context of the deceit they are helping to work
against him, it is not without shabbiness. Yet their hypocrisy is as noth-
ing compared to the smug snobbery of Neoptolemos, whose reply apes
the aristocratic, heroic flavor of Philoktetes' untraditionally humane
ethics. It would be "shameful" (*aiskhra*) for him to prove inferior to the
chorus in taking pains in the interest (*to kairion*) of a stranger (525).

The apparent selflessness of this act is met by Philoktetes with an ec-
static expression of affection (*philtaton* [dearest] . . . *hēdistos* [sweet-
est] . . . *philoi* [friends]) and a wish to be able to prove in action the
affectionate bond they have inspired in him (*hōs m' ethesthe prosphilē,*
530–32). The embarrassing naivete of Philoktetes' openness to the
bond of *philia* in this feigned social compact is immediately juxtaposed,
with tremendous dramatic power, to a proud invitation to Neoptolemos
to learn (*mathēis*) of his own real daring (*tlēnai*), the harsh schooling
(*proumathon*) he has gradually gained under the necessity (*anankēi*) of
the grim circumstances of his struggle to survive in his primitive non-
home (*aoikon eisoikēsin,* 533–38).

The conception of friendship as affectionate mutual service articu-
lated in this scene is echoed several times (557–58, 583, 587–88) in
more cynical, third-stage terms during the scene with the disguised

agent of Odysseus.[46] The concept reemerges on an idealistic plane af-
ter the merchant departs, as Neoptolemos takes his first step toward
gaining control of the bow. Neoptolemos phrases his request to handle
the bow in the language of religious awe (*proskusai . . . hōsper theon*,
657). Philoktetes treats the request as a welcome opportunity to dem-
onstrate his commitment to the self-interest (*hopoion an soi ksumferē
genēsetai*) of his friend (658–59). When Neoptolemos displays some
hesitation whether his request is *themis*, a word that nicely equivocates
between religious sanction and proper human behavior, Philoktetes'
grateful reply defines holiness (*hosia*), right action (*themis*), and human
excellence (*aretē*) in terms of an act of kindly service (*euergetōn*) to a
friend, such as he thinks he is receiving from Neoptolemos and such as
he himself had performed for Herakles in winning the bow (662–70).
Thus the bow, which in the absolute battle for primitive survival had
emerged as a symbol of the technology that separates man from beast,
becomes here a symbol of the service to a suffering friend which is held
up as the fundamental basis both for affection and for a shared ethics
in a social compact.[47]

Neoptolemos also couches friendship in terms of mutual service, but
he adds special emphasis on his own enlightened self-interest in this
friendship:

> I am not sorry that I met and took you as my friend:
> For he who knows the art of making fair return for fair service
> Must prove a friend worth more than any possession [*ktēmatos*].
>
> (671–73)

The audience's knowledge of the intended crass exploitation of this
"friend" by Neoptolemos inevitably sharpens the dramatic contrast be-
tween the two definitions of friendship.[48] This impression would as

[46]Laurenti 1961: 46–47 emphasizes that the merchant and Odysseus "speak a differ-
ent language" from that of Philoktetes; cf. Parlavanza-Friedrich 1969: 59.

[47]I disagree with Harsh's whole interpretation of the symbolism of the bow, and in par-
ticular with the notion that it is an objective and unchanging symbol. Part of the richness
of the symbolism is precisely that it changes with the different stages of society envi-
sioned in different scenes. Musurillo (1967: 121–22) is much better on the range of sym-
bolic associations of the bow. Segal's pervasively religious emphasis emerges again in
positing the bow's "broader meaning as a gift of the gods, immortal and bearer of a god-
given destiny" (1981: 299). It is true that the bow figures in a complex destiny inacces-
sible to ordinary human calculations, but the crucial emphasis is on Philoktetes' having
earned it by his action.

[48]Webster assures us (1970, ad loc.) that "again the emotion is genuine: Neoptolemos
feels a natural sympathy for Philoktetes as a like-minded hero." Similarly, Kirkwood de-
scribes the lines as heartfelt (1958: 60). Reinhardt's comment apropos of an earlier pas-
sage seems to me to be valid here too: "Even the gnomic generalization is put in the
service of the deceitful game" (1947: 179). Parlavanza-Friedrich (1969: 58) speaks more

well be reinforced for those who retain the echo of Odysseus' seductive argument that "seizing hold of victory is sweet possession" (*hēdu . . . ktēma*, 81). As so often in Sophokles, Neoptolemos' words turn out to be true in a sense he cannot envision at this point.

The smugness of Neoptolemos' false friendship is immediately juxtaposed to a further reminder of Philoktetes' long struggle to survive. The chorus at 676–729, "the only proper stasimon of the play" as Jebb noted, sustains the harsh reality of Philoktetes' situation for ten years alone on Lemnos. Thus it holds up for the audience a touchstone against which to test both the second-stage values of pity and friendship and the more ruthlessly utilitarian values of the third stage. After insisting on the absolutely undeserved character of Philoktetes' sufferings by the negative paradigm of Ixion, the chorus repeat their earlier expression of awe at Philoktetes' capacity to endure, then narrow their focus to a further exploration of a central theme of the anthropologists' account of the presocial battle to survive, namely, the lack of an abundance of material resources (*eumarei'. . . porou*, 704–5); cf. the ironic use of *eumareia* at 284). In particular, the theme of food is developed in the second stage of social development. The chorus offers a sustained contrast between the pathetically haphazard food and drink (i.e., game and standing water) of an isolated individual and the food and drink (i.e., bread and wine) that are consequences of the organized work of civilization (706–17).[49]

bluntly of Neoptolemos' repeated use of "platitudes." Calder (1971) insists that Neoptolemos is an unredeemed villain from beginning to end and is accordingly most harsh on the "naiveté of those victimized by Neoptolemos idolatry" (1959). His attempt to present the mythic tradition about Neoptolemos as uniformly black (168) is an important reminder, but it conveniently (for his argument) brackets Odysseus' speech to Achilles (*Od.* 11.505–37), in which, even allowing for Odysseus' tactful suppressions, Neoptolemos figures as the very embodiment of the successful son of a great father. Sophokles is clearly inviting his audience to meditate on *both* aspects of the character. At the same time that the smugness of tone in this immediate context deserves to be stressed, it is also true that in the broader context the lines reflect the clear dramatic irony that characterizes much of this section of the play; the terms of the deceit are in fact the terms on which real friendship will at last be established. Neoptolemos will reject the *hēdu ktēma* ("sweet possession") of victory offered by Odysseus (81) for the friendship of one ready to risk his life for the man who has saved his life (see 1404–8 and my subsequent discussion).

[49] Albert Henrichs has called my attention to the excellent, nearly contemporary parallel in Teiresias' "Prodicean" discourse on Demeter and Dionysos (Euripides *Ba.* 274–85, with Dodds's note). See also Diodorus 1.8.6–8; *Ancient Medicine* 3.7, 13; Lucretius 5.944–45 and Cole's discussion (1967: 36–38). The emphasis in the *Philoktetes* on hunting alone rather than on gathering fruits and nuts represents, I believe, Sophokles' concentration of dramatic interest on the bow. At the same time, there is perhaps also an element of class ideology at work. For all his wretchedness, Philoktetes remains exclusively an aristocratic hunter; food gathering might associate him too closely with peasant farmers.

For the chorus there seems to be no sense of conflict between their expression of pity for Philoktetes and the personal advantage they expect to win from him without his consent through their elaborate lies.[50] Neoptolemos, though he appears earlier to be even more smugly confident in the pursuit of his own advantage, now begins to break down in the face of a direct experience of Philoktetes' hideous suffering from a sudden attack of his disease.[51] One of the fundamental ironies built into Sophokles' plot consists in the fact that it is precisely the direct experience of Philoktetes' hideous scream of pain—the reason alleged by the rest of the Greeks for abandoning him—that precludes Neoptolemos' abandoning him.[52] It sweeps away his narrowly selfish defenses against the genuine pity and affection he has begun to feel for Philoktetes. Thus conditions for a genuine social compact between

[50]Reinhardt's attempt (1947: 191) to defend the chorus by distinguishing a double function (supporting the intrigue, stressing the sufferings of Philoktetes) pinpoints a problem rather than solves it. He is followed closely by Burton (1980: 226–50). Linforth's attempt to exonerate the chorus (1956: 127–30) and in particular his argument that they only express Neoptolemos' suppressed sympathies (cf. Schlesinger 1968: 138) gives us a curious sort of psychodrama that obscures Sophokles' sharp sense of a class difference between the perceptions and emotions of the chorus and those of the son of Achilles (see Gardiner 1987: 48–49).

[51]In general I agree with Erbse's impressive refutation (1966: 189–90) of attempts such as those of K. Alt (1961) and Schmidt (1973) to find mitigating hints of Neoptolemos' pity as early as possible in the play. Winnington-Ingram has stressed to me the implications of the repetition of *palai* (806, 906, 966) in Neoptolemos' expression of pity and shame. Seale too speaks persuasively of "sustained ambiguity which forms the basis of the dramatic tension, allowing two possible interpretations of the behavior of Neoptolemos and the Chorus, deception or sincerity" (1972: 98). Of course, a good actor playing the part of Neoptolemos would attempt to exploit this dramatic possibility to the hilt, and it is equally true that Neoptolemos' conversion must be dramatically credible. At the same time, defenders of Neoptolemos tend, in my view, to take inadequate account of the far more impressive dramatic tension between, on the one hand, the shabbiness and narrow selfishness of Neoptolemos' conversion to Odysseus' goals and means in the prologue and, on the other hand, the terrible misery, amazing inner strength, and decency of the victim constantly before our eyes to whom Neoptolemos keeps lying so long and so effectively. Whatever hints of distress might be conveyed by gesture and however much ambiguity the initial conflict of values with Odysseus in the prologue may lend to Neoptolemos' situation, the actual content of his words and behavior toward the helpless and trusting Philoktetes remain morally shocking until the attack of the disease finally breaks down his defenses. Grene puts it well: "It is surely remarkable how very sharply Sophokles has chosen to mark the limits of Neoptolemos' decency. . . . He takes a very long time to come to himself, to realize that he cannot win his objective at such a price of torturing another human being" (1967: 145).

[52]Knox (1964: 130–31) has a powerful discussion of this scream, yet his own irony blurs the dramatic irony in the play; he declares, "We understand now fully why the Achaeans abandoned him" (131). Ronnet (1969: 256) even defends as valid the "religious scruple" alleged for abandoning Philoktetes. Craik's attempt (1979: 28) to find "an element of burlesque" in this scene strikes me as grotesque. Gardiner (1987: 37) is especially good on the way the text, with its "frantic antilabe, the stumbling meter," the explicit question from Philoktetes, "Why are you silent?" (805), clearly marks Neoptolemos' deep reaction to the horror of human pain.

them begin to emerge. Philoktetes' agonized cry for pity (*oiktire me*, 756) and Neoptolemos' own inability to help him (757) elicit from Neoptolemos a highly emotional, heavily alliterative lament: "Alas! Alas! You poor man!/ Truly, poor man you clearly appear through all your pains!" (*iō iō dustēne su/ Dustēne dēta dia ponōn pantōn phaneis*, 759–60). His own long-suppressed pain at the pain of his friend is soon expressed openly in terms that echo, with great dramatic irony, his own earlier injunction to Philoktetes not to "groan at the pains of his neighbor" (340): "I have long been in pain, groaning at your sufferings" (806).

Philoktetes now swoons into unconsciousness, after entrusting his bow to his friend with a strong affirmation of their mutual dependence (772–73) and exacting a pledge (*pistin*, 813) that Neoptolemos will stay. The split between the chorus and Neoptolemos at this point emerges sharply. He refuses to accept their broad hints that he take the bow and leave the man.[53] Yet at this point there is only a hint that his motives involve a fundamental agreement with Philoktetes about ethical values; he echoes emphatically Philoktetes' transformed moral terminology of the shame culture (*aiskhron oneidos*, 842, cf. 476–77).[54] The chorus perceive only a simple choice between something that involves fear (*phobōn*, 864) and pain (*pathē*, 854) on the one hand, and, on the other, an opportunity for their advantage (*kairos*, 837; *kairia*, 863). Philoktetes' ecstatic praise of Neoptolemos on regaining consciousness sharpens further the conflict of values. For Philoktetes, the fact that Neoptolemos has remained transforms the light he now sees again into a symbolic victory light (*phengos*), confirming, beyond expectation, the bond between them based on a new kind of heroic endurance (*tlēnai*) that in turn consists of pity (*eleinōs*) and cooperation help (*ksunōphelounta moi*, 867–71).

[53]Hinds (1967: 175–76), though excessively tentative, correctly refutes Linforth's (1956) absurd defense of the chorus on the grounds that they do not explicitly say, "Take the bow and leave the man." There are good reasons for being vague when one makes so cruel a suggestion. Gardiner (1987: 38) rightly points to the chorus being the first to introduce the idea that the bow is worth having without the man so that it is less of a shock when Odysseus takes it up subsequently. D. M. Jones (1949: 83–84) nicely reminds us that Hera fetches Hypnos from Lemnos (*Il.* 14.230–31) to aid her seduction of Zeus. He suggests plausibly that in their hymn to Hypnos (827–32) the chorus have in mind the ambiguity of his role as both bringing relief from pain and rendering his victims helpless and vulnerable to trickery.

[54]Winningham-Ingram (1969: 49) offers the attractive suggestion that Neoptolemos' use of hexameters here suggests not the sudden insight of an oracle (Bowra 1965: 281) but heroic action. "There is a discord between the Homeric metre and the unheroic enterprise in which the son of Achilles has allowed himself to be engaged." This view does not, I think, conflict with my argument that the context of Philoktetes' unusual predicament and his entire interaction with Neoptolemos substantially have altered the moral content of these shame culture terms.

In Neoptolemos' ensuing painful confession of fraud, in the dramatization of his gradually completed alienation from Odysseus and his achievement of a full compact with Philoktetes, the decisive factors are pity, cooperative help, and a deeply transformed heroic ethic. Neoptolemos at first insists that his real intention in taking Philoktetes to Troy still includes the humane motive of saving him (*sōsai*, 918). But when Philoktetes demands back the bow, which is his only means of survival on Lemnos, Neoptolemos refuses on the grounds that obedience to the army involves a harmony of proper behavior (*to endikon*) and private advantage (*to sumpheron*, 926). A scathing denunciation by Philoktetes and his pathetic lament, evoking the death he must suffer without his bow, force Neoptolemos to acknowledge the terrifying pity (*oiktos deinos*) that has "attacked" him (965–66).

Throughout this exchange, a noteworthy series of verbal echoes highlights the fact that for Neoptolemos, locked into the crass calculations and manipulations that characterize "advanced" society, spontaneous feelings of pity and decency occasion an inner agony (806, 906, 913), a terrifying attack (965), a sense of inner disgust (902) that directly contrast with the physical agony (e.g., 283, 731–820) that attacks (699) Philoktetes and the physical disgust (473, 900) occasioned by his wound. This careful symbolism of a wound in Neoptolemos' psyche resulting from his association with a corrupted society suggests the need for some caution in too easy an acceptance of the popular interpretation of Philoktetes' wound as a symbol of the hero's alleged pathological incapacity to relate to society.[55] On the contrary, the wound, like the rest of Philoktetes' appearance, functions as a particularly striking instance of Sophokles' characteristic fondness for contrasting appearances with reality. The handsome young prince, shining with confidence and promise, turns out to have the real wound deep within. It is the scruffy old cripple who, as we have noted, reverses all expectations by his generous outpouring of affection for human strangers, his readiness to trust and serve his new-found friends; *he* has all the social instincts and basic decency that can reasonably be expected of any human being. His wound represents one of those arbitrary, inexplicable impositions of forces external to and beyond human control—an

[55]See note 41 above. The view was first popularized in Wilson's famous essay *The Wound and the Bow* (1941 [1929]: 272–95). Biggs, despite excellent perceptions of the ways Philoktetes' disease is sharply differentiated from those of Ajax and Herakles, still speaks of "the poison of deep grief" and interprets the emphasis on the stench of the wound as symbolic of the hero's fostering of his own self-pity and hate which "makes association with the sufferer so difficult" (1966: 233). Schlesinger also cautiously sets forth a psychological explanation of the wound symbolism (1968: 154–55). Segal (1981: esp. 292), as noted earlier, repeats the notion so often that it takes on, for all his caution, the force of a de facto "tragic flaw."

amoral *anankē* that is as much a given as the harshness of the physical environment unmediated by society.[56] The consistent characterization of the wound itself as a beast involves a symbolic intensification of the hostile presocial world from which Philoktetes must wrest his survival.[57] Only in this sense does it symbolize his need for society, but clearly not just any society. His afflictions, both general and specific, require a society characterized by decency and pity.

Neoptolemos' vulnerability to these essential social emotions of pity and moral shame now opens the possibility for genuine social bonds. Philoktetes immediately fastens onto the idea of pity (*eleēson*, 967) and links it, just as he had in his first appeal to be saved (476–78), with the shame culture ethic (*oneidos*, 968). Neoptolemos now is morally paralyzed and can only exclaim in terms that echo Orestes' moral paralysis when confronted by his mother's breast (*Ch.* 899), "What am I to do?" (969), "What are we to do?" (974). But from the angry exclamation of Odysseus, who now intervenes, Neoptolemos seems to have been in the process of returning the bow. After the intervention of Odysseus, pity seems something Philoktetes can only pray for from the gods (1042). But his desperation as Odysseus, Neoptolemos, and the chorus prepare to abandon him leads to a further appeal—first to Neoptolemos, then, when he fails to respond, to the chorus, whom he can no longer consider friends: "O strangers [*ksenoi*], will I really be left behind—desolate like this—/ By you as well, and will you show me no pity?" (1070–71). Their reply affirms once more (see 139–43, 963–64) their total dependence on the judgment of Neoptolemos. Once again the pity felt and acted on by Neoptolemos plays a decisive role in the unfolding of the drama: he orders his men to remain with Philoktetes in the hope he will change his mind but comments: "True, I will have it said of me that my nature is full of *pity*/ —Said by this man, but all the same, stay" (1074–75). His assumption that this act of pity will win him a bad reputation (*akousomai*) in the eyes of Odysseus contrasts ironically with Philoktetes' earlier, apparently naive assumption that a failure in pity would bring Neoptolemos reproach in the eyes of mankind (*brotois oneidos*, 968).

In the ensuing lyric dialogue between Philoktetes and the chorus, the themes of friendship and pity are set in sharp relief against the full,

[56]Of itself, belief in necessity implies neither an archaic, demonic view of the world nor an anthropological view. But Biggs (1966: 233) rightly notes that, although Philoktetes can speak in generally pessimistic terms of the gods (e.g., 452), he does not, in contrast to Ajax and Herakles, attribute his wound to divine persecution or punishment. Only Neoptolemos raises such a moral/religious interpretation of the wound. In Neoptolemos' later allusion to a vaguely divine source of Philoktetes' sufferings (1316–17) the emphatic *tukhas* ("chances") precludes a moral view.

[57]This symbolism is beautifully worked out in Kamerbeek 1948.

grim evocation of Philoktetes' inability to survive on Lemnos without his bow; the apparent breakdown of the social compact leaves him no longer able to confront successfully the presocial conditions of existence. The chorus chide him for rejecting their affectionate feeling for him (*philotēt'*, 1121); they declare that they draw near him with complete concern for his best interest (*eunoiai pasai pelatan*, 1164) and describe the doom awaiting him on Lemnos as pitiful (*oiktra*, 1167). Yet they deny that they have had any part in a deception (*dolos*, 1117) of Philoktetes, reject any criticism of Odysseus (1140–45), and twice express their great eagerness to leave Philoktetes to his fate (1177–81, 1218).[58] Indeed, the idiom they first choose to express this eagerness (*phila moi, phila*, 1177) seems to embody the poet's ironic comment on the superficiality of their *philotēs* (bond of affection) for Philoktetes.

The consequence of the delay won by Neoptolemos' pity is course not the submission of Philoktetes but the completion of Neoptolemos' break with Odysseus. In the staccato exchange between the returning Neoptolemos and the unsuccessfully obstructive Odysseus, Neoptolemos describes his earlier behavior as a crime (*hos' eksēmarton*, 1224, cf. 1248) involving shameful deceptions (*apataisin aiskhrais . . . kai dolois*, 1228, cf. 1233, 1249) and contrary to right (*dikēi*, 1233). He declares his imperviousness to fear (1251), even of the entire army (1243), as long as he is allied with "what is right" (*tōi dikaiōi*, 1251). This passage is not uncommonly cited as marking a definitive repudiation of sophistic thought.[59] It does clearly mark a particularly self-conscious internalization of the heroic shame ethic: terms that normally derive their validity from the approval or disapproval of the group are here held up as a basis for defying the group's opinion. The attempt to found a more inner-directed morality based on traditional terminology is generally associated with the name of Sokrates, who in turn is presented by Plato as the very antithesis of a Sophist. Yet the process, never complete, by which the traditional shame culture's ethical terminology was transformed into a set of mental constructs affecting the psyche of an individual apart from witnesses was longer and

[58]Twice, that is, if the much suspected (see Jebb, ad loc.) lines 1218–21 are retained. Taplin (1971: 39–44) has renewed the attack on them. It is hard to say how much his conviction of their inappropriateness is affected by his false view that the chorus's attempt at persuasion has been honest (38). Gardiner (1987: 42–44) is particularly good on this "dialogue of the deaf" (44) in which she sees a "genuine attempt on the part of the chorus to persuade Philoctetes, an attempt which Sophocles deliberately designed to fail, in order that we may see Philoctetes' refusal to go to Troy as a natural consequence of the brutal treatment he has received, rather than as merely petulant obstinacy. . . . The chorus seem to be engaged not so much in persuasion as in recrimination" (42).

[59]E.g., Knox 1964: 136 and Pohlenz 1954: 335. Opstelten (1952: 108–9), though he does not specifically cite this passage, seems to have it particularly in mind. Again, Nestle (1910: 155) seems to have set the pattern.

more complex than Plato suggests. We have already seen how central such an internalization of values is to Aeschylus' vision of democracy. The anthropologically oriented thinkers who explored the origin of ethics in the survival needs of the group also examined the subtle socialization process by which necessary values are internalized in members of the group. They recognized that without some internalization of ethical values no social intercourse is possible, that instead of relations based on persuasion there would be only deceit or brute force.[60] Thus, despite the clear admixture in the ethical assumptions of the *Philoktetes* of nonsophistic or even antisophistic elements, the dramatization of the break between Neoptolemos and Odysseus is in harmony with significant aspects of the sophistic analysis of the social compact. The emergence of fundamental agreement about ethical matters between Neoptolemos and Philoktetes is presented as an integral factor in the establishment of bonds of true friendship and sincere pity, which in turn are the prerequisites for the survival and joint action of these two men.

The break with Odysseus is followed by the reestablishing of bonds of pity and friendship, based on a concern for the best interest of one's friend, presupposing fundamental agreement about ethics and directed toward the salvation of both. Thus, just as there were two views of the presocial battle to survive—one successful with the bow, the other impossible without the bow—so there is a double dramatization of the process of establishing the social compact—one perverted by the intrusion of deceit, the other purged of suspicion caused by previous deceit. In this second version there is an important difference of opinion between friends on a matter that affects the survival of each. Thus this scene dramatizes the problem of the grounds of persuasion, which is presented as a fundamental need if human beings are to survive in a group.

Neoptolemos begins by expressing his desire to persuade through speech (1278) and to speak *pros kairon* (1278), which in the context of his retention of the bow retains an ambiguity: does it mean "seasonably" to Philoktetes' advantage or does it retain Neoptolemos' earlier expressed commitment to the intentions of the Atreidai? Philoktetes at

[60]Adkins's chapters (1970: chaps. 4 and 5) on the Presocratics and Sophists are disappointing on this topic, due in part, I suspect, to his ignorance or disregard of Havelock's work. Adkins does not even discuss anthropological speculation until he deals with the Epicureans and deals only superficially with a few of the ethical fragments of Democritos (1970: 101, 107, 110). Guthrie too is deficient on this topic for similar reasons: he is unduly hesitant to take Democritos seriously (*HGP* 2.489–91). On Democritos, see Vlastos 1945 and 1946. On the whole topic, see Havelock 1957: esp. chaps. 6–8. On the need for internalization of ethical values, particularly in a democracy, see Chapter 4 on fear (*to deinon, deos*) in the *Eumenides*.

first rejects persuasion on the grounds that Neoptolemos' previous deception precludes genuine friendship, that is, friendship based on sincere concern for the friend's best interest (*eunoun*, 1281).[61] But once Neoptolemos has returned the bow and restored to Philoktetes the means of minimal survival, spontaneous affection (*ō philtat' eipōn*, 1290) begins to return. Once this bond is reestablished, Neoptolemos sets about the task of serious persuasion (1315–96). He begins by setting forth quite abstractly the conditions under which human beings merit pity (*epoiktirein*, 1320), namely, when their sufferings are imposed and enduring them is inevitable (*anankaion*, 1317). Philoktetes, he argues, by refusing proffered social ties demonstrates the characteristics of a beast (*ēgriōsai*, 1321). Bestiality is further defined as a refusal to accept joint decision making by failing to distinguish friend from enemy. The whole argument recalls sophistic attempts to define what is peculiarly human as a basis for exploring the foundations of human social bonds.[62]

After Neoptolemos has raised these general preliminaries to persuasion, he catalogues a series of concrete advantages that will accrue to Philoktetes if he returns to Troy. These include cure for his malady and winning supreme renown as the sacker of Troy.[63] Philoktetes' agonized reply is first a wish that he were dead. The intensity with which he states his predicament suggests that he is by no means devoid of human susceptibility to the kindly intentioned (*eunous*) advice of a friend: "Ah me, what am I to do? How can I distrust speech/ Coming from this man, who has advised me with good will?" (1350–51).[64] With-

[61]The theses of Knox (1964: 119–20) that Odysseus' choice of *dolos* ("deceit") over *bia* ("force") or *peithō* ("persuasion") precludes the success of *peithō*, which might have worked if it had been tried first, is taken up by Schlesinger, who adds a suggestive analysis (1968: 103–5) of the embassy in *Il.* 9 as a parallel and a useful discussion of the ambiguity of persuasion in Gorgias (123). The thesis is attractive insofar as it casts light on the meanness of Odysseus' assumptions and reminds us of the very solid grounds for Philoktetes' distrust, but Schlesinger in particular tends to argue the matter as if the primary intention of Sophokles were to display his cleverness in writing a drama of intrigue.

[62]The gist of Neoptolemos' argument has some affinities with Protagoras' analysis of faults that merit pity and those that are punished (*Prot.* 323c8–324c1), the unusual character of which is well emphasized by Havelock (1957: 174) and Guthrie (*HGP* 3.67). For the beast analogy, see Democritos *D-K* B 57, 198, 278, and perhaps Antiphon *D-K* B 48.

[63]Machin (1981: 61–103) treats in great detail the dramatic mechanisms by which this information, which Neoptolemos seems to know now for the first time, emerges as just barely plausible from his lips in this context.

[64]Philoktetes' use of the virtual formula for climactic tragic helplessness at an impossible decision ("What should I do?" *ti drasō*, 1350, cf. Aeschylus *Ch.* 899) echoes Neoptolemos' earlier pained declarations of helplessness (908, 969, 974) and dramatically underlines the intensity of his dilemma. This strong expression of Philoktetes' openness to genuinely friendly persuasion is undervalued by those who present Philoktetes as impiously stubborn or psychologically damaged by his hatred of his enemies (e.g., Bowra 1965: 293; Ronnet 1969: 255–58, Winnington-Ingram 1980: 296–97). To be open to the persuasion of friends is the mark of a true aristocrat (see *Ajax* 330), but to refuse—in the

out denying the advantages cited by Neoptolemos, Philoktetes implies, through a series of passionate rhetorical questions, that the most elementary social intercourse (*prosēgoros*, 1352; *ksunonta*, 1356) is unthinkable with men who are not kindly intentioned, who have treated him as Odysseus and the Atreidai have. But he is not simply motivated by bitterness for past crimes; it is the strong probability, based on their previous and recent behavior, of equally unjust treatment in the future which seems to preclude social ties and joint action with such men (1359–61).[65] Philoktetes strikingly clinches his argument with what is in effect a sophistic argument from probability, but couched in language that fuses the metaphors of birth and education:[66] "For men whose judgment/ Becomes the mother of evils, it teaches the rest evils" (1360–61).[67]

Philoktetes now turns the tables on Neoptolemos. It is not to Neoptolemos' advantage to associate with such men, much less give them help (*epōphelōn*, 1371). Neoptolemos acknowledges the plausibility of Philoktetes' arguments but appeals simply for trust (*pisteusanta*, 1374) and reaffirms the bond of a friend (*philou . . . andros toude*, 1375).[68] Once more he declares his own belief that a return to Troy represents

face of the strongest inducements—to allow a criminal society to define one's role is the special characteristic of the Sophoklean hero; cf. Knox 1964: chaps. 1 and 2, esp. pages 8–9. K. Alt (1961: 169) has a good appreciation of Philoktetes' vulnerability to Neoptolemos here: if he gave in at this point, it would be only out of friendship, not from hope of a cure.

[65]At line 685 Jebb accepts Schultz's and Lachmann's *isos ōn isois*, for the reading of L, *isōs en isois*, and specifically denies that the text "implies that he dealt with *isoi* in one way and *adikoi* in another." Yet Philoktetes' argument at lines 1354–61 seems to imply precisely that familiar code; he cannot envision consorting with the Atreidai and Odysseus on the same terms as with Neoptolemos. Thus the reading of A rec, *isos en isois*, or Hermann's *isos en g' isois* (to correct the meter), only are not closer to L but more accurately describe Philoktetes' conception of fairness with a nice touch of dramatic irony: the chorus, like their political leaders, are not among the *isoi* and accordingly have no claim on Philoktetes.

[66]Cole (1967: 145–46) notes that the "the appeal to *eikos* [probability] was probably the most characteristic form of argumentation in the late fifth century, evident alike in drama, history, and oratory. . . . What evidence we have suggests that the appeal to *eikos* was much less popular in the fourth century." To be sure, the word *eikos* is not used by Philoktetes here (note its earlier use by him at 230 and 498 and by Neoptolemos at 361 and 1373, with Winnington-Ingram's comment 1980: 296), but the gesture of predicting future behavior on the basis of past action, especially when cast in terms of education, has a sophistic flavor to it.

[67]Retaining *kaka* of the manuscript where Jebb reads *kakous*.

[68]Lesky (1972: 245) remarks on the artistically fine irony that it is Neoptolemos' own previous lies that render Philoktetes' arguments against participating in the Greek army even more plausible. Schlesinger (1968: 133) goes even farther, suggesting that the details of the lie Neoptolemos tells Philoktetes, inasmuch as they recall Agamemnon's theft of Achilles' prize of honor and Odysseus' defeat of Ajax in the judgment of the arms, turn out to be a poetic image of the real relationship of Neoptolemos to the Atreidai and Odysseus.

the best interest of both Philoktetes and himself (1381). The issue of whose benefit (*ōpheloumenos*, MSS 1383; *ophelos*, 1384) sparks further debate and provokes from Neoptolemos a strikingly relativistic argument: the Atreidai, who have cast Philoktetes from society, will "save him back" into it (*palin sōsous'*, 1391).[69]

When agreement on this sort of salvation seems impossible, Neoptolemos declares that he sees no alternative but to leave Philoktetes in his present circumstances, which he describes as "living" (*zēn*), but living without the salvation of social supports (*aneu sōtērias*, 1396). Philoktetes now insists that Neoptolemos abide by his earlier dishonest promise to convey Philoktetes home. By his agreement now, however reluctant, the social compact of these two men is formally set in complete opposition to the third or contemporary stage of Greek society. It is this opposition that elicits the fullest mutuality in the bond between these two friends. When Neoptolemos asks how he will escape the attack of the Greeks, Philoktetes pledges his presence. Using a solemn polysyllable, a unique coinage that emphasizes the significance of the concept (Long 1968: 67), Neoptolemos asks "What act of helpfulness will you perform?" (*tina prosōphelēsin erkseis*, 1406). Philoktetes replies by pledging to hold off the Greeks with the arrows of Herakles. Thus the weapon Philoktetes had earlier defined in terms of mutual aid (662–70) is confirmed in that function as the final basis of their compact.[70]

In the foregoing discussion of the relations of Philoktetes to the chorus and to Neoptolemos, I have featured several dominant, related themes: spontaneous affection and pity, concern for the best interest of

[69]Democritos *D-K* B 172 and 173 are particularly suggestive of the peculiar delight in paradox characteristic of sophistic relativism.

[70]I cannot agree with those who, like Harsh, (1960: 408), Knox (1964: 139–40), K. Alt (1961: 172), and Segal (1981: 320), see Philoktetes' commitment here to defend his friend against the putative aggression of other Greeks as simply a misuse of the bow of Herakles. The bow has not been defined in this play in terms of civilizing service to Greece at large, but of special service of one friend to another. Nothing in Sophokles' play suggests that the destruction of Troy is inherently a service to the common good—indeed, the worth of the commonality as embodied in Odysseus and the Atreidai is much in question. Patriotic appeals are conspicuous by their absence here. This lack is particularly striking in view of the emphasis on patriotism in Euripides' version (Dio. Chrys. *Or.* 52.13, 59.1; *ponein huper thēs koinēs sōtērias kai nikēs*) presented at the outbreak of the war in 431 B.C. Since we are dealing with Euripides, however, there is a strong likelihood that these sentiments would emerge as heavily ironic if we had the whole play (see Webster 1967: 61). The date of Aeschylus' version is unknown, but it is hard to imagine an Aeschylean treatment of such a theme not being strongly patriotic. I do agree that the reference here to Herakles is one of several preparations for his later appearance; but his words consistently focus on the greater destiny awaiting Philoktetes and Neoptolemos. Troy is the proper arena for the exercise of Philoktetes' *aretē* and that in turn is seen as in accord with the slow-moving justice of Zeus; but the common good of Greece is not presented as a specific component of that justice but rather as the punishment of the guilty and the reward of the best (1425–26).

one's friends, the exploration of true persuasion, the process of arriving at agreement about ethical values. I believe that these themes, presented in constant juxtaposition to Philoktetes' isolated struggle to survive on Lemnos, constitute a dramatic exploration of the fundamental ties between human beings which reflects the anthropological speculations of the Sophists. Those speculations, as we noted, posit a presocial struggle to survive followed by a social-compact stage during which the achievement of human ties enables successful escape from the insecurity, isolation, and physical discomfort of the presocial stage.

Contemporary Society: The Sophist's Way to Survive

Though I have postponed full consideration of the many transformations by which Sophokles sets his own distinct ideological stamp on the sophistic matrix he employs in the *Philoktetes*, a few of the poet's changes are already obvious. We noted the decisive intrusion of the deceit from the contemporary sphere into the more naive and spontaneous interactions that characterize the bonds established between Philoktetes and Neoptolemos. Moreover, despite what I consider the dramatist's emphasis on the peculiarly sophistic bases of those ties, it is obvious that a bond between the two men against the whole world is radically different from the spirit of the older Sophists' view of a broad social compact based on common human needs. In Sophokles' version, the consolidation of the bond between Philoktetes and Neoptolemos before the entrance of Herakles seemed, as we noted, to imply irreconcilable alienation from Odysseus and more broadly from the Atreidai and the whole Greek army. Sophokles' sense of a gap and perhaps even of open hostility between, on the one hand, the social and ethical implications of the first two stages and, on the other, the contemporary world represented by Odysseus colors the entire dramatization of that contemporary world, giving it at times the air of a diatribe. Here in this isolated play, far more than in Aeschylean trilogy, tragedy seems to confront the audience directly with contradictions presented as irreconcilable (cf. Vernant and Vidal-Naquet 1988: 33; Segal 1981: 51).

We come then to the point at which most discussions of the sophistic influence on the *Philoktetes* begin and end, the character of Odysseus and the educational implications of the addition of Neoptolemos to the traditional myth.[71] As we noted earlier, the Sophists' interest in the

[71]E.g., Nestle 1910: 154–55, Weinstock 1937: 100, Pohlenz 1954: 334–35, Lesky 1939: 370–73, Bengl 1942: 144–46, and Craik 1980. Ronnet (1969: 259–62) is the only work I have seen that undertakes to refute the association of Odysseus with the Sophists.

presocial struggle to survive and in the bases for a social compact constituted a philosophical or pseudohistorical prop for their analysis and education in the technique of survival—of acquiring and exercising political power—in contemporary society, especially democratic Athens. Odysseus is unmistakably presented as a contemporary politician imbued with sophistic doctrines. He has distinctive ethical views and his own clear terminology of survival. In relation to Neoptolemos, he clearly enacts the role of teacher, and his difficulties in teaching are emphatically presented as a consequence of Neoptolemos' inherited nature, thus dramatizing a fundamental issue in the educational debate of the fifth century.

Odysseus' relation to Philoktetes, by which he functions in a large part as the spokesman of state authority, brings into sharp focus the sense of a potential conflict between the natural needs of the individual and the impositions of the community. This conflict, often loosely associated with all the Sophists under the tag *phusis/nomos* (nature vs. law or custom), probably became a central concern only toward the last quarter of the fifth century when its most radical implications were explored by the Sophist Antiphon.[72] Thus we should note that even what appears to be the strongly antisophistic opposition in Sophokles' play between the first two societal stages and the third stage probably has its

Ronnet's main arguments are Odysseus' lack of eloquence and brusque reliance on threats and force in his one sustained encounter with Philoktetes (974–1080) and even in his interactions with Neoptolemos. She speaks instead of Odysseus' "laconisme" (261). This argument ignores the strong Athenian associations of his allusion to Athena Polias (134), but her emphasis on his relative lack of (flowery) eloquence, his open disparagement of long speeches (1047–48), and his reliance on force and threats is valuable. It closely parallels the role of the Athenian spokesmen in the Melian dialogue, a passage in which, as far as I know, sophistic influence has never been doubted. In fact, Bowra (1965: 286) cites this passage as an illustration of Odysseus' character. Moreover, a distinction must be made between eloquence, reserved as in Sophokles' other plays for the hero, and effective manipulation of arguments. In this skill Odysseus is quite impressive, as Knox (1964: 125) emphasizes.

[72]Fuqua (1964: 55, 70, 215) maintains that this antithesis is the underlying organizational principle of the play. In the rather loose sense in which he uses the terms, I agree. He appears, however, unaware of the decisive role of anthropological speculation both in the formulation of the antitheses and in the structure of the play. In particular, despite a lengthy summary of the views of *phusis* set forth by Diller, Lesky, Heinimann, K. Alt, Muth, and others, there does not emerge from his argument a clear sense that the sophistic use of the term *phusis* grew directly out of an anthropological orientation that saw in the individual's basic physical and emotional needs a common core of fundamental similarity between all human beings and a link with other animals (see especially Antiphon D-K B 44). As the scholars cited by Fuqua have noted, Sophokles' uses of the term are strongly aristocratic in flavor, emphasizing the moral factors that establish a rigid social hierarchy. Sophokles' juxtaposition of the needs of this aristocratic *phusis* to the impositions of organized society thus involves a virtual subversion of the egalitarian thrust of sophistic/anthropological *phusis*. It is just possible that Sophokles contributed as much to the assumptions of a Kallikles (see Plato's *Gorgias*) as did any Sophist.

roots largely in the thought of more radical late fifth-century Sophists.[73] Odysseus' ethical views and terminology of survival are consistently juxtaposed to those of Philoktetes and gain much of their pejorative or ironic color from the implicit contrast to the grimness of the reality or necessity that conditions Philoktetes' struggle to survive.

The chief means by which Odysseus expects to achieve success he calls at the outset of the play his *sophisma* ("trick," "piece of cleverness," or "sophistry," 14, compare *sophisthēnai*, 77), which he himself redefines as "devising evils" (*tekhnasthai kaka*, 80).[74] Neoptolemos immediately echoes this description by alluding to Odysseus' plan as acting from an evil devise or plan (*ek tekhnēs prassein kakēs*, 87). This pejorative sense of *tekhnē* as a deceitful contrivance is as old as Homer, but it has already gained special irony in the prologue by the contrast to Philoktetes, whose rough wooden cup is described as a "devise of some crude craftsman" (*phlaurourgou tinos/ tekhnēmat' andros*, 35–36). Similarly, Odysseus' Homeric aspect as the "man of many devices" (*polumēkhanou andros*, 1135) is given a particularly negative force, not only by its association in the immediate context with shameful deceits (1136) but by the contrast to Philoktetes' more fundamental "contrivance" of the bare necessities of survival (*emēkhanōmēn*, 295).

Philoktetes' primary weapon in his physical struggle to survive is his bow. Odysseus' weapon in the battles of the contemporary world is his tongue:

> Son of a noble father, I too once, when young,
> Kept my tongue unemployed and my hand a hard worker.
> Now that I've come to the test, I see that
> The tongue, not action, has total sway over men.
>
> (96–99)

Certainly the commitment to speech as opposed to the violence of weapons was a cardinal element in the more benign, pro-democratic sociology of the older Sophists. But Sophokles' characterization of Odysseus' commitment to speech clearly implies not progress but degeneracy; it is constantly associated with trickery (*dolos*, 91, 101, 102, 107, 608, 948, 1112, 1117, 1228, 1282), deceit (*apatē*, 1136, 1128), and lying

[73]Moulton has argued persuasively for a closer relationship between Democritos' views of the potential conflicts between the individual and society and the views of Antiphon. He does conclude, however, that "Democritus was certainly more optimistic about *nomos*" (1974: 139). On the relative dates of the forms of the antithesis, see also Havelock 1957: 255–94 and Guthrie *HGP* 3: chap. 4.

[74]Craik 1980: 249–51 is a useful historical survey of the change in *soph-* words from positive to negative connotations.

(*pseudos*, 100, 108, 109, 842, 1342), not only in the view of others but often in Odysseus' own language.[75] Indeed, his first description of Neoptolemos' goal, "to steal Philoktetes' soul [*psukhēn*] by speaking with speeches" (54–55), is closely paralleled by Gorgias' triumphant allusion to "speech which has persuaded and deceived the soul" (*logos ho peisas kai tēn psukhēn apatēsas*) (D-K B 11 = Praise of Helen 8). Although this "sophistic" aspect of Odysseus is frequently noted, scholars often ignore the fact that this aspect is counterpointed in the play to a full celebration of the triumph of sincere *peithō* over both verbal deceit and physical violence in the bonds of mutual support established between Neoptolemos and Philoktetes. Thus here too Sophokles seems to have exploited a contrast between the humane enlightenment implicit in the anthropological speculations of the older Sophists and the ferocity he perceived in the contemporary application of sophistic doctrines.

Ferocity is not too strong a term for Odysseus' behavior, since perhaps Sophokles' most pointed contrast between the contemporary and presocial struggles for survival is in his handling of the hunting motif. Not only is hunting constantly associated with Philoktetes' isolated struggle, but we recall that his bow is personified as "discovering the things needed for his belly" (*gastri men ta sumphora/ tokson tod' ekhēuriske*, 288). Because Odysseus' weapon is his tongue, his "discoveries" are in fact nothing but the invention of ingenious lying arguments (*hoia k' aksaneuriskeis legein*, 991).[76] His values, goals, and achievements are characterized as "hunting," fundamentally the hunting of human beings. The metaphor is first introduced to show dramatically Neoptolemos' decision to accept Odysseus' assessment of the situation: "If that is the case, it would appear they are worth hunting for" (*thēratea*, 116). The verbal adjective is applied with heavy dramatic irony to the bow (*toksa*, 113) of Philoktetes, which Odysseus asserts is the only means by which Neoptolemos will be able to sack Troy.

It is not until the audience has been fully exposed to Philoktetes' literal hunting of birds and beasts with this same bow (165, 185, 288–90) that the hunting metaphor is applied directly to Odysseus' characteristic behavior as a hunter of human beings. The alleged ship captain describes how tricky (*dolios*) Odysseus seized the noble son of Priam, Helenos, and displayed him in the midst of all the Greeks, a "fine

[75]Podlecki, though he begins his article (1966b) with a line from Gorgias, fails to set his survey of the allusions to speech and persuasion in the *Philoktetes* within the context of the fifth-century sophistic explorations of those ideas.

[76]Note the *Hēttōn logos* (the inferior or worse argument) in Aristophanes' *Clouds* who boasts that he will gain victory over the *kreittōn logos* (the stronger or better argument) "by inventing bizarre arguments" (*gnōmas kainas ekseuriskōn*, 896). Forms of *heuriskō* are, not surprisingly, common throughout the *Clouds*.

catch" (*thēran kalēn*, 609). Neoptolemos' first effective turning away from Odysseus' views echoes ironically his own earlier use of the metaphor (116) as well as the passage just quoted. Despite the urging of the chorus, he perceives that the bow alone without the man is a futile "catch" (*thēran*) for them (839–40). But it is reserved for the man himself, Philoktetes, to articulate the bitter reversals of nature involved in Odysseus' theft of his bow: not only will he, the hunter of beasts, become the hunted of beasts (956–58), but he has been reduced to this subhuman state as a result of being hunted (*sunthērōmenai*, 1005; *ethēraso*, 1007) himself by a fellow human being who has used the unknown youth as his "hunting screen" (*problēma*, 1008; see Jebb, ad loc.).

Sophokles further displays the anthropological character of the parallel activities of Odysseus and Philoktetes by summing up the goals of each with forms of the term *sōtēria*. When Neoptolemos objects in the prologue to Odysseus' scheme on the grounds that it is shameful, Odysseus retorts that it is not if the lie achieves at least "being saved" (*to sōthēnai*, 109). Having won Neoptolemos to his position, Odysseus leaves the stage at the end of the prologue with a prayer that encapsulates his guiding principles in the contemporary battle for survival: "May tricky Hermes be our guide and leader/ And Victory, and Athena-of-the-polis, who always saves me" (133–34).[77] Odysseus defines himself in terms of deceit (*dolios*) and a commitment to victory (*Nikē*). For his safety he counts on Athena Polias, an epithet that implies broadly the supports of organized political life but also strongly suggests contemporary democratic Athens. This final phrase of Odysseus' credo (*hē sōizei m' aei*) is later echoed in Philoktetes' equally climactic summation of his triumph over the primitive forces of the environment by making fire (*ephēn' aphanton phōs, ho kai sōizei m' aei*, 297).

This sustained parallel between Odysseus' vocabulary for successful political manipulation and Philoktetes' description of his isolated struggle for minimal survival is one of the crucial factors unifying the intellectual matrix of the play. The inherent bitterness of the juxtaposition is made explicit again by Philoktetes. When he first realized the full import of the trick perpetrated against him, his outburst against Neoptolemos treats him as if he were Odysseus himself and strikingly combines the notions of fire, artifice, and deceit: "You fire! you total

[77]Calder declares: "The patron saint [Athena] was not to be contaminated by collaboration with oligarch [Odysseus]. Soph. *Phil.* 134 is a fourth century (?) interpolation, a doublet to 133, inserted by an ignorant chauvinist, possibly to agree with Euripides' version" (1971: 169 n. 94). Though Calder claims the authority of Fraenkel, he offers no account of the echo of the phrase *hē sōizei m' aei* by Philoktetes at 297 (*ho kai sōizei m' aei*). Calder moves in a familiar circle when he expunges a line that does not jibe with his peculiar reading of the politics of the play.

monster! you utterly hateful/ Contrivance of clever criminality! Look what you've done to me!/ How you've tricked me!" (927–29). Fire (*pur*), the symbol of his salvation through a literal technology of survival, is transformed here into the symbol of Philoktetes' destruction through the contrivance (*tekhnēma*, 36) of a liar. The word "monster" (*deima*) may further suggest the bestiality that characterizes the behavior of "advanced" society toward "wild" Philoktetes.[78]

The contrast between the values of Odysseus and Philoktetes is, however, most sharply focused in their respective relations to Neoptolemos. This aspect of this much-studied play has been dealt with especially fully, but we can set that exploration of sophistic educational theory within the broader framework of sophistic anthropology and sociology.[79] As we noted earlier, for the anthropologically oriented Sophists, their own activity as educators received philosophical validation in the fundamental role played by the learning process in the presocial battle to survive and by the educational process that inculcates the skills and ethical values essential for the preservation of the social compact. At the same time, their views and activities were deeply involved in the class conflicts of fifth-century Greece, particularly those of democratic Athens.

The relation of the Sophists to the class divisions of Athens is rather complex and explains in part the almost universally negative view preserved of their educational role: there was something about them to offend every class sooner or later. As we noted earlier, the general thrust of their anthropology was egalitarian, and most Sophists are associated with a pro-democratic perspective.[80] Indeed, as Havelock has shown (1957), the fragments of their texts are the best single source from which to attempt to reconstruct the contours of democratic ideology.[81] On the other hand, their large fees and foreign status precluded their serving the demos directly. Whatever their sentiments, they served the interests of those who had money, and accordingly they

[78]Jebb cites a parallel (Aristophanes *Lys.* 1014) for the use of *pur* where *thērion* (wild beast) would correspond to *deima* here. See also Euripides *Heracles Furens* 700, *deimata thērōn*, noted by Webster (1970, ad loc.).

[79]I find Erbse's 1966 article a most penetrating discussion, but he has nothing to say about the sophistic background.

[80]Kerferd (1981a: 18–19) rightly emphasizes the patronage of Perikles, whose name is clearly associated with Damon, Anaxagoras, Hippodamos, Zeno, Protagoras, Herodotus, and, of course, Sophokles. The choice of Protagoras in 444 B.C. to compose the constitution for Perikles' pet project of the panhellenic colony at Thourioi, presumably intended to be a showcase for democracy, is particularly revealing.

[81]A. H. M. Jones's otherwise excellent chapter "The Athenian Democracy and Its Critics" (1964: 41–72) makes good use of the "Great Speech" of Protagoras in reconstructing democratic ideology, but it generally ignores the Sophists.

seem to have been distrusted by the demos pretty early.[82] Within the monied classes, their readiest pupils would appear to come from the newly rich, who were in a hurry to achieve political power in the democratic assembly and lacked the traditions of public life that characterized the older aristocratic families.[83] To this bond with the newly rich we might reasonably attribute in part the tendency of several Sophists to downgrade or openly disparage inherited characteristics. We may reasonably attribute to the same cause the common hostility, first articulated by Pindar, of the born aristocrat to the activity of teaching and in particular teaching by Sophists. As I hope is clear by now, the qualities a Greek aristocrat claimed by birth were not primarily physical but moral and political, a point that is especially clear in the poetry of Pindar, whose genre invites emphasis on purely physical inherited superiority.

Still, the association of the Sophists with the non-aristocratic rich is sometimes exaggerated. Protagoras and Anaxagoras were closely associated with Perikles, whose lineage was second to none; and Plato's picture of the Sophists' clientele includes many scions of aristocratic families. The Sophists in fact seem to have been closely associated with what we might call the liberal wing of the ruling class, those who, regardless of their lineage, were open to employing the most up-to-date sentiments and methods—including professional education—to maintain or extend their power.

In the light of these divergent trends—on the one hand, sophistic education as a vehicle for the newly rich to achieve power and, on the other, sophistic education as an enlightened means of maintaining the status of the old ruling class—we should view Sophokles' second major innovation in the traditional plot of the Philoktetes myth, the inclusion of Neoptolemos. The emphasis on Neoptolemos' noble nature, inherited from his noble father Achilles—an emphasis no study of the play can ignore—is by no means incompatible with an important trend in sophistic educational theory.[84] On the contrary, the use of stories

[82]See Guthrie *HGP* 3: 37–39. Whether Protagoras' book was ever burned (*D.L.* 9.52 = *D.K.* A 1) or Anaxagoras was ever in serious danger (Plutarch *Per.* 32.2 = *D.K.* A 17) is much disputed (see Kerferd 1981a: 43, 21–23; Muir 1985). But it does seem a reasonable inference from Aristophanes' *Clouds* that the demos had no love for Sophists.

[83]See Adkins 1970: 94. Connor, however, makes an interesting case for the anti-intellectualism of many of the "new politicians" in the last quarter of the century (1971: 163–68). As our own era has taught us, anti-intellectualism is not at all incompatible with the use of intellectuals to help manipulate public opinion.

[84]Here I am most at odds with Diller (1936: 245–46) and Lesky (1939: 370–73). Although there is no explicit modification of his earlier view in a later edition of *Dichtung* (1972: 246), Lesky was far more definite in the earlier edition, which was translated into English (1965): as his final comment on the *Philoktetes* he cited Pindar *Ol.* 9.100 and concluded that "this world of thought is a complete contrast to that of the sophists and of

about the offspring of famous noble heroes to illustrate educational doctrines seems a particular feature of sophistic teaching. Rather than attacking the pretensions of the aristocrats, they chose to set them in a new context that stressed the need for the noble *phusis* to be supplemented by *paideia*.

We know that the Sophist Hippias wrote a dialogue in which Nestor lays down the proper pursuits by which young Neoptolemos may show himself a "good [ruling-class] man" (*agathos anēr*, D-K 86 A 2.4). Prodicus' educational myth of Herakles' choice is especially suggestive of Sophokles' treatment of Neoptolemos.[85] Baseness or Evil (*Kakia*) addresses Herakles first with words that perfectly sum up the dramatic interest of Neoptolemos in Sophokles' play: "I see, Herakles, that you are at a loss [*aporounta*] what path to turn to for your life." She then offers him the pleasantest (*hēdistēn*) and easiest path (D-K 84 B 2.23). Excellence or Goodness (*Aretē*) begins her subsequent appeal to Herakles by an emphatic allusion to his high ancestry and early upbringing: "I too have come to you, Herakles, knowing your parentage [*tous gennēsantas se*] and having observed the nature [*phusin*] that is yours through your education [*en tēi paideiai*]. On these grounds, I have hope . . ." (D-K 84 B 2.27). Prodicus implies no sharp Pindaric antithesis of education and inherited qualities (*Ol.* 9.100; *Ne.* 3.41).[86] He grants and builds on the idea that noble parentage augurs well. But, true to his profession, he attributes the actual *phusis* of Herakles to his early education. This combination of high birth and the proper early rearing will, given the appropriate encouragement in early manhood by the right mature voice, achieve greatness. At the same time, the specific point of the myth is to emphasize the threat to the noble nature of the youth which is ready at hand in the appeals to short-term pleasures.

Those who see in Neoptolemos' final rejection of Odysseus a simple, old-fashioned affirmation of aristocratic *phusis* and an equally simple repudiation of sophistic educational theory ignore the structure and

Socrates" (126). Bengl (1942: 142) cites and echoes much the same view from an even earlier edition of Lesky.

[85]Ronnet goes out of her way to denounce a "Manichean" view of the play presenting "the two protagonists as Goodness and Evil between whom the young man hesitates" (1969: 258–59). Sophokles is, to be sure, subtler than Prodicus, whose young Herakles is offered a choice between discourses presented by the allegorical figures Kakia and Aretē (D-K 84 B 1 and 2). Yet the absolutism of the antithesis and of Sophokles' own moral judgment is parallel, as is the explicitly educational focus of Sophokles' version of the myth.

[86]To be sure, Pindar has kind words for the teaching of athletic trainers (e.g., *Ol.* 8. 54–61) and was perfectly aware that talent needed hard work and guidance. But this only makes his attack on "learned *aretai*" the more clearly ideological; he seems to imply that only those with the right ancestry can achieve authentic success—the rest is "mere" learning.

dramatic development of the myth. Neoptolemos is on stage with Od-
ysseus for a mere 134 lines, and in fact it takes only some 80 lines for
Odysseus to lay out his plan and overcome Neoptolemos' objections by
offering something *hēdu* (lit. "sweet," 81). After this brief "education"
by Odysseus, Neoptolemos, despite Philoktetes' compliments to his
parentage and early rearing (242–43), despite his outpouring of af-
fection and truly pitiful circumstances, displays consummate skill as
a liar and hypocrite. He is on stage with Philoktetes an extraordinary
amount of dramatic time, more than 1,000 lines, before he is fully won
over to Philoktetes' side.

The painfully slow process by which he moves from his initial callous
readiness to use brute force (90)—a revealing indication of the content,
so to speak, of his untutored *phusis*—to a surrender of all the ambitions
inevitable in such a youth is a primary dramatic interest of the play.
There is nothing automatic or inevitable about the emergence of his
good *phusis*.[87] His rejection of the chorus's invitation to steal the bow
and leave the man does force him to reveal the truth to Philoktetes;
but, as we have seen, he still insists on following Odysseus' orders and
insists on a basic harmony of his own narrow self-interest and what is
right (926). When pity makes him waver, the mere appearance of his
first mentor, Odysseus, seems adequate to suppress all but the most
hesitant gesture of sympathy (1074–80).[88] Neoptolemos' return with
the bow is definitely a calculated dramatic surprise, and even then he
attempts persuasion *before* actually returning the bow (D. Robinson
1969: 45–51). Despite all the particularly Sophoklean emphasis on
Neoptolemos' inherited nature, Sophokles has controlled the action in
such a way as to dramatize the educational dictum of Antiphon: "One
must necessarily become, with respect to character [*tous tropous*], of the
same sort as the person with whom one spends the greatest part of the
day" (*D-K* 87 B 62).[89] Sophokles in the *Philoktetes* is far nearer to Plato's

[87]Emphasized by Knox (1964: 122–23). Erbse (1966: 187) remarks that what Neop-
tolemos calls his *phusis* in the prologue is nothing more than a claim (*Anspruch*) which for
a considerable part of the play he lacks the courage to validate. This seems an improve-
ment over Diller's declaration that the real theme of the play is "the imperviousness of
nature to external influences" (1936: 245). But the inadequacy even of Erbse's formu-
lation is that it too accepts at face value the poet's verbal insistence on the emergence of
Neoptolemos' noble *phusis* as if it were a fixed, unalterable entity while ignoring the full
dramatization of a fundamentally different and richer content imparted to that *phusis* by
good education—not to mention its vulnerability to bad education.

[88]Taplin (1971: 35) nicely emphasizes the visual presentation of Neoptolemos' vulner-
ability to Odysseus' influence, who stops him in the very act of returning the bow and
reduces him to silence for almost the whole rest of the scene.

[89]See also Democritos' emphasis on education by imitation and association (*D-K* B 154,
39, 79, 184) and Protagoras' similar focus on the consequences of association (Plato, *Prot.*
316c5–d3). Concern for the "right" company was, as Guthrie (*HGP* 3.250–51) stresses,

sense (particularly in the *Republic*) of profound anxiety for the fate of the well-born in the corrupting environment than to Pindar's confident affirmation that "thanks to birth the noble temper shines forth in sons from their fathers" (*Py.* 8.44–45). Like Plato and the Sophists, Sophokles dramatizes the absolute necessity of such a nature meeting with the right education.

But uniquely in Sophokles' play the conflict of the values between which the pupil, Neoptolemos, must choose is explored within the framework of learning to survive in three stages of the development of human society. Philoktetes has had to learn to acquiesce in sufferings imposed by necessity during his long struggle to eke out bare survival in isolation (538). In order to be saved out of that isolated struggle into a civilized human compact, both Philoktetes and Neoptolemos must, as we have seen, establish bonds based on pity, affection, and a sincere concern for each others' best interest. At this stage too they must agree on definitions of "daring," "noble," "right," "shameful," and "holy." The content, so to speak, of the good *phusis* which has been tested and educated in terms of this anthropological vision of reality emerges as more complex than could be inferred from Neoptolemos' initial commitment to truth, success, and violence.

The education Odysseus attempts to give Neoptolemos on survival in the contemporary world at times echoes these same terms, but in a strikingly different sense, and at times it directly repudiates them. Pity and affection are not in Odysseus' vocabulary. He occasionally takes a paternal tone, addressing Neoptolemos as son (*pai, teknon*), but words in *phil-* (i.e., "love," "dear") come not from his lips.[90] We have no reason, given Odysseus' past and present treatment of Philoktetes, to believe that Neoptolemos is mistaken in assuming pity to be grounds for reproach from Odysseus (1074–75). Odysseus does attempt unsuccessfully to define the term "noble" (*gennaion*, 51) in a self-consciously new (*kainon*, 52) sense, but soon he frankly acknowledges that the inherited *phusis* (79–80) of Neoptolemos is an obstacle. Later he expresses a fear that this very nobility (*gennaios per ōn*, 1068) may ruin everything. The situation with "daring" is a bit more complex because the idea itself is ambiguous and, depending on context, can imply heroic courage or behavior that flies in the face of public opinion. Odysseus urges Neoptolemos to be daring (*tolma*, 82) in the pursuit of victory (81), which

also an aristocratic idea; but Guthrie underestimates the special emphasis of the Sophists on the decisive role of socialization in determining character.

[90]Avery (1965: 285) counts two instances: *teknon* at 130 and *pai* from Neoptolemos' lie at 372. He omits *pai* at 79, an emendation, and those where the addition of a reference to his father (50, 96) tempers the potentially affectionate tone. In contrast, Avery finds 52 instances of the paternal address from Philoktetes.

sounds a bit heroic, but the action is soon frankly described as shameless (*anaides*, 83, cf. Kirkwood 1958: 234–35 n. 23). Odysseus equivocates about the term for "right" (*dikaios*) behavior, now claiming it irrelevant for the present (82), later amplifying this relativism by the assertion that when circumstances require it he can be as devoted to right behavior as anyone (1049–51). But at one point, where the tone of his sophistry approaches broad comedy, he attempts a definition of "right" that would guarantee him the fruits of a theft on the grounds that he had planned it (1246–47).[91] Holiness (*eusebeia*) he first presents a virtually synonymous with *dikaios* and, like that value, irrelevant in the present but available when the circumstances require (85, cf. 1051). The chorus, speaking of the arms of Achilles which the Atreidai allegedly gave Odysseus improperly, describe them as an "object of religious awe" (*sebas*, 402) for Odysseus. This suggests a pointed contrast to the religious awe (656–62) that both Neoptolemos and Philoktetes express in relation to the bow of Herakles, there explicitly defined in terms of helping friends (*euergetōn*, 370). Odysseus later claims with great solemnity that his behavior is the will of Zeus (989–90) and attempts to prevent Neoptolemos from returning the bow by calling the gods to witness (1293). Finally, when it comes to what is shameful, Odysseus is only mildly equivocal. In pointed contrast to Philoktetes, who asks Neoptolemos to endure less than one whole day of physical distress in return for the greatest prize of glory (*pleiston eukleias geras*) of saving a fellow human being (478–80), Odysseus asserts that if Neoptolemos gives himself over to Odysseus shamefully (*eis anaides*) for the short space of a day he will in the future have the reputation of being the most pious of all mortals (83–85). But generally Odysseus characterizes himself and is characterized by others as completely indifferent to the shame ethic, precisely the terms on which the Athenians at Melos most sharply differentiate themselves from their traditionalist opponents.

The terms in which Odysseus first expresses that indifference strongly state what is also the primary basis on which his values and his behavior have been defended.[92] He urges Neoptolemos, when he

[91] Lesky, without explicitly saying that the scene is comic, notes (1972: 244) the similarity to Old Comedy. Taplin (1971: 36–37) goes farther and argues, rightly I believe, that both this scene and Odysseus' final exit are so close to the style of brief defeats of villains in Old Comedy that they dramatically confirm the impression of his baseness. As suggested earlier, however, these comic elements focused on the "low" character Odysseus do not justify Craik's attempt to treat the whole play as "a tragedy of less than complete seriousness" (1980: 247).

[92] This is most fully defended in Ronnet 1969: 259–62, as noted earlier. See also Norwood 1948: 162: "It is easy but mistaken to label Odysseus the 'villain.' In reality he is the State personified." Yes, he is; but it is precisely in that role that he emerges as a villain. Muth's attempt to defend Odysseus on religious grounds (1960: 652–56) is even less

meets Philoktetes, to say of Odysseus the worst possible insults. With true sophistic bravado he casts the issue in terms of a hedonistic calculus (*alguneis* vs. *lupēn*): "You will hurt me not at all by this. But if you do/ Not do this, you will impose pain on all the Argives" (66–67). The chorus, in its lyric dialogue with Philoktetes when he has been stripped of his bow and abandoned, defends Odysseus in just these terms, namely, his service to the group as a whole (*koinan*). But here alone Odysseus' relation to the group echoes the theme of social bonds based on a tie of *philia* (cf. *philous* 1143): "That man, one from many—/ Ordered by their behest—/ Achieved general rescue for his friends" (1143–45). If we were able to ignore the context and take their view at face value, then the sense of a deep conflict between the social bonds that will save Philoktetes and the social bonds governing the contemporary world of the Greek army at Troy would be, as many readers have argued, merely an illusion of the psychologically disturbed Philoktetes, who must then be seen as the truly bad teacher.

Odysseus, true to the reasoning of most of the anthropological thinkers, does assume a complete harmony between his own best interest and the best interest of the community as a whole. But to stress this attitude as a basis for arguing that Odysseus is dramatically justified by the whole of the play is to ignore the thrust of the whole play. The myth of the play, even if it were free of innovations, confronts us with and initially negative image of the society in whose interest Odysseus claims to act; at the same time, Sophokles takes pains to dramatize through his characterization of Odysseus the underlying selfish individualism, hypocrisy, and brutality of that society.

Sophokles normally presents Odysseus' conception of success, not in terms of the anthropological standards of what is useful, helpful, or advantageous, but in the strongly pejorative terms of commercial profit and a markedly unheroic victory. Segal (1981: 304) points to the specifically aristocratic bias of this characterization, which, as we have seen, is as old as the *Odyssey*. Odysseus uses the term for "advantageous" only once and in a context that has distinct dramatic irony when contrasted to Philoktetes' struggle to find what is advantageous to his belly (287–88) or his generous commitment to whatever brings advantage to his friend (659). Odysseus, having won Neoptolemos to his scheme, tells him that in the event of a delay he will send someone who "having practiced deception with respect his clothing" (*morphēn dolōsas*, 128–29) will look like a captain and speak craftily (130). Neoptolemos should "constantly take up whatever is advantageous in his words" (*dekhou ta sumpheronta tōn aei logōn*, 131).

satisfactory. Even Bowra (1965: 287), whom Muth otherwise follows closely, recognizes the play's implicit indictment of Odysseus' self-serving egoism.

Apart from this calculation in trickery and lying, Odysseus' materialism has a less anthropological flavor. He tells Neoptolemos that victory is a sweet possession (81); when his attempt to argue against ethical compunctions seems to fail, he cites profit (*kerdos*) as the consideration that should override hesitation (111). Philoktetes describes the island on which Odysseus marooned him as a place where no merchant can find a business profit (*eksempolēsei kerdos*, 303). It is as a groveling merchant that Odysseus' representative soon appears, and his devious manner inspires in Philoktetes an all too legitimate fear that he is being "sold in speech" by this merchant (579). The instant Philoktetes recognizes Odysseus, he exclaims "I've been bought and sold!" (978). That this view of Odysseus' behavior is not merely Philoktetes' illusion is strongly suggested by the cruel sarcasm with which Odysseus releases Philoktetes to die alone on Lemnos without his bow:

> But victory is my natural need in every case—
> Except yours. Now to you I shall willingly yield place.
> Release him! Keep your hands off him from now on!
> Let him stay. We don't even need you any more,
> Inasmuch as we have this bow. For there is
> Teucer among us with this particular skill
> And I, who consider myself not a bit your inferior
> At wielding this bow or at aiming it straight.
> Yes! What need is there of you? Walk about Lemnos and good luck!
> We must be on our way. And perhaps your heroic prize
> May award to me the honor that ought to have been yours.
>
> (1052–62)

One may debate whether this is a further deception aimed at persuading Philoktetes to come to Troy or a blunt statement of Odysseus' spur-of-the-moment decision to exploit for his own advantage (cf. 1069) Philoktetes' intransigence.[93] But the narrowly selfish cruelty of his line of reasoning is indisputable. Nothing Odysseus does or says elsewhere in the play contradicts the impression that this speech accurately represents his characteristic way of thinking. Yet Odysseus', and to a lesser degree the chorus's, calculations and values constitute the only evidence we have in the play for those that predominate in the society of the Greek army as a whole. Odysseus' reasoning here is the ugly obverse of the sophistic thought that views society as founded on mutual

[93]Lesky (1972: 243–44) says cautiously that the poet gives us no clear answer to this question. Linforth argues (1956: 135–56) emphatically that Odysseus must be only bluffing here; so too Kitto 1956: 124, Hinds 1967: 177, and Calder 1971: 161. Contra, T. Wilamowitz-Moellendorff 1969 [1917]: 304–7, Bowra 1965: 286–87, Knox 1964: 134, and D. Robinson 1969: 45–51, which I find particularly persuasive.

human need. We have stressed Sophokles' dramatization of the humane consequences in the bonds of pity and affection established between Philoktetes and Neoptolemos. Here we see a callous calculation of what is *not* needed (*oude sou proskhrēizomen*, 1055; *ti dēta sou dei?* 1060). Philoktetes becomes society's first throw-away person; Odysseus is the man who undertakes here, as he had ten years before, to handle the disposal operations and to glory in the personal profit he will gain from it; for victory is all he "needs" (*khrēizōn*, 1052).

A more obvious aspect of Sophokles' dramatic emphasis on the hypocrisy of Odysseus' claim to work only for the public good is the ironic contrast between Odysseus' and Philoktetes' respective relationship to necessity. Philoktetes, as we have seen, knows the necessity of his day-to-day struggle to survive the threats of the elements (538) and to endure the physical pain imposed on him by circumstances (1317). But in relation to human beings he displays an iron commitment to personal freedom which is proof against bribery, force, the threat of death, or even the sincere appeal of a friend. The social bonds he adheres to involve freely volunteered service to his friends, Herakles (670) and Neoptolemos (1404–5). His participation in the Trojan expedition is pointedly presented as this same sort of freely volunteered service (1027). Odysseus, in sharp contrast, himself acknowledges that he participated in the expedition out of necessity (*eks anankēs*, 73), and Philoktetes reminds the audience that in fact Odysseus had to be tricked as well as forced to participate (1025). This is the man who repeatedly describes himself as a mere servant following orders.

The society of the Greek army as a whole is characterized almost exclusively as an entity that gives orders. The first of these we hear of in the play is the callous order to maroon Philoktetes (6). This same society requires that Neoptolemos serve the orders of Odysseus (*hypēretēs*, 53, cf. 93–94). Nowhere does Odysseus associate, as most of the anthropologists do, this obligation to subordination with the idea of compensating long-term advantages in a civilized polity. Those advantages are an important theme in the play; but only the chorus, Neoptolemos, and Herakles are permitted to articulate them in contexts in which they are explicitly hostile to or override the political dominance of Odysseus and the Atreidai. Thus Sophokles seems perhaps in the very choice of his myth and certainly in his development of it to echo the most pessimistic of the Sophists, Antiphon and perhaps Thrasymachos.[94]. The

[94]See Havelock 1957: 23–29 on Thrasymachos and 1957: chap. 10 on Antiphon. See also Moulton 1974 on the shift toward pessimism. Guthrie (*HGP* 3: esp. 91–92) makes an interesting case for a more sympathetic view of Thrasymachos as parodied in the *Republic*. Kerferd (1981a: 122) makes the more traditional association with Kallikles; Contra see Furley (83) in Kerferd 1981b.

state, through a crass calculation of its own needs, which seem synonymous with the convenience of its rulers, imposes horrible suffering on a citizen who is not merely guiltless (676–86) but ready to contribute generously to a common effort (1027). It exacerbates rather than relieves his physical pain; and when the occasion arises which requires a reversal of his exclusion from society, the state is ready to give orders (1144) that violate his self-respect by deceit and force. Like Zeus in the *Prometheus*, the state is cast in the image of a brutal tyrant, hostile to all the advantages of human society which are symbolized in the hero (Pohlenz 1954: 330, 332).

It is possible to surmise an evolutionary solution of the apparently irreconcilable conflict in the *Prometheus;* but, as we have seen, Sophokles seems to treat his myth in a way that evokes anthropological speculation about the development of human society but precludes a positive view of the third or contemporary state of that process. The fascination, frustration, and much of the tragic pathos of this play thus depend on Sophokles' paradoxical exploitation of sophistic anthropological speculation. His dramatization of Philoktetes' grim, isolated struggle to survive the threats of beasts and harsh elements poses most absolutely, almost "scientifically," the need of human beings for society; yet the only society available is characterized as subhuman.

The Way Out: The Supersession of the Sophists

If there is any real resolution of the dilemma posed by this play, and many sensitive modern readers see none, we may approach it by summarizing Sophokles' debts to the Sophists and his departures from them.[95] Sophokles' response to the Sophists, though not as thorough or explicit as Plato's, moves along lines we see Plato exhausting in the next chapter. Sophokles exploits, as we have seen, the sophistic analysis of the origin and development of society in such a way as to imply a strong condemnation of the Sophist in contemporary society. Although the main thrust of sophistic anthropology was egalitarian, we have seen evidence that some Sophists were willing to equivocate about aristocratic birth in their attempt to demonstrate that even the

[95]Linforth's whole study of the play (1956: esp. 95–97) has the primary aim of demonstrating that Sophokles did not and could not accept the traditional ending of the myth, the return of Philoktetes to Troy, as true to the logic of the rest of the myth. The ending we have then is a more or less cynical bow to tradition; T. Wilamowitz-Moellendorff (1969: 311) and Ronnet (1969: 274) agree. Whitman (1951: 187–88) offers the most impressive defense of the ending. See also Pratt 1949: esp. 286–87, Kirkwood 1958: 39, and Winnington-Ingram 1980: 297–303.

well-born needed professional education. Sophokles exploits this equivocation to offer a militant affirmation of inherited excellence. Similarly, he exploits the sophistic analysis of ethical values along lines that culminate in aristocratic absolutism for which metaphysical, that is, divine, validation is claimed.

Sophokles' major transformations of the presocial struggle for survival consist of this downgrading the heavily intellectual emphasis of the Sophists and stressing the extraordinary aristocratic superiority of Philoktetes. Thus, despite the relative obscurity of Philoktetes' family in the broad spectrum of Greek heroes, Philoktetes is described almost at the outset of the play as "perhaps second to none in his noble origins" (180–81). Similarly, though we have noted the careful use of the technological vocabulary (*tekhnēma, mēkhanaomai, ekseuriskō, pur*) to give Philoktetes' struggle an anthropological coloring, Sophokles does not celebrate primarily the intellectual ingeniousness of his hero but his unique courage, which sets him above his enemies.[96] Thus, when Philoktetes thinks he is about to leave, he is anxious that his young friend look at his cave home to learn (*mathēs*) how he manifested his uniquely courageous *nature* (*hōs . . . ephun eukardios*) and in particular his qualities of daring and endurance (*tlēnai*); he has learned day-to-day acquiescence in sufferings that no one else could even stand to look at (533–38).

The aristocratic slant Sophokles gives to his exploration of the social compact stage is even more striking. Although the chorus, representing in this context the ordinary mass of human beings, are open to spontaneous feelings of pity, they are incapable of acting independently, caught in playing out the lies concocted by their superiors, and in the final analysis committed only to time-serving. It is only Neoptolemos, "son of the best of the Greeks" (3), possessed of "primeval god-sanctioned royal power" (138–41), who is able at last to validate the implications of his inherited nature by responding to pity and affection sufficiently to make the ultimate commitment to his friend's interest. The linguistic emphasis throughout the play on such aristocratic ethical terminology as *gennaios, eugenēs*, and *phuō/phusis* in the

[96]Letters (1953: 273–74) dourly speaks of Philoktetes as "not just a skill-less Robinson Crusoe, though he has spent so many years without any recorded improvements in his savage economy." Then, more blatantly ignoring the strong emphasis in the play on the struggle to survive, he concludes: "The introvert of Sophokles' play finds occupation enough in brooding over his wrongs." Sophokles in fact has a special problem in his chosen material: he must sharply differentiate his hero's arts of survival from those of the mythic figure who is most traditionally associated with *sophia*. Indeed, Vlastos (1946: 61) speaks of Democritos' concept of *sophia* as "Ulysses-like resourcefulness." I believe that there is a similar factor at work in the exclusion of allusions to primitive gardening or food gathering: for all his wretchedness, Philoktetes must remain the aristocratic hunter, sharply distinguished from any form of activity that smacks of the peasant.

context of pervasive allusions to paternity tends to mask the sophistic core with a Pindaric overlay.[97] For, as we have noted, the content of the ethical choices Philoktetes imposes on Neoptolemos owes more to the Sophists than to Homer or Pindar; and the dramatization of the impact of Philoktetes' experience and character on Neoptolemos owes much to sophistic theorizing about educational companionship (*sunousia*). Yet the bond established between Neoptolemos and Philoktetes is neither explicitly educational nor explicitly a social compact; it is rigorously cast in the mold of traditional heroic, aristocratic male bonding in which the older man is inevitably cast in the role of a father figure and thus a natural educator by example. Tacitly parallel to the more explicitly erotic friendship of Achilles and Patroklos (434), it is more immediately modeled on the friendship of Herakles and Philoktetes (670, 1436–37).[98] Sophokles thus seems at pains to imply that the natural consequence of this interaction of two heroic friends is the confirmation of an excellence of character in Neoptolemos that is already his by birth. Neoptolemos' shockingly hypocritical and manipulative behavior is repeatedly presented as an intrusion from the contemporary world; he is the victim of bad education (971, 1014–15) by Odysseus, who, as we have seen, is explicitly characterized as a Sophist.

Generally, bad education and low birth are presented as the chief faults of the third or contemporary level of society. Bad education by the leaders is offered as an explanation for all the city's and the entire army's misconduct (384–85), and the subservience of the chorus to their leaders confirms the fact that this indictment is not merely a lie concocted by Neoptolemos for the immediate situation. The inhumane and manipulative conduct of Odysseus is associated not only with his sophistry (14, 77, cf. 431, 1015, 1244) but repeatedly with his low birth from Sisyphos (384, 417, 1311). Finally, Sophokles ignores a minor detail of the mythic tradition in order to associate Odysseus with the virtual paradigmatic figure of low birth, Thersites (Gellie 1972: 291–92; contra Huxley 1967: 6).

[97]*gennaios:* 51, 475, 799, 801, 1068, 1462; *eugenēs:* 336, 604, 874; *phuō:* 79, 88, 326, 558, 910, 1052, 1074, 1244, 1372; *ekphuō:* 89, 996; *phusis:* 79, 874, 902, 1310; *patēr:* 3, 96, 242, 260, 347, 434, 362, 453, 468, 490, 625, 996, 1284, 1311, 1314, 1365, 1371, 1430; Achilles: 4, 50, 57, 62, 260, 328, 331, 364, 542, 582, 940, 1066, 1220, 1237, 1312, 1443; Poias: 5, 263, 318, 329, 461, 1230, 1261, 1410, 1430; Sisyphos: 384 (by implication), 417, 1311. Not every instance in a Greek tragedy of address to a character by reference to his paternity must be seen as implying a belief in inherited excellence. In this play, however, where the theme is so explicit, I believe that the cumulative impact of these allusions is quite striking.

[98]Calder (1971: 169 n. 88) reviews with savage skepticism the attempts of "refined critics" to find an "erotic" dimension to the play. It takes, I think, something quite different from refinement to deny the general homoerotic pattern of Greek aristocratic culture, though to be sure the reference in the *Philoktetes* is quite indirect.

Sophokles' solution of the conflict between the implications, on the one hand, of the first and second stage of his anthropology and, on the other, of those of the third stage lies in the radically hierarchical perspective he has built into the analysis of society and develops through his control of the dramatic action. By the end of that action he has claimed, with a religiously archaizing self-consciousness nearer Plato than Homer, the absolute validation of this social and political hierarchy in the will of Zeus.

The low point of pessimism in the play occurs in a digression of some fifty lines (410–55) on the effects of war, a passage that has long been recognized as vividly contemporary in its impact. Achilles is dead, Ajax is dead, Antilochos is dead and his father Nestor has lost his position as the respected adviser. Patroklos too is dead. But Diomedes, Odysseus, the Atreidai, and Thersites flourish. The obvious human lesson (*ekdidaksō*) from these facts is stated first by Neoptolemos: "In a brief saying / I'll draw the lesson: of its own will War / Seizes no worthless man, but takes the good always" (435–37). The bitter, despairing implication for the governance of the universe is in turn stated by Philoktetes:

> Nothing bad has ever perished.
> Rather, the gods carefully bundle them up to shield them
> And somehow take delight in turning back from Hades
> The jaded, criminal elements; while the right-acting,
> The decent sort, they dispatch there constantly.
> What reckoning must I make of this? How shall I praise, when
> In setting praise on divinity, I find the gods bad?
>
> (446–52)

And as if the point was not clear and sweeping enough, Neoptolemos sums up the case for despair in a neat, redundant Gorgianic truism: "Where the worse over better rules in might / The worthy all perish and the trickster's[99] right" (456–57).

Commentators and critics occasionally cite the contemporary evidence that would justify so bitter a view of the effect of a long war.[100] Some (e.g., Calder 1971) see this speech as merely a further instance of Neoptolemos' deceit. What is rarely pointed out is how fully these sentiments correspond to Odysseus' analysis of present realities:

> Son of a noble father, I too once, when young,
> Kept my tongue unemployed and my hand a hard worker.

[99]I retain the *deinos* of the manuscripts where Jebb reads *deilos*.

[100]See Jebb of 435; Webster 1970 on 436; Bowra 1965: 277, 286. M. H. Jameson's 1956 article contains a wealth of contemporary data, but it also suggests some contemporary grounds for the relative optimism of the ending.

Now that I've come to the test, I see that
The tongue, not action, has total sway over men.

(96–99)

All three major characters look at the reality of the war and conclude
that moral values and courage in action count for nothing in the strug-
gle for survival and success. Both Odysseus—with his commitment to
verbal manipulation and his guardian gods, Tricky Hermes and Political
Athena—and Philoktetes—with his direct experience of gross injustice
apparently triumphant—infer that the gods uphold such an analysis.
But it is the full exploration of Philoktetes' own successful battle to
overcome the worst assaults of a corrupt contemporary society, and fi-
nally, his capacity to inspire the emergence of the highest social virtues
in the promising noble pupil which lay the emotional and intellectual
foundations for the tremendous, utopian affirmation of aristocratic
human worth—an affirmation that sweeps away the pettiness and vi-
ciousness of Odysseus in the epiphany of an apotheosized Herakles.[101]

Philoktetes himself has come to recognize the invasion of a reality
overriding the shortsighted calculations of the Atreidai. Though he re-
jects bitterly what he perceives as Odysseus' cynical exploitation of re-
ligion for gross ends (991–92) (see Spira 1960: 22), he is soon moved
from his despair to perceive an implicit divine concern for right in the
"divine goad" that has prodded Odysseus to come for the crippled,
foul-smelling man who had interfered with their rituals (1031–39). It is
the quasi-scientific, existential demonstration of Philoktetes' absolute
superiority in circumstances in which he is stripped of every social and
religious support that endow this divine validation with the aura of
something more solid than pious wish fulfillment. By the end of the
play, it is dramatically credible that Philoktetes is needed by the Greek
army, not just through some quirk of fate or, as Odysseus seems to
think, by virtue of the fact that he happens to possess a magic weapon.
Philoktetes is dramatically represented as the best human being left
alive, and the bow of Herakles is not the cause of his superiority but the
clearest external symbol of it.[102] Similarly, Philoktetes' wound is the
clearest symbol of his need for society, of the intolerable pain of isola-
tion from the positive virtues of communal life.

[101]I had hoped to pass over in well-deserved silence the absurd thesis of Errandonea
(1956) that the appearance of Herakles represents the final ploy of a disguised Odysseus;
but alas a later discussion of the play, Shucard's (1974), informs us: "Errandonea . . . bril-
liantly shows that Herakles is actually Odysseus" (135 n. 20). I do not know how one
would set about refuting so inherently preposterous a view; I only record here that I am
aware of it and do not see any merit in it. In general, Gardiner is quite sensible about
what is explicit and what can be inferred from the text of a tragedy (1987: 37, 47–48).

[102]Kirkwood (1958: 77) is surely right in describing Helenus' prophecy as "a commen-
tary on Philoktetes' greatness, just as his possession of the weapons of Herakles is."

The appearance of Herakles confirms on an absolute plane the data resulting from Sophokles' aristocratic exploration of the presocial and social compact phases of the struggle to survive. Though this solution grows organically from Sophokles' particular "thinking through" sophistic social and political teachings, the appearance of Herakles is the most self-consciously archaizing aspect of the play: "epic," "heroic," "aristocratic," "religious"—the antitheses of the style and values one associates with the Sophists. The tonality of the play is decisively shifted from a world apparently dominated by the Atreidai and Odysseus. In perhaps Sophokles' most grimly realistic play, if by that characterization we mean focused on the ugliest contemporary realities, this ending succeeds in achieving an eminently ideological aura of grandeur drawn from the reservoir of aristocratic myth: Zeus's favorite son affirms the justice of Zeus.

Though critics have often spoken crudely of orders from Zeus delivered by Herakles, the tone of address recalls the deferential courtesy of some Homeric exchanges between gods and heroes (Snell 1960: 32).[103] Herakles' first words, responding to Neoptolemos' injunction to Philoktetes to "bid the land farewell and start out" (1408), emphasize the option of their proceeding on their chosen course: "Not yet, at least until you have heard our tale" (1409–10), and then add a deferential vocative, "son of Poias." Again, after explaining who he is and why he has come, he uses a polite Homeric injunction for a sympathetic hearing (*epakouson*).[104] After a play shot through with sophistic exploration of the powers and limitations of *logos*, Herakles describes his speech—and Philoktetes repeats the word—by the archaic, heroic term *muthoi* (1410, 1417, 1447; Winnington-Ingram 1956: 633 n. 1). Herakles' prime motive in coming is designated by the word *kharis*, which conveys the reciprocity of concern characteristic of heroic friends and at the same time the peculiar Greek notion of a divine grace reserved for heroes, for winners by birth. The phrase used for the will of Zeus (*ta Dios . . . bouleumata*) recalls the *Dios boulē* of the *Iliad*, which there describes, not the cynical aim of ridding the earth of excess population found in the *Kupria (Homeri Opera* 5:117) but Zeus' commitment to val-

[103]T. Wilamowitz-Moellendorff (1969: 311) speaks misleadingly of Herakles' coming to command (*befehlen*) Philoktetes to go to Troy. He is followed by Grene (1967: 140) and Gellie (1972: 157) among others. K. Alt (1961: 173) emphasizes rightly the purely persuasive tone of Herakles' speech; but since Kitto (1956: 137) seems to have convinced too many readers that there is nothing of interest in Herakles' speech, I have considered it in some detail.

[104]*LSJ* s.v. 4 suggest the de facto sense of "obey" citing this passage; but the only pre-Sophoklean passages cited, *Il.* 2.143 and Hesiod *Op.* 275, do not justify seeing more than the usual confidence conveyed by the word that a careful hearing will win agreement. In the case of the Hesiodic passage, the author is clearly whistling in the wind.

idating Achilles' absolute superiority in the face of rejection and injury by the highest political authority in his society (Whitman 1958: 132–37).

Like traditional heroic advisers such as Nestor or Phoenix who can be and sometimes are ignored, Herakles prefaces his detailed advice with a paradigmatic tale. In this case, the tale is the speaker's own career and recalls broadly Herakles' similar exhortation to the heroic Odysseus in the underworld (*Od.* 11.615–26). The figure who for Achilles in the *Iliad* represents the ultimate futility of birth from divinity (*Il.* 18.117–19) spurs the hero of the *Odyssey* with a tale of sufferings finally compensated in dazzling triumph. Here the specific inducements are strictly individual and heroic: immortal success and a life of glory (1420–21). Philoktetes' real superiority will be validated by the whole community, thus answering earlier legitimate fears of the probability of further mistreatment by the Atreidai and Odysseus. The phrase used to express this (*aretēi te prōtos ekkritheis strateumatos,* 1425) recalls a Pindaric description of a winner in the great games (*Ne.* 7.7) and, combined with a promise of winning the *aristeia* (1429), offers reassurance that the dark fate of Ajax alluded to earlier in the play (410–15) will not be repeated in the case of Philoktetes.[105] The honorific allusion to Philoktetes' father with which Herakles begins is echoed in the full reassurance that not only is Poias alive but Philoktetes, unlike so many other heroes, will succeed in returning to his father and his home (1430). Herakles then lays a specific obligation on Philoktetes, to dedicate a thank-offering from the spoils for Herakles' bow at the scene of his funeral pyre (1431–33). The allusion reinforces the personal sense of *kharis* at the outset of the speech (1413) by reminding the audience of the service that won Philoktetes his bow.

Enjoining a parallel mutual dependence on Philoktetes and Neoptolemos expressed with a heroic lion simile, Herakles announces that he will personally send the divine doctor to cure Philoktetes' wound. This action is linked causally to the only explicit allusion in the speech to the fate of Troy's fall: "For it [Ilion] is fated a second time to be taken by my bow" (1438–39). The very vagueness of such a fate, its air of sheer mystery and individual heroic fetishism, should preclude reading into this speech the faintest hint of divine concern for the interests of the Atreidai and Odysseus. Indeed the final solemn injunction to show reverence to the gods in the sacking of Troy (1440–44) is distinctly ominous. It recalls the many desecrations of the final night of Troy which spell later disaster for so many Greek chieftains including the Atreidai,

[105]It is not necessary to retain the normally bracketed lines at 1365–67 (see Jebb's appendix ad loc.) to see in the allusion to Ajax's death an adequate reference for the audience to the *Hoplōn krisis.* They will recall Neoptolemos' emphasis in his lie on Odysseus' possession of his father's arms.

Odysseus, and Neoptolemos himself. The allusion is at best only implicit, but if it is present, it focuses awesomely the final ambiguity of Sophokles' vision: on the one hand, the divine validation of the good Philoktetes and punishment of the evil powers that marooned him are reaffirmed; on the other hand, the fragility, the terrible vulnerability to corruption, of the noble young *phusis* is confirmed in a dark allusion to Neoptolemus' subsequent development into the most impious of all the criminals at Troy.[106]

Apart from this possible dark note, the utopian direction of the play's resolution is clearly dominant in Philoktetes' full achievement of *sōtēria* and Neoptolemos' realization of the best potentialities of his noble *phusis*. Herakles furnishes absolute, "divine" confirmation of both by recalling in style and content the whole aristocratic tradition of myths celebrating the dependence of society on the single superior individual and the intense suffering that unique superiority entailed— not as in Aeschylus for the community, but for the superior individual himself or herself. The pragmatic political consequences of such an ending may appear to be a simple glorification of the old-time religion and the old-time ruling class. Yet anyone who responded to the agonizing and profound exploration of all the new intellectual and political realities threatening the underlying assumptions of the old views must have recognized that the affirmation of the ending is not naively or cheaply won. Sophokles' ideological counteroffensive is eminently indirect and cautiously circumscribed with what might almost be called escape-clause ambiguities. Depending on how far one takes the allusion to the crimes committed in the destruction of Troy, one may indeed subscribe to Winnington-Ingram's perception of a preponderantly ironic vision in Sophokles.

Philoktetes' final farewell to his island is in one sense a reminder of the whole anthropological metaphor that framed the hero's struggle to survive and make social ties possible. At the same time, the transformation of the formerly harsh, impersonal arena of that isolated struggle into a mythic, animate, and benign array of divine presences who

[106]Jebb cites with apparent approval the observation of the scholia: "This warning derives force from the tradition that, after the fall of Troy, Neoptolemos 'slew Priam, when he had taken refuge at the altar of *Zeus herkeios.*'" Neither Jebb nor, as far as I can recall, anyone else has explored the important implications for the whole education motif in the play of such an allusion. Craik rightly observes that, as far as concerns Sophokles' "conviction . . . that the preeminent principle governing a man's course of action is his inborn inherited tendency to nobility or the reverse, . . . the only new element is the prominence given . . . to the recognition that *phusis* can be corrupted and diverted from its proper track" (1980: 253). She does not, however, speak to this passage. Christian Wolff nicely spells out the ambiguities of the lion image by reviewing its traditional associations (1979: 144–50).

may guarantee the *sōtēria* implicit in the hero's return suggests the poet's own will to transcend and leave behind the Sophists from whom he had learned so much. He has turned their most powerful grounds for endorsing an egalitarian society based on persuasion and education into a ringing affirmation of the old hierarchies, which, in the midst of democracy's demise, were asserting their claims to power on new ideological foundations.

The Athens of 409 B.C.

Those few critics who have explored possible connections between the world and the text (Said 1983) of the *Philoktetes* have understandably been tempted by what might be called the *roman à clef* approach, identifying the protagonists with this or that political figure. One obvious drawback of this approach is that, for every detail that seems to support a fit, there are others so grossly incongruous that, as in the case of older attempts at historicizing Pindar, the whole enterprise of considering the relation of the literary text to the society in which and for which it was produced is discredited. We are then invited to fall back on the "Olympian" Sophokles, "'unpolitical' as far as any Athenian of that generation could be unpolitical" (Ehrenberg 1954: 138). Yet, as I have tried to demonstrate, the level on which the Athenian dramatic text responds to its context is highly abstracted from the immediate, day-to-day struggles of the assembly and the war. As an ideological construct, it engages in the politics of world views. It picks and chooses from the available concrete data of the political, social, and economic realities of Athens in its twenty-second year of war—ignoring much that leaves no trace, bracketing other data in a structured silence that requires a search for symptoms (Macherey 1978), and constructing a dream world out of other data which is thus distorted past recognition.

If we seek to construct what we can from the surviving sources of the realities of class warfare both internal to Athens and external in the war against the Spartan alliance, a few potentially relevant elements stand out. The tragic trade-off envisioned in the *Eumenides,* in which war with Sparta emerges as the price for banishing war at home between the Athenian rich and poor, had by the time of the *Philoktetes* utterly collapsed. The Sicilian disaster of 413 B.C. had so strengthened the hands of the oligarchs that they succeeded in having government authority turned over to special councillors (*Probouloi*), of whom one was the octogenarian Sophokles (Aristotle *Rhet.* 1419a–26). In 411 B.C., the Four Hundred took over, initiated a bloodbath, and did their best to turn Athens over to Sparta.

Aristotle's tantalizing evidence about Sophokles' own apparent complicity in this right-wing coup curiously parallels mutatis mutandis—Plato's relation, a few years later, to the even more violent oligarchic rule of the thirty tyrants. Aristotle, in a passage of the *Rhetoric* that reviews various ways of using interrogation, informs us, "When Sophokles was asked by Peisander [one of the leaders of the coup] if he had not voted as the other *porbouloi* had to set up the 400, he answered yes. 'Why?' said Peisander, 'Didn't this seem evil to you?' He answered yes. 'Well then,' said Peisander, 'Didn't you commit evil?' 'Yes I did,' Sophokles said, 'For there was nothing better'" (1419a26–30). Calder (1971) is surely wrong to conclude from this passage that the excesses of these aristocrats turned Sophokles into a committed democrat who apologizes for his complicity through the *Philoktetes*. Yet the reminder of Sophokles' direct political involvement, shortly before the play, is valuable and legitimate as a caution for those readers inclined to view Sophokles as a figure of Olympian distance. To me the parallel to Plato—who was invited by his uncle Kritias to join the Thirty, hesitantly declined, but soon became repelled by their behavior (*Epist.* 7) is more suggestive: a clear demonstration of the capacity of the present aristocracy for amoral ferocity worse than the worst follies of the democracy does not bring him any closer to the democracy, for which he retains at best a patronizing pity. Rather, Sophokles, like Plato, turns to an in depth "thinking through" the most intellectually rigorous critique of aristocracy produced by democratic theory only to use it in an attempt to establish a solider ground in anthropology and educational theory for the principle of inherited excellence.

Shortly after the coup of the Four Hundred, when their policies had utterly failed, power was entrusted to a so-called moderate oligarchy of Five Thousand. Nothing reveals more clearly the class character of the Athenian empire (Ste. Croix 1954–55: 1–41) or the real stakes in the war than the role of Samos and other so-called "allies" of Athens in the fall of the Four Hundred. The Samian demos revolted in 412 B.C. against their big landowners (*geōmoroi*). The success of this revolution spread to the sailors of the Athenian fleet stationed at Samos. The sailors threw out their oligarchic officers and elected democrats: "In consequence the fleet, the instrument of Athenian power, stood as the bulwark of democracy, in opposition to the native city governed by the oligarchs!" (Bengston 1988: 150). Other crucial reverses for the Four Hundred resulted from their imposition of oligarchies on allied cities such as Thasos, which revolted to get rid of both oligarchs and Athenian tribute all at once. An ultimatum from the Athenian fleet at Samos under Alcibiades set in motion the final discomfiture of the Four Hundred, which was sped on, to be sure, by the loss of Euboea

(Thucycides 8.87–97). The naval successes of Thrasyboulos and Alcibiades in 411 and 410 B.C. led to the restoration of the full democracy in July of 410.

As the nephew of Perikles, Alcibiades was certainly the scion of one of the most distinguished aristocratic families in Athens. As the victim of jealous plotting that caused his exile and sentence of death in absentia at the outset of the great expedition to Sicily and one recently associated with an island symbolic of democratic integrity, he has perhaps inevitably occurred to some as the model for Philoktetes.[107] But the consequences of taking such an identification seriously are grotesque. What could be further from the grim isolation and utterly uncompromising integrity imparted to the dramatic character of Sophokles' Philoktetes than the truly amazing array of manipulations and tergiversations of Alcibiades' whole career, especially between 413 and 410? Moreover, Alcibiades' successes as a flamboyant demagogue are hard indeed to square with the dour image of the "miseducated" and opportunistic demos evoked in the play.

More ingenious but equally unsatisfactory is the effort to see Perikles' son and namesake as the inspiration of Neoptolemos (M. H. Jameson 1956: 222–24). This Perikles was the result of his father's extramarital liaison with Aspasia and was only retroactively declared legitimate by the assembly out of pity for the elder Perikles' loss of all his legitimate sons in the plague (Plutarch *Per.* 37). The scholar who proposed this identification gives one of the best pieces of evidence against it: "In Eupolis' *Demi* of 412 B.C. Pericles asks a newcomer to the underworld if his bastard son still lives. 'He does,' is the answer, 'and would be a man by now if he were not ashamed of his harlot mother'" (M. H. Jameson 1956: 223). In view of the extraordinary bias against Aspasia and in general against mixed birth on the part at least of non-aristocratic Athenians, it strikes me as highly unlikely that a figure still mocked for his illegitimate birth as late as 412 B.C. would easily come to mind three years later as the embodiment of aristocratic excellence of birth.

But such specific identifications are a snare and a delusion. The broader picture suggests an all but total alienation from the whole spectrum of deceitful, ambitious, and potentially murderous leadership of both the oligarchic and democratic factions on the grounds that the war has already destroyed virtually all the good (cf. *Ph.* 446–500). Both the epigraphic and historical sources suggest that the old aristocracy had been substantially diminished by the long war (MacKendrick

[107]M. H. Jameson (1956: 219) traces this identification back to Lebeau in the eighteenth century and offers excellent reasons for rejecting it.

1969: 3). The absence of patriotic appeals beside the ultimately personal rationale offered by Herakles for successfully concluding the war against Troy suggests at best a grudging acquiescence to the dogged determination of the demos to reject all opportunities for peace. But, as I have tried to demonstrate, the primary level at which the text of the play responds to the present is, first, its full-scale subversion of the sophistic anthropology to the extent that that doctrine offered a warrant for an egalitarian society based on open debate and, second, its tentative affirmation that the combination of inherited excellence with the right education and some superhuman support just might salvage an otherwise hopelessly corrupt body politic. The utopian nostalgia for the Pindaric securities of noble birth beside the grimly realistic appraisal of the social, political, and in the broadest sense educational forces arrayed against that elite point forward to the far more rigorous attempt of Plato to solve this ideological crisis of the ruling elite.

The Utopian Moment

As the foregoing analysis suggests, the utopian element in this play seems especially thin—archaic even for its own time. A vision of an all-male world of born aristocrats exercising political supremacy through martial prowess offers most of us nothing new with which to chart a course toward an ampler, more just world. Yet the haunting and enduring appeal on this play is inseparable not only from this vision but from the calculated ambiguities of its integration of sophistic anthropology. Sophokles succeeds, in no small measure precisely through the anthropological imagery of unaccommodated man, in transforming the Pindaric aristocratic hero into an image of radical human integrity. We respond to the play's celebration of a capacity for sheer endurance, for an existential affirmation of consciously chosen values against the combined violence of raw nature and of human society at its most vicious and oppressive. This icon of human authenticity is inextricably linked to hideous and repellent physical suffering. The dramatization of the power of such a figure to inspire another human being with such pity and such admiration that he is at last willing to forego all the seductions of assured success and face all the risks of repudiating all established authority remains for me incomparably moving in an age so marked by both systematic, state-supported torture and heroic revolutionary struggle to affirm elemental human rights.

6

Plato's Solution to the Ideological Crisis of the Greek Aristocracy

> The division of labor is a skillful deployment of man's powers; it increases society's production—its power and its pleasures—but it curtails, reduces the ability of every person taken individually.
>
> —Adam Smith
> *The Wealth of Nations*

If it is legitimate to see in Sophokles' *Philoktetes* an implicit appropriation and transformation of sophistic anthropology and educational theory, it must be acknowledged that such a reading places a heavy burden of meaning on the frame of ancient myth which constitutes the poet's narrative raw material. That frame, as Sophokles has tailored it, is just a story of three men on a deserted island. This cannot be in any real sense a society, and even as a putative metaphorical image of a society it is remarkably restricted—just two older men battling for the adherence of a third, younger man. There are no women, no children, no economy other than the elemental survival efforts of one of the men. The form of Greek tragedy is inextricably bound with the profoundly ambiguous and indirect communicative mode of mythic narrative.

When we turn to the *Republic,* we find an explicit examination of not only the constitutive elements of a society but also the issue of the modes of communication. One cannot but be struck by the will of this text to be explicit, to escape from the shadow world of mythic, narrative representations and spell out at last the "whole truth." We are accordingly tempted to read it on its own terms as somehow the final word. It is just the sort of text that the New Right has in mind when it celebrates the classics as monumental repositories of eternal truths.[1]

[1] Is it an accident that one of Allan Bloom's major intellectual endeavors before *The Closing of the American Mind* was a militantly proclaimed and mechanically executed literal translation with notes and an interpretive essay of Plato's *Republic?* One brief sample suffices: "Socrates, in leading them [his pupil interlocutors] to a justice which is not Athenian, or even Greek, but is rather human, precisely because it is rational, shows the way

Both the liberal denunciations of the *Republic* by Karl Popper (1963) and the equally passionate (in its own quiet English way) defense by Guthrie (*HGP* 4) tend toward a certain monumentalizing of Plato, treating him as an atemporal essence to be combatted or protected in the light of atemporal projections of personal faith. While I focus primarily on Plato's ideological contributions in the long discourse of inherited excellence, what I explore most in this text are its contradictions, its puzzling lacunae, the questions posed by its shifts in tone from mystic rapture to savage bitterness and despair, from confident protreptic to ferocious diatribe—all the complex ways it is imbedded in the muck of a real, unique historical conjuncture. To explore these is not to disparage Plato, nor to lock him safely in an irretrievably dead past, but to try to come closer to the sources of the *Republic*'s relevance for us—caught as we are in our own unique historical muck.

Ideology and History

A work of the magnitude of the *Republic* does not emerge from a vacuum. But how we conceive of its background or context is not so simple. It is a response, but not a reflection. What the text responds to is in a substantial sense the raw material out of which it is produced. These raw materials include both what the author repudiates and what he or she transforms from a specific culture and society. To adapt a famous saying of Marx, authors make texts, but not under conditions of their own choosing. Moreover, how one envisions the fullness of what this text responds to is not available simply as a straightforward inference from the text itself, for the strategy of passing over in silence what is deeply disturbing is among the most powerful weapons in the arsenal of ideological warfare.[2] Thus the silences in the text may be fully as revealing of the meaning of the *Republic* to its own audience as what we have in our text.

One of the fascinations of the *Republic* is how consciously it designates what it rejects as a "system of representations" (Althusser 1969:

to the truth about political things and develops the extremely complex relationship of that truth to civil society. These questions are most relevant to modern man, although they are perhaps harder for him to understand than for men of any previous generation" (1968: 309–10).

[2] In focusing on meaningful silences and the raw materials of literary production I am indebted to the work of Pierre Macherey (1978). Pindar declares, "What is without god is best passed over in silence," suggesting a conscious strategy of suppressing denigrated material. Macherey tentatively proposes what becomes the title and point of departure of Jameson's *Political Unconscious* (1981). I am not concerned in dealing with Plato to distinguish systematically what I consider conscious or unconscious silences.

231), an imaginary or dream relation to reality, which is embedded in specific apparatuses (compare Althusser 1971: 143) of the democratic state (the assembly, the courts, the theaters, the army camps; *Rep.* 6.492b5–c2). For most readers it is Plato, rather than the Sophists whom he follows, and most of all in the *Republic,* who first designates this whole realm of the cultural sphere (broadly defined) as the decisive site of political struggle (compare Althusser 1971: 147). The self-consciousness and explicitness of much of the *Republic* would seem then to free it of a meaningful unconscious and to render its silences irrelevant; but, as I hope becomes clear, the situation is not so simple.

The notion of a meaningful silence is inherently problematic. The field of what might be left out as opposed to what is actually in the text seems potentially infinite and easily lends itself to a reductio ad absurdum. There must then be at least some hint, a symptom as Althusser would say, that the author is somehow aware of what is silenced and has reasons for this silence which admit of meaningful analysis (Macherey 1978: 125–28).

Such an approach implies an inevitable circularity between the text and sources outside the text about the text's potential raw materials. An uncritical survey of what any handbook might designate as the subject matter of the *Republic* suggests the multiple levels and spheres of reality to which we may envision the text responding: politics, economics, education and culture, philosophy, the meaning of justice. Thus the specific political institutions of Athens and Greece, the internal politics of Athens and to some extent the rest of the Greek world and at least its recent political history, the economic structures of Greece and its economic relations throughout the Mediterranean, the contemporary content and practice of education in Athens and Greece, whatever was available to Plato within the broadest conceivable purview of philosophy, the whole range of ideas and institutions associated with justice—all these are potentially relevant to assessing the *Republic* as a response to its concrete historical moment.

Finally, as suggested above, we must consider Plato's response on the level of form. Admittedly, in dealing with a literary text there is always an inevitable distortion that accompanies the analytic advantages of a separation of form and content. But if the medium is literally the message, it remains true that different messages are in fact conveyed within what broadly may be called the same medium. In a work as radically self-conscious about media as the *Republic,* we must also consider in what sense its own medium entails a response to the range of available options.

The paralyzing vastness of this array can be somewhat narrowed if we assume that one responds only to what one perceives as requiring a

response, in short, what is perceived as a threat or a crisis. On this view, the institution of slavery, which for an older orthodox Marxism was virtually the only aspect of antiquity worth talking about, does not qualify. Even Gouldner, who is close to that orthodoxy, acknowledges: "Although Plato recognizes the tensions between masters and slaves—indeed, he has no doubt that slaves will, given the chance, murder their masters—these are viewed as within the nature of things. Slavery is not regarded, as other tensions he discusses, as a source of disunity to be remedied or a diversity to be mediated" (1969: 78). This is not to deny that such elements as slavery, so deeply naturalized in the consciousness of the Athenian citizenry, leave no traces in the thought processes of the text.[3] But Plato, born in the early 420s[4] and writing the *Republic* perhaps in the decade of the 370s,[5] had lived through and, one may say from his other presumably earlier writings, thought through several more immediate crises than slavery. That these included especially those of the latter half of the fifth century is a reasonable inference from Plato's choice of a form that specifically sets the issues in an earlier historical context, even if we cannot precisely fix the dramatic date of the dialogue.[6] At the same time, this historical displacement is one of the most obvious factors that justifies our looking for structured silences: fateful changes had taken place between 409, the latest dra-

[3] I admire Gouldner's ingenious speculations, based as they are on Farrington's more orthodox Marxism, about the relation between a free aristocrat's socialization in a slave-owning society and a metaphysics that sees the "material universe as a disorderly subject" (194). I even agree that "Greek slavery is intrinsically conducive to a view of the material universe as a disorderly subject" (195). But the best textual evidence Gouldner cites is from the *Laws*, written at a time when perhaps indeed "the latent social problems implicit in slavery are slowly becoming manifest social problems" (195). In treating the *Republic*, I am more concerned with those problems that leave more readily discernible symptoms in the text than the single admittedly revealing fantasy Gouldner cites from *Rep.* 578e. One can as easily and more relevantly say of the *Republic* that Athenian *democracy* was, from the perspective of an Athenian aristocrat, intrinsically conducive to a view of the material universe as a disorderly subject. In this I am nearer the emphasis of the Woods (1978) on laboring citizens, though I did not look at their work until I had worked out my own analysis.

[4] Guthrie (*HGP* 4.10) opts for 427 B.C. Davies (1971: 333) gives a fuller account of reasons for 428–27. The standard older date (e.g., *The Oxford Classical Dictionary* 1949) was 429, to coincide with the death of Perikles.

[5] Guthrie (*HGP* 4.437) considers c. 374 the prevailing view. MacKendrick (1969: 12) opts for "publication" of the *Republic* in 372 on the grounds that Plato sets down fifty-five as the age of one's maximum intellectual powers, a slightly silly hypothesis but not perhaps incompatible with the coy indirection of Plato's self-praise elsewhere in the *Republic*.

[6] Guthrie (*HGP* 4.437–38) reviews various dates and opts for Taylor's 421 as a rough approximation. Although it is generally recognized that Plato is little concerned with chronological accuracy, I am inclined to believe that the battle of Megara referred to at *Rep.* 368a is far more likely to be the one in 409 than in 424. My reason is the perhaps circular one that only in 409 would Plato himself have been of military age and therefore legitimately included in the striking praise of the "sons of Ariston."

matic date posited for the dialogue, and c. 370, the latest date proposed for the completion of the *Republic*.[7] Is it remotely plausible that Plato could be responding exclusively to the crises remembered from his twenties without at least filtering them through the hindsight of a man who had lived into his fifties?

What Crises?

The first blatant political crisis undergone by Athenian democracy was the demonstration of its vulnerability to oligarchic subversion and domination (the Four Hundred in 411 masterminded by Plato's relative Antiphon; the Thirty imposed by Sparta in 403 and among whom were Plato's relatives Kritias and Kharmides). Then, after the death of Perikles, Athenian democracy suffered increasingly from what Hignett (1958: 259–68; see 280–84) describes as a constitutional separation of word and deed. The Periklean model of aristocratic *strategoi*, who both articulated and carried out policy, was largely supplanted by orators who persuaded the assembly which paths to follow and by professional military men who carried out the assembly's decrees.[8] At the same time, the success of the Spartan full-time military machine seemed to spell the doom of the versatile democratic citizen-soldier, who farmed in the cool months, rowed or acted as hoplite in the hot ones, and participated in the business of government to the extent that his geographic location, leisure, and inclination allowed.

But if the model democracy seemed to be self-destructing, the model oligarchy was also manifesting some striking drawbacks. The enormous moral prestige of Sparta, particularly in the eyes of non-Spartan aristocrats, had been seriously impaired by the brutality, insensitivity, and greed so abundantly displayed in their brief period of unchallenged mastery of the Greek world (Cartledge 1987: 82–96). In an amazingly short period they succeeded in alienating their oldest allies (Thebes and Corinth) and pushing them into the arms of their oldest enemies (Athens and Argos). In any case, after the battle of Leuctra (371 B.C.) the unique economic basis of their way of life, the enslaved Greeks

[7]Cross and Woozley (1979: xii–xiv) describe the problem only to mystify it: "There is no abrupt change between the closing quarter of the fifth century and fourth century when he was writing the *Republic*. The problems about moral standards and about government . . . are perennial problems anyhow." If nothing else qualifies as an abrupt change, at least the decisive defeat of the Athenian empire in 404 should give one pause about this judgment.

[8]B. Strauss qualifies this generally valid analysis with examples from the 390s of several successful generals who were also politically active (1987: 14).

of Messenia, was dismantled (A. H. M. Jones 1967: 94–146; Davies 1978: 147–64).

Finally, autocratic rule—whether inherited as in the case of Archelaos of Macedon (reigning 413–399) or the result of a forcible seizure of power as in the case of Dionysios of Syracuse (reigning c. 406–367)—had taken a new lease on life with the predominance of mercenary soldiers in the fourth century (Davies 1978: 202–11). Polos in the *Gorgias* actually names Archelaos as an ideal, one vigorously defended by Kallikles later in the dialogue and confidently consigned by Sokrates to the tortures of Hades at the end of that dialogue. Dionysios is never named in the extant dialogues of Plato, a suggestive silence, but the "Seventh Letter" recounts repeated journeys by Plato to his court in the vain hope of implementing the program of the philosopher-monarch.[9] Indeed, we are tempted by a hindsight not available to Plato to pronounce the monarchic form of government the wave of the future in light of Philip's and Alexander's subsequent subjugation of the exhausted city-states of Greece.[10] It would be more accurate to say that, as a consequence of the record of both democracy, dependent on an amateur military and an amateur bureaucracy, and oligarchy, torn by the feuds of men bent above all on individual power and revenge, authoritarian monarchy—supported by professional mercenary armies and a new class of well-trained, professional bureaucrats (Davies 1978: chap. 10)—loomed on the horizon as an alternative with enormous appeal to some segments of the old ruling classes.

The condition of the economy can be separated only arbitrarily from the political and social crises of the period. The collapse of the lucrative sea empire of Athens and its humiliating defeat by oligarchic Sparta brought in their wake an insoluble economic crisis for the restored democracy, and the attempt to revive the empire in 377 fostered old hostilities without dramatically improving the economic situation.[11] It is plausible to infer that, even before the fall of the empire, the war costs imposed on what Davies calls the liturgical class (the 1–2 percent of the citizenry capable of annually bearing the cost of outfitting a trireme;

[9]On the genuineness of the "Seventh Letter," see, in addition to Guthrie *HGP* 5.401–2 n. 1, Raven 1965: 20–26. Both Raven and Guthrie are at pains to read this evidence exactly as Plato, or his apologist, would most like it to be read. That Plato had serious misgivings about the whole project is plausible enough, but that he actually went to Sicily three times suggests to me at least that he had some hopes beyond gratifying his friend Dion.

[10]For important qualifications, see Gomme 1937: 204–47.

[11]See Davies 1981: esp. 24, French 1964: esp. 175, A. H. M. Jones 1964: 3–20, Meiggs 1972: 255–72, and Ste. Croix 1981: 292–93. Ste. Croix's note 37 on 607 gives an impressive list of evidence for the economic straits of fourth-century Athens. B. Strauss 1987 is an admirably succinct and well-documented account of the economic, social, and political consequences of the foreign and civil wars of Athens.

1981: 9–28) played a significant role in driving even those aristocrats who had originally been enthusiastic supporters of Periklean democracy to explore ever more radical oligarchic alternatives.[12] A second economic, social, and political consequence of this development was the physical and economic decimation of the old ruling class not only in thirty years of foreign war but as well in the ferocious factionalism of the last decade of the fifth century (B. Strauss 1987: 54–55).[13] Beside this gradual diminution of the old aristocracy we find the increasing prominence, beginning already in the wake of Perikles' death and dramatically expanding in the fourth century, of nouveaux riches.[14] Finally, though the matter is debated, there is significant evidence for a general economic decline not only of Athens but of all Greece in the fourth century.[15]

How should we conceive of the educational and cultural crisis to which the *Republic* putatively responded? I believe that a key dimension is what Havelock has called the literate revolution (1963, 1978, 1982). He contends that well into the fifth century the majority of Greeks, whether they had learned the alphabet or not, continued to "process" their relation to the world in oral terms, in the concrete, sensuously engaging publically performed discourse of poetry. Meanwhile, an ever wider gap was opening between this majority and the elite, whose longer education gave them the opportunity to absorb and begin to think through the implications of a world perceived, analyzed, and reconceived through the medium of texts. The emergence of institutions of advanced learning, such as Isocrates' school (in the late 390s B.C.), provided a formal structure for consolidating this growing split. Certainly the *Republic*, insofar as it is manifesto for a concrete institution, the Academy, represents on this level at least an eminently practical response.

Vernant and many others, pointing to written laws and constitutions as well as to other sorts of public inscriptions including *ostraca*,

[12]Field (1967: 5), cited with approval by Guthrie (*HGP* 4.12), argues that the war was especially burdensome to the Athenian ruling class. This claim is disputed by A. H. M. Jones (1964: 23–30) and Ste. Croix (1981: 290), but Ste. Croix acknowledges (291) that the attempted coup of 411 was carried out by the "wealthiest Athenians: the trierarchs (Thuc. VIII.47.2)"—exactly Field's point. We might add that Plato himself describes democracy in Bk. 8 as a form of government in which "the drones pasture on" the rich, who in turn are described as "most orderly/upright by nature" (*kosmiōtatoi phusei*, 8.564e6–13). But the sense of "especially" in assessing such burdens has much to do with the virtual monopoly of cultural production by the ruling class.

[13]B. Strauss also argues that the disproportionately large number of *thetes* killed in the war actually lessened the tensions between rich and poor: "Politics might [otherwise] have taken on a more radical colour" (1987: 58).

[14]On the nouveaux riches of the fourth century, see MacKendrick 1969: 3, 5–6, and B. Strauss 1987: 47–50. For the fifth century, see Connor 1971: 155–68, Ste. Croix 1981: 290, and Davies 1981: 68–72.

[15]In favor of decline see Ste. Croix 1981: 294, citing Rostovtzeff (1941) and Mossé (1962).

present an alternative picture of widespread functional literacy as early as the sixth century.[16] But this evidence points also to a whole new impetus for a specifically democratic oral culture: the polis opened new realms for public discourse in the political and juridical spheres and committed significant resources of the state to religious events where poetic discourse inevitably became, if it had not been so before, the dominant medium for articulating the entire community's representations of its values, conflicts, anxieties, and aspirations—in Althusser's terms, key ideological apparatuses of the state and the site par excellence of ideological struggle. The twin developments of rhetoric and public poetry in Athens of the fifth and fourth centuries might thus be said to reinvent a new oral age in which, regardless of the number of technically literate citizens, the medium of oral, artful speech dominated every aspect of life and thought.

In this framework, what we can tell of the nature of formal education for the fortunate few males needs to be kept in tandem with what we know of the massive public education conducted in the *pnyx* (assembly), the agora, the courts, the theater of Dionysos, and other festival locations and encompassing in many cases the entire population including women, slaves, and children.[17] Both forms of education seemed to involve a tremendous amount of memorization, internalization, of poetic discourse. Xenophon's representation (*Symposium* 3.5–6) of someone who claimed to have memorized all of Homer, when it is set beside Aristophanes' frequent parodies of tragedy and epic and Plutarch's story (*Nicias* 29) of Athenian sailors who won their freedom in Syracuse by singing choruses of Euripides, confirms the picture Plato's own dialogues give us of Athenians who always have lines of Homer, lyric, and drama at the tips of their tongues and—more to the point—who consistently cite poetry as a warrant for an enormous array of social values and practices. The institutional threat of the Sophists' advanced education available for any males who could pay for it was twofold. Within the established ruling class it threatened the system of interfamily alliances. This system in turn was sustained in no small measure, it seems, through the practice of aristocratic pederasty completely imbedded in the twin institutions of the gymnasia and the symposia, which constituted the very essence of the old Athenian *paideia.*[18]

[16]Vernant 1982: esp. 52–54, Marrou 1982: 43, and Murray 1980: 91–99.

[17]"It should be remembered that the way of life of the city itself constituted a powerful informal education" (Barrow 1976: 13). Though there is no uncontested evidence, there seems to be general agreement today that women were present at Greek drama; see Picard-Cambridge 1968: 264–65. On women's religious festivals, see Pomeroy 1975: 75–78 and Zeitlin 1982. On Athenian festivals in general, see Parke 1977.

[18]On the "old" Athenian education, see Marrou 1982: 36–45; on pederasty, 26–35. Marrou stresses the anti-intellectualism of the world of sport and gymnastics but recog-

A more obvious political and social crisis triggered by the Sophists was the rise of so-called "new men" with skills formerly monopolized by the aristocracy in Athenian politics. We have independent evidence in Thucydides and Aristophanes of the ferocious, ruling-class bitterness inspired by Kleon and other new men in Athenian politics.[19] The range of Lysias' clients attests independently to his political success, and Plato himself offers powerful evidence for the impact of this "mere" metic on Athenian intellectual life.[20]

As I demonstrated in the preceding chapter, the Sophists' education involved a great deal more than how to play tricks with words. But their focus on an ever more self-conscious practice of the art of verbal persuasion had a contradictory relation to the new orality of fifth-century Athens. On the one hand, it inevitably fostered that orality by heightening the excitement of public discourse, which under their influence became more sensuously gratifying—more poetic—even as poetry became more rhetorical (J. H. Finley: 1967; Denniston 1952: 10–21). On the other hand, their theorization of the power of language deepened the growing sense of an unbridgeable epistemological gulf between the world represented in sensuously gratifying poetic and rhetorical discourse and the analytic constructs achieved through the textual vision.[21] Here the Sophists were simply pursuing specifically in the

nizes the symposium as the site par excellence of aristocratic homosexual *paideia*. See also Dover 1978: esp. 202–3 and Havelock 1952: 95–108.

[19]Thucydides 3.36.6–41; 4.21.3–22.3 and 39.3; 5.16.1. Aristophanes refers to Kleon constantly: *Birds* 6, 299–300, 377, 502, 659; *Knights* 976; *Clouds* 586, 591; *Peace* 47; *Frogs* 569; and *Wasps* passim. Connor (1971: 163–68) is at pains to stress the anti-intellectualism and lack of culture of the new politicians. Kleon, the prime example, may not have been adept on the lyre at the symposium (see *Wasps* 1220–42 and MacDowell, ad loc.), but he was no untutored orator. B. Strauss (1987: 12) assumes that those who governed Athens c. 400 "could afford to be educated by sophists" and, citing the allusion to Kleon at a symposium, questions Connor's belief that Kleon did without a network of political allies (*philoi*), relying "exclusively on oratory to build a political following" (16). Many of the fourth-century nouveaux riches, however, shared the political quietism MacKendrick (1969: 3) notes as characteristic of much of the old aristocracy; see also Carter 1986: 155–86 on Plato's relation to this withdrawal from political activism (*apragmosunē*).

[20]The *Phaedrus* purports to give us the text of one of Lysias' speeches which inspired sufficient enthusiasm to be memorized by the young aristocrat Phaidros. The scene of the *Republic* is the home of Lysias' father Kephalos, where aristocrats are much in evidence. Lysias is also mentioned twice in the little dialogue *Kleitophon*.

[21]E.g., Gorgias: "Nothing exists; second, even if it exists it is inapprehensible to man; third, even if it is apprehensible, still it is without a doubt incapable of being expressed or explained to the next man" (*D-K* B 3, trans. Kennedy in Sprague 1972), or Protagoras on the gods: "Concerning the gods I cannot know either that they exist or that they do not exist, or what form they might have, for there is much to prevent one's knowing: the obscurity of the subject and the shortness of man's life" (*D-K* B 4, trans. O'Brien in Sprague 1972). Cf. Democritos on sense perception: "There are two forms of knowledge, one genuine, one obscure. To the obscure belong all the following: sight, hearing, smell, taste, touch. The other is genuine, and quite distinct from this" (*D-K* B 68, trans. Kirk in Kirk and Raven 1957).

realm of language the explorations of the *physikoi*—Herakleitos, Parmenides, Empedocles, and the Pythagoraeans—which opposed in more and more categorical terms the realm of the senses, of engendering and of dying, to the stable structural determinants revealed by (literate) analysis. Whether these were termed *logos* or *philia* or *theos* or *harmonia*, they were equally inaccessible to the senses and equally at odds with the oral poetic version of reality.[22]

As we have seen, in their social and anthropological speculations both the Presocratic teachers and the Sophistic teachers of rhetoric forged a fundamental ideological assault on the philosophical foundations of the domination of society by an aristocracy of birth. If human beings were like other animals and their most relevant features were their intelligence and capacity to learn and to form social bonds, then claims to power based on descent from divinity emerged as quite irrelevant. Though the Sophists acknowledged *phusis* in the sense of superior innate endowments, education became far more decisive than inherited qualities.[23]

In any case, the Sophists seem to have dissociated completely innate abilities from specific genealogy. Protagoras' analogy, in Plato's dialogue named after him, of a city where everyone is single-mindedly engaged in flute playing acknowledges that there are natural differences in individuals' abilities, but it specifically denies that these are likely to be transmitted from parent to child. Such differences are purely accidental and relatively insignificant compared to the impact of the mobilization of all the educational resources of the city toward guaranteeing that everyone is at least an adequate flute player. Thus we find Protagoras resorting to such new coinages as *euphuēs* or *aphuēs pros ti* (with or without natural talent for something) with no indication of this talent deriving from parentage.[24]

Protagoras offers the first extant serious analysis of the socialization process, education conceived of in the broadest terms, ranging from the ministrations of nurses and parents to the whole array of public discourses learned in formal education and by participation in the cultural and political life of the state. The breadth and subtlety of this conception went far toward questioning the long-established associations

[22]See Guthrie *HGP* 1 and 2. For a specifically Marxist analysis of this development (not in my judgment entirely convincing), see Thomson 1961 and Sohn-Rethel 1978.

[23]E.g., "Education requires natural ability [*phuseōs*] and training [*askēseōs*]" (Protagoras *D-K* B 3). But "more become excellent [*agathoi*] from practice [*meletēs*] than from natural endowment [*phusios*]" (Democritos *D-K* B 242).

[24]These usages pervade Protagoras' "great speech" in Plato's dialogue of that name. That they are not purely platonic is suggested by phrases such as "without natural endowment for learning [*aphuēs es mathēsin*]" (Democritos *D-K* B 85; cf. Democritos B 56, B 109; Pythagoras D 11).

of *phusis* with stability, permanence, and immutability—pushing the concept nearer, as we have seen already in the case of Neoptolemos, to mere potentiality, which, deprived of the right education, might be quite easily perverted. Democritos articulates perhaps the most subversive juxtaposition of *phusis* and education: "Nature and teaching are similar. And the reason is that teaching transforms the rhythm of a human being, and in changing the rhythm creates the nature" (*Hē phusis kai hē didakhē paraplēsion esti. Kai gar hē didakhē metarhusmoi ton anthrōpon, metarhusmousa de phusiopoiei; D-K B 33*). The bold coinage *phusiopoiei* (lit. "makes nature") claims for education fully equal power with *phusis* to determine the actual constitution of the individual. The power of this analysis, supported by real-life instances of the mediocrity of some sons of Athens' greatest political and military figures (*Prot.* 319e3–b3, 328c5–d1; *Laches* 179a1–d7) left no room for the aristocratic confidence of a Pindar in the automatic emergence of aristocratic superiority. At the same time, the Sophists' emphasis on success through education contributed to the professionalization of politics that ultimately spelled the death of the democracy that had summoned the Sophists into existence in the first place.

Plato's Response: The Form and Structure of the *Republic*

Prose

As Macherey has argued, "the work contains its ideological content, not just in the propagation of a specific ideology but in the elaboration of a specific form" (1978: 116). In considering Plato's response to the diverse developments reviewed in the previous section, I begin on the formal level with Plato's medium of communication. The Presocratics and lawgivers of the sixth century may tentatively be given credit for the invention of prose, if by prose we mean specifically the composition, recording, and dissemination of nonmetrical communication.[25] It is surely not accidental that this formal innovation corresponds with the first recorded assaults on the poetic *paideia* of Homer and Hesiod (Havelock 1982: 220–60). Perhaps even more revealing is the presence of this same critical note in Xenophanes (*D-K B* 10, 11, 12), who chose to communicate in the poetic medium. It is as if he calls attention to the apparent contradiction between his repudiation of the oral-poetic vision of reality and his desire to compete with that view in a medium

[25]See Denniston 1952: 1. For a subtler meditation on the implications of the emergence of prose, see Kittay and Godzich 1987, which focuses on medieval Europe.

so deeply entwined with it. The formal innovation of the Sophists was to compose in prose writing a specifically political discourse that had previously been framed orally. The consequence was to some extent a new politics. The combination of more tightly structured argument and more sensuously engaging style must have widened the gap between those who could afford such training and those who could not. As we have already indicated, this is arguably an anti-democratic side of their practice. But to the extent that their new discourse was poetic, it bathed the business of democracy in the aura of the heroic world. To the extent that it applied new analytic perspectives to that practice, it underlined the fundamental break with the values of the heroic world. The speeches in Thucydides, especially those of the Sophists' chief sponsor, Perikles, are perhaps our best indication of this dual movement.[26]

Plato's formal response in the *Republic,* dramatic dialogue, is in one sense something he had already employed for perhaps thirty years—in the dramatized conversations between Sokrates and others. The relation of this dialogue form to the the mimes of Sophron or to mostly lost attempts by other pupils of Sokrates to preserve or imitate the flavor of actual socratic conversations is much debated, but the existence of some immediate models, however remote they may have been from what we have in Plato, nonetheless suggests that here too there is no creation ex nihilo.[27] On the contrary, Plato's handling of the dialogue form in the *Republic* suggests that he is attempting to compete with the dominant media of Greek culture before him—Homeric epic and tragedy—while implicitly being trapped in the very mode of representation he seeks to overthrow and supplant.[28]

Much has been written about the philosophical and psychological advantages of platonic dialogue form, its capacity to engage the reader in the actual struggle for the truth and its dramatization of Plato's battles against part of his own nature (e.g., Friedländer 1958: 154–70;

[26]For me, the best analysis of the fusion of heroic aura with new techniques of analysis in the speeches of Thucydides remains de Romilly's (1963). See also J. H. Finley 1967 and Stadter 1973. There are also valuable comments scattered through Connor 1984.

[27]Wilamowitz-Moellendorff (1920: 2.21–31) reviews various attempts to fined preplatonic sources for the socratic dialogue. Although he insists on the absence of real models, he notes crucial antecedents in comedy and in the sophistic *agōnes logōn* (31). In a similar vein, see Friedländer 1958: 137. Adam 1963 on 5.451c notes Plato's partiality for Sophron and an apparent allusion to his *gunaikeioi mimoi.*

[28]Bakhtin (1981: 22–26) focuses perceptively on the novelistic aspect of the socratic dialogue. This parallel holds especially well for the dialogue's relation to other genres: "The novel parodies other genres (precisely in their role as genres); it exposes the conventionality of their forms and their language; it squeezes out some genres and incorporates others into its own peculiar structure, re-formulating them and re-accentuating them" (5). On the other hand, Bakhtin does not seem to see any contradiction between the new valorization of the present, of the openness of the historical moment (7, 11, 30) in this form, and the specific other-worldly metaphysics of Plato.

Guthrie *HGP* 4.56–66). More recently we have been enlightened about the "metaphilosophic" function of dialogue (Griswold 1988: 143–67). But these and other claimed advantages must also be situated within the context of Plato's profound ambivalence toward writing and his equally profound distrust of all sensuously engaging discourse, a distrust that stems in part from the literate revolution.[29] The elaborated dialogue with richly drawn characters, thematically suggestive settings and actions, is *not* the same as dialectics, the rigorous cooperative and confrontational quest for ever more logically complete and coherent formulations. One may well argue that the former leads to the latter, but the latter by no means requires the former—as is clearly demonstrated by the example of the sophistic antithetical arguments.[30] That in fact Plato was aware of a profound tension between the two seems clear. The whole direction of Plato's philosophical development is toward a medium of expression as devoid of sensuously distracting ambiguities as possible. The fact that his low opinion of most people leads him on occasion to defend an admixture of play with serious philosophy or the fact that most readers prefer that mixture does not diminish this tension.[31]

The form of the *Republic* as a whole is a conversation repeated by Sokrates speaking in the first person to an unspecified audience. Among generally acknowledged earlier dialogues, only the *Lysis* has precisely this form. The *Protagoras* and *Euthydemos* begin with short sections of direct dialogue after which Sokrates narrates the rest to his interlocutor. At *Republic* 3.392d5, Sokrates suggests a fundamental tripartite division of forms of mythic narration between simple narration

[29]Guthrie (*HGP* 4.56–60) and Friedländer (1958: 110–25) both discuss the issue of writing, but only in terms that justify Plato's own practice, while reassuring us that what we have is worth reading. Guthrie even uses Plato's attack on writing in the "Seventh Letter" as the epigraph for his first volume on Plato (*HGP* 4.1). Jacques Derrida (1974 and 1981) has put the platonic denigration of writing on a wholly different plane. He sees the disparagement of writing as the necessary, prerequisite mystification for the founding of Western metaphysics. There is a tantalizing potential overlap between Derrida's conception of this role of writing and Havelock's association of literacy with the growth of abstract thought (see esp. Havelock 1963). Havelock commented (alas rather superficially) on Derrida in his last book (1986: 50). In "Plato's Pharmacy" Derrida also notes, citing Vernant, the democratic aspect of writing (1981: 144 n. 68).

[30]E.g., Protagoras' *Antilogikoi* (*D-K* B 5), the anonymous *Dissoi logoi*, and Aristophanes' parody in the debate between different *logoi* in the *Clouds*, where to be sure some *ēthopoiia* enters. See Kerferd 1981a: 59–67.

[31]"Not only are the poets expelled, in *Republic* X, from the ideal state, but the poetic strain gradually vanishes from Plato's writing until, in the *Laws*, little remains but a prosaic monologue" (Raven 1965: 79). Cf. the conclusion of Stenzel that by the time of the *Timaeus*, which he views as very late, "one thing alone is an object of serious Philosophy—a mystical and spiritualized *meteōrologia*, a religious astronomy, with which Plato surely reaches his farthest distance from Socrates" (1973: 22). For some qualifications, see Guthrie *HGP* 4.56–65, Friedländer 1958: 164–70, and Desjardins 1988: 110–25.

(*haplē diēgēsis*), imitation/representation (*mimēsis*), and a combination of the two. Dithyrambs are his only example of simple narration, tragedy and comedy are pure imitation, and Homer is analyzed as the prime example of the mixture of narrative and imitation. Sokrates then offers a detailed analysis of the psychological and moral damage done by any *mimēsis* except of what one already is or seeks to become. On these grounds there is a certain distancing involved in the choice of a narrated dialogue over the most common form of those dialogues assumed to be early, namely, direct dialogue or pure *mimēsis*. Nonetheless, virtually all of Sokrates' interlocutors in Bk. 1 are inadequate models of the *kalos k' agathos* ("true aristocrat," lit. "beautiful and good"), who alone is worthy of imitation (see 396b10–c3). Moreover, even if by a certain stretch one could argue that all the interlocutors after the second beginning in Bk. 2 are truly *kaloi k' agathoi*,[32] the fact remains that from the perspective of the more radical critique of *mimēsis* in Bk. 10 Plato is still using a Homeric mixture of narrative and drama which he invites his audience to reject, a form of discourse conspicuous by its absence from the advanced curriculum of the true philosophers described in Bk. 7.[33]

The Superdialogue as Critique of Dialogue

Readers of earlier dialogues would be familiar with periodic challenges and counterdefenses of the dialogue form but would be quite unprepared for the staggering length of the *Republic*. Accepting here for the sake of argument Guthrie's cautious chronology and the standard pagination of the Renaissance Stephanus edition, we find the longest dialogue before the *Republic* to be the *Gorgias* at 81 Stephanus pages. The presumed earliest examples of the platonic dialogue average 10–20 pages. The *Republic*, with roughly 280 Stephanus pages, represents a major departure that generates a new "convention," so to speak.[34] Beside the more familiar sorts of passages in which a speaker (Thrasymachos) attacks dialogue as such is a whole string of passages in which the very project of continuing so complex a line of argument summons forth repeated expressions of hesitation, fear, or embarrassment by Sokrates followed by assurances that it is indeed worth the trouble and by exhortations not to flag from completing the task

[32]In fact, the "evil" Thrasymachos rather surprisingly says a word or two at 5.450a5–6.

[33]For an impassioned defense of the consistent relevance of myth to all of Plato's work, see Friedländer 1958: 171–210.

[34]A few pages seem to be taken up with irrelevant matter between each book in Stephanus pagination. Guthrie (*HGP* 4.434) notes, "The *Republic* . . . is almost five times as long as the longest dialogue so far considered."

(*ergon*).[35] We may compare this procedure with Barthes' hermeneutic code (1974: 19, 262–63): here too the reader is invited to participate in solving a kind of tantalizing mystery, and in this case we are repeatedly reminded that it is the mystery on which ultimate happiness both in this life and hereafter depends.

The two phenomena, the use of sensuously engaging discourse and the self-conscious attempt in the *Republic* to extend the scope of the dialogue, are intimately related and are reflected in the structure of the dialogue as a whole. The familiar argument that Bk. 1 is merely an early aporetic dialogue onto which a new form has been more or less awkwardly grafted (Guthrie *HGP* 4.437; Friedländer 1969: 63–67) is likely to be an error that contains a grain of truth. It is preferable, I think, to read the movement from Bk. 1 to the second beginning in Bk. 2 as a highly self-conscious meditation on the inadequacies of the dialogue form as earlier employed. It may also be implicitly a turning away from fundamental directions in socratic *praxis*—from confrontations with the unconverted, from what Ricoeur calls the school of suspicion, the "reduction of the illusions and lies of consciousness," to the school of reminiscence, "the recollection of meaning" (1970: 32).[36]

The dialogue begins with the exploration of the naive confusion about central moral issues of an ordinary man of the older generation (Kephalos, the father of Lysias) and proceeds to demolish a parallel naivete in his son (Polemarchos), who relies on arguments that illustrate pointedly the consequences of his education in poetry. We then move on to a full-scale confrontation with a professional intellectual, a rival Sophist (Thrasymachos). Although this encounter does take the argument deeper—it is forced into the political sphere out of the initial private sphere—the rivalry and the fundamental character of the gulf between the assumptions of Thrasymachos and of Sokrates about the world lead to a frustrating stand-off, an *aporia*.

Bk. 2 begins again with two young interlocutors, who are already convinced of the inherent superiority of Sokrates as a human being and teacher. They share the fundamental epistemological premise that there *is* such a thing as justice in itself, apart from its consequences and from any particular just person or just action. This sort of interlocutor releases, as it were, a new Sokrates or at least one only glimpsed before

[35]E.g., 2.368b3–c2, 2.369b2–3, 2.372a3–4, 2.374e6–11, 2.376c7–d10, 4.432b7–c5, 4.435c4–d9, 4.445a5–c2, 5.449c7–451b5 (this is probably the most elaborate one), 5.484a1–b1 (self-congratulation for efforts).

[36]Cf. R. Robinson apropos of the *Meno:* "With the introduction of this method he is passing from destructive to constructive thinking, from elenchus and the refutation of other men's views to the elaboration of positive views of his own" (1953: 122, cited in Raven 1965: 62–63).

in the latter parts of those dialogues generally considered nearest the *Republic* in time of composition,[37] a Sokrates who expounds positive doctrine—but now at such length and in such detail that the very notion of "dialogue" is called into question.

From Dialogue to *Logos*

From Bk. 2 rare interventions by one of the interlocutors serve more obviously structural functions to shift the argument to a new level or a new topic. Glaukon's objection to the first ideal city proposed by Sokrates, the "city of pigs" (2.373d4), is the pretext for updating the imaginary polis to include enough of the complexities of a contemporary city to have a more immediate relevance than the initial rather Hesiodic utopia.[38] Moreover, the project now becomes the more politically immediate one of purging (3.399e5–6) a city suffering from inflammation (*phlegmainousan*, 2.372e8). Adeimantos' interruption to complain that the rulers get no happiness or advantage out of ruling (4.419a1–420a1) triggers a deeper analysis of the economic causes of dissension both within and between Greek cities. Adeimantos' question about the meaning of "women in common" (5.449c8) permits a detailed exegesis of arrangements for mating and rearing of infants. Within that exposition, Glaukon's expression of doubt about its feasibility (5.457d3) allows elaborations that culminate in the paradox of the philosopher-monarch.[39] Here objections by Glaukon (5.475d1) and later by Adeimantos (6.487b1) facilitate both the elaboration of a new epistemology and a sustained assault on Plato's professional and

[37]For the middle dialogues, Guthrie's order of treatment, which is only partly a chronology he endorses and partly for convenience of exposition (*HGP* 4.53–54) is *Protagoras, Meno, Euthydemus, Gorgias, Menexenus, Phaedo, Symposium, Phaedrus, Republic.* Raven (1965) argues for the following chronology: *Protagoras, Gorgias, Meno, Phaedo, Symposium, Republic, Phaedrus.*

[38]Clay makes much of the fact that the founding gesture of the polis most fully elaborated in the *Republic* is the injustice of an acquisitiveness that necessitates war and therefore an army (1988: 28–29, 33). But it is precisely this will to turn away from a purely fantasized and ultimately irrelevant utopia and rather to deal with the real, corrupt society that motivates the most radical negations of that reality—in particular the abolition of private property and the family for the ruling class. Clay subtly surveys the ambivalences toward the possibility of realization of this polis, but his familiar solution of celebrating individualism all too conveniently endorses a total abandonment of *any* political relevance—something deeply alien to much that is most engaging in the *Republic*.

[39]Okin (1979: 40) notes the sexism of the traditional locution "philosopher-kings." Reeve, who devotes three pages to women, under the heading "Invalids, Infants, Women, and Slaves," in a book of some 320 pages on "the argument of Plato's *Republic*" has titled his study *Philosopher-Kings* (1988). I should add that he treats Plato's radical suggestions with sympathy and goes out of his way to argue that even the drone women of the lower orders will perform the tasks for which they are suited by birth, which he takes to imply the full range of traditionally male-dominated crafts.

political competitors, who are blamed for the deplorable state of philosophy. This analysis in turn justifies a return to the issue of educating the guardians and the elaboration of an advanced curriculum that would prevent the aberrations from which philosophy is alleged to suffer.

These obvious examples of a functional role of interlocutors in organizing an essentially expository text must be considered alongside those new, frankly expository formulas for transitions: "What distinctions must we make next?" (3.412b8); "What's left for us in our lawmaking enterprise?" (4.427b1); "The next point is to establish securely from our argument [*para tou logou*] . . ." (5.461e8); "We must now examine the points of our argument agreed on [*ta tou logou homologēmata*] to see whether . . ." (5.462e5). It is the *logos* that now directs the exposition, which in turn is only facilitated by dialogue as such.

The Utopian *Logos*

These innovations are formal dimensions of a more basic aspect of the dramatically new form the expository role of Sokrates now takes. In the *Gorgias* and other dialogues presumed to be chronologically near the *Republic*, readers would have encountered myths that pointed by a cautious indirection toward the exposition of doctrines about which the author chose to express no certainty, only a plausible account (*kata ton logon ton eikota*, *Timaeus* 30b7).[40] They may also have encountered the elaborate distancing device of Diotima's reported doctrine in the *Symposium*. In the *Republic*, the device of the city *en logōi* involves the first explicitly utopian alternative to the status quo in Western literature. As modern readers, we may discern a utopian thrust in Homer's tragic vision of a perfect military meritocracy gone amuck. The Phaiakian episode in the *Odyssey* has long been thought to have a utopian dimension—so too Aeschylus' celebration of a *stasis*-free Athens or Aristophanes' fantastic alternative polis in the sky. These texts and many others were clearly raw materials for Plato's own utopia. In the *Republic*, however, the text itself confronts the gap between the existing reality and what can be represented in argument, *en logōi*.[41] The ambiguity of the status of such a construct somewhere between *muthos* and *logos*, between *logos* and *ergon*, seems underlined by Sokrates' curious locution when he states the necessity of the philosopher breed (*philosophon genos*) achieving power as the essential condition before

[40]Most scholars place the *Timaeus* later in the canon, but this phrase is often cited in defenses of Plato's use of myth.

[41]Manuel and Manuel (1979) begin their massive study of utopian thought by "bypassing . . . a rigid definition" (5). But Mumford begins his account (1962) with Plato's *Republic*. My point is only to focus on the new self-reflexiveness of Plato's gesture.

"the constitution which we mythologized in discourse achieve accomplishment in fact" (*hē politeia hēn muthologoumen logōi ergōi telos lēpsetai,* 6.501e2–5).

Between Dialogue, Treatise, and Myth

This utopian logos, by virtue of its systematicity, dictates, as I have tried to illustrate, the formal direction of its own exposition and exploration in an uneasy if provocative tension with the relative freedom of a real dialogue. Thus, for example, the long digression on the abolition of the family, philosophy, the good, and higher education (Bks. 5, 6, and 7) is sandwiched between a programmatic declaration by Sokrates at the end of Book 4 that the proper assessment of the ideal city requires analysis of contemporary alternatives and a lengthy pursuit of just that line of argument, in Books 8 and 9.

Once the city *en logōi* is complete and the conditions of discourse set by the ideal interlocutors have been met, it is again the issue of the form of discourse which forces on us the awkward, seemingly gratuitous return to the assault on *mimēsis*. But it is only after we have been exposed to the detailed psychology of Bk. 4 and the elaborate epistemology of Bks. 6 and 7 that we are in a position to grasp the full implications of the initial, concrete assault on representation in Bks. 2 and 3. The dominant modes of discourse in Athens are now measured against the reality of the eternal forms, even as, in the final myth, the life choices and pursuits of traditional heroes and Plato's contemporaries are measured against the standard of the immortality of the soul. One may say that the final myth is overdetermined, but surely the author's use of a myth in the immediate context of so categorical a repudiation of representation confronts the reader with a final juxtaposition that speaks of the tension between form and doctrine throughout the *Republic*.

General Characteristics of Plato's Solutions

In the preceding discussion I have tried to show how on the formal level the major articulations of the argument of the text as a whole reveal a pervasive tension between how the argument is presented and what it affirms. I now argue that virtually every other component of Plato's response to the perceived crises of his moment involves a parallel internal tension that constantly threatens the text with breakdown. Most broadly and obviously, the realizability, the ontological

status of the ideal city itself, is caught in an inescapable web of irreconcilable tensions.

At times Socrates is strenuous in his defense of the possibility of realizing the project of the city *en logōi* and expresses his disdainful apprehension "lest the argument seem a mere prayer" (*mē eukhē dokēi ho logos*, 5.450d1–2). At perhaps his most desperate, he asserts that the ideal city may simply be "laid up as a paradigm in the sky" (*en ouranōi*, 9.592b2–3, a phrase which Guthrie, *HGP* 4.543, points out does not mean "in heaven"). Generally, in pessimistic moments, the characterization of the obstacles to the city's implementation appears quite insurmountable. The savagely anti-democratic parable of the ship of state (6.488a7–489a6) categorically precludes any effective role for the true philosopher. In response to a later question from Glaukon whether the true philosopher will be willing to enter politics, Sokrates gives the extraordinarily ambiguous answer, "Yes, by the dog—at least in his own city. Perhaps not in his native land, unless some divine chance befall him" (9.592a5–9). His own city turns out to be precisely the one they have envisioned and which may only exist in the sky. The analyses of the corruptions threatening the philosophical nature (*phusis*, see 6.489d1–5) and of the futility of private education culminate in ominous anticipations of Sokrates' own trial and execution (6.494e6), while the murderous ferocity of the shadow gazers in the cave toward one who has seen the light (7.517a5–6) scarcely inspires confidence. Then there is the inevitable final undermining gesture, marked by the weird discourse of the magic number (8.546a2–547a5), that since the ideal polis partakes inherently of the realm of the human and changeable, its rulers will eventually err in choosing breeding times and the state of affairs decline from the ideal. Thus the driving goal of political stability—freedom from *stasis*—which emerges as the most blatant, pervasive, and poignant component of Plato's response to his historical moment, is despairingly abandoned precisely sub specie aeternitatis.[42]

This element of other-worldly despair raises the perhaps more fundamental question, explored, for example, by Jaeger, Guthrie, and more recently Clay, whether we should even take the *Republic* as a genuinely political text. Is it not rather all a metaphor for the real object, individual spiritual stability and harmony? Guthrie concludes after repeated protests that Plato never had a serious interest in implementing the city outlined in the *Republic*: "Essentially . . . the *Republic* is not a piece of political theory but an allegory of the individual human spirit,

[42]It is striking that Plato begins his tale of decline with an invocation of the Muses and a mock-heroic allusion to Homer—a parody of *Iliad* 16.113: "the way indeed factionalism first fell upon [them]" (*hopōs dē prōton stasis empese*, 8.545d7–e1).

the psyche. The city is one which we may 'found in ourselves' " (*HGP* 4.561, see 486).[43] So too Clay concludes, "In Kallipolis, Sokrates would be king, perhaps; but in Athens he is at least the ruler over the polity within his soul" (1988: 33). On this reading, the enabling analogy of the individual psyche to the polis, which is the literal pretext for the entire analysis of both the ideal state and those states and individuals that depart from it, emerges as incurably flawed or, as Clay would have it, reversed. There is support for such a reading in the recurrent notes of quietism throughout the *Republic*, moments when participation in any sort of politics in the real world is characterized as too dangerous or too degrading for a serious intellectual: he is "like someone who has fallen among wild beasts. . . . Inadequate to hold out against them alone. . . . he must keep quiet and do what is his own [*ta hautou prattōn*], like a man in a storm of dust and hard rain driven by the wind, he must stand apart under a small wall" (6.496d2–e2).[44]

These tensions or ambiguities are, I believe, best appreciated in all their rawness rather than subsumed in some totalizing reading, whether defensive or denunciatory.[45] They do not imply a straightforward repudiation of the political sphere any more than they support a view of Plato as the unreflective proponent of a program he is promising to implement. Rather, they underline the inevitable tentativeness, the provisional character, of any solutions Plato may be proposing within the conditions of possibility briefly sketched above. Still, perhaps the most striking features of Plato's solutions are their radicalness and their self-conscious striving for comprehensiveness. If not all possible crises are met in equal detail, the thrust of Plato's utopian project

[43]Cf. Jaeger 1945: vol. 2, esp. 347–57, "The State within Us." It is striking, however, that in his opening overview of the fourth century Jaeger writes: "But the men of that age, even Plato, still believed that their task was a practical one. They had to change the world, *this* world—even although they might not manage to do it completely at the moment" (2:4).

[44]Cf. Guthrie *HGP* 4.486. It is striking that the key phrase describing justice, *ta hautou prattōn*, is here simply synonymous with the political quietism of the Athenian aristocracy in the fourth century on which MacKendrick comments (1969: 3–4). Carter (1986: 155–86) stresses the social and political roots of Plato's conception of the contemplative life (*bios theorētikos*).

[45]Here I dissociate myself from Wood and Wood (1978: esp. 145–71). Their whole approach, while perhaps a salutary counterweight to the usual idealist decontextualization of Plato, ignores the element of radical negation in the *Republic*. Symptomatic of their reflectionism is the omission of all but the most cursory allusions to Plato's provisions for women. After noting that Spartan laws on marriages for heiresses were probably less rigid than in democratic Athens, they comment, "It is also worth noting that Plato, whose political doctrine is profoundly aristocratic and anti-democratic, proposes a considerable degree of freedom and equality for women—at least women of the ruling class" (1978: 50). This statement, not even formally part of their discussion of the *Republic*, and a three-line comment in a chapter on Aristotle (248) is all they see fit to say about Plato and women.

is to insist on the total integration of all the sources of the crises: politics, economics, education and culture, the dynamics of sociopolitical bonding, modes of representation, epistemology, and ontology are all subjected to a dazzling impulse of totalization.

Plato's Discourse of *Phusis*

In the impulse to comprehensiveness, the discourse of *phusis* plays a decisive role. *Phusis*, variously as "innate character" *with* strong connotations of derivation from a specific ancestry and *without* such connotations, as "authentic essence," even as the de facto equivalent of the platonic Form or Idea, is in constant combination and tension with terms denoting the whole range of the politically and historically contingent. Chief among these contingencies is the entire process of socialization, which, as we have learned from the *Protagoras*, includes rearing (*trophē*), childhood games (*paidia*), education (*paideia*) in the widest sense, as well as experience of the discourses of the courts, assembly, and theater. It is Plato's uses of and obvious investments in the discourse of *phusis* more than any tantalizing bits of plausible or implausible biography that lead me to presume to situate Plato's solutions in a specific class, the Athenian aristocracy.

Yet Plato is himself far too much a Sophist, far too imbued with their analyses of social existence and education to fit simply into so narrow a category. Broadly speaking, I would say that Plato constantly exploits for his own ends all the ambiguities of the term *phusis* without acknowledging that there are potentially fundamental conflicts in these usages. Indeed, the suppression of those sophistic teachings that lead toward radically different conclusions and goals constitute the major structured silence of the *Republic*.[46] One could never deduce from the brief squabble with Thrasymachos in Bk. 1 and the brief direct indictment of the Sophists in Bk. 6 how much of the argument of the *Republic* as a whole presupposes and subverts their doctrines by situating them in an entirely alien framework. Like Sophokles before him, Plato employs the critical insights of the Sophists in the service of a social and political goal categorically at odds with their own project. The older Sophists at least laid the philosophical foundations for a society based on equal access to participation by all adult males and the supplanting of force by persuasion. Plato's city is controlled by a highly trained, tiny elite—he seems indifferent whether it be a monarchy or an oligarchy (cf. 4.445d5–6)—recruited from a fully professionalized military, which is

[46]In such a reading of the *Republic* I am indebted to Havelock (1957).

constituted as much to control its own population as to protect it from foreign enemies (see 3.415d9–e4, note the *malista*, "especially," for domestic threats).[47] Persuasion as such plays no structural role in the society at large; it is useful only as necessary manipulation. Once the ideal city is constituted, we, the founders, must try to persuade not only the masses but even the new guardians of the "noble lies" about their origins.[48]

The Sophists, as noted earlier, appeared to have launched a fatal attack on the philosophical underpinnings of the aristocracy's pretensions to inherited superiority. If any innate superiority is accidental rather than a consequence of specific parentage and if education is far more relevant to the formation of moral qualities and capacity for rule—for these rather than simply physical or technical prowess were the chief content claimed for aristocratic inherited excellence—then it

[47]Guthrie (*HGP* 4.467 n. 1) suggests that Popper (1963: e. g., 50–51) has grossly exaggerated, but he ignores the *malista*. Moreover, the whole elaboration of the analogy of the soul implies the exclusively internal focus of the repressive activities of the two higher elements of the soul on the lower, appetitive element (442a4–b3), which is explicitly equated with the ruled element in the city. The fear that this lower part might grow strong and undertake to "enslave and rule over what is not not appropriate to its race" (442a8–b3) is also explicit. Finally, it is internal discord, *stasis*, which is repeatedly cited as the great enemy.

[48]Like so many other key motifs, despair of persuasion is introduced in the opening scene of the *Republic*. When Polemarchos playfully suggests that Sokrates and his companion must either defeat (*kreittous genesthe*) Polemarchos and his companions or remain, Sokrates replies, "Isn't there one alternative left, namely, if we persuade you that we must go away?" Polemarchos in turn replies, "And would you be able to persuade us if we don't listen?" "Impossible [*oudamōs*]," comments Glaukon (1.327c9–13). An examination of all instances of the infinitive form *peithein* throughout the *Republic* suggests how regularly the connotations of persuasion are negative. Thus as 2.361b3 the thoroughly evil man is envisioned as good enough at speaking to persuade his way out of trouble; at 3.391d6 the rulers will use persuasion on children about gods and demigods; at 3.414d3 Sokrates declares that he does not know where he will find the nerve (*tolmēi*) to persuade the rulers, soldiers, and rest of the city to believe the noble lie; at 5.458d5 he distinguishes geometric from erotic necessity, which is "doubtless keener for persuading and dragging the majority of people;" at 471e4 Glaukon suggests that they should try to persuade themselves of the questionable feasibility of Sokrates' proposals about women; at 476e1, faced with the anger of one who has only opinion (*dokhazein*) but not knowledge (*gignōskein*), Sokrates asks coyly if there is not some way "we might appease him [lit. "divert him with a story," *paramutheisthai*] and persuade him gently, concealing the fact that he is out of his mind"; at 6.489a10 Sokrates recommends teaching the parable of the cave to someone with a false view of the attitude of cities toward philosophers; at 7.525b12 Sokrates recommends "laying down a law [*nomothetēsai*] and persuading" future rulers to study mathematics seriously. In each case, persuasion involves either deceit, condescension toward the object of persuasion, or, as in the last, the addition of something stronger. Raven notes the citation in the *Gorgias* at 493a1 of the Pythagorean doctrine that "the part of our soul in which desires arise is liable to over-persuasion and vacillation to and fro" (1965: 53–54)—the same view as in the attack on *mimēsis* in *Rep.* 10.603a10–b2. Raven's major reason for dating the *Phaedrus* after the *Republic* is the lack of any positive account of persuasion in the *Republic* (1965: 189–96).

seemed nothing was left of those claims. The sophistic critique of traditional religion undermined these same claims from a different angle. If anthropomorphic gods were a human invention, there was no ontological ground for a fixed hierarchy of human society.

Plato's response in the *Republic* takes both a mimetic or traditional paradigmatic form as well as a pragmatic, programmatic form. Plato's own brothers, Glaukon and Adeimantos, central figures in the mimetic dialogue, and by implication Plato himself constitute the primary paradigmatic demonstration of the continued validity of aristocratic *phusis*. The first line of the whole work contains an indirect sort of signature, *Glaukōnos tou Aristōnos*, the names of Plato's brother and father. Glaukon, the signature figure of the opening line, is again the decisive vehicle for the second, deeper beginning at the outset of Bk. 2. His consistent "courage" (*aei . . . dē andreiotatos*, 357a2) is offered as the motive that transforms what our narrator considered a complete dialogue into a mere prooimion. This passionate intervention, seconded and eloquently abetted by Plato's other brother Adeimantos, provokes the most extraordinary outburst of praise from Sokrates, who cites the opening of an elegy attributed to the lover of Glaukon: "Sons of Ariston, divine offspring of a glorious Man" (*paides Aristōnos, kleinou theion genos andros*, 2.368a4). The terms of this amazing self-praise by Plato, the son of Ariston, adumbrate some of the major themes of what I am referring to as the discourse of *phusis*.[49] Although the homoerotic context of the poem gives no hint of the forthcoming radical proposals about women, the focus on noble sons of a noble father is amplified by reference to the process of begetting (*genos* carries strong etymological echoes of *gignesthai*, "to beget") and thus anticipates Plato's eugenics. Plato's almost obsessive quest for the "best" (connoted by the name *Aristōn*) culminates in the rule of the best, aristocracy, Plato's own term for the ideal form of government to establish in his polis (4.445d6). Designating Glaukon's verbal activity as courage reflects a consistent goal of fusing a new, purely intellectual conception of such traditional *aretai* ("virtues") as courage with the most traditional military and therefore, in a Greek context, political senses. Plato thus seeks to reestablish on a philosophically more respectable foundation the traditional grounds of heroism, both its extraordinary prestige (*kleinou*) and more specifically its blurring of the line between human and divine (*theion*). All these suggest the key terms in the discouse of *phusis* throughout the *Republic*. But most extraordinary is the eminently personal vehicle Plato has chosen to display these themes. By implication he himself is the ideal pupil

[49]The case for Plato's self-praise would be far stronger if we could establish that the battle of Megara alluded to is the one in 409 at which he could have participated.

of the ideal master, the flower of an aristocratic family, bearing the attributes of both hero and god and inspiring homoerotic admiration in virtually the only good kind of poetry—praise of the *kaloi k' agathoi* (10.607a3–8). This line of elegy thus anticipates the even more radical self-praise in the pun with which Plato introduces his own "noble lie"—the capstone to his eugenics—namely, "the god Plato" (*ho theos plattōn*, "the god in the process of fashioning/molding," 3.415a4).[50]

This paradigmatic validation and transformation of aristocratic *phusis* is combined with a detailed, analytic, radical program to solve the ideological crisis provoked jointly by the realities of fifth- and fourth-century history and by the Sophists' ideological assault on the foundations of aristocratic hegemony.

Eugenics

Plato meets head-on the Sophists' critique of the aberrations of the transmission of alleged inherited excellence, excellent fathers who have mediocre sons, by establishing the most rigorous eugenics.[51] The fundamental assumption of his eugenics, supported by the naturalistic analogy of breeding animals (e.g., 5.451c7–8, 459a2–5), is that excellent qualities, both moral and physical, observable in parents are normally transmitted to offspring by the process of sexual reproduction.[52] At the same time, the most elaborate precautions are taken against the breakdown of this inheritance principle. The guardians are repeatedly exhorted to the most careful surveillance (3.413c7–414a4, 415b3–c6, 4.423c8) of offspring to prevent an inferior progeny from remaining in the ruling elite and to discover accidentally superior offspring produced by inferior parents.

[50]I find no indications of this pun in any commentary, but I do find it in Clay's essay (1988: 19).

[51]See, e. g., the mild jibes in the *Protagoras* about Perikles' sons (319e3–320a3, 328c5–d2). It is possible that the presence of Kleinias (320a4), the younger brother of Alcibiades, described at *Alcibiades* I 118e5 as mad (*mainetai*), is itself a standing indictment of inherited excellence. The same passage in *Alcibiades* I (118d10–e2) also cites Perikles' failure to teach his sons anything of value. The *Laches*, in which the mediocre descendants of Aristeides and Thucydides, son of Melesias, are prominent, focuses on the same issue of the general neglect of education by fathers as a potential explanation of the failure of sons. The reverse phenomenon, exceptional sons born from nondescript fathers, is not something an aristocrat would celebrate, but it is the assumption of Protagoras in his analysis of the city of flute players, as noted earlier.

[52]Note the initial, enabling analogy of the noble puppy (*gennaiou skulakos*, 2.375a2) with the well-born youth (*neaniskou eugenous*). The immediate allusion here to the *phusis* of a well-born puppy implies an early choice; it also initiates the running analogy of the guardians/auxiliaries to dogs (2.375e1–4, 3.404a10, 3.416a4, 4.422d4–7, 4.440d2–3), which prepares us to accept the explicitly eugenic analogies.

There is here a revealing disparity between the elaborateness of the provisions spelled out for testing the offspring of the elite and the extreme vagueness about the rest of the population of the polis. The provision of wives and children in common and the supervised marriages apply only to the guardian class (see 5.459e2–3, 461e5–6). Only they are exhorted to be pitiless in demoting to lower classes any of their children who prove inferior (415b6–c2). Only for them is the destruction of deformed or inferior newborns specified (460c1–6). Finally, only those presumed fit for the guardian class are educated and tested throughout their youth.[53] It is therefore hard to figure out how there could be any effective upward mobility for the vast majority of the population,[54] most of whom are not in any real political sense even citizens.[55]

Everyone in the city (414d2–4) is to be indoctrinated from youth with the notorious noble lie (*gennaion ti hen pseudomenous*, 414b9–c1)— not simply as many commentators and translators have it a "generous-sized" lie or even milder Guthrie's "grand fiction," but one integral to a program of controlled generation (see *gennaō*, "beget" used at 415a8 and b1) to produce rulers who are noble or well-born (i.e., *gennaioi, eugeneis*).[56] An essential function of the myth of five races is to insist on an ontological basis for an absolute separation of social classes.[57]

The lengths to which Plato is ready to go in pursuit of and for the maintenance of this rigidly aristocratic hierarchy would probably

[53]See Guthrie *HGP* 4.455–57 on the question, is the education meant for the guardians alone?

[54]Guthrie (*HGP* 4.464) is at pains to stress that Plato does allude more than once to such mobility (4.423c-d, 5.468a), but his apologetics ignore the disparity to which I allude in the text.

[55]It is clear from 3.416b2–d1, 4.423d3, and 5.463a10 that Plato describes the demos as *politai*. On the other hand, his discussion of the advantages of wives in common creating a citizenry who all mean the same thing by "mine" (5.464a4) clearly refers only to the guardians and auxiliaries. At 2.371e1–7 he speaks of various wage-earning menials (*diakonoi*) who are not worthy of full sharing in the community (*mē panu aksiokoinōnētoi*) but fill out the population. He does not even mention slaves here, but their existence is assumed; see Vlastos 1968: 291–95; 1981: 140–47. Vlastos's argument about slavery still begs the question whether there is any truly political function for the demos in the ideal state. See the debate between Leys and Sparshott, "Was Plato Non-Political/Anti-Political," in Vlastos 1983: 144–86.

[56]Translators: Jowett, "one royal lie"; Grube, "noble fiction"; Cornford, "something in the way of those convenient fictions we spoke of earlier, a single bold flight of invention" (see his long note ad loc. in which he glosses *gennaion* as "on a generous scale"); Lindsay, "one noble falsehood"; Richards, "one spirited false statement"; Bloom, "some one noble lie" (see his note); Sterling and Scott, "a noble lie." Adam 1963 on 414B offers "a heroic falsehood." Cf. Guthrie *HGP* 4.462.

[57]This interpretation is vigorously denied by Guthrie (*HGP* 4.464–66). There is the interesting problem, which he ignores, that Sokrates offers a myth of five metals for a three-tiered state. The simplest explanation is that Plato is so anxious to absorb the Hesiodic myth into his own that he ignores the problem. But his ignoring it is also symptomatic of his indifference to those below the auxiliary class.

appall most surviving members of Plato's own class, if by that we mean both those who have traditionally belonged to Davies's liturgical class and those who take great pride in tracing their ancestry back several generations. If Plato's commitment to the discourse of *phusis* suggests his political predisposition in traditional class terms, it is nonetheless essential to keep in mind the severe limitations of any such label in dealing with so radical a thinker. If Plato's project may be said to aim at saving essential features of a political and social ideal traditionally espoused by a recognizable Athenian class, it is nonetheless true that central features of his program would prove quite shocking to members of that class. Indeed, one of the subsidiary functions of Plato's brothers in the dialogue is to signal the points that would, initially at least, most obviously strike his intended audience as quite unacceptable. Thus, as we noted earlier, the puritanism of the vegetarian idyll first proposed by Sokrates is quite unacceptable to Glaukon, who called it a "city of pigs" (2.373d4).

More fundamental objections are raised by Adeimantos to the absence of private property for the guardians, a key element in Plato's solution to the destructive greed his ancestor Solon had so vigorously chided in the aristocracy of his day. Inherited wealth is the economic reality underlying ideological claims of inherited excellence. This is as true of Homer's Agamemnon as of Aeschylus' haughty king. But Plato is ready to sweep away the economic foundations of the great aristocratic *oikoi* precisely because of the social disruptions arising from great inequities in the distribution of social surplus. In the process, he also precludes the only claim to prominence of the nouveau riches and eliminates a key factor in the indictment of Spartan ideological leadership of the Greek aristocracy. Plato's reduction of the ontological claims of *his* ruling elite to pure genetics, as then understood, thus entails both a backward-looking gesture and a radical negation of the status quo.[58]

Feminism

An even more troubling innovation, if we judge by the intervention of Plato's brothers, is the most logical and daring aspect of Plato's eu-

[58]Wood and Wood (1978) are at pains to minimize the radicalism of the abolition of private property in the *Republic* by stressing Plato's return to a rigid insistence on inherited property in the *Laws*. They do in this connection make a valid, if ahistorical, point: "Both the propertylessness of the *Republic*'s ruling class and the hereditary landed property of the *Laws* are opposed to private property in a narrower sense: what we might call bourgeois property, the . . . more freely disposable property that is the basis of a commercial society" (142–43). It is worth noting, in view of their earlier comments, that the abolition of private property would also entail the irrelevance of the elaborate provisions about legitimacy and heiresses which are central in the institutional oppression of women in Athens (see 1978: 50).

genics—his declaration that women must be presumed equals and the family as known in Greece be abolished. The rationale for this departure is again the naturalistic analogy to the breeding of hunting dogs, a line of argument in which the sophistic anthropological demystification of the human species ironically coincides with the bitterest of aristocratic polemics in Theognis.[59] Plato is thus able to cut the ground from under his shadow opponents, the Sophists, and appeal to the snobbery of his perhaps equally shadowy elite audience, for whom breeding well-bred animals is a favorite pastime (cf. 5.459a1).

There is a less explicit sense in which the proposal for wives in common and the abolition of the family follows logically from proposals already adopted for the ideal, the *stasis*-free state. Okin has stressed the deep linkage in the Greek male mind between women and private property (1979: 31–33).[60] If the private wealth of the aristocratic *oikos* is a major source of discord within the state, as Solon and Aeschylus among others had argued, why not get rid of that traditionally most troublesome "property," wives? From Homer through Aeschylus to Herodotus, it would be easy to trace the sentiments that attribute the worst domestic and interstate frictions to wife stealing.

But it would be an error to see Plato's "feminist" discourse as simply a logical outgrowth of his prior discourse without recognizing that it too constitutes a response to a crisis—even if we are far less informed about the dimensions of this crisis. Our earliest Greek sources, Homer and Hesiod, are in their different ways both haunted by women, not just wives, as a problem. The *Oresteia* is perhaps the first text to pose the problem in a context in which at least the concept if not the realization of radical change is envisioned. To historicize, even tentatively as Aeschylus does, the relation between the dominant economic and political structures of society and the behavior of women is to open a

[59]We have already seen that, In Plato's *Protagoras,* the Sophist insists that human beings are animals (*zōia*, 321c4) like other animals. Democritos, who perhaps furthest elaborates anthropological speculation about the origins and early existence of the human animal (Cole 1967), nonetheless repudiates the animal breeding analogy in favor of a factor more susceptible to education: "In the case of cattle good breeding/nobility [*eugeneia*] amounts to the good strength [*eulstheneia*] of the body; but in the case of human beings it is a matter of the good turning [*eutropiē*, usually translated "versatility"] of the character [*ētheos*]" (*D-K* B 57). For Theognis, see Chapter 4.

[60]Okin cites Morrow 1960 for the "peculiarly close relation thought to hold between a family and its landed property" (33). Guthrie (*HGP* 4.480 n. 1) comments, "Interestingly enough, P [Plato] the advocate of equality speaks twice of the 'possession' of women (*ktēsis* 423e and 451c)." It is interesting to compare Marx's early, heavily Hegelian critique of earlier theories of communism: "This movement of counterposing universal private property to private property finds expression in the brutish form of opposing to *marriage* (certainly a *form of exclusive private property*) the *community of women,* in which a woman becomes a piece of *communal* and *common* property. It may be said that this idea of the *community of women gives away the secret* of this as yet completely crude and thoughtless communism" (*MECW* 3.294).

fissure in the seamless ideology of a fated woman's lot in life. Toward the latter part of the fifth century and into the early fourth we are confronted with a great deal of highly contradictory evidence, all from male sources, that the woman question was not going away but on the contrary was becoming a male obsession and provoking "hysterical" male responses.

It has been plausibly suggested that the heavy casualties of the latter half of the Peloponnesian War together with the long absences from home necessitated by the war substantially threatened the traditional seclusion and repression of Athenian women.[61] We can infer from Euripides and Aristophanes, with the wild fluctuations in their texts between deeply moving sympathy for women and savage misogyny, that this period witnessed a great deal of serious debate about the status of women. Though we lack positive evidence, I would agree with those who infer from Euripides' articulate heroines and Aristophanes' parodies that there existed serious appeals for the equality of women and for their full participation in political life.[62] In light of the relentless polemics over female sexuality, it is hard to imagine that part of such a positive feminist discourse did not challenge the lack of freedom of choice of sexual partners for women.[63] Certainly Aristophanes' most ferocious assaults are reserved for this most threatening of notions, and his bitterest jibes at Euripides are focused on those of his characters who dared to exercise such freedom.

If there did exist such a positive feminist discourse, then Plato's proposals, for all their radicalism compared to actual Greek practice, may nonetheless also involve a gesture of containment of far more serious threats—again presumably in the public discourse of the Sophists,

[61]See Pomeroy 1975: 119 and Keuls 1985: chap. 16. B. Strauss, writing primarily of the fourth century, notes that "citizen women sometimes had to take jobs usually reserved for slaves or men: nursing, working at the loom or working in the vineyards" (1987: 56).
[62]See, e. g., Adam's appendix (1963: 1.345–55) to Bk. 5, "On the relation of the fifth book of the *Republic* to Aristophanes' *Ecclesiasiazusae*." Zeitlin's brilliant analysis (1981) of Euripides as reflected in Aristophanes' *Thesmophoriazousae* eschews any reference to actual politics but has rich implications for the last quarter of the fifth century.
[63]See Pomeroy 1975: 115. Havelock (1957: 292–94) speculates on admittedly slim evidence that Antiphon conceived of "mating as a union of natural spontaneous affection" and attacked "the institution of the Greek family as understood in his day." Knox (1979: 311–12) also looks to Antiphon, citing J. H. Finley's (1967: 92–94) comparison of Medea's speech with Antiphon's attack on marriage. He concludes, "One cannot help suspecting that much later, Plato, when he says in the *Republic* that to divide male and female for the purposes of public life or education or anything, except the begetting and bearing of children, is just as absurd as to divide it into the long-haired and the bald, may well be adapting to his own purpose, as he does so often, ideas that were first put into circulation by the sophistic radicals of the fifth century." See also Winnington-Ingram 1983b: 234–36.

though some have suggested Sokrates himself as a key figure.[64] On the one hand, women receive the same tests as men, and to the extent that they succeed, the same education and training as men. Those women who are potentially members of the ruling class are completely removed from any direct influence qua mothers over children; both men and women will do childcare, but no aristocrats (5.46ob9). Like the males of the ruling elite, guardian-class women's sexuality is completely controlled by the state. There is the implicit reward system that grants more frequent sexual activity to those presumed to be breeding the best offspring, but this is only a relatively greater frequency in elaborately controlled state breeding festivals. Presumed good breeders will win the rigged lottery more often, but this is far from either free choice of partners or the potential frequency of cohabitation, which is nonexistent except perhaps for older men and post-menopausal women (5.461b9–c1). It is also true that the emphasis on sex as a reward is expressed primarily in terms of the males.[65]

In spite of this containment, in spite of scattered stereotypical sexist remarks let slip here and there throughout the *Republic,* and in spite of the substantial retreat in the *Laws,* the philosophical rigor of Plato's response here to the putative woman crisis remains dazzling.[66] Perhaps its most striking feature—particularly in light of the essentialism that

[64]Wender (1973: 75–90) notes the lack of evidence for views sympathetic toward women in the Sophists (Democritos is "distinctly hostile") and endorses with some qualifications Taylor's view of a feminist Sokrates. It is perhaps safest to say (following Laclau and Mouffe 1985) that doctrines of natural equality or equality of rights for all tend to appeal to those human beings, whether slaves, women, or racial minorities, who may well have been bracketed out by the original proponents of the doctrines. It is striking, considering the grim view most contemporary students take of the status of women in Athenian democracy, that Plato cites as a mark of the excessive license under a democracy "how much equality before the law [*isonomia*] and freedom [*eleutheria*] arises among women with respect to men and among men with respect to women" (8.563b7–9). Aristotle associates democracies with tyrannies because of the "power given to women in their families." "Women," he asserts, "are of course friendly to tyrannies and also to democracies, since under them they have a good time" (*Pol.* 1313b34–38 Barnes (1984: 2085–86), cited in Vidal-Naquet 1970a: 65). In looking for male sources for these doctrines, I have in mind only the realm of public discourse, from which women were, as far as we know, excluded. It seems to me evident that the initial impulse for rethinking the status of women came from women themselves.

[65]See Pomeroy 1975: 116, a bit unfairly stated. See 5.468c3, where those best in battle may kiss anyone they desire, male or female, and 5.468e1–2, where honors are for "both heroic men and women (*tous agathous andras te kai gunaikas*)."

[66]Cf. Wender 1973. Irigaray 1985: 152–59 is a convenient listing of passages on woman in Plato's works apart from *Republic* Bk. 5 and the *Laws*. Okin (1979: 42–50) shows some of the ways in which, despite its formal retreats, the *Laws* contains some philosophically more radical defenses of feminism, especially the analogy of ambidexterity. Bluestone (1987) is perhaps the strongest modern feminist defender of "the continuing importance of Plato's questions"—the title of her final chapter. She ignores the objections raised by French feminism.

normally seems, as it were, Plato's middle name—is his rigorous critique of an essentialist discourse of women. He grants only that women are generally weaker than men (5.451e1, 455c4) but adds that many women are unquestionably superior to some men (5.455d3). If one takes seriously Plato's usual logic that even a single exception philosophically invalidates any generalization, this addition implies a categorical refutation of his own generalization about female weakness; no philosophically valid conclusion can be drawn from the phenomenon that many women are weaker than men. Beyond that, Plato argues with a telling analogy that the presumed differences between men and women are as inessential as the putative differences between bald and nonbald men (5.454c2). As far as guardianship is concerned—that is, the capacity for total control of the military and political power in society—men and women have the same *phusis* (*hē autē phusis*, 5.456a).

To many contemporary feminists the solution implicit in effacing all differences between male and female is not acceptable.[67] The long debate, better conceived of as a dialectic, between equally legitimate demands for equality and for recognition of difference has not infrequently focused on the *Republic*.[68] But in the face of a long specifically Greek tradition of intense misogyny based on a frightening and repellent otherness of the female, Plato's daring remains awesome. He does not go into details, but even this silence is powerful. He feels no need to refute or endorse the array of misogynist Greek discourses elaborated over centuries. He is not shocked, as his brothers clearly are, at the prospect of nude gymnastics with women (457a6). With a certain self-righteous eloquence he concludes, "The female guardians must indeed strip inasmuch as they shall clothe themselves with excellence (*aretē*) instead of garments" (5.457a6–7). And even if, as some scholars have pointed out, he seems to have forgotten about women during much of the rest of the dialogue, he never shrinks from the implication that women will participate in the severest rigors of advanced dialectics, that women as such are fully qualified physically and mentally for the highest tasks of the ideal society. These more progressive features of his

[67]I can only agree with Okin's focus on the critique of essentialism (1979: 39–40) as the most original and radical feature of Plato's discourse of women; cf. Bluestone 1987: 95–96. For an attack on Plato's treating women as indistinguishable from men, see Irigaray 1985, e. g., "Apart from the fact that she will perform her duties less well, as a result of her inferior nature, she will also participate only insofar as she is the same as a man" (157); "In order to take full possession of himself, man will need to take over not only the potentiality and potency, but also the place, and all the little chinks (re)produced in his ceaseless drive to transform anything different and still self-defining into his own likeness" (165–66).

[68]I am indebted to Michèle Barrett for a stimulating overview of the equality–difference debate in feminism at the 1989 meeting of the Modern Language Association in Washington, D.C. See also Joan Scott 1988: 167–98.

utopia lay dormant like a mute indictment of Western society during the long centuries in which so many repressive features of his vision were eagerly endorsed and grimly implemented (Bluestone 1987: esp. 4–19).

Justice and *Phusis*

Plato's feminism is one dimension of his discourse of *phusis*, namely, his program of eugenics, which most obviously situates him in the "camp" of aristocratic ideology vis-à-vis the threats of sophistic teaching, even as the radicalism of his solution carries him beyond his class base. But eugenics is only a revealing subsidiary of Plato's primary discourse of *phusis* which emerges as the solution to the most explicitly posed and most comprehensive crisis envisioned in the *Republic*, namely, the question of justice. Justice, the central goal relentlessly sought through the long dialectic of the *Oresteia* and figured there in the utopian image of democratic Athens, is in the *Republic* the vehicle—at times one is tempted to say the pretext—for the utopian leap to the ideal city. This leap, in turn, for Plato implies the negation of the whole cultural heritage of Greece, the analysis of the psyche, the elaboration of a new epistemology, the critique of all existing forms of government, the sustained repudiation of all forms of *mimēsis,* and finally the eschatology of the myth with which he concludes. But like Plato's eugenics, the essence of justice turns out to be firmly rooted in the traditional aristocratic ideology of inherited excellence and aims most immediately at the repudiation of Athenian democracy and the sophistic ideology that sustains it.

The most concise definition of the principle of justice is *ta hautou prattein* (433a8), "doing what is one's own." But what is one's own turns out to be that one thing for which each of us is best suited by birth (*phusei*). Lurking behind the sophistic apparatus of a social contract (Havelock 1957: 94–101) in which this principle is first articulated, we can hear something nearer the blatant declaration of Pindar, "What is by birth is most powerful in every case" (*phuai to kratiston hapan, Ol.* 9.100). Rather coyly Plato introduces his fundamental principle in the context of envisioning a society at its simplest, conceived initially in terms of the Greek anthropologists' materialist criterion of *khreia* ("need," 2.369c2, 10) which dictates food production, manufacture of clothing, and building of shelter. The sophistic valorization of *koinōnia* ("sharing," "communality") is then invoked against individual efforts to achieve individual *autarkia* ("self-sufficiency," "economic independence," 2.369b6), which is described with disparaging redundancy as *auton di' hauton to hautou prattein* ("doing oneself one's own [tasks] though one's own [efforts]," 2.370a4). Plato would be well aware from

Homer and especially Hesiod's *Works and Days* that this was the earliest known pattern in Greece, but he also knows that it was accompanied by minimal social bonding in a polis. It is precisely the lack of individual *autarkia* which is given as the initial impulse for founding cities (2.369b5). Sokrates then proceeds with apparent casualness to invoke the discourse of *phusis* to confirm the communal mode of production based in the most rigid division of labor: "It occurs to me too now that you've spoken, that in the first place each of us is born [*phuetai*] not quite the same as each, but since each differs with respect to innate character [*tēn phusin*], one will perform one task [or function, *ergon*] and another another" (2.370a7–b2).

What is most striking here is the pseudo-casualness with which this concept is introduced and the blatancy with which it is justified by a totally unphilosophical, commonsense appeal to empirical observation. It is when he resorts to empirical commonsense that Plato reveals most openly the ideological direction of the argument.[69] The experience of humble craftspeople is first invoked as the proof of the thesis that each of us is born fit to do only one thing (2.370a6–b6). It would be hard to guess from this seemingly inoffensive, practical-sounding line of argument that this principle entails the most fundamental repudiation of the alternative democratic and sophistic discourse of human nature.

Central to sophistic anthropological speculations—which are also reflected in the *Prometheus Bound* and the famous chorus of Sophokles' *Antigone* which meditates on the achievements and dangers of the human species (*Ant.* 332–83)—is the celebration of human craft inventiveness as the achievement of the whole species, as characteristic of the innate capacities, the tremendous potential versatility of human beings qua human beings, not as a principle of hierarchy distinguishing some from others. The specifically democratic corollary of this view of human nature is the assertion that political freedom releases human potential, enables the full development of the capacity for a thoroughly admirable versatility. The thought is expressed with a certain dour power by Herodotus as he comments on the Athenians' success in repulsing all the reactionary powers who banded together to crush the new democratic revolution:

[69]Another obvious instance of the appeal to empirical commonsense is the enabling analogy of the philosophical dog, which combines the apparent contraries of ferocity and knowledge (375a2–376c5). Socrates has himself raised the objection to his own principle of specialization of labor in the case of the full-time professional army, which he presents as essential to the state (the rationale for this militarization of society is another ideological detour). The parallel of the dogs establishes only that versatility is not necessarily against nature, but Plato is not about to abandon his principle of specialization as a result. On the contrary, this point simply becomes a basis for defending the paucity of those with access to rule.

The Athenians now flourished [*euksēnto*]. It makes clear, and not just from this one instance but in all respects, that the right to equal speech in the assembly [*hē isēgoriē*] is an excellent thing [*khrēma spoudaion*], if the Athenians, who, when they had tyrants were—where wars were concerned—no better than any of their neighbors, but when they got free of their tyrants, became by far the best [*prōtoi*]. These things then make clear that when they were held back, they willingly played the coward because they were working for a master, but when they were liberated, each one was eager to work on behalf of himself [*autos hekastos heōutōi*]. (5.78)

Herodotus' celebration of individualism may misleadingly suggest nineteenth-century liberalism; but, unlike Plato, Herodotus assumes a perfect harmony of self-motivated, self-interested labor and the keenest commitment to the defense of the polis-community as a whole. The same perspective is clear in Thucydides' account of Perikles' funeral oration:

In sum, I say that the whole city is the education [*paideusis*] of Greece and with respect to the individual citizen, he seems to me to present himself [lit. "his body"] from among us as self-sufficient [*autarkes*] in the face of the most varied situations and with the greatest grace and versatility [*eutrapelōs*]. (2.41.1–2)

For Plato, however great his own versatility, this democratically celebrated versatility is the ultimate nightmare.[70] The worst consequence for the individual of *mimēsis*, in the sense of acting or emotionally associating with literary characters, is that it leads to moral and emotional versatility (3.395d). In Plato's vocabulary versatility is synonymous with meddling, being a troublesome busybody (*polupragmonein*, lit. "doing many things"), and the very antithesis of justice:[71] "Each individual ought to pursue the one thing in the business of the city for which his nature was born and has grown most suited [*eis ho autou hē phusis epitēdeiotatē pephukuia eiē*]. . . . And indeed the doing of what is one's own and not being a busybody [*mē poluprogmonein*] is justice" (4.433a5–9). The negation is fully as integral to the definition as the affirmation. Half a page later Plato again describes justice as the principle "that each person, being one person, perform that which is his/hers and not meddle [*kai ouk epolupragmonei*]" (4.433d4–5). Moreover, the allegedly

[70]"Of all men who ever lived Plato must have been one of the most versatile" (Raven 1965: 9).

[71]Ehrenberg 1947: 46–67 is a masterful survey of the history of the term, which is overwhelmingly negative in our predominantly anti-democratic sources but completely bound up with the Athenian democracy's positive self-image. For the term's interaction with its apposite, *apragmosunē*, see Carter 1986: esp. 117–18.

self-evident empirical data of the specialization of practical crafts which initially validated this principal of innate differentiation turns out to be a matter of relative indifference for Plato:

> If a carpenter undertakes the function of a shoemaker or vice versa . . . or if the same person undertakes doing both jobs, do you think that does any damage to the city? Not at all. . . . But I believe that if a worker or someone who is a moneymaker by nature [*phusei*] undertakes to enter the military class, or if someone in the military undertakes to enter the class of deliberation and guardianship without being worthy of it, *then* I believe it seems to you as well that *this* change and meddling [*polupragmosunē*] means destruction for the city. (4.434a2–b7)

Thus it emerges that the only critical capacity determined by one's inherited nature is the capacity to rule—just the issue in the ideological debate over birth which is central to Homer, Pindar, Aeschylus, and Sophokles (to pick some nonrandom examples). In Plato's utopia, then, justice turns out to be a willing adherence to the hierarchical division of classes achieved by Plato's eugenics (Cross and Woozley 1979 [1964]: 109–10; contra Guthrie *HGP* 4.473 n.2).

This discourse of *phusis* as a principle dividing rulers from ruled by birth is recapitulated in the analysis of the individual psyche, in which justice is also the principle of subordination of the naturally inferior parts to the naturally superior part. Here, however, the discourse of nature is ontologically linked not to human procreation or aristocratic ancestry but to the structure of reality and ultimately the Form of the Good, which in turn is associated with divinity. The calculating element in the soul is the only part that sees reality as it truly is—the reality of the Forms, which are divine. It is only by contemplating these that a human being can approach the condition of divinity: "Indeed, by consorting with what is divine and orderly the philosopher at least becomes both orderly and divine to the extent possible for a human being" (6.500c9–d1).

The gap between the discourse of human *phusis*, encompassing both eugenics and the organizational principle of the just polis, and *phusis* as the organizational principle of ultimate reality is the point at which the specifically political project founders on the rock of platonic ontology. The realm of the good, knowledge of which is fundamental to the success of rulers, is by definition totally separate from the realm of human generation. To be sure, Plato constantly suggests a clear connection by his elaborate description of the philosophical *phusis* (6.485a4–8)—where the term *phusis* ought to mean simply natural endowment without reference to specific parentage—in terms that constantly re-

call the *phusis* of the guardian which *is* presented as in some sense a product of the eugenic arrangements. The philosophical *phusis* is hypothetically presumed to come from a rich and noble family (*plousios te kai gennaios*, 494c6), and the catalogue of its virtues corresponds to those of the guardian as genetically engineered in the earlier books.

Yet finally Plato himself explicitly insists on the relevance to the political project of this separation of the realm of generation from the realm of the Forms by his recourse to the heavenly number (8.546a7–547a5). I, at least, deduce from this endlessly debated passage that (1) the cosmos is presumed to be mathematically ordered, (2) that there is potentially a connection between this order and the process of human procreation, but (3) that even to the most perfectly trained philosopher-rulers this order is ultimately inaccessible.[72] On this catch-22 the ideal city meets its inevitable doom.

Phusis and *Didachē:* The Collapse of an Opposition

The disjunction between, on the one hand, human *phusis* with its fatal baggage of mortality and, on the other, the pure realm of the good is not the only basis on which Plato's discourse of *phusis* is deconstructed within the text of the *Republic*. The sophistic alternative to aristocratic *phusis* is *paideia*, education and socialization in the broadest sense as the far more relevant determining factors of character. Here Plato is far more a Sophist himself than a conservative aristocrat. For all his attachment to the connotations of *phusis* and in spite of his otherworldly distrust of education as itself inherently contingent, he accepts the core of the sophistic analysis. Yet his constant harking back to aristocratic *phusis* mystifies his acknowledgment of the overwhelming power of *didachē*.

In earlier dialogues Socrates is represented as opposing the view that *aretē* can be taught. His initial, ironic proof of this proposition in the *Protagoras* is that the Athenian assembly lets all comers speak on issues of general policy for which *aretē* is relevant (*Prot.* 319a10–d7). On the one hand, this argument seems to anticipate the quest for government by highly educated experts rather than constituting a serious repudiation of teaching. It was just such experts that the Academy, itself adumbrated in the account of the advanced curriculum in the *Republic*,

[72]Adam 1963: 2.264–312 is a long appendix on interpretations of the magical number. Guthrie *HGP* 4.529 n. 1 brings the vast bibliography up to 1975. I agree with Guthrie that "Plato amuses himself with a pedantic theory" (528), but I think the philosophical point is in deadly earnest.

would produce to serve (and on occasion to murder) various kinglets and tyrants (Davies 1978: 235–36; Field 1967: 43–45). On the other hand, the *Meno*, with its doctrine of *anamnēsis* (recollection), suggests how desperately Plato sought some alternative to a sophistic view of education as adding to and transforming an essentially indifferent raw material. This doctrine of *anamnēsis* is presumed to be operative in the parable of the cave and the myth of Er (Guthrie *HGP* 4.559 n. 1; Raven 1965: 176), but these passages show traces of a fundamental ideological suture (Laclau and Mouffe 1985: 88 n. 1), a stitching over a hole in the argument made by an ideologically unacceptable implication of Plato's own argument. The doctrine of *anamnēsis*, first illustrated with a slave in the *Meno*, is a general statement about the educability and capacity for knowledge of human beings qua human beings. It is an unalienable potentiality. In the parable of the cave, Sokrates spells out the potentially democratic thrust of his theory of education:

> We must, if these things are true, believe some such thing as this about them: education is not the sort of thing some people announce that it is. They say, I infer [*pou*], that they put knowledge into a soul that does not have it—as if they had put sight into blind eyes.... But our present argument ... indicates that this faculty [*dunamin*] is in the psyche of each person as well as the organ with which each person learns. (7.518b6–c6)

The logical possibility that everyone qua human being is capable of being turned toward the light is explicit. Despite the radically different *telos* of platonic education, this account of human beings corresponds closely to the position taken by Protagoras in the *Protagoras*. Everyone who actually lives in society is by definition capable of learning what the society wants its members to learn, and the entire analysis of the socialization process Protagoras offers insists on the effectiveness of this mass education. Yet, despite the fact that the rationale for educating everyone in the polis is present in the text, the idea as such is scrupulously avoided. How?

The entire discourse of *phusis* in the *Republic* seems on this level designed to give some ontological support to a view of education that would *not* be available to all comers. In this context, a glance at the hostility of those who are uneducated and the indifference of the overeducated (7.519b7–c6) leads to this rigidly elitist non sequitur: "Our task as founders is to compel the best natures [*tas beltistas phuseis*] to arrive at the study which before we declared was the greatest, to see the Good, to make that ascent" (7.519c8–d1). Throughout the *Republic* Socrates again and again emphasizes all the factors that determine the extreme rarity of the appropriate *phusis* for the ruler's education, and

this rarity is from the outset associated with noble birth. We have already noted the exceptional weight placed on the well-born puppy analogy for separating guardians from ordinary brutal soldiers, and there is no particular point in going over the other natural aptitude tests invoked in the first-round choice of the guardian class. It is when the paradox of the philosopher-ruler is enunciated that the second round of arguments from *phusis* is invoked to keep the pool of potential leaders as small as possible. The rarity of the right *phusis* is first invoked as a defense against those who would immediately attack Sokrates for his paradox: "It is fitting for some by nature [*phusei*] to embrace philosophy and rule in the city, but for others not to embrace it, but to follow the leader" (5.474b4–c3).

After a long detour detailing all those unfit for philosophy, we come back to the definition of those who have this capacity, "the nature [*phusin*] that one who is to become *kalos k' agathos* must be born with [*phunai*]" (6.489e4–490a1). Again a traditional term for an aristocratic gentleman is equated with the true philosopher. This "true [in contradistinction to all those who have just been decisively excluded] lover of learning would have a birth-given capacity [*pephukōs eiē*] to strive toward reality [*to on*]" (6.490a8–9). Sokrates continues with a sexual metaphor to elaborate on this striving toward reality:

> He would not remain among those things which are believed in opinion to be many particulars, but rather he would go on and would not blunt the edge of his desire [*erōtos*] or give it up before he has seized the essence [*phuseōs*] itself of each thing with that part of the soul with which it is fitting to seize on such an object—fitting because akin to it [*sungenei*]. With this part he approaches closely and truly has intercourse [*migeis*] with reality [*tōi onti*], engendering [*gennēsas*] understanding and truth, and he will gain knowledge and truly live and thrive and in this way leave off his birth pang [*ōdinos*] and not before that. (6.490b1–b7)[73]

This extraordinary passage, a metaphorical cross between a Spartan-style marriage, incest, and male parthenogenesis, insists in terms diametrically opposed to the species-wide capacity for learning articulated in the cave passage that only the true philosopher has the innate capacity and the organ for this union with the real.

After detailing the other virtues of this *phusis* and announcing that he will explain how it is corrupted so that only a few (*smikron ti*) escape,

[73]See duBois' analysis (1988: 169–83) of the general tendency, well illustrated in this passage, of Plato's sexualization of philosophy to appropriate both female and male imagery of procreation. Thus the initially purely phallic intercourse of the philosophical *phusis* with reality culminates in a kind of self-impregnation entailing a normally female birth pang.

Sokrates, the philosophical enemy par excellence of the opinions of the many, makes another of his rare and ideologically symptomatic appeals to a *consensus gentium:* "On this point then I imagine everyone will agree with us, that such a nature [*phusin*], having all the attributes which we just now catalogued, if it is to become perfectly [*teleōs*] philosophical, is rarely [*oligakis*] born [*phuesthai*] among human kind and few in number [*oligas*]" (6.491a8–b2). This triumphant conclusion precedes the parable of the cave, so the audience has already been heavily pressured to accept this narrow conception of human educability before being exposed to a view with markedly different implications.

Plato's solemn silence on the issue of educating the many is as clear an evidence of his horror of democracy as his explicit glossing of *ta hautou prattein* (doing one's own) by *kai mē polupragmonein* (and not being a meddler) (4.433a8). For, as we have seen, the democratic celebration of the human capacity for versatility goes hand in hand with the sophistic celebration of all that can be added to the *phusis* of the pupil by education. To this extent, the combination in the *Republic* of absolute state control of breeding and of every phase of socialization seems to meet the sophistic threat irrefutably. In so absolutist a thinker, however, the compound proves quite unstable. The elaboration of the impact of the wrong sort of socialization beside the detailed presentation of all that the correct socialization would entail ends in confirming the sophistic downgrading of the relative importance of *phusis*. Plato concedes indeed that, the better the *phusis*, the more vulnerable it is to corruption by the wrong socialization; he even confirms it by the naturalistic analogy of a plant in the wrong soil (6.491d1–5). This analogy represents a revealingly pessimistic and characteristically aristocratic reversal of Antiphon's use of the same analogy:

> The first thing, I believe, among human beings is education [*paideusis*]. For whenever one makes the beginning correctly of anything whatsoever, it is likely as well that the end will turn out correctly. And whatever seed one plants in the ground, such are the fruits one must expect. And whenever one plants a noble [*gennaian*] education in a young body, it lives and thrives through his whole life, and neither downpour nor drought will tear it away. (*D-K* B 60)

Antiphon presents nobility as an attribute of education itself. The body of the pupil is the soil, the character of which appears in his wording to be a matter of indifference, while the seed is daringly equated with education. The consequences of the process have the very stability and permanence that the medical writers attribute to the individual *phusis*. For Plato, as for Pindar (*Ne.* 8.40–43), the plant is associated with in-

nate virtues that require the right soil. But more pessimistic than Pindar, Plato seems obsessed with the unavailability of such an educational environment in his world.

Plato's anxiety over the necessity of the correct socialization repeatedly brings him to the verge of echoing Democritos' devastating assault on the exclusive claims of *phusis*. For Plato too education "makes *phusis*" (*phusiopoiei*). Plato's own analogies of education to molding or setting a stamp in clay (2.377b1–2) or to dyeing cloth (429d4–e5) imply as much, but always in the negative sense of the threat of the wrong education. To sum up his horror of the wrong sorts of *mimēseis*, he states explicitly: "Don't you realize that imitations, if they are carried on through from youth become established with respect to one's behavior and nature [*eis ethē te kai phusin kathistantai;* Grube translates 'become part of one's nature']" (3.395d1–3).

To put it most accurately, Plato does not seem to acknowledge explicitly that education "makes" *phusis;* more poignantly, in the real world of democratic Athens, it breaks *phusis*. Still, as Okin acutely points out (1979: 57), the deeper reason that the noble lie is a lie is that it implicitly acknowledges that the precious *phuseis* of the guardians are in fact socially, *educationally* constructed—not consequences of their genetic endowments.

Conclusion

The *Republic* gives us at once both the most powerfully articulated defense of aristocratic inherited excellence and the fullest demonstration of its fragility and inadequacy before the ideological apparatuses of the state. The Pindaric *phusis* Plato seeks to save is doubly trapped: it partakes of the vagaries of mere generation and it is ultimately defenseless against the power of poeticized public discourses promulgated by state power. Nonetheless, the radicalism of his attempted solution—his utopian negation of the whole range of democratic discourses as he posits an ideally rational state in which both birth and education are perfectly harmonized with the dictates of reason—represents an at least provisional ancient closure on the still hotly contested terrain of nature versus nurture. We may justly feel a certain horror at what this particular utopian model has inspired through the centuries, but any serious attempt to find better alternatives must lie on the far side of confronting Plato's attempted solutions.

Afterword

We are taught to read classical texts teleologically—to understand the rationale for whatever comes before in the text as an anticipation of or preparation for whatever comes at the end. So too there is a strong disposition among interpreters of ancient Greek civilization to read what comes before Plato as caught in a Hegelian dialectical spiral ascending inevitably toward its culmination in Plato. Thus what is negated along the way is felt to be somehow superseded—not annihilated but preserved on a more sublime plane.

The Marxist model I have applied in the preceding chapters treats both the reading process and the study of historical continuities and disjunctures rather differently. The winners in particular struggles are not endowed with any a priori claim to virtue, but there are reasons worth looking for in assessing why the winners won and the losers lost. Particularly in examining the ideological level of struggle, Benjamin's dictum that "even the dead will not be safe from the enemy if he win" (1969: 255) is a salutary corrective to the more blandly optimistic Hegelian model. The winners determine what if anything is remembered of the losers, and they are in a position to distort whatever is remembered beyond all recognition. Plato's representation of the Sophists, Greek tragedy, lyric, or epic expresses his own ideological agenda. That agenda deserves to be appreciated in its own right as an extraordinarily creative response to a set of conditions not of Plato's making. That Homer's Achilles is convicted of undignified excess in grief, greed, immoderate brutality, and contempt of men and of gods (*Rep.* 3.388a5–391b6), that Odysseus must be stripped of his will to achieve and

dominate the polis and instead become an *apragmōn*, a political quietist (*Rep.* 10.620c3–7), that the drama and public discourse of democratic Athens become figured as meaningless and seductive idols of the cave—all this is quite intelligible in terms of that Platonic ideological agenda. Even Pindar, whose vision of an ideal community dominated by the scions of the great families seems to have contributed so much to Plato's own utopian project, appears in the *Republic* only as one who fosters the illusion that wealth is equivalent to justice (1.331a1-b1) and along with the tragedians perpetuates morally reprehensible myths (3.408b7-c1). The dazzling, hypnotic power over sound effects, images, and narratives by which Pindar claims to lift us into a divine realm is precisely what must be mercilessly expunged from the new education.

Plato's version won in the sense that the new monarchs and their essential support systems of professional mercenaries and bureaucrats had the power both to crush the amateur citizen-soldiers of the democracy and to set the educational agenda for the foreseeable future. But because ideological struggle seeks to resolve real conflicts with imaginary solutions, because the form of those imaginary solutions must confront and respond to the forms of alternative visions, ideological victories are rarely complete or permanent. Were there no oppressed underclass challenging the claims of the oppressors to define reality, there would be no specifically ideological struggle. The voices of the challengers must be somehow incorporated in however a distorted form in the discourse that seeks to answer their challenge. Moreover, because this impulse to define reality in terms favorable to the oppressors is doomed to promise more than it can deliver, there is an inherent utopian negation of the status quo in the very defense of that status quo. Such in summary form is the rationale for the hermeneutic means by which we have sought to let speak the multiple voices of these canonical texts. We have listened for the voices of contending classes and utopian negation in the allegedly homogenized aristocratic discourse of the traditional epics. In Pindar's towering vision of the constitutive power of poetic language, we have heard the emergence of a rhetoric that will sweep aside the old rules of political discourse. In the very sensuous richness of his idealization of aristocratic society we have heard the voice of its negation, the declaration of its inadequacy. In Aeschylus' triumphant vision of the dialectical emergence of democratic justice, we have heard the smouldering threat of aristocratic stasis and an implicit demand for sexual justice that indicts the society it celebrates. Sophokles' seemingly nostalgic cooptation of an anthropological ground for aristocratic *phusis* lets us hear the democratic case for the social construction of identity by education. The drama's celebration of aristocratic male-bonding enlists us in a cry of common

humanity over inhuman pain, a sympathy that defies the impositions of any state. Finally, in Plato's apparently seamless totalization of state control over both birth and éducation, we can hear the negation of private property and that systematic subordination of women that were the founding conditions of the aristocratic valorization of inherited excellence. We also hear, beside the denigrating assault on the Sophists' mode of discourse and democratic arena of activity, a despairing acknowledgment that they were right about the priority of education over birth.

The formal trajectory from epic formulas to choral lyric, trilogy, single play, philosophical dialogue is similarly not intelligible on the basis of a purely internal Hegelian logic of forms. Concrete political, economic, and technological developments called forth the mammoth poems that signaled the death of epic. The development of literacy and the specific institutional forms of aristocratic struggle for legitimacy are specific preconditions of the epinician form. No less the specific forms of class struggle in Athens during the sixth and fifth centuries B.C. are necessary contributory factors in the emergence of tragedy and trilogy. So too the impact of literacy and the political role of both drama and rhetoric are essential to our grasp of the conditions of possibility of Plato's massive prose dialogue.

At the same time these various forms do have their own material weight and their own internal dynamic that cannot be reduced to a simple reflex of their conditions of possibility. Homeric formulas, type-scenes, and traditional story patterns preclude certain kinds of discourse even as they enable others. The fact of cultural continuity within the period we have considered means that Homeric forms continue to exert a distinct pressure on all subsequently dominant forms of discourse, since these later forms are not free not to respond to Homer. If changed conditions call into being new forms, these must compete with the existing forms. Homer is more than a quarry of stories and phrases to be mined and reworked at will. Those stories and phrases manifest their own specific gravity, however self-conscious the will to transform them may be. Pindar's efforts to forge more memorable images of heroic grandeur and break the relative predictability of the hexameter line reminds us of the model phrases even as we catch the echo of the hexameter's opening cadence in the creative play of the dactylo-epitrite. The images and narratives by which Aeschylus launches his massive assault on the aristocratic heroic *ēthos* bring to life again that Homeric world as the price of its negation. Sophokles' nostalgic celebration of Achilles-like radical negation of the status quo carries into democratic and Sophist-taught Athens a Homeric aura that bespeaks its own age. Finally, Plato, who feels the compulsion to launch

a last attack on Homer's Odysseus on virtually the last page of his vast opus, testifies throughout to the pressure exerted by Homer's mixed mode of narrative and drama as well as by Homer's ethical weight.

The play between ideological struggle and formal struggle is only discernible by analytic abstraction. But such an analysis helps clarify why neither aspect can be grasped within a purely internal history. Real history, the history of living human beings confronting conditions not of their own making and struggling to make a livable life, generates the terms of ideological struggle and educates the five senses through the struggle of forms.

References

La chair est triste, hélas! et j'ai lu tous les livres.

—Stéphane Mallarmé
"Brise marine"

All works referred to in the text are included below. Although I include as much relevant material as possible, I favor work in English and give only translations of those German and French works available in translation, even though in some cases I first encountered them in the original. It is not possible to cite every work that has influenced the formation of my views.

Abbreviations

D-K Hermann Diels and Walther Kranz, eds. *Die Fragmente der Vorsokratiker.* 11th ed. 3 vols. Zurich/Berlin: Weidmann, 1964.

HGP W. K. C. Guthrie. *A History of Greek Philosophy.* 6 vols. Cambridge: Cambridge University Press, 1962–81.

LSJ Henry George Liddell, Robert Scott, and Henry Stuart Jones. *A Greek-English Lexicon.* rev. ed. Oxford: Oxford University Press, 1940.

MECW Karl Marx and Frederick Engels. *Collected Works.* New York: International Publishers, 1975– . vols. 1–26, 28–32, 38–44 (in progress).

Greek Texts

I list here only texts on which I comment in detail. Passing references to other Greek authors may be assumed to come from the Oxford Classical Text editions unless otherwise noted.

Aeschyli Septem Quae Supersunt Tragoedias. Edited by Denys Page. Oxford: Oxford University Press, 1972.

Aristotelis Atheniensium Respublica [*Ath. Pol.*]. Edited by F. G. Kenyon. Oxford: Oxford University Press, 1958 [1920].

Bacchylidis Carmina cum Fragmentis. Edited by Bruno Snell. Leipzig: Teubner, 1961.
Hesiodi Fragmenta Selecta. Edited by R. Merkelbach and M. L. West. Oxford: Oxford University Press, 1970.
Hesiodi Theogonia, Opera et Dies, Scutum. Edited by Friedrich Solmsen. Oxford: Oxford University Press, 1970.
Homeri Opera. 3d ed. Edited by David B. Monro and Thomas W. Allen. 4 vols. Oxford: Oxford University Press, 1920. A fifth volume contains the "Homeric Hymns" and ancient testimonia about the epic cycle.
Iambi et Elegi Graeci Ante Alexandrum Cantati. Edited by M. L. West. 2 vols. Oxford: Oxford University Press, 1971.
Pindarus. Edited by Bruno Snell. 2 vols. Leipzig: Teubner, 1964.
Platonis Opera. Edited by John Burnet. Oxford: Oxford University Press, 1957 [1902].
Poetarum Lesbiorum Frangmenta. Edited by Edgar Lobel and Denys Page. Oxford: Oxford University Press, 1963.
Sophocles, The Plays and Fragments, pt. 4: The Philoctetes. Edited by R. C. Jebb. Amsterdam: Servio, 1962 [1898].

Works Cited

Adam, James. 1963. *The Republic of Plato.* 2d ed. 2 vols. Cambridge: Cambridge University Press.
Adkins, Arthur W. H. 1960. *Merit and Responsibility: A Study in Greek Values.* Oxford: Oxford University Press.
——. 1970. *From the Many to the One: A Study of Personality and Views of Human Nature in the Context of Ancient Greek Society, Values, and Beliefs.* Ithaca: Cornell University Press.
Adorno, Theodor W. 1981. *Prisms.* Translated by Samuel and Shierry Weber. Cambridge: MIT Press.
——. 1984. *Against Epistemology.* Translated by Willis Domingo. Cambridge: MIT Press.
Albert, Michael. 1987. "Why Marxism Isn't the Activist's Answer." *Monthly Review* 39 (December): 43–49.
Alt, John. 1981. "Alvin W. Gouldner, 1920–1980." *Telos* 47 (Spring): 198–203.
Alt, Karin. 1961. "Schicksal und ΦΥΣΙΣ im *Philoktet* des Sophokles." *Hermes* 89:141–74.
Althusser, Louis. 1969. *For Marx.* Translated by Ben Brewster. New York: Random House.
——. 1971. *Lenin and Philosophy.* Translated by Ben Brewster. New York: Monthly Review Press.
——. 1984. *Essays on Ideology.* London: Verso.
——, and Etienne Balibar. 1970. *Reading "Capital."* Translated by Ben Brewster. London: New Left Review Editions.
Amis, Kingsley. 1960. *New Maps of Hell: A Survey of Science Fiction.* London: Victor Gollancz.
Amory, Anne. 1963. "The Reunion of Odysseus and Penelope." In Charles H. Taylor, Jr., ed., *Essays on the Odyssey.* Bloomington: Indiana University Press.
——. 1966. "The Gates of Horn and Ivory." *Yale Classical Studies 20: Homeric Studies:* 1–58.

Anderson, Perry. 1974. *Passages from Antiquity to Feudalism.* London: New Left Books.

Andrëev, Juri V. 1979. "Könige und Königsherrschaft in den Epen Homers." *Klio* 61:361–84.

Andrewes, Antony. 1956. *The Greek Tyrants.* London: Hutchinson University Library.

———. 1961. "Phratries in Homer." *Hermes* 89:129–40.

———. 1966. "The Government of Classical Sparta." In *Ancient Society and Institutions: Studies Presented to Victor Ehrenberg* [no editor listed]. Oxford: Basil Blackwell.

———. 1967. *The Greeks.* New York: Knopf.

Apollodorus. *The Library.* Translated by Sir James George Frazer. 2 vols. Cambridge: Harvard University Press.

Arac, Jonathan, Wlad Godzich, and Wallace Martin, eds. 1983. *The Yale Critics: Deconstruction in America.* Minneapolis: University of Minnesota Press.

Arato, Andrew, and Eike Gebhardt, eds. 1978. *The Essential Frankfurt School Reader.* New York: Urizen Books.

Arend, W. 1933. *Die typischen Scenen bei Homer.* Berlin: Weidmann.

Armstrong, James I. 1958. "The Arming Motif in the *Iliad.*" *American Journal of Philology* 79:337–54.

Arnheim, M. T. W. 1977. *Aristocracy in Greek Society.* London: Thames & Hudson.

Arthur, Marylin B. 1973. "Early Greece: The Origins of the Western Attitude toward Women." *Arethusa* 6 (Spring): 7–58.

———. 1982. "Cultural Strategies in Hesiod's *Theogony:* Law, Family, Society." *Arethusa* 15 (1–2): 63–82.

———. 1983. "The Dream of a World without Women: Poetics and the Circles of Order in the *Theogony* Prooemium." *Arethusa* 16 (1–2): 97–116.

———, and David Konstan. 1984. "Marxism and the Study of Classical Antiquity." In Bertell Ollman and Edward Vernoff, eds., *The Left Academy,* vol. 2. New York: Praeger.

Asimov, Isaac. 1953. "Social Science Fiction." In Reginald Bretnor, ed., *Modern Science Fiction.* New York: Coward McCann.

Atchity, Kenneth John. 1978. *Homer's "Iliad": The Shield of Memory.* Carbondale: Southern Illinois University Press.

Athenaeus of Naucratis. 1927. *The Deipnosophists.* Translated by Charles Burton Gulick. 7 vols. New York: Putnam's Sons.

Austin, M. M., and P. Vidal-Naquet. 1977. *Economic and Social History of Ancient Greece.* London: Batsford.

Austin, Norman. 1975. *Archery at the Dark of the Moon: Poetic Problems in Homer's "Odyssey."* Berkeley: University of California Press.

Authenrieth, Georg. 1958 [1876]. *A Homeric Dictionary.* Translated by Robert P. Keep and Rev. Isaac Flagg. Norman: University of Oklahoma Press.

Avery, H. C. 1965. "Heracles, Philoctetes, Neoptolemus." *Hermes* 93:279–97.

Bachofen, Johann J. 1973 [1861]. *Myth, Religion, and Motherright: Selected Writings.* Translated by Ralph Manheim. Princeton: Princeton University Press.

Badian, Ernst. 1982. "Marx in the Agora." Review of *The Class Struggle in the Ancient Greek World* by G. E. M. de Ste. Croix. *New York Review of Books,* December 2: 47–51.

Bakhtin, M. M. 1981. *The Dialogic Imagination.* Translated by Caryl Emerson and Michael Holquist. Austin: University of Texas Press.

Barnes, Jonathan. 1982. [1979]. *The Presocratic Philosophers*. London: Routledge & Kegan Paul.

——, ed. 1984. *The Complete Works of Aristotle*. 2 vols. Princeton: Princeton University Press.

Barrett, Michèle. 1988. *Women's Oppression Today*. rev. ed. London: Verso.

Barrow, Robin. 1976. *Plato and Education*. London: Routledge & Kegan Paul.

Barthes, Roland. 1967. *Writing Degree Zero/Elements of Semiology*. Translated by Annette Lavers and Colin Smith. Boston: Beacon Press.

——. *Mythologies*. 1972. Translated by Annette Lavers. New York: Hill & Wang.

——. 1974. *S/Z*. Translated by Richard Miller. New York: Hill & Wang.

——. 1982. "L'effet du réel." *Communications* 11:1968 (reprinted and translated as "The Reality Effect," in Todorov 1982).

Baudrillard, Jean. 1975. *The Mirror of Production*. Translated by Mark Poster. St. Louis: Telos Press.

Baxandall, Lee, and Stefan Morawski, eds. 1973. *Marx and Engels on Literature & Art: A Selection of Writings*. St. Louis: Telos Press.

Beardslee, John Walter, Jr. 1918. *The Use of ΦΥΣΥΣ in Fifth-Century Greek Literature*. Ph.D. diss., University of Chicago, Chicago.

Beauvoir, Simone de. 1989 [1953]. *The Second Sex*. Translated by H. M. Parshley. New York: Random House.

Bendix, Reinhard, and Seymour Martin Lipset. 1966. *Class, Status, and Power*. 2d ed. New York: Free Press.

Bengl, H. 1942. "Erbgut und Umwelteinflüsse." *Neue Jahrbücher für Antike und deutsche Bildung* 5:142–49.

Bengtson, Hermann. 1988. *History of Greece from the Beginnings to the Byzantine Era*. Translated by Edmund F. Bloedow. Ottawa: University of Ottawa Press.

Benhabib, Seyla, and Drucilla Cornell, eds. 1987. *Feminism as Critique*. Minneapolis: University of Minnesota Press.

Benjamin, Walter. 1969. *Illuminations*. Translated by Harry Zohn. New York: Schocken Books.

——. 1977. *The Origin of German Tragic Drama*. Translated by John Osborne. London: New Left Books.

Benveniste, Emile. 1969. *Le vocabulaire des institutions indo-européennes*. 2 vols. Paris: Editions de Minuit.

Bérard, Victor. 1931. *Did Homer Live?* Translated by Brian Rhys. New York: E. P. Dutton.

——. 1933. *Dans le sillage d'Ulysse*. Paris: A. Colin.

Bernal, Martin. 1987. *Black Athena: The Afroasiatic Roots of Classical Civilization*. vol. 1. New Brunswick: Rutgers University Press.

Bettelheim, Charles. 1985. "Reflections on Concepts of Class and Class Struggle in Marx's Work." In Stephen Resnick and Richard Wolff, eds. *Rethinking Marxism*. Brooklyn: Automedia.

Beye, Charles Rowan. 1975. *Ancient Greek Literature and Society*. Garden City, N.Y.: Doubleday.

Bickerman, E. J. 1968. *Chronology of the Ancient World*. Ithaca: Cornell University Press.

Bieler, L. 1951. "A Political Slogan in Ancient Athens." *American Journal of Philology* 72:181–84.

Biggs, Penelope. 1966. "The Disease Theme in Sophocles' *Ajax, Philoctetes,* and *Trachiniae.*" *Classical Philology* 61:223–35.

Bilinski, Bronislaw. 1959. *L'Agonistica Sportiva nella Grecia Antica.* Rome: Angelo Signorelli.

Blake, William. 1982. *The Complete Poetry and Prose.* Revised edition by David V. Erdman, with commentary by Harold Bloom. Berkeley: University of California Press.

Bloch, Ernst. 1986a. *The Principle of Hope.* Translated by Neville Plaice, Stephen Plaice, and Paul Knight. 3 vols. Cambridge: MIT Press.

——. 1986b. *Natural Law and Human Dignity.* Translated by Dennis J. Schmidt. Cambridge: MIT Press.

——. 1988. *The Utopian Function of Art and Literature: Selected Essays.* Translated by Jack Zipes and Frank Mecklenburg. Cambridge: MIT Press.

——, George Lukács, Bertolt Brecht, Walter Benjamin, and Theodor Adorno. 1977. *Aesthetics and Politics.* Afterword by Fredric Jameson. London: New Left Books.

Bloch, Marc. 1964 [1961]. *Feudal Society.* Translated by L. A. Manyon. 2 vols. Chicago: University of Chicago Press.

Bloom, Allan, trans. 1968. *The Republic of Plato: Translated with Notes and an Interpretive Essay.* New York: Basic Books.

——. 1987. *The Closing of the American Mind.* New York: Simon & Schuster.

Bloom, Harold, et al. 1979. *Deconstruction and Criticism.* New York: Seabury Press (Continuum).

Bluestone, Natalie Harris. 1987. *Women and the Ideal Society: Plato's "Republic" and Modern Myths of Gender.* Amherst: University of Massachusetts Press.

Boardman, John, Jasper Griffin, and Oswyn Murray, eds. 1986. *The Oxford History of the Classical World.* Oxford: Oxford University Press.

Boeckh, August, ed. 1963 [1821]. *Pindari Epiniciorum Interpretatio Latina.* Hildesheim: Georg Olms.

Bohannan, Paul, and John Middleton, eds. 1968. *Kinship and Social Organization.* Garden City, N.Y.: Natural History Press.

Bonner, R. J. and G. Smith. 1930. *The Administration of Justice from Homer to Aristotle.* vol. 1. Chicago: University of Chicago Press.

Bottomore, Tom, et al., eds. 1983. *A Dictionary of Marxist Thought.* Cambridge: Harvard University Press.

Bourriot, Félix. 1976. *Recherches sur la nature du genos: Etude d'histoire sociale athénienne—périodes archaique et classique.* Lille: Université Lille.

Bowra, C. M. 1950 [1930]. *Tradition and Design in the "Iliad."* Oxford: Oxford University Press.

——. 1961. *Greek Lyric Poetry.* 2d ed. Oxford: Oxford University Press.

——. 1964a. *Heroic Poetry.* London: Macmillan.

——. 1964b. *Pindar.* Oxford: Oxford University Press.

——. 1965 [1944]. *Sophoclean Tragedy.* Oxford: Oxford University Press.

——, trans. 1969. *The Odes of Pindar.* Harmondsworth, Middlesex: Penguin.

Bradford, Ernle. 1963. *Ulysses Found.* New York: Harcourt.

Braudel, Fernand. 1972. *The Mediterranean and the Mediterranean World in the Age of Philip II.* Translated by Sian Reynolds. 2 vols. New York: Harper & Row.

Brown, N. O. 1951. "Pindar, Sophocles, and the Thirty Years' Peace." *Transactions of the American Philological Association* 82:1–28.

——. 1953. *Hesiod's "Theogony."* New York: Liberal Arts Press.

——. 1969. *Hermes the Thief.* New York: Vintage Books.

Buck-Morss, Susan. 1977. *The Origin of Negative Dialectics: Theodor W. Adorno, Walter Benjamin, and the Frankfurt Institute.* New York: Macmillan (Free Press).

Bundy, Elroy L. 1954. *"Hesychia* in Pindar." Ph.D. diss., University of California, Berkeley.

———. 1962. *Studia Pindarica I & II.* Berkeley: University of California Press.

Burckhardt, Jacob. 1958 [1929]. *The Civilization of the Renaissance in Italy.* Translated by S. G. C. Middlemore. 2 vols. New York: Harper (Colophon).

Burkert, Walter. 1966. "Greek Tragedy and Sacrificial Ritual." *Greek, Roman, and Byzantine Studies* 7:87–121.

———. 1972. "Die Leistung eines Kreophylos: Kreophyleer, Homeriden und die archaische Heraklesepik." *Museum Helveticum* 29:74–85.

Burn, A. R. 1960. *The Lyric Age of Greece.* London: Arnold.

Burton, R. W. B. 1962. *Pindar's Pythian Odes: Essays in Interpretation.* Oxford: Oxford University Press.

———. 1980. *The Chorus in Sophocles' Tragedies.* Oxford: Oxford University Press.

Busse, A. 1927. "Kulturgeschichliche Anschauungen in den Dramen des Sophokles." *Neue Jahrbücher für Wissenschaft und Jugendbildung* 3:129–35.

Butler, Samuel. 1967 [1897]. *The Authoress of the "Odyssey."* Chicago: University of Chicago Press.

Buttigieg, Joseph, ed. 1986. *The Legacy of Antonio Gramsci. Boundary* 2 14 (Spring): special issue devoted to Gramsci.

Calder, William M., III. 1971. "Sophoclean Apologia: *Philoctetes.*" *Greek, Roman, and Byzantine Studies* 12:153–74.

———. 1981. "The Anti-Periklean Intent of Aeschylus' *Eumenides.*" In Ernst Günther Schmidt, ed., *Aischylos und Pindar.* Berlin: Akademie Verlag.

———, and Jacob Stern, eds. 1970. *Pindaros und Bakchylides.* Wege der Forschung 134. Darmstadt: Wissenschaftliche Buchgesellschaft.

Caldwell, Richard. 1970. "The Pattern of Aeschylean Tragedy." *Transactions of the American Philological Association* 101:77–94.

Calhoun, George M. 1933. "Homeric Repetitions." *University of California Publications in Classical Philology* 12 (1): 1–26.

———. 1934a. "Classes and Masses in Homer." *Classical Philology* 29:192–208, 301–16.

———. 1934b. "Télémaque et le plan de l'Odyssée." *Revue des études grècques* 47:153–63.

———. 1935. "God the Father in Homer." *Transactions of the American Philological Association* 66:1–17.

Cameron, Kenneth Neill. 1987. *Stalin: Man of Contradiction.* Toronto: NC Press.

Campbell, David A. 1967. *Greek Lyric Poetry.* New York: St. Martin's Press.

Cantarella, Eva. 1987. *Pandora's Daughters: The Role and Status of Women in Greek and Roman Antiquity.* Translated by Maureen B. Fant. Baltimore: Johns Hopkins University Press.

Carne-Ross, D. S. 1985. *Pindar.* New Haven: Yale University Press.

Carpenter, Rhys. 1962. *Folk Tale, Fiction, and Saga in the Homeric Epics.* Berkeley: University of California Press.

Carter, L. B. 1986. *The Quiet Athenian.* Oxford: Oxford University Press.

Cartledge, Paul. 1977. "Hoplites and Heroes: Sparta's Contribution to the Technique of Ancient Warfare." *Journal of Hellenic Studies* 97:11–27.

———. 1987. *Agesilaos and the Crisis of Sparta.* Baltimore: Johns Hopkins University Press.

Chesler, Phyllis. 1973 [1972]. *Women and Madness.* New York: Avon.

Clark, Katerina, and Michael Holquist. 1984. *Mikhail Bakhtin.* Cambridge: Harvard University Press.

Clark, Ronald W. 1984. *The Survival of Charles Darwin: A Biography of a Man and an Idea.* New York: Avon Books.

Clarke, Howard W. 1967. *The Art of the Odyssey.* Englewood Cliffs, N.J.: Prentice-Hall.

Claus, David B. 1975. "Aidos in the Language of Achilles." *Transactions of the American Philological Association* 105:13–28.

Clay, Diskin. 1969. "Aeschylus' Trigeron Mythos." *Hermes* 97:1–9.

———. 1988. "Reading the *Republic.*" In Charles L. Griswold, ed., *Platonic Writings, Platonic Readings.* New York: Routledge.

Clifford, James. 1988. *The Predicament of Culture: Twentieth-Century Ethnography, Literature, and Art.* Cambridge: Harvard University Press.

Cole, Thomas. 1960. "The Anonymous Iamblichi and His Place in Greek Political Theory." *Harvard Studies in Classical Philology* 65:127–63.

———. 1967. *Democritus and the Sources of Greek Anthropology.* American Philological Association Monograph 25, Western Reserve Press.

Comparetti, Domenico P. A. 1908. *Vergil in the Middle Ages.* Translated by E. F. M. Benecke. London: Allen & Unwin.

Connor, W. Robert. 1971. *The New Politicians of Fifth-Century Athens.* Princeton: Princeton University Press.

———. 1984. *Thucydides.* Princeton: Princeton University Press.

Cornford, Francis MacDonald. 1965 [1907]. *Thucydides Mythistoricus.* London: Routledge & Kegan Paul.

Craik, Elizabeth M. 1979. "Philoktetes: Sophoklean Melodrama." *L'Antiquité Classique* 48:15–29.

———. 1980. "Sophokles and the Sophists." *Antiquité Classique* 49:247–54.

Crews, Frederick. 1970. "Anaesthetic Criticism." In Frederick Crews, ed., *Psychoanalysis and Literary Process.* Cambridge, Mass.: Winthrop.

Croiset, Alfred. 1880. *La poésie de Pindare et les lois du lyrisme grec.* Paris: Hachette.

Cross, R. C., and A. D. Woozley. 1979 [1964]. *Plato's "Republic": A Philosophical Commentary.* London: Macmillan.

Cunliffe, Richard John. 1963 [1924]. *A Lexicon of Homeric Greek.* Norman: University of Oklahoma Press.

Dale, A. M. 1969. *Collected Papers.* Cambridge: Cambridge University Press.

Davidson, Olga Merck. 1980. "Indo-European Dimensions of Herakles in *Iliad* 19.95–133." *Arethusa* 13 (Fall): 197–202.

Davies, J. K. 1971. *Athenian Propertied Families, 600–300 B.C.* Oxford: Oxford University Press.

———. 1978. *Democracy and Classical Athens.* Atlantic Highlands, N.J.: Humanities Press.

———. 1981. *Wealth and the Power of Wealth in Classical Athens.* New York: Arno Press.

Davison, J. A. 1953. "Protagoras, Democritus and Anaxagoras." *Classical Quarterly* 67:33–45.

———. 1966. "Aeschylus and Athenian Politics, 472–456 B.C." In *Ancient Society and Institutions: Studies Presented to Victor Ehrenberg* [no editor listed]. Oxford: Basil Blackwell.

———. 1968. *From Archilochus to Pindar.* London: Macmillan.

Dawe, R. D. 1963. "Inconsistency of Plot and Character." *Proceedings of the Cambridge Philological Association* 198:21–62.
———, ed. 1985. *Sophocles Tragoediae*, vol. 2. Leipzig: Teubner.
Deger, Sigrid. 1970. *Herrshaftsformen bei Homer*. Diss., Universitat Wien.
Delebecque, Edouard. 1958. *Télémaque et la structure de l'Odyssée*. Aix-en-Provence: Editions Ophrys.
Delphy, Christine. 1984. *Close to Home: A Materialist Analysis of Women's Oppression*. Translated by Diana Leonard. Amherst: University of Massachusetts Press.
Demetz, Peter. 1967. *Marx, Engels, and the Poets*. Translated by Jeffrey L. Sammons. Chicago: University of Chicago Press.
Denniston, J. D., ed. 1939. *Euripides: "Electra."* Oxford: Oxford University Press.
———. 1952. *Greek Prose Style*. Oxford: Oxford University Press.
———, and Denys Page, eds. 1957. *Aeschylus' "Agamemnon."* Oxford: Oxford University Press.
Derrida, Jacques. 1974. *Of Grammatology*. Translated by Gayatri Chakravorty Spivak. Baltimore: Johns Hopkins University Press.
———. 1979. "Living On: Border Lines." In Harold Bloom et al., *Deconstruction and Criticism*. New York: Seabury Press.
———. 1981. *Dissemination*. Translated by Barbara Johnson. Chicago: University of Chicago Press.
———. 1985. "Racism's Last Word." Translated by Peggy Kamuf. *Critical Inquiry* 12 (Autumn): 290–99.
———. 1986. "But. beyond (open letter to Anne McClintock and Rob Nixon." *Critical Inquiry* 13 (Autumn): 155–70.
———. 1988. "Paul de Man's War." Translated by Peggy Kamuf. *Critical Inquiry* 14 (Spring): 590–652.
Desborough, V. R. d'A. 1972. *The Greek Dark Ages*. London: Ernst Benn.
Desjardins, Rosemary. 1988. "Why Dialogues? Plato's Serious Play." In Charles L. Griswold, ed., *Platonic Writings, Platonic Readings*. New York: Routledge.
Detienne, Marcel. 1963. *Crise agraire et attitude religieuse chez Hésiode*. Brussels: Latomus.
———. 1979 [1977]. *Dionysos Slain*. Translated by Mireille Muellner and Leonard Muellner. Baltimore: Johns Hopkins University Press.
———, and Jean-Pierre Vernant. 1978. *Cunning Intelligence in Greek Culture and Society*. Translated by Janet Lloyd. Atlantic Highlands, N.J.: Humanities Press.
Dews, Peter. 1986. "Adorno: Post-Structuralism and the Critique of Identity." *New Left Review* 157 (May/June): 28–44.
Diels, Hermann, and Walther Kranz, eds. 1964 [1952]. *Die Fragmente der Vorsokratiker*. 11th ed. 3 vols. Zurich/Berlin: Weidmann.
Diller, Hans. 1936. "Die griechische Naturbegriff." *Neue Jahrbücher für antike und Deutsche Bildung* 2:241–57.
———. 1956. "Uber die Selbstbewusstsein der sophokleischen Personen." *Wiener Studien* 69:70–85.
Dimock, George E., Jr. 1956. "The Name of Odysseus." *Hudson Review* 9 (Spring): 52–70.
Dobb, Maurice. 1982. "Marx's Critique of Political Economy." In Eric J. Hobsbawm, ed., *The History of Marxism*, vol. 1: *Marxism in Marx's Day*. Bloomington: Indiana University Press.

Dodds, E. R. 1951. *The Greeks and the Irrational.* Berkeley: University of California Press.

——. 1960. "Morals and Politics in the *Oresteia.*" *Proceedings of the Cambridge Philological Association* 186:19–31.

——. 1973. *The Ancient Concept of Progress.* Oxford: Oxford University Press.

Donlan, Walter. 1973. "The Tradition of Anti-Aristocratic Thought in Early Greek Poetry." *Historia* 22:145–54.

——. 1979. "The Structure of Authority in the *Iliad.*" *Arethusa* 12 (Spring): 51–70.

——. 1980. *The Aristocratic Ideal in Ancient Greece.* Lawrence, Kans.: Coronado Press.

——. 1982. "The Politics of Generosity in Homer." *Helios,* n.s. 9:1–15.

——. 1984. Review of Robert Drews, *Basileus. Classical World* 77:201–2.

——. 1985. "The Social Groups of Dark Age Greece." *Classical Philology* 80:293–308.

——. 1989. "The Unequal Exchange between Glaucus and Diomedes in Light of the Homeric Gift-Economy." *Phoenix* 43:1–15.

Donovan, Josephine. 1985. *Feminist Theory.* New York: Ungar.

Dover, K. J. 1957. "The Political Aspect of Aeschylus' *Eumenides.*" *Journal of Hellenic Studies* 77:230–37.

——. 1978. *Greek Homosexuality.* Cambridge: Harvard University Press.

Drachmann, A. B., ed. 1964 [1903]. *Scholia Vetera in Pindari Carmina.* 3 vols. Leipzig: Teubner.

Drews, Robert. 1983. *Basileus: The Evidence for Kingship in Geometric Greece.* New Haven: Yale University Press.

duBois, Page. 1982. *Centaurs and Amazons: Women and the Pre-History of the Great Chain of Being.* Ann Arbor: University of Michigan Press.

——. 1988. *Sowing the Body: Psychoanalysis and Ancient Representations of Women.* Chicago: University of Chicago Press.

Duby, Georges. 1982 [1980]. *The Three Orders: Feudal Society Imagined.* Translated by Arthur Goldhammer. Chicago: University of Chicago Press.

Eagleton, Terry. 1983. *Literary Theory: An Introduction.* Minneapolis: University of Minnesota Press.

Easterling, P. E. 1973. "Presentation of Character in Aeschylus." *Greece and Rome* 20:3–19.

Edwards, Anthony T. 1985. *Achilles in the "Odyssey."* Konigstein/Ts.: Hain.

Edwards, Mark W. 1977. "Agamemnon's Decision: Freedom and Folly in Aeschylus." *California Studies in Classical Antiquity* 10:17–38.

——. 1987. *Homer: Poet of the "Iliad."* Baltimore: Johns Hopkins University Press.

Ehrenberg, Victor. 1947. "*Polypragmosyne*: A Study in Greek Politics." *Journal of Hellenic Studies* 67:46–67.

——. 1954. *Sophocles and Pericles.* Oxford: Basil Blackwell.

——. 1966. *Ancient Society and Institutions: Studies Presented to Victor Ehrenberg* [no editor listed]. Oxford: Basil Blackwell.

Eisenstein, Zillah R., ed. 1979. *Capitalist Patriarchy and the Case for Socialist Feminism.* New York: Monthly Review Press.

Eliade, Mircea. 1954. *Cosmos and History: The Myth of the Eternal Return.* Translated by Williard Trask. New York: Harper & Row.

Else, Gerald F. 1965. *The Origin and Early Form of Greek Tragedy.* Cambridge: Harvard University Press.

Erbse, Hartmut. 1966. "Neoptolemos und Philoktet bei Sophokles." *Hermes* 94:177–201.

Errandonea, I. 1956. "Filoctetes." *Emerita* 24:72–107.

Euben, J. Peter, ed. 1986. *Greek Tragedy and Political Theory*. Berkeley: University of California Press.

Farenga, Vincent. 1977. "Pindaric Craft and the Writing of Pythian IV." *Helios* 5:3–37.

Farnell, Lewis Richard. 1965 [1932]. *Critical Commentary to the Works of Pindar*. Amsterdam: Hakkert.

Feder, Lillian. 1963. "The Symbol of the Desert Island in Sophocles' *Philoctetes*." *Drama Survey* 3:33–41.

Feenberg, Andrew. 1986 [1981]. *Lukács, Marx and the Sources of Critical Theory*. Oxford: Oxford University Press.

Femia, Joseph V. 1987 [1981]. *Gramsci's Political Thought: Hegemony, Consciousness, and the Revolutionary Process*. Oxford: Oxford University Press.

Fenik, Bernard. 1968. *Typical Battle Scenes in the "Iliad."* *Hermes* Einzelschriften 21. Weisbaden: Franz Steiner Verlag.

——. 1974. *Studies in the "Odyssey."* *Hermes* Einzelschriften 30. Weisbaden: Franz Steiner Verlag.

——, ed. 1978. *Homer: Tradition and Invention*. Cincinnati Classical Studies, n.s. 2. Leiden: Brill.

Field, G. C. 1967. *Plato and His Contemporaries*. 3d ed. London: Methuen.

——. 1969. *The Philosophy of Plato*. 2d. Oxford: Oxford University Press.

Figueira, Thomas J. 1985. "The Theognidea and Megarian Society." In Thomas J. Figueira and Gregory Nagy, eds., *Theognis of Megara: Poetry and the Polis*. Baltimore: Johns Hopkins University Press.

Finley, John H., Jr. 1955. *Pindar and Aeschylus*. Cambridge: Harvard University Press.

——. 1966. *Four Stages of Greek Thought*. Stanford: Stanford University Press.

——. 1967. *Three Essays on Thucydides*. Cambridge: Harvard University Press.

——. 1978. *Homer's "Odyssey."* Cambridge: Harvard University Press.

Finley, Moses I. 1955. "Marriage, Sale and Gift in the Homeric World." *Revue Internationale des Droits de l'Antiquité*, 3e ser.: 167–94.

——. 1957. "Homer and Mycenae: Property and Tenure." *Historia* 6:133–59.

——. 1968. *Aspects of Antiquity: Discoveries and Controversies*. London: Chatto & Windus.

——. 1973. *Ancient Economy*. Berkeley: University of California Press.

——. 1978. *The World of Odysseus*. rev. ed. New York: Viking Press.

——, J. L. Caskey, G. S. Kirk, and D. L. Page. 1964. "The Trojan War." *Journal of Hellenic Studies* 84:1–20.

Finnegan, Ruth. 1977. *Oral Poetry: Its Nature, Significance and Social Context*. Cambridge: Cambridge University Press.

Firestone, Shulamith. 1974 [1970]. *The Dialectic of Sex: The Case for Feminist Revolution*. New York: William Morrow.

Fitzgerald, Robert, trans. 1963 [1961]. *The "Odyssey" of Homer*. Garden City, N.Y.: Doubleday.

Foley, Helene P. 1978. "Reverse Similies and Sex Roles in the 'Odyssey.' " *Arethusa* 11:7–26.

Foley, John Miles. 1985. *Oral-Formulaic Theory and Research: An Introduction and Annotated Bibliography*. New York: Garland.

Forgacs, David, ed. 1988. *An Antonio Gramsci Reader: Selected Writings 1916–1935*. New York: Schocken Books.

Forrest, W. G. 1966. *The Emergence of Greek Democracy, 800–400 B.C.* New York: McGraw-Hill.

———. 1968. *A History of Sparta, 950–192 B.C.* London: Hutchinson University Library.

Foucault, Michel. 1970. *The Order of Things* [no translator listed]. New York: Random House.

———. 1972. *The Archaeology of Knowledge.* Translated by A. M. Sheridan Smith. New York: Harper.

———. 1973 [1965]. *Madness and Civilization.* Translated by Richard Howard. New York: Random House.

———. 1977. *Discipline and Punish: The Birth of the Prison.* Translated by Alan Sheridan. New York: Pantheon.

———. 1978. *The History of Sexuality,* vol. 1: *An Introduction.* Translated by Robert Hurley. New York: Random House.

Fowler, R. L. 1983. " 'On Not Knowing Greek': The Classics and the Woman of Letters." *Classical Journal* 78 (April-May): 337–49.

———. 1987. *The Nature of Early Greek Lyric Poetry: Three Preliminary Studies.* Toronto: University of Toronto Press.

Fraenkel, Eduard, ed. and trans. 1950. *Aeschylus: Agamemnon.* 3 vols. London: Oxford University Press.

Frame, Douglas. 1978. *The Myth of Return in Early Greek Epic.* New Haven: Yale University Press.

Franco, Jean. 1985. "William Bennett and the Massa's Family Jewels." (author's typescript) = "La politica cultura de Reagan." *Nexos* (Mexico) 8 (October): 5–15.

Fränkel, Hermann. 1973. *Early Greek Poetry and Philosophy.* Translated by Moses Hadas and James Willis. New York: Harcourt.

French, A. 1964. *The Growth of the Athenian Economy.* London: Routledge & Kegan Paul.

Freud, Sigmund. 1958–74. *The Standard Edition of the Complete Psychological Works.* Translated and edited by James Strachey. 24 vols. London: Hogarth Press and Institute of Psycho-Analysis.

Friedländer, Paul. 1958. *Plato: An Introduction.* Translated by Hans Meyerhoff. New York: Harper.

———. 1969. *Plato 3: The Dialogues: Second and Third Periods.* Translated by Hans Meyerhoff. Princeton: Princeton University Press.

Friedrich, Paul, and James Redfield. 1978. "Speech as Personality Symbol." *Language* 54:263–88.

———. 1981. "Contra Messing." *Language* 57:901–3.

Fuqua, Charles. 1964. "The Thematic Structure of Sophocles' *Philoctetes.*" Ph.D. diss., Cornell University.

Furley, David. 1970. Review of A. T. Cole, *Democritus and the Sources of Greek Anthropology. Journal of Hellenic Studies* 90:147–48.

Fuss, Diana. 1989. *Essentially Speaking: Feminism, Nature, and Difference.* London: Routledge.

Gagarin, Michael. 1974. "Dikē in Ancient Greek Thought." *Classical Philology* 68:186–97.

———. 1976. *Aeschylean Drama.* Berkeley: University of California Press.

———. 1986. *Early Greek Law.* Berkeley: University of California Press.

———. 1987. "Morality in Homer." *Classical Philology* 82 (4): 285–306.

Gailey, Christine Ward. 1987. *Kinship to Kingship: Gender Hierarchy and State Formation in the Tongan Islands.* Austin: University of Texas Press.

Gardiner, Cynthia P. 1987. *The Sophoclean Chorus: A Study of Character and Function.* Iowa City: University of Iowa Press.

Gaspar, Camille. 1900. *Essai de chronologie pindarique.* Brussels: H. Lamertin.

Geertz, Clifford. 1973. *The Interpretation of Cultures.* New York: Basic Books.

Gellie, G. H. 1972. *Sophocles: A Reading.* Netley: Melbourne University Press.

Gellrich, Michelle. 1988. *Tragedy and Theory: The Problem of Conflict since Aristotle.* Princeton: Princeton University Press.

Gentili, Bruno. 1988. *Poetry and Its Public in Ancient Greece.* Translated by A. Thomas Cole. Baltimore: Johns Hopkins University Press.

Geras, Norman. 1983. *Marx and Human Nature: Refutation of a Legend.* London: Verso.

———. 1987. "Post-Marxism?" *New Left Review* 163 (May/June): 40–82.

———. 1988. "Ex-Marxism without Substance Being a Real Reply to Laclau and Mouffe." *New Left Review* 169 (May/June): 34–61.

Gerber, Douglas E. 1970. *Euterpe.* Amsterdam: Hakkert.

Gildersleeve, Basil L. 1965 [1890]. *Pindar: The Olympian and Pythian Odes.* Amsterdam: Hakkert.

Girard, René. 1977. *Violence and the Sacred.* Translated by Patrick Gregory. Baltimore: Johns Hopkins University Press.

Giroux, Henry. 1983. "Theories of Reproduction and Resistance in the New Sociology of Education: A Critical Analysis." *Harvard Educational Review* 35 (3): 257–93.

Godelier, Maurice. 1965. "La notion de 'Mode de production asiatique.' " *Les Temps Modernes* 228 (May): 2002–27.

———. 1977. *Perspectives in Marxist Anthropology.* Translated by Robert Brain. Cambridge: Cambridge University Press.

Goheen, Robert F. 1955. "Aspects of Dramatic Symbolism: Three Studies in the *Oresteia.*" *American Journal of Philology* 76:113–37.

Goldhill, Simon. 1984. *Language, Sexuality, Narrative: The Oresteia.* Cambridge: Cambridge University Press.

Gomme, A. W. 1937. "The End of the City-State." In *Essays in Greek History and Literature.* Oxford: Basil Blackwell.

———, A. Andrewes, and K. J. Dover. 1956–81. *A Historical Commentary on Thucydides.* 5 vols. Oxford: Oxford University Press.

Goold, George P. 1977. "The Nature of Homeric Composition." *Illinois Classical Studies* 2:1–34.

Gorz, André. 1968. *A Strategy for Labor.* Translated by Martin A. Nicolaus and Victoria Ortiz. Boston: Beacon Press.

———. 1980. *Ecology as Politics.* Translated by Patsy Vigderman and Jonathan Cloud. Boston: South End Press.

———. 1982. *Farewell to the Working Class.* Translated by Michael Sonensher. Boston: South End Press.

Gould, John. 1973. "Hiketeia." *Journal of Hellenic Studies* 93:74–103.

Gould, Stephen Jay. 1980. "Sociobiology and Human Nature: A Postpanglossian Vision." In Ashley Montagu, ed., *Sociobiology Examined.* New York: Oxford University Press.

———. 1981. *The Mismeasure of Man.* New York: Norton.

Gouldner, Alvin. 1969 [1965]. *Enter Plato,* pt. 1: *The Hellenic World.* New York: Harper & Row.

———. 1971 [1966]. *Enter Plato,* pt. 2: *Classical Greece and the Origins of Social Theory.* New York: Harper & Row.

———. 1980. *The Two Marxisms: Contradictions and Anomalies in the Development of Theory.* New York: Seabury Press.

Gramsci, Antonio. 1971. *Selections from the Prison Notebooks.* Edited and translated by Quinton Hoare and Geoffrey Nowell Smith. New York: International Publishers.

———. 1977. *Selections from the Political Writings (1910–1920).* Translated by John Mathews. New York: International Publishers.

———. 1978. *Selections from the Political Writings (1921–1926).* Translated by John Mathews. New York: International Publishers.

———. 1985. *Selections from Cultural Writings.* Edited by David Forgacs and Geoffrey Nowell-Smith and translated by William Boelhower. Cambridge: Harvard University Press.

Green, Peter. 1983. Review of *The Class Struggle in the Ancient Greek World* by G. E. M. de Ste. Croix. *Times Literary Supplement* 29 (February 11): 125–26.

Greengard, Carola. 1980. *The Structure of Pindar's Epinician Odes.* Amsterdam: Hakkert.

Grene, David. 1967. *Reality and the Heroic Pattern: Last Plays of Ibsen, Shakespeare, and Sophocles.* Chicago: University of Chicago Press.

Griffin, Jasper. 1980. *Homer on Life and Death.* Oxford: Oxford University Press.

Griffith, Mark. 1977. *The Authenticity of "Prometheus Bound."* Cambridge: Cambridge University Press.

Griswold, Charles L., ed. 1988. *Platonic Writings, Platonic Readings.* New York: Routledge and Kegan Paul.

Gschnitzer, Fritz, ed. 1969. *Zur griechischen Staatskunde* Wege der Forschung 96. Darmstadt: Wissenschaftliche Buchgesellschaft.

———. 1971. "Stadt und Stamm bei Homer." *Chiron* 1:1–17.

Gundert, Hermann. 1935. *Pindar und sein Dicterberuf.* Frankfurt am Main: Klostermann.

Gunn, David M. 1971. "Thematic Composition and Homeric Authorship." *Harvard Studies in Classical Philology* 75:1–31.

Guthrie, W. K. C. 1954 [1950]. *The Greeks and Their Gods.* Boston: Beacon Press.

———. 1962–81. *A History of Greek Philosophy.* 6 vols. Cambridge: Cambridge University Press.

Habermas, Jürgen. 1975. *Legitimation Crisis.* Translated by Thomas McCarthy. Boston: Beacon Press.

Haedicke, Walter. 1936. *Die Gedanken der Griechen über Familienherkunft und Vererbung.* Ph.D. diss., Martin Luther-Universität, Halle-Wittenberg.

Hainsworth, J. B. 1968. *The Flexibility of the Homeric Formula.* Oxford: Oxford University Press.

Hamilton, Richard. 1974. *Epinikion.* The Hague: Mouton.

Hammond, N. G. L. 1959. *A History of Greece to 322 B.C.* Oxford: Oxford University Press.

———. 1965. "Personal Freedom and Its Limitations in the *Oresteia.*" *Journal of Hellenic Studies* 85:43–55.

———. 1975. "The Literary Tradition for the Migrations." In *Cambridge Ancient History,* vol. 2: *History of the Middle East and the Aegaean Region c. 1380–1000 B.C.* 3d ed. Cambridge: Cambridge University Press.

———. 1982. "The Emergence of the City-State from the Dark Age." In *The Cambridge Ancient History,* vol. 3 pt. 1: *The Prehistory of the Balkans: The Middle East and the Aegean World, Tenth to Eighth Centuries B.C.* 2d ed. Cambridge: Cambridge University Press.

Handley, E. W., ed. 1965. *The "Dyskolos" of Menander.* Cambridge: Harvard University Press.

Harris, Marvin. 1968. *The Rise of Anthropological Theory: A History of Theories of Culture.* New York: Crowell.

Harsh, Philip Whaley. 1960. "The Role of the Bow in the *Philoctetes* of Sophocles." *American Journal of Philology* 81:408–14.

Hartmann, Heidi. 1981. "The Unhappy Marriage of Marxism and Feminism." In Lydia Sargent, ed., *Women and Revolution.* Boston: South End Press.

Hartsock, Nancy C. M. 1983. *Money, Sex and Power: Toward a Feminist Historical Materialism.* Boston: Northeastern University Press.

Havelock, Eric A. 1952. "Why Was Socrates Tried?" *Phoenix,* suppl. 1: 95–108.

——. 1957. *The Liberal Temper in Greek Political Thought.* New Haven: Yale University Press.

——. 1963. *Preface to Plato.* Cambridge: Harvard University Press.

——. 1966. "Thoughtful Hesiod." *Yale Classical Studies* 20:59–72 (= Havelock 1982: 208–19).

——. 1978. *The Greek Concept of Justice: From Its Shadow in Homer to Its Substance in Plato.* Cambridge: Harvard University Press.

——. 1982. *The Literate Revolution and Its Cultural Consequences.* Princeton: Princeton University Press.

——. 1986. *The Muse Learns to Write: Reflections on Orality and Literacy from Antiquity to the Present.* New Haven: Yale University Press.

Headlam, Walter, and George Thomson, eds. 1966 [1938]. *The "Oresteia" of Aeschylus.* Amsterdam: Hakkert.

Hegel, G. W. F. 1967 [1807]. *The Phenomenology of Mind.* Translated by J. B. Baillie. New York: Harper.

Heinemann, Felix. 1965 [1945]. *Nomos und Physis.* Basel: Friedrich Reinhardt.

Held, David. 1980. *Introduction to Critical Theory: Horkheimer to Habermas.* Berkeley: University of California Press.

Henrichs, Albert. 1975. "Two Doxographical Notes: Democritus and Prodicus on Religion." *Harvard Studies in Classical Philology* 79:93–123.

Henry, A. S. 1974. "ΒΙΟΣ in Sophocles' *Philoctetes.*" *Classical Review* 24:3–4.

Hermassi, Karen. 1977. *Polity and Theater in Historical Perspective.* Berkeley: University of California Press.

Hester, D. A. 1981. "The Casting of the Vote." *American Journal of Philology* 102:265–74.

Heubeck, Alfred, Stephanie West, and J. B. Hainsworth. 1988. *A Commentary on Homer's "Odyssey."* 2 vols. Oxford: Oxford University Press.

Hignett, C. 1958 [1952]. *A History of the Athenian Constitution to the End of the Fifth Century B.C.* Oxford: Oxford University Press.

Hindess, Barry, and Paul Hirst. 1975. *Pre-Capitalist Modes of Production.* London: Routledge & Kegan Paul.

——. 1977. *Mode of Production and Social Formation.* London: Macmillan.

Hinds, A. E. 1967. "The Prophecy of Helenus in Sophocles' *Philoctetes.*" *Classical Quarterly* 17:168–80.

Hobbes, Thomas. 1950 [1651]. *Levithan.* New York: E. P. Dutton.

Hobsbawm, E. J. 1982. *The History of Marxism,* vol. 1. Bloomington: Indiana University Press.

Hoekstra, A. 1964. *Homeric Modifications of Formulaic Prototypes.* Amsterdam: North-Holland.

Hoey, Thomas. 1965. "Fusion in Pindar." *Harvard Studies in Classical Philology* 70:235–62.

Holland, Norman. 1968. *The Dynamics of Literary Response.* New York: Norton.

Holoka, James P. 1979. "Homer Studies 1971–1977." Special Survey Issue. *Classical World* 73 (October).

Hooks, Bell, 1981. *Ain't I a Woman: Black Women and Feminism.* Boston: South End Press.

———. 1984. *Feminist Theory: From Margin to Center.* Boston: South End Press.

Hopper, R. J. 1976. *The Early Greeks.* New York: Harper & Row.

Horkheimer, Max, and Theodor W. Adorno. 1972. *Dialectic of Enlightenment.* Translated by John Cumming. New York: Herder & Herder.

How, W. W., and J. Wells. 1961 [1912]. *A Commentary on Herodotus with Introduction and Appendices.* 2 vols. Oxford: Oxford University Press.

Hubbard, Thomas K. 1985. *The Pindaric Mind.* Leiden: Brill.

Hudson, Wayne. 1982. *The Marxist Philosophy of Ernst Bloch.* New York: St. Martin's Press.

Huelsberg, Werner. 1985. "The Greens at the Crossroads." *New Left Review* 152 (July/August): 5–29.

Humphreys, S. C. 1978. *Anthropology and the Greeks.* London: Routledge & Kegan Paul.

Huxley, G. L. 1966. *The Early Ionians.* London: Faber & Faber.

———. 1967. "Thersites in Sophocles' *Philoctetes.*" *Greek, Roman, and Byzantine Studies* 8:33–34.

———. 1975. *Pindar's Vision of the Past.* Belfast: distributed by Blackwell.

Immerwahr, Henry A. 1966. *Form and Thought in Herodotus.* Cleveland: American Philological Association.

Irigaray, Luce. 1985. *Speculum of the Other Woman.* Translated by Gillian C. Gill. Ithaca: Cornell University Press.

Jacoby, Felix. 1933. "Die geistige Physiognomie der *Odyssee.*" *Die Antike* 9: 159–94.

Jaeger, Werner. 1945. *Paideia.* Translated by Gilbert Highet. 3 vols. New York: Oxford University Press.

Jameson, Fredric. 1971. *Marxism and Form: Twentieth-Century Dialectical Theories of Literature.* Princeton: Princeton University Press.

———. 1979a. *Fables of Agression.* Berkeley: University of California Press.

———. 1979b. "Marxism and Historicism." *New Literary History* 10 (Autumn): 41–74.

———. 1979c. "Reification and Utopia in Mass Culture." *Social Text* 1 (Winter): 130–48.

———. 1981. *The Political Unconscious.* Ithaca: Cornell University Press.

———. 1988a. *The Ideologies of Theory: Essays 1971–1986.* 2 vols. Minneapolis: University of Minnesota Press.

———. 1988b. "*History and Class Consciousness* as an Unfinished Project." *Rethinking Marxism* 1 (Spring): 49–72.

Jameson, Michael H. 1956. "Politics and the *Philoctetes.*" *Classical Philology* 51:217–27.

Janko, Richard. 1982. *Homer, Hesiod, and the Hymns.* Cambridge: Cambridge University Press.

Jarratt, Susan C. 1991. *Rereading the Sophists: Classical Rhetoric Refigured.* Carbondale: Southern Illinois University Press.

Jarratt, Susan C., and Nedra Reynolds. 1992. "The Splitting Image: Postmodern Feminism and the Ethics of *Ethos.*" In James S. Baumlin and Tita French Baumlin, eds., *Ethos: New Essays in Rhetorical and Critical Theory.* Dallas: Southern Methodist University Press.

Jay, Martin. 1973. *The Dialectical Imagination: A History of the Frankfurt School and the Institute of Social Research, 1923–1950.* Boston: Little Brown.
Jebb, R. C. 1962 [1887–96]. *Sophocles: The Plays and Fragments.* 7 vols. Amsterdam: Servio.
Jeffery, L. H. 1976. *Archaic Greece: The City-States c. 700–500 B.C.* New York: St. Martin's Press.
Johansen, H. Friis. 1962. "Sophocles 1939–1959." *Lustrum* 7:94–288.
Jones, A. H. M. 1964 [1957]. *Athenian Democracy.* Oxford: Basil Blackwell.
———. 1967. *Sparta.* Oxford: Basil Blackwell.
Jones, D. M. 1949. "The Sleep of Philoctetes." *Classical Review* 63:83–85.
Jones, John. 1962. *On Aristotle and Greek Tragedy.* London: Chatto and Windus.
Kabeer, Naila. 1988. "Subordination and Struggle: Women in Bangladesh." *New Left Review* 168 (March/April): 95–121.
Kagan, Donald. 1969. *The Outbreak of the Peloponnesian War.* Ithaca: Cornell University Press.
Kakrides, Johannes Theophanous. 1949. *Homeric Researches.* Lund: C. W. K. Gleerup.
———. 1971. *Homer Revisited.* Lund: C. W. K. Gleerup.
Kammerbeek, J. C. 1948. "Sophoclea II." *Mnemosyne* 4:198–204.
Katz, Barry. 1982. *Herbert Marcuse and the Art of Liberation.* London: Verso.
Kelly, Joan. 1984. *Women, History, and Theory.* Chicago: University of Chicago Press.
Kerferd, G. B. 1981a. *The Sophistic Movement.* Cambridge: Cambridge University Press.
———, ed. 1981b. *The Sophists and Their Legacy.* Proceedings of the Fourth International Colloquium on Ancient Greek Philosophy at Bad Homburg, 1979. Wiesbaden: Steiner.
Keuls, Eva C. 1985. *The Reign of the Phallus: Sexual Politics in Ancient Athens.* New York: Harper & Row.
Kiernan, Ben. 1985. *How Pol Pot Came to Power.* London: Verso.
Kirk, Geoffrey S. 1962. *The Songs of Homer.* Cambridge: Cambridge University Press.
———. 1970. *Myth: Its Meaning and Functions in Ancient and Other Cultures.* Berkeley: University of California Press.
———. 1975. "The Homeric Poems as History." In *The Cambridge Ancient History,* vol. 2: *History of the Middle East and the Aegaean Region c. 1380–1000 B.C.* 3d ed. Cambridge: Cambridge University Press.
———, ed. 1985. *The Iliad: A Commentary,* vol. 1: *Bks. 1–4.* Cambridge: Cambridge University Press.
———, and J. E. Raven. 1957. *The Presocratic Philosophers: A Critical History, with a Selection of Texts.* Cambridge: Cambridge University Press.
Kirkwood, G. M. 1958. *A Study of Sophoclean Drama.* Ithaca: Cornell University Press.
Kittay, Jeffrey, and Wlad Godzich. 1987. *The Emergence of Prose: An Essay in Prosaics.* Minneapolis: University of Minnesota Press.
Kitto, H. D. F. 1955 [1950]. *Greek Tragedy: A Literary Study.* Garden City, N.Y.: Doubleday.
———. 1956. *Form and Meaning in Greek Tragedy.* New York: Barnes & Noble.
———. 1958. *Sophocles, Dramatist and Philosopher.* Oxford: Oxford University Press.
Kliem, Manfred, ed. 1967. *Karl Marx und Friedrich Engles Über Kunst und Literatur.* Berlin: Dietz.

Knight, W. F. Jackson. 1954. *Roman Vergil*. London: Faber & Faber.

Knox, Bernard. 1952. "The Lion in the House." *Classical Philology* 47:17–25 (= Knox 1979: 27–38).

———. 1964. *The Heroic Temper: Studies in Sophoclean Tragedy*. Berkeley: University of California Press.

———. 1979. *Word and Action: Essays on the Ancient Theatre*. Baltimore: Johns Hopkins University Press.

———. 1983. "Sophocles and the *Polis*." In *Fondation Hardt pour l'Etude de l'Antiquité Classique: Entretiens XXIX: Sophocles*. Geneva: Fondation Hardt.

Köhnken, Adolf. 1971. *Die Funktion des Mythos bei Pindar*. Berlin: Walter de Gruyter.

Kolakowski, Leszek. 1978. *Main Currents of Marxism*. Translated by P. S. Falla. 3 vols. Oxford: Oxford University Press.

Krader, Lawrence. 1982. "Theory of Evolution, Revolution and the State: The Critical Relation of Marx to his Contemporaries Darwin, Carlyle, Morgan, Main and Kovalevsky." In E. J. Hobsbawm, ed., *The History of Marxism*, vol. 1. Bloomington: Indiana University Press.

Lacey, W. K. 1968. *The Family in Classical Greece*. Ithaca: Cornell University Press.

Laclau, Ernesto, and Chantal Mouffe. 1985. *Hegemony and Socialist Strategy: Towards a Radical Democratic Politics*. Translated by Winston Moore and Paul Cammack. London: Verso.

———. 1987. "Post-Marxism without Apologies." *New Left Review* 166 (November/December): 79–106.

Lang, M. L. 1969. "Homer and Oral Techniques." *Hesperia* 38:159–68.

Larsen, J. A. O. 1966 [1955]. *Representative Government in Greek and Roman History*. Berkeley: University of California Press.

Lattimore, Richmond, trans. 1947a. *The Odes of Pindar*. Chicago: University of Chicago Press.

———. 1947b. "The First Elegy of Solon." *American Journal of Philology* 68: 161–79.

———, trans. 1953. *Aeschylus I: The Oresteia*. Chicago: University of Chicago Press.

Laurenti, Renato. 1961. "Interpretazione del Filottete di Sofocle." *Dioniso* 35:36–57.

Leaf, Walter, and M. A. Bayfield, eds. 1965 [1895]. *The "Iliad" of Homer*. London: Macmillan.

Lebeck, Anne. 1971. *The Oresteia: A Study in Language and Structure*. Washington, D.C.: Center for Hellenic Studies.

Lee, Hugh. 1978. "The 'Historical' Bundy and Encomiastic Relevance in Pindar." *Classical World* 72:65–70.

Lefkowitz, Mary R. 1963. "ΤΩ ΚΑΙ ΕΓΩ: The First Person in Pindar." *Harvard Studies in Classical Philology* 67:176–253.

———. 1975a. "Influential Fictions in the Scholia to Pindar's *Pythian 8*." *Classical Philology* 70:173–85.

———. 1975b. "Pindar's Lives." In P. T. Brannan, ed., *Classica et Iberica*, a Festschrift in honor of Joseph M. F. Marique. Worcester: Institute for Early Christian Iberian Studies.

———. 1976a. *The Victory Ode*. Park Ridge: Noyes Press.

———. 1976b. Review of *Epinikion*, by Richard Hamilton. *Classical World* 69:340–41.

Lekas, Padelis. 1988. *Marx on Classical Antiquity: Problems of Historical Methodology.* New York: St. Martin's Press.

Lentricchia, Frank. 1980. *After New Criticism.* Chicago: University of Chicago Press.

Lesky, Albin. 1939. "Erbe und Erziehung im griechischen Denken des fünften Jahrhunderts." *Neue Jahrbücher für Antike und deutsche Bildung* 2:361–81.

——. 1965. *Greek Tragedy.* Translated by H. A. Frankfort. London: Ernest Benn.

——. 1966a. "Decision and Responsibility in the Tragedy of Aeschylus." *Journal of Hellenic Studies* 86:78–85.

——. 1966b. *A History of Greek Literature.* Translated by James Willis and Cornelis de Heer. London: Methuen.

——. 1967. *Homeros.* Stuttgart: Druckenmuller.

——. 1972. *Die tragische Dichtung der Hellenen.* 3d ed. Göttingen: Vanderhoeck & Ruprecht.

Lessing, Gotthold Ephraim. 1962 [1766]. *Laocoön.* Translated by Edward Allen McCormick. Indianapolis: Bobbs-Merrill.

Letters, F. J. H. 1953. *The Life and Works of Sophocles.* London: Sheed & Ward.

Lévi-Strauss, Claude. 1966. *The Savage Mind.* [No translator listed.] Chicago: University of Chicago Press.

——. 1967. *Structural Anthropology.* Translated by Claire Jacobson and Brooke Grundfest Schoepf. Garden City, N.Y.: Doubleday.

——. 1974. *Tristes Tropiques.* Translated by John and Doreen Weightman. New York: Atheneum.

——. 1976. *Structural Anthropology,* vol. 2. Translated by Monique Layton. New York: Basic Books.

Lewis, Thomas E. 1983. "Aesthetic Effect/Ideological Effect." *Enclitic* 7:4–16.

Lidell, Henry George, Robert Scott, and Henry Stuart Jones. 1940. *A Greek-English Lexicon.* Rev. ed. Oxford: Oxford University Press.

Linforth, Ivan M. 1956. "Philoctetes: The Play and the Man." *University of California Publications in Classical Philology* 15:95–156.

Lintott, Andrew. 1982. *Violence, Civil Strife and Revolution in the Classical City: 750–330 B.C.* Baltimore: Johns Hopkins University Press.

Livergood, N. D. 1967. *Activity in Marx's Philosophy.* The Hague: Matinus Nijhoff.

Livingstone, R. W. 1925. "The Problem of the Eumenides of Aeschylus." *Journal of Hellenic Studies* 45:120–31.

Lloyd, G. E. R. 1983. *Science, Folklore and Ideology: Studies in the Life Sciences in Ancient Greece.* Cambridge: Cambridge University Press.

——. 1987 [1966]. *Polarity and Analogy: Two Types of Argumentation in Early Greek Thought.* Bristol: Bristol Classical Press.

Lloyd-Jones, Hugh. 1956. "Zeus in Aeschylus." *Journal of Hellenic Studies* 76:55–67.

——. 1962. "The Guilt of Agamemnon." *Classical Quarterly,* n.s. 12:187–99.

——. 1963. "The Appendix: Containing the More Considerable Fragments Published since 1930 and a New Text of Fr. 50." in *Aeschylus II.* Loeb Classical Library.

——, trans. and comm. 1970. *Agamemnon by Aeschylus.* Englewood Cliffs, N.J.: Prentice Hall.

——. 1971. *The Justice of Zeus.* Berkeley: University of California Press.

——. 1973. "Modern Interpretations of Pindar: The Second Pythian and Seventh Nemean Odes." *Journal of Hellenic Studies* 93:109–37.

Long, A. A. 1968. *Language and Thought in Sophocles: A Study of Abstract Nouns and Poetic Technique*. London: Athlone Press.

Lord, Albert B. 1965 [1960]. *The Singer of Tales*. New York: Atheneum.

———. 1967. "Homer as Oral Poet." *Harvard Studies in Classical Philology* 72:1–46.

———. 1974. "Perspectives on Recent Work on Oral Literature." *Forum for Modern Language Studies* 10:187–210.

———. 1991. *Epic Singers and Oral Tradition*. Ithaca: Cornell University Press.

Lord, George deForrest. 1954. "The *Odyssey* and the Western World." *Sewanee Review* 62 (Summer): 406–27.

Lowenthal, Leo. 1987–88. "Caliban's Legacy." *Cultural Critique* 8:5–17.

Löwy, Michael. 1979. *Georg Lukács—from Romanticism to Bolshevism*. Translated by Patrick Camiller. London: New Left Books.

Lukács, Georg. 1968 [1923]. *History and Class Consciousness*. Translated by Rodney Livingston. Cambridge: MIT Press.

———. 1971 [1920]. *The Theory of the Novel*. Translated by Anna Bostock. Cambridge: MIT Press.

Lynn-George, M. 1982. Review of Jasper Griffin, *Homer on Life and Death*. *Journal of Hellenic Studies* 102:239–45.

Lyotard, Jean-François. 1984. *The Postmodern Condition: A Report on Knowledge*. Translated by Geoff Bennington and Brian Massumi. Minneapolis: University of Minnesota Press.

MacCary, W. Thomas. 1982. *Childlike Achilles*. New York: Columbia University Press.

Macherey, Pierre. 1978. *A Theory of Literary Production*. Translated by Geoffrey Wall. London: Routledge & Kegan Paul.

Machin, Albert. 1981. *Cohérence et continuité dans le théâtre de Sophocle*. Quebec: Serge Fleury.

MacKendrick, Paul. 1969. *The Athenian Aristocracy: 399 to 31 B.C.* Cambridge: Harvard University Press.

MacKinnon, Catharine A. 1982. "Feminism, Marxism, Method, and the State: An Agenda for Theory." *Signs* 7 (3): 515–44.

Macleod, C. W. 1982. "Politics and the *Oresteia*." *Journal of Hellenic Studies* 102:124–44.

Maguinness, W. S. 1958. "Sophocles, *Philoctetes* 546." *Classical Quarterly* 8:17.

Malinowski, Bronislaw. 1971 [1926]. *Myth in Primitive Psychology*. Westport: Negro Universities Press.

Manuel, Frank E., and Fritzie P. Manuel. 1979. *Utopian Thought in the Western World*. Cambridge: Harvard University Press.

Marable, Manning. 1983. *How Capitalism Underdeveloped Black America*. Boston: South End Press.

Marcuse, Herbert. 1969 [1968]. *Negations: Essays in Critical Theory*. Translated by Jeremy J. Shapiro. Boston: Beacon Press.

———. 1974 [1955]. *Eros and Civilization*. Boston: Beacon Press.

Marrou, H. I. 1982 [1956]. *A History of Education in Antiquity*. Translated by George Lamb. Madison: University of Wisconsin Press.

Martin, Richard P. 1989. *The Language of Heroes: Speech and Performance in the "Iliad."* Ithaca: Cornell University Press.

Marx, Karl, and Frederick Engels. 1964. *Pre-Capitalist Economic Formations*. Edited with an introduction by Eric J. Hobsbawm. New York: International Publishers.

———. 1967. *Capital*. 3 vols. New York: International Publishers.
———. 1973. *Grundrisse*. Translated by Martin Nicolaus. Harmondsworth, Middlesex: Penguin.
———. 1975–. *Collected Works* 38 vols. New York: International Publishers.
McClintock, Anne, and Rob Nixon. 1986. "No Names Apart: The Separation of Word and History in Derrida's 'Le Dernier mot du racisme.' " *Critical Inquiry* 13 (Autumn): 140–54.
McCracken, G. 1934. "Pindar's Figurative Use of Plants." *American Journal of Philology* 55:340–45.
McLellan, David. 1969. *The Young Hegelians and Karl Marx*. New York: Praeger.
———. 1973. *Karl Marx: His Life and Thought*. New York: Harper & Row.
———. 1975. *Karl Marx*. Harmondsworth, Middlesex: Penguin.
———. 1977. *Friedrich Engels*. Harmondsworth, Middlesex: Penguin.
———. 1979. *Marxism after Marx*. Boston: Houghton Mifflin.
———. 1985. "Marx's Concept of Human Nature." Review of *Marx and Human Nature: Refutation of a Legend* by Norman Geras. *New Left Review* 149 (January/February): 121–24.
McMurtry, John, 1978. *The Structure of Marx's World-View*. Princeton: Princeton University Press.
Méautis, Georges. 1962. *Pindare le Dorien*. Neuchatel: A La Baconnière.
Mehlman, Jeffrey. 1977. *Revolution and Repetition: Marx/Hugo/Balzac*. Berkeley: University of California Press.
Meiggs, Russell. 1972. *The Athenian Empire*. Oxford: Oxford University Press.
Merchant, Carolyn. 1980. *The Death of Nature: Women, Ecology, and the Scientific Revolution*. New York: Harper.
Meritt, Benjamin D., H. T. Wade-Gery, and Malcolm F. McGregor. 1950. *The Athenian Tribute Lists*. 3 vols. Princeton: Princeton University Press.
Messing, Gordon M. 1981. "On Weighing Achilles' Winged Words." *Language* 57:888–900.
Meuli, Karl. 1941. "Die Ursprung der olympischen Spiele." *Antike* 17:189–208.
Mezger, Friedrich. 1880. *Pindars Siegeslieder*. Leipzig: Teubner.
Michelet, Jules. 1864. *Bible de l'humanité*. 3d ed. Paris: F. Chamerot.
Michelini, Ann N. 1979. "Character and Character Change in Aeschylus: Klytemnestra and the Furies." *Ramus* 8:153–64.
Modleski, Tania. 1982. *Loving with a Vengeance*. Hamden: Archon Books.
Monro, D. B., ed. 1884. *Homer: "Iliad."* 2 vols. Oxford: Oxford University Press.
Montagu, Ashley, ed. 1980. *Sociobiology Examined*. New York: Oxford University Press.
Morgan, Robin, ed. 1970. *Sisterhood Is Powerful: An Anthology of Writings from the Women's Liberation Movement*. New York: Random House (Vintage).
Morrow, Glen R. 1960. *Plato's Cretan City: A Historical Interpretation of the "Laws."* Princeton: Princeton University Press.
Mossé, Claude. 1962. *La Fin de la démocratie Athénienne*. Paris: Presses Universitaires de France.
Most, Glenn W. 1985. *The Measures of Praise: Structure and Function in Pindar's Second Pythian and Seventh Nemean Odes*. Göttingen: Vandenhoeck & Ruprecht.
Mouffe, Chantal, ed. 1979. *Gramsci and Marxist Theory*. London: Routledge & Kegan Paul.
Moulton, Carroll. 1974. "Antiphon the Sophist and Democritus." *Museum Helveticum* 31:129–39.

Mouzelis, Nicos. 1988. "Marxism or Post-Marxism?" *New Left Review* 167 (January/February): 107–23.

Mueller, Martin. 1984. *The "Iliad."* (Unwin Critical Library) London: George Allen & Unwin.

Muir, J. V. 1985. "Religion and the New Education: The Challenge of the Sophists." In P. E. Easterling and J. V. Muir, eds., *Greek Religion and Society.* Cambridge: Cambridge University Press.

Mullen, William. 1982. *Choreia: Pindar and Dance.* Princeton: Princeton University Press.

Mumford, Lewis. 1962. *The Story of Utopias.* New York: Viking.

Murnaghan, Sheila. 1987a. *Disguise and Recognition in the "Odyssey."* Princeton: Princeton University Press.

———. 1987b. "Penelope's *Agnoia*: Knowledge, Power, and Gender in the *Odyssey.*" *Helios,* s. 13 (2): 103–14.

Murray, Oswyn. 1980. *Early Greece.* Atlantic Highlands, N.J.: Humanities Press.

Musurillo, Herbert. 1967. *The Light and the Darkness.* Leiden: Brill.

Muth, R. 1960. "Gottheit und Mensch im *Philoktet* des Sophokles." in *Studi in onore di L. Castiglioni* [no editor listed]. Firenzi: Sansoni.

Nagler, Michael N. 1974. *Spontaneity and Tradition: A Study in the Oral Art of Homer.* Berkeley: University of California Press.

Nagy, Gregory. 1974. *Comparative Studies in Greek and Indic Meter.* Cambridge: Harvard University Press.

———. 1979. *The Best of the Achaeans: Concepts of the Hero in Archaic Greek Poetry.* Baltimore: Johns Hopkins University Press.

Nancy, Jean-Luc. 1986. *La communauté désoeuvrée.* Paris: Christian Bourgois.

Natunewicz, Chester F. 1971. "The Ancient Classics in East Europe: A General Bibliography." *American Classical Review* 1:146–50.

———. 1975. "East European Classical Scholarship: Some Recent Trends." *Arethusa* 8 (Spring): 171–97.

Nestle, Wilhelm. 1910. "Sophokles und die Sophistik." *Classical Philology* 5:129–57.

———. 1940. *Vom Mythos zum Logos.* Stuttgart: A. Kröner.

Nicolaus, Martin. 1969. "The Unknown Marx." In Carl Oglesby, ed., *The New Left Reader.* New York: Grove Press.

Nilsson, Martin P. 1964 [1952]. *A History of Greek Religion.* 2d ed. New York: Norton.

———. 1968 [1933]. *Homer and Mycenae.* New York: Cooper Square.

Nimis, Stephen A. 1986. "The Language of Achilles: Construction vs. Representation." *Classical World* 79:217–25.

———. 1987. *Narrative Semiotics in the Epic Tradition: The Simile.* Bloomington: Indiana University Press.

Nisetich, Frank J., trans. 1980. *Pindar's Victory Songs.* Baltimore: Johns Hopkins University Press.

North, Helen. 1966. *Sophrosyne.* Ithaca: Cornell University Press.

Norwood, Gilbert. 1948. *Greek Tragedy.* 4th ed. London: Methuen.

———. 1956. *Pindar.* Berkeley: University of California Press.

Nussbaum, Martha. 1987. "Undemocratic Vistas." Review of *The Closing of the American Mind* by Allan Bloom. *New York Review of Books* 34 (November 5): 20–26.

O'Connor, James. 1988. "Capitalism, Nature, Socialism: A Theoretical Introduction." *Capitalism, Nature, Socialism* 1 (Fall): 11–38.

Oglesby, Carl, ed. 1969. *The New Left Reader.* New York: Grove Press.
Okin, Susan Moller. 1979. *Women in Western Political Thought.* Princeton: Princeton University Press.
Ollman, Bertell, and Edward Vernoff, eds. 1984. *The Left Academy: Marxist Scholarship on American Campuses,* vol. 2. New York: Praeger.
Ong, Walter J. 1962. "Latin and the Social Fabric." In *The Barbarian Within.* New York: Macmillan.
——. 1982. *Orality and Literacy.* London: Methuen.
Onians, R. B. 1988 [1951]. *The Origins of European Thought.* Cambridge: Cambridge University Press.
Opstelten, J. C. 1952. *Sophocles and Greek Pessimism.* Translated by J. A. Ross. Amsterdam: North-Holland.
Ostwald, Martin. 1969. *Nomos and the Beginnings of Athenian Democracy.* Oxford: Oxford University Press.
Packard, David W., and Tania Meyers. 1974. *A Bibliography of Homeric Scholarship: Preliminary Edition, 1930–1970.* Malibu, Calif.: Undena.
Padgug, Robert A. 1975. "Select Bibliography on Marxism and Antiquity." *Arethusa* 8 (Spring): 199–201.
Page, Denys. 1940. "Conjectures in Sophocles' *Philoctetes.*" *Proceedings of the Cambridge Philological Society* 6:49–55.
——. 1959. *Sappho and Alcaeus.* Oxford: Oxford University Press.
——. 1963. *History and the Homeric "Iliad."* Berkeley: University of California Press.
——. 1966 [1955]. *The Homeric "Odyssey."* Oxford: Oxford University Press.
Palmer, L. R. 1955. *Achaeans and Indo-Europeans.* Oxford: Oxford University Press.
Parke, H. W. 1977. *Festivals of the Athenians.* Ithaca: Cornell University Press.
Parlavanza-Friedrich, U. 1969. *Täuschungsszenen in den Tragödien des Sophokles.* Berlin: Walter de Gruyter.
Parry, Adam. 1956. "The Language of Achilles." *Transactions of the American Philological Association* 87:1–7.
——. 1966. "Have We Homer's *Iliad?*" *Yale Classical Studies* 20:175–216.
——. 1972. "Language and Characterization in Homer." *Harvard Studies in Classical Philology* 76:1–22.
Parry, Milman. 1971. *The Making of Homeric Verse.* Edited by Adam Parry. Oxford: Oxford University Press.
Pembroke, Simon. 1967. "Women in Charge: The Function of Alternatives in Early Greek Tradition and the Ancient Idea of Matriarchy." *Journal of Warburg and Courtauld* 30:1–35.
Peradotto, John J. 1969. "The Omen of the Eagles and the ΗΘΟΣ of Agamemnon." *Phoenix* 23:237–61.
Picard-Cambridge, Arthur. 1962. *Dithyramb, Tragedy and Comedy.* 2d ed. Revised by T. B. L. Webster. Oxford: Oxford University Press.
——. 1968. *The Dramatic Festivals of Athens.* 2d ed. Revised by John Gould and D. M. Lewis. Oxford: Oxford University Press.
Pini, G. 1967. "Correzioni di miti in Pindaro." *Vichiana* 4:339–82.
Pippin, Robert, et al., eds. 1988. *Marcuse: Critical Theory and the Promise of Utopia.* South Hadley, Mass.: Bergin & Garvey.
Place, Janey Ann. 1974. *The Western Films of John Ford.* Secaucus, N.J.: Citadel Press.
Podlecki, Anthony J. 1966a. *The Political Background of Aeschylean Tragedy.* Ann Arbor: University of Michigan Press.

———. 1966b. "The Power of the Word in Sophocles' *Philoctetes*." *Greek, Roman, and Byzantine Studies* 7:233–50.

———. 1984. *The Early Greek Poets and Their Times*. Vancouver: University of British Columbia Press.

———. 1986. "*Polis* and Monarch in Early Attic Tragedy." In J. Peter Euben, ed., *Greek Tragedy and Political Theory*. Berkeley: University of California Press.

Pohlenz, Max. 1953. "Nomos und Physis." *Hermes* 81:418–38.

———. 1954. *Die griechishe Tragödie*. 2d ed. Göttingen: Vandenhoeck & Ruprecht.

Pollitt, J. J. 1986. *Art in the Hellenistic Age*. Cambridge: Cambridge University Press.

Pomeroy, Sarah B. 1975. *Goddesses, Whores, Wives, and Slaves: Women in Classical Antiquity*. New York: Schocken Books.

Popper, Karl R. 1963 [1962]. *The Open Society and Its Enemies*, vol. 1: *The Spell of Plato*. New York: Harper.

Porter, Howard. 1962. Introduction to *The Odyssey: Homer*. New York: Bantam Books.

Pratt, Norman T., Jr. 1949. "Sophoclean 'Orthodoxy' in the *Philoctetes*." *American Journal of Philology* 70:273–89.

Prawer, S. S. 1978 [1976]. *Karl Marx and World Literature*. Oxford: Oxford University Press.

Pucci, Pietro. 1977. *Hesiod and the Language of Poetry*. Baltimore: Johns Hopkins University Press.

———. 1987. *Odysseus Polutropos: Intertexual Readings in the "Odyssey" and the "Iliad."* Ithaca: Cornell University Press.

Puech, A. 1970 [1922–23]. *Pindare*. 4 vols. Paris: Les Belles Lettres.

Race, William H. 1986. *Pindar*. Boston: Twayne.

———. 1987. "P.OXY.2438 and the Order of Pindar's Works." *Rheinisches Museum fur Philologie*, n.f. 130:407–10.

———. 1989. "Climactic Elements in Pindar's Verse." *Harvard Studies in Classical Philology* 92:43–69.

Radt, Stefan. 1974. Revision of Adolf Köhnken, *Die Funktion des Mythos bei Pindar*. *Gnomon* 46:113–21.

Raman, Rahim A. 1975. "Homeric *aōtos* and Pindaric *aōtos*: A Semantic Problem." *Glotta* 53:195–207.

Raulet, Gérard. 1983. "Structuralism and Post-Structuralism: An Interview with Michel Foucault." *Telos* 55 (Spring): 195–211.

Raven, J. E. 1965. *Plato's Thought in the Making*. Cambridge: Cambridge University Press.

Redfield, James M. 1973. "The Making of the *Odyssey*." In Anthony C. Yu, ed., *Parnassus Revisited: Modern Critical Essays on the Epic Tradition*. Chicago: American Library Association.

———. 1975. *Nature and Culture in the "Iliad": The Tragedy of Hector*. Chicago: University of Chicago Press.

———. 1983. "The Economic Man." In Carl A. Rubino and Cynthia W. Shelmerdine, eds., *Approaches to Homer*. Austin: University of Texas Press.

Reeve, C. D. C. 1988. *Philosopher-Kings: The Argument of Plato's "Republic."* Princeton: Princeton University Press.

Reeve, M. D. 1973. "The Language of Achilles." *Classical Quarterly*, n.s. 23:193–95.

Reeves, Charles H. 1960. "The Parodos of the *Agamemnon*." *Classical Journal* 55:99–105.

Reinhardt, Karl. 1947. *Sophokles.* 3d ed. Frankfurt am Main: Klostermann.
——. 1949. *Aischylos als Regisseur und Theologe.* Bern: A. Franke.
Reinhold, Meyer. 1975. *The Classik Pages: Classical Readings of Eighteenth-Century Americans.* University Park, Pa.: American Philological Association.
Reiter, Rayna Rapp, ed. 1975. *Toward an Anthropology of Women.* New York: Monthly Review Press.
Resnick, Stephen, and Richard Wolff. 1982. "Classes in Marxian Theory." *Review of Radical Political Economics* 13 (4): 1–18.
——, eds. 1985. *Rethinking Marxism.* Brooklyn: Automedia.
Rhodes, P. J. 1985 [1981]. *A Commentary on the Aristotelian "Athenaion Politeia."* Oxford: Oxford University Press.
Ricoeur, Paul. 1970. *Freud and Philosophy.* Translated by Denis Sauvage. New Haven: Yale University Press.
Roberts, Jennifer Tolbert. 1989. "Athenians on the Sceptered Isle." *Classical Journal* 84 (February/March): 193–205.
Robinson, David B. 1969. "Topics in Sophocles' *Philoctetes.*" *Classical Quarterly* 19:34–56.
Robinson, R. 1953. *Plato's Earlier Dialectic.* 2d ed. Oxford: Oxford University Press.
Roebuck, Carl. 1955. "The Early Ionian League." *Classical Philology* 50:26–40.
Romilly, Jacqueline de. 1958. *La crainte et l'angoisse dans le theâtre d' Eschyle.* Paris: Les Belles Lettres.
——. 1963. *Thucydides and Athenian Imperialism.* Translated by Philip Thody. Oxford: Basil Blackwell.
——. 1966. "Thucydide et l'idée de progrès." *Annali della Scuola Normale Superiore di Pisa* 35:143–91.
Ronnet, Gilberte. 1969. *Sophocle, poète tragique.* Paris: Editions E. de Boccard.
Rosaldo, Michelle Zimbalist, and Louise Lamphere, eds. 1974. *Women, Culture & Society.* Stanford: Stanford University Press.
Rose, Peter W. 1974. "The Myth of Pindar's First Nemean: Sportsmen, Poetry and Paideia." *Harvard Studies in Classical Philology* 78:145–75.
——. 1988. "Thersites and the Plural Voices of Homer." *Arethusa* 21:5–25.
Rosenmeyer, Thomas G. 1965. "The Formula in Early Greek Poetry." *Arion* 4:295–311.
——. 1982. *The Art of Aeschylus.* Berkeley: University of California Press.
Rostovtzeff, M. 1941. *The Social and Economic History of the Hellenistic World.* 3 vols. Oxford: Oxford University Press.
Rousell, Denis. 1976. *Tribu et cité.* Paris: Les Belles Lettres.
Rousselle, Aline. 1988. *Porneia: On Desire and the Body in Antiquity.* Translated by Felicia Pheasant. Oxford: Basil Blackwell.
Roux, Georges. 1980. *Ancient Iraq.* 2d ed. Harmondsworth, Middlesex: Penguin.
Russo, Joseph A. 1963. "A Closer Look at Homeric Formulas." *Transactions of the American Philological Association* 94:235–47.
——. 1966. "The Structural Formula in Homeric Verse." *Yale Classical Studies* 20:217–40.
——. 1968. "Homer against His Tradition." *Arion* 7 (Summer): 275–95.
——. 1974. "The Inner Man in Archilochus and the *Odyssey.*" *Greek, Roman, and Byzantine Studies* 15:139–52.
——. 1976. "How, and What, Does Homer Communicate? The Medium and the Message of Homeric Verse." *Classical Journal* 71:289–99.

Ryan, Michael. 1982. *Marxism and Deconstruction: A Critical Articulation*. Baltimore: Johns Hopkins University Press.

Saffioti, Heleieth I. B. 1978. *Women in Class Society*. Translated by Michael Vale. New York: Monthly Review Press.

Sagan, Eli. 1979. *The Lust to Annihilate: A Psychoanalytic Study of Violence in Ancient Greek Culture*. New York: Psychohistory Press.

Sahlins, Marshall. 1976. *The Use and Abuse of Biology: An Anthropological Critique of Sociobiology*. Ann Arbor: University of Michigan Press.

Said, Edward. 1983. *The World, the Text and the Critic*. Cambridge: Harvard University Press.

Ste. Croix, G. E. M. de. 1954–55. "The Character of the Athenian Empire." *Historia* 3:1–41.

———. 1972. *The Origins of the Peloponnesian War*. Ithaca: Cornell University Press.

———. 1981. *The Class Struggle in the Ancient Greek World*. Ithaca: Cornell University Press.

Sale, William. 1963. "Achilles and Heroic Values." *Orion* 3:86–100.

Salmon, John. 1977. "Political Hoplites?" *Journal of Hellenic Studies* 97:84–101.

Sargent, Lydia, ed. 1981. *Women and Revolution*. Boston: South End Press.

Sartre, Jean-Paul. 1971. "Replies to Structuralism: An Interview with Jean-Paul Sartre." Translated by Robert D'Amico from "Sartre Aujourd'hui." *Arc*. 30. *Telos* 9 (Fall): 110–16.

Sassoon, Anne Showstock, ed. 1982. *Approaches to Gramsci*. London: Writers and Readers.

———. 1987. *Gramsci's Politics*. 2d ed. Minneapolis: University of Minnesota Press.

Schadewaldt, Wolfgang. 1965. *Von Homers Welt und Werk*. Stuttgart: K. F. Koehler.

———. 1966 [1928]. *Der Aufbau des pindarischen Epinikion*. Tubingen: Max Neimeyer.

Schein, Seth L. 1980. "On Achilles' Speech to Odysseus, *Iliad* 9.308–429." *Eranos* 78:125–31.

———. 1984. *The Mortal Hero: An Introduction to Homer's "Iliad."* Berkeley: University of California Press.

Schlesinger, Eilhard. 1968. "Die Intrige im Aufbau von Sophokles' *Philoktet*." *Rheinisches Museum*, n.f. 111:97–156.

Schmidt, Jens-Uwe. 1973. *Sophokles' "Philoktet": Eine Strukturanalyse*. Heidelberg: C. Winter.

Scott, J. A. 1931. "The Poetic Structure of the *Odyssey*." Martin Classical Lecture 1 (1930). Cambridge: Harvard University Press.

———. 1965 [1921]. *The Unity of Homer*. New York: Biblo & Tannen.

Scott, Joan Wallach. 1988. *Gender and the Politics of History*. New York: Columbia University Press.

Scott, William C. 1974. *The Oral Nature of the Homeric Simile*. *Mnemosyne* supp. 28. Leiden: Brill.

Seale, David. 1972. "The Element of Surprise in Sophocles' *Philoctetes*." *Bulletin of the Institute of Classical Studies, University of London* 19:94–102.

Sealey, Raphael. 1976. *A History of the Greek City-States ca. 700–338 B.C.* Berkeley: University of California Press.

———. 1982. Review of *The Class Struggle in the Ancient World* by G. E. M. de Ste. Croix. *Classical Views*, n.s. 26 (1): 319–35.

Segal, Charles P. 1962. "The Phaeacians and the Symbolism of Odysseus' Return." *Arion* 1:17–64.

——. 1963. "Nature and the World of Man in Greek Literature." *Arion* 2:19–53.

——. 1964. "Sophocles' Praise of Man and the Conflicts of the *Antigone.*" *Arion* 3:46–66.

——. 1981. *Tragedy and Civilization: An Interpretation of Sophocles.* Cambridge: Harvard University Press.

——. 1982. "Afterword: Jean-Pierre Vernant and the study of Ancient Greece." *Arethusa* 15 (Spring and Fall): 221–34.

——. 1986a. *Pindar's Mythmaking: The Fourth Pythian Ode.* Princeton: Princeton University Press.

——. 1986b. *Interpreting Greek Tragedy: Myth, Poetry, Text.* Ithaca: Cornell University Press.

Sherfey, Mary Jane. 1970. "A Theory of Female Sexuality." In Robin Morgan, ed., *Sisterhood Is Powerful: An Anthology of Writings from the Women's Liberation Movement.* New York: Random House (Vintage).

Shipp, G. P. 1972. *Studies in the Language of Homer.* 2d ed. Cambridge: Cambridge University Press.

Showalter, Elaine. 1985. "Feminist Criticism in the Wilderness." In Elaine Showalter, ed., *The New Feminist Criticism: Essays on Women, Literature, Theory.* New York: Pantheon.

Shucard, Steven C. 1974. "Some Developments in Sophocles' Late Plays of Intrigue." *Classical Journal* 70:133–38.

Simon, Bennett. 1978. *Mind and Madness in Ancient Greece.* Ithaca: Cornell University Press.

Slater, Philip E. 1968. *The Glory of Hera.* Boston: Beacon Press.

Slater, William J. 1969a. *Lexicon to Pindar.* Berlin: Walter de Gruyter.

——. 1969b. "Futures in Pindar." *Classical Quarterly* 19:86–94.

——. 1977. "Doubts about Pindaric Interpretations." *Classical Journal* 72:193–208.

Smith, Adam. 1937 [1776]. *The Wealth of Nations.* New York: Modern Library.

Smith, Paul. 1988. *Discerning the Subject.* Minneapolis: University of Minnesota Press.

Smith, Peter M. 1980. *On the Hymn to Zeus in Aeschylus' "Agamemnon."* Chico, Calif.: Scholars Press.

Smyth, Herbert Wier. 1926. *Aeschylus with an English Translation,* vol. 2. Loeb Classical Library.

Snell, Bruno. 1960 [1953]. *The Discovery of the Mind: The Greek Origins of European Thought.* Translated by T. G. Rosenmeyer. New York: Harper.

Snodgrass, Anthony M. 1971. *The Dark Age of Greece.* Edinburgh: Edinburgh University Press.

——. 1974. "An Historical Homeric Society?" *Journal of Hellenic Studies* 94:114–25.

——. 1980. *Archaic Greece: The Age of Experiment.* Berkeley: University of California Press.

——. 1982. "Central Greece and Thessaly." In *Cambridge Ancient History,* vol. 3, pt. 1: *The Prehistory of the Balkans: The Middle East and the Aegean World, Tenth to Eighth Centuries B.C.* 2d ed. Cambridge: Cambridge University Press.

Snowden, Frank M., Jr. 1970. *Blacks in Antiquity.* Cambridge: Harvard University Press.

Sohn-Rethel, Alfred. 1978. *Intellectual and Manual Labor.* Atlantic Highlands, N.J.: Humanities Press.

Solmsen, Friedrich. 1949. *Hesiod and Aeschylus.* Ithaca: Cornell University Press.

Solomon, Maynard, ed. 1979. *Marxism and Art: Essays Classic and Contemporary.* Detroit: Wayne State University Press.

Sommerstein, Alan H., ed. 1989. *Aeschylus' "Eumenides."* Cambridge: Cambridge University Press.

Sontag, Susan. 1966. *Against Interpretation.* New York: Dell.

Spira, A. 1960. *Untersuchungen zum Deus ex machina bei Sophokles und Euripides.* Kalmünz: M. Lassleben.

Spivak, Gayatri Chakravorty. 1980. "Revolutions That As Yet Have No Model." *Diacritics* 10 (Winter): 29–49.

———. 1984. "Marx after Derrida." In William E. Cain, ed. *Philosophical Approaches to Literature: New Essays on Nineteenth- and Twentieth-Century Texts.* Lewisburg, Pa.: Bucknell University Press.

———. 1988. *In Other Worlds: Essays in Cultural Politics.* New York: Routledge.

Sprague, Rosamond Kent, ed. 1972. *The Older Sophists: A Complete Translation.* Columbia: University of South Carolina Press.

Stadter, Philip, ed. 1973. *The Speeches in Thucydides: A Collection of Original Studies with a Bibliography.* Chapel Hill: University of North Carolina Press.

Stalin, Joseph. 1940. *Dialectical and Historical Materialism.* New York. International Publishers.

Stanford, W. B. 1963. *The Ulysses Theme.* Oxford: Basil Blackwell.

———, ed. 1964–65. *The "Odyssey" of Homer.* 2 vols. New York: St. Martin's Press.

———, and J. V. Luce. 1974. *The Quest for Ulysses.* New York: Praeger.

Starr, Chester. 1961. *The Origins of Greek Civilization: 1100–650 B.C.* New York: Alfred Knopf.

———. 1977. *The Economic and Social History of Early Greece, 800–500 B.C.* New York: Oxford University Press.

———. 1986. *Individual and Community: The Rise of the Polis, 800–500 B.C.* New York: Oxford University Press.

Steiner, Deborah. 1986. *The Crown of Song: Metaphor in Pindar.* Oxford: Oxford University Press.

Steiner, George. 1970. *Language and Silence.* New York: Atheneum.

Stenzel, Julius. 1973. *Plato's Method of Dialectic.* Translated by D. J. Allan. New York: Arno Press.

Stewart, Douglas J. 1976. *The Disguised Guest: Rank, Role, and Identity in the "Odyssey."* Lewisburg, Pa.: Bucknell University Press.

Strasburger, Hermann. 1953. "Die soziologische Aspekt der homerischen Epen." *Gymnasium* 60:97–114.

Strauss, Barry S. 1987. *Athens after the Peloponnesian War: Class, Faction, and Policy, 403–386 B.C.* Ithaca: Cornell University Press.

Strauss, Leo. 1959. "The Liberalism of Classical Political Philosophy." *Review of Metaphysics* 12:390–439 (reprinted in Leo Strauss, *Liberalism Ancient and Modern.* With a foreword by Allan Bloom. Ithaca: Cornell University Press, 1989).

Suchting, W. A. 1983. *Marx: An Introduction.* New York: New York University Press.

Sullivan, J. P., ed. 1975. *Marxism and Classics. Arethusa* 8 (Spring).

Suzuki, Mihoko. 1989. *Metamorphoses of Helen: Authority, Difference, and the Epic.* Ithaca: Cornell University Press.

Taplin, Oliver. 1971. "Significant Actions in Sophocles' *Philoctetes.*" *Greek, Roman, and Byzantine Studies* 12:25–44.

———. 1977. *The Stagecraft of Aeschylus: The Dramatic Use of Exits and Entrances in Greek Tragedy.* Oxford: Oxford University Press.

Taylor, Charles. 1979. *Hegel and Modern Society.* Cambridge: Cambridge University Press.

Thalmann, William G. 1984. *Conventions of Form and Thought in Early Greek Epic Poetry.* Baltimore: Johns Hopkins University Press.

Theiler, Willy. 1970. *Untersuchungen zur antike Literatur.* Berlin: Walter de Gruyter.

Thimme, Otto. 1935. ΦΥΣΙΣ, ΤΡΟΠΟΣ, ΗΘΟΣ: *Semasiologishe Untersuchung über die Auffassung des menschlichen Wesens (Charakters) in der alteren griechischen Literatur.* Ph.D. diss., Georg-August-Universitat zu Göttingen, Göttingen.

Thomas, C. G. 1966. "The Roots of Homeric Kingship." *Historia* 15:387–407.

———. 1978. "From Wanax to Basileus: Kingship in the Greek Dark Age." *Hispania Antiqua* 6:187–206.

Thomson, George. 1946. *Aeschylus and Athens.* 2d ed. London: Lawrence & Wishart.

———. 1961. *The First Philosophers.* 2d ed. London: Lawrence & Wishart.

Thornton, Agathe. 1970. *People and Themes in Homer's "Odyssey."* London: Methuen.

———. 1984. *Homer's "Iliad": Its Composition and the Motif of Supplication.* Göttingen: Vandenhoeck & Ruprecht.

Thummer, Erich. 1957. *Die Religiosität Pindars.* Innsbruch: Universitäts Verlag.

———. 1968. Pindar: *Die Isthmischen Gedichte.* 2 vols. Heidelberg: Carl Winter.

Todorov, Tzvetan. 1977. *The Poetics of Prose.* Translated by Richard Howard. Ithaca: Cornell University Press.

———, ed. 1982. *French Literary Theory Today.* Cambridge: Cambridge University Press.

Treadgold, Donald W. 1987. *Twentieth-Century Russia.* 6th ed. Boulder, Colo.: Westview Press.

Tuchman, Barbara. 1978. *A Distant Mirror: The Calamitous Fourteenth Century.* New York: Knopf.

Tucker, Robert C. 1972. *Philosophy and Myth in Karl Marx.* 2d ed. Cambridge: Cambridge University Press.

———, ed. 1978. *The Marx-Engels Reader.* 2d ed. New York: Norton.

Turner, Frank M. 1981. *The Greek Heritage in Victorian England.* New Haven: Yale University Press.

van Groningen, B. A. 1958. *La composition littéraire archaique grecque.* Amsterdam: North-Holland.

Van Sickle, John. 1975. "Archilochus: A New Fragment of an Epode." *Classical Journal* 71:1–15.

Ventris, Michael, and John Chadwick. 1973. *Documents in Mycenaean Greek.* 2d ed. Cambridge: Cambridge University Press.

Vermeule, Emily. 1972. *Greece in the Bronze Age.* Chicago: University of Chicago Press.

Vernant, Jean-Pierre. 1965. *Mythe et pensée chez les grecs.* Paris: Maspero.

———. 1979. *Religions, histoires, raisons.* Paris: François Maspero.

———. 1980 [1974]. *Myth and Society in Ancient Greece.* Translated by Janet Lloyd. New York: Zone.

———. 1982 [1962]. *The Origins of Greek Thought.* [No translator listed.] Ithaca: Cornell University Press.

——, and Pierre Vidal-Naquet. 1988 [1972]. *Myth and Tragedy in Ancient Greece.* Translated by Janet Lloyd. New York: Zone.

Veyne, Paul. 1988. *Did the Greeks Believe in Their Myths?* Translated by Paula Wissing. Chicago: University of Chicago Press.

Vickers, Brian. 1979 [1973]. *Towards Greek Tragedy.* London: Longman.

Vidal-Naquet, Pierre. 1970a. "Esclavage et gynécratie dans la tradition, le mythe, l'utopie." in C. Nicolet, ed. *Recherches sur les structures sociales dans l'antiquité classique.* Paris: Editions du centre national de la recherche scientifique.

——. 1970b. "Valeurs religieuses et mythiques de la terre et du sacrifice dans l'*Odyssée.*" *Annales; Economies, Sociétés, Civilisations* 25:1278–97.

Vlastos, G. 1945. "Ethics and Physics in Democritus (Part 1)." *Philosophical Review* 54:578–92.

——. 1946. "Ethics and Physics in Democritus (Part 2)." *Philosophical Review* 55:53–64.

——. 1968. "Does Slavery Exist in Plato's *Republic?*" *Classical Philology* 63:291–95.

——, ed. 1978a. *Plato: A Collection of Critical Essays*, vol. 1: *Metaphysics and Epistemology.* Notre Dame: University of Notre Dame Press.

——, ed. 1978b. *Plato: A Collection of Critical Essays*, vol. 2: *Ethics, Politics, and Philosophy of Art and Religion.* Garden City, N.Y.: Doubleday (Anchor).

——. 1981. *Platonic Studies.* 2d ed. Princeton: Princeton University Press.

Vogel, Lise. 1983. *Marxism and the Oppression of Women: Toward a Unitary Theory.* New Brunswick, N.J.: Rutgers University Press.

Voloshinov, V. N. [Bahktin?]. 1973. *Marxism and the Philosophy of Language.* Translated by Ladislav Matejka and I. R. Titunik. New York: Seminar Press.

——. 1987 [1976]. *Freudianism: A Critical Sketch.* Translated by I. R. Titunik. Bloomington: Indiana University Press.

Wace, Alan J. B., and Frank H. Stubbings, eds. 1962. *A Companion to Homer.* London: Macmillan.

Wade-Gery, H. T. 1952. *The Poet of the "Iliad."* Cambridge: Cambridge University Press.

Walcot, Peter. 1966. *Hesiod and the Near East.* Cardiff: University of Wales Press.

Waldock, A. J. A. 1966 [1951]. *Sophocles the Dramatist.* Cambridge: Cambridge University Press.

Walsh, George B. 1984. *The Varieties of Enchantment: Early Greek Views of the Nature and Function of Poetry.* Chapel Hill: University of North Carolina Press.

Webster, T. B. L. 1964. *From Mycenae to Homer.* London: Methuen.

——. 1967. *The Tragedies of Euripides.* London: Methuen.

——. 1969. *An Introduction to Sophocles.* 2d ed. London: Methuen.

——, ed. 1970. *Sophocles' "Philoctetes."* Cambridge: Cambridge University Press.

Weil, Simone. 1956 [1940]. "The *Iliad*, or The Poem of Force." Translated by Mary McCarthy. Pendle Hill Pamphlet 91. Wallingford, Pa.

Weinstock, Heinrich. 1937. *Sophokles.* 2d ed. Berlin: Die Runde.

Wellek, René, and Austin Warren. 1956 [1942]. *Theory of Literature.* New York: Harcourt.

Wender, Dorothea. 1973. "Plato: Misogynist, Paedophile, and Feminist." *Arethusa* 6:75–90.

——. 1978. *The Last Scenes of the "Odyssey."* Leiden, the Netherlands: E.J. Brill.

West, Cornel. 1982a. *Prophesy Deliverance! An Afro-American Revolutionary Christianity.* Philadelphia: Westminster Press.

———. 1982b. "Fredric Jameson's Marxist Hermeneutics." *Boundary* 2 11 (Fall/Winter): 177–200.

West, M. L., ed. 1966. *Hesiod, "Theogony."* Oxford: Oxford University Press.

———. 1971a. *Iambi et Elegi Graeci*. 2 vols. Oxford: Oxford University Press.

———. 1971b. *Early Greek Philosophy and the Orient*. Oxford: Oxford University Press.

———, ed. 1978. *Hesiod, "Works and Days."* Oxford: Oxford University Press.

Weston, Jack. 1990. "For an Ecological Politics of Hope." *Monthly Review* 41 (February): 1–11.

Whallon, William. 1958. "The Serpent at the Breast." *Transactions of the American Philological Association* 94:271–75.

Whitman, Cedric H. 1951. *Sophocles: A Study in Heroic Humanism*. Cambridge: Harvard University Press.

———. 1958. *Homer and the Heroic Tradition*. Cambridge: Harvard University Press.

———. 1964. *Aristophanes and the Comic Hero*. Cambridge: Harvard University Press.

Wilamowitz-Moellendorff, Tycho von. 1969 [1917]. *Die dramatische Technik des Sophokles*. Zurich: Weidmann.

Wilamowitz-Moellendorff, Ulrich von. 1920. *Platon*. 2 vols. Berlin: Weidmann.

———. 1966 [1922]. *Pindaros*. Berlin: Weidmann.

Will, Edouard. 1957 "Aux origines du régime foncier grec: Homère, Hésiode et l' arrière-plan mycénien." *Revue des études anciennes* 59:5–50.

Willcock, M. M. 1970. "Some Aspects of the Gods in the *Iliad*." *Bulletin of the Institute of Classical Studies, University of London* 17:1–10.

———, ed. 1978. *The "Iliad" of Homer*. London: Macmillan.

Williams, Raymond. 1980. *Problems in Materialism and Culture*. London: Verso.

Wilson, Edmund. 1941 [1929]. *The Wound and the Bow*. Cambridge: Riverside Press.

———. 1953 [1940]. *To the Finland Station: A Study in the Writing and Acting of History*. Garden City, N.Y.: Doubleday.

Wimsatt, W. K., and Monroe Beardsley. 1954. *The Verbal Icon: Studies in the Meaning of Poetry*. Lexington: University Press of Kentucky.

Winnington-Ingram, R. P. 1948. "Clytemnestra and the Vote of Athena." *Journal of Hellenic Studies* 68:130–47.

———. 1956. Review of Ivan M. Linforth, "Philoctetes: The Play and the Man." *Gnomon* 28:632–34.

———. 1965. "Tragedy and Greek Archaic Thought." In Anderson, Michael J., ed. *Classical Drama and Its Influence: Essays Presented to H. D. F. Kitto*. New York: Methuen.

———. 1969. "Tragica." *Bulletin of the Institute of Classical Studies, University of London* 16:44–54.

———. 1974. "Notes on the *Agamemnon* of Aeschylus." *Bulletin of the Institute of Classical Studies, University of London* 21:3–19.

———. 1977. "Septem contra Thebas." *Yale Classical Studies* 25:1–46.

———. 1980. *Sophocles: An Interpretation*. Cambridge: Cambridge University Press.

———. 1983a. *Studies in Aeschylus*. Cambridge: Cambridge University Press.

———. 1983b. "Sophocles and Women." In *Entretiens sur l'antiquité classique, tome 29: Sophocle*. Paris: Klicksieck.

Wolff, Christian. 1979. "A Note on Lions and Sophocles, *Philoctetes* 1436." In Glen W. Bowersock, Walter Burkert, and Michael C. J. Putnam, eds., *Ark-*

touros, Hellenic Studies Presented to Bernard M. W. Knox on the Occasion of His 65th Birthday. Berlin: Walter de Gruyter.

Wood, Ellen Meiksins. 1986. *The Retreat from Class: A New "True" Socialism*. London: Verso.

————. 1989 [1988]. *Peasant-Citizen and Slave: The Foundations of Athenian Democracy*. London: Verso.

————, and Neal Wood. 1978. *Class Ideology and Ancient Political Theory: Socrates, Plato, and Aristotle in Social Context*. Oxford: Basil Blackwell.

Woodhouse, W. J. 1969 [1930]. *The Composition of Homer's "Odyssey."* Oxford: Oxford University Press.

Yalouris, Nicolaos, ed. 1979. *The Eternal Olympics*. New Rochelle, N.Y.: Caratzas Brothers.

Young, David C. 1964. "Pindaric Criticism." *Minnesota Review* 4:584–641 (Reprinted with changes in William Calder III and Jacob Stern, eds. *Pindaros und Bakchylides*. Wege der Forschung 134 (1970):1–95. Darmstadt: Wissenschaftliche Buchgesellschaft).

————. 1968. *Three Odes of Pindar*. Leiden: Brill.

————. 1971. *Pindar, "Isthmian 7," Myth and Exempla*. Leiden: Brill.

————. 1985. *The Olympic Myth of Greek Amateur Athletics*. Chicago: Ares.

Young, Douglas. 1967. "Never Blotted a Line?" *Arion* 6 (3): 279–324.

————, trans. 1974. *Aeschylus: The Oresteia*. Translated into English verse from a scientifically conservative Greek text. Norman: University of Oklahoma Press.

Zeitlin, Froma I. 1965. "The Motif of the Corrupted Sacrifice in Aeschylus' *Oresteia*." *Transactions of the American Philological Association* 96:463–508.

————. 1978. "The Dynamics of Misogyny: Myth and Mythmaking in the *Oresteia*." *Arethusa* 11:149–84.

————. 1981. "Travesties of Gender and Genre in Aristophanes' *Thesmophoriazousae*." In Helene Foley, ed., *Reflections of Women in Antiquity*. New York: Gordon and Breach Science Publishers.

————. 1982. "Cultic Models of the Female: Rites of Dionysus and Demeter." *Arethusa* 15:129–57.

————. 1990. "Patterns of Gender in Aeschylean Drama: *Seven against Thebes* and the Danaid Trilogy." In M. Griffith and D. J. Mastronarde, eds., *Cabinet of the Muses*. Atlanta, Ga.: Scholars Press.

Zumthor, Paul. 1990. *Oral Poetry: An Introduction*. Translated by Kathryn Murphy-Judy. Minneapolis: University of Minnesota Press.

Index

Adam, J., 342n, 358n, 365n
Adkins, A. W. H., 51n, 72
Adorno, T., 35, 41, 42
Aeschylus, 266–70, 327, 347, 356, 357
Alkaios, 145
Alt, K., 291n, 303n, 304n, 324n
Althusser, L., 19, 27, 30–33, 37, 55, 123, 165, 332–33, 338
Ancient Near East, 56n, 88n, 94n
Andrewes, A., 160, 248
Antiphon, 306, 318, 358n, 368
Apollo, 227, 241, 246n, 253n, 259
Archilochos, 133n, 142
Areiopagos council, 187, 246–48, 257, 263
Aristocracy. See Oligarchy
Aristophanes, 227, 251, 259n, 268, 285, 308n, 311n, 338, 339, 358
Aristotle, 21n, 25, 33, 49–50, 145, 153, 190, 202n, 203, 250, 259, 269, 327–28, 350n, 359n
Arthur, M., 86, 126, 222n
Athletic contests/gymnasia, 96–97, 100–101, 136, 144, 147–48, 156, 158, 160, 162, 172, 182, 185, 338

Bacchylides, 155, 156, 161, 176–77
Bakhtin, M., 13–14, 27–29, 32, 46, 56–57, 342n
Barrett, M., 14n, 360n
Barthes, R., 258, 345
Base/superstructure, 7n, 11n, 28–29, 32, 58. See also economics
Baudrillard, J., 14, 15n, 18n
Beauvoir, S. de, 221

Benjamin, W., 35, 137n, 370
Bennett, W., 5, 38, 39
Benveniste, E., 79n
Bernal, M., 121n
Birth as determinant of social status. See Inherited excellence
Bloch, E., 13
Bloom, A., 4, 38, 39, 273n, 331n
Bluestone, N., 359n
Bowra, M., 151–54, 156, 163n, 181, 271, 297n, 302n, 317n, 322n
Braudel, F., 55
Brown, N. O., 5, 96, 115, 154, 196
Bundy, E., 142n, 152, 154–59, 161n, 163–66, 169, 176, 177, 243
Burkert, W., 187n, 188
Burton, R. W. B., 169, 176, 178n, 181, 182n, 296n

Calder, W. 264, 295n, 309n, 317n, 321, 328
Caldwell, R., 196
Calhoun, G., 151, 236
Carne-Ross, D., 164–65
Carter, L., 339n, 350n, 363n
Cartledge, P., 146n, 335
Classics, discipline of, 3–6, 184; and philology, 28
Class struggle, 8, 29, 35, 137, 140, 148, 173, 184, 187, 202, 204, 216, 327, 371–72
Claus, D., 65
Clay, D., 195–96, 237n, 346n, 349–50, 354n
Cole, T., 273, 275, 276n, 303n

Colonization, 55, 120, 134–40, 143–45, 186
Connor, W. R., 311n, 337n, 339n, 242n
Contradiction, 40–42, 50–52, 56, 58, 66–69, 75, 78–82, 91, 94, 246, 257, 258, 261, 264, 267, 305
Cornford, F. M., 146n
Craik, E., 279n, 281, 296n, 305n, 307n, 315, 326n

Dale, A. M., 163–64n
Davies, J. K., 204, 247, 249, 261n, 263, 334n, 336n, 356, 366
Deconstruction, 16, 365
Democracy, 138, 158, 177, 188, 194, 197, 211, 225, 233, 235, 238–40, 246–65, 269, 271, 272, 277, 301, 306, 310, 328–30, 334–41, 349, 361, 368, 371–72; and discouse of human nature, 362–63
Democritos, 1n, 239n, 274n, 275n, 277n, 301n, 313n, 339n, 359n, 369
Demos (the people), 190, 192, 202, 203n, 210–12, 215, 219, 224, 225, 355n
Denniston, J., 339, 341n
Derrida, J., 16, 343n
Detienne, M., 96, 118, 121, 125n, 188n
Dialectics: Aeschylean, 194–97, 271; Hegelian, 370; Marxian, 11; Platonic, 360; sophistic, 343
Dimock, G., 117, 121, 129, 135
Dodds, E. R., 132n, 194n, 203n, 212, 238, 246, 264, 262, 272, 278n
Donlan, W., 90n, 97n, 110n
Double hermeneuetic, 33–42, 140, 158–59, 165–82, 225, 370–73
Dover, K., 248, 261, 264, 285n, 339n
DuBois, P., 31n, 134, 221, 230, 257n, 367n
Dylan, Bob, 92, 107n

Eagleton, T., 4, 154n
Earth, children of, 271, 274n
Easterling, P., 199n
Eastern Europe, 8, 28
Economics, 333, 335–37, 346, 356, 357, 361, 372
Education, 102–5, 119, 152, 254–56, 281, 303, 305, 306, 310–16, 321, 326–28, 333, 337–41, 347, 348, 351, 365–69; and professionalization of politics, 337, 341, 352, 365–66, 371–72. *See also* Oral poetry; Sophists
Edwards, A. T., 93n, 122n
Edwards, M., 44n, 45, 89n, 90n, 116n, 199

Ehrenberg, V., 271, 327, 363n
Else, G., 150n, 188–90
Engels, F., 9
Epistemology, 339–40, 346, 361. *See also* Literacy; Modes of communication; Orality
Erbse, H., 296n, 310n, 313
Essentialism, 1, 14, 359, 360n
Euripides, 2, 111, 272, 285, 304n, 338, 358

Feminism, 1n, 2, 14, 26n, 33, 133, 225–26, 244; and Plato, 356–61; and sexist translation, 7n; and sexual hierarchy, 21, 26, 144, 194n. *See also* Misogyny; Patriarchy; Sexual politics; Women
Field, G., 337n, 366
Finley, J. H., 93, 99n, 102, 121n, 124, 130, 131n, 157, 171n, 180, 183, 201, 211, 212, 261n, 339, 342n, 358
Finley, M. I., 21n, 53n, 54n, 57, 59–61, 76, 78n, 94n, 100, 106, 107n, 110n, 113, 114, 151–52, 172; functionalism of, 52
Forms: dialogue, 2, 333, 341–48; epinician, 159–65; epistemology of, 166; politics of, 27–29, 41–46, 141–43, 152, 159–65, 183, 185, 266, 341, 371–73; tragedy and trilogy, 185–94, 266, 268–69. *See also* Oral poetry
Forrest, W. G., 248n, 261, 262, 263n
Foucault, M., 1, 16n, 30, 33, 123n
Fraenkel, Eduard, 199n, 212
Fränkel, Hermann, 142n, 157, 158n, 159n, 162, 164n, 167
Frankfurt School, 13, 26n, 31–33, 37, 41, 42, 181. *See also* Adorno, T.; Marcuse, H.; Jameson, F.
Freud, S., 31, 35–38, 52, 85, 102, 123, 125n, 128n, 133, 182
Friedländer, P., 342, 343n, 344n, 345

Gagarin, M., 70n, 72, 139, 191, 202, 203, 238–40, 257
Gardiner, C., 291n, 296n, 297n, 300n, 323n
Gellrich, M., 190n
Genre. *See* Forms
Gentili, B., 163
Girard, R., 187n, 190
Goldhill, S., 198n, 199n, 202n, 213, 224, 239n, 242, 243, 246n, 256n, 257
Gorgias, 302n, 308, 322, 339n
Gouldner, A., 19n, 107, 334
Gramsci, A., 5–6, 13, 16, 25, 27, 29–30, 37
Griffith, M., 190n, 194n

Guthrie, 149, 150, 273, 275, 278n, 290n, 301n, 302n, 307n, 311n, 318n, 332, 334n, 337n, 343–45, 346n, 349, 350n, 355, 365n, 366

Habermas, J., 143
Hamilton, R., 156n, 164n, 167
Hammond, N. G. L., 166, 199n
Hartsock, N., 226
Havelock, E. A., 94, 110n, 116n, 118n, 163n, 175n, 271–73, 274n, 281, 301n, 302n, 307n, 318n, 337, 339n, 341, 343n, 351n, 358n, 361
Hegel, G. F., 10–12, 11n, 13n, 16–18, 23, 30, 32, 34, 66, 191, 195, 370, 372
Hegemony, 29, 148, 186, 262–63, 271
Henrichs, A., 278n, 295
Herakleitos, 150, 177
Herakles, 82–84, 168, 172, 280n, 281n, 294, 304, 312, 315, 318, 321, 323–25, 330
Herodotus, 146n, 150, 166, 177, 186n, 198, 203, 204, 206, 207, 227, 240n, 242, 249, 250, 253–54, 262, 282, 310n, 362–63
Hesiod, 2, 55, 94–98, 108–14, 117, 118, 121n, 124, 126, 130–31, 134, 138, 139, 141–44, 164, 195–98, 212, 221, 224, 229, 237, 258, 260, 324n, 346, 355n, 357, 362
Hignett, C., 100, 247, 335
Hippias, 312
Historiography, historicizing, 21–24, 27, 31n, 47, 53–56, 85, 92, 107n, 121, 123, 135, 140–58, 183, 186n, 191, 198n, 214, 236, 240, 255–57, 267, 327, 332–41, 370; vs. antiquarianism, 22n
Homer: and Aeschylus, 206, 211, 212, 226, 229, 236–37, 245, 246n, 255, 260; and Hesiod as bad teachers, 149, 341; *phuê* and *phusis* in, 149–50; and Pindar, 175–76; Philoktetes in, 280n; and Plato, 338, 344, 347, 356, 362, 371–73; and Sophokles, 279, 292, 307, 324–25; women in, 85–89, 122–34, 357
Homosexuality, 182, 321n, 338, 339n, 353–54
Hoplites, 144, 146–48, 160, 186
Hubbard, T., 156n, 190

Ideologues, 26, 29–30, 53, 58n, 144. *See also* Poets; Presocratics; Sophists
Ideology, 7, 21, 25, 36, 40–42, 55, 57–64, 76, 79, 88, 94, 106–7, 119, 121–23, 133, 140, 144, 158, 164, 165, 169, 173, 178, 183–84, 193, 198, 220, 225, 236, 244, 250, 255, 259, 262, 267, 269, 273, 274, 279, 281n, 295n, 310, 324, 326–27, 332–41, 358, 362, 370–73
Inherited character (*êthos, phusis*), 201, 205–14; as term, 212n, 231, 233–35, 306, 314, 326
Inherited evil (guilt), 185, 214–21, 251, 255, 260
Inherited excellence, 62–63, 75–77, 85–89, 93, 97–98, 102–6, 114, 119, 132, 140, 144–46, 150–51, 160–63, 168, 181, 182, 185, 193, 255, 269, 277, 311–14, 319, 320, 328, 340–41; and kinship with divinity, 67–70, 83, 88, 90, 149–50—terminology associated with: in Homer 63, 149–50; in Plato, 340–41, 353–69, 372; in sophists, 252–53, 340–41; in Sophokles, 269–71, 292, 320–21. *See also* Nature; *Phusis*
Irigaray, L., 359n, 360n

Jaeger, W., 157, 349, 350n
Jameson, F., 13, 16n, 22n, 27, 29, 33–37, 40–42, 55, 92, 123, 130, 137, 165, 173, 182, 185, 215, 332n
Jarratt, S., 212n, 273n
Jebb, R., 282n, 284n, 287n, 295, 322n, 326n
Jeffrey, L., 147n
Jones, A. H. M., 187n, 248, 253, 254, 310n, 336, 337n
Jones, J., 198, 199n
Justice: in Aeschylus, 197–221, 361; and class, 197–214; and democracy, 250–53 and gods, 238, 241; in Hesiod, 139; in Homer, 82–89, 287n; oligarchic/monarchic, 210–12, 234, 236, 240–41, 260; patriarchal, 131, 245–46; in Plato, 333, 345, 361–65; in Sophokles, 300, 304n, 315; and Trojan War, 86

Kakrides, J., 85n, 86
Kerferd, G. G., 310n, 311n, 318n
Keuls, E., 358n
Kingship (inherited monarchy), 55, 64–77, 94–97, 100–106, 110, 112, 119, 131, 137, 143, 146, 166–67, 195, 197, 203, 206, 219, 232, 235, 240, 246, 261, 336, 351. *See also* Philosopher-monarch
Kirk, G., 53n, 93, 113, 127, 137
Kirkwood, G., 294n, 315, 319n, 323n
Kitto, H. D. F., 202n, 236, 245, 283, 290n, 317n, 324n

Kleisthenes, 222, 247, 261
Knox, B., 190, 198–202, 228, 246, 267n, 269, 271n, 272n, 279n, 282, 296n, 300n, 303n, 304n, 313n, 317n, 358n
Köhnken, A., 166, 171, 179n, 181

Lacey, W. K., 221, 222n
Laclau, E., 14n, 25–26, 359n, 366
Lattimore, R., 202n, 251
Lebeck, A., 200, 201n, 202n, 259
Lefkowitz, M., 164n, 167, 178n
Lekas, P., 11n, 12n, 21n, 22n, 53
Lesky, A., 94, 159, 188n, 199n, 217, 303n, 305n, 311n, 315n, 317n
Lévi-Strauss, C., 14, 36, 48–50, 52, 53, 56–57, 76n, 122, 126
Linforth, I., 290n, 296n, 297n, 317n, 319n
Literacy, 93, 116, 139, 163, 178, 337–38, 343, 372
Lloyd, G. E. R., 179, 259
Lloyd-Jones, H., 191, 199, 211, 214, 216n, 235n, 238n, 256
Long, A., 272n, 286n, 304
Lord, A. B., 44n, 48, 106, 107, 116
Lucía (film), 225n, 232n
Lukács, G., 9n, 11, 13, 16, 32, 42, 45n, 183
Lysias, 339

MacCary, W. T., 23n
Macherey, P., 36, 59, 327, 332n, 333, 341, 351
Machin, A., 290, 302n
MacKendrick, P., 329, 334n, 337n, 339n, 350n
Macleod, C. W., 189, 202n, 211, 238n, 240, 248, 253
Marcuse, H., 35, 37–40, 51
Martin, R., 46, 47, 48n, 66, 84n, 89n, 114n
Marx, K., 7n, 195, 199n; and classics, 17, 25, 191, 215n; and cultural production, 24–26; and Darwin 11n; and double hermeneutic, 34–35; and environment, 14n; and feminism, 14n; and five senses, 18, 20, 25, 38, 373; and labor, 18, 20n, 25; and precapitalist society, 53; and race, 14n; and scientism, 10–12, 18; and utopia, 17–26; and women, 357n
Marxism, orthodox, 6–12, 14, 21n, 27, 106, 334
"Marxist," 1, 6, 9n, 15, 24
Medical writers (of 5th century B.C.), 150, 206, 259

Meter, 43–45, 159, 163, 173–74, 296n, 297n, 341, 372
Michelini, A., 199n
Misogyny, 86, 130, 182, 224–32, 242–46, 256, 258, 358, 360. *See also* Women: male ambivalence toward
Mode of production, 6, 7
Modes of communication/representation/media, 331, 341
Monarchy. *See* Kingship
Money economy, 138, 232
Mouffe, C., 14n, 25–26, 359n, 366
Muir, J. V., 278, 311
Mullen, W., 174
Murnaghan, S., 106n, 107n, 111, 121n, 124n
Murray, O., 138, 142n, 144–46, 186, 187, 188n, 204, 261
Mycenae, 53–54, 94, 203n, 282
Mythic narrative mode, 330, 344n, 348, 361, 366

Nagler, M., 44n, 50–51
Nagy, G., 51, 93n, 122n, 163n
Nature, 19, 31; and culture, 32, 93, 120, 122, 134–39, 213; and feminism, 1n; and nurture, 1, 119, 214, 369; and perversion, 213; in Presocratics, 150
Negation, 40, 66, 82, 84, 89, 90, 119, 158, 176, 180, 182–83, 195, 226, 232, 251, 257, 260, 356, 361, 363, 369, 370–72
Nestle, W., 271, 300n, 305
New Criticism (Anglo-American), 157, 158n, 164
New Right, 3–5, 331
Nimis, S., 49, 65–66
North, H., 238n
Norwood, G., 152, 157, 172, 177, 315

Okin, S., 346n, 357, 359n, 360n, 369
Oligarchy (aristocracy), 55, 94–102, 105–6, 114, 118–20, 138–51, 160, 166n, 177, 185, 193, 196, 203, 204, 214, 219, 231, 239, 240, 248–49, 253–55, 261–63, 281, 324, 328–30, 335–36, 351
Orality, 44, 337–38, 341
Oral poetry: audience reception of, 44, 89–90; formulas in, 44–48, 53, 58, 59, 65–66, 73, 78, 80–81, 116, 119, 175, 206; repeated story patterns in, 44, 49; type-scenes in, 44, 49, 58, 78–82
Ostwald, M., 148n, 216n, 249n

Page, D., 145n, 199n
Paideia, 159

Parry, A., 47, 64–65, 73, 82, 84n,
 85, 88n
Parry, M., 44, 47–48, 155
Patriarchy, 84–90, 105, 127, 132, 196,
 215, 221–32, 242–46, 251, 257, 265
Peasants, 22, 98, 110, 114, 120, 130,
 139, 143–44, 147, 186–87, 192,
 225, 237
Pesistratos, 150n, 186–89, 204, 222,
 250n
Peradotto, J., 198, 199, 200n, 206,
 211, 235
Perikles, 263, 265, 271, 310n, 311, 329,
 334n, 335, 337, 342, 354n, 363
Persuasion, 264, 275, 279n, 301–2, 305,
 308, 313, 317, 327, 339, 351–52. *See
 also* Rhetoric
Philosopher-monarch, 336, 346n
Phusis: and education, 312–13; philo-
 sophical, 349, 364–69; Plato's
 discourse of, 351–69. *See also* Inher-
 ited character; Inherited excellence,
 terminology associated with *Phusus/
 nomos,* 306
Pindar, 37, 120, 274n, 281n, 332n; and
 education, 311, 312, 314, 341, 361;
 and Sophokles, 325, 330, 368–69
Plato, 145, 148; critique of predecessors,
 370–71; *Euthyphro,* 221; and relativity
 of justice, 198; and social compact,
 275; and sophists, 255, 266, 282n,
 311, 370; and Sophokles, 313–14,
 319–20, 351; and Thirty Tyrants,
 335; and women, 260, 265, 350n,
 356–61
Podlecki, A., 142n, 203n, 249n, 250n,
 281, 308n
Poets, 89–90, 98, 112–20, 137, 186, 229,
 149, 164, 173–82, 186, 237, 243n,
 256, 258. *See also* Self-reflexivity
Pomeroy, 193, 338, 358
Post-Marxists, 14–17, 25. *See also* Baud-
 rillard, J.; Laclau, E.; Mouffe, C.
Presocratics, 2, 19, 148–50, 160, 161,
 178n, 259n, 340; anthropological
 speculations of, 216. *See also* Sophists
Prodicus, 312
Protagoras, 254n, 274n, 277n, 278n,
 288n, 302n, 310n, 311n, 313n, 339n,
 343n, 354n, 366
Pucci, P., 113, 115, 116, 118, 122

Race, W., 142n, 155n, 175n
Raven, J., 336n, 343n, 345n, 346n,
 363n, 366
Redfield, J., 49–50, 51, 65, 85, 99, 110n,
 120n, 121n, 129n, 130n, 134n, 137n

Reflectionism, 27, 36, 41, 55, 63–64,
 106, 143, 159, 173, 226, 229, 257,
 261, 350n
Reinhardt, K., 194, 294n, 296n
Religion, 149, 160, 163n, 178; in
 Aeschylus, 236–42, 252–53, 267n,
 268, 272, 276, 277, 278n, 290, 294,
 299n, 315, 322–26, 343n, 364–65
Representation (*mimêsis*). *See* Modes of
 communication
Rhetoric, 338, 341–42, 371. *See also*
 Persuasion
Rhodes, P. J., 186, 246, 262
Ricoeur, P., 345
Romilly, J. de, 254n, 271, 342n
Ronnet, G., 283n, 288n, 302n, 305n,
 306n, 312n, 319n
Rosenmeyer, T., 198, 199n
Rouselle, A., 259
Russo, J., 44n, 45n, 49, 61n, 118n, 125n

Said, E., 30
Ste. Croix, G. E. M. de, 9, 15, 21, 22n,
 27, 98n, 114n, 146n, 188n, 191n,
 192n, 202n, 221, 222, 225, 252, 261,
 263, 336n
Sappho, 184
Sartre, J. P., 215n
Schadewaldt, W., 106, 113, 160
Segal, C., 122, 123, 125, 131, 136, 158n,
 160, 257n, 258, 272, 276n, 281n,
 283n, 294n, 298, 304n, 316
Self-reflexivity/self-consciousness of cul-
 tural producers, 149, 164, 173–82,
 186, 237, 243n, 256, 258, 333, 345,
 347n, 350, 354
Sexual politics, 93, 134, 195–97, 218–
 19, 225–32, 242–46, 371–72; and aris-
 tocracy, 221–32, 252; and democracy,
 252, 256–60. *See also* Feminism;
 Women
Shame culture, 292, 297, 298, 300,
 315–16
Showalter, E., 228
Simonides, 145, 159–60, 162, 177, 181,
 256n
Slater, P., 126, 182n
Slater, W., 154n, 164n, 166
Slavery, 21, 35, 107–8, 110, 334; of tyr-
 anny, 233
Smith, Paul, 33, 37, 42
Smith, Peter, 191, 236, 237n, 238n
Snodgrass, A., 52, 53n, 94n, 97n
Snowden, F., 117n
Social compact, 274–75, 276n, 288–305,
 320, 361

Socialization, 340, 351, 365, 368. *See also* Education

Solmsen, F., 192, 195, 216, 237

Solon, 2, 145, 147, 150n, 184, 187–88, 192–94, 206, 208, 209, 216, 222, 225, 247, 260, 356, 357

Sophists, 2, 19, 153, 174, 178n, 235, 254, 256n, 270–82; anthopological speculations of, 271–78, 357, 361–62; and educational crisis, 338; and Sophokles, 266–330; as term, 277, 307n; and feminism, 358–59

Sophokles: and Aeschylus, 245, 266–70; *Ajax*, 262, 267–70, 302n; *Antigone*, 270; and democracy, 253n, 269–71; and Four Hundred, 327–28; and Plato, 322, 328, 330; and sophists, 266–330; and third actor, 190

Stalin, J., 7n, 10, 13, 16n, 26n, 32, 34

Stanford, W. B., 115, 117n, 121

Starr, C., 97, 110n

Strauss, B., 335n, 336n, 337, 339n, 358n

Strauss, L., 273

Structuralism, 14, 122

Suzuki, M., 79n, 86, 114n, 116, 131n, 134, 187n

Symposia, 147–49, 185, 338

Taplin, O., 201n, 202n, 227, 248, 282, 300n, 313n, 315n

Thalmann, W., 43–45, 68n

Theognis, 2, 145–46, 151

Thomson, George, 8–9, 191

Thornton, A., 44n, 85, 94n, 124

Thrasymachos, 344n, 345

Thucydides, 69, 239n, 240n, 263, 271, 289n, 306n, 315, 329, 339, 342

Trade, 101, 109, 120–21, 138, 144–46, 185, 316–17

Tyranny, 95, 119, 139, 144, 146, 147n, 185–89, 194, 196, 202, 203, 207, 219, 232–35, 240, 250, 251, 277, 319, 359n

Tyrtaios, 64, 74n, 148n, 160

Utopian projection/vision, 33–42, 56, 58, 77, 91, 119, 140, 146, 162, 180, 182, 184, 197, 216, 225, 252, 253, 255, 257, 258, 260–66, 271, 323, 326, 330, 346–48, 350, 361, 364, 369. *See also* Marx, K., and utopia

Vernant, J.-P., 15, 20, 96, 97, 118, 125n, 198, 199, 215, 226, 237, 257, 305

Vickers, B., 191, 200n, 201n, 202n, 207n, 213, 218, 224, 225n, 242, 243n, 246n, 261

Vidal-Naquet, P., 101, 105n, 110n, 122, 135, 359n

Vlastos, G., 278, 301n, 355n

Wade-Gery, H. T., 114, 119n, 137, 253n

Waldock, A. J. A., 279n, 283n

Wallon, W., 214

Warfare: in Athenian Empire, 252; in heroic ideology, 59–61; professionalization of, 336, 351, 362n, 371

Wealth, 145, 206–10, 220, 225, 235, 240, 241, 245, 250–51, 356. *See also* Economics; Money economy

Webster, T. B. L., 271n, 288n, 294n, 304n, 322n

Wender, D., 105n, 359n

West, C., 16n, 40n

West, M. L., 94, 96, 97, 118n, 198n

Whitman, C., 64, 75, 80, 82, 89n, 99, 121n, 163n, 212, 272, 285n, 319n, 325

Wilamowitz-Moellendorff, T. von, 279n, 317n, 319n, 324n

Wilamowitz-Moellendorff, U. von, 153, 166n, 181, 342n

Winnington-Ingram, R. P., 189, 192–94, 198, 199n, 217n, 223n, 226n, 228, 229, 240n, 259, 266–69, 272n, 292n, 296n, 297n, 302n, 303n, 319n, 324, 326, 358n

Women: and Athenian democracy, 224–25, 228, 250, 350; "in common," 346, 355; exclusion of, 192; male ambivalence toward, 124–34, 229; and property, 222, 356, 357; at tragic performances, 338n. *See also* Feminism; misogyny; Patriarchy

Wood, E. M., 3n, 9, 14n, 21n, 187, 188n, 198, 222, 350n, 356n

Wood, N., 350n, 356n

Xenophanes, 148–49, 160, 162, 177, 184, 341

Xenophon, 338

Young, D. C., 144n, 147–48, 154n, 156, 158n, 159, 160, 161n, 162, 163n, 169n

Young, Douglas, 207n, 212n, 233n, 241n

Zeitlin, F., 194, 200n, 201n, 213, 221, 225n, 230, 239n, 257, 259, 338n, 358n

Library of Congress Cataloging-in-Publication Data

Rose, Peter W. (Peter Wires), 1936-
 Sons of the gods, children of earth : ideology and literary form in ancient Greece /
Peter W. Rose.
 p. cm. 5
 Includes bibliographical references and index.
 ISBN 0-8014-2425-9 (alk. paper).—ISBN 0-8014-9983-6 (pbk. alk. paper)
 1. Greek literature—History and criticism. 2. Politics and literature—Greece. 3.
Greece—Politics and government. 4. Marxist criticism. 5. Literary form. I. Title.
PA3015.P63R67 1992 5
880.9′358′0901—dc20 91-31562 V